# UNIVERSITY AND COLLEGE MUSEUMS, GALLERIES, AND RELATED FACILITIES

# UNIVERSITY AND COLLEGE MUSEUMS, GALLERIES, AND RELATED FACILITIES

A Descriptive Directory

VICTOR J. DANILOV

**Greenwood Press**
**Westport, Connecticut · London**

**Library of Congress Cataloging-in-Publication Data**

Danilov, Victor J.
    University and college museums, galleries, and related facilities
 : a descriptive directory / Victor J. Danilov.
      p.   cm.
    Includes bibliographical references and index.
    ISBN 0–313–28613–2 (alk. paper)
    1. Museums—United States—Directories.   2. College museums—
United States—Directories.   3. College museums—United States—
History.   I. Title.
    AM11.D35   1996
    061'.3—dc20        95–20544

British Library Cataloguing in Publication Data is available.

Library of Congress Catalog Card Number: 95–20544
ISBN: 0–313–28613–2

First published in 1996

Greenwood Press, 88 Post Road West, Westport, CT 06881
An imprint of Greenwood Publishing Group, Inc.

Printed in the United States of America

The paper used in this book complies with the
Permanent Paper Standard issued by the National
Information Standards Organization (Z39.48–1984).

10 9 8 7 6 5 4 3 2 1

*Dedicated to staff members of
museums, galleries, and related facilities
who seek to further professional standards and
institutional missions under difficult circumstances
at universities and colleges throughout the nation.*

# Contents

# Preface

This book is about one of the nation's greatest educational and cultural resources—museums, galleries, and related facilities at American universities and colleges. It is the first comprehensive look at such institutions since the publication of Laurence Vail Coleman's *College and University Museums* in 1942.

Relatively little is known about the many types of campus museums and similar facilities, especially from an overview standpoint, even though they comprise more than 13 percent of the 8,179 museums, galleries, and related facilities identified by the American Association of Museums in its 1989 National Museum Survey.

This book is based largely on a survey conducted by the author from 1993 to 1995 of museums and related institutions that are part of American universities and colleges. Of the 1,200 questionnaires mailed, 708 responses were received, although some were incomplete. Additional information about nonresponding institutions was obtained through correspondence, telephone calls, interviews, and other sources. As a result, this volume contains descriptions of 1,108 museums, galleries, and related facilities and has 450 cross-references.

The survey also revealed that there are additional campus museums and similar facilities—particularly art galleries—for which information could not be gathered to be included in this publication. It is clear, however, that there are far more than 1,100 museums, galleries, and related facilities at American universities and colleges, although the exact number is difficult to determine because of the low profile and/or informal structure of some museum-like facilities.

At least 24 different types of museums, galleries, and related facilities can be found at universities and colleges. Approximately half are art museums and

galleries. Other numerous types include natural history museums and centers; archaeology, anthropology, and ethnology museums; historical museums, houses, and sites; botanical gardens, arboreta, and herbaria; and planetaria and observatories.

In addition, there are more specialized museums and other facilities within the art, history, and science fields, covering such disciplines as photography, costumes/textiles, and sculpture in the art field; agriculture, medicine/dentistry/health, music, religion, and library/archives in the history area; and geology/mineralogy/paleontology, zoology, entomology, marine sciences/aquariums, and science/technology in the sciences. Some are combinations with several different types of collections and exhibits.

These various institutions have many similarities and differences in how they are founded, governed, organized, funded, and operated. This volume examines their history, role, management, collections, exhibits, programming, facilities, funding, attendance, needs, likely future, and other areas.

The first university and college museums and related facilities in the United States began to appear in the early nineteenth century, with the largest growth occurring in the last 50 years since World War II. Many of the institutions evolved from the teaching and research collections of academic departments and their faculty members. Some were established to provide such resources, while others resulted from gifts of funds and collections. Still others were founded primarily for the education and enjoyment of the university/college community or other purposes.

Most of the museums and similar facilities have extensive collections of artifacts, artworks, and/or specimens that are invaluable in teaching, research, and public education, while others rely more on participatory exhibits, theater presentations, costumed interpretations, and other educational experiences in telling their stories. In general, campus museums and related facilities are internally focused, although some also seek to attract and serve the public at large.

Over the years, museums and similar facilities have earned a greater role and higher exposure on the campus. They also have grown in size, staff, budget, and attendance. Yet, most still suffer from the lack of adequate space, personnel, funding, and/or other needs. Increased support and appreciation are necessary to help these institutions that provide such great service in developing and caring for artistic, historic, scientific, and cultural treasures; enhancing instruction; advancing knowledge; and furthering campus and public understanding in their respective fields.

This volume would not have been possible without the extraordinary cooperation of those who participated in the survey, provided additional information, and facilitated the gathering and interpretation of data. The author is extremely grateful to all who have assisted with the work.

*Chapter 1*

# The Campus Museum

More than 1,100 museums, galleries, and museum-like facilities can be found at universities and colleges in the United States. They come in many types, sizes, and configurations. They are similar, yet different, from the nation's comparable nonacademic institutions.

Like many other museums and related facilities, they usually collect, preserve, display, and interpret collections of artifacts, artworks, specimens, and/or other objects of intrinsic value. But they differ in one fundamental respect—their "study" function. They have instructional and research roles that many public and private museums do not. They also are aimed primarily at campus audiences—students, faculty, and staff—rather than the general public, although many also try to attract and serve residents in their community and region, alumni, and tourists.

Approximately half of the institutions are art museums and galleries. Other types of museums, galleries, and related facilities found on campuses cover such diverse fields as agriculture, anthropology, archaeology, astronomy, botany, costumes, dentistry, entomology, ethnology, geology, history, horticulture, marine sciences, medicine, mineralogy, music, natural history, paleontology, photography, religion, science, sculpture, technology, textiles, and zoology. In addition, there are general museums, museums in other fields, libraries and archives with collections and galleries, contract science facilities, and even some museums not part of the universities and colleges where they are located.

Some universities and colleges have a single museum or gallery, while others have multiple facilities. A number have "umbrella" art and/or natural history complexes, such as Harvard University and the Universities of California, Kan-

sas, and Michigan. It is not unusual to find campus museums and similar facilities tucked away in small spaces in old buildings, while some—such as the art museums at Wellesley and Vassar colleges and the universities of Florida and Minnesota—are housed in new multi-million-dollar structures.

## SMALL TO LARGE FACILITIES

Many museums and related facilities—particularly art galleries and highly specialized museums—have only several thousand square feet for their operations. Most facilities are small or medium-sized, while a few large museums have buildings of 200,000 square feet or more, as is the case with the University of Pennsylvania Museum of Archaeology and Anthropology and the Harvard University Art Museums.

Some colleges and universities have large spaces devoted to outdoor living history museums, such as those covering 250 acres administered by Earlham College and 120 acres operated by Utah State University. Even more extensive acreage can be found at some arboreta and forests. These include a 3,000-acre forest and 2,500-acre arboretum at Harvard University, a 3,000-plus-acre arboretum at Cornell University, and the 1,600-acre campus of Ohio State University used as an arboretum.

Most university and college museum, gallery, and related facility staffs and budgets are relatively small, primarily because of the modest size of their operations and because many are part of academic departments, with faculty members often serving as curators and students assisting with the work. Some of the larger museums, however, have much bigger staffs and budgets, as with the University of Florida's natural history museum, which has a full-time staff of 84, a part-time staff of 150, and an annual budget of nearly $6 million, and Harvard University's art museums, with a full-time staff of 69, a part-time staff of 87, and a budget of approximately $8 million.

The attendance at many campus museums, galleries, and related facilities is quite small, often being less than 5,000 or 10,000 a year, consisting largely of students, faculty, and staff. But some have sizable numbers of off-campus visitors because they also attract and serve school groups and residents from the area, as well as alumni and tourists. The University of Wisconsin–Madison Arboretum has over 600,000 visitors annually. Among those with 300,000 to 400,000 annual attendances are the Michigan State University Museum; University of Texas Institute of Texan Cultures at San Antonio; U.S. Naval Academy Museum; Stephen Birch Aquarium-Museum, Scripps Institution of Oceanography, University of California, San Diego; Waikiki Aquarium, University of Hawaii; Lawrence Hall of Science, University of California, Berkeley; and Washington Park Arboretum, University of Washington. Two federal facilities located on university campuses also have attendances in the same range—the Lyndon Baines Johnson Library and Museum at the University of

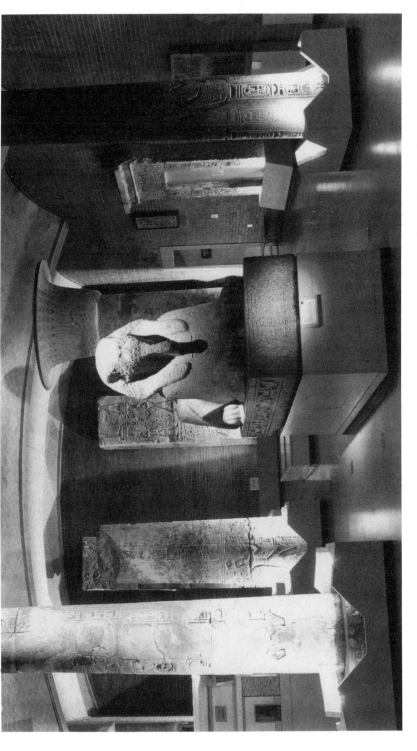

**Figure 1.** The Sphinx of Rameses II is the focus of the Egyptian Gallery at the 246,000-square-foot University of Pennsylvania Museum of Archaeology and Anthropology in Philadelphia. This 12-ton sphinx (ca. 1293–1185 B.C.) is one of the largest that survives. (*Courtesy University of Pennsylvania Museum of Archaeology and Anthropology*)

Texas at Austin and the George Washington Carver Museum at the Tuskegee Institute National Historic Site at Tuskegee University.

## EARLY COLLECTIONS AND MUSEUMS

Although most university and college museums, galleries, and related facilities were not founded until the twentieth century, many began as teaching and research collections of academic departments and faculty members in the nineteenth century, and a few in the late eighteenth century. Among the early collections that later developed into museums were art collections at Dartmouth College, Bowdoin College, and the University of Michigan; mineral collections at Harvard and Yale universities; natural history collections at Princeton University and Amherst College; and mineral and fossil collections at the University of South Carolina.

In the art field, the nation's first art school and art museum (Museum of American Art) were founded at the Pennsylvania Academy of the Fine Arts in Philadelphia. Other early art facilities were the Trumbull Gallery at Yale University (which later developed into the Yale University Art Gallery) and an art museum (which evolved into the Frances Lehman Loeb Art Center) established at the founding of Vassar College.

The first natural history "museums" on campuses were a cabinet of natural history at the University of Michigan (which became the Museum of Zoology and then the University of Michigan Museums of Natural History) and a museum-like facility at Amherst College (evolving into the Pratt Museum of Natural History). The first major natural history museum (later renamed the Museum of Comparative Zoology) was established at Harvard University in the mid-nineteenth century.

Among the museums and similar facilities in other fields that trace their foundings to the nineteenth century are the Harvey Cushing/John Hay Whitney Medical Library at Yale University, Haverford College Arboretum, Harvard University Observatory, U.S. Naval Academy Museum, Harvard University Herbaria, Peabody Museum of Archaeology and Ethnology at Harvard University, and W.J. Beal Botanical Garden at Michigan State University.

## TWENTIETH-CENTURY DONORS

In the twentieth century, numerous campus museums, galleries, and related facilities were founded and/or provided with new buildings as a result of major contributions by individuals, frequently alumni. Most of these institutions are in the art field and are named for the donors—such as the David and Alfred Smart Museum of Art at the University of Chicago, Hood Museum of Art at Dartmouth College, Herbert F. Johnson Museum of Art at Cornell University, Samuel P. Harn Museum of Art at the University of Florida, and Frederick R. Weisman Art Museum at the University of Minnesota. Among those in other fields are

the James Ford Bell Museum of Natural History at the University of Minnesota, Boyce Thompson Southwestern Arboretum at the University of Arizona, and Stephen Birch Aquarium-Museum at the University of California, San Diego.

Some major donors with large collections also have given all or part of their collections—often with funds—to help start university and college museums (again principally in the art field), as occurred in the launching of such museums as the Yale Center for British Art, Arizona State University Art Museum, Philip and Muriel Berman Museum of Art at Ursinus College, Henry Art Gallery at the University of Washington, Cranbrook Academy of Art Museum, and Monte L. Bean Life Science Museum at Brigham Young University.

Collections are the core of university and college museums, with the largest being systematics collections at natural history museums, such as the University of Nebraska State Museum, Peabody Museum of Natural History at Yale University, and Florida Museum of Natural History at the University of Florida— all with over 10 million specimens and artifacts.

Among the substantial collections in other fields—ranging from 2 to 5 million—are those at the Bohart Museum of Entomology at the University of California, Davis; Harvard University Herbaria; Phoebe A. Hearst Museum of Anthropology at the University of California, Berkeley; Thomas Burke Memorial Washington State Museum at the University of Washington; and History of Aviation Collection at the University of Texas at Dallas.

Collections at art museums tend to be much smaller, but frequently more highly valued dollar-wise because of the worth of artworks. Art museums with more than 100,000 objects include the Harvard University Art Museums, Museum of Art at the Rhode Island School of Design, and Yale University Art Gallery. Most art galleries do not have collections or engage in research. They feature changing exhibitions, usually of a contemporary nature and based on art from outside sources, traveling shows, and student/faculty works.

## RESEARCH, EXHIBITS, AND PROGRAMS

Most collections are used in teaching and research programs on the campus. They often are utilized to illustrate classroom, studio, and laboratory instruction and are the basis of much graduate and research work in their fields. Some of the larger museums and related facilities have curators and graduate assistants who devote a considerable amount of their time and energy to research projects and publications based on their investigations.

Collections also are the key ingredients of many permanent exhibits, temporary exhibitions, and public programs, such as gallery talks, guided tours, lectures, films, and outreach activities. It is the artifacts, artworks, and specimens displayed in museums and other such facilities that most visitors come to see. The objects on exhibit usually represent only a small percentage of a museum's or similar facility's total collections.

Some exhibits consist almost entirely of artworks displayed on the wall or

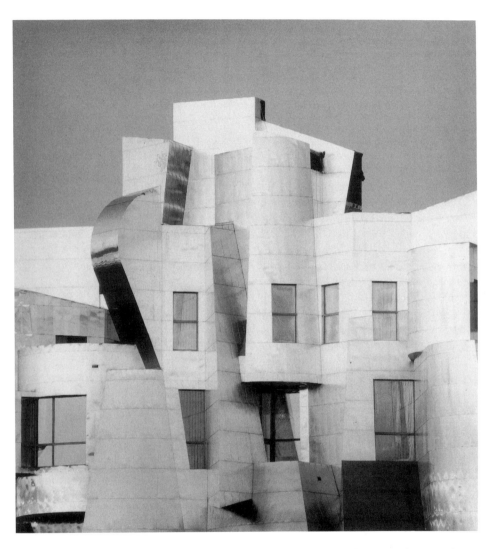

**Figure 2.** This $10.3 million, 47,300-square-foot building is the home of the Frederick R. Weisman Art Museum at the University of Minnesota in Minneapolis. The spectacular stainless steel structure, designed by Frank O. Gehry, opened in 1993 on a bluff overlooking the Mississippi River. *(Courtesy Frederick R. Weisman Art Museum and photographer Chris Faust)*

artifacts and specimens in cases. Others make use of dioramas, interactive techniques, and/or audiovisual devices in displaying and/or interpreting the objects.

Many of the museums and related facilities also use duplicates or illustrations of collection objects in public programming activities on and off the campus. Some even have loan kits of materials, especially in the natural history field, that are made available to schools as part of outreach activities.

## LOOKING AHEAD

University and college museums, galleries, and related facilities in the United States have come a long way in two centuries. They have gone from miscellaneous collections to comprehensive institutions that play a significant role in the instructional, research, and cultural life of the campus. They have increased enormously in number, size, and importance, and some now rank among the leading facilities in the nation and/or world in their fields.

New museums and new buildings continue to be developed on the campus—largely through the generosity of alumni and other donors. But the pace is slowing, and most museums are struggling as university and college budgets become tighter and costs continue to rise. Academic departments responsible for museums and related facilities also are less supportive in many instances because of their financial crunch as well as other instructional and research needs.

The author's survey of America's museums, galleries, and related facilities at universities and colleges clearly shows that many lack sufficient funding and have other needs—such as space and staffing—and that the future does not look encouraging in an era of cutbacks and no growth. Most museums and similar facilities urgently need more funding to better store and care for collections, maintain their buildings, expand and compensate their staffs, present better exhibits and programs, and market their offerings. Yet, they are facing increasing institutional pressure to do more with less—or to find outside funds or cut back on their operations.

*Chapter 2*

# A Historical Overview

Universities and colleges have had collections, museums, galleries, and related facilities since the earliest days. The world's first museum is believed to have been a museum with statues, astronomical and surgical instruments, animal hides, elephant trunks, and a botanical and zoological park, founded at a philosophical academy/university in the third century B.C. in Alexandria, Egypt.

The first true botanical gardens were developed in the sixteenth century. They were followed by the initial public museums—the cabinets of art and natural curiosities at Basel University in Switzerland and the Ashmolean Museum of natural history at Oxford University in England in the late seventeenth century. In the years that followed, university and college museums began developing throughout the Continent and other parts of the world.

The founding of collections, museums, galleries, and related facilities at American universities and colleges occurred nearly simultaneously with the growth of such activities off campus in communities—first on the East Coast and then across the country as the emerging nation developed westward.

It was in the late eighteenth century that the first teaching and research collections of artifacts, artworks, and specimens began appearing at early American universities and colleges, primarily in New England and the mid-Atlantic region. By the early and mid-nineteenth century, the first campus museums were being established. These collections and museums were the forerunners of today's more than 1,100 university and college museums, galleries, and related facilities.

The early collections were assembled largely by faculty members and academic departments, initially for instructional and research purposes and later for exhibit and study in museums and comparable institutions. In other cases, the

original collections were donated by individual collectors and supporters of the universities and colleges.

## EARLY COLLECTIONS

Harvard University began collecting as early as 1750 (portraits on walls considered furnishings), but it was not until the late eighteenth century and early nineteenth century that more typical academic collections were started—many of which led to the founding of campus museums.

One of the first university and college art collections began at Dartmouth College in 1772 when Governor John Wentworth gave the college a silver bowl made by two of Paul Revere's competitors, Daniel Henchman and Nathaniel Hurd. This led to a large, diverse collection that was exhibited at various campus locations over the years, eventually being housed in the Hopkins Center for the Creative and Performing Arts in 1962 and then the new Hood Museum of Art in 1985. The 41,535-square-foot museum now has approximately 60,000 objects in its collection, which is strongest in Old Master prints, American art, and Native American, African, and Oceanic art.

Another early collection started in 1784 at Harvard University. It was a collection of minerals in what later became the Department of Earth and Planetary Sciences. That collection developed into a major systematic collection of over 250,000 minerals, ores, rocks, meteorites, and gems at the Mineralogical and Geological Museum, now part of the Harvard University Museums of Natural History complex. A third early collection was the Georgetown University Collection, consisting of art and historical objects, which began in 1789.

The number of campus collections increased substantially in the early 1800s, and many of these collections later evolved into museums. Among these collections were a mineral collection at Yale University (which later became the Peabody Museum of Natural History), started in 1802; a natural history cabinet at Princeton University (Princeton University Museum of Natural History), 1805; an art collection at Bowdoin College (Bowdoin College of Art), 1811; and a mineral and fossil collection at the University of South Carolina (McKissick Museum), 1823.

Other early mineral and natural history collections started during this period were those at the University of Pennsylvania in 1808, Williams College in 1816, and Amherst College in 1825. As Laurence Vail Coleman, director of the American Association of Museums and author of *College and University Museums,* observed in 1942:

These and other beginnings were inspired by interest in what was still an unfamiliar environment, and collecting was a sampling process, just as it was with state geological and natural history surveys which were soon to follow. In fact, the surveys themselves created several cabinets, most notably that of Michigan in 1837.

## THE FIRST MUSEUMS

The nation's first art school and art museum were founded in 1805 at the Pennsylvania Academy of Fine Arts in Philadelphia. The academy was established by Philadelphia artists and business leaders to provide classical training for artists in a period when the teaching of art still was not common in colleges and universities. The museum—now the Museum of American Art—was started to allow students the opportunity to study the Old Masters. Since then, the museum has developed one of the finest collections of American art.

Another early development in the art field was the founding of Trumbull Gallery at Yale University in 1832. It resulted from the gift of 100 paintings to the institution by Colonel John Trumbull in exchange for an annual stipend for the aging patriot-artist. The agreement included a separate gallery structure to display Trumbull's Revolutionary War–period paintings. It was this collection that led to the formation of the Yale University Art Gallery, which now occupies a 100,123-square-foot building and has more than 100,000 works in its collection, best known for its American decorative arts and furniture.

Several natural history facilities displaying collections followed in the 1830s. The first was a cabinet to display scientific specimens at the University of Michigan. It was established at the first meeting of the Board of Regents after the university was founded in 1837. However, the cabinet did not have a separate room until 1856 and had to wait until 1882 for its own building. The collection became the Museum of Zoology and later part of the University of Michigan Museums of Natural History, now housed in the 1928 Ruthven Museums Building.

The Pratt Museum of Natural History at Amherst College started as a museum-like facility in 1838. It resulted from the fossil footprint and rock collection and interests of President and Professor Edward Hitchcock. Since then, the collection has been supplemented in other fields by other faculty members and alumni. The present museum opened in 1947 in a converted 1883 gymnasium and now features vertebrate paleontology, ichnology, and anthropology collections.

Among the other types of museums and facilities that appeared during this period were a medical library that later had museum-like collections and exhibits (now the Harvey Cushing/John Hay Whitney Medical Library at Yale University), 1814; an arboretum (which became the Haverford College Arboretum), 1833; a college observatory (now Harvard University Observatory), 1839; and a history museum (U.S. Naval Academy Museum), 1845.

The Harvard College Observatory was a pioneering astronomical facility in the United States. A 15-inch telescope—called the ''Great Refractor''—was installed in 1847 and was the nation's largest telescope for 20 years. The telescope, which still can be seen at the observatory, was instrumental in many early observations and discoveries, experiments with photography, and star cataloging programs. Since 1955, the observatory has been part of the Harvard-Smithsonian

Center for Astrophysics, a joint operation of Harvard and the Smithsonian Institution, based in Cambridge.

The U.S. Naval Academy Museum was the first of three military historical museums founded in the mid-nineteenth century. The other two were the West Point Museum at the U.S. Military Academy and the VMI Museum at the Virginia Military Institute. All three, which trace the history of their institutions and military services, are still in operation today.

## A PERIOD OF RAPID GROWTH

The second half of the nineteenth century was a period of rapid development of university and college collections, museums, galleries, and related facilities. Collections for what later became the University of Michigan Museum of Art began in 1855 with the purchase of a set of engravings to illustrate lectures on classical antiquity; a collection of geological specimens—which developed into the Strecker Museum—was formed at Baylor University in 1856; the first collections that led to the founding of the Michigan State University Museum, a museum of natural and cultural history, were initiated in 1857; the Iowa legislature charged the University of Iowa in 1858 with housing a collection of geological specimens that developed into the Museum of Natural History; and two museums were founded at Harvard University—the Museum of Vegetable Products in 1858 and the Museum of Comparative Zoology in 1859.

The Museum of Vegetable Products, which later was renamed the Botanical Museum, became known for its spectacular collection of plants and flowers made of delicate blown glass. Approximately 847 life-sized models and over 3,000 models of enlarged plants and flowers were made by a father-and-son team of German glass artisans, Leopold and Rudolph Blaschka, over a half century. Professor George Goodale, the first director of the Botanical Museum, decided that a museum of dried plants and flowers was insufficient to convey the beauty and delicacy of botanical specimens. When he saw the replicas of marine invertebrates created by the Blaschkas in Dresden, he convinced them to come to Harvard to produce the detailed glass models of plants and flowers still featured at the museum.

The other Harvard museum was the first major natural history museum on a university/college campus. The Museum of Comparative Zoology often is called the Agassiz Museum because it was founded by noted Swiss zoologist Louis Agassiz, who believed learning was more effective when students could look at and feel actual specimens of animals, rather than relying entirely upon books. The focus of the museum's current research and exhibits is on animals and how they evolved, where they live, and their similarities and differences. Both the Botanical Museum and the Museum of Comparative Zoology are part of the present-day Harvard University Museums of Natural History complex, which includes four museums (the other two being the Mineralogical and Geological Museum and the Peabody Museum of Archaeology and Ethnology).

The Peabody Museum of Archaeology and Ethnology was founded in 1866 with a grant from philanthropist George Peabody, who also was responsible for establishing the Peabody Museum of Natural History at Yale University in the same year. The Harvard museum is the oldest in this hemisphere devoted entirely to the disciplines of archaeology and ethnology and houses treasures from prehistoric and historic cultures throughout the world. The Peabody museum at Yale now has one of the largest campus collections, consisting of more than 10 million specimens in natural history, archaeology, and ethnology.

## A Surge in Science Museums

Numerous other natural history and specialized scientific collections, museums, and facilities—in such fields as astronomy, entomology, geology, mineralogy, paleontology, and zoology—followed these initial efforts. Among today's museums that trace their beginnings to this period are the University of Kansas Natural History Museum, 1866; Museum of Natural History, University of Illinois, 1867; University of Nebraska State Museum, 1871; James Ford Bell Museum of Natural History, University of Minnesota, 1872; Colorado School of Mines Geology Museum, 1874; Benedictine College Museum, 1878; Stephens Museum of Natural History, Central Methodist College, 1879; University of North Dakota Zoology Museum, 1883; Museum of Geology, South Dakota School of Mines and Technology, 1885; Leander J. McCormick Observatory, University of Virginia, 1885; University of Wisconsin Zoological Museum, 1887; Geological Museum, University of Wyoming, 1887; Lick Observatory, University of California, 1888; University of Arizona Mineral Museum, 1891; University of Northern Iowa Museum, 1892; Orton Geological Museum, Ohio State University, 1893; Charles R. Conner Museum, Washington State University, 1894; Snow Entomological Museum, University of Kansas, 1897; and Oklahoma Museum of Natural History, University of Oklahoma, 1899.

In addition to the new Peabody museums at Harvard and Yale founded in 1866, many other collections and museums of archaeology, anthropology, and/or ethnology had their start during the second half of the nineteenth century, including the Johns Hopkins University Archaeological Collection, 1884; Thomas Burke Memorial Washington State Museum, University of Washington, 1885; University of Pennsylvania Museum of Archaeology and Anthropology, 1887; Harvard University Semitic Museum, 1889; Arizona State Museum, University of Arizona, 1893; Logan Museum of Anthropology, Beloit College, 1894; and Oriental Institute Museum, University of Chicago, 1896.

A number of leading archaeological museums—such as those at the Universities of Pennsylvania and Chicago—were among those most active during the period of great exploration in the Near East and elsewhere. The first excavation by staff members of the 246,000-square-foot University of Pennsylvania Museum of Archaeology and Anthropology was in 1888–1890 at Nippur in Iraq. The museum has since engaged in more than 300 expeditions in 33 countries. The Oriental Institute at the University of Chicago developed a major museum

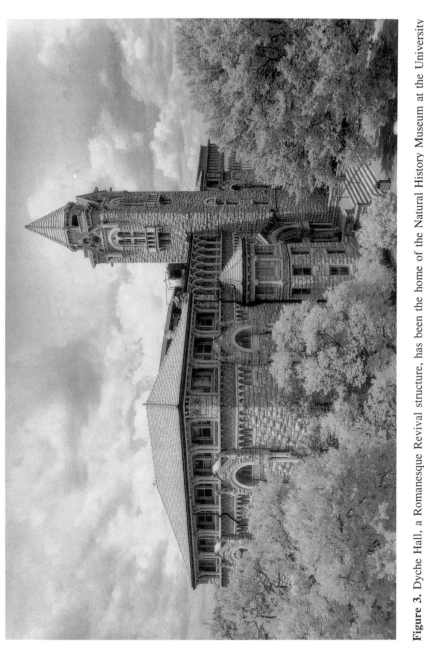

**Figure 3.** Dyche Hall, a Romanesque Revival structure, has been the home of the Natural History Museum at the University of Kansas in Lawrence since 1903. The museum now is one of five comprising the University of Kansas Natural History Museum, an umbrella natural history administrative system. (*Courtesy University of Kansas Office of University Relations*)

of the history, art, and archaeology of the ancient Near East as a result of numerous expeditions to Egypt, Iraq, and other parts of the Near East.

This period also spawned various other science-related facilities—including botanical gardens, arboreta, and herbaria. Among the first botanical gardens were the W.J. Beal Botanical Garden at Michigan State University, 1873, and the Botanic Garden of Smith College, 1895. Two of the largest and most highly regarded arboreta were founded during the latter part of the nineteenth century— the Arnold Arboretum of Harvard University, 1872, and the Morris Arboretum of the University of Pennsylvania, 1887. Many herbaria also came into being— the Beal-Darlington Herbarium, Michigan State University, 1863; Harvard University Herbaria, 1864; Kansas State University Herbarium, 1871; University Herbarium, University of California, Berkeley, 1872; Greene-Nieuwland Herbarium, University of Notre Dame, 1879; Arthur Herbarium, Purdue University, 1887; and Rocky Mountain Herbarium, University of Wyoming, 1893.

The Arnold Arboretum, the oldest public arboretum in the United States, now occupies 265 acres and has over 7,000 varieties of ornamental trees and shrubs, while the Morris Arboretum is a 166-acre living museum of approximately 6,800 labeled trees and shrubs. Both are deeply involved in plant research, instruction, and public programs.

## Early Art Collections, Museums, and Galleries

Art collections, museums, and galleries paralleled the development of science-oriented collections and facilities in the second half of the nineteenth century. In addition to the casts of classical sculpture obtained by the University of Michigan in 1855, Harvard University accepted the Gray collection of engravings in the 1850s, and Yale acquired the Jarves collection of Italian primitives in the 1860s for its evolving art collection, which later became the Yale University Art Gallery.

Many other universities and colleges began art collections and/or museums during this period. Among the present-day museums that resulted from these early efforts are the Frances Lehman Loeb Art Center, Vassar College, 1864; Smith College Museum of Art, 1875; Mabee-Gerrer Museum of Art, Saint Gregory's College, 1875; Michael C. Carlos Museum, Emory University, 1875; Mount Holyoke College Art Museum, 1876; Museum of Art, Rhode Island School of Design, 1877; Washington University Gallery of Art, 1881; Princeton University Art Museum, 1882; Davis Museum and Cultural Center, Wellesley College, 1889; Fogg Art Museum, Harvard University, 1891; Wright Museum of Art, Beloit College, 1892; Stanford University Museum of Art, 1894; and Bowdoin College Museum of Art, 1894.

Some of these art collections developed into major campus art museums. Perhaps the best known is the Fogg Art Museum, which received a $220,000 bequest for its founding in 1891 and opened in 1895. It originally housed mostly reproductions, but then developed into one of the nation's leading art museums and the core of the Harvard University Art Museums complex, which also in-

cludes the Busch-Reisinger Museum and the Arthur M. Sackler Museum. The Fogg Art Museum now specializes in the art of Europe and North America in all media from the Middle Ages to the present, and the Harvard art complex has the largest collection of artworks (over 130,000) at any American university or college.

Instead of starting art collections and museums during this period, some universities and colleges created art galleries primarily for the display of art from students, faculty, and/or outside sources. They included such current galleries as the Lehigh University Art Galleries, 1864; San Francisco Art Institute galleries (which began as San Francisco Art Association showings), 1870; and Wood Art Gallery, Vermont College, 1891. As some galleries evolved, they also developed small collections and/or managed an institution's art collection.

A number of general museums also began on campuses during the second half of the nineteenth century. Among the early museums that collected and exhibited a variety of materials—such as artworks, historical objects, scientific specimens, and/or other items—were the Hampton University Museum, founded in 1868; University Museum, Southern Illinois University at Carbondale, 1869; University Museum, University of Arkansas, 1873; and McPherson Museum, McPherson College, 1890. One of the first historic houses—the 1803 John C. Calhoun House, called Fort Hill—was bequeathed to Clemson University and opened in 1889.

## TURN-OF-THE-CENTURY DEVELOPMENTS

The early twentieth century saw the development of more collections, museums, galleries, and related facilities, including some in new fields, such as religion, musical instruments, marine sciences and aquariums, and outdoor statuary halls of fame.

The largest number of new collections and facilities in the first two decades appeared in the natural history and science-related fields. They included the Mineral Museum at Montana College of Mineral Science and Technology, 1900; North Museum of Natural History and Science, Franklin and Marshall College, 1901; Northwestern Oklahoma State University Museum, 1902; University of Colorado Museum, 1902; Joseph Moore Museum of Natural History, Earlham College, 1904; Minerals Museum, University of Missouri–Rolla, 1904; University of Cincinnati Geology Museum, 1907; Museum of Vertebrate Zoology, University of California, Berkeley, 1908; and Florida Museum of Natural History, University of Florida, 1917.

Four major outdoor facilities also came into being—the Harvard Forest at Harvard University, 1907; Nichols Arboretum and Matthaei Botanic Gardens at the University of Michigan, 1907; and Harold L. Lyon Arboretum at the University of Hawaii at Manoa, 1918. In addition, the Phoebe A. Hearst Museum of Anthropology at the University of California, Berkeley, and the World Her-

itage Museum at the University of Illinois can trace their origins to this period, 1901 and 1911, respectively.

Among the art collections, museums, and galleries that received their start at this time were the Museum of Ceramic Art, Alfred University, 1900; Fine Arts Collection, Luther College, 1900; Busch-Reisinger Museum, Harvard University, 1901; Memorial Art Gallery, University of Rochester, 1913; Renaissance Society, University of Chicago, 1915; University Art Museum, University of California, Santa Barbara, 1916; and Allen Memorial Art Museum, Oberlin College, 1917.

The Jewish Museum, a Judaica cultural history and art museum, also was founded in New York City in 1904 under the auspices of the Jewish Theological Seminary of America, and the Skirball Museum, a more religiously oriented cultural and art museum, was established as the Union Museum at the Hebrew Union Museum–Jewish Institute of Religion in Cincinnati in 1913.

Other new museum-like institutions initiated after the turn of the century were the Hall of Fame for Great Americans, a collection of outdoor busts of illustrious Americans, started by New York University in 1900 and now part of the Bronx Community College of the City University of New York; two musical instruments collections—the Yale University Collection of Musical Instruments, 1900, and the Stearns Collection of Musical Instruments at the University of Michigan, 1912; and two marine sciences museums and aquariums—the present-day Stephen Birch Aquarium-Museum at the Scripps Institution of Oceanography at the University of California, San Diego, 1903, and the Waikiki Aquarium, which began as a commercial attraction in 1904 and became part of the University of Hawaii in 1919.

## AN ACCELERATING PACE

The development of new university and college collections, museums, and related facilities accelerated in the period from the 1920s through the early 1940s. This was especially true in the art field, which began to see increasing support and contributions of art from individuals outside the academic community. Some art museums and galleries also benefited from the Works Progress Administration (WPA) arts program.

Among the art museums initiated by private gifts were the Harwood Foundation Museum, started by Lucy Case Harwood in 1923 and transferred to the University of New Mexico in 1935; Mulvane Art Museum, a gift to Washburn University by Joab Mulvane, 1924; Henry Art Gallery, made possible by a collection of 126 paintings and $100,000 received by the University of Washington from Horace C. Henry, 1927; Spencer Museum of Art at the University of Kansas, started with an art collection from Sallie Casey Thayer in 1928 and later housed in a building constructed with funds from Helen Foresman Spencer in 1978; Bayly Art Museum, resulting from a 1929 bequest of $100,000 from Evelyn Bayly Tiffany to establish an art museum at the University of Virginia,

1935; Cranbrook Academy of Art Museum, featuring the private collection of George and Ellen Booth, founders and patrons of the Cranbrook Educational Community, 1930; Robert Hull Fleming Museum, made possible by a gift to the University of Vermont by Fleming's niece, 1931; University of Oregon Museum of Art, built to house a founding gift of Asian art and other contributions, 1933; Ball State University Museum of Art, assisted by five members of the Ball family, 1935; and Fisher Gallery at the University of Southern California, which received 72 paintings and funds from Elizabeth Holmes Fisher to build an art museum, 1939.

Those campus art institutions that were helped in their foundings through the acquisition of art and/or funds from the WPA program included the Fred Jones Jr. Museum of Art at the University of Oklahoma, 1936, and the Indiana University Art Museum, which opened as a gallery in 1941.

Other art museums continued to be generated internally by art departments, faculty, and/or administrators, including the Williams College Museum of Art, 1926; Frederick R. Weisman Art Museum (which began as a gallery) at the University of Minnesota, 1934; and Weatherspoon Art Gallery at the University of North Carolina at Greensboro, 1942.

Among the current art galleries started during this period are the Schick Art Gallery, Skidmore College, 1926; Oregon State University Memorial Union Gallery, 1927; Wisconsin Union Art Galleries, University of Wisconsin–Madison, 1928; Doris Ulmann Galleries, Berea College, 1935; Ruth Chandler Williamson Gallery, Scripps College, 1936; Frank T. Tobey Memorial Gallery, Memphis College of Art, 1936; Turman Art Gallery, Indiana State University, 1939; University of Colorado Art Galleries, 1939; and Eagle Gallery, Murray State University, 1941.

## Internally Generated Science Museums

Most natural history and related specialized museums and facilities established at this time evolved from departmental and faculty collections—and many of them were named for professors who collected and used the founding specimens in teaching and research. They included the Wilbur Greeley Burroughs Geologic Museum at Berea College and Fryxell Geology Museum at Augustana College in the 1920s; Essig Museum of Entomology at the University of California, Berkeley, 1939; and Frost Entomological Museum at Pennsylvania State University, 1937.

Among the other current natural history museums and related science facilities started were the John E. Conner Museum at Texas A&M University–Kingsville, 1925; University of Alaska Museum, 1929; Museum of Southwestern Biology, University of New Mexico, 1930; Earth and Mineral Sciences Museum and Gallery, Pennsylvania State University, 1930; University of Texas McDonald Observatory, 1932; Museum of Natural Science, Louisiana State University, 1936; Museum of Natural History, University of Oregon, 1936; Texas Memorial Museum, University of Texas at Austin, 1936; Centennial Museum, University

of Texas at El Paso, 1937; and Museum of Geology, South Dakota School of Mines and Technology, 1939.

New archaeology, anthropology, and/or ethnology museums included the Kelsey Museum of Archaeology, University of Michigan, 1928; Museum of Anthropology, University of Michigan, 1929; Museum of Anthropology, University of Kentucky, 1931; Wickliffe Mounds (an archaeological site), Murray State University, 1932; Ataloa Lodge Museum, Bacone Junior College, 1932; Maxwell Museum of Anthropology, University of New Mexico, 1932; and Jesse Peter Museum, started with a WPA grant at Santa Rosa Junior College, 1935.

Among the botanical gardens, arboreta, herbaria, and related facilities that originated in this period were the Herbarium of the University of Michigan, 1921; Herbarium at the University of the Pacific, 1926; Orland E. White Arboretum, University of Virginia, 1927; Scott Arboretum, Swarthmore College, 1929; Boyce Thompson Southwestern Arboretum, University of Arizona, 1929; Mildred E. Mathias Botanical Garden and UCLA Herbarium, University of California, Los Angeles, 1930; Connecticut College Arboretum, 1931; Intermountain Herbarium, Utah State University, 1931; Washington Park Arboretum, University of Washington, 1934; University of Wisconsin–Madison Arboretum, 1934; Fay Hyland Botanical Plantation, University of Maine, 1934; Cornell Plantations, Cornell University, 1935; Fisher Museum at the Harvard Forest, 1940; and three Michigan State University off-campus facilities—W.K. Kellogg Bird Sanctuary, 1927; W.K. Kellogg Experimental Forest, 1930; and Fred Russ Experimental Forest, 1942.

## Increase in Historical Facilities

Universities and colleges also started to become more active in developing historical museums, houses, sites, and libraries. Among the new museums were the Panhandle-Plains Historical Museum, Western Texas A&M University, 1921; Ralph Foster Museum, College of the Ozarks, 1922; Fellow-Reeve Museum of History and Science, Friends University, 1929; Roosevelt County Museum, built as a WPA project by a local historical society and given to Eastern New Mexico University, 1934; George W. Carver Museum, which later became part of the National Park Service, Tuskegee University, 1938; and Kentucky Museum, Western Kentucky University, 1939. The Chapin Library of Rare Books also was founded at Williams College in 1923.

Historical houses and sites included the 1867 Lee Chapel, which became a museum at Washington and Lee University in the 1920s; the 1799 Ash Lawn–Highland home of James Monroe, opened by a philanthropist-owner in 1931 and turned over to the College of William and Mary in 1975; Sam Houston Memorial Museum at his home and farm site, Sam Houston State University, 1936; Stone Fort Museum, a replica of the 1788–1902 fort, Stephen F. Austin State University, 1936; and Gannon Erie Historical Museum, located in an 1891 mansion, which became part of Gannon University in 1941.

Three other important historically oriented facilities were established during

this period. They were the Dittrick Museum of Medical History, operated by the Cleveland Medical Library Association and Case Western Reserve University, 1926; Folger Shakespeare Library, a part of Amherst College, 1932; and Dumbarton Oaks Research Library and Collection, a Harvard University branch, 1940. The Folger is a major historic book and manuscript library and museum in the English and Continental Renaissance field, while Dumbarton Oaks is a leading research center for Byzantine, pre-Columbian, and landscape architecture study and an architectural, botanical, and historical showcase.

Among the new general museums—most with extensive historical holdings—founded in the 1920s and 1930s were the Horner Museum, Oregon State University, 1925; Museum of Texas Tech University, 1929; Principia School of Nations Museum, Principia College, 1929; and ASU Museum, Arkansas State University, 1936. The Texas Tech museum now covers 167,591 square feet in five primary buildings and has a Ranching Heritage Center with 33 structures in a 14-acre outdoor area.

## ENORMOUS POSTWAR GROWTH

After a lull in expansion during World War II, universities and colleges experienced a tremendous growth in enrollments, faculties, supporting staffs, research, budgets, and activities. This included museums, galleries, and related facilities, the number of which increased greatly in the postwar period and over the next half century.

Nearly 500—or almost half—of the nation's museums and similar facilities at universities and colleges were founded in the 50-year span between 1945 and 1995. The greatest growth in the number of new museums and museum-like facilities occurred in the 1960s and 1970s, when approximately two-thirds were established.

Most of the new institutions were in the art field, accounting for close to 300 of the 500 facilities. It was a period of tremendous growth in art galleries, with almost half of the total 350-plus campus galleries being opened. This expansion in the number of art museums and galleries coincided with growth of universities and colleges and the development and expansion of art history, studio, and related academic programs.

The rate of development of new museums of natural history and related science fields slowed during this period in comparison to the prior 100 years, although a number of major museums were launched in the sciences. History museums and related historical facilities, on the other hand, increased substantially, especially during the nation's bicentennial celebration in the mid-1970s.

It took a few years after World War II before the museum boom began. Relatively few museums were founded in the 1940s following the war. However, there was some significant development. Among the art museums founded at that time were the University of Michigan Museum of Art, 1946; University of

Maine Museum of Art, 1946; Georgia Museum of Art, University of Georgia, 1948; and Universities Galleries, Fisk University, 1949.

The pace picked up in the 1950s, which gave birth to such present-day art museums as the Mead Art Museum, Amherst College, 1950; University Art Museum, Arizona State University, 1950; Lowe Art Museum, University of Miami, 1952; Herbert F. Johnson Museum of Art, Cornell University, 1953; University of Arizona Museum of Art, 1955; Museum of Art and Archaeology, University of Missouri–Columbia, 1957; and Kresge Art Museum, Michigan State University, 1958. It also was in 1953 that Louis I. Kahn designed Yale's first modern building to house the Yale University Art Gallery, which had one of the nation's first campus art collections in 1832.

Many art museums began during this period as galleries or under other names and later became museums and/or assumed the names of their benefactors. Among the new art museums initiated in the 1960s were the Krannert Art Museum and Kinkead Pavilion, University of Illinois at Urbana-Champaign, 1961; Rose Art Museum, Brandeis University, 1961; University Art Museum, University of New Mexico, 1963; Sheldon Memorial Art Gallery and Sculpture Garden, University of Nebraska–Lincoln, 1963; Archer M. Huntington Art Gallery, University of Texas at Austin, 1963; William Benton Museum of Art, University of Connecticut, 1966; Jane F. Voorhees Zimmerli Art Museum, Rutgers University, 1966; Burchfield Art Center, State University of New York at Buffalo, 1966; and University of Iowa Museum of Art, 1969.

The 1970s gave rise to over 30 art museums, including those that became the Elvehjem Museum of Art, University of Wisconsin–Madison, 1970; University Art Museum and Pacific Film Archive, University of California, Berkeley, 1970; Palmer Museum of Art, Pennsylvania State University, 1972; David and Alfred Smart Museum of Art, University of Chicago, 1974; Edwin A. Ulrich Museum of Art, Wichita State University, 1974; Neuberger Museum of Art, State University of New York College at Purchase, 1974; Yale Center for British Art, Yale University, 1977; and Miami University Art Museum, 1978. The several separate collections initiated in 1772 at Dartmouth College also were consolidated in 1974 and became the Hood Museum of Art in 1985, while the University of Kansas Museum of Art, founded in 1928, changed its name to the Spencer Museum of Art and moved into a new and larger building in 1978.

In the 1980s, many more new art museums were founded, including the Patrick and Beatrice Haggerty Museum of Art at Marquette University, 1984, and the Arthur M. Sackler Museum at Harvard University, 1985. In addition, universities and colleges continued to gather together and/or expand their collections, find interested donors, and open new facilities, as was the case with the Snite Museum of Art at the University of Notre Dame in 1980, Indiana University Art Museum (constructing a 105,000-square-foot triangular building designed by I.M. Pei) in 1982, Michael C. Carlos Museum (occupying a thoroughly renovated old law building) at Emory University in 1985, and Me-

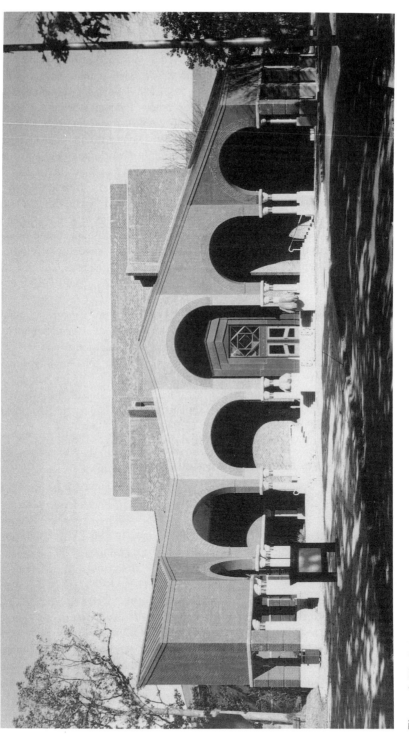

**Figure 4.** The Palmer Museum of Art at Pennsylvania State University was founded in 1972 and expanded to 50,000 square feet in 1993, when it was given its present home. This is the entrance to the enlarged building. (*Courtesy Palmer Museum of Art and photographer Howard P. Nuernberger*)

morial Art Gallery at the University of Rochester (which enlarged its building in 1926, 1968, and 1987).

The first half of the 1990s was marked by the construction of striking new buildings, the changing of names at a number of existing museums, and the opening of several new museums at other campuses. Among the museums with new buildings and names in 1993 were the Frances Lehman Loeb Art Center, which added a 30,200-square-foot structure to 29,500 square feet of renovated space in the former Vassar College Art Gallery; Davis Museum and Cultural Center, housed in a new 61,000-square-foot building near the museum's former home in the Jewett Arts Center at Wellesley College; and the Frederick R. Weisman Art Museum, which replaced the University Art Museum with a 47,300-square-foot facility at the University of Minnesota, Twin Cities. Other museums with new buildings in 1993 included the Museum of Art at Brigham Young University and the University of Wyoming Art Museum. Some of the new museums were the Samuel P. Harn Museum of Art, University of Florida, 1990; Kemper Museum of Contemporary Art and Design, Kansas City Art Institute, 1994; and Marianna Kistler Beach Museum, Kansas State University, 1994.

Additions also were made to the Palmer Museum of Art at Pennsylvania State University, 1993, and to the Museum of Art at the Rhode Island School of Design, 1994, and work began on a 35,000-square-foot addition to the 10,000-square-foot Henry Art Gallery at the University of Washington. Another development in 1994 was the signing of an operating agreement under which the University of California, Los Angeles, assumed management of the privately operated Armand Hammer Museum of Art and Cultural Center and two of the university's art facilities—the Wight Art Gallery and the Grunwald Center for the Graphic Arts—moved into the Hammer complex.

## Speciality Arts Museums and Facilities

The second half of the twentieth century saw the development of a number of specialized art-oriented museums and related facilities. They covered such diverse fields as graphic arts, ethnic arts, nature art, ceramic art, photography, costumes and textiles, and outdoor sculpture gardens.

Among the new specialty art institutions were the Grunwald Center for the Graphic Arts, University of California, Los Angeles, 1956; Institute of American Indian Arts Museum, 1962; Mattye Reed African Heritage Center, North Carolina Agricultural and Technical State University, 1968; Lora Robins Gallery of Design from Nature, University of Richmond, 1977; and Museum of Ceramic Art, New York State College of Ceramics at Alfred University, 1991.

Many art museums have collections and exhibits of photographs, costumes and textiles, and sculpture. But after World War II, separate specialized museums and other facilities began to be established at universities and colleges with large collections of—or great interest in—photography and costumes and/or textiles. One of the first photography facilities was the University of Louisville

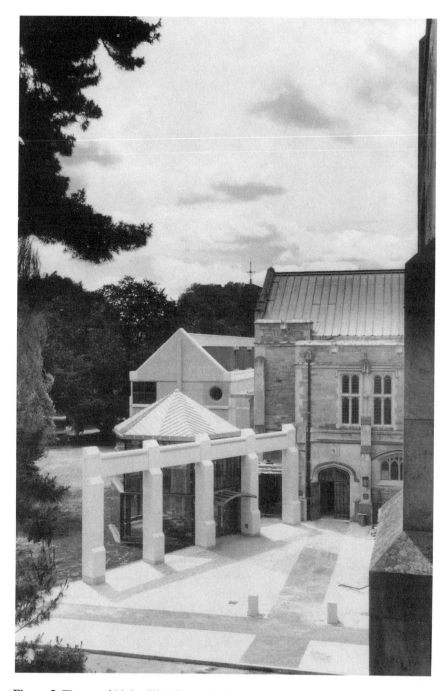

**Figure 5.** The new $15.6 million Frances Lehman Loeb Art Center at Vassar College in Poughkeepsie, New York, incorporated a 30,200-square-foot building with 29,500 square feet of renovated space from the college's former art gallery. Designed by Cesar Pelli, it opened in 1993. *(Courtesy Frances Lehman Loeb Art Center and photographer Peter Aaron/Esto)*

Photographic Archives, which was founded in 1968 and now has over 1.2 million items in its collections. Among the others were the Northlight Gallery, Arizona State University, 1972; California Museum of Photography, University of California, Riverside, 1973; Center for Creative Photography, University of Arizona, 1975; University of Kentucky Photographic Archives, 1978; Southeast Museum of Photography, Daytona Beach Community College, 1979; and Museum of Contemporary Photography at Columbia College in Chicago, 1984.

Collections of costumes and textiles also became museums and galleries during this period. They included two of the largest specialized facilities in the field—the Museum at F.I.T., Fashion Institute of Technology, 1944, and the Paley Design Center, Philadelphia College of Textiles and Science, 1978. The former has the world's largest collection of costumes, textiles, and accessories of dress, while the latter contains international textiles dating from the first century to the present and a fabric archive of over 300,000 original samples of actual work and design models. Among the other costume/textile museum-like facilities started were the Gustafson Gallery, Colorado State University, 1950; Historic Costumes and Textiles Collection, Mount Mary College, late 1960s; Helen Louise Allen Textile Collection, University of Wisconsin–Madison, 1968; and Goldstein Gallery, University of Minnesota, Twin Cities, 1976.

Works of sculpture have been among the collections of American university and college art museums since the nineteenth century. Some museums have sculpture courts inside and/or some pieces outside their buildings, and sculptures even can be found at a few arboreta. But large-scale outdoor sculpture gardens— sometimes with works by leading sculptors, scattered throughout the campus grounds—are a more recent development. Some of these sculpture gardens are administered independently, while others are extensions of—or part of the collections of—art museums and galleries.

The first ''sculpture garden'' on a campus really was a historical hall of fame with busts of individuals who had contributed to the American experience. Called the Hall of Fame for Great Americans, it was founded by New York University in 1900 and now is part of the Bronx Community College of the City University of New York. One of the newer self-contained outdoor displays of sculpture is the Sculpture Park, with more than 20 works on the campus of Governors State University.

Several art museums and galleries have ''sculpture'' in their names because of their emphasis on such works. They include the University of Nebraska's Sheldon Memorial Art Gallery and Sculpture Garden, which opened in 1963 and features a 15-acre sculpture garden, and Saginaw Valley State University's Marshall M. Fredericks Sculpture Gallery, with a dozen bronze casts of the sculptor's works outside the 1988 gallery.

More often, sculpture gardens are part of art museums or galleries or are administered by them. The Franklin D. Murphy Sculpture Garden, for example, consists of 59 works and is an outdoor extension of the Wight Art Gallery, founded in 1952 at the University of California, Los Angeles. At Wichita State

University, the Edwin A. Ulrich Museum of Art, opened in 1974, administers the university's outdoor collection of 54 sculptures around the campus.

A number of other university and college museums and galleries also are responsible for sculptures placed throughout the campus. They include the Art Museum at Princeton University, which has its collection of twentieth-century sculpture outdoors on the campus; Western Gallery, established in 1950, which oversees 20 outdoor works at Western Washington University; Hofstra Museum, founded in 1963 as the Emily Lowe Gallery at Hofstra University, with sculptures throughout the 238-acre campus; and Hood Museum of Art, which developed from the consolidation of separate collections at Dartmouth College in 1974, has a number of outdoor sculptures on the campus as part of its holdings.

The best-known sculpture garden adjacent to a university art museum probably is the B. Gerald Cantor Rodin Sculpture Garden, completed in 1985 and containing 20 sculptures by Rodin, at the Stanford University Museum of Art. Among the other museums and galleries with substantial sculpture gardens next to their buildings are the Memorial Art Gallery at the University of Rochester, David and Alfred Smart Museum of Art at the University of Chicago, Mary and Leigh Block Gallery at Northwestern University, and Philip and Muriel Berman Museum of Art at Ursinus College. Two others with what they call outdoor "sculpture courtyards" are the Tweed Museum of Art at the University of Minnesota, Duluth, 1950, and Radford University Galleries, 1965.

## Explosion of Art Galleries

The largest growth, by far, in the number of new facilities occurred in art galleries during the second half of the twentieth century. They began appearing on campuses throughout the nation, and especially at universities and colleges without art museums. Some developed into art museums, but most continued to stay as galleries, with their emphasis on changing exhibitions—usually of contemporary art—rather than on collections.

Although most art galleries do not have collections, many campus galleries do. These collections generally were donated or are limited in number and scope, or the gallery is charged with the care and use of a university or college's institutional art collection. Among those galleries with collections are the Watkins Gallery, founded at American University in 1947 to exhibit the memorial collection of artist/educator C. Law Watkins and student and temporary shows; Moss-Thorns Gallery, which traces its beginning and diversified collection to 1953 at Fort Hays State University; Picker Art Gallery, with a collection of works on paper and other works at Colgate University, 1966; David Winton Bell Gallery, which has a collection of works on paper from the sixteenth century to the present and contemporary painting and sculpture at Brown University, 1971; and Ashby-Hodel Gallery of American Art, having a large collection of American art at Central Methodist College, 1993.

A considerable number of facilities describe themselves as combination art galleries and museums because of their collections, although most function more

like galleries. They include the University Gallery, University of the South, 1954; Mary Washington College Galleries, 1956; Montgomery Gallery, Pomona College, 1958; College Art Gallery, State University of New York College at New Paltz, 1964; Anderson Gallery, Virginia Commonwealth University, 1970; Ad Gallery, Gonzaga University, 1971; Sarah Campbell Blaffer Gallery, University of Houston, 1973; Lamar Dodd Art Center, LaGrange College, 1981; List Gallery, Swarthmore College, 1991; and Ruth Chandler Williamson Gallery (formerly Lang Gallery, 1936), Scripps College, 1994.

Some universities and colleges have more than one art gallery—nearly all founded since World War II. There are seven galleries in various locations on the Pennsylvania State University campus. Other institutions with multiple galleries include San Francisco State University and the University of Massachusetts at Amherst, six; Lehigh University, five; Temple University, four; and Bowling Green State University, Moore College of Art and Design, University of Arkansas at Little Rock, University of Florida, and University of Rhode Island, three.

Most galleries are initiated by art departments as teaching galleries and seek to display professional, faculty, and/or student art, as occurs at the DuPont Gallery at Washington and Lee University, 1952; Rosenberg Gallery, Goucher College, 1962; University Art Gallery, California State University, San Bernardino, 1970; Gallery of Art, University of Northern Iowa, 1978; Xavier University Art Gallery, 1980; and Center for the Visual Arts, Metropolitan State College of Denver, 1990.

Sometimes it is largely the work of a dedicated department head or single faculty member that brings about the establishment of a campus gallery. This is what happened in the founding of the Western Gallery, Western Washington University, 1950; Elder Gallery, Nebraska Wesleyan University, 1964; Dwight Frederick Boyden Gallery, Saint Mary's College of Maryland, 1971; Founders Gallery, University of San Diego, 1971; Art Gallery, Lower Columbia College, 1978; and Parkland College Art Gallery, 1981.

Other times the donation of a collection and/or funds spurs the development of a gallery. Among the galleries started in this manner were the Davis Art Gallery at Stephens College, 1964; Thorne-Sagendorph Art Gallery, Keene State College, 1965; Roberts Gallery in the Asian Arts Center, Towson State University, 1972; Iris and B. Gerald Cantor Art Gallery, College of the Holy Cross, 1983; and Douglas F. Cooley Memorial Art Gallery, Reed College, 1989.

Many art galleries begin as part of new buildings—art and visual arts buildings, arts centers, student unions, libraries, and other structures. The most frequent launching pads are new art, visual arts, and arts center buildings. New art buildings resulted in the founding of the Peppers Art Gallery, University of Redlands, 1964; Norman Eppink Art Gallery, Emporia State University, 1965; and James Howe Gallery, Kean College of New Jersey, 1972. New visual arts facilities included the Boehm Gallery, Palomar College, 1966; Jarti Gallery, Weber State University, 1968; and MIT-List Visual Arts Center, Massachusetts

Institute of Technology, 1950. Space for galleries also has been part of many new fine arts centers, such as the Watson Gallery at Wheaton College in Massachusetts, 1961; Perkinson Gallery, Millikin University, 1969; Crossman Gallery, University of Wisconsin–Whitewater, 1971; Sarah Campbell Blaffer Gallery, University of Houston, 1973; University Art Gallery, State University of New York at Stony Brook, 1975; and Wellington B. Gray Gallery, East Carolina University, 1978. Other times galleries have found a home in renovated campus buildings, such as the Trout Gallery, Dickinson College, 1983, and the Morris B. Belknap Jr. Gallery and Daria A. Covi Gallery, University of Louisville, 1986.

## New Science Museums and Facilities

Although most new museums and related facilities during the second half of the nineteenth century were in the art field, numerous natural history and other science-oriented museums and facilities also were launched. Some resulted from the consolidation of collections or the formalization of a museum from an academic department's collection, while others were developed through the efforts of a science department, faculty member, and/or donor.

Two early collections were converted to new museums in 1947—the Pratt Museum of Natural History, which evolved from an 1838 collection at Amherst College, and the Oklahoma Museum of Natural History, where initial collection at the University of Oklahoma began with an Oklahoma territorial legislature act in 1899. Natural history collections were consolidated to form museums at a number of institutions, including the University of Utah, which established the Utah Museum of Natural History in 1969 after state legislation mandated the centralization of all collections and exhibits in anthropology, biology, and geology, and the University of Georgia, which established the Museum of Natural History in 1978 to function as a consortium of eight longstanding separate research collections. Another restructuring took place at the University of Kansas, where four systematics museums were reorganized into a single administrative unit, known as the University of Kansas Natural History Museum, in 1994.

Among the other new natural history museums were the Idaho Museum of Natural History, Idaho State University, 1956; Museum of the Rockies, Montana State University, 1956; Museum of Natural History, University of Wisconsin–Stevens Point, 1966; Oklahoma State University Museum of Natural and Cultural History, 1966; Natural History Museum, Eastern New Mexico University, 1968; Museum of Natural History, Wayne State University, 1972; Natural History Museum, College of the Atlantic, 1982; and Virginia Museum of Natural History, Virginia Polytechnic Institute and State University, 1990.

This period saw the development of nature and environmental centers with interpretive exhibits, hiking trails, and sometimes live animals by a number of universities and colleges. Among the new facilities of this type were the Trailside Museum, Antioch College, 1952; Whitehouse Nature Center, Albion College, 1972; and Shaver's Creek Environmental Center, Pennsylvania State

University, 1976. A related environmental education development was the Arizona Center for Education and the Natural Environment at Arizona State University in 1993.

A considerable number of geology, mineralogy, and/or paleontology museums also were founded. They included the Gillespie Museum of Minerals, Stetson University, 1958; Center for Meteorite Studies, Arizona State University, 1961; Trailside Museum, University of Nebraska–Lincoln, 1961; Miles Mineral Museum, Eastern New Mexico University, 1969; A.M. and Alma Fiedler Memorial Museum, Texas Lutheran College, 1973; Meteorite Museum, University of New Mexico, 1974; Museum of Geology, Arizona State University, 1977; and Earth Science Museum, Brigham Young University, 1987.

Various other new specialized museums in related science fields were founded or expanded during this period. They included the Entomological Teaching and Research Collection at the University of California, Riverside, 1962, and the Bohart Museum of Entomology at the University of California, Davis, 1970. Among the new or enlarged marine sciences facilities and aquariums were the Mark O. Hatfield Marine Science Center, Oregon State University, 1965; Virginia Institute of Marine Science Fish Collection, College of William and Mary, 1968; J.L. Scott Marine Education Center and Aquarium, University of Southern Mississippi, 1984; and the renamed and expanded Stephen Birch Aquarium-Museum, Scripps Institution of Oceanography at the University of California, San Diego, 1992.

## Museums of Cultural History and Related Fields

Many new museums were founded in the archaeology, anthropology, and ethnology fields during this period. Some of the museums focused on one of the disciplines, while others covered several fields. Those with an archaeological emphasis included the Louden-Henritze Archaeology Museum, Trinidad State Junior College, 1954; Horn Archaeological Museum, Louisville Presbyterian Theological Seminary, 1963; Western New Mexico University Museum, 1974; Lois Dowdle Cobb Museum of Archaeology, Mississippi State University, 1975; and Tech Museum, Louisiana Tech University, 1982.

Three university museums were opened at archaeological sites. They were the Chucalissa Museum, founded in 1955 and transferred to University of Memphis in 1962, which features a partially reconstructed fifteenth-century Native American village; Blackwater Draw Museum, established in 1967 and operated by Eastern New Mexico University since 1969 to interpret artifacts and related faunal materials excavated from the site; and Deer Valley Rock Art Center, opened in 1994 by Arizona State University to display rock art uncovered in the construction of a flood control dam.

Among the more anthropology-oriented museums started were the Haffenreffer Museum of Anthropology, Brown University, 1955; Matson Museum of Anthropology, Pennsylvania State University, 1968; Treganza Anthropology Museum, San Francisco State University, 1969; Anthropology Museum,

Northern Kentucky University, 1976; Merritt Museum of Anthropology, Merritt Community College, 1976; Museum of Anthropology, University of Kansas, 1979; New Mexico State University Museum, 1981; Museum of Anthropology, Arizona State University, 1983; and Hudson Museum, University of Maine, 1986.

Ethnology-based museums frequently overlap with anthropology museums, which often have extensive ethnographic materials about different cultures, especially Native Americans. New present-day museums specializing in ethnology included Seton Hall University Museum, 1960; Fowler Museum of Cultural History, University of California, Los Angeles, 1963; William Hammond Mathers Museum, Indiana University, 1963; Center of Southwest Studies, Fort Lewis College, 1964; Spertus Museum, Spertus College of Judaica, 1968; Yeshiva University Museum, 1973; Mitchell Indian Museum, Kendall College, 1977; Indian Arts Research Center, School of American Research, 1978; and Schingoethe Center for Native American Cultures, Aurora University, 1989.

The Fowler Museum of Cultural History, one of the leading museums in the field, was created at the University of California, Los Angeles, to consolidate all ethnographic collections on campus and to make them accessible to the university community and the general public. It now has a permanent collection of over 750,000 artifacts representing contemporary, historic, and prehistoric cultures in Africa, Oceania, Asia, and the Americas.

Some museums encompass all three disciplines of archaeology, anthropology, and ethnology, such as the Herrett Museum, founded in 1957 and becoming part of the College of Southern Idaho in 1980; Museum of Peoples and Cultures, Brigham Young University, 1961; and South Carolina Institute of Archaeology and Anthropology, University of South Carolina, 1963.

## Museums in Other Science Fields

In the science and technology fields three historically based museums were established in the post–World War II era—the Museum of Early Philosophical Apparatus, Transylvania University, 1948; Collection of Historical Scientific Instruments, Harvard University, 1949; and MIT Museum, Massachusetts Institute of Technology, 1971. The first university hands-on contemporary science and technology center—Lawrence Hall of Science—was opened in 1968 at the University of California, Berkeley, to interpret scientific principles and technological applications. The University of California also established a science museum and a visitor center at two federal nuclear laboratories operated on contract for the U.S. Department of Energy—the Bradbury Science Museum at Los Alamos National Laboratory and the Visitors Center at Lawrence Livermore National Laboratory. The Fermi National Accelerator Laboratory, operated on contract by the Universities Research Association Inc., now has three science exhibit areas.

This also was the period of space exploration during which planetaria and observatories multiplied rapidly, sometimes together and other times separate.

More than 40 such facilities were developed during the second half of the twentieth century to observe and/or study the solar system with the aid of projected celestial images or telescopes.

Some planetaria are part of science and technology centers, such as the William K. Holt Planetarium at the Lawrence Hall of Science, while others are located at natural history museums, as is the case with the Ruth and Vernon Taylor Planetarium at the Museum of the Rockies at Montana State University. In a few instances, planetaria developed into broader-based science centers, as occurred with the Cernan Earth and Space Center, Triton College, 1974; Flandrau Science Center and Planetarium, University of Arizona, 1975; and Clever Planetarium and Earth Science Center, San Joaquin Delta College, 1983.

More often planetaria were founded as extensions of academic departments of physics, astronomy, or space sciences or were operated as separate entities. Among the major planetaria established during this period were the Morehead Planetarium, University of North Carolina at Chapel Hill, 1949; Fleischmann Planetarium, University of Nevada at Reno, 1963; Abrams Planetarium, Michigan State University, 1964; and W.A. Gayle Planetarium, Troy State University, 1968.

Many planetaria have one or more telescopes mainly for student and public use as part of their facilities. Some even have "observatory" in their names, such as the Weitkamp Observatory/Planetarium at Otterbein College, 1955, and the Astronaut Memorial Planetarium and Observatory at Brevard Community College, which was founded in 1976 and underwent a major renovation in 1994.

Major observatories, however, are not connected with planetaria. They are research facilities located away from the campus, usually on mountain tops, and operated separately by academic departments, consortia, or associations of universities. Some have museums, visitor centers, or viewing galleries, such as the Palomar Observatory, opened in 1948 by the California Institute of Technology, and the Mauna Kea Observatories of the University of Hawaii, which built its first optical telescopes in 1968–1969 and since has become the site of numerous other university and government observatories. Among the many facilities is the new W.M. Keck Observatory, which began operations in 1994 as a facility of the California Association for Research in Astronomy (a partnership between the California Institute of Technology and the University of California). It has the world's largest and most powerful optical and infrared telescope—a 33-foot mirror array with four times the light-gathering power of the 200-inch Hale Telescope at Palomar.

Two major observatory programs started in the 1950s are operated by university astronomical associations under National Science Foundation contracts. They are the National Optical Astronomical Observatories, operated by the Association of Universities for Research in Astronomy Inc. and consisting of three astronomical research centers—the National Solar Observatory, Kitt Peak National Observatory, and Cerro Tololo Inter-American Observatory—and the National Radio Astronomy Observatory, operated by Associated Universities Inc.

and based in West Virginia with branches in various locations around the country. The WIYN Observatory, operated by a consortium consisting of the University of Wisconsin, Indiana and Yale universities, and the National Optical Astronomical Observatories, also opened at the Kitt Peak facilities in 1994.

Most of the major botanical gardens, arboreta, and herbaria were founded many years before the mid-twentieth century. A substantial number also were established during the half century following World War II.

Among the new botanical gardens were the Hidden Lake Gardens, Michigan State University, 1945; North Carolina Botanical Garden, University of North Carolina at Chapel Hill, 1952; South Carolina Botanical Garden, Clemson University, 1959; and State Botanical Garden of Georgia, University of Georgia, 1968. As the names imply, most now serve as the state botanical gardens.

New arboreta included the Core Arboretum, West Virginia University, 1954; Minnesota Landscape Arboretum, University of Minnesota, 1958; University of Alabama Arboretum, 1958; Morea Gardens Arboretum, University of Virginia, 1963; and Red Butte Garden and Arboretum, which began as an arboretum in 1965 and added a botanical garden in 1983, University of Utah. The Robert F. Hoover Herbarium also was opened at California Polytechnic State University in 1946.

Another important facility was the Hunt Institute for Botanical Documentation, founded in 1961 as the Rachel McMasters Miller Hunt Botanical Library at Carnegie Mellon University. By 1971, its extensive collections and activities in botanical literature, art, and archival materials had so expanded and diversified that the name was changed.

## Growth of Historical Facilities

Approximately 40 historical museums, houses, sites, and related facilities were established by universities and colleges during the second half of the twentieth century. Many were the result of increased interest in history during the nation's bicentennial celebration in the mid-1970s. Others evolved from historical collections, gifts of historic houses, restoration of historic sites, and development of historically oriented research centers. One even was a converted pavilion from a world's fair—the University of Texas Institute of Texan Cultures, which opened in 1968 as the Texas Pavilion at the HemisFair in San Antonio.

The new historical museums took various forms—the Skinner Museum, which featured four historic buildings and collections depicting early American domestic life and work, Mount Holyoke College, 1946; Citadel Museum, containing weaponry, uniforms, and other materials from various wars and historical exhibits on The Citadel, The Military College of South Carolina, 1956; Berea College Museum, dealing with the history and culture of the Appalachian region, 1973; Sweet Briar Museum, located on a former 10,000-acre nineteenth-century plantation, Sweet Briar College, 1980; and Labor Museum and Learning Center

**Figure 6.** The visitor center and conservatory are located in this building at the 313-acre State Botanical Garden of Georgia at the University of Georgia in Athens. The garden, which features native and exotic plants, attracts 150,000 visitors each year. (*Courtesy State Botanical Garden of Georgia, University of Georgia*)

of Michigan, focusing on the state's labor history, Mott Community College, 1992.

Some university and college museums were developed around the lives and times of historical figures, including the Winston Churchill Memorial and Library, Westminster College in Missouri, 1962; Jackson's Mill Museum (where General Stonewall Jackson once lived and worked), West Virginia University, 1968; Abraham Lincoln Museum, Lincoln Memorial University, 1977; and President Andrew Johnson Museum and Library, Tusculum College, 1993. A major unaffiliated historical library/museum, the Lyndon Baines Johnson Library and Museum, opened in 1971 on the Austin campus of the University of Texas. It is a presidential library/museum operated by a federal agency, the National Archives and Records Administration.

Many historic houses and sites—often with structures going back to the eighteenth and nineteenth centuries—were opened in the second half of the twentieth century. Among the house museums founded were the 1950s Evergreen House, Johns Hopkins University, 1952; 1716 Hanover House, Clemson University, 1953; 1914 Henry Ford Estate, University of Michigan–Dearborn, 1957; 1833 William Holmes McGuffey House and Museum, Miami University, 1960; 1856 Jane Addams' Hull-House Museum, University of Illinois at Chicago, 1967; 1790s Belmont, The Gari Melchers Estate and Memorial Gallery, Mary Washington College, 1975; 1844 Reynolds Homestead, Virginia Polytechnic Institute and State University, 1976; and 1908 Glensheen, University of Minnesota, Duluth, 1979.

Among the largest and best-known historical museums are the outdoor or living history museums. Among those founded during this period were Conner Prairie, a re-creation of an early-nineteenth-century village with 37 buildings in a 55-acre historic area that is part of a 250-acre site, Earlham College, 1964; Winedale Historical Center, a restoration of an 1834 farmstead, University of Texas at Austin, 1967; Rural Life Museum, with over 20 original structures from the antebellum and postbellum eras, Louisiana State University, 1970; Historic New Harmony, featuring 32 historic structures at the site of two early-nineteenth-century utopian experiments, University of Southern Indiana, 1973; Pioneer Heritage Center, consisting of 6 historic structures—each an example of the vernacular architecture of the region, Louisiana State University in Shreveport, 1977; and Blue Ridge Farm Museum, a re-created farmstead reflecting German-American settlement in the area, Ferrum College, 1991.

Other museum-like collections and exhibits grew out of historical, library, and archival centers, such as the American Heritage Center, University of Wyoming, 1946; Confederate Research Center, Hill College, 1963; Center for Lowell History, University of Massachusetts, Lowell, 1971; Cammie G. Henry Research Center, Northwestern State University of Louisiana, 1974; Moorland-Spingarn Research Center, Howard University, 1979; and Avery Research Center, College of Charleston, 1990.

Among the new libraries and archives displaying historical collections were

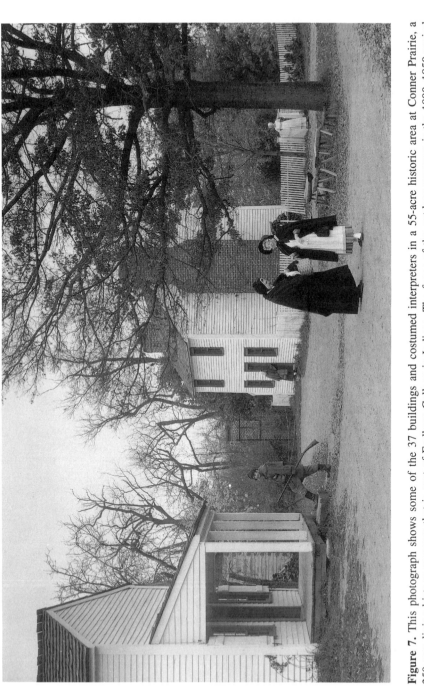

**Figure 7.** This photograph shows some of the 37 buildings and costumed interpreters in a 55-acre historic area at Conner Prairie, a 250-acre living history museum that is part of Earlham College in Indiana. The focus of the outdoor museum is the 1800–1850 period in central Indiana and America. (*Courtesy Conner Prairie, subsidiary of Earlham College*)

the Armstrong Browning Library, Baylor University, 1951; Sam Rayburn Library and Museum, University of Texas at Austin, 1957; Lilly Library, Indiana University, 1960; History of Aviation Collection, McDermott Library, University of Texas at Dallas, 1963; and LaGuardia and Wagner Archives Museum, Fiorello H. LaGuardia Community College of the City University of New York, 1993.

## Specialized Historical Museums

An increasing number of historically oriented specialized museums—such as those in medicine, dentistry, agriculture, musical instruments, and religion—appeared during the second half of the twentieth century.

Among the new medical museums were the Clendening History of Medicine Library and Museum, University of Kansas Medical Center, 1945; History of Medicine Collections, Duke University Medical Center Library, 1956; and University of Iowa Hospitals and Clinics Medical Museum, 1989. New dental history museums included the Friends Museum, University of Connecticut Health Center, 1979, and the Dr. Samuel D. Harris National Museum of Dentistry, University of Maryland at Baltimore, 1988.

The Medical University of South Carolina opened both medical and dental facilities—the Waring Historical Library in 1967 and the Macaulay Museum of Dental History in 1976, while the Southern Illinois University School of Medicine incorporated medical, dental, and pharmaceutical artifacts and exhibits in the new Pearson Museum, 1974. In other fields, the Kirksville College of Osteopathic Medicine founded a three-part Still National Osteopathic Museum in 1978, and the School College of Podiatric Medicine opened the *Feet First* exhibit in 1993. At the University of Virginia Health Sciences Center, a hands-on health museum for young children—called the Children's Museum—was established in 1980.

In the agricultural field, the new museums included the McCormick Farm, Virginia Polytechnic Institute and State University, 1953; Ronald V. Jensen Living Historical Farm, Utah State University, 1971; and Pasto Agricultural Museum, Pennsylvania State University, 1975. Among the others were some of the historic houses and living history museums mentioned earlier, as well as several unaffiliated museums—the State Agricultural Museum, administered by the South Dakota State Historical Society at South Dakota State University, 1967, and the New Jersey Museum of Agriculture, an independent nonprofit at Rutgers University, 1984.

Two new musical instruments museums were the Shrine to Music Museum at the University of South Dakota, 1973, and the George E. Case Collection of Antique Keyboards at the University of South Carolina at Spartanburg, 1990.

Numerous religion-based museums also were founded during this period at institutions largely operated by various denominations. They included the Gustav Jeeninga Museum of Bible and Near Eastern Studies, Anderson University, 1963; Joseph A. Callaway Archaeological Museum, Southern Baptist Theolog-

ical Seminary, 1963; Center for Western Studies, Augustana College in South Dakota, 1970; Missouri United Methodist Archives, Central Methodist College, 1972; and Billy Graham Center Museum, Wheaton College in Illinois, 1975.

## General Museums and Other Facilities

Most general museums feature historical holdings, but they also have materials in such other fields as art, natural history, and material culture. Among the new general museums were the Henderson State University Museum, 1953; Reuel B. Pritchett Museum, Bridgewater College, 1954; Frank H. McClung Museum, University of Tennessee at Knoxville, 1961; Luther E. Bean Museum, Adams State College, 1968; Central Missouri State University Archives/Museum, 1968; University Museum, Indiana University of Pennsylvania, 1976; and McKissick Museum, University of South Carolina, 1976.

The McKissick Museum is one of the largest and most active general museums on a university or college campus. Occupying a 53,800-square-foot building, it has collections that began in 1823 and now contains objects and exhibits of material culture, natural science, and decorative and fine arts. The emphasis is on materials that relate to the social, cultural, and scientific development of South Carolina and the Southeast.

Various other types of campus collections, museums, and exhibits have emerged in the last half century. They cover such fields as sports, politics, and culinary and maritime interests.

Two universities have established museums covering their football history and highlights—the Paul W. Bryant Museum at the University of Alabama and the Penn State Football Hall of Fame at Pennsylvania State University. In the maritime area, the Steamship Historical Society of America Collection is housed at the University of Baltimore, and the *Treasures of the Sea* exhibit is located at the Delaware Technical and Community College.

Two other unusual museums were founded in 1989—the Museum of American Political Life at the University of Hartford and the Culinary Archives and Museum at Johnson and Wales University. The former has over 60,000 political mementos—from George Washington's inaugural buttons to materials from recent presidential campaigns—while the latter contains cookbooks, menus, postcards, pamphlets, prints, and silver pieces relating to culinary and gastronomy topics.

Some museums located on campuses in the second half of the twentieth century are not operated by universities and colleges. They usually are part of government agencies, historical societies, religious groups, or other nonprofit organizations.

Included among such facilities are the National Scouting Museum, started in 1959 and relocated to Murray State University in 1980; Botanical Gardens of Asheville, operated by an independent nonprofit on land owned by the University of North Carolina at Asheville, 1960; Eichold-Heustis Medical Museum of the South, privately owned at the University of South Alabama—Springhill,

1962; Nebraska Conference United Methodist Historical Center, operated by the church at Nebraska Wesleyan University, 1968; Lyndon Baines Johnson Library and Museum, administered by the National Archives and Records Administration at the University of Texas at Austin, 1971; George Washington Carver Museum, founded by Tuskegee University in 1938 and donated to the National Park Service in 1977; Oklahoma Museum of Higher Education, operated by the Oklahoma Historical Society at Oklahoma State University, 1982; New Jersey Museum of Agriculture, an independent nonprofit at Rutgers University, 1984; and National Cable Television Center and Museum, founded and operated by the cable television industry at Pennsylvania State University, 1988.

## THE CAMPUS MUSEUM MOVEMENT

It is difficult to generalize about university and college museums, galleries, and related facilities. As the history of the campus museum movement shows, they started in many different ways and cover a wide range of fields. Many began as teaching and research collections, but often did not become museums or similar facilities for many years. Others were born almost instantly with gifts of collections and/or funds from donors. Still others are owned and operated by outside parties and have little or no relationship to the institutions where they are located.

Yet, it is possible to make some broad observations about how university and college museums, galleries, and related facilities have evolved over the last two centuries in the United States:

• Nearly all were initiated by academic departments and/or their faculty members.
• Most started with teaching and research collections.
• Collections remain the core of virtually all the museums and similar facilities and the standard by which they are measured.
• Gifts of collections and/or funds often make the difference in the size and quality of a museum or related facility.
• A museum-like facility need not be located on a campus to be effective.
• Nearly all are dedicated to serving the university or college community primarily—and the general public secondarily.
• They perform educational, research, and service roles that usually are not played by any other university or college facility or activity.

University and college museums, galleries, and related facilities have made remarkable progress. They have grown from small collections and cabinets of curiosities to important centers of education and research. From a slow beginning, they have increased in number and have experienced tremendous expansion in their collections, offerings, facilities, and services to the campus and to society in general.

*Chapter 3*

# The Mission

What is the purpose of museums, galleries, and related facilities at universities and colleges? How do their missions differ from those of comparable nonacademic institutions? Why are they necessary? These are questions that museum and other campus administrators are being asked increasingly as the cost of operating universities and colleges—as well as their museums and similar facilities—continues to climb in these difficult economic times.

It is true that university and college museums and related facilities are similar to public and private museums and other such institutions in the community at large. They all tend to collect, preserve, display, and interpret artifacts, artworks, specimens, and other objects of intrinsic value. But campus museums and similar facilities are part of the instructional, research, and/or overall educational functions of a university or college.

The collections, exhibits, programs, and other resources of academic museums and related institutions are used in teaching, in research investigations, and in the learning process of all students. Art students see and learn from important original art in museum collections; science students obtain first-hand knowledge from being able to examine a wide variety of specimens and material culture; history students find out about the past from historical artifacts; graduate students work with collections in research projects; and all students can benefit from viewing and studying the treasures of museums and related facilities.

Museum and similar collections are a vital part of the instructional, research, and publication activities of faculty members, curators, and their graduate and staff assistants, as are the studio and laboratory studies, field investigations, and exhibits, lectures, films, seminars, and other programs at such facilities. Campus

museums and related facilities also are an important part of museum studies programs at many institutions.

University and college museums and related facilities are largely internally focused—to serve the institution's students, faculty, and staff primarily, rather than the general public as with most nonacademic museums. However, many also attempt to attract and serve people from the immediate community and region, alumni, and others interested in the institution and/or subject matter.

## ART MISSION STATEMENTS

Nearly every museum, gallery, and related facility has a mission statement or some description of its purpose. Some are quite short (a paragraph or two), while others are lengthy (several pages or more) with a list of how the institution intends to accomplish its stated mission. Most mission statements are rather general, although some are very specific.

The Art Museum at Princeton University has a broad mission statement that describes the function of most university and college museums, and especially art museums. The mission is given as follows:

"The foundation of any system of education in Historic Art must obviously be in object-teaching. A museum of art objects is so necessary to the system that, without it, we are of the opinion it would be of small utility to introduce the proposed department. Courses of lectures, while conveying some instruction, would be of little practical benefit without objects to be seen and studied in connection with instruction . . ." William Cowper Prime in 1882, at the moment when Allan Marquand was charged by President McCosh with the formation of a curriculum in art history at Princeton University.

The fundamental responsibility of all museums is to the collections: the conservation, security, presentation, and interpretation of works of art.

The founding principle and distinguishing characteristic of university and college museums is to complement and enrich the instructional and research activities of the institution as vital resources for teaching and scholarship. As important regional cultural resources, academic museums extend their educational missions beyond the universities and colleges and contribute to the education and quality of life of the community.

Some museums, such as the William Benton Museum of Art at the University of Connecticut, have a brief one-paragraph mission statement:

The William Benton Museum of Art, the University of Connecticut, has been established for the collection, preservation, research, and interpretation of works of art. The Museum exists for the University of Connecticut academic community, for the citizens of the state of Connecticut, and for the general public to add through its educational and other programs to the greater understanding and appreciation of art.

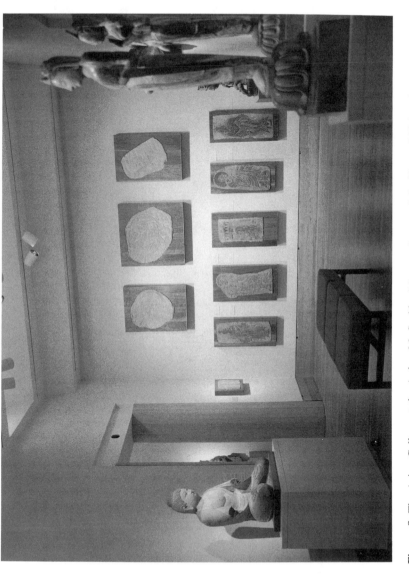

**Figure 8.** The Asian Gallery at the Arthur M. Sackler Museum is part of the Harvard University Art Museums complex in Cambridge. The museum, which opened in 1985, houses the university's collections of ancient, Asian, and Islamic art. (*Courtesy Arthur M. Sackler Museum, Harvard University Art Museums*)

Others, like the Harvard University Art Museums, have lengthy statements of their roles. In Harvard's case, the statement runs five single-spaced pages and includes the role of the director. It begins:

The basic mission of the Harvard University Art Museums, as for all museums, is to acquire, preserve, interpret, exhibit, and otherwise make accessible works of art for the benefit of a variety of interested audiences, recognizing that art is fully understood and enjoyed through direct contact with original works of genuine aesthetic merit. Those who direct university museums can usually identify a number of audiences which they try to serve. These audiences include professors and students of Fine Arts, faculty and students in other departments of the University, visiting scholars, and the general public.

A university art museum such as Harvard's, serves all of these audiences. To a large extent, the needs of each can be addressed by carrying out the fundamental educational mission of the museum, and an imaginative director will seek to do so insofar as possible. Priorities need to be established, particularly when financial resources are limited. The Harvard University Art Museums exist principally for educational reasons and thus owe their primary responsibility to students and faculty at Harvard.

The Harvard statement points out that "the concern for education should characterize and inform every aspect of the Harvard University Art Museums" and gives nine examples, as well as a description of the director's role.

A number of art museums have mission statements with a short introductory statement and a list of the museum's specific purposes, as for the Middlebury College Museum of Art:

The purpose of Middlebury College Museum of Art is to utilize its resources to serve as an integral educational and cultural component of Middlebury College and to enrich the educational and cultural environment of Vermont. The specific purposes for which the College maintains its Museum of Art are to. . . .

The statement then goes on to list such things as preserving the college's art collections, exhibiting the art collections and other works that support the educational and cultural needs of the academic community and regional public, acquiring works that will enrich the collections, facilitating appreciation and use of the collections, furthering scholarly research of the collections, facilitating the interpretation and dissemination of such research findings, maintaining an exhibition program that encourages an appreciation and understanding of artistic achievements by diverse cultures, and engaging in ongoing collaborative efforts to enhance the understanding and importance of the role of art in society.

Some university and college art museums emphasize their particular areas of interest, such as the Yale Center for British Art, which states that it "exists to foster an appreciation and understanding of works of art which are the product of a single culture, a culture which is closely linked to our own," while Wesleyan University's Davison Art Center is "a university museum with a collection specializing in works on paper from about 1450 to the present."

The Yale University Art Gallery, on the other hand, takes a broader view, stating that its purpose is "to acquire, preserve and exhibit the best possible examples of the art of world cultures from ancient times to the present day" and that it is "aware of its dual role as both a university museum with teaching responsibilities, and as one of the leading general art museums in New England." It also states:

As a university museum, we are committed to making our collections available for the education of undergraduates and for the training of graduate students who will be the museum curators, university professors, artists and designers of the future. Students and faculty are involved in almost every aspect of our museum's operation and program. We are equally committed to ongoing research and publication of our collections and to the interpretation of those collections for the benefit of the general public.

Art galleries have mission statements that are similar—but that emphasize exhibitions, rather than collections. One such statement is that of the Thorne-Sagendorph Art Gallery at Keene State College:

The purpose of the Keene State College Thorne-Sagendorph Art Gallery shall be to encourage a broader and deeper appreciation of the visual arts by bringing to Keene State College and the greater Monadnock community a broad selection of paintings, graphics, sculpture and other works of art. These must be of significant quality and educational value.

The MIT List Visual Arts Center, which presents changing exhibitions of contemporary art in three galleries at the Massachusetts Institute of Technology, uses four points as its statement of purpose:

1. To present, through its internationally recognized contemporary exhibition program, the highest quality, most challenging contemporary art and design by professionals practicing in diverse media.
2. To provide associated educational activities which create a context for understanding how the contemporary visual arts reflect and express the complex issues underlying a changing society.
3. To provide a daily experience with original works of art through three rotating, publicly-sited art collections.
4. To contribute significantly to the cultural vitality of the region and beyond.

## MISSIONS OF OTHER TYPES OF MUSEUMS

Mission statements of other types of university and college museums and related facilities also vary as greatly as those for art museums and galleries. Some are broad in scope, while others are more narrow in approach.

The James Ford Bell Museum of Natural History at the University of Min-

nesota, for instance, takes the broad view in the natural sciences, encouraging "curiosity for and a better understanding of the natural world through research, teaching, and public education in the natural sciences." It seeks to accomplish this by encouraging and conducting research in the natural sciences, providing a permanent record of biotic diversity throughout time and space through collections, and presenting and interpreting the facts, principles, and controversies of the natural sciences to the public and the university community.

The mission statement of the Peabody Museum of Archaeology and Ethnology at Harvard University—the nation's oldest museum devoted entirely to anthropology—places great emphasis on research and collections, stating:

A primary objective of the museum is to promote research on the past and the present through archaeological and ethnological collections. The mission of the museum involves the dissemination of knowledge from that research through scholarly publications, exhibits, and other educational programs; it also fosters academic research among Harvard faculty, students, staff, and outside researchers. Its charge is in the broadest relevance of collections and research to anthropological issues, past and present.

The University of Texas Institute of Texan Cultures at San Antonio takes a different approach, being aimed more at multicultural public education through exhibits, programs, and publications. Its purpose is described in a one-paragraph mission statement:

The Institute of Texan Cultures is a university educational center dedicated to the enhancement of historical and multicultural understanding through exhibits, programs, and publications that encourage acceptance and appreciation of our differences as well as our common humanity. Operating on the premise that people are stronger citizens when they know more about themselves and each other, the Institute serves as a forum for multicultural education efforts in the state and symbolizes the state's strength in diversity.

A more specific area of the world is the focus of the Peary-MacMillan Arctic Museum at Bowdoin College. Its statement of purpose says:

The Peary-MacMillan Arctic Museum and Arctic Studies Center of Bowdoin College exists to encourage the understanding of, and appreciation for, the cultural and natural history of Arctic and Subarctic regions. It achieves these goals by sponsoring educational, scholarly, research, and outreach programs that focus on northern peoples and environments; past and present.

## CHANGING MISSION STATEMENTS

Mission statements sometimes change, usually amplifying or refining an institution's role. The California Museum of Photography at the University of California, Riverside, for example, adopted a one-sentence mission statement in 1988 and then added two paragraphs in 1990 to elaborate on the museum's

current philosophy of purpose. The original statement said, "The California Museum of Photography promotes understanding of photography's role in modern culture through collection, research, exhibition, and instruction." The added sections included the museum's intention to play "a leading role in the definition and redefinition of the uses, theory, history, and practice of photography" and the museum's "commitment to broad accessibility and community relevance in order to bring the most challenging art to the widest possible audience."

Some statements are modified over the years, but the mission remains basically the same. The Arnold Arboretum, founded in 1872 at Harvard University, updated its mission statement in 1988, saying, "Although there have been many changes in the fields of botany and horticulture and the Arnold Arboretum itself has fulfilled many different purposes during the past century, the basic premises . . . still hold." It then stated the mission as follows:

1. to develop, curate, and maintain a well-documented collection of living woody plants from around the world that are hardy in the Boston area;

2. to study these plants and their relatives and associates in nature through the maintenance of a herbarium and library and through directly related research in botany and horticulture;

3. to provide instruction in botany, horticulture, dendrology, and other fields related to the living collections.

## GOALS AND VISION STATEMENTS

Mission statements sometimes include goals to be met in order to carry out the mission. The Robert Hull Fleming Museum at the University of Vermont included goals in five areas as part of its mission statement. The museum's purpose was described as follows:

The Robert Hull Fleming Museum of the University of Vermont is an educational institution dedicated to the collection, preservation, interpretation, and exhibition of art and artifacts. The Museum's comprehensive collections represent the artistic achievements of world cultures and highlight the visual arts of Vermont. The Museum promotes understanding and enjoyment of the arts by presenting a wide range of exhibitions, programs, and events for the University of Vermont and the public.

The statement also gave the institution's goals in collections, exhibitions, public education, scholarship, and resource base in achieving the mission.

The University of Maryland Art Gallery followed a similar path in its mission statement, saying:

The mission of The Art Gallery of the University of Maryland at College Park is to educate the university community, as well as the greater Washington and Baltimore communities, in both contemporary and historic forms of visual art from all cultures; to

present an innovative exhibition program that complements and enhances the academic curriculum; to offer museum training to students; and to collect and preserve an art collection for study and research.

The statement also included such goals as originating contemporary and historical art exhibitions, producing exhibition catalogs, presenting exhibitions developed by other institutions, exposing university students to museum issues, educating the university and surrounding communities through supplemental programming, increasing accessibility of artworks that otherwise might not be available, providing first-hand exposure to original works of art, and upholding the highest standards for handling works of art.

Some university and college museums, galleries, and related facilities adopt annual goals instead of, or in addition to, putting goals in the mission statement. The Mills College Art Gallery adopts annual goals, in addition to those in the mission statement, designed to implement its stated purpose: "The gallery serves as a museum for the College, as a laboratory for the Department." The gallery's 1993–1994 academic year goals covered programs, exhibitions, publications, facilities, and fund raising. In presenting its annual goals, the gallery also gave a seven-point list of "what the present administration would like to be remembered for":

1. Making the gallery's programs and collections a distinctive and memorable part of a Mills education.
2. Bringing the environment of the exhibition space up to modern professional standards by controlling light, heat and dirt.
3. Establishing a national reputation among college galleries and improving our local reputation.
4. Contributing to the well-being of neighboring communities.
5. Strengthening and focusing the college collection through gifts and purchases.
6. Establishing an effective, enthusiastic support group.
7. Increasing the gallery's endowments for programs and collections.

Another type of institutional statement is the vision statement. It usually is part of the strategic or long-range planning process aimed at achieving the mission of the museum, gallery, or related facility.

The vision statement of the Kemper Museum of Contemporary Art and Design, which opened in 1994 at the Kansas City Art Institute, is similar to a mission statement, starting out as follows:

The vision of the Kemper Museum of Contemporary Art and Design is twofold: to enrich the cultural life of Kansas City by serving as a center for the presentation of contemporary art and design of the highest aesthetic quality, and to provide a vital educational resource for the students of Kansas City Art Institute.

The statement then summarizes the museum's collections, temporary exhibition program, founding and support, and educational role. Most vision statements go beyond this point, citing what the institution hopes to accomplish by some future date, and often how it intends to reach the goals.

Whatever approach a university or college museum, gallery, or related facility takes, it is essential that it have a mission statement, a list of goals, and/or a vision statement to help define its purpose and to serve as a guide in planning and implementing its operations.

*Chapter 4*

# Types of Institutions

University and college museums, galleries, and related facilities take many different forms—varying in subject matter, mission, organization, name, and many other ways. This chapter looks at campus museums and their counterparts from the standpoint of their primary fields of emphasis and how they normally are categorized.

Museums and similar facilities at universities and colleges can be grouped in at least 24 categories, with some falling into several classifications. Approximately half of the institutions are in the art field, with art galleries accounting for 33 percent and art museums more than 14 percent.

Other types of museums and related facilities often found on university and college campuses—each ranging from 6 to 8 percent of the total—include natural history museums and centers; archaeology, anthropology, and ethnology museums; historical museums, houses, and sites; botanical gardens, arboreta, and herbaria; and planetaria and observatories.

These seven types of institutions comprise more than 80 percent of the nation's museums, galleries, and related facilities at universities and colleges. The remaining 20 percent consist largely of specialized types of museums in art, history, science, and other fields.

In the art field, there are three types of specialized museums and facilities on the campus in addition to art museums and galleries—photography museums, costume and textile museums, and sculpture gardens. In some cases, such collections are part of the art museums and galleries, rather than being separate institutions.

At least five types of specialized history-oriented museums and facilities be-

yond traditional historical museums, houses, and sites are operated by universities and colleges. They include agricultural museums; medical, dental, and health museums; musical instruments museums; religious museums; and library and archival collections and galleries.

In addition to natural history museums, planetaria and observatories, and botanical gardens, arboreta, and herbaria, universities and colleges have five types of specialized science museums—entomology museums; geology, mineralogy, and paleontology museums; marine sciences museums and aquariums; science and technology museums and centers; and zoology museums. Sometimes medical, dental, and health museums and contract federal facilities also are grouped in this category.

Four other types of specialized museums and facilities include general museums, museums in other fields, contract science facilities, and unaffiliated museums located on campuses, but operated independently.

A description of the various types of museums, galleries, and related facilities follows.

## THE MOST NUMEROUS MUSEUMS, GALLERIES, AND RELATED FACILITIES

### Art Museums

University and college art museums basically are institutions that collect, preserve, exhibit, and interpret permanent collections of art. The artworks most often consist of paintings, prints, drawings, and sculpture, but also frequently include decorative arts, photographs, ceramics, furniture, costumes, textiles, design, silver, glass, jade, metalwork, engravings, jewelry, antiquities, and/or other works. Art museums—which number more than 160—also usually present temporary exhibitions and public programs and often are used for teaching and research.

Art museums are among the oldest, largest, and best known, attended, and supported campus museums. Many have extensive collections and exhibits, beautiful sculpture gardens or courts, and/or new buildings underwritten by private individuals, while others are relatively small, are more narrowly focused, and/or occupy some of the most historic buildings at colleges and universities. Not all have "museum" in their names; some are called galleries, collections, art centers, or other names.

Art collections and museums were among the first cultural collections and facilities at American universities and colleges. Many began as institutional, teaching, or research collections that later evolved into museums—frequently many years after the collections began. At Dartmouth College, for example, the collections began in 1772, but it was not until 1974 that several collections were consolidated to form a museum that became the Hood Museum of Art in 1985.

The first collections of the Bowdoin College Museum of Art originated in 1811. However, the museum was not formalized until 1894.

The nation's first art school and art museum were founded in 1805 in Philadelphia. The Museum of American Art still is part of the Pennsylvania Academy of Fine Arts. Among the other early efforts were the Trumbull Gallery (which later developed into the Yale University Art Gallery), established in 1832 at Yale University; a collection of engravings used to illustrate classical antiquity lectures in 1855 that eventually led to the establishment of the University of Michigan Museum of Art in 1946; and the inclusion of an art museum (now known as the Frances Lehman Loeb Art Center) for display of a teaching collection as part of the founding of Vassar College in 1861.

The largest university art museum complex today is the Harvard University Art Museums, which include the Fogg Art Museum, Busch-Reisinger Museum, and Arthur M. Sackler Museum. The three facilities occupy approximately 200,000 square feet and have over 130,000 objects in their collections and an annual attendance of nearly 240,000.

Among the other leading art museums are the Yale University Art Gallery and Yale Center for British Art, Art Museum at Princeton University, University of Michigan Museum of Art, Elvehjem Museum of Art at the University of Wisconsin–Madison, Spencer Museum of Art at the University of Kansas, Indiana University Art Museum, Memorial Art Gallery at the University of Rochester, Henry Art Gallery at the University of Washington, Herbert F. Johnson Museum of Art at Cornell University, Museum of Art at the Rhode Island School of Design, and Snite Museum of Art at the University of Notre Dame.

Some highly regarded art museums that have moved into new facilities in the 1990s include the Frederick R. Weisman Art Museum at the University of Minnesota, Twin Cities; Frances Lehman Loeb Art Center at Vassar College; and Davis Museum and Cultural Center at Wellesley College. Another major development was the movement of the Wight Art Gallery and the Grunwald Center for the Graphic Arts into the Armand Hammer Museum of Art and Cultural Center, which turned over its management to the University of California, Los Angeles.

A number of important art museums have their dual functions reflected in their names, such as the Sheldon Memorial Art Gallery and Sculpture Garden at the University of Nebraska–Lincoln and the University Art Museum and Pacific Film Archive at the University of California, Berkeley. Others without ''art'' in their names frequently have collections that span several disciplines, such as the Michael C. Carlos Museum at Emory University, which features art and archaeological antiquities.

Specialty art museums and galleries generally are included in other categories because of their emphasis on a particular aspect of the art field. They most often are classified as photography museums, costume and textile museums, or sculpture gardens. Other art facilities with small or no collections or permanent exhibits generally are considered art galleries, rather than museums.

Many museums in other fields often also have art collections and exhibitions. This generally occurs among museums of archaeology, anthropology, and ethnology; general museums; historical museums, houses, and sites; and religious museums.

## Art Galleries

One out of three museums and galleries at American universities and colleges is an art gallery. The number of campus art galleries now exceeds 380, and the total keeps growing. Many of the largest institutions have more than one gallery. They are found most commonly at universities and colleges that do not have art museums, although they sometimes function as a showcase for a university's or museum's extensive collection.

Art galleries differ from art museums in that they usually do not have a permanent art collection (although some do, they are generally limited). They normally also are smaller in terms of space, staff, and budget; feature changing exhibitions, frequently of contemporary art; rely heavily on outside sources for the content of exhibitions; and rarely engage in research. Many are part of art departments and schedule faculty and student shows as extensions of academic programs.

Some art museums began as art galleries or collections of art used in instructional programs, including the Jane Voorhees Zimmerli Art Museum at Rutgers University; Frederick R. Weisman Art Museum at the University of Minnesota, Twin Cities; Lowe Art Museum at the University of Miami; and Frances Lehman Loeb Art Center at Vassar College.

A number of art museums still have ''gallery'' in their names, such as the Washington University Gallery of Art, Weatherspoon Art Gallery at the University of North Carolina at Greensboro, Memorial Art Gallery at the University of Rochester, Fisher Gallery at the University of Southern California, and Hearst Art Gallery at Saint Mary's College of California. A few galleries have ''museum'' as part of their names—such as the Wignall Museum/Gallery at Chaffey Community College and John J. McDonough Museum of Art at Youngstown State University—but they do not have collections, and they function as galleries with changing exhibitions.

One of the earliest galleries opened in 1871 at what later became the San Francisco Art Institute. It evolved into the present-day Walter/McBean Gallery. It was not until the 1920s and 1930s, however, that many of today's collegiate galleries began to appear with increasing frequency. They included the Wisconsin Union Art Galleries, University of Wisconsin–Madison, 1928; Doris Ulmann Galleries, Berea College, 1935; Tobey Gallery, Memphis College of Art, 1936; and Armstrong Gallery, Cornell College, 1937. But the surge in the number of galleries did not come until the 1960s through the 1980s.

Art galleries now are the fastest-growing segment of the campus museum/ gallery movement. Among the many new galleries opened in the 1990s are the Center for the Visual Arts at Metropolitan State College of Denver, Diggs Gal-

lery at Winston-Salem State University, Blum Art Gallery at the College of the Atlantic, and Ashby-Hodge Gallery of American Art at Central Methodist College. Others have moved into new facilities, including the Harder Center Gallery at Presbyterian College, Tufts University Art Gallery, and Thorne-Sagendorph Art Gallery at Keene State College.

Among the best-known galleries are the Joe and Emily Lowe Art Gallery at Syracuse University, List Visual Arts Center at the Massachusetts Institute of Technology, Dimock Gallery at George Washington University, Mary and Leigh Block Gallery at Northwestern University, Rubelle and Norman Schafler Gallery at the Pratt Institute, and Hopkins Hall Gallery and Wexner Center for the Arts at Ohio State University.

Most art galleries are relatively small—ranging from several hundred to several thousand square feet. But some are quite large, such as the Lehman College Art Gallery and the J. Wayne Stark University Center Galleries at Texas A&M University, each of which has 20,000 square feet, and the new Visual Art Center at North Carolina State University, with 18,000 square feet.

Many universities and colleges have multiple gallery spaces—sometimes with different names and other times grouped together under "galleries." For instance, the Lehigh University Art Galleries present exhibitions at five campus locations; Bowling Green State University, Arizona State University, and Moore College of Art and Design have three galleries with different names; and the Pratt Institute operates galleries on the campus and in Manhattan with the same name.

Some museums in other fields also have gallery spaces to display artworks relating to their fields. They include the Earth and Mineral Sciences Museum and Gallery at Pennsylvania State University, which has a gallery for paintings, drawings, and sculptures relating to the mineral industries, and the Museum of the Rockies at Montana State University, with a gallery for displaying western and Native American art.

## Natural History Museums and Centers

Natural history museums are concerned with the natural sciences and with objects such as animals, birds, fish, rocks, minerals, fossils, insects, plants, planets, humans, and other aspects of systematic and evolutionary biology. Most university and college museums of natural history are collection, teaching, and research oriented, while nature and environmental centers are more limited in scope and more interpretive in purpose.

Over 70 universities and colleges have natural history museums or centers, and more than 60 other institutions have museums in other categories with substantial collections of natural history objects. The latter include archaeology, anthropology, and ethnology museums; entomology museums; geology, mineralogy, and paleontology museums; marine sciences museums and aquariums; and zoology museums, as well as some general museums, historical museums, planetaria and observatories, and science and technology museums and centers.

**Figure 9.** The Dorothy Uber Bryan Gallery is one of three contemporary art galleries in the Fine Arts Center at Bowling Green State University in Ohio. The gallery was opened in 1992—with the Hiroko Nakamoto Gallery—as part of an addition to the arts center. The Fine Arts Gallery was founded in 1960 with the construction of the center. *(Courtesy Dorothy Uber Bryan Gallery and university public relations office)*

History, University of Oklahoma; Texas Memorial Museum, University of Texas at Austin; and University of Georgia Museum of Natural History.

Some of the more specialized natural history facilities also have large collections, such as the Bohart Museum of Entomology at the University of California, Davis and the Harvard University Herbarium. Nature and environmental centers, which tend to be located off-campus, have much smaller collections, which usually include live plants, animals, birds, and/or fish. Among such facilities are Antioch College's Trailside Museum, Indiana University's Hilltop Garden and Nature Center, and Pennsylvania State University's Shaver's Creek Environmental Center.

In addition to their comprehensive collections and extensive research activities, natural history museums are known for their spectacular dinosaur and other fossil displays and lifelike dioramas. The Peabody Museum of Natural History at Yale has one of the nation's largest collections and exhibits of dinosaurs. Among the other museums with extensive dinosaur fossil holdings are the Oklahoma Museum of Natural History, University of Oklahoma; University of Nebraska State Museum; Exhibit Museum, University of Michigan; Museum of the Rockies, Montana State University; and Utah Museum of Natural History, University of Utah. Some other types of museums, such as the Earth Science Museum at Brigham Young University, also have large dinosaur fossil collections.

At the University of Minnesota, the James Ford Bell Museum of Natural History has over 100 dioramas and habitat groups featuring the flora and fauna of Minnesota. Walk-through diorama-like displays are featured at the Florida Museum of Natural History, University of Florida. Other museums making effective use of dioramas include the Michigan State University Museum; Museum of Natural History, University of Iowa; and Texas Memorial Museum, University of Texas at Austin.

## Archaeology, Anthropology, and Ethnology Museums

Archaeology, anthropology, and ethnology are among the fields frequently covered—at least partially—by natural history museums. More often they are the focus of separate museums specializing in social history and material culture, with the latter referring to artifacts made by human beings through a combination of raw material and technology.

Universities and colleges have more than 70 museums that deal primarily with archaeology, anthropology, and/or ethnology. Over 40 museums in other fields, such as natural history, religion, or history, also have such artifacts as part of their collections and exhibitions.

One of the first museums in the field was the Peabody Museum of Archaeology and Ethnology, founded at Harvard University in 1866 with a George Peabody trust fund grant and opened in 1877. The museum, which houses treasures of prehistoric and historic cultures from throughout the world, now is one

of four museums that comprise the Harvard University Museums of Natural History.

Other early collections and museums include the Johns Hopkins University Archaeological Collection, 1884; Thomas Burke Memorial Washington State Museum, University of Washington, 1885; University of Pennsylvania Museum of Archaeology and Anthropology, 1887; Semitic Museum, Harvard University, 1889; Logan Museum of Anthropology, Beloit College, 1894; and Oriental Institute Museum, University of Chicago, 1896.

Most of the museums in the field—including the Peabody Museum of Archaeology and Ethnology at Harvard and the University of Pennsylvania Museum of Archaeology and Anthropology—are broad based. Others tend to specialize, such as the Oriental Institute Museum at the University of Chicago, which features the art and archaeology of the ancient Near East; Kelsey Museum of Archaeology at the University of Michigan, with classical antiquities as the core of its collections; Phoebe A. Hearst Museum of Anthropology at the University of California, Berkeley, which emphasizes its California archaeological and ethnographic materials; Maxwell Museum of Anthropology at the University of New Mexico, a major resource of Southwest archaeological and ethnological materials; Semitic Museum at Harvard University, dedicated to Semitic languages and history; and Thomas Burke Memorial Washington State Museum at the University of Washington, which focuses on the state of Washington, Pacific Northwest, and Pacific region.

Among the other archaeology, anthropology, and ethnology museums with unusual specialties are the Jewish Museum, operated under the auspices of the Jewish Theological Seminary of America, devoted to Judaic art, history, and culture; Peary-Macmillan Arctic Museum at Bowdoin College, with collections relating to the exploration, archaeology, anthropology, and ecology of the Arctic region; and C.H. Nash Museum-Chucalissa, which is an archaeological park, museum, and partially reconstructed fifteenth-century Native American village, operated by the University of Memphis.

Some museums have extensive ethnographic collections resulting from the consolidation of artifacts from various academic departments, as occurred in the founding of the World Heritage Museum at the University of Illinois at Urbana-Champaign and the Fowler Museum of Cultural History at the University of California, Los Angeles.

Museums of archaeology, anthropology, and ethnology often have large collections. Two museums—the Thomas Burke Memorial Washington State Museum at the University of Washington and the Phoebe A. Hearst Museum of Anthropology at the University of California, Berkeley—have nearly 4 million artifacts and other materials. Other museums with substantial collections are the University of Pennsylvania Museum of Archaeology and Anthropology, approximately 1.5 million; Museum of Anthropology at the University of Kentucky, almost 1 million; Fowler Museum of Cultural History, over 750,000; and Peabody Museum of Archaeology and Ethnology, more than 500,000.

## Historical Museums, Houses, and Sites

Historical museums and related facilities take many forms at universities and colleges. They include historical museums, historic houses and sites, living history farms, re-created communities, and specialized museums covering the history of universities and colleges and such diverse fields as geographic regions, agriculture, religious bodies, medicine, sports, and politics.

Nearly 90 historical museums, houses, sites, and related facilities are located on campuses, and more than 80 other facilities are at least partly historical in nature. The latter tend to be in general museums and those in specialized fields.

Among the first campus historical museums were those at military academies, such as the U.S. Naval Academy Museum, 1845; West Point Museum, U.S. Military Academy, 1854; and VMI Museum, Virginia Military Institute, 1856. They trace the history of the services and of their institutions through military artifacts, artworks, and exhibits.

Most historical museums and related facilities were not established until the last half of the twentieth century, but they frequently are dedicated to people, places, and events from the eighteenth and nineteenth centuries. Perhaps the best-known campus historic site is the Rotunda at the University of Virginia, which was designed by Thomas Jefferson. Built in 1822–1826, it is the focal point of Jefferson's ''academical village,'' which includes pavilions and formal gardens.

Two historical facilities commemorate the life of James Monroe, the nation's fifth president. His 1799 home, known as Ash Lawn–Highland, and the surrounding 535-acre working farm are now part of the College of William and Mary, while the largest collection of Monroe's possessions can be found at the James Monroe Museum and Memorial Library at Mary Washington College.

Among the other memorial museums are the ca. 1803 John C. Calhoun House, where the eminent South Carolina statesman lived during the last 25 years of his life, at Clemson University; President Andrew Johnson Museum and Library in an 1841 building at Tusculum College; Sam Houston Memorial Museum, on the site of the pioneer Texas leader's 1847–1857 homestead, administered by Sam Houston State University; Abraham Lincoln Museum, with one of the largest collections of Lincoln and Civil War items, at Lincoln Memorial University; Lee Chapel and Museum, which marks the life and contributions of General Robert E. Lee, at Washington and Lee University; Jackson's Mill Museum, where Confederate General Stonewall Jackson worked as a boy, administered by West Virginia University; and Winston Churchill Memorial and Library in the United States at Westminster College in Fulton, Missouri, where the British prime minister delivered his famous Sinews of Peace speech in 1946.

Numerous museums are concerned with the history of a state or region. Some representative institutions are the Panhandle-Plains Historical Museum (history of the Panhandle area as it relates to Texas and the Southwest) at West Texas A&M University, Ralph Foster Museum (history of the Ozark region) at the College of the Ozarks, Museum of the Big Bend (history of the Big Bend region

in western Texas) at Sul Ross State University, and Institute of Texan Cultures (ethnic and cultural history of the state) at the University of Texas at San Antonio.

Some universities and colleges have historical complexes or living history museums. They include Historic Bethany, a complex of historical buildings and collections largely from the 1840s, at Bethany College; Old Castle Museum, a historic building complex from the mid-nineteenth century, at Baker University; Pioneer Heritage Center, containing buildings and collections from the nineteenth-century Red River region, at Louisiana State University in Shreveport; Conner Prairie, a 250-acre living history museum that offered the first costumed interpreters in a historical village, which is part of Earlham College; and Historic New Harmony, located on the site of two early-nineteenth-century utopian experiments, operated by the University of Southern Indiana and a state natural resources agency.

Among the museums in other fields with historical aspects are the LSU Rural Life Museum, an outdoor folk museum featuring the life styles and cultures and pre-industrial Louisianians, at Louisiana State University; Ranching Heritage Center, a historical ranching exhibit with 33 structures, which is part of the Museum of Texas Tech University; Ronald V. Jensen Living Historical Farm, a 120-acre farm that tells the story of agriculture, operated by Utah State University; and World Heritage Museum, an ethnologically oriented museum of world history and culture, at the University of Illinois at Urbana-Champaign.

## Botanical Gardens, Arboreta, and Herbaria

Although not called "museums," botanical gardens, arboreta, and herbaria are museum-like in their collections and operations and normally are included as part of the museum field. A botanical garden is a garden—often with one or more greenhouses—for the culture, study, and exhibition of special plants; an arboretum is a place where trees, shrubs, and herbaceous plants are cultivated primarily for scientific and educational purposes; and a herbarium is a collection of dried plant specimens, usually mounted and systematically arranged for reference purposes.

These botanical facilities normally are separate, with botanical gardens and arboreta usually being located outdoors and herbaria indoors. In most instances, a university or college has only one of the collections, although a few institutions have two or all three. When not independently administered, botanical gardens and arboreta usually are operated by the academic departments of biology, botany, forestry, or horticulture or by the physical plant department of the university or college. Herbaria generally are in the biological sciences department or natural history museum.

Universities and colleges have approximately 80 botanical gardens, arboreta, and herbaria, and nearly 25 others are part of museums or other facilities. The collections range from a few hundred specimens to over 5 million (at the Harvard University Herbaria).

The first campus botanical gardens were established during the latter part of the nineteenth century. The nation's oldest continuously operating botanical garden is the W.J. Beal Botanical Garden at Michigan State University, founded in 1873. Other early gardens include the University of California Botanical Garden at Berkeley, 1890, and the Botanic Garden of Smith College, 1895.

The first public arboretum in the United States was the Arnold Arboretum of Harvard University, founded in 1872. However, as early as 1834, an English gardener was hired by Haverford College to convert farmland into an attractive campus—which led to the establishment of the Haverford College Herbarium. Among the other early arboreta were the Vanderbilt University Arboretum, 1873, and the Morris Arboretum of the University of Pennsylvania, founded privately in 1887 and becoming part of the university in 1932.

Herbaria are the most numerous of the museum-like facilities in the plant sciences. The Harvard University Herbaria began in 1864, followed by such facilities as the Kansas State University Herbarium, 1871; University Herbarium at the University of California, Berkeley, 1872; Greene-Nieuwland Herbarium at the University of Notre Dame, 1879; Arthur Herbarium at Purdue University, 1887; and Rocky Mountain Herbarium at the University of Wyoming, 1893.

Two other types of botanical institutions—the Botanical Museum at Harvard University and the Hunt Institute for Botanical Documentation at Carnegie Mellon University—usually are included in this category. The Botanical Museum, which started as the Museum of Vegetable Products in 1858, is commonly known as the Garden of Glass Flowers because of its 3,000 glass models of 800 plant species created by Leopold Blaschka and his son, Rudolph, between 1887 and 1936. The Hunt Institute, founded in 1961, is a botanical gallery/library/archives/bibliography, with more than 30,000 watercolors, drawings, and original prints; over 23,000 books; approximately 2,000 letters and 280 sets of botanists' private papers; and several hundred thousand reference plant sciences books, periodicals, articles, and other publications.

Harvard University has five museum-like facilities in the plant sciences, including some of the most prominent. They are the Arnold Arboretum, Harvard University Herbaria, Botanical Museum, Harvard Forest, and Fisher Museum of Forestry. Michigan State University also has five botanical facilities, while the University of Virginia has four.

Among the leading facilities in the field are Harvard's 2,500-acre Arnold Arboretum, with over 7,000 varieties of ornamental trees and shrubs in Jamaica Plain, Massachusetts (Harvard also has a 3,000-acre forest in Petersham); Morris Arboretum of the University of Pennsylvania, which has approximately 6,800 labeled temperate-zone trees and shrubs on 175 acres; Harold L. Lyon Arboretum of the University of Hawaii at Manoa, with approximately 4,000 tropical trees and other plants on 193 acres; Cornell Plantations of Cornell University, which has 2,700 acres of natural areas, a 200-acre arboretum, and 14 separate gardens as part of a biological garden; Boyce Thompson Southwestern Arboretum of the University of Arizona, featuring approximately 12,000 plant spec-

imens representing 2,350 taxa in Superior, about 100 miles north of the Tucson campus; Scott Arboretum, with 5,000 kinds of plants on 300 acres at Swarthmore College; Minnesota Landscape Arboretum of the University of Minnesota, which has research and display gardens on 905 acres; University of Wisconsin–Madison Arboretum, containing the world's oldest and largest collection of restored biological communities on its 1,280 acres; University of California Botanical Garden at Berkeley, consisting of approximately 12,500 accessions representing more than 300 plant families; and Mildred E. Mathias Botanical Garden at the University of California, Los Angeles, which has more than 4,000 species in 225 families and an herbarium.

Some arboreta include the entire campus. At Haverford College, over 1,000 campus trees are labeled, and self-guided specialty tours are featured. A two-mile walking tour that winds past 61 species of trees on the 350-acre campus is part of the Vanderbilt University Arboretum. The Chadwick Arboretum at Ohio State University has pocket gardens scattered through the 1,600-acre campus, with 40 acres being the focal gardens.

## Planetaria and Observations

American universities and colleges have approximately 300 planetaria, where an optical device projects various celestial images and effects on a dome for the benefit of audiences. Most of the planetaria are used for instructional purposes and do not present public programs. Nearly 70, however, serve a dual purpose and sometimes have collections. Over 15 others are part of natural history and other museums.

Some of the planetaria also have observatories, used primarily by students, faculty members, and the public to view and/or study distant natural phenomena with telescopes. Larger and more powerful telescopes designed for research generally are part of astronomical observatories that stand alone and frequently are located on mountain tops many miles from campuses. Some of the latter are operated by groups of universities and colleges on a contract basis for the federal government.

Observatories came before planetaria. The first American university/college observatory was the Harvard College Observatory, founded in 1839. Its Great Reflector—a 15-inch telescope installed in 1847—was the nation's largest telescope for 20 years. In 1973, the Harvard observatory joined with the Smithsonian Astrophysical Observatory to form the Harvard-Smithsonian Center for Astrophysics, based in Cambridge with a joint faculty and facilities. The center now operates two major field stations—the Oak Ridge Observatory in Harvard, Massachusetts, and the Fred Lawrence Whipple Observatory near Amado, Arizona.

Another large university observatory developed in the late nineteenth century was the University of California's Lick Observatory on Mount Hamilton, near San Jose and Santa Cruz. A major astronomical research center since it opened in 1888, it has a visitor center and a public gallery overlooking its largest tel-

escope—the 120-inch Shane reflecting telescope. A smaller facility—the Leander J. McCormick Observatory, with a 26-inch refracting telescope—was established at the University of Virginia in 1885.

Most of the leading astronomical research facilities (nearly all with visitor centers and/or viewing galleries) were established by universities and colleges in the twentieth century. They include the Palomar Observatory, opened on Palomar Mountain in 1948 by the California Institute of Technology (it features the 200-inch Hale telescope); University of Texas McDonald Observatory, founded in 1932 in the Davis Mountains near Fort Davis in Texas; Mauna Kea Observatories, an astronomical complex started in 1968 by the University of Hawaii near Hilo (and now the site of many other university and government observatories); W.M. Keck Observatory, a newly opened facility that has the world's largest and most powerful optical and infrared telescope at Mauna Kea, operated by a partnership of the University of California and the California Institute of Technology; and WIYN Observatory, opened in 1994 on Kitt Peak near Tucson by a consortium of three universities (Indiana, Wisconsin, and Yale) and the National Optical Astronomy Observatories.

The National Optical Astronomy Observatories are one of two major government operations—the other being the National Radio Astronomy Observatory—managed for the National Science Foundation on a contract basis by two associations of research universities. The optical observatories, consisting of three astronomical research centers (National Solar Observatory, Kitt Peak National Observatory, and Cerro Tololo Inter-American Observatory) are operated by the Association of Universities for Research in Astronomy Inc. The radio astronomy observatory (located in Green Bank, West Virginia, with facilities at other locations) is administered by Associated Universities Inc.

Three of the earliest and best-known campus planetaria are the Morehead Planetarium at the University of North Carolina at Chapel Hill, opened in 1949; Fleischmann Planetarium, founded in 1963 at the University of Nevada at Reno; and Abrams Planetarium at Michigan State University, opened in 1964. The Morehead Planetarium has the largest theater (330 seats) and displays exhibits and artworks on astronomy and space; Fleischmann Planetarium offers sky shows, Cinema-360 hemispheric films, exhibits, and observatory viewing; and Abrams Planetarium has 252 theater seats, telescopic observing, and exhibits on astronomy, meteorites, and space exploration.

Some planetaria are part of broader-based planetaria/space/science centers, such as the Flandrau Science Center and Planetarium at the University of Arizona and Cernan Earth and Space Center at Triton College. Planetaria also are found at other types of museums: natural history museums, including the Ruth and Vernon Taylor Planetarium at the Museum of the Rockies at Montana State University and the Ralph Teetor Planetarium at the Joseph Moore Museum of Natural History at Earlham College; hands-on science/technology centers, such as the William K. Holt Planetarium at the Lawrence Hall of Science at the

University of California, Berkeley; and even what is primarily an art museum, the I.P. Stanback Museum and Planetarium at South Carolina State University.

Laser light shows that choreograph laser images and special visual effects to music are presented by some planetaria, including the Cernan Earth and Space Center at Triton College and the Clever Planetarium and Earth Science Center at San Joaquin Delta College. One of the largest and most technologically advanced planetarium/observatory complexes was opened in 1994 at Brevard Community College in Florida. The Astronaut Memorial Planetarium and Observatory is a 51,455-square-foot facility—a remodeled, expanded, and renamed 1976 planetarium—that contains a 70-foot-diameter planetarium with a Minolta Infinium projector, a 70mm IWerks theater, a 24-inch Cassegrain telescope, and exhibits devoted to American astronauts and the space program.

## OTHER ART-ORIENTED MUSEUMS

### Photography Museums

Nearly all campus museums have photographs in their collections, but the greatest concentration usually can be found in separate photography museums. Some art, archaeology, anthropology, and ethnology museums also have large photography collections. In such art and cultural museums, however, photographs are only part of much more extensive collections.

Approximately 10 institutions have photography museums. One of the nation's largest collections of documentary photographs—numbering more than 1 million images—is located at the University of Louisville's Photographic Archives in the Ekstrom Library. Many of the photographs show the faces, houses, streets, industry, and life of the Louisville area over the last century.

Another large photography collection can be found at the California Museum of Photography at the University of California, Riverside. It is one of the largest, most comprehensive, and most diverse photographic resources in the West, interpreting photography as technology, social history, and artistic endeavor. The collection includes cameras, viewing devices, glass plates, paper prints, publications, and other materials related to photography.

Among the other university and college photography museums are the University of Kentucky Photographic Archives, with over 100,000 photographs and manuscripts documenting the history of photography; Center for Creative Photography at the University of Arizona, with more than 70,000 photographs by over 1,800 photographers and a photographers' archives, galleries, a library, and research facilities; Southeast Museum of Photography at Daytona Beach Community College, featuring contemporary and historical photography collections and exhibits; and Museum of Contemporary Photography at Columbia College Chicago, which focuses on contemporary American photography.

Some museums in other fields have photography collections—many of which are specialized. One of the largest is the collection of over 500,000 images at

the Peabody Museum of Archaeology and Ethnology at Harvard University. Harvard's Fogg Art Museum also has a twentieth-century photography collection in which over 300 artists are represented.

The Yale Center for British Art contains more than 75,000 photographs of British art, while the Yale University Art Gallery has a large collection of contemporary photographs. Other photography specialties include a collection of nineteenth-century European photographs at the Snite Museum of Art at the University of Notre Dame, Native American photographs at the William Hammond Mathers Museum at Indiana University, and motion picture prints at the University Art Museum and Pacific Films Archive at the University of California, Berkeley.

Among the other art museums with large photography collections are the University Art Museum at the University of New Mexico, Henry Art Gallery at the University of Washington, and Museum of Art at the Rhode Island School of Design.

## Costume and Textile Museums

A few museums are devoted entirely to costumes and textiles, while smaller collections of such materials can be found at a number of art, ethnographic, general, and other types of museums. Eight universities and colleges have costume/textile museums and galleries.

Two costume and textile museums with the largest collections are the Fashion Institute of Technology's Museum at F.I.T. in New York City and the Paley Design Center at the Philadelphia College of Textiles and Science. The F.I.T. museum has two block-long storerooms containing indexed collections of clothing and more than 4 million textile swatches. The collections include regional clothing, furs, children's wear, and lingerie, ranging from the eighteenth century to the present, and 300 textile mill swatch books and samples of fabric dating from 1835. The Paley Design Center features international textiles dating from the first century to the present and a fabric archive of over 300,000 original samples of actual work and design models from many American and European textile mills.

Among the other specialized museums in the field are the Helen Louise Allen Textile Collection at the University of Wisconsin–Madison and Goldstein Gallery at the University of Minnesota, Twin Cities, both of which have more than 12,000 examples of historic and contemporary clothing, textiles, and related objects; Gustafson Gallery, with over 7,000 historical costumes and 500 textile pieces, at Colorado State University; Historic Costumes and Textiles Collection of more than 6,000 items at Mount Mary College; Elizabeth Sage Historic Costume Collection, featuring collections and exhibits of nineteenth- and twentieth-century American and Western European clothing, textiles, and accessories, at Indiana University; and DAR Museum/First Ladies of Texas Historic Costumes Collection, containing inaugural ball and other gowns worn by the wives of the governors of Texas, the presidents of the Republic of Texas, and two presidents

and a vice president of the United States, displayed at Texas Woman's University.

Museums at two art/design institutions also have extensive collections of historic and contemporary costumes and textiles. They are the Museum of Art at the Rhode Island School of Design and the Kemper Museum of Contemporary Art and Design. Among the other museums with costume and textile collections are the University of Washington's Henry Art Gallery, with ethnic textiles and costumes from 131 countries; Kent State University Museum, which has nine galleries and collections of Western dress from 1750 to the present, as well as Asian and African regional dress; and Brown University's Haffenreffer Museum of Anthropology, with collections that include textiles, art, and other ethnographic materials.

## Sculpture Gardens

Works of sculpture can be found inside and outside museums. Outdoor sculpture gardens on university and college campuses usually feature large works of contemporary sculpture, while sculpture collections inside museums generally consist of small to medium works ranging from ancient times to the present. Most sculpture gardens are part of art museums, although a few are operated by art galleries or independently. Sculpture collections also can be part of other types of museums. Four outdoor sculpture gardens are administered independently, while nearly 30 museums and other facilities have such collections.

Among the major sculpture gardens that have works throughout the campus are the Franklin D. Murphy Sculpture Garden, administered by the Wight Art Gallery and featuring 59 works by some of the world's leading sculptors at the University of California, Los Angeles; Edwin A. Ulrich Museum of Art outdoor collection of 54 sculptures on the Wichita State University campus; Princeton University Art Museum's John B. Putnam Jr. Memorial Collection of twentieth-century sculpture displayed about the campus; Hofstra Museum's outdoor sculpture collection on Hofstra University's 238-acre campus; 20 outdoor works from the Western Gallery at Western Washington University; and Stuart Collection of 14 sculptures throughout the 1,200-acre campus of the University of California, San Diego.

Outdoor sculpture gardens more often are found adjacent to art museums and galleries, as is the case with the Vera and A. Elden Sculpture Garden at the David and Alfred Smart Museum of Art at the University of Chicago, Sheldon Memorial Art Gallery and Sculpture Garden at the University of Nebraska–Lincoln, Philip and Muriel Berman Museum of Art at Ursinus College, Frances Lehman Loeb Art Center at Vassar College, Mary and Leigh Block Gallery at Northwestern University, and Snite Museum of Art at the University of Notre Dame.

Some arboreta contain sculptures on their grounds, including the Morris Arboretum of the University of Pennsylvania and the Vanderbilt University Arboretum. A few colleges and universities have independently administered

outdoor sculpture displays. One of the first outdoor sculpture courts was the Hall of Fame for Great Americans, founded in 1900 by New York University to honor significant individuals who have contributed to the American experience. The Hall of Fame, which now contains busts of 97 of the 102 persons honored, has become part of the Bronx Community College of the City University of New York. Three other outdoor displays are the Governors State University Sculpture Park, Marshall M. Fredericks Sculpture Gallery on the Saginaw Valley State University campus, and Sculpture Garden at Winston-Salem State University.

Among the varied indoor sculpture collections at art and other museums are works ranging from Romanesque stone pieces to twentieth-century sculpture at the Fogg Art Museum at Harvard University; Assyrian, South Asian, and Italian sculpture at the Williams College Museum of Art; medieval to modern sculpture at the Robert Hull Fleming Museum at the University of Vermont; 275 pieces of Romanesque and Gothic sculpture at the Duke University Museum of Art; twentieth-century works at the Indiana University Art Museum; Egyptian predynastic to Roman wood and stone sculpture at the Museum of Art and Archaeology at the University of Missouri–Columbia; 300 American sculptures at the Museum of American Art at the Pennsylvania Academy of the Fine Arts; sculpture of Ivan Meštrović at the Snite Museum of Art at the University of Notre Dame; and early Modernist, African, and other sculptures at the Yale University Art Gallery.

## OTHER HISTORY-ORIENTED MUSEUMS

### Agricultural Museums

Nearly all agricultural museums—which number 10—are historical museums, telling the story of life on the farm, ranch, or plantation in a particular area during a specific period. Most have collections of tools, implements, clothing, furniture, and other belongings. Some are outdoor museums that also have multiple historic and/or replicated structures and often costumed interpreters.

Among the largest agricultural museums are the 120-acre Ronald V. Jensen Living Historical Farm, a restored 1917 farm operated by Utah State University, which has 7 historic structures, implements, wagons, household items, and even work horses, dairy cows, sheep, hogs, poultry, and heritage crops; Louisiana State University Rural Life Museum, with 20 buildings containing country furniture, cooking utensils, wrought iron objects, and other materials on 430 acres; Ranching Heritage Center, a part of the Museum of Texas Tech University, which consists of a 14-acre outdoor exhibit area with 33 structures; and Ferrum College's Blue Ridge Farm Museum, consisting of two re-created farmsteads that illustrate a century of change in the life, architecture, decorative arts, labor, crafts, and agriculture of German-American settlers in western Virginia between 1800 and 1900.

Other living history museums that have agricultural components are Conner Prairie, a 250-acre outdoor museum from the 1800–1850 period, with 37 buildings, costumed interpreters, and a 60,000-square-foot modern museum center, a satellite of Earlham College; Winedale Historical Center, a restored 1834-period farmstead with houses, furniture, art, tools, and agricultural implements, operated by the University of Texas at Austin; and Governor Bill and Vara Daniel Historic Village, a part of the Strecker Museum, located on a 13-acre site on the Baylor University campus.

Some plantations with historic houses that have been donated to colleges and universities also have agricultural aspects. For example, the Sweet Briar Museum occupies a nineteenth-century Tuscan villa left to Sweet Briar College with a 9,000-acre plantation and the donor's clothing, furniture, and farm tool collection, and the 1,100-acre Chinqua-Penn Plantation, now owned by North Carolina State University, has a historic house, support structures, and land used for experimental research by the university. At Iowa State University, the Farm House Museum is where the university's model farm was founded. The structure, located on what now is the central campus, has been restored in the late Victorian style of 1860–1910.

Pennsylvania State University has three agriculturally oriented museums—the Pasto Agricultural Museum, containing approximately 300 farm and household items dating back to the 1840s; Clark Kerr Apple Variety Museum, with 50 unusual varieties of living apple trees; and Mascaro/Steiniger Turfgrass Museum, which features lawn equipment used by professional turf managers. Michigan State University operates a working farm—the 1,100-acre Kellogg Farm Diary Center—which has a visitor center, milking observation room, and self-guided tours as part of its W.K. Kellogg Biological Station.

Three agricultural and related museums operated by others also are located on campuses. They are the New Jersey Museum of Agriculture, an independent nonprofit, at Rutgers University; State Agricultural Heritage Museum, administered by the South Dakota State Historical Society, at South Dakota State University; and George Washington Carver Museum, which honors the noted botanist responsible for many agricultural innovations, operated by the National Park Service at Tuskegee University.

## Medical, Dental, and Health Museums

Medical and dental museums typically are specialized historical museums with collections and displays of medical, dental, and/or pharmaceutical artifacts, while health museums tend to be hands-on health education centers. Most of the approximately 15 medical and dental museums at universities and colleges are historical in nature—and frequently are part of libraries at medical or dental centers. Collections and exhibits of old medical and dental instruments, equipment, and other artifacts also can be seen at some historical, general, and science museums.

One of the first medical museums was the Dittrick Museum of Medical His-

tory, founded in 1926 by the Cleveland Medical Library Association and operated since 1967 through a partnership with Case Western Reserve University. It has more than 50,000 historical objects related to the practice of medicine, dentistry, pharmacy, and nursing. Originally used only by the medical profession and historians, it was opened to the public in 1936.

Medical libraries also have museum-like collections at Yale University, University of Kansas, Medical University of South Carolina, Duke University, and other institutions. Founded in 1814, the Yale University School of Medicine Library became the Harvey Cushing/John Hay Whitney Medical Library after major contributions in 1941 and 1970. It has an internationally recognized historical library that contains early medical manuscripts, 317 incunabula, over 2,000 medical images, and a collection of weights, measures, and other historical objects.

More than 30,000 printed volumes and thousands of medical instruments and pieces of medical equipment are featured at the Clendening History of Medicine Library and Museum at the University of Kansas Medical Center, while the Waring Historical Library at the Medical University of South Carolina has over 7,000 early medical books, publications, and papers related to South Carolina medicine and approximately 500 historical objects, ranging from instruments to medical saddle bags. The Duke University Medical Center Library's History of Medicine Collections contain medical instruments, artifacts, books, journals, manuscripts, prints, and photographs.

The University of Iowa Hospitals and Clinics Medical Museum started with a gift of old surgical instruments, but has since broadened to include exhibits on the progress of medicine and patient care. An even more health-oriented museum is the University of Virginia Health Sciences Center Children's Museum, which is a health education center where three- to six-year-old children can learn about themselves. The Lawrence Hall of Science, a science/technology center at the University of California, Berkeley, has health exhibits for the general public among its diverse offerings.

The story of medicine in the Southeast in the last 200 years is told in the Eichold-Heustia Medical Museum of the South, which is located at the University of South Alabama–Springhill, but operated independently. Among the museums in other fields with historical medical collections is the Museum of Early Philosophical Apparatus at Transylvania University.

Some medically oriented museums cover medicine, dentistry, and pharmacy. The Pearson Museum at the Southern Illinois University School of Medicine, for instance, has medical, dental, and pharmaceutical artifacts and exhibits pertaining to practices in the upper Mississippi River Basin in the nineteenth and early twentieth centuries.

Among dental museums, the Dr. Samuel D. Harris National Museum of Dentistry at the University of Maryland at Baltimore is a continuation of the original Baltimore College of Dental Surgery Museum founded in 1840. It has approx-

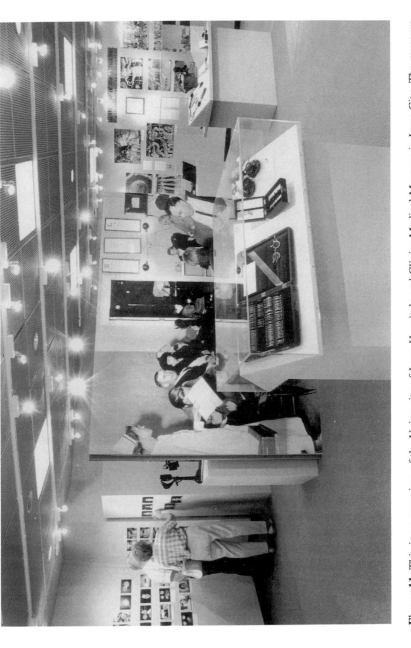

**Figure 11.** This is an overview of the University of Iowa Hospitals and Clinics Medical Museum in Iowa City. The museum deals with the progress in medicine and patient care and serves as an educational resource for patients, visitors, the hospital community, and the general public. (*Courtesy University of Iowa Hospitals and Clinics Medical Museum*)

imately 20,000 dental objects, including dental instruments, equipment, furniture, materials, and historic artifacts, such as George Washington's dentures.

Other dental museums include the Macaulay Museum of Dental History at the Medical University of South Carolina, with nearly 6,000 dental artifacts and books; Temple University School of Dentistry's Historical Dental Museum, containing dental artifacts and oddities; and Friends Museum of the University of Connecticut Health Center, a dental health museum with a collection of dental antiques and memorabilia.

Among the museums and exhibits in related fields are the Still National Osteopathic Museum at the Kirksville College of Osteopathic Medicine in Missouri and the *Feet First* exhibit at the Scholl College of Podiatric Medicine.

## Musical Instruments Museums

Four universities have museums of musical instruments. They document and exhibit the history of music through historical instrumentation and/or display antique and modern musical instruments and related materials. In several instances, the restored instruments are played in public performances and demonstrations at the museum.

The Shrine to Music Museum at the University of South Dakota has one of the world's most comprehensive collections of musical instruments. Its collection includes more than 6,000 musical instruments, as well as sheet music, recordings, tools, books, periodicals, photographs, and related musical memorabilia. The museum has seven galleries and a concert hall where instruments of various historical periods are played in performances.

Founded in 1900, the Yale University Collection of Musical Instruments has grown to more than 800 instruments, with particular strength in European music from 1550 to 1850. It has two permanent exhibits and presents changing exhibitions, concerts, and demonstrations of various instruments.

The Stearns Collection of Musical Instruments at the University of Michigan is a museum of antique and modern Western and non-Western musical instruments. Opened in 1912, it consists of three galleries and hall exhibits and features European traditional and electronic instruments.

The University of South Carolina at Spartanburg has a more specialized musical instruments museum. The George E. Case Collection of Antique Keyboards contains eighteenth- and nineteenth-century keyboards that show the evolution of keyboard instruments from early types to the modern piano.

Among the other museums with music collections are the William Hammond Mathers Museum, a museum of world cultures at Indiana University, which has an Ethnomusicology Collection of over 1,200 non-Western traditional musical instruments from throughout the world, and the Stephen C. Foster Memorial, a tribute to America's first professional songwriter at the University of Pittsburgh, which contains a collection of original documents, instruments, music editions, photographs, and other artifacts of Foster and artworks inspired by his music.

## Religious Museums

Museums with a religious emphasis usually are part of seminaries, colleges, and universities operated by religious organizations, but such collections also can be found at art, history, and cultural museums at other institutions. Most religious museums and related facilities are historical and/or archaeological in nature and often are part of libraries and archives. In addition to the more than 10 religions-based museums, nearly 20 other museums have religious collections.

Among the historically oriented religious museums are the Billy Graham Center Museum at Wheaton College in Illinois, featuring a visual history of the growth of evangelism in the United States; Center for Western Studies at Augustana College in South Dakota, which is a library, archives, and museum concerned primarily with the history and study of the Episcopal Church, United Church of Christ, and Plains Indians in the region; Missouri United Methodist Archives at Central Methodist College, containing materials related to the development of the Methodist Church in the state and area; William A. Quayle Bible Collection at Baker University, consisting of approximately 600 Bibles or portions thereof; and Mission Basilica de Alcala, a 1769 historic site affiliated with the University of San Diego and the Roman Catholic Diocese.

Archaeologically based religious museums include the Horn Archaeological Museum at the Louisville Presbyterian Theological Seminary, with collections of Palestinian and Israeli religious artifacts; Joseph A. Callaway Archaeological Museum at the Southern Baptist Theological Seminary, a Biblical archaeology museum; Bade Institute of Biblical Archaeology and Howell Bible Collection at the Pacific School of Religion, which has a collection of Bibles and religious archaeological artifacts; and Gustav Jeeninga Museum of Bible and Near Eastern Studies at Anderson University, with archaeological objects and replicas of major Biblical finds.

One of the most outstanding collections of religious art in the United States is the Bob Jones University Collection of Sacred Art in South Carolina. The museum has 30 galleries with more than 400 paintings and other works from the thirteenth to the nineteenth centuries. Another religious art museum with substantial collections—over 300 major works of liturgical objects, jewelry, paintings, and sculpture from 1100 to 1750—is the Martin D'Arcy Gallery of Art at Loyola University in Chicago.

Broad-based university and college art museums with some religious collections include the Hearst Art Gallery at St. Mary's College of California, de Saisset Museum at Santa Clara University, Georgetown University Collection, Patrick and Beatrice Haggerty Museum of Art at Marquette University, Indiana University Art Museum, and University of Wisconsin–Milwaukee Art Museum.

Four museums deal with the art, history, culture, and archaeology of Judaica. They have collections of ceremonial and other objects relating to Jewish customs, rituals, and life-cycle events—the Skirball Museum at Hebrew Union College in Los Angeles; Skirball Museum, Cincinnati Branch, at Hebrew Union

College–Jewish Institute of Religion in Ohio; Spertus Museum at the Spertus College of Judaica in Chicago; and Jewish Museum, which operates independently under the auspices of the Jewish Theological Seminary of America in New York City and has ceremonial objects as part of an extensive art, history, and cultural collection.

A number of religious museums and collections are located on campuses, but are not part of the universities and colleges. They include the Nebraska Conference United Methodist Historical Center at Nebraska Wesleyan University and the Virginia Baptist Historical Society Exhibit Area and Archives at the University of Richmond. Such facilities generally trace the history and preserve the records of a particular religious group.

## Library and Archival Collections and Galleries

Nearly every university and college has a library and/or archive, but relatively few have such facilities with museum-like collections, galleries, or exhibits. In most cases, the libraries and archives display rare books, art, and/or artifacts from their collections. Other times they have galleries that show art or other materials from other sources. More than 25 institutions have museum-like library and/or archival collections and galleries, and over 55 others have museums and galleries with such facilities.

Among the campus libraries that have regular exhibitions of selections from their collections are the Chapin Library of Rare Books at Williams College, which has a collection of 45,000 volumes of original books and manuscripts; Milberg Gallery for the Graphic Arts at the Princeton University Library, focusing on prints, drawings, illustrated books, and other aspects of the arts of the book; History of Aviation Collection at the Eugene McDermott Library at the University of Texas at Dallas, a major aeronautical research library with over 2.5 million items in more than 200 collections; and American Heritage Center at the University of Wyoming, featuring exhibitions of western history and art.

The Lilly Library at Indiana University mounts 3 to 4 major exhibitions and 15 to 20 minor shows each year in the arts, humanities, and sciences. Some library galleries present changing art exhibitions, including the Magale Library Gallery at Centenary College of Louisiana, Sturgis Library Gallery at Kennesaw State College, and Queens College Art Center in the Benjamin S. Rosenthal Library at Queens College of the City University of New York.

Medical libraries sometimes function like museums with collections and exhibitions. They include the Historical Library at the Harvey Cushing/John Hay Whitney Medical Library at the Yale University School of Medicine, which has early medical volumes, graphics, paintings, and medical instruments and equipment; Clendening History of Medicine Library and Museum at the University of Kansas Medical Center, with exhibits of printed volumes, early medical instruments and equipment, and other artifacts; Waring Historical Library at the Medical University of South Carolina, a combination library and museum with largely rare books and historical objects; and Dittrick Museum of Medical His-

tory, operated by Case Western Reserve University and the Cleveland Medical Library Association, which has historical objects related to the practice of medicine, dentistry, pharmacy, and nursing.

Some campus libraries are devoted to the works, lives, and/or times of individuals. For example, the Sam Rayburn Library and Museum at the University of Texas at Austin has collections and exhibits about the Texan who served as speaker of the United States House of Representatives longer than any other person. The Armstrong Browning Library at Baylor University has the world's largest collection of material relating to Robert Browning and his poetry, while the Annmary Brown Memorial at Brown University is a library, museum, and mausoleum named for the daughter of the founder of the university that contains books, paintings, and family heirlooms and mementos (Annmary Brown and her husband are buried in the building).

Most people do not know that two of the nation's best-known libraries—the Dumbarton Oaks Research Library and Collection and the Folger Shakespeare Library in Washington, D.C.—are part of Harvard University and Amherst College, respectively. They were entrusted with the libraries' oversight by their donors, who were alumni. Dumbarton Oaks, one of the world's leading centers of Byzantine, pre-Columbian, and landscape architecture study, also is an architectural, botanical, and historical showcase, while the Folger Shakespeare Library is a historic book and manuscript library and museum that is a major resource on the Renaissance civilization of England and the European continent.

Some libraries also have archival collections. In other instances, archives are operated separately and often have exhibited collections open to the public, as is the case with the Mississippi University for Women Archives and Museum, Hartwick College Archives, and Penn State Room/University Archives at Pennsylvania State University.

The LaGuardia and Wagner Archives Museum at the Fiorello H. LaGuardia Community College of the City University of New York has special exhibits on the social and historical aspects of twentieth-century New York City and the life and times of former mayors LaGuardia and Robert F. Wagner. Another archive, the Southeastern Architectural Archive at Tulane University, displays architectural models, drawings, and other materials from Louisiana and the southeastern region of the nation.

A number of historical centers have a combination library, archive, and museum or exhibit area. They include the Center for Western Studies at Augustana College in South Dakota, which focuses on the history and study of the Episcopal Church, United Church of Christ, and Plains Indians; Center for Southwest Studies at Fort Lewis College, with a museum containing southwestern Native American and other artifacts and artworks; and Center for Lowell History at the University of Massachusetts, Lowell, which presents exhibitions related to the local area.

## OTHER SCIENCE-ORIENTED MUSEUMS

### Science and Technology Museums and Centers

Traditional science and technology museums are largely historical and collection based, while science and technology centers are primarily contemporary and rely heavily on participatory constructed exhibits instead of collections. Some institutions are a blend of the two approaches. Six facilities are devoted entirely to science and technology, while more than 10 others have some such collections and exhibits.

Three of the more artifact-based science and technology museums are the Collection of Scientific Instruments at Harvard University; MIT Museum at the Massachusetts Institute of Technology; and Museum of Early Philosophical Apparatus at Transylvania University.

The Harvard collection is a repository of 15,000 scientific apparatus used in teaching and research, such as microscopes, vacuum pumps, and early computing devices, while the Transylvania museum features scientific instruments and equipment utilized in teaching medicine in the nineteenth century. The MIT Museum—which has three specialized branches on the campus—contains materials associated with the development of science and technology as interrelated with the university. It includes a wide variety of objects, such as instruments, ship models, inertial guidance records, architectural drawings, disc and video recordings, portraits and paintings, and other materials.

The Lawrence Hall of Science at the University of California, Berkeley, is the largest of the contemporary hands-on science centers on campuses. It features exhibits on lasers, astronomy, computers, the body, and other aspects of science and technology. It also has a planetarium, a computer laboratory, and an extensive program of science/math curriculum and teacher development. The State University of New York College at Oneonta has a smaller Science Discovery Center, with exhibits largely in the physical sciences.

Some science centers have developed around planetaria, such as the Flandrau Science Center and Planetarium at the University of Arizona, Cernan Earth and Space Center at Triton College, and Fiske Planetarium and Science Center at the University of Colorado. They usually have exhibits on astronomy, space, and related science fields in addition to planetarium shows.

Other types of museums sometimes have science and technology collections and exhibits as part of their offerings. They include the University Museums of the University of Mississippi, a general museum complex with approximately 500 nineteenth-century scientific instruments; Southwestern Michigan College Museum, a history museum with exhibits on scientific principles and technological applications; College of Southern Idaho's Herrett Museum, an archaeology, anthropology, and ethnology museum with hands-on science exhibits; and I.P. Stanback Museum and Planetarium at South Carolina State University,

which is basically an art museum with planetarium shows and some science-oriented exhibits.

Three federal government laboratories operated on a contract basis by universities also have science and technology museums or exhibits that relate largely to their activities. They include the Bradbury Science Museum at the Los Alamos National Laboratory in New Mexico and the Lawrence Livermore National Laboratory Visitors Center in California (both operated by the University of California), as well as three exhibit areas at the Fermi National Accelerator Laboratory in Illinois (operated by the Universities Research Association Inc.).

## Geology, Mineralogy, and Paleontology Museums

Museums of geology, mineralogy, and paleontology either specialize in one of the disciplines or are a combination of two or all three fields. Approximately 35 museums contain collections and exhibits of rocks, minerals, ores, gems, meteorites, and/or fossils, and some even have historic mining equipment. About the same number of natural history museums have one or more collections of such specimens as part of their offerings.

The Mineralogical and Geological Museum at Harvard University grew out of an academic department's teaching and research collections that began in 1784. Its internationally recognized systemic collection now contains more than 250,000 minerals, ores, rocks, meteorites, and gems, including many rare species. The museum is one of four museums that comprise the Harvard University Museums of Natural History.

Among the other early collections resulting in geological museums are the Colorado School of Mines Geological Museum, 1874; South Dakota School of Mines and Technology Museum of Geology, 1885; University of Wyoming Geological Museum, 1887; Orton Geological Museum, Ohio State University, 1893; University of Cincinnati Geology Museum, 1907; and W.M. Keck Museum, University of Nevada at Reno, 1908.

The Colorado School of Mines museum includes mining equipment and artifacts among its collections and exhibits; Badlands fossils and Black Hills minerals are featured at the South Dakota School of Mines and Technology; the University of Wyoming Geological Museum evolved from a small natural history museum that was part of the university's first building; Ohio State University's museum began with a gift of 10,000 specimens from the university's first president, who also was a professor of geology; the University of Cincinnati Geology Museum now has over 745,000 catalogued fossils; and the Keck Museum contains rocks, minerals, ores, fossils, and mining artifacts, mostly from Nevada.

Some museums in the field emphasize minerals. They include the A.E. Seaman Mineral Museum at Michigan Technological University, which features crystals and lapidary works from 1886 to the present; Miles Mineral Museum at Eastern New Mexico University, containing calcite, gypsum, and other col-

lections; Mineral Museum at the Montana College of Mineral Science and Technology, with a mineral collection that began in 1901; and University of Arizona Mineral Museum, which started in 1891 as an original part of the land grant university and now is located in the Flandrau Science Center building.

Fossils are the focal point of paleontology-oriented museums. The Museum of Invertebrate Paleontology—one of four museums administered as part of the University of Kansas Natural History Museum—has over 500,000 specimens. Among the other fossil-based museums are the Museum of Paleontology at the University of California, Berkeley, with collections that began in 1873; Museum of Paleontology at the University of Michigan, which is used primarily for research; and Earth Science Museum at Brigham Young University, which has one of the largest collections of Jurassic-period dinosaur fossils.

Among the other specialized museums are the Meteorite Museum at the University of New Mexico, containing one of the largest collections of meteorites in the nation; Comer Museum at West Virginia University, with coal, oil, and natural gas collections and exhibits; and Earth and Mineral Sciences Museum and Gallery at Pennsylvania State University, which has paintings, drawings, and sculptures relating to the mineral industries as well as over 20,000 mineral, gem, and fossil specimens.

Among the natural history museums with important geology, mineralogy, and/or paleontology collections are the Peabody Museum of Natural History at Yale University, possessing one of the largest dinosaur fossil collections and exhibits; Texas Memorial Museum at the University of Texas at Austin, containing over 50,000 rocks, minerals, gems, meteorites, and textiles; Utah Museum of Natural History at the University of Utah, with extensive holdings in geology, rocks, minerals, gems, and fossils; Museum of Natural Science at Louisiana State University, which has a large geoscience collection; Museum of the Rockies at Montana State University, with a geological collection and fossilized remains of dinosaurs and Ice Age mammoths; McKissick Museum at the University of South Carolina, having over 100,000 research and exhibit specimens in geology and paleontology, Oklahoma Museum of Natural History at the University of Oklahoma, containing invertebrate and vertebrate fossils, paleobotanical materials, and minerals; Princeton University Museum of Natural History, with invertebrate paleontology, geology, and mineralogy collections; and University of Nebraska State Museum, featuring several hundred Cenozoic mammal fossils, a large vertebrate paleontology collection, and extensive geology and meteorite specimens.

## Zoology Museums

Museums of zoology—a science that deals with animals—were among the first of the specialized natural history museums on university campuses. They began to appear in the mid-nineteenth century and now number at least eight. They are relatively small in number because most zoological collections now are part of more comprehensive museums of natural history.

The first American university zoology museum was the Museum of Comparative Zoology at Harvard University. It was founded in 1859 by Swiss zoologist Louis Agassiz. Its collections and exhibits range from the earliest fossil invertebrates and reptiles to present-day fish and reptiles. Among its outstanding specimens are whale skeletons, the Harvard mastodon, the largest turtle shell ever found, a lobe-finned coelacanth, a giant sea serpent, and extinct birds such as the great auk and the passenger pigeon. The museum now is one of four that comprise the Harvard University Museums of Natural History.

A zoological collection began at the University of Michigan even earlier (with the founding of the university in 1837), but did not result in a formal Museum of Zoology until 1913. In the intervening years, zoological specimens merely were exhibited. The Museum of Zoology was the first of the five institutions that became part of the University of Michigan Museums of Natural History.

Among the other early zoological collections that evolved into museums are the Museum of Zoology, University of Massachusetts, Amherst, 1863; University of North Dakota Zoology Museum, 1883; University of Wisconsin Zoological Museum, 1887; Museum of Vertebrate Zoology, University of California, Berkeley, 1908; and University of Montana Zoological Museum and Herbarium, 1909.

Nearly all natural history museums have some zoological specimens, and a considerable number have extensive collections. The University of Georgia Museum of Natural History, for example, has specimens of approximately 300,000 fish, 25,000 amphibians and reptiles, 5,000 birds, and 10,000 mammals from the region. The University of Nebraska State Museum has 16 dioramas of Nebraska wildlife and synoptic collections of animal groups among its exhibits, while the Utah Museum of Natural History at the University of Utah has biological collections of more than 250,000 specimens, with the greatest number being birds, mammals, reptiles, fish, plants, shells, and insects.

The Florida Museum of Natural History at the University of Florida has a satellite entomology museum (Allyn Museum of Entomology) and a 9,300-acre open-air research facility to study Florida's living collections (Swisher Memorial Sanctuary and Katherine Ordway Preserve). Among the other university and college facilities with live animals are the Santa Fe Community College Teaching Zoo in Florida, Marjorie Barrick Museum of Natural History at the University of Nevada at Las Vegas, Trailside Museum at Antioch College, and Shaver's Creek Environmental Center at Pennsylvania State University.

## Entomology Museums

Entomology is a branch of zoology that deals with insects. Such collections usually are found in natural history or zoology museums, but there are at least five museums that specialize in insects and are called entomology museums.

Three campuses of the University of California have museums of entomology—Berkeley, Davis, and Riverside. The Bohart Museum of Entomology at Davis has a collection of 6 million arthropod specimens, the Essig Museum of

Entomology at Berkeley has more than 4.5 million specimens, and the UCR Entomological Teaching and Research Collection at Riverside has both insects and related non-insectan arthropods on display.

Two other universities with large entomological collections housed in museums are the University of Kansas and Pennsylvania State University. The Snow Entomological Museum at University of Kansas was one of the first such museums, being founded in 1897 as part of a cabinet of natural history. Now a division of the University of Kansas Natural History Museum, it has over 3.2 million specimens, including world-representative collections of bees, scorpion flies, lygaeid bugs, and other insects. The Frost Entomological Museum at Pennsylvania State University has three specialty collections—dragonfly and damselfly, aphid, and louse collections.

Many natural history museums have entomological collections. The Florida Museum of Natural History at the University of Florida has the largest collections of butterflies and moths in the Western Hemisphere, located at its satellite Allyn Museum of Entomology. Among the others with extensive insect collections are the University of Georgia Museum of Natural History, University of Nebraska State Museum, Oklahoma Museum of Natural History at the University of Oklahoma, and Utah Museum of Natural History at the University of Utah.

Entomology also is one of the subjects covered at most zoology museums, including the University of Michigan Museum of Zoology and the University of North Dakota Zoology Museum.

## Marine Sciences Museums and Aquariums

Universities and colleges near oceans and other large bodies of water sometimes have marine sciences museums and/or aquariums that are used for instruction, research, and public education. These facilities now number six. A few natural history museums and science/technology museums and centers also have collections and exhibits of marine life.

The first university marine museum-aquarium started in 1903 as the Marine Biological Association of San Diego at the Scripps Institution of Oceanography, which became part of the University of California, San Diego in 1912. The initial public display opened in 1905, followed by expanded offerings in 1915. The aquarium-museum moved into its own building in 1951 and then into a new structure in conjunction with the renaming of the facility as the Stephen Birch Aquarium-Museum in 1992. The aquarium-museum interprets ocean sciences and the Scripps Institution's research program. It has 33 tanks and over 3,000 fish from the cold waters of the Pacific Northwest to the tropical waters of Mexico and the Indo-Pacific.

Another early facility was the Waikiki Aquarium, which began as a commercial attraction in 1904 and became part of the University of Hawaii in 1919. It now is a major center for marine education and research in Hawaiian and Pacific Ocean tropical fauna and flora. It was the first in the United States to

display chambered nautiluses, cuttlefish, and black-tip reef sharks and has one of the world's largest collections of corals from Hawaii.

Other leading marine centers with aquariums include the Mark O. Hatfield Marine Science Center Aquarium of Oregon State University and the J.L. Scott Marine Education Center and Aquarium at the Gulf Coast Research Laboratory, a state facility administered by the University of Southern Mississippi. The Hatfield aquarium has approximately 20 exhibit tanks with about 1,300 specimens of 120 species of saltwater animals native to Oregon's shores, bays, and ocean floor. At the Scott aquarium, 41 tanks feature native fish and other creatures whose habitats range from the open ocean to coastal streams.

Among the other marine facilities are the College of William and Mary's Virginia Institute of Marine Science Fish Collection and the Marine Sciences Museum at the University of Puerto Rico. The Virginia collection contains approximately 90,000 specimens of preserved fish, marine fish from the Chesapeake Bay and mid-Atlantic; deep-sea fish and sharks, and Appalachian freshwater fish. In Puerto Rico, the marine museum has collections of invertebrates, fish, shells, copepoda, and tropical algae.

Natural history and zoological museums with marine collections include the Museum of Natural Science at Louisiana State University, Museum of Comparative Zoology at Harvard University, and University of Wisconsin Zoological Museum.

## OTHER CATEGORIES OF MUSEUMS

### General Museums

General museums are those institutions that cover a range of fields, rather than specializing in a single discipline or related combination of fields. They frequently have diversified art, history, science, and/or other collections and exhibits, although they may be stronger in one area than others.

Among the more than 20 museums that fall in this category are the McKissick Museum at the University of South Carolina, Museum of Texas Tech University, University Museum at the University of Arkansas, Frank H. McClung Museum at the University of Tennessee at Knoxville, and Hampton University Museum.

The McKissick Museum has collections and exhibits in material culture, natural science, and decorative and fine arts that largely relate to the social, cultural, and scientific development of South Carolina and the Southeast. Although the museum did not open until 1976, its collections began in 1823 when the university purchased an extensive mineral and fossil collection.

The Museum of Texas Tech University is a general museum concerned largely with regional history, culture, and natural history. The 167,591-square-foot museum, which has approximately 1.5 million objects in its collections, has five primary structures—a main building, a planetarium, a natural science lab-

oratory, a research center, and an orientation building for the Ranching Heritage Center, which consists of 33 structures in a 14-acre outdoor exhibit area.

The University Museum at the University of Arkansas traces its beginnings to 1873 when its diverse collections on history, ethnology, and natural history were started. The McClung Museum has an even broader scope of interest, covering anthropology, archaeology, decorative arts, medicine, local history, and natural history. The Hampton University Museum, on the other hand, concentrates mainly on ethnic art, although it has collections in art, anthropology, and history.

Other examples of general museums include the University Museum at Southern Illinois University at Carbondale, with collections and exhibits in the fine and decorative arts, anthropology, archaeology, history, geology, and natural history; Horner Museum at Oregon State University, which focuses on Oregon's pre-history, history, natural history, and ethnic heritages; University Museum at Indiana University of Pennsylvania, emphasizing art, history, and anthropology; and Center for Cultural and Natural History at Central Michigan University, with collections and exhibits predominantly of regional history and natural history.

## Other Types of Museums

At least six museums do not fit into standard categories of university and college museums. Most are unique or cover subjects that rarely are the subject of separate campus museums.

Two universities, for example, have sports museums dedicated to football— the Paul W. Bryant Museum at the University of Alabama and the Penn State Football Hall of Fame at Pennsylvania State University. The Alabama museum traces the history of football at the university and honors the coaching achievements of the late Paul "Bear" Bryant, while the Penn State museum chronicles the university's football history and highlights. A university's athletics history usually is included in an institution's history museum, if it has one, as in the case of the University of Colorado Heritage Center.

Johnson and Wales University in Rhode Island has a culinary and gastronomy museum, called the Culinary Archives and Museum. It contains over 30,000 cookbooks, 20,000 menus, 20,000 culinary-related postcards, 10,000 culinary pamphlets, and thousands of other culinary items.

More than 60,000 political mementos from George Washington's inaugural buttons to materials from recent presidential campaigns are featured at the Museum of American Political Life at the University of Hartford in Connecticut.

Two other unusual museum-like facilities are the Steamship Historical Society of America Collection at the University of Baltimore and the *Treasures of the Sea* exhibit at the Delaware Technical and Community College. The Baltimore collection consists of 100,000 photographs, 25,000 postcards, 5,000 books, and other materials pertaining to powered shipping and navigation, while the Dela-

ware exhibit contains such shipwreck artifacts as coins, firearms, jewelry, cannons, and gold and silver bars.

## Contract Facilities

Some research-oriented universities individually or jointly operate federal government scientific facilities with museums, visitor centers, and/or public observatory viewing. Three of these contract operations are in the energy field and three in astronomical research.

The University of California, Berkeley, administers two government laboratories—the Los Alamos National Laboratory in New Mexico and the Lawrence Livermore National Laboratory in California—for the U.S. Department of Energy. At Los Alamos, the Bradbury Science Museum has exhibits on the nuclear and other research and development work at the laboratory, while the Lawrence Livermore National Laboratory Visitors Center does the same on a smaller scale for its laboratory.

Three other government facilities are operated by associations of research universities. The Universities Research Association Inc. is responsible for the operations of the Fermi National Accelerator Laboratory, a U.S. Department of Energy high-energy physics national laboratory in Illinois, which has three exhibit areas. The other two contract operations are the National Optical Astronomical Observatories, managed by the Association of Universities for Research in Astronomy Inc., and the National Radio Astronomy Observatory, administered by Associated Universities Inc. for the National Science Foundation. Some aspects of both operations are open to the public through visitor centers, tours, and/or telescope or astronomical viewing.

The National Optical Astronomical Observatories consist of three major research facilities—the National Solar Observatory in New Mexico, Kitt Peak National Observatory in Arizona, and Cerro Tololo Inter-American Observatory in Chile. The National Radio Astronomy Observatory is located in West Virginia and has facilities at a number of other locations.

The National Optical Astronomy Observatories also participate in the WIYN Consortium, which includes Indiana, Wisconsin, and Yale universities and operates the new WIYN Observatory at Kitt Peak in Arizona. The University of Hawaii's Mauna Kea Observatories also have a considerable number of other university and government observatories located at their site near Hilo.

Another facility—the National Center for Atmospheric Research, operated by the University Corporation for Atmospheric Research—is an independent nonprofit funded by the National Science Foundation. It has science-oriented exhibits open to the public.

## Unaffiliated Museums

A wide range of museums and similar facilities are located on campuses, but are not operated by the universities and colleges. They are independently operated by historical societies, churches, nonprofit organizations, and state and

federal agencies. Such museums usually are on the campus because of some relationship to the institution.

Most of the nearly 25 unaffiliated museums are historical in nature and generally are operated by historical societies. They include the Oklahoma Museum of Higher Education, operated by the Oklahoma Historical Society at Oklahoma State University; State Historical Society of Missouri Gallery, part of the society headquartered at the University of Missouri–Columbia; No Man's Land Historical Museum, operated by a local historical society at Panhandle State University; American Jewish Historical Society Library, Archives, and Museum, located in the society's national headquarters at Brandeis University; and Norwegian-American Historical Association Archives, operated by the association with offices in the campus library at Saint Olaf College.

Some unaffiliated museums contain religious artifacts and historical records and are operated by churches, such as the Virginia Baptist Historical Society Exhibit Area and Archives at the University of Richmond and the Nebraska University Methodist Historical Center at Nebraska Wesleyan University.

A considerable number of unaffiliated campus facilities are operated by other types of nonprofit organizations, including the National Scouting Museum of the Boy Scouts of America at Murray State University; National Cable Television Center and Museum, founded as a cable industry nonprofit, at Pennsylvania State University; New Jersey Museum of Agriculture, operated by a nonprofit agricultural group, at Rutgers University; Scurry County Museum, operated by a local museum association, at Western Texas College; and Botanical Gardens of Asheville, operated by a local botanical nonprofit, at the University of North Carolina at Asheville.

State agencies operate some unaffiliated campus museums, including the New Mexico Bureau of Mines Mineral Museum at the New Mexico Institute of Mining and Technology; State Agricultural Heritage Museum at South Dakota University; W.H. Over State Museum, devoted to South Dakota's natural and cultural heritage, at the University of South Dakota; and Sheldon Jackson Museum, a one-room anthropology museum that is part of the Alaska State Museums system, at Sheldon Jackson College.

Several federally operated museums are located at universities. The Lyndon Baines Johnson Library and Museum is operated by the National Archives and Records Administration at the University of Texas at Austin, and the George Washington Carver Museum is administered by the National Park Service as part of the Tuskegee Institute National Historic Site.

## AN INVALUABLE CAMPUS ASSET

As can be seen, university and college museums, galleries, and related facilities cover many fields and come in a wide range of configurations. Some are extensions of academic departments, while others are virtually independent entities. Many different disciplines are represented—sometimes within the same

museum or similar facility. Nearly all serve an important instructional and/or research function on the campus with their collections and exhibits of artifacts, artworks, specimens, and/or other materials that are invaluable in teaching, advancing knowledge through research, and furthering campus and public understanding and appreciation of the subject matter.

Museums and similar facilities have a unique role on the campus that differs from that of any other aspect of the institution. The offerings of these museums, galleries, botanical gardens, arboreta, herbaria, planetaria, observatories, science centers, visitor centers, libraries, archives, and other such facilities usually stimulate formal and informal learning by making it possible to see, study, and often touch and interact with objects and exhibits that otherwise would not be available. They also provide a cultural diversion that often is entertaining as well as educational.

## Chapter 5

# Governance, Organization, and Staffing

Most museums, galleries, and related facilities at American universities and colleges have less independence and flexibility in their operations than do their nonacademic public and private counterparts. They are only a small part of a spectrum of concerns of their parent institutions and have restrictions on governance, organization, personnel, and many other aspects of their operations.

Nearly all campus museums and similar facilities do not have a separate board of trustees or directors. Instead, they normally are responsible to a university or college governing board, with the director reporting to an academic department head, dean, provost, vice president, vice chancellor, president, or some other office.

The organization and staffing usually are limited in size and scope because most facilities are closely tied to an academic department or other structure that frequently determines the mission and allocates the space, budget, and personnel. Museums, galleries, and related facilities also typically must rely upon other university/college offices to provide such services as utilities, security, marketing, fund raising, and maintenance—which can be an advantage or a drawback.

There are exceptions, particularly among the larger museums and similar facilities, which often have more sizable staffs, collections, exhibits, programs, budgets, and attendances—and sometimes their own buildings, membership programs, fund-raising activities, and other capabilities. But even in such cases, management and operations almost always are limited by institutional and/or departmental policies and practices.

Another factor is the multifaceted role of many campus museums, galleries, and similar facilities. They nearly always have collections, exhibits, and facilities

that are used for instruction and research, and many directors are in charge of museum studies programs. Some also have a broader mission in serving school groups and the general public.

In general, university and college museums and other museum-like facilities are underfunded, understaffed, underutilized, and underappreciated. Despite these circumstances, university and college museums, galleries, and related facilities have continued to increase in number, have grown in the size and quality of their operations, and often have made important contributions to the advancement of their fields and institutions.

At one time, it was unusual for a university or college to have more than one museum or similar facility. Today many institutions have a considerable number of museums and similar facilities, covering a wide range of fields. Among those with the greatest number of museums and museum-like facilities are Pennsylvania State University, 17; Harvard University, 15; Michigan State University, 11; University of Michigan, 10; University of California, Berkeley, 9; and University of Kansas, 8. Single facilities are likely to be found largely at the smaller universities and colleges, and they are generally art galleries.

Relatively little coordination of multiple museums, galleries, and related facilities appears to exist on most campuses. Even when a university or college has a coordinating system, it rarely covers all the museums and similar facilities. Harvard, for example, has two umbrella museum complexes—Harvard University Art Museums, including three art museums, and Harvard University Museums of Natural History, consisting of four museums—which cover only half of its museums and related facilities.

A few institutions have tried to have greater coordination by putting their two or three museums under a single director and giving the group an all-inclusive name, such as Hartwick College's Museums at Hartwick and the University Museums of Iowa State University. Two institutions that are part of the Claremont Colleges—Pomona College and Scripps College—combined their art galleries as the Galleries of the Claremont Colleges in 1974, but then separated the galleries again in 1993.

## GOVERNANCE PATTERNS

The governing body for virtually every campus museum, gallery, and related facility is the board of trustees or directors of the university or college. It is the board that approves the establishment of the facility and usually its director, general policies, and budget—all upon the recommendation of the institution's president or other administrator. Because museums and other such facilities at universities and colleges rarely are autonomous, they almost never have their own governing boards.

Some governing structures are complex. At Harvard University, for example, the university has two governing boards—the 7-member Corporation (consisting of the president and fellows) and the 30-member Board of Overseers. The Cor-

poration has primary oversight responsibility for university operations and reviews and approves the Harvard University Art Museums' mission statement, all professional appointments (administrative as well as curatorial), annual operating budgets, capital projects, fund-raising campaigns, and other significant projects.

The Board of Overseers appoints a Committee to Visit the Art Museums to conduct an annual review of the museum activities. The visiting committee is comprised of 30 outside experts in the field, who meet with museum staff, fine arts faculty, and students to address a variety of topics each year; review the financial condition; and submit a detailed report to the Board of Overseers, with copies to the president, the dean of the Faculty of Arts and Sciences, and the director of the art museums. The visiting committee also is involved throughout the year when issues of special importance arise. In practice, the director has considerable autonomy over museum operations, and the governing boards are involved only in the highest-level decisions.

In those few cases where a campus museum has a separate board, it usually involves special circumstances that differ from normal practices. At Earlham College, for instance, Conner Prairie, a living history museum located 70 miles from the campus, is a wholly owned subsidiary that operates with its own Board of Directors, president, and administrative staff. However, the museum president reports to the president of Earlham College and meets with the university's Board of Trustees on major issues and expenditures.

Other examples of separate boards can be found at the Jewish Museum, which operates under the auspices of the Jewish Theological Seminary of America and has a board with total authority for policy, collections, programs, personnel, and budget; Danforth Museum of Art, a joint project of Framingham State College and the City of Framingham, Massachusetts, with a governing board consisting of representatives of the college and the community; and Armand Hammer Museum of Art and Cultural Center, now managed by the University of California, Los Angeles, and housing its Wight Art Gallery and Grunwald Center for the Graphic Arts, where the university has three representatives on a nine-member board. At Emory University, the Michael C. Carlos Museum has a 40-member Board of Directors, which is responsible for nearly everything except the administrative budget, which is allocated by the university's governing board.

More often museum and gallery boards are supplemental and advisory in nature, assisting with fund-raising collections, programming, and/or other areas. For example, the University of Wyoming Art Museum has a 25-member National Advisory Board that recently helped raise $20 million for a new building that houses the museum and the American Heritage Center. Among the other institutions with advisory boards or committees are the University of Pennsylvania Museum of Archaeology and Anthropology, which has a Board of Overseers appointed by the university president to look after the museum's operations; California Museum of Photography at the University of California, Riverside, has a Chancellor's Committee to serve as a national advisory and

fund-raising group to promote the interests of the museum; Krannert Art Museum and Kinkead Pavilion at the University of Illinois at Urbana-Champaign uses a National Advisory Board for advice on fund development, acquisitions, accessions, deaccessions, exhibitions, and special events; and Marianna Kistler Beach Museum of Art, recently founded at Kansas State University, is administered largely with the assistance of a Museum Advisory Board.

Advisory boards, committees, and councils can be of great assistance and/or a problem, as Nancy R. Axelrod points out in her booklet on advisory bodies, *Creating and Renewing Advisory Boards: Strategies for Success*:

A successful advisory group can do much to help an organization fulfill its mission. Advisory Board members have helped enormously in raising funds, addressing political problems, handling public relations, and reviewing programs. An unsuccessful advisory group, on the other hand, can be a costly drain on precious institutional resources, image, and good will.

A number of university and college museums and similar facilities have formed partnerships with city, county, or state governments that sometimes involve joint governing and/or reporting responsibilities, such as the Hilltop Garden and Nature Center, a cooperative project of Indiana University and the City of Bloomington; W.W. Gayle Planetarium, a facility of Troy State University and the City of Montgomery, Alabama; Washington Park Arboretum, a partnership of the University of Washington and the City of Seattle; Fullerton, Arboretum, operated under a joint-powers agreement between California State University, Fullerton, and the City of Fullerton; Scurry County Museum at Western Texas College, which receives city, county, and university support; Kalamazoo Public Museum, which is part of the county's Kalamazoo Valley Community College district; the official visual art collection of the State of Nebraska at the University of Nebraska–Kearney; State Botanical Garden of Georgia at the University of Georgia; and Oklahoma Museum of Natural History, the designated state natural history museum at the University of Oklahoma.

## MANAGEMENT STRUCTURES

The management structures and reporting systems of museums, galleries, and related facilities vary greatly. The author's survey showed that approximately 30 percent of the directors reported to the heads of academic departments, while 22 percent were accountable to deans, 12 percent to vice presidents, 11 percent to provosts, 9 percent to presidents, 2 percent to vice chancellors, and 14 percent to others, such as the directors of arts centers, libraries, student unions, and coordinating offices, as well as directly to university, college, and museum governing boards.

A majority of museums and similar facilities operate as independent departments within the institutional framework. However, the patterns differ consid-

erably with the type of facility—and frequently with the size of the university or college. More than half of the art galleries, for example, are part of art, art history, and fine arts departments and report to the chairperson. Art museums, on the other hand, nearly always function independently and report to the dean, provost, vice president, or president.

Most specialized science-oriented museums and such related facilities as planetaria, observatories, botanical gardens, arboreta, and herbaria follow the departmental reporting approach, but natural history, archaeology, anthropology, and ethnology museums generally are divided, often reporting instead to deans, provosts, vice presidents, or their equivalents. Historical museums, houses, and sites are more likely to report to a vice president or the president. In smaller universities and colleges with fewer departments and administrative offices, it is not uncommon for museums to be responsible directly to the president's office.

Some universities and colleges with more than one museum, gallery, or related facility seek to coordinate the activities through an administrator, committee, council, grouping, or other formal or informal method. These mechanisms range from oversight of certain similar types of facilities to across-the-board coordination in the museum or arts field. Sometimes they are created by the president or some other administrative officer, while other times they are initiated by the directors of the museums and related facilities for the exchange of information, cooperation, and joint action.

A number of institutions designate a single administrative official to be responsible for all museum, cultural, or arts activities. At the University of Arizona, campus museum directors report to and meet regularly with the vice president for academic support and international programs. Virginia Military Institute has an executive director of museum programs, while Louisiana State University relies upon an executive director for its Museum Complex. Among the broader coordinating efforts are the use of an Office of the Arts at the Massachusetts Institute of Technology, arts coordinator at the University of Puget Sound, coordinator of collateral activities at Jacksonville University, and dean of cultural affairs at the University of Maine.

At some universities and colleges, the director of galleries is charged with overseeing all the art installations on the campus, as occurs at Austin Peay State University, Baruch College of City University of New York, Dickinson College, and Lehigh University. In other instances, the committee approach is utilized in arts coordination—such as the President's Advisory Committee on Art Policy and the President's Visual Arts Coordinating Committee at Texas A&M University and the Commission on the Arts at Saint Anselm College.

A few universities and colleges have oversight committees concerned only with museums, galleries, and related facilities. They include the Museum Governance Committee at Housatonic Community Technical College and the Faculty Committee for Museums and Galleries at Oregon State University.

## MUSEUM GROUPINGS

Among the more effective systems for coordinating and making effective use of resources has been the placing of museums into umbrella groups—either in broad or in specific fields. When they are organized broadly, the museums normally have the same director, which is not necessarily the case with those museums in specialized fields.

Broad-based groups include the Museums of Hartwick, which has four facilities—an anthropology museum, an art gallery, an herbarium, and an archive—at Hartwick College; Museums of Beloit College, consisting of an art museum and an anthropology museum; University Museums, composed of two connecting museums with archaeological, historical, and folk art materials at the University of Mississippi; and University Museums, with an art museum, a historic building, and a campus art program at Iowa State University.

In the specialized fields, Harvard University has two major groupings—Harvard University Art Museums, composed of three major art museums (Fogg Art Museums, Busch-Reisinger Museum, and Arthur M. Sackler Museum), and Harvard University Museums of Natural History, with four science-oriented museums (Botanical Museum, Mineralogical and Geological Museum, Museum of Comparative Zoology, and Peabody Museum of Archaeology and Ethnology). The Center for Conservation and Technical Studies, a research, training, and service institution in the conservation of artistic and historical works, also is part of the complex.

Three other universities have organized their natural history museums into a single composite unit. They include the University of Michigan Museums of Natural History, with five components (Exhibit Museum, Museum of Anthropology, Museum of Paleontology, Museum of Zoology, and University of Michigan Herbarium); University of Kansas Museum of Natural History, with four parts (Museum of Natural History, Snow Entomological Museum, Museum of Invertebrate Paleontology, and McGregor Herbarium); and University of California Museums of Natural History, containing four museums (Phoebe A. Hearst Museum of Anthropology, Essig Museum of Entomology, Museum of Paleontology, and Museum of Vertebrate Zoology).

These museums generally share facilities or are located nearby, work together on exhibits and programs, exchange information, avoid some duplication of staff and services, and often effect cost savings as a result of the combined structure.

Whatever the type of facility or the nature of the university or college system, however, museums and similar facilities tend to reflect ''the mission of their parent institutions through an emphasis on research and education, a more specialized conception of the disciplines that comprise their focus, and an emphasis placed on audiences that (are) also constituents of the parent organization,'' as pointed out by Paisley S. Cato in his study of natural history museums in *Museum Management and Curatorship.*

## INFORMAL COOPERATION

Many forms of informal cooperation and collaboration take place among museums, galleries, and related facilities on university and college campuses. They include occasional meetings of directors to discuss issues of mutual interest, formation of joint committees in special fields, cooperative projects, and a variety of other activities.

Informal meetings are the most common. Directors of all the museums and galleries on the six Claremont Colleges campuses meet and work together regularly. Harvard University has a Museums Council, consisting of directors and often involving exhibit designers. At Yale University, communication among museum directors also is informal. In addition, there are committees related to conservation and museum shops and a joint membership program between the Yale University Art Gallery and the Yale Center for British Art.

The University of Utah museums of fine arts and natural history, arboretum, and performing arts theater have an informal coalition and cooperate on obtaining increased funding and other matters affecting their operations. A loose consortium of campus resources, called Cultural and Natural Outreach Programs, at the University of Northern Iowa is concerned with campus and community programs offered by the university's museum, art gallery, greenhouse, biological preserves, and one-room school.

One of the most frequent types of cooperation is in the collections area. Among the universities and colleges where directors, curators, and/or collections managers communicate, cooperate, and share mutual support are Luther College, which has a Collections Committee; Michigan State University, with a Collections Council; and University of Iowa, which works through a Collections Coalition.

Other examples of informal cooperation and collaboration include a Museum Informatics Project to collect information on collections and other systems at campus museums and an informal group that meets to discuss issues of common interest, particularly marketing, at the University of California, Berkeley; periodic meetings of museum conservators at Indiana University, where campus museums also belong to the newly formed Alliance of Bloomington Museums; an ad hoc consortium of university and city museums and related facilities at the University of Michigan; and a five-college consortium that includes representatives of museums and galleries at Amherst College, Hampshire College, Mount Holyoke College, Smith College, and the University of Massachusetts.

## ORGANIZATION AND STAFFING

Most museums, galleries, and related facilities at universities and colleges have relatively simple organizational structures and rather small staffs. Since few museum-like facilities have their own governing boards, nearly all the directors are appointed by and report to an academic department chairperson; the

dean of the college to which the facility is attached; a campuswide senior administrator, such as the provost, vice president, vice chancellor, or president; or the director of the library, arts center, student union, or other building where the museum or gallery is located.

The director frequently is the only full-time museum or gallery staff member, with other staff members often being part-time people—such as curators from the academic department or college faculty, office help, volunteers, and work/study students, interns, and other students. It is only in the larger institutions that there are more extensive organizational structures and staffs resembling those of their nonacademic counterparts.

The smallest staffs—usually one to four full-time and/or part-time people— are found at art galleries, historical facilities, planetaria, and small specialized museums and related facilities. They generally include a director/curator, a secretarial/clerical assistant, and collections, exhibits, and/or other personnel. Faculty members also may be involved from a curatorial standpoint, and students may be used to assist with the research, mounting, maintenance, security, and/or other such functions. Some facilities do not have any full-time staff members.

Among the facilities with small staffs are the Arrott Art Gallery, New Mexico Highlands University, one full-time and two part-time; Wrather West Kentucky Museum, Murray State University, two full-time and three part-time; and Bowling Green State University Planetarium, one full-time and one part-time. Those without any full-time staff members include the Rosenberg Gallery, Goucher College, one part-time; Fellow-Reeve Museum of History and Science, Friends University, one part-time and three aides; and Weitkamp Observatory/Planetarium, Otterbein College, one part-time.

Most medium-sized and large museums, galleries, and related facilities have more extensive organizational structures and staffs, often with a number of departments and various specialized staff members, such as curators, collections managers, conservators, exhibit designers, preparators, public programming personnel, security and physical plant people, librarians, and/or others.

The University of Nebraska State Museum, for instance, has a staff of 38 full-time and 6 part-time employees, as well as many part-time students and over 170 volunteers. It has a director, two assistant directors—for research (with eight curators and six collection managers in the division) and for public programs (overseeing three departments [exhibits with five full-time employees, education with a staff of three, and planetarium staff of two]—and administrative, security, gift shop, bookkeeping, library, and secretarial personnel.

At the University of Kansas Natural History Museum, the staff consists of 64 people. It includes a director, an associate director for administration, 17 faculty/curators, 23 adjunct/emeritus faculty/curators, 9 collection managers/preparators, a public education director and 2 program assistants, an exhibits director and preparator, 2 coordinators for museum development, a managing editor and a publications assistant, 3 clerical support staff, and an accountant. In addition,

the museum employs numerous graduate and undergraduate research assistants on a part-time basis.

The Lawrence Hall of Science at the University of California, Berkeley has the biggest staff, with 270 full-time and 100 part-time employees, as well as 75 volunteers. Others with large staffs include Conner Prairie, Earlham College, 90 full-time and 110 part-time employees and 500 volunteers; University of Pennsylvania Museum of Archaeology and Anthropology, 90 full-time and 33 part-time employees, as well as 21 curators whose primary appointments are as faculty in academic departments, 36 honorary, visiting, and emeritus curators, and 250 volunteers; Florida Museum of Natural History, University of Florida, 84 full-time and 150 part-time employees and 150 volunteers; and Harvard University Art Museums, 69 full-time and 87 part-time employees and 50 volunteers.

Many museums, galleries, and related facilities are involved in museum studies programs and often make use of interns and work/study students. The University of Arizona Museum of Art, for example, has a two-semester internship program and opportunities for independent studies. During the first semester of the internship program, students concentrate on readings in the museum field, have discussions with the internship director, undergo a two-week introduction to each museum department, keep a journal, and prepare a short paper. During the second semester, the intern selects and works in a museum department (curatorial, collections, registration, administration, education, or exhibition preparation).

The Fine Arts Center Galleries at the University of Rhode Island utilize approximately 10 interns a year. Among those institutions using work/study students are the Robert Hull Fleming Museum at the University of Vermont, which has as many as 40 work/study students to supplement its six full-time and four part-time staff members; Gallery of Art at the University of Northern Iowa, from 15 to 20 work/study students per semester; Connecticut College Arboretum, six to eight work/study students a semester; and University of California Botanical Garden at Berkeley, four interns a year. Some museums and other facilities merely hire students for part-time work, as is the case at the Mount Holyoke College Art Museum, which has from 30 to 35 student assistants a year, and the Washington University Gallery of Art, with 25 temporary student positions annually.

## OPERATING PRACTICES

Operating decisions usually are made by the director of the museum, gallery, or related facility—often in consultation with the office to which he or she reports and/or after discussions with the facility's department heads, senior staff members, and/or advisory committee. But there are many differences, particularly in such matters as collections, exhibitions, fund raising, planning, and the use of advisory and other committees.

Advisory committees can be invaluable in discussing and providing guidance

in matters of policy, direction, acquisitions, and exhibitions. "They can provide a salutary check and balance on the director, as well as support and protection," Allen Rosenbaum, director of the Princeton University Art Museum, pointed out at a symposium at Vassar College. He believes the composition of such committees in the art field "should reflect the interests of the art history department, but should not be weighted in favor of the department and should certainly not be composed exclusively of members of that department."

The University of Michigan Museum of Art, which reports to the vice provost for academic affairs, has a nine-member Executive Committee composed of university faculty, administrators, and community representatives to advise the museum on acquisitions, loans, and general policy.

The Museum of Art and Archaeology at the University of Missouri–Columbia makes use of an Advisory Committee in decisions regarding exhibition themes, long-range planning, and other aspects of its operations, while Bowling Green University's three galleries have a Gallery Advisory Board that consults on planning and programming.

At the University of Nebraska State Museum, a Museum Advisory Board (consisting of the chairs or directors of six university departments or divisions directly related to the museum's activities) must approve plans for any major fund-raising drives. These plans then go to the vice chancellor of research and graduate studies and the chancellor of the Lincoln Campus before being forwarded to the University of Nebraska Foundation, which works with the museum to raise the funds.

The Ruth Chandler Williamson Gallery at Scripps College has a Gallery Advisory Committee consisting of administrators, trustees, faculty members, students, and staff members, while the Fine Arts Center Galleries at the University of Rhode Island work with a Gallery Committee comprised of studio and art history faculty.

Many other art galleries also have exhibition committees, generally composed of art faculty members. They include the Davis Art Gallery at Stephens College, with a Gallery Committee that oversees acquisitions and the permanent collection and determines what works are to hang on the campus; Frank T. Tobey Memorial Gallery at Memphis College of Art, which relies upon a committee of five faculty to coordinate the exhibition program; and Boston University Art Gallery, which makes use of an Exhibition Board of university and arts administrators that meets once or twice a year to approve exhibition schedules and related matters.

In addition to the methods mentioned earlier, various other means are used to oversee certain museum, gallery, and related activities. At the U.S. Military Academy's West Point Museum, coordination is organized by mission (e.g., facility requirements are under the director of engineering, security is overseen by the provost marshal, and budget issues fall under the resource management director). Museum and gallery publications and marketing are centralized at Eastern Washington University. And no campus museum can be disbanded with-

out the approval of a committee of all museum curators at Pennsylvania State University.

Peter B. Tirrell, assistant director of the Oklahoma Museum of Natural History at the University of Oklahoma, has pointed out the need for more strategic planning at campus museums and related facilities, saying:

University museums usually face a heavily bureaucratized system of planning, dwindling support, inconsistent criteria for evaluation, constantly changing administration, and special interest pressures from inside and outside their university communities. Strategic planning enhances the ability of university museums to anticipate their environment, maintain a clearer view of what they really want to be, and effectively compete in the challenging economic, academic, administrative, and community climate.

## DIFFERENCES OF OPINION

Differences of opinion often are expressed about the governance, organization, and staffing of museums, galleries, and related facilities at American universities and colleges. Sometimes advocates want campus museums and similar facilities to be tied more closely to academic teaching and research programs, while others would like to see museum-like facilities have more operational independence.

Selma Holo, director of the Fisher Gallery and Museum Studies Program at the University of Southern California, has stated:

The academic mission must be incorporated into the museum mission of collecting, preserving, and interpreting objects. As long as faculties feel that their museum perceives itself as separate from the academic mission, every advance the museum makes financially will be resented, and every loss will be seen as a weakness to be exploited. As part of a university or college, the uneasy fit that we represent must be refashioned. We must become part of the teaching and research role of the institution.

Most campus museum professionals agree that their facility's mission should match that of the university or college, but there is considerable disagreement over the reporting relationship.

The Association of Art Museum Directors, for example, believes the director of a university or college art museum should report to the central administration instead of the department, division, or school head. In its *Professional Practices in Art Museums,* the association explained:

Since the museum (like the library) is seen as one of those resources of a university/ college responding to the needs of the entire university/college community, and frequently to those of the general public, it is appropriate that the Director should report to the central administration of the university/college rather than to some section/part of the university/college such as a department, division head, or school. Placing the museum

thus in the larger administrative pattern will encourage its responding to the greater needs of the university/college rather than to some part thereof.

The director of a museum should be given ''authority commensurate with his or her responsibility and the complexity of the task,'' according to Rosenbaum of the Princeton University Art Museum;

The museum should not be subordinate to a single department, especially one with . . . strong vested interests, nor should the director report to the chairperson of that department. Even if a concession is made on the issue of reporting, the department may only be willing to cede custodial responsibility but not governance.

Donald Gilbertson, former director of the Bell Museum of Natural History at the University of Minnesota, Twin Cities, made a study of campus natural history museums in 1989 in which he concluded that no museum in which the director or curators reported to a department head was extremely productive or rated highly in the field.

In a 1992 article in *Curator,* Philip S. Humphrey, then director of the University of Kansas Museum of Natural History, sought to differentiate between university and nonuniversity museums, saying:

University museums and collections are distinguished by their purposes, organizational contexts and reward systems—all of which enable them to provide essential benefits to their parent institutions' academic programs, to the national and international scholarly communities, and to the national museum community.

Humphrey then proceeded to point out how he saw the differences: The missions of university museums are subsumed under the academic goals of their parent institutions and thus have a primary academic role different from those museums in the public sector; campus museums and collections are units or entities of their parent educational institutions rather than free standing; their administration is without direct trustee oversight, since they lack their own governing boards; the missions and needs of university museums and collections are only a small part of the broad spectrum of concerns and priorities of their parent institutions; most universities provide their campus museums and collections with various services, academic resources, and participation in graduate and undergraduate programs at no cost; most curators are full-time, tenure-track faculty members whose principal responsibilities are scholarship and teaching; because of the tenure system, university museums have the potential to address controversial issues and to be more innovative than nonuniversity museums; and university museums and their associated graduate programs are a major—and, in some disciplines, the primary—source of Ph.D.-level scholar curators employed by both university and nonuniversity museums.

Not everyone agrees that university museums are more likely to address con-

troversial issues and be innovative in some areas. For instance, Judy Diamond, assistant director for public programs at the University of Nebraska State Museum, feels that few campus museums have realized their potential in dealing with controversies and innovations, especially in public programming. She points out that under half of the universities in Humphrey's survey have public programs and that few "are known for their first-class public programs."

Rosenbaum of Princeton University also has reservations about faculty serving as curators, stating:

Faculty curators may be of the greatest benefit to the museum or simply ciphers—but good, bad, or indifferent, they rarely have time or feel any obligation to deal with the many ongoing curatorial duties, the housekeeping, for often substantial collections. A list of faculty curators (in addition to, and often outnumbering, in-house curators) may give the impression that the museum is well staffed. However, the existence of the faculty curator is often the reason for the chronic understaffing of university and college museums.

Despite these differences of opinion and other difficulties mentioned earlier, university and college museums and similar facilities have made considerable progress in improving their management, organization, and staffing in recent decades. But much still remains to be accomplished at many institutions in refining their role, structure, and operations.

## Chapter 6

# Collections and Research

Nearly every university and college museum and related facility—including some that are not collection oriented, such as art galleries and planetaria—have collections of artifacts, artworks, specimens, and/or other objects. The collections range from a few hundred to millions of items. In most cases, these objects of intrinsic value and their study are the reasons for the existence of these facilities.

Many American university and college museums had their origins in teaching and research collections accumulated by academic departments and their faculty members, while others were founded with gifts of art, natural history, history, and other collections beginning in the late eighteenth century and continuing to the present.

Among the early departmental and faculty collections that resulted in museums—often many years later—were an academic department's teaching and research collections that began in 1784 and evolved into the Mineralogical and Geological Museum at Harvard University, an 1838 faculty collection of fossil footprints and rocks that later developed into the Pratt Museum of Natural History at Amherst College, and the 1855 purchase of engravings to illustrate lectures on classical antiquities that led to a collection of artworks and the establishment of the University of Michigan Museum of Art.

Donations of collections—especially artworks—were instrumental in launching many early university and college museums. Among the art museums that trace their foundings to such gifts are the Bowdoin College Museum of Art, which originated with a collection bequest from the college's founder in 1811; Yale University Art Gallery, where its beginning goes back to an 1832 gift of

100 paintings by a Revolutionary War artist; and Mount Holyoke College Art Museum, which began with donations of paintings from artists Albert Beirstadt and George Inness in 1876.

In the natural history field, museums frequently began with a cabinet of curiosities or natural history—often the result of state legislation regarding state universities, as occurred at the University of Michigan, 1837; University of Iowa, 1858; and University of Kansas, 1864. Sometimes they resulted from a geological and/or natural history survey, as took place with the museum at the University of Minnesota in 1872.

These patterns have continued to the present day. At the University of New Mexico, for example, the Maxwell Museum of Anthropology grew out of expanding departmental collections in 1932, while the University of Maine Museum of Art was started in 1988 with a faculty collection of regional artworks. Among the museums established with gifts in the last half century are the Arizona State University Art Museum, which began in 1950 following a gift of approximately 130 major American works; University Art Museum and Pacific Film Archive, founded in 1963 at the University of California, Berkeley, after a bequest from abstract expressionist Hans Hofmann; Mitchell Indian Museum at Kendall College, resulting from a 1977 donation of art and ethnographic materials from many North American tribes; Monte L. Bean Life Science Museum, started in 1978 at Brigham Young University with a major gift of natural history specimens; and Philip and Muriel Berman Museum of Art at Ursinus College, which began in 1987 with a donation of over 3,000 artworks and an endowed directorship.

## TYPES AND SIZES OF COLLECTIONS

Collections at university and college museums and similar facilities are used for many different purposes—research, exhibits, instruction, public programming, and publications. Sometimes artifacts, artworks, and specimens from collections also are placed on loan to other institutions, usually for temporary exhibitions.

The Bylaws of the University of Nebraska–Lincoln, for instance, specify that the University of Nebraska State Museum, a museum of natural history, shall be

the depository of the University for specimens and related literature documenting the natural history and cultural heritage of Nebraska, the Great Plains, and whatever other areas are deemed suitable. Said specimens shall be maintained as a public trust and curated and preserved in an appropriate Museum division. These materials shall be made available for teaching, research, and interpretation, the results of which shall be communicated wherever possible to the scientific community and general public through publication, interpretive display, and educational programming.

The Museum of Art and Archaeology at the University of Missouri–Columbia states that its primary purpose is "to serve the teaching and research programs of the student body and community of scholars of the University" and then adds that "of almost equal importance is its service to the people of central Missouri." The Elvehjem Museum of Art at the University of Wisconsin–Madison says, "all objects, either on display or in storage, are available for teaching purposes, and the museum develops displays designed to enrich university curriculum"—in addition to having its collections serve as "an exceptional research center for the museum's staff, university faculty and students, visiting scholars, and the general public."

The most important collection objects generally are utilized for research by museum curators, departmental faculty, graduate students, and visiting scholars. Selections from a collection often are displayed in exhibits. They usually represent about 10 percent of the total collections. At museums with large collections, the percentage is much smaller (such as 1 percent at the Florida Museum of Natural History at the University of Florida) and considerably higher at places with smaller collections (15 percent at the University of Arizona Museum of Art and 18 percent at the Museum of Art and Archaeology at the University of Missouri–Columbia). In most cases, the displayed objects are rotated to prevent damage from light, dirt, and handling and to show more of the collections to the visiting public.

Some collection materials also may be used as a supplement to lectures, slides, and other teaching presentations or in such public programming as gallery talks, live demonstrations, lectures, school programs, and loan kits (these almost always are duplicates, replicas, and other less-valuable objects that would not be a serious loss if possibly damaged).

Collections can consist of historic objects, works of art, mineral and animal specimens, dried and living plants, slides and photographs, manuscripts and publications, and/or various other objects of intrinsic value. The size of collections varies greatly. The largest collections are found at natural history and related specialized museums, with systematics collections often consisting of millions of specimens. Natural history museums with the most substantial collections include the University of Nebraska State Museum, over 13 million; Peabody Museum of Natural History at Yale University, 11 million; Florida Museum of Natural History at the University of Florida, 10 million; University of Kansas Natural History Museum, nearly 9 million; and Oklahoma Museum of Natural History at the University of Oklahoma, Texas Memorial Museum at the University of Texas at Austin, and University of Georgia Museum of Natural History, all exceeding 5 million.

Among the related science-oriented museums and similar facilities with extensive collections are the Bohart Museum of Entomology at the University of California, Davis, 6 million; Harvard University Herbaria, more than 5 million; Phoebe A. Hearst Museum of Anthropology at the University of California, Berkeley, and Thomas Burke Memorial Washington State Museum at the Uni-

versity of Washington, nearly 4 million; University of Wisconsin Zoological Museum, over 2 million; and University of Pennsylvania Museum of Archaeology and Anthropology, 1.5 million.

Art museums normally have much smaller collections. However, the collections often are highly valued because of the more precious nature of artworks. Some of the largest art collections are at the Harvard University Art Museums, 130,000 works; Museum of Art at the Rhode Island School of Design, over 100,000; Yale University Art Gallery, 100,000; Princeton University Art Museum, more than 35,000; and Indiana University Art Museum and University Art Museum at the University of New Mexico, 25,000.

Collections at a number of specialized art-oriented museums are considerably larger because of the nature of their holdings, consisting primarily of photographs, graphics, costumes, textiles, and/or other such materials. For example, the University of Louisville Photographic Archives has 1.2 million items in its collections, and the Fashion Institute of Technology's Museum at F.I.T. has two block-long storerooms of indexed clothing and more than 4 million textile swatches.

Some of the more extensive collections in other fields—especially history—are located at the Panhandle-Plains Historical Museum at West Texas A&M University, more than 3.5 million objects; History of Aviation Collection, University of Texas at Dallas, 2.5 million; Museum of Texas Tech University, 1.5 million; Museum of the Big Bend, Sul Ross State University, 80,000; and U.S. Naval Academy Museum, 37,000.

Even some art galleries—which normally do not have collections—possess sizable collections of artworks. These galleries, which function almost like museums, include the Montgomery Gallery at Pomona College, with 8,500 works, and the Picker Art Gallery at Colgate University, having over 6,000. A few art galleries, such as the Lehigh University Art Galleries and the Elder Gallery at Nebraska Wesleyan University, do not have their own collections, but administer the university's permanent collection.

Those museum-like facilities without or with only small collections—such as art galleries, science centers, planetaria, and observatories—usually place greater emphasis on exhibitions and/or experiences than on artifacts, artworks, specimens, or other such objects. Among the various facilities without collections are the Boston University Art Gallery, Ohio State University Planetarium, and U.S. Air Force Center for Educational Multimedia. Small collections can be found at such places as the Fine Arts Center Gallery at Arkansas State University; Lawrence Hall of Science at the University of California, Berkeley; and Fleischmann Planetarium at the University of Nevada at Reno.

Sometimes collections are shared. The Washington State University Museum of Art, as an example, is a founding member of the Washington Art Consortium art collection. It is a partnership of six art museums in Tacoma, Seattle, Bellingham, Spokane, and Pullman, formed in 1975 to acquire and administer a collection of works on paper by twentieth-century American artists—a collection

that none of the museums could afford individually. In 1978, a second collection of American photographs was added to the program.

## CATEGORIES OF FACILITIES

It is impossible for any museum or similar facility—on or off campus—to cover everything in its field. No one has the space, staff, funds, and other resources necessary to be that inclusive. Therefore, museums and related facilities make choices in what they collect, preserve, study, exhibit, and interpret. As a result, museums and other such facilities generally fall into three basic categories—those that specialize in some aspect of a field, those that cover a broad field comprehensively, and those that are a combination of specialized and broad collections, exhibits, and programs.

Most university and college museums are a combination of specialized and broad offerings, while art galleries, historical facilities, botanical gardens, and other facilities are more specialized—focusing on contemporary art, local or regional history, living plants of a particular zone, or some other specialty.

Some museums are quite specialized, focusing on a segment of a broader field. They include the Meadows Museum at Southern Methodist University, which emphasizes Spanish art from the fourteenth through the twentieth centuries; Oriental Institute Museum at the University of Chicago, devoted to archaeological materials from the ancient Near East; Burchfield Penney Art Center at the State University of New York at Buffalo, which concentrates on art from western New York State; Berea College Museum, with only Appalachian cultural artifacts and crafts; Museum of American Art at the Pennsylvania Academy of the Fine Arts, devoted to American art; and Lora Robins Gallery of Design from Nature at the University of Richmond, with works of beauty in the form of minerals, seashells, corals, fossils, gems, and other such materials.

Major campus museums and related facilities frequently attempt to give a broad view of their fields, such as the Harvard University Art Museums, with a comprehensive art collection ranging from antiquity to the present; University of Pennsylvania Museum of Archaeology and Anthropology, which has an extensive collection spanning the archaeological and ethnographic world; University of California Botanical Garden at Berkeley, where its worldwide collection is displayed geographically by continent; and Peabody Museum of Natural History, Yale University, with approximately 11 million specimens in natural history, archaeology, and ethnology.

More often museums and similar facilities have mixed collections—with some objects being representative of the whole field and other parts consisting of specialized collections and miscellaneous items, frequently donated or collected in earlier years. Among those in this category are the Museum of Peoples and Cultures at Brigham Young University, where 60 percent of the collection was amassed through excavation (largely artifacts from the Great Basin and Mesoamerica), with the remainder being primarily donated ethnographic and

prehistoric objects from the American Southwest, Polynesia, and elsewhere; Robert Hull Fleming Museum at the University of Vermont, which has a fine print collection, as well as Native American, ancient Egyptian, and other collections; Kalamazoo Public Museum, a part of the Kalamazoo Valley Community College, containing a mixture of historical, anthropological, archaeological, and technological materials; Williams College Museum of Art, which features the works of Charles and Maurice Prendergast, but also has American art, modern and contemporary art, and art of non-Western peoples; and McKissick Museum at the University of South Carolina, with collections of material culture, natural science, and decorative and fine arts.

Collections at some university and college museums and related facilities are considered among the largest and/or most highly regarded in the nation or world. They include the art collection at the Harvard University Art Museums; collection of holograms at the MIT Museum, Massachusetts Institute of Technology; archives of major figures in photography at the Center for Creative Photography, University of Arizona; butterfly and moth collections at the Allyn Museum of Entomology, a part of the Florida Museum of Natural History, University of Florida; meteorite collection at the Meteorite Museum, University of New Mexico; dinosaur collection at the Peabody Museum of Natural History, Yale University; collection of surgical instruments at the Dittrick Museum of Medical History, Case Western Reserve University; graphic arts collection at the Grunwald Center for the Graphic Arts, University of California, Los Angeles; material on Robert Browning and his poetry at the Armstrong Browning Library, Baylor University; collection of costumes, textiles, and accessories of dress at the Museum at F.I.T., Fashion Institute of Technology; palm collection at the Harold L. Lyon Arboretum, University of Hawaii at Manoa; materials on the Renaissance civilization of England and the European continent at the Folger Shakespeare Library, Amherst College; Mimbres pottery collection at the Western New Mexico University Museum; and collection of restored biological communities at the University of Wisconsin–Madison Arboretum.

Among the 130,000 objects in the Harvard University Art Museums' prized collections are 3,500 Western paintings and sculptures; over 10,000 drawings; more than 60,000 Western prints; over 6,000 photographs; 11,500 Asian works; more than 6,000 objects from ancient civilizations; approximately 1,200 Islamic works; over 1,200 textiles; more than 3,750 objects in Western decorative arts; a large collection of ancient coins; and various other items.

## EMPHASIS ON RESEARCH

Many university and college museums and related facilities make extensive use of their collections for research. Such investigations usually are conducted by museum curators and researchers, faculty members, graduate students, and visiting scholars and generally seek to catalog the collection, advance knowl-

edge, publish the findings, fulfill degree or grant requirements, and/or develop content for exhibitions and related programs.

The preservation, increase, and dissemination of knowledge of the natural history of plants and animals is a major part of the University of Kansas Natural History Museum's purpose. The museum describes its research mission as follows:

to use the principles and practices of modern systematic biology to describe and catalog the diversity of fossil and recent plants and animals, understand their evolutionary relationships, characterize their past and present distributions and the mechanisms responsible for them, and elucidate the evolutionary processes that result in organic diversity.

Some facilities, such as the Boyce Thompson Southwestern Arboretum of the University of Arizona, have a list of research objectives. The Boyce Thompson arboretum's research objectives are

1. To build and characterize an extensive collection of desert legumes.
2. To augment research facilities.
3. To develop and study landscape plants and conditions for their growth and maintenance.
4. To conduct research on propagation of desert plants.

The Yale Center for British Art at Yale University calls itself "both an art gallery and a research institute," while the Peabody Museum of Archaeology and Ethnology at Harvard University says, "a primary objective of the museum is to promote research on the past and present through archaeological and ethnological collections."

Museum collections sometimes are largely the result of field research, such as excavations at archaeological sites, as exemplified by the Near Eastern findings at the Oriental Institute Museum at the University of Chicago, Egyptian objects at the Kelsey Museum of Archaeology at the University of Michigan, and Mississippian-period Indian artifacts at the C.H. Nash Museum–Chucalissa at the University of Memphis.

Some campus museums and similar facilities engage in research only as part of exhibit development. They include such facilities as the Patrick and Beatrice Haggerty Museum of Art at Marquette University, Emerson Gallery at Hamilton College, and Hudson Museum at the University of Maine.

In addition to the many art galleries and planetaria without collections, a number of other facilities do not have research programs, including the David and Alfred Smart Museum of Art at the University of Chicago, North Dakota Museum of Art at the University of North Dakota, Museum of Natural History at Princeton University, Lee Chapel and Museum at Washington and Lee University, Orton Geological Museum at Ohio State University, and Clendening

History of Medicine Library and Museum at the University of Kansas Medical Center.

Most university and college museums and related facilities encourage—and some even require—staff members to conduct research. At the University of Nebraska State Museum, for example, scientific curators are expected to devote 40 percent of their time to original research—the same as other faculty members. The Museum of Art at the Rhode Island School of Design provides paid research leaves and travel grants to stimulate staff research.

The number of museum staff members engaging in research can be quite large. The Florida Museum of Natural History at the University of Florida has 26 curators, 43 research scientists, and 78 graduate students involved in research, while the Michigan State University Museum has 28 curatorial staff members, 10 affiliated research associates, and 20 graduate assistants.

In addition to their collections, many museums and similar facilities have extensive library, archival, and related resources for research and reference purposes. They include the Kohler Art Library, with 110,000 publications and 300,000 slides, at the Elvehjem Museum of Art at the University of Wisconsin–Madison, and the world's largest collection of archival materials relating to the history of twentieth-century American photography at the Center for Creative Photography at the University of Arizona. Among the other special collection–related facilities are the Museum of Applied Science Center for Archaeology, engaged in the development and application of natural science techniques to solve archaeological problems at the University of Pennsylvania Museum of Archaeology and Anthropology, and the Center for Conservation and Technical Studies, which provides professional care in the conservation of artistic and historical works and trains conservation professionals at the Harvard University Art Museums.

Many graduate students make use of collections as part of their degree programs. At the Florida Museum of Natural History at the University of Florida, more than 200 students have completed honors projects, master's theses, and doctoral dissertations based on the museum's collections and directed by museum faculty in recent years. Students frequently are assigned to collections research, as occurs in art history and classical studies at the Duke University Museum of Art, anthropology courses at the Treganza Anthropology Museum at San Francisco State University, and museum studies at the University of Iowa Museum of Natural History.

In describing the educational role of the Harvard University Art Museums, the policy statement says: "Harvard museums should try to involve students in all phases of museum activity—in conservation labs, in planning exhibitions, in undertaking research for collections and catalogues. . . . Where appropriate, faculty should be encouraged to include objects from the museums in their courses and to engage students in study of original works of art."

Museum collections also are utilized by visiting scholars, writers, students, and others from elsewhere. More than 1,300 scholars from throughout the world,

for instance, typically come to the Harvard University Art Museums each year to use collections, and nearly 1,200 requests are received for photographs of objects for individual study. The number of visiting scholars is approximately 1,500 annually at the Florida Museum of Natural History at the University of Florida and over 250 annually at the California Museum of Photography at the University of California, Riverside.

Some museums and related facilities are quite active in loaning collection objects for research, exhibitions, teaching, and other purposes. The Peabody Museum of Archaeology and Ethnology at Harvard University has a Collection-Sharing Program to make large-scale loans to augment or supplement the holdings and interests of other museums. Started in 1980, the loans have been used primarily in the development of traveling exhibitions. The University of California Botanical Garden exchanges plants with scientists and botanical institutions around the world. Research materials are shipped to approximately 50 individuals and institutions each year. Some museums, such as Museum of Art and Archaeology at the University of Missouri–Columbia, organize exhibitions and/or groups of objects from their collections to travel to other museums.

## A RANGE OF PUBLICATIONS

University and college museums and related facilities publish many different types of publications and other printed materials concerning their collections, research activities, and exhibitions, utilizing objects from their and other collections. Staff members—as well as faculty, graduate students, and visiting scholars who use the collections for research—also write about their findings in professional journals and other publications.

These publications take many forms—annual reports with collection and research summaries, collection and exhibition catalogs, research reports, scholarly journals and books, descriptive gallery handouts, and newsletters with information on collection acquisitions and research projects.

Some museums have extensive publication programs. The Museum of Art at the Rhode Island School of Design, for example, has published over 30 catalogs and numerous brochures on its permanent collections. In addition, it issues an annual report, exhibition brochures, calendars of events, education announcements, and other publications each year.

At the University of Kansas, the Spencer Museum of Art produces an annual scholarly journal/annual report, art lecture reprints, exhibition catalogs, gallery guides, educational materials, and a monthly newsletter, which frequently includes collection and research news. The Indiana University Art Museum publishes gallery handouts on the permanent collections, an annual report, a brochure on the museum and its holdings, and at least one major exhibition catalog a year, as well as monthly flyers, calendars, and visitor information and fund-raising brochures emphasizing its offerings.

Among the other types of collection- and research-based publications found

at museums and related facilities are a collections handbook at the University of Kentucky Art Museum; occasional papers on natural and cultural history at the Strecker Museum, Baylor University; catalogs and brochures with interpretive essays on collections and exhibitions at the Weatherspoon Art Gallery, University of North Carolina at Greensboro; research notes at the Frank H. McClung Museum, University of Tennessee; and scholarly bulletins at the Allen Memorial Art Museum, Oberlin College, and the Kresge Art Museum, Michigan State University.

Some publications are aimed beyond the campus, such as the Andersen Horticultural Library's *Source List,* Minnesota Landscape Arboretum, University of Minnesota; *Lincoln Herald,* a quarterly journal for Lincoln scholars and enthusiasts, Abraham Lincoln Museum, Lincoln Memorial University; program notes for almost every film and video presentation, used by scholars and curators from around the world, University Art Museum and Pacific Film Archive, University of California, Berkeley; *Restoration and Management Notes,* an international biennial journal for scientists and land managers, and books on how to restore and use natural communities on school grounds, University of Wisconsin–Madison Arboretum; *The International Review of African American Art,* a quarterly journal, and books on specific subcollections for scholars and the general public, Hampton University Museum; and *Sky Calendar,* a monthly guide to the night sky that goes to over 30,000 sky-watchers throughout the world, Abrams Planetarium, Michigan State University.

Museum staff members often write books and articles and present papers at professional meetings. In a recent year, the Florida Museum of Natural History curatorial staff at the University of Florida published over 115 scientific papers in reference journals, more than 60 articles in popular publications, and 7 books, as well as delivering 55 papers at scientific meetings. At the University of Nebraska State Museum, a one-year output of staff members included 49 scientific papers, monographs, or reviews and 30 scientific papers at regional, national, and international professional meetings.

The objectives of all such publications, articles, and presentations are to increase campus and public interest and knowledge in the field, to further the stature of the individuals and institutions, and/or to share collection, research, and related information and findings with colleagues for the advancement of the profession and society.

*Chapter 7*

# Exhibits and Public Programming

The popularity of a museum, gallery, or related facility usually revolves around its exhibits and other public programming. It is the permanent exhibits, temporary and traveling exhibitions, and such interpretive programs as gallery tours and talks, demonstrations, classes, school programs, lectures, films, field trips, workshops, and other such activities that largely attract, facilitate the learning of, and affect the experiences and impressions of those visiting the museum or similar facility.

Nearly all university and college museums and related facilities have exhibits and public programs of some kind. The only exceptions are a few research-oriented museums and some galleries, herbaria, planetaria, and other specialized facilities. Among those without exhibits or public programs are the Museum of Anthropology at the University of Michigan; Essig Museum of Entomology at the University of California, Berkeley; University of Georgia Museum of Natural History; and Intermountain Herbarium at Utah State University. On the other hand, some galleries, such as the List Gallery at Swarthmore College, present only changing exhibitions without related programming, while many planetaria, including the Bowling Green State University Planetarium, have sky shows and lectures, but no exhibits.

Permanent collections normally are central to a museum's exhibition program, while temporary and traveling exhibitions are the focus of an art gallery. At the Elvehjem Museum of Art at the University of Wisconsin–Madison, 80 percent of the museum's 26,637 square feet of gallery space is dedicated to permanent installation. The Museum of Art at the Rhode Island School of Design devotes 36 of its 47 galleries to the permanent collection, while Widener University Art

Museum divides its exhibition space equally between selections from its collection (rotating every three to six months) and changing contemporary art shows (four to five per academic year). The Sheldon Memorial Art Gallery and Sculpture Garden at the University of Nebraska–Lincoln follows a tripartite exhibition plan that normally incorporates approximately one-third drawn from the permanent collection, one-third contracted from other institutions, and one-third organized from outside sources. In the history and science fields, the museums and related facilities commit nearly all of their exhibit space to their collections, although some have active temporary and traveling exhibition programs.

Most campus museums have approximately 10 percent of their collections on display at any time. But the percentages vary considerably with the type of museum, the size of the collections, and the space for exhibitions. At a large museum with a collection of specimens and artifacts in the millions—such as the Florida Museum of Natural History at the University of Florida—only 1 percent or less of the collection may be on exhibition. At a museum with a much smaller collection—as is the case at the University of Arizona Museum of Art—the percentage of works on display may be 15 percent or more.

## MUSEUM EXHIBITION PHILOSOPHIES

Many museums and similar facilities have stated exhibition philosophies or goals. They range from brief statements, particularly in the art field, to longer lists of objectives, usually in science-oriented facilities.

The goals of the exhibition program at Robert Hull Fleming Museum, an art and anthropology museum at the University of Vermont, are

1. To exhibit and interpret the collections based on current scholarship.
2. To mount special exhibitions which supplement the Museum's holdings or explore in depth an aspect of the collection.
3. To feature work by artists of national stature associated with the state or with the University.
4. To enrich the University's programs for cultural diversity and international perspective.

The Laband Art Gallery at Loyola Marymount University, a Catholic liberal arts university administered by the Society of Jesus, has a three-fold exhibition policy that reflects the religious nature of the institution: "thematic projects featuring traditional and non-traditional spirituality; the exploration of social and political issues; and ethnological and/or anthropological displays."

At the University of Missouri–Columbia, the Museum of Art and Archaeology's exhibition philosophy is "to try to embody the essence of our teaching and research purpose, and to educate the university community and the general public through shows relating historical and current events to various artistic

endeavors.'' The Fowler Museum of Cultural History at the University of California, Los Angeles says its exhibition policy is ''to develop audience-centered exhibitions which increase the public's understanding of non-western cultures,'' with exhibitions placing ''a heavy emphasis on providing cultural context and interpretive perspectives for the artifacts, cultures or topics on which they are focused.''

The University of Kansas Natural History Museum has a more detailed exhibition philosophy, saying it seeks

1. to provide real natural history specimens, to be examined, appreciated, and enjoyed, and to care for the specimens in a manner that meets modern conservation standards;

2. to present scientifically accurate and current natural science information, featuring (when possible) research by museum staff and students;

3. to use varied presentation methods, including interpretive and interactive exhibits, dioramas, and synoptic exhibits, supplemented by graphic and audio-visual materials and by printed handouts, to facilitate varied approaches to learning and access by all members of the audience; and

4. to support the development of an understanding of plants and animals, their interactions, their environments, their significance in our world, and their conservation.

A similarly focused natural history museum—the University of Nebraska State Museum—defines its exhibition goals somewhat differently, stating that exhibits should

• offer real natural history specimens, not models or reproductions, to be examined, scrutinized, appreciated, and wondered about;

• interpret the specimens in terms of their place in nature and their meaning to other living things;

• increase their understanding of the natural history of the Plains, its uniqueness and its relationship to other ecological zones;

• educate the visitor about the implications of public policies and land management practices;

• inspire visitors to seek more information about natural history and the world in which we live;

• relate to the casual visitor as well as the university student or the dedicated scholar; and

• delight the visitor with the wonders of nature.

Some campus museums and related facilities give more emphasis to teaching in their exhibition considerations. The Harvard University Art Museums, for example, state that in selecting and designing exhibitions, ''the first priority is teaching in the broadest sense.'' Several galleries are rehung periodically with exhibitions organized in conjunction with fine arts courses, and teaching exhi-

bitions also are organized by faculty from other Harvard departments, graduate students, and occasionally undergraduates. Other exhibition priorities are "to highlight the strengths of the collections for the general public and the Museums' academic audience; to present an organized view of a certain school, subject, or technique; to acquaint the public with the latest scholarly or technical research; to present new acquisitions in context; or to explore a new approach to art or art history."

The Arizona State University Museum of Anthropology actually uses the museum as a laboratory primarily for graduate students in the museum studies program, with students doing most of the exhibit research and organizing many of the exhibitions. At the Merritt Museum of Anthropology at Merritt Community College, from 1 to 10 students are trained each semester to select, research, design, and install an exhibit.

## EXHIBIT TYPES AND TECHNIQUES

Exhibits usually are regarded as permanent or as temporary. Permanent exhibits normally are on display for two, three, or more years, while temporary exhibitions can last from a few weeks to several months or more (generally no longer than a year). A third category—traveling exhibitions—is a form of temporary exhibition that is obtained for a short period from another institution or other source and is circulated to a number of facilities. Sometimes a museum, gallery, or other facility will organize a temporary exhibition that becomes a traveling exhibition by intent or because of requests from other institutions.

Most campus exhibitions are internally generated by the director and/or curator, who may be assisted by other faculty members and students; exhibits, collections, and public programming staff members; and/or advisory committee members, consultants, or other outside specialists.

The exhibits themselves usually are located inside the museum building or related facilities, but they also can be outside as sculpture gardens, open-air history museums, botanical gardens, arboreta, and other such locations. Some art museums have outdoor sculptures throughout the campus, as occurs at Hofstra, Princeton, Western Washington, and Wichita State universities and the University of California, Los Angeles. One museum, the Joseph and Margaret Muscarelle Museum of Art at the College of William and Mary, has an outdoor $65 \times 13$-foot passive solar wall that glows as multicolor stripes at night on the side of its building, while another, the Edwin A. Ulrich Museum of Art at Wichita State University, has a large Miró mural at its entrance.

In addition to art galleries with a number of exhibition spaces around campus (as at Arizona State, Bowling Green State, and Lehigh universities), a number of art museums have a substantial part of their collections on display in various campus offices, hallways, and buildings, as occurs at Housatonic Community-Technical College, Iowa State University, and Southern Illinois University at Edwardsville.

Most museum and gallery exhibits have artifacts, artworks, or specimens displayed on the walls or in cases. In many museums, the objects are grouped in sections devoted to a specific period, type, classification, or theme. Some museums employ a wide variety of exhibit techniques—in addition to labels, photographs, and graphics—to assist with the explanations and interpretations. They take such forms as the following:

- Huge murals (such as *Cosmic Blink* at the William M. Staerkel Planetarium at Parkland College and *The Age of Reptiles* and *The Age of Mammals* at the Peabody Museum of Natural History at Yale University).

- Dioramas (miniatures or life-sized scenes, frequently with wildlife specimens in natural surroundings and painted backgrounds, as at the University of Iowa Museum of Natural History, the Utah Museum of Natural History at the University of Utah, and the Natural History Museum at the University of Kansas).

- Period rooms or structures (actual or re-created, such as rooms from the early seventeenth century to the present at the Louisiana State University Museum of Art; an outdoor re-creation of an oil boomtown at the Spindletop/Gladys City Boomtown Museum, which is part of Lamar University; and several doctors' offices at the Dittrick Museum of Medical History at Case Western Reserve University).

- Life-sized reconstructed skeletons (as exemplified by the elephants at the University of Nebraska State Museum and the dinosaurs at the Peabody Museum of Natural History at Yale University).

- Models and replicas (such as a small-scale space shuttle model at Cernan Earth and Space Center at Triton College and an alabaster model of the Taj Mahal at the Lora Robins Gallery of Design from Nature at the University of Richmond).

- Animated models (such as the 23-foot-high model of a *Triceratops* dinosaur at the Museum of the Rockies at Montana State University).

- Walk-through natural environments (such as the north Florida cave re-creation in which cave formation, inhabitants and their bioenergetics, ground water, land use, and environmental health issues are interpreted in the Florida Museum of Natural History at the University of Florida).

- Hands-on exhibits (where visitors can interact with such exhibits as computer and science units at the Lawrence Hall of Science at the University of California, Berkeley; 30 pushbutton exhibitions showing mineral properties at the Earth and Mineral Sciences Museum and Art Gallery at Pennsylvania State University; and hands-on exhibits that measure children's hands, feet, height, weight, coordination, and ability to match colors and shapes and to recognize words at the University of Virginia Health Sciences Center Children's Museum).

- Touch tanks and animals (including the touch tank that provides opportunities for visitors to have experiences with a variety of marine organisms at the J.L. Scott Marine Education Center and Aquarium, operated by the University of Southern Mississippi, and the farm animals at the Ronald V. Jensen Living Historical Farm, which is part of Utah State University).

- Slide, film, video, and multimedia shows (ranging from a three-dimensional slide show

**Figure 12.** This diorama is one of 130 exhibits at the Natural History Museum at the University of Kansas. The museum is one of five museums under a single administrative unit on the Lawrence campus. (*Courtesy University of Kansas Natural History Museum*)

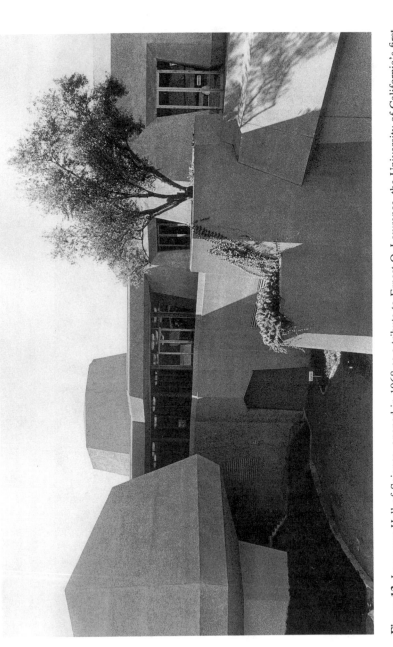

**Figure 13.** Lawrence Hall of Science, opened in 1968 as a tribute to Ernest O. Lawrence, the University of California's first Nobel laureate and inventor of the cyclotron, is a hands-on science center on the Berkeley campus that seeks to further knowledge and understanding of science. The 134,000-square-foot facility has exhibits, educational programming, and a planetarium and is internationally recognized as a science/mathematics curriculum development center and a teacher education resource. (*Courtesy Lawrence Hall of Science and photographer Larry Nimmer*)

on Montana and the northern Rocky Mountains at Montana State University's Museum of the Rockies to a multimedia exhibit with videos and computer simulations relating to eight Mesozoic excavation sites at the University of Nebraska State Museum).

• Collection access systems (the Ball State University Museum of Art has an ART [Art Reference Terminal] system that provides visitors with access to an on-line catalog of all objects in the museum's collections, while the Michael C. Carlos Museum at Emory University is developing an interactive system that enables visitors at seven kiosks to obtain collection images and information through sound, video, graphics, photography, hypertext, and computer animation).

• Live demonstrations (including demonstrations by artists at art museums and galleries, such as the Spencer Museum of Art at the University of Kansas and the Fine Art Galleries at the University of Arkansas at Little Rock, and household craft demonstrations by costumed interpreters at outdoor historical museums, such as Earlham College's Conner Prairie and Ferrum College's Blue Ridge Institute Farm Museum).

• Discovery rooms and exhibits (an increasing number of museums have rooms or exhibits designed primarily for children to be able to touch and explore actual objects, as occurs with natural history specimens at the James Ford Bell Museum of Natural History at the University of Minnesota, Twin Cities, with southern folk art at the University Museums at the University of Mississippi, and with artifacts at the Spertus Museum at the Spertus College of Judaica).

Whatever the exhibit techniques, it nearly always is the collections and selections on display that really distinguish a campus museum or other facility. The techniques, however, can make museums and their exhibits more interesting, effective, and popular with the visiting audience.

## TEMPORARY AND TRAVELING EXHIBITIONS

Most university and college museums and similar facilities mount special exhibitions for short-term periods. They usually are organized internally and are based on objects from collections that normally are not on display. Sometimes they include loans of objects from other institutions to fill gaps in the storyline. The staff also may develop exhibitions with materials obtained from artists and other sources. Two other types of campus-originated exhibitions are the art faculty and graduate student shows. Some museums and galleries—particularly in the art field—also schedule traveling exhibitions organized by other institutions, and a number are developers and circulators of traveling exhibitions.

Most museums, galleries, and related facilities have a temporary exhibition policy, especially in the art field. The University of Arizona Museum of Art, for instance, believes temporary shows "serve as an adjunct to the permanent collection, and generate a broader view of the kinship of all art and artists through time, a dividend which even the broad holdings of the permanent collection can only begin to provide." The museum's goal for such venues is "to

educate students, faculty, staff, (and) citizens of the community, state and South-west in the understanding and appreciation of art.''

The Elvehjem Museum of Art at the University of Wisconsin–Madison views its exhibition program as follows: ''In developing a presentation or deciding to host a traveling exhibition from another institution, the Elvehjem strives to pres-ent new insight, information, and perspective on the artist(s), theme, or period, and to present this information in the most informative, accessible, and aes-thetically pleasing manner possible.''

Most museums have one or more galleries devoted to temporary exhibitions, including traveling shows. The Krannert Art Museum and Kinkead Pavilion at the University of Illinois at Urbana-Champaign have three galleries and organize and/or present 14 to 16 different exhibitions a year. ''Programming is scholarly and innovative without being exclusive; concerted efforts are made to program exhibitions and special events that appeal to a broad audience.''

The McKissick Museum, a general museum at the University of South Car-olina, presents 12 temporary exhibitions—ranging in size from 500 to 2,500 square feet—for approximately 10 weeks each year. The University of Arizona Museum of Art schedules even more—from 16 to 20 a year. Smaller museums and galleries with smaller staffs, spaces, and budgets may have far fewer, per-haps from several to a half dozen, exhibitions.

Student and faculty exhibitions are presented most often at art galleries. The Hopkins Hall Gallery at Ohio State University has undergraduate juried shows, Master of Fine Arts thesis and other graduate exhibitions, and faculty shows among its 30 to 40 temporary exhibitions each year. At Parkland College Art Gallery, the temporary exhibition program includes an annual art faculty show and two juried student exhibitions. More than 200 student exhibitions are pre-sented in the School of Art and Design's Gallery 1 at San Jose State University.

Some museums and galleries also have rather unusual exhibition presenta-tions. For example, Ohio State's Hopkins Hall Gallery organizes an annual 48 Hour Turnover Exhibition Series, in which five shows are presented in 10 days. Others host competitions and invitationals, such as the annual Science in Art Competition at the Materials Research Laboratory Museum of Art and Science at Pennsylvania State University and the biennial National Invitational Water-color Show and the Invitational Show of Ceramic Art at the Parkland College Art Gallery.

Among those university and college museums that organize traveling exhi-bitions are the Florida Museum of Natural History at the University of Florida, which has approximately 10 exhibitions circulating at any time; California Mu-seum of Photography at the University of California, Riverside, where many of its exhibitions become traveling shows after opening at the museum; and Har-vard University Art Museums, which typically organize traveling exhibitions in conjunction with other institutions, often with curators trained at Harvard.

Many museums lend objects from their collections to other institutions for special or traveling exhibitions. The Peabody Museum of Archaeology and Eth-

nology at Harvard University even has a Collection-Sharing Program, in which objects are placed on loan to serve as the thematic focus of an exhibition. The loans generally consist of more than 20 objects and usually are exhibited together.

## PUBLIC PROGRAMMING EFFORTS

Public programming—also known as education programs—can be found at virtually all university and college museums, galleries, and related facilities. It consists of a wide range of supplemental programming designed to interpret exhibits, collections, and research and to further public understanding and appreciation of the subject matter.

The most common such activities are gallery tours and talks, lectures, films, demonstrations, classes, and school group programs. Among the other frequent public programs are panel discussions, seminars, symposia, workshops, conferences, field trips, teacher institutes, summer camps, storytelling, speakers' bureaus, special events, and outreach activities. In addition, some museums and similar facilities offer concerts, dance and theater performances, poetry readings, and other such cultural activities, often related to membership programs and efforts to attract and serve visitors.

The rationale for such programs is explained in various ways. In describing its public programming, the Fowler Museum of Cultural History at the University of California, Los Angeles, states:

The Museum develops and implements various educational programs for distinct purposes and target audiences: lectures and gallery tours for the general public, weekend festivals for families, roundtable discussions for scholars and students, lectures for educators, and a school tour program for local elementary and high school students. The Museum designs these programs in conjunction with its exhibitions, departmentally-generated academic activities, course curricula, symposia, and scholarly research.

The University of Kansas Natural History Museum says its public education programs "help the museum expand public appreciation and enjoyment of all natural history by offering programs for children, families, and adults," while Hood Museum of Art at Dartmouth College designs its public programs "to utilize the museum as an educational resource for the public schools in the region" and "to attract adult audiences to the museum."

The McKissick Museum at the University of South Carolina explains its public programming as follows:

As part of an institution of higher education, McKissick stresses education as one of its primary activities. Programs utilize McKissick's permanent collections as well as temporary exhibitions to increase knowledge of South Carolina history, natural science, folk culture and art. . . . Types of programming . . . include lectures and symposia, film series,

teacher training workshops, gallery guides, art classes and participation in the USC Elderhostel program. Programming for children includes school-based education programs, week-long summer programs, gallery guides, storytelling, field trips to area sites, art and craft classes and weekend workshops.

Art museums are the most active in public programming. Among these programs are the following:

- Spencer Museum of Art, University of Kansas: lectures, gallery talks, films and videos, symposia, artist demonstrations, concerts and performances, tours, teacher training workshops, faculty training, and other special programs.
- Museum of Art, Rhode Island School of Design: youth and school programs, art talks and classes, study kits, teacher workshops and summer institutes, field trips, family tours and workshops, programs for seniors and developmentally disabled adults, musical and theater performances, and various collaborative efforts.
- Elvehjem Museum of Art, University of Wisconsin–Madison: audiotaped tours, lectures, films, art and theatrical performances, field trips to other institutions, teacher in-service days and workshops, and outreach programs to schools and community groups.
- Yale University Art Gallery: gallery talks, films, lectures, symposia, docent-led tours, school and outreach programs, and special events linked to exhibitions.

Some museums and related facilities in other fields also have extensive public programs. For example, the University of Nebraska State Museum has a hands-on natural history learning facility and programs in galleries; slide and audio orientation programs; bimonthly special events related to collections, research, or other topics of public interest; school programs, including planetarium shows; a Junior Curator's program; 25 outreach kits; and a teachers' resource center. In 1994, approximately 43,000 children in school groups visited the museum, and 22,000 others used the outreach kits.

Others with multifaceted programs include the Peabody Museum of Archaeology and Ethnology at Harvard University, with exhibit tours, a hands-on Discovery Room, school programs, adult seminars, Saturday morning programs, a series of special events, and object identification services; University of Arizona's Boyce Thompson Southwestern Arboretum, offering tours of plant exhibits, bird walks, lectures, workshops, school programs, publications, and special events; and J.L. Scott Marine Education Center and Aquarium, operated by the University of Southern Mississippi, which has guided tours, hands-on activities, a sea day camp, field trips, camp-ins, a preschooler program, lectures, a school program, family seminars and weekends, and mini-camps, workshops, and classes for teachers.

Some facilities are specially known for one of their public programs, such as the concerts with antique instruments at the Shrine to Music Museum, University of South Dakota; monthly guide to the night sky at Abrams Planetarium, Michigan State University; free plant identification program at the Kansas State Uni-

versity Herbarium; and living history demonstrations by costumed interpreters in such areas as textiles, pottery, cooking, black powder, woodworking, blacksmithing, and glassblowing at Sam Houston Memorial Museum, Sam Houston State University.

A number of museums and similar facilities have mini-exhibits and other special outreach programs, including the Hicks Art Center at Bucks County Community College, which operates an Artmobile that takes artworks and programs to area schools; University of Maine Museum of Art, where 153 exhibits are circulated to over 150 classrooms each year as part of its Museums by Mail Program; University of Pennsylvania Museum of Archaeology and Anthropology, which uses Mobile Guides to take mini-exhibits, lectures, and workshops to Philadelphia schools; University of Wyoming Art Museum, which provides exhibitions and hands-on art activities in traditional and nontraditional settings throughout the state as part of its Art Mobile Program; University of Colorado Museum, which sends its BugMobile and natural history Discovery Kits to schools; and Bohart Museum of Entomology at the University of California, Davis, where 24 traveling exhibits and an insect zoo are circulated on loan.

As mentioned earlier, special events are part of the public programming at many campus museums and similar facilities. They take many forms and include such diverse events as an Old Fashioned Fall Festival, featuring museum artifacts and demonstrations on how they were used in pioneer days, at the McPherson Museum at McPherson College; spring and fall Family Festivals at the Krannert Art Museum and Kinkead Pavilion at the University of Illinois at Urbana-Champaign; Dinosaur Days, Black History Awareness Day, and Earth Day at the Peabody Museum of Archaeology and Ethnology at Harvard University; and an Ethnic Festival, Honohono Orchid and Hibiscus Show and Sale, Lyon Arboretum Plant and Craft Sale, and Chef Showcase at the Harold L. Lyon Arboretum at the University of Hawaii at Manoa.

All of these exhibitions, public programs, and related activities have the same primary purposes—to make available and interpret an institution's holdings and other resources and to further public interest in and understanding of the field. Secondary objectives frequently are to obtain greater exposure and to increase attendance and support while serving more people. It is these publicly oriented activities that often give university and college museums, galleries, and related facilities their popularity—or lack of it.

## Chapter 8

# Facilities and Funding

The facilities and funding of university and college museums, galleries, and related facilities differ widely. They range from small to large and old to new buildings, from single to multifaceted sources of funding and minuscule to multi-million-dollar budgets. As might be expected, those museums and their counterparts with more support internally and/or externally usually have the better facilities.

Most campus museums and similar facilities are located in a single building, frequently shared with academic departments or activities in the same or related fields. Some actually are part of libraries, arts centers, student unions, and other such facilities. Others are located in various buildings, and a number are at off-campus facilities.

Nearly all of the large museums have their own buildings, including the Indiana University Art Museum, Museum of the Rockies at Montana State University, and Lawrence Hall of Science at the University of California, Berkeley. Many galleries, on the other hand, are located in libraries (Arrott Art Gallery at New Mexico Highlands University and Sturgis Library Gallery at Kennesaw State College), arts centers (Picker Art Gallery at Colgate University and Lafayette College Art Gallery), and student unions (J. Wayne Stark University Center Galleries at Texas A&M University and Wisconsin Union Art Galleries at the University of Wisconsin–Madison).

Some museums operate out of multiple buildings, including the Connecticut State Museum of Natural History at the University of Connecticut (with collections in 14 buildings); Oklahoma Museum of Natural History at the University of Oklahoma (in four contiguous buildings—one for exhibits and the other three

for collections storage and laboratory work); Yale University Art Gallery (in two connecting buildings); and Texas Memorial Museum at the University of Texas at Austin (with a central exhibit building and collection facilities in other campus buildings and at the university's outlying Balcones Research Center).

It is not unusual for museums to have branches at other sites. For example, the Strecker Museum at Baylor University has two other facilities—the Governor Bill and Vara Daniel Historic Village on a 13-acre site and the Youth Cultural Center, a hands-on learning center, in downtown Waco; the University Art Museum at the University of New Mexico also operates the Jonson Gallery across campus; the University of Nebraska State Museum has two branches— Trailside Museum and Ashfall Fossil Beds State Historical Park; and the Alabama Museum of Natural History at the University of Alabama operates the Moundville Archaeological Park in addition to the Smith Hall Natural History Museum on the campus.

Many of the art galleries have exhibition spaces at a number of locations on the campus, such as the Lehigh University Art Galleries (which present exhibitions at five locations); Mary Washington College Art Galleries (with two exhibition spaces); Fine Arts Center Galleries at the University of Rhode Island (having three galleries in different locations); and Kent State University Art Galleries (with galleries in the art school and the music center).

Several art galleries and museums operate off-campus satellite galleries— sometimes of a sales nature—in metropolitan areas. They include the Rubelle and Norman Schafler Gallery at the Pratt Institute, which also has a Manhattan gallery, and the School of the Art Institute of Chicago and the Northern Illinois University Art Museum, both with branch galleries on Chicago's North Side gallery row.

Many university and college museum-like facilities, such as botanical gardens, arboreta, observatories, and special libraries, are located some distance from the campus. Among such facilities are the University of Utah's Red Butte Garden, a 350-acre botanical garden and natural area at the mouth of Butte Canyon in the foothills outside Salt Lake City; Boyce Thompson Southwestern Arboretum, approximately 100 miles from the University of Arizona; Palomar Observatory Museum and Gallery, a part of the California Institute of Technology, which is three hours' driving time from the Pasadena campus; and Harvard University's Dumbarton Oaks Research Library and Collection in Washington, D.C.

## WIDE RANGE OF FACILITIES

University and college museums, galleries, and related facilities come in virtually all sizes and shapes. Some buildings date back to the eighteenth century, with many being conversions from other uses. Others are much more recent, being designed and built specifically for use as museums or similar facilities in the last decade or two.

Building facilities range from less than 100 to 246,100 square feet, with art

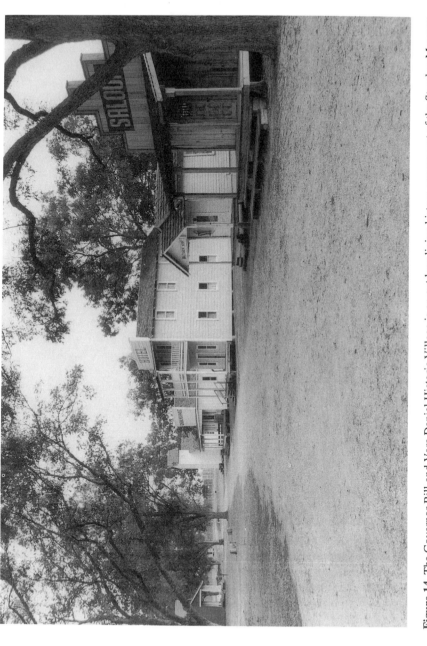

**Figure 14.** The Governor Bill and Vara Daniel Historic Village is an outdoor living history component of the Strecker Museum of Baylor University in Waco, Texas. (*Courtesy Strecker Museum Complex*)

galleries generally being the smallest and art and natural history museums the largest. Botanical gardens, arboreta, and open-air history museums cover even larger spaces—as much as 3,000 acres.

Among the smallest facilities are the Art Gallery at Lake-Sumter Community College, which occupies 50 square feet in the lobby of a multipurpose building; Grace Phillips Johnson Gallery, Phillips University, 270 square feet; Davis Art Gallery, Stephens College, 300 square feet; and Xavier University Art Gallery, 500 square feet.

Not all campus galleries are small. A few have sizable spaces, including the Mills College Art Gallery, 10,000 square feet; Sarah Campbell Blaffer Gallery, University of Houston, 10,000 square feet; Visual Arts Center, North Carolina State University, 18,000 square feet; Lehman College Art Gallery, City University of New York, 20,000 square feet; and J. Wayne Stark University Center Galleries, Texas A&M University, 20,000 square feet.

The largest concentration of art museums is in the 10,000- to 40,000-square-foot range. But there are some well-known museums with even less square footage, such as the Kresge Art Museum, Michigan State University, 6,000 square feet; Fisher Gallery, University of Southern California, 7,000 square feet; and Colby College Museum of Art, 8,500 square feet. Among those in the 10,000–40,000-square-foot range are the Allen Memorial Art Museum, Oberlin College, 22,724 square feet; University of Michigan Museum of Art, 29,000 square feet; David and Alfred Smart Museum of Art, University of Chicago, 29,200 square feet; Mead Art Museum, Amherst College, 30,454 square feet; and Utah Museum of Fine Arts, University of Utah, 35,000 square feet.

The second largest grouping of art museums is in the 40,000- to 90,000-square-foot range, which includes the Spencer Museum of Art, University of Kansas, 43,813 square feet; Stanford University Museum of Art, 55,765 square feet; Yale Center for British Art, Yale University, 59,157 square feet; Samuel P. Harn Museum of Art, University of Florida, 62,000 square feet; Princeton University Art Museum, 65,592 square feet; and Neuberger Museum of Art, State University of New York College at Purchase, 78,000 square feet.

The largest campus art museums fall in the 90,000- to 200,000-square-foot range—Elvehjem Museum of Art, University of Wisconsin–Madison, 90,000 square feet; University Art Museum and Pacific Film Archive, University of California, Berkeley, 95,000 square feet; Yale University Art Gallery, 100,123 square feet; Indiana University Art Museum, 105,000 square feet; and Harvard University Art Museums, 200,000 square feet.

The natural history field also has museums with over 100,000 square feet, although most are in the 1,000- to 10,000-square-foot range. They include the Florida Museum of Natural History, University of Florida, 104,000 square feet; Peabody Museum of Natural History, Yale University, 125,000 square feet; University of Nebraska State Museum, 180,000 square feet; and University of Kansas Natural History Museum, 190,326 square feet. Other large natural history museums include the Oklahoma Museum of Natural History, University of

Oklahoma, 53,000 square feet; University of Georgia Museum of Natural History, 60,000 square feet; James Ford Bell Museum of Natural History, University of Minnesota, Twin Cities, 80,762 square feet; and Museum of the Rockies, Montana State University, 92,000 square feet.

In the archaeology, anthropology, and ethnology fields, where most museums are in the 10,000- to 25,000-square-foot range, the largest museum by far is the University of Pennsylvania Museum of Archaeology and Anthropology, with 246,000 square feet. Other large museums are the Thomas Burke Memorial Washington State Museum, University of Washington, 62,000 square feet; Peabody Museum of Archaeology and Ethnology, Harvard University, 70,000 square feet; and Phoebe A. Hearst Museum of Anthropology, University of California, Berkeley, over 70,000 square feet.

Museums in other fields tend to be less than 25,000 square feet in size, with many in the 1,000- to 10,000-square-foot range. But there are a number of large facilities, such as the Astronaut Memorial Planetarium and Observatory at Brevard Community College, 51,455 square feet; Center for Creative Photography, University of Arizona, 55,000 square feet; Kentucky Museum, Western Kentucky University, 60,000 square feet; Henry Ford Estate, University of Michigan–Dearborn, 65,000 square feet; Lawrence Hall of Science, University of California, Berkeley, 135,000 square feet; and Museum of Texas Tech University, 167,000 square feet.

Open-air history museums, botanical gardens, and arboreta may not have large buildings, but usually cover the most acreage—with the outdoor historical museums also having the most buildings. For instance, the Ronald V. Jensen Living Historical Farm, Utah State University, has 7 buildings on a 120-acre farm; the Louisiana State University Rural Life Museum features more than 20 buildings over 5 acres; and Earlham College's Conner Prairie has 37 buildings in a 55-acre historic area, as well as a 60,000-square-foot museum center, a crafts/maintenance center, and a large amphitheater on the 250-acre total site.

Among the larger botanical gardens are the South Carolina Botanical Garden, Clemson University, 256 acres, and the State Botanical Garden of Georgia, University of Georgia, 313 acres. Arboreta—which often include botanical gardens and are located away from the campus—have the most acreage, with the largest being the Minnesota Landscape Arboretum, University of Minnesota, 905 acres; University of Wisconsin–Madison Arboretum, 1,280 acres; Harvard Forest, Harvard University, 3,000 acres; and Cornell Plantations, Cornell University, over 3,000 acres. Many of the leading arboreta actually have far less acreage, such as the Morris Arboretum, University of Pennsylvania, 166 acres; Harold L. Lyon Arboretum, University of Hawaii at Manoa, 194 acres; and Arnold Arboretum, Harvard University, 265 acres.

## OLD AND NEW STRUCTURES

The buildings housing university and college museums, galleries, and related facilities are a mixture of old and new. Many of the structures were classroom

buildings, libraries, mansions, chapels, dormitories, gymnasiums, and other fa-
cilities before being converted to museums, while others are new buildings de-
signed specifically as museums by some of the most highly regarded architects.

Historical museums, houses, and sites are located in some of the oldest build-
ings, including houses, mansions, and chapels built in the eighteenth and nine-
teenth centuries and later restored. Among the oldest are Hanover House,
Clemson University, constructed in 1716; Belmont, The Gari Melchers Estate
and Memorial Gallery, Mary Washington College, 1790s; Historic Bethany,
Bethany College, built in stages from 1792 through the 1850s; Ash Lawn–
Highland (home of James Monroe), College of William and Mary, 1799; U.S.
Naval War College Museum, 1820; William Holmes McGuffey House and Mu-
seum, Miami University, 1833; Reynolds Homestead, Virginia Polytechnic In-
stitute and State University, 1844; Evergreen House, Johns Hopkins University,
1850s; and Lee Chapel and Museum, Washington and Lee University, 1867.

Among the museums and galleries in converted facilities are the University
of Maine Museum of Art, a 1904 neoclassical granite structure that was origi-
nally the university library; Eastern New Mexico University Natural History
Museum, a renovated dormitory; Church Gallery, University of Alabama in
Huntsville, an 1840s Greek Revival chapel; Pratt Museum of Natural History,
Amherst College, an 1883 renovated gymnasium; Palm Beach Community Col-
lege Museum of Art, a 1939 art deco movie theater; and Oklahoma Museum of
Natural History, University of Oklahoma, converted campus buildings con-
structed during the 1930s and 1940s.

Some museums, galleries, and related facilities share facilities, frequently with
academic departments, libraries, arts centers, student unions, and other campus
activities. They include the Ashby-Hodge Gallery of American Art, Central
Methodist College, library; Logan Museum of Anthropology, Beloit College,
anthropology department; Middlebury College Museum of Art, arts center; Wis-
consin Union Art Galleries, University of Wisconsin–Madison, student union;
Augustana College Art Gallery in Illinois, fine arts building; Sidney Mishkin
Gallery, City University of New York, Baruch College, administrative building;
Haas Gallery of Art, Bloomsburg University of Pennsylvania, auditorium bal-
cony; and Bowling Green State University Planetarium, science laboratory
building.

Many buildings have been constructed specifically for use as museums and
similar facilities, such as the homes for the Mills College Art Gallery; Contem-
porary Art Museum, University of South Florida; University of Oregon Museum
of Natural History; Ruth Chandler Williamson Gallery, Scripps College; Patrick
and Beatrice Haggerty Museum of Art, Marquette University; Museum of the
Rockies, Montana State University; Samuel P. Harn Museum of Art, University
of Florida; Lawrence Hall of Science, University of California, Berkeley; Mu-
seum of Art, Brigham Young University; Southwestern Michigan College Mu-
seum; and Wallace Fiske Planetarium and Science Center, University of
Colorado.

In recent years, many strikingly beautiful and innovative buildings—largely

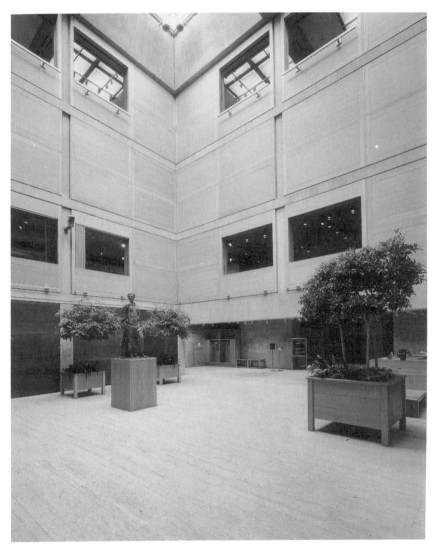

**Figure 15.** Architect Louis I. Kahn designed two art museum buildings for Yale University—the Yale University Art Gallery and the Yale Center for British Art. This is the entrance court for the latter's four-story concrete, steel, and glass structure built on a double courtyard plan. *(Courtesy Yale Center for British Art and photographer Richard Caspole)*

art museums—have been designed by architects with national or international reputations. They have included the Yale University Art Gallery and Yale Center for British Art, designed by Louis I. Kahn; Neuberger Museum of Art, State University of New York College at Purchase, Philip Johnson; University Art Museum and Pacific Film Archive, University of California, Berkeley, Mario Ciampi; Busch-Reisinger Museum, Harvard University, James Sterling; Herbert F. Johnson Museum of Art, Cornell University, and Indiana University Art Museum, I.M. Pei; David and Alfred Smart Museum of Art, University of Chicago, Edward Larrabee Barnes; Frances Lehman Loeb Art Center, Vassar College, Cesar Pelli; Frederick R. Weisman Art Museum, University of Minnesota, Twin Cities, Frank O. Gehry; Davis Museum and Cultural Center, Wellesley College, Rafael Moneo; and Centennial Complex, housing the University of Wyoming Art Museum and American Heritage Center, Antoine Predock.

## FUNDING OF BUILDINGS

Many of the foregoing buildings were made possible by private fund raising—a growing trend among university and college museums, galleries, and related facilities. A considerable number of early museums and galleries were started with gifts of collections—and sometimes funds. The pace has accelerated in recent years, particularly in the art field, as the need for new facilities has grown and institutional support has plateaued or diminished, with tighter budgets at many universities and colleges.

Historically, contributions of artworks, historical artifacts, natural history specimens, and other collections have been instrumental in starting campus museums and similar facilities, as occurred with the Mount Holyoke College Art Museum, University of Oregon Museum of Art, Monte L. Bean Life Science Museum at Brigham Young University, and other institutions.

Other times donors have given entire facilities with collections, such as the Reynolds Homestead at Virginia Polytechnic Institute and State University, Boyce Thompson Southwestern Arboretum at the University of Arizona, and Hunt Institute for Botanical Documentation at Carnegie Mellon University.

Funds were donated less frequently in the past to start museums and similar facilities. The largest early gift was $3 million from James Lick in 1874 to the University of California to build the Lick Observatory, which now has a visitor center and viewing gallery. Monetary gifts in the first half of the twentieth century that resulted in the founding of museums included a donation of funds and paintings from Elizabeth Holmes Fisher to create the Fisher Gallery at the University of Southern California; a contribution from Katherine Wolcott to establish the Robert Hull Fleming Museum at the University of Vermont; and a bequest from William Hayes Ackland to found the Ackland Art Museum at the University of North Carolina at Chapel Hill.

It usually took considerably smaller amounts of money to launch campus museums in those days. For example, two art museums—Bayly Art Museum at

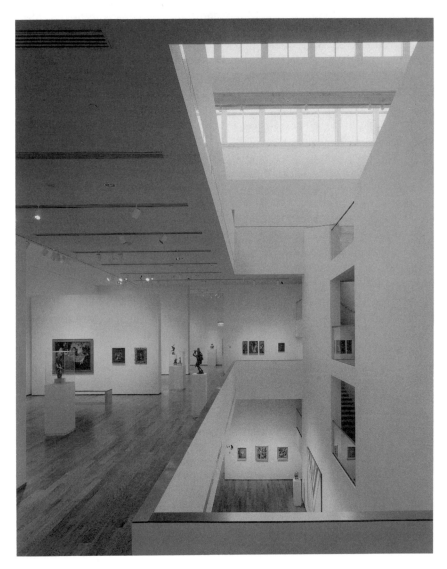

**Figure 16.** This gallery is part of the new Davis Museum and Cultural Center at Wellesley College. The 61,000-square-foot facility, designed by Spanish architect Rafael Moneo, opened in 1993—more than a century after the college's first art museum was established in 1889. *(Courtesy Davis Museum and Cultural Center, architect Rafael Moneo, and photographer Steve Rosenthal)*

the University of Virginia and Henry Art Gallery at the University of Washing-ton—were established following $100,000 gifts from Evelyn Bayly Tiffany and Horace C. Henry (who also gave paintings), respectively. Today the cost of starting a museum or constructing a new building can run into millions of dollars and generally requires a major fund-raising campaign.

Among the recent new museums and/or buildings made possible by major gifts were the Krannert Art Museum at the University of Illinois at Urbana-Champaign, where Mr. and Mrs. Herman Krannert provided the funds for the building and $1 million for art purchases; Samuel P. Harn Museum of Art at the University of Florida, which received a $3 million founding gift from the Harn family, supplemented by other contributions and $4 million from the state; Frederick R. Weisman Art Museum at the University of Minnesota, with a major gift helping to build a new $10.3 million structure; Stephen Birch Aquarium-Museum at the University of California, San Diego, where its new building resulted largely from a $6 million grant from the Stephen and Mary Birch Foun-dation; and Kemper Museum of Contemporary Art and Design at the Kansas City Art Institute, founded with a $6.6 million gift from R. Crosby and Bebe Kemper.

Numerous other museums also were founded largely through the generosity of donors, including the Yale Center for British Art, Yale University, made possible with funds and artworks from Paul Mellon; Herbert F. Johnson Museum of Art, Cornell University; David and Alfred Smart Museum of Art, University of Chicago; Philip and Muriel Berman Museum of Art, Ursinus College; Frances Lehman Loeb Art Center, Vassar College; Marianna Kistler Beach Museum of Art, Kansas State University; and Davis Museum and Cultural Center, Wellesley College.

## SOURCES OF OPERATING FUNDS

Private individuals, foundations, and companies also have helped with the operating budgets of university and college museums, galleries, and related fa-cilities, although the principal source of operational support continue to be the institutions themselves in most cases.

The author's survey of campus museums and their counterparts showed that 38 percent received some or all of their funding from institutional budgets. Twenty-six percent reported contributions, but private support approached 50 percent when endowment funding (23 percent) was included. Other sources of operating funds were other grants, 30 percent; memberships and sales, 21 per-cent each; research grants, 12 percent; admissions and other sources, 11 percent each.

A surprising number of museums, galleries, and related facilities still receive 100 percent of their funding from the universities and colleges. This is especially true among art galleries, but it also includes some art, history, and science museums and similar facilities—many of which are small. Among those relying

entirely on institutional support are such diverse facilities as the List Gallery, Swarthmore College; Middlebury College Museum of Art; University of Kentucky Museum of Anthropology; Essig Museum of Entomology, University of California, Berkeley; Duke University Museum of Art; Central Missouri State University Archives/Museum; Perkinson Gallery, Millikin University; Miles Mineral Museum, Eastern New Mexico University; Lee Chapel and Museum, Washington and Lee University; University of Georgia Museum of Natural History; University of Tennessee Arboretum; and W.J. Beal Botanical Garden, Michigan State University.

Contributions play an important role at a large number of museums and similar facilities, such as Hartnell College Gallery, 100 percent; Alexander Brest Museum and Gallery, Jacksonville University, 90 percent; Contemporary Art Museum, University of South Florida, 64 percent; South Carolina Botanical Garden, Clemson University, 35 percent; Lowe Art Museum, University of Miami, 43 percent; World Museum of Natural History, La Sierra University, 100 percent; William Benton Museum of Art, University of Connecticut, 25 percent; and Museum of Art, Rhode Island School of Design, 30 percent.

Many museums and other facilities have substantial endowments that make up a large share of their budgets. At Harvard University, for instance, endowment funds account for 60 percent of the budget for the Peabody Museum of Archaeology and Ethnology and 54 percent of the budget for the Harvard University Art Museums. Among the others that draw heavily upon endowments for annual operating funds are the Museums at Hartwick, Hartwick College, 100 percent; Meadows Museum of Art, Centenary College of Louisiana, 99 percent; Yale Center for British Art, Yale University, 70 percent; Orland E. White Arboretum, University of Virginia, 40 percent; Luther E. Bean Museum, Adams State College, 100 percent; McCormick Farm, Virginia Polytechnic Institute and State University, 95 percent; Edwin A. Ulrich Museum of Art, Wichita State University, 69 percent; Hidden Lake Gardens, Michigan State University, 80 percent; Rose Art Museum, Brandeis University, 65 percent; and Scott Arboretum, Swarthmore College, 40 percent.

At some research-oriented museums and similar facilities, research grants are important budget items, as is the case at Leander J. McCormick Observatory, University of Virginia, 50 percent; University of Kansas Natural History Museum, 22 percent; University Art Museum and Pacific Film Archive, University of California, Berkeley, 32 percent; Kelsey Museum of Archaeology, University of Michigan, 20 percent; Kansas State University Herbarium, 40 percent; and Florida Museum of Natural History, University of Florida, 20 percent.

Grants for other purposes can figure prominently in some budgets. Among those museums and galleries where such grants account for high budget percentages are the Lawrence Hall of Science, University of California, Berkeley, 60 percent; North Dakota Museum of Art, University of North Dakota, 47 percent; Henry Art Gallery, University of Washington, 25 percent; Hampton University Museum, 60 percent; David and Alfred Smart Museum of Art, University

of Chicago, 47 percent; Norman Eppink Art Gallery, Emporia State University, 70 percent; and Haffenreffer Museum of Anthropology, Brown University, 37 percent.

Earned income—such as admissions, sales, and membership fees—affects many budgets, particularly those that have a special appeal to the general public. Those museums and related facilities where admissions income is a major factor in their budgets include Jackson's Mill Historic Area, West Virginia University, 95 percent; Glensheen, University of Minnesota, Duluth, 80 percent; Stephen Birch Aquarium-Museum, University of California, San Diego, 53 percent; Clever Planetarium and Earth Science Center, San Joaquin Delta College, 70 percent; Ash Lawn–Highland, College of William and Mary, 45 percent; Maynard E. Jordan Planetarium, University of Maine, 50 percent; Conner Prairie, Earlham College, 33 percent; and Minnesota Landscape Arboretum, University of Minnesota, 40 percent.

Sales also are a large portion of budgets at some institutions, such as the Western New Mexico University Museum, nearly 27 percent; Fleischmann Planetarium, University of Nevada at Reno, 25 percent; Museum of the Big Bend, Sul Ross State University, 15 percent; Boyce Thompson Southwestern Arboretum, nearly 22 percent; Oriental Institute Museum, University of Chicago, 20 percent; Red Butte Garden and Arboretum, University of Utah, 25 percent; and Earth Science Museum, Brigham Young University, 16 percent.

About 20 percent of university and college museums, galleries, and related facilities have membership programs that contribute to their budgets—with nearly half being at art museums. They include the Haverford College Arboretum, 40 percent; James Monroe Museum and Memorial Library, Mary Washington College, 30 percent; North Museum of Natural History and Science, Franklin and Marshall College, 20 percent; Mulvane Art Museum, Washburn University, 13 percent; Connecticut College Arboretum, 20 percent; Museum of Ceramic Art at Alfred, New York State College of Ceramics at Alfred University, 30 percent; Frank H. McClung Museum, University of Tennessee, 13 percent; Kauffman Museum, Bethel College, 20 percent; and North Carolina Botanical Garden, University of North Carolina at Chapel Hill, 15 percent.

Some museums and similar facilities have other sources of income, such as the Henry Ford Estate, University of Michigan–Dearborn, 66 percent from a restaurant and catered events; Idaho Museum of Natural History, Idaho State University, 84 percent from a state line item appropriation; Mabee-Gerrer Museum of Art, Saint Gregory's College, 35 percent from abbey funds; Harwood Foundation Museum, University of New Mexico, 20 percent from rentals; State University of New York College at Plattsburgh Art Museum, 50 percent from the student association; Yeshiva University Museum, 22 percent from the state and city; Shrine to Music Museum, University of South Dakota, 4 percent from interest and dividends; and Anderson Gallery, Virginia Commonwealth University, 5 percent from exhibition rental fees.

## WIDE RANGE IN BUDGETS

University and college museums, galleries, and related facilities are largely a reflection of their budgets. Those with small budgets generally cannot afford extensive collections, staffs, research, or facilities—characteristics of the larger and better-funded institutions.

Some museums and galleries—such as the Lois Dowdle Cobb Museum of Archaeology at Mississippi State University—do not have a separate budget because they are funded as part of an academic department's budget. Others, including the University Art Gallery at Saint Bonaventure University, lack a separate budget because they are part of arts centers, student unions, or other such facilities. A few, such as the Ohio State University Planetarium, do not have any budget and operate with volunteers.

In general, art galleries have the smallest budgets—some less than $1,000, such as the Xavier University Art Gallery with a $500 budget. Among the others with limited budgets are the Grace Phillips Johnson Gallery, Phillips University, where the annual budget ranges from $400 to $1,000; Elder Gallery, Nebraska Wesleyan University, $1,500; Davis Art Gallery, Stephens College, $1,800; Fine Arts Center Gallery, Arkansas State University, $2,300; and Founders Gallery, University of San Diego, $3,000.

However, not all gallery budgets are small. Some of the larger budgets are at the Sarah Campbell Blaffer Gallery, University of Houston, $609,000; University Gallery, University of Massachusetts, Amherst, $271,000; Tufts University Art Gallery, $256,000; Wellington B. Gray Gallery, East Carolina University, $250,000; Art Gallery, University of Hawaii at Manoa, $225,000; and Montgomery Gallery, Pomona College, $220,000. But gallery budgets usually are in the $10,000 to $100,000 range.

Small and no budgets also can be found in other fields, as indicated by the funding at the Miles Mineral Museum, Eastern New Mexico University, no budget; Museum of Early Philosophical Apparatus, Transylvania University, no budget; Wallis Museum, Connors State College, $100; Weitkamp Observatory/Planetarium, Otterbein College, $500; Museum of Natural History, Wayne State University, $500; Merritt Museum of Anthropology, Merritt Community College, $800; University of the Pacific Herbarium, $1,000; Wilbur Greeley Burroughs Geologic Museum, Berea College, $1,450; Jackson's Mill Historic Area, West Virginia University, $3,000; and Frost Entomological Museum, Pennsylvania State University, $3,500. For most museums outside the art fields, except the very small facilities, the budgets normally are in the $100,000 to $250,000 range.

Art museums typically have the largest budgets, although some institutions' budgets are quite modest, such as at the Widener University Art Museum, $32,000; College of Wooster Art Museum, $35,000; and Steensland Art Museum, Saint Olaf College, $50,000. Most are in the $100,000 to nearly $1 million range, including the Mead Art Museum, Amherst College, $380,000; Rose Art

Museum, Brandeis University, $500,000; Krannert Art Museum and Kinkead Pavilion, University of Illinois at Urbana-Champaign, $600,000; Stanford University Museum of Art, $740,000; and Weatherspoon Art Gallery, University of North Carolina at Greensboro, $915,000.

The Harvard University Art Museums have the largest budget of any university or college museum or similar facility—$8 million. Other art museums with large budgets include the Yale University Art Gallery, $5 million; University Art Museum and Pacific Film Archive, University of California, Berkeley, $4.3 million; Yale Center for British Art, Yale University, $3 million; and Museum of American Art, Pennsylvania Academy of the Fine Arts, nearly $3 million.

Among those art museums with budgets between $1.5 and $2 million are the Hood Museum of Art, Dartmouth College; Herbert F. Johnson Museum of Art, Cornell University; Museum of Art, Rhode Island School of Design; Jane Voorhees Zimmerli Art Museum, Rutgers University; Neuberger Museum of Art, State University of New York College at Purchase; Samuel P. Harn Museum of Art, University of Florida; Spencer Museum of Art, University of Kansas; Lowe Art Museum, University of Miami; Museum of Art, University of Michigan; Frederick R. Weisman Art Museum, University of Minnesota, Twin Cities; Elvehjem Museum of Art, University of Wisconsin–Madison; Archer M. Huntington Art Gallery, University of Texas at Austin; and Williams College Museum of Art.

Art museums with budgets of $1 to $1.25 million include the University Art Museum, California State University, Long Beach; Indiana University Art Museum; Allen Memorial Art Museum, Oberlin College; Museum of Art, University of Iowa; and Henry Art Gallery, University of Washington.

Budgets in excess of $1 million also can be found in other fields, with the largest being the Florida Museum of Natural History, University of Florida, $5.6 million; Conner Prairie, Earlham College, $5 million; Peabody Museum of Archaeology and Ethnology, Harvard University, $4 million; Lawrence Hall of Science, University of California, Berkeley, $4 million; Stephen Birch Aquarium-Museum, University of California, San Diego, $3.3 million; Peabody Museum of Natural History, Yale University, $3.2 million; Michigan State University Museum, $3 million; Minnesota Landscape Arboretum, University of Minnesota, $2.8 million; Thomas Burke Memorial Washington State Museum, University of Washington, $2.3 million; University of Kansas Natural History Museum, $2 million; and University of Nebraska State Museum, $1.9 million.

Those museums and similar facilities in the $1.25 to $1.5 million range include the Cornell Plantations, Cornell University; Hampton University Museum; Museum of Texas Tech University; and MIT Museum, Massachusetts Institute of Technology. Among the museums with $1 million budgets are the Center for Creative Photography, University of Arizona; Phoebe A. Hearst Museum of Anthropology, University of California, Berkeley; University of Colorado Mu-

seum; Maxwell Museum of Anthropology, University of New Mexico; and Oklahoma Museum of Natural History, University of Oklahoma.

## A DIVERSITY OF APPROACHES

As indicated, wide differences exist among campus museums, galleries, and related facilities with respect to the sources of their funding. The same can be said about how they spend their funds. Some institutions have little or no paid staff and depend largely on academic department faculty, students, and/or volunteers. In other cases, much of the budget goes into collections, exhibitions, research, programs, staff, and/or facilities.

Differences in sources of funding can vary greatly, as illustrated by these recent examples of three types of museums with differing patterns:

• Indiana University Art Museum: university, 85 percent; contributions, 10 percent; grants, 3 percent; endowment, 1 percent; and sales, 1 percent.

• University of Pennsylvania Museum of Archaeology and Ethnology: university, 47 percent; sales and rentals, 17 percent; endowment, 14 percent; contributions, 11 percent; grants, 6 percent; membership, 4 percent; and admissions, 1 percent.

• Utah Museum of Natural History, University of Utah: state and local support, 50 percent; earned income (such as admissions, memberships, fees, publications, and interest), 28 percent; federal grants, 13 percent; individual contributions, 5 percent; foundation grants, 3 percent; and corporate contributions, 1 percent.

Following are the recent annual expenses—and how they were reported—at a number of institutions:

• Museum of Art, Washington State University: salaries, wages, and related expenses, 52 percent; indirect costs, 27 percent; materials, equipment, and supplies, 13 percent; printing and publications, 3 percent; travel and lodging, 3 percent; and communications, 2 percent.

• Florida Museum of Natural History, University of Florida: salaries, 57.7 percent; materials and supplies, 22.3 percent; operating expenses, 9.7 percent; university support, 7.7 percent; and overhead, 2.6 percent.

• Conner Prairie, Earlham College: educational programs and special activities, 34.5 percent; general and administrative, 26.2 percent; retail, restaurant, and real estate, 17.7 percent; historic grounds upkeep and maintenance, 10.7 percent; marketing and public relations, 7.5 percent; and development and membership, 3.4 percent.

• Museum of the Rockies, Montana State University; operations, 35 percent (including general and administration, 20.5; auxiliary services, 12.9; and fund raising, 1.6); education, 33 percent (exhibits, 15.4; education, 10.3; and planetarium, 7.3); and research, 32 percent.

Many of these differences can be attributed to such factors as how each museum evolved, the nature of its organization and activities, the level of its funding, the institutional policies and pressures, the local circumstances, and the composition, direction, and talents of its staff.

The university/college museum world consists of many types of museums, galleries, and related facilities—small, medium, and large, with differing missions, collections, exhibits, programs, staffs, facilities, funding, and degrees of success. No single approach appears to apply to all or even most campus museums, galleries, and similar facilities.

*Chapter 9*

# Attendance, Marketing, and Evaluation

Attendance can be a major factor in the operations of a university or college museum, gallery, or related facility. If it is, then marketing and public relations assume a more important role, as does evaluation of the exhibits, programs, and impressions of visitors.

At some institutions, increasing the attendance is not a priority. In such cases, the emphasis is on collections, teaching, research, and/or possibly exhibitions, with relatively little concern about reaching more people, improving the quality of the offerings and visitors' experiences, and/or raising more funds through the admissions, sales, memberships, and contributions that usually accompany increased attendance.

Unlike their nonacademic counterparts, many campus museums and similar facilities do not have the pressures to balance the budget through greater earned income and contributions—particularly where the budget is funded 100 percent or largely by the university or college. Perhaps that is why the attendance of many museums, galleries, and other facilities rarely exceeds several thousand. Other factors—such as sparse collections, unimaginative exhibits, small size, poor location, inadequate facilities, little or no staff, and insufficient institutional support—also can significantly influence the public offerings and attendance. Some museums and facilities also are entirely or largely devoted to research and have limited appeal to the public, and/or the staff does not want visitors to disturb their work environment.

Relatively few people visit some museums, galleries, and related facilities, as indicated by attendance figures at the Museum of Natural History, Wayne State University, 200 visitors a year; Miles Mineral Museum, Eastern New Mexico

University, 500; Lewis R. Hershey Museum, Tri-State University, 250; Treganza Anthropology Museum, San Francisco State University, 300; Tech Museum, Louisiana Tech University, 800; Museum of Early Philosophical Apparatus, Transylvania University, 350; Northern Kentucky University Anthropology Museum, 900; Esther Thomas Atkinson Museum, Hampden-Sydney College, 400; and Moudy Gallery, Texas Christian University, 1,000. Some collection- and research-based facilities have even smaller attendances, such as the Greene-Nieuwland Herbarium, University of Notre Dame, with 75 a year, and the Essig Museum of Entomology, University of California, Berkeley, with approximately 125.

Those institutions that are larger, have more to offer, and/or make a greater effort to attract the public generally have considerably more visitors from the campus, community, and elsewhere. University and college museums and similar facilities with the largest annual attendances include the University of Wisconsin–Madison Arboretum, 650,000; Michigan State University Museum, 400,000; University of Texas Institute of Texan Cultures at San Antonio, 400,000; U.S. Naval Academy Museum, 350,000; Stephen Birch Aquarium-Museum, University of California, San Diego, 350,000; Waikiki Aquarium, University of Hawaii, 320,000; Lawrence Hall of Science, University of California, Berkeley, 300,000; Washington Park Arboretum, University of Washington, 300,000; and Conner Prairie, Earlham College, and Mark O. Hatfield Marine Science Center Aquarium, Oregon State University, 250,000 to 400,000 annually. Two federal facilities on university campuses also have attendances of approximately 325,000—the Lyndon Baines Johnson Library and Museum at the University of Texas at Austin and the George Washington Carver Museum at the Tuskegee Institute National Historic Site at Tuskegee University.

Various other museums and similar facilities also have attendances of 100,000 or more, including the Harvard University Art Museums, 240,000; Peabody Museum of Natural History, Yale University, 182,000; Glensheen (former Congdon estate), University of Minnesota, Duluth, 100,000; Museum of Texas Tech University, 200,000; University of Nebraska State Museum, 240,000; Museum of Art, University of Michigan, 118,000; Ash Lawn–Highland (home of James Monroe), College of William and Mary, 100,000; University of Pennsylvania Museum of Archaeology and Ethnology, 160,000; University of Alaska Museum, 142,000; McKissick Museum, University of South Carolina; 150,000; Yale University Art Gallery, 150,000; and Monte L. Bean Life Science Museum, Brigham Young University, 200,000.

Despite these large numbers for some institutions, attendance at most university and college museums, galleries, and related facilities is much lower—often being less than 5,000 to 10,000 a year. Unfortunately, some museums and facilities do not even count the number of visitors—often because they lack the necessary personnel, the numbers are so small, and/or attendance is not considered relevant to the operations.

## ATTRACTING VISITORS

Visitors come from a variety of sources, as indicated in this breakdown of the Harvard University Art Museums' attendance of 240,000 in a recent year— in addition to Harvard students, the visitors included approximately 47,200 paid visitors, 31,200 admitted free under various fee exemptions (such as Harvard staff and affiliates, members, Saturday morning visitors, children under 18, and promotions); and the balance coming from those visiting facilities within the museums.

The public goes to campus museums, galleries, and related facilities for many different reasons, as shown in this audience analysis at the Museum of Art at Washington State University: exhibitions, 75 percent; exhibit openings and other public functions, 7 percent; lectures, 6 percent; exhibit tours, 6 percent; noontime presentations, 2 percent; films, 2 percent; theater and music performances, 1 percent; and special university classes, 1 percent.

The nature, quality, and direction of exhibits and educational activities can greatly affect attendance and the impact of an institution on the visiting public. Christopher A. Miller, director of Berea College Museum, has said that his museum's greatest need is "reorientation as a client centered" institution. "The change is happening," he pointed out, "with repercussions throughout the program."

Bonnie Gibbs, director of the Principia School of Nations Museum at Principia College, cites "a more visible location on campus" as a crucial need in the museum's service and recognition. At the University of Arizona's Boyce Thompson Southwestern Arboretum, the director, William R. Feldman, sees the need for "greater exposure to and appreciation by its various communities and constituent groups, both to increase its base of material and financial support and to better realize its mission of 'instilling in people an appreciation of plants.' "

Lucinda H. Gedeon, director of the Neuberger Museum of Art at the State University of New York College at Purchase, believes better marketing would be extremely helpful to her institution. This usually means effective publicity efforts, publications, direct mail, membership solicitation, special events, community relations, and other such activities to supplement high-quality exhibits and public programming, as well as an inviting environment.

Some campus museums and similar facilities already are quite active in marketing and public relations. At Parkland College Art Gallery, for instance, news releases are distributed to the press, public service announcements are broadcast on local radio and television stations, direct mail is sent out on new exhibits, and newsletters are produced to inform the public about the gallery's activities. In addition to normal public relations activities, the University of Memphis Art Museum publishes tabloid-sized information pieces that are inserted in the campus newspaper, mailed to the museum list, and enclosed with hand-out brochures. The City University of New York's Queens College Art Center uses

announcements, brochures, and press releases—as well as posters and catalogs when funding permits—to promote its offerings.

At many institutions, special programming is used to reach the academic community, school children, and the public at large. At Rutgers University, the Jane Voorhees Zimmerli Art Museum schedules demonstrations, hands-on workshops, tours, lectures, symposia, and outreach programs. The University Art Museum at the University of New Mexico circulates video programs of its collections to public schools, as well as providing gallery tours and talks, symposia, lectures, and other services to entice and serve visitors.

Extensive public programming at the University of Pennsylvania Museum of Archaeology and Ethnology serves marketing as well as educational purposes. It includes gallery tours, workshops, lectures, courses, school outreach programs, and such special events as members' nights, exhibition openings, family "world culture" days, symposia, and music and dance performances. The museum also has media, publications, and other programs to further the institution and its mission.

## PRODUCING DIVIDENDS

Many of the foregoing marketing and programming activities often result in more memberships, admissions, and sales, which help support the institution. This is especially important at those museums, galleries, and related facilities that rely upon earned income to help balance the budget.

Membership fees contribute substantially to the funding of such facilities as the University of Missouri–Kansas City Gallery of Art and Haverford College Arboretum, where 40 percent of the budget comes from membership; Museum of Ceramic Art at Alfred, New York State College of Ceramics at Alfred University, 30 percent; New Mexico State University Museum, 20 percent; and Orland E. White Arboretum, University of Virginia, 20 percent.

The Museum of Art at the University of Michigan has a friends organization—known as Friends of the Museum of Art—with approximately 1,000 members who provide crucial support for museum programs; a Connoisseurs Club of the Friends organization, which sponsors studio and gallery tours; and ChAMPS (Children's Art Museum Programs), a Friends organization for children 5 to 12, which provides a series of workshops and programs for that age group.

Increased attendance means greater revenues for those museums and similar facilities that charge an admission (about 20 percent of campus institutions). In some instances, admissions income is a large part of the budget, as at the Stephen Birch Aquarium-Museum, University of California, San Diego, 53 percent; Minnesota Landscape Arboretum, University of Minnesota, 40 percent; VMI Museum, Virginia Military Institute, 30 percent; Fleischmann Planetarium, University of Nevada at Reno, 30 percent; Buehler Planetarium, Broward Com-

munity College, 25 percent; and Michell Indian Museum, Kendall College, 20 percent.

More visitors generally mean more sales at the gift shop, bookstore, food services, and other such operations. These revenues are substantial at some museums and similar facilities, such as Conner Prairie, Earlham College, 33 percent; Art Galleries, California State University, Northridge, 30 percent; Thomas Burke Memorial Washington State Museum, University of Washington, 29 percent; Red Butte Garden and Arboretum, University of Utah, 25 percent; and Oriental Institute Museum, University of Chicago, 20 percent.

## EVALUATING EXHIBITS AND PROGRAMS

Many university and college museums, galleries, and related facilities engage in evaluation studies of their exhibits, programs, and sometimes the institution as a whole. Such evaluations can be informal or formal in nature and usually are designed to find out how the visiting public receives a particular exhibit or program for the purpose of determining its effectiveness. Some studies are more market oriented, seeking demographics and impressions of visitors, while others tend to find out how well an exhibit, program, or other activity meets its intended purposes.

Evaluation takes many forms, with some studies using more scientific techniques than others, illustrated by the following examples:

• Museum of Art and Archaeology, University of Missouri–Columbia: Exhibition and program evaluation is carried out through staff meetings; informal conversation with faculty members, advisory committee members, students, docents, and general visitors; and more formal questionnaires, generally using museum studies students to assist in conducting the evaluations.

• Florida Museum of Natural History, University of Florida: Exhibits and programs are evaluated by written survey instruments, formal comparative studies using treatment and control groups to measure cognitive and affective changes, informal discussions with participants, and formal and informal observation studies of participant behavior.

• Museum of Art, Washington State University: Evaluation takes place at staff and exhibit meetings, based on staff observations, responses from faculty, letters from the public, input from docents and guards, student essays on exhibitions, attendance figures, art critic reviews, and outside evaluators' reports for grants.

• California Museum of Photography, University of California, Riverside: Evaluation of exhibitions includes quantifiable data (attendance figures, press exhibition notices, etc.) and subjective interpretation (viewer comment books or response walls). The curatorial staff also meets to discuss the response to all programs (exhibitions, symposia, lectures, and other public activities), with the criteria including the relevance to the field, the effectiveness of accompanying text materials, and the degree to which the program attracts its target group. Museum advisory committees and other outside interest groups also comment on the programs.

- University of Kansas Natural History Museum: Exhibits are evaluated through visitor surveys, comments solicited from individuals and family groups at the information desk, comments from teachers and other group leaders questioned by museum staff members, and observations of visitor behavior. Program evaluation methods include feedback from teachers, parents, and participants; written evaluations by teachers and participants in special workshops; pilot tests of kit texts and materials; questionnaires completed by users of traveling kits; and continued high levels of enrollment in programs.

- Weatherspoon Art Gallery, University of North Carolina at Greensboro: Evaluation is based on attendance statistics, visitor comment books, program participant evaluation forms, and word-of-mouth responses.

- University of Nebraska State Museum: Interactive and multimedia exhibits are developed first as prototypes and then evaluated with the public to assess their effectiveness; visits and programs are evaluated with forms made available to visitors when leaving the museum, hands-on center, or special event; and users of outreach materials are asked to complete evaluation forms with the return of the loans.

Some of these evaluation approaches are more effective than others, but all such input is helpful to campus museums and similar facilities in improving their offerings and attracting and serving the visiting public.

# Chapter 10

# Status and the Future

American university and college museums, galleries, and related facilities have changed dramatically in their 200-year history. Once small in number and size and used primarily for instructional purposes, they have grown to more than 1,100 museums and similar institutions with a wide range of collections, research activities, exhibits, public programs, facilities, services, and missions on and off the campus.

In addition to being invaluable teaching resources, many of the museums and similar facilities have become major repositories of artworks, artifacts, and specimens; centers of research; showcases for experimental art and other works; and instruments of public education. Some are considered among the leading institutions in their fields.

The campus museum movement has experienced a tremendous proliferation in the number and types of institutions. The last half century has seen the greatest increase in the founding and expansion of university and college museums, galleries, and related facilities, especially in art museums and galleries. Among the many new art museums established were those at such universities as Michigan, Georgia, Arizona State, Miami, Cornell, Arizona, Missouri, Michigan State, Illinois, Brandeis, New Mexico, Nebraska, Texas, Connecticut, Rutgers, Iowa, Wisconsin, California, Pennsylvania State, Chicago, Yale, Marquette, Notre Dame, Indiana, Florida, and Kansas State, as well as colleges like Amherst and Dartmouth. The largest number of new facilities were art galleries—at such universities as American, Fort Hays State, Washington and Lee, Northern Iowa, Colgate, Brown, Virginia Commonwealth, Gonzaga, San Diego, Western Washington, and Houston and at Mary Washington, Pomona,

Stephens, Reed, Parkland, Swarthmore, Goucher, Central Methodist, and Scripps colleges.

Many museums and similar facilities in other fields also were founded in the last 50 years. In the science field, for example, new natural history museums emerged at such universities as Oklahoma, Utah, Georgia, Idaho State, Montana State, and Virginia Polytechnic; archaeology, anthropology, and ethnology museums at Western New Mexico, Mississippi State, Brown, Memphis, Kansas, Maine, Indiana, Brigham Young, and California (Los Angeles) universities; geology, mineralogy, and paleontology museums at Stetson, Arizona State, New Mexico, Nebraska, and Brigham Young universities; science and technology museums at Harvard University, University of California, Berkeley, and Massachusetts Institute of Technology; and planetaria at North Carolina, Nevada, Michigan State, Arizona, and Troy State universities and at Triton, San Joaquin Delta, Otterbein, and Brevard Community colleges.

Since 1980, numerous campus museum buildings have been constructed or greatly expanded, with art museums being the greatest beneficiaries. Virtually all these buildings were funded with major donations from individuals. They included art museums at such universities as Harvard, Marquette, Notre Dame, Indiana, Emory, Rochester, Minnesota, Pennsylvania State, Brigham Young, Florida, Wyoming, Kansas State, and Washington, as well as at the Rhode Island School of Design, Kansas City Art Institute, and Vassar and Wellesley colleges.

This boom in university and college museum, gallery, and related facilities— which reached its height in the 1960s and 1970s—also has produced some concerns, as indicated in the following 1988 comments by Allen Rosenbaum, director of the Princeton University Art Museum:

Like their counterparts in the public sector, university and college museums have been drawn into a period of remarkable growth over the past two decades. And while this ''boom'' has brought with it many benefits, success has also exerted enormous pressures on museums as cultural, educational, and social institutions. Such pressures have strained and even distorted the fabric of and, at the same time, developed higher professional standards and practices.

Rosenbaum goes on to say that campus museums largely have become ''more conspicuous'' within the parent institution, as well as becoming more public institutions, often functioning as local community or regional museums. ''But the university is not always prepared for the museum to take on a complex life of its own as a more sophisticated professional organization, one no longer manageable by an active member of the faculty.''

In 1992, James Cuno, director of the Harvard University Art Museums, said he found himself, together with colleagues, ''facing a future not of seemingly unbridled growth as in the late '60s and early '70s, but of little or no growth and even retrenchment.''

## A CHANGE OF CLIMATE

Museums, galleries, and related facilities continue to be founded and expanded at universities and colleges—but the pace is being slowed considerably by economic conditions, tighter institutional budgets, and a lessening of support and role appreciation by university and college presidents and other administrators.

In 1986, three directors of campus museums—David Huntley of the University Museums at Southern Illinois University at Edwardsville, Lyndel King of what was then the University Art Museum at the University of Minnesota, and Tom Toperzer of the University of Oklahoma Museum of Art—conducted a survey of campus art museums and those museums with collections that included objects considered "art." They concluded that large and small museums share similar problems and that they are "walking the tightrope." As a safety net, they stated:

Our consensus is that we need to talk more to each other; we need to keep the lines of communication open. We each need to devote some time to sharing information with one another. We need to develop better networks for sharing exhibitions and publications. We need to band together to make our voices heard in ways that our presidents and vice presidents will understand.

Museums and similar facilities in other fields also are experiencing problems that threaten their collections, exhibits, programs, and other aspects of their operations and roles, as pointed out for many science museums at small institutions in 1988 by Ronald C. Wilson, who was director of the University of Northern Iowa Museum at the time:

Natural science museums at small universities contain significant collections often overlooked and undervalued by university administrators and by museum professionals. These museums are typically understaffed and inadequately funded and facilities are often substandard.

A 1993 survey of members of the State University of New York Gallery and Museum Association found conditions "pretty depressing," according to Janet B. Steck, who compiled the results:

In most instances, they reported that their programs are understaffed and underfunded, their facilities . . . are in failing condition and inadequately equipped, their programs are not perceived as being crucial . . . to the academic mission of their host institutions. . . . At the same time, they noted that, aside from doing more with less, they also are struggling to meet professional standards in regard to the care and management of objects and . . . feeling very frustrated when they fall short due to the lack of resources and appropriate support.

The author's survey of university and college museums, galleries, and similar facilities also showed that many are hurting—some institutions have closed, others are endangered, and most have pressing needs. Only 3 of the approximately 700 responding institutions indicated that they did not have any needs—the University of Georgia Museum of Natural History, Lora Robins Gallery of Design from Nature at the University of Richmond, and North Florida Junior College Art Gallery.

Among those that have closed permanently or indefinitely in recent years are the Howard University Museum and Sale Planetarium at Virginia Military Institute. The Horner Museum at Oregon State University was closed in 1993 for budgetary reasons and then reopened in 1994 as a result of campus and community pressure. A study is under way to determine its future. At Oklahoma State University, the administration is trying to close the Museum of Natural and Cultural History. In this case, the most pressing need is "survival," according to Tracy S. Carter, director.

Numbers of institutions have been affected by budgetary cutbacks. The Benedictine College Museum had to auction off or place on long-term loan some of its natural history collections and operate on an appointment-only basis; the Museum of Systematic Biology at the University of California, Irvine, has been forced to release part of its staff and change visiting hours to appointments; the University of Kentucky Museum of Anthropology had to discontinue guided tours for school groups; and the University of Arizona Museum of Art has suffered from three university budget cuts and the loss of personnel since 1990.

## THE MOST PRESSING NEEDS

University and college museums and similar facilities "deserve sufficient and consistent support in both word and deed," believes James Cuno of the Harvard University Art Museums.

Unfortunately, while this is clearly understood and even loudly championed by the leaders of some of our institutions, especially the president of my own, it is not sufficiently understood by others. Those who do not understand this look upon their museums and galleries as operational liabilities rich in fungible assets. This should not be the case. Now, more than one hundred years after the founding of the earliest college and university art museums, we are forced yet again to proclaim: yes, our collections are assets, but assets of a very specific, pedagogical kind. They are not just one "good" among many, but are vital components of the teaching and scholarly resources that comprise the very heart of the university or college itself. That, and nothing less.

The author's survey revealed that many museums, galleries, and related facilities are suffering from a lack of institutional commitment and/or support, as indicated in these comments about pressing needs:

The university wants us to be financially self-sufficient, so we need about $75,000 a year more than we now have. (*Carl Belz, director, Rose Art Museum, Brandeis University*)

[We need] some kind of commitment from the administration that we deserve support not only as a valuable teaching resource, but also as an excellent public relations gem in the University's relationship with the local community. (*Elizabeth Horn, curator, Princeton University Museum of Natural History*)

Our administration has never made a full-hearted commitment to the gallery and its programs [after mentioning the need for refurbishing, lighting, environmentally controlled storage, more secure funding, and more staff]. (*Janet B. Steck, director, Dowd Fine Arts Gallery, State University of New York College at Cortland*)

I believe that universities must think carefully before being dragged by consultants into in-vogue management strategies that purport to save a few dollars now but may have serious consequences later. Many consultants . . . recommend eliminating museums as "not central to the university's mission"—a short-sighted short term saving that is aborting the research material of the future. (*Lucy Skjelstad, director, Horner Museum, Oregon State University*)

Many museums, galleries, and related facilities have multiple needs, usually revolving around funds, space, and staff. Among the survey responses citing those needs were these:

Space, money, and additional staff. We have first-rate collections housed in second-rate facilities and exhibited in a third-rate hall. Staff is insufficient to carry out the mission effectively. (*Frank A. Norick, principal museum anthropologist, Phoebe A. Hearst Museum of Anthropology, University of California, Berkeley*)

More funding, more professional staff, and more space. (*Kenneth D. Perry, director, Museum of the Big Bend, Sul Ross State University*)

More storage space with temperature and humidity controls; more office space for staff; more money to increase staff to full time. (*Stephen L. Whittington, director, Hudson Museum, University of Maine*)

Increase in budget, space, and staff. (*Edgar Rasch, executive director, planning/research, Maryville University [for Morton May Gallery]*)

Additional funding—especially endowment funds—was given as the most pressing need by a majority of the survey respondents, including the Hofstra Museum at Hofstra University, U.S. Naval Academy Museum, Art Gallery at the University of Hawaii at Manoa, Cornell Plantations at Cornell University, Lafayette College Art Gallery, Red Butte Garden and Arboretum at the University of Utah, and Museum of Contemporary Photography at Columbia College Chicago.

Endowment funds are the principal need of such institutions as the Marianna Kistler Beach Museum of Art at Kansas State University, Core Arboretum at West Virginia University, Maxwell Museum of Anthropology at the University

of New Mexico, Jane Voorhees Zimmerli Art Museum at Rutgers University, University of Oregon Museum of Art, and University Gallery at the University of Massachusetts, Amherst.

Snow Entomological Museum at the University of Kansas wants endowment funds to provide "long-term, stable support for maintaining the curatorial condition and availability of the collection," curator James S. Ashe explained. At the University Art Museum and Pacific Film Archive at the University of California, Berkeley, the most pressing needs are "a substantially increased endowment so that we do not have to raise two-thirds of our budget each year" and increased funds for acquisitions and staffing, according to Laurie Kossoff, personnel analyst.

Space ranked next in the needs of campus museums, galleries, and similar facilities. "Space. Space. And money" are the greatest needs at Mulvane Art Museum at Washburn University, stated Donald Bartlett Doe, director. Karl L. Hutterer, director of the Thomas Burke Memorial Washington State Museum at the University of Washington, wants space for "galleries and expanding collections, laboratories, and educational programs." Peggy Kayser, administrator of the Skirball Museum at Hebrew Union College in Los Angeles, needs "more office, exhibit, and programming space."

Storage for collections, exhibits, and other purposes is one of the most frequently mentioned space needs. The Georgia Museum of Art at the University of Georgia wants additional storage space, as well as "a decent loading dock and doors that will accommodate large works," registrar Lynne Bowenkamp reported. The University of Michigan Museum of Anthropology needs "expanded storage facilities with improved environmental control," according to David Kennedy, collections manager. At Yeshiva University Museum, "expansion and renovation of storage facilities, including a receiving area and improvement of climate control," and a fund-raising program are the greatest needs, stated Randi Glickberg, administrator.

Among the other institutions where increased space is a pressing need are the Bayly Art Museum at the University of Virginia, Widener University Art Museum, Shrine to Music Museum at the University of South Dakota, Seton Hall University Museum, Collection of Historical Scientific Instruments at Harvard University, Mary Washington College Galleries, Utah Museum of Natural History at the University of Utah, University of Memphis Art Museum, Fleischmann Planetarium at the University of Nevada at Reno, and University of Kansas Natural History Museum.

Philip S. Humphrey, who oversaw the recent reorganization of the natural history museum at Kansas, said the museum's most urgent need is for 70,000 to 80,000 square feet of new space in close juxtaposition to its main facility (Dyche Hall) in order to centralize the staffs and collections of all units in the reorganized museum in one complex of closely adjacent facilities, provide adequate space for undergraduate and graduate students undertaking their degree work in association with museum faculty curators, reduce current crowding and

provide adequate space for rapidly growing systematics collections, and provide more adequate space for the public education and exhibits programs.

Some museums and similar facilities occupy spaces that are so inadequate that they list a new building as the top priority. They include the Iris and B. Gerald Cantor Art Gallery at the College of the Holy Cross, University of Illinois Museum of Natural History, Kelsey Museum of Archaeology at the University of Michigan, and Confederate Research Center Museum at Hill College.

Staffing is the third most pressing need among museums, galleries, and related facilities, based on survey results. Many institutions want full-time staffing; others require additional personnel; some give personnel and better pay as prime needs.

A large number of museums and similar facilities are still operating with part-time directors and/or staff members. The Harry Wood Art Gallery at Arizona State University and the Parkland College Art Gallery, for instance, would like to convert their half-time directors to full-time and add more staffing. The Louden-Henritze Archaeology Museum at Trinidad State Junior College lists a full-time director (as well as conservation practices and exhibit expansion) as its most pressing needs. At the Wilbur Greeley Burroughs Geologic Museum at Berea College, curator Z.L. Lipchinsky needs ''full-time help and the money to pay for it!'' Judith Tolnick, director of the Fine Arts Center Galleries at the University of Rhode Island, is seeking a ''full-time professional staff and budget stability.''

A shortage of time is a major obstacle at many other institutions, including the Goshen College Art Gallery, where the director needs more time ''to do what she should do,'' and the Robert Hull Fleming Museum at the University of Vermont, which gives ''increased professional staff time for key positions'' as its first priority.

The MIT Museum at the Massachusetts Institute of Technology needs institutional funding for many key curators who now must depend upon grants. Among those museums and other facilities with more staff as the most pressing need are the Schumacher Gallery at Capital University, I.P. Stanback Museum and Planetarium at South Carolina State University, Palmer Museum of Art at Pennsylvania State University, Greene-Nieuwland Herbarium at the University of Notre Dame, and Oliver Art Center at the California College of Arts and Crafts.

Some institutions list specific positions that need to be funded, such as education professional and volunteer coordinator at the University of Memphis Art Museum; full-time curator, conservator, collections manager, development officer, and various support personnel at the Museum of Peoples and Cultures at Brigham Young University; and full-time computer programmer, conservator, and exhibits and public education personnel at the University of Kansas Natural History Museum.

Among the other personnel-related needs reported in the survey were pay equity (in addition to space and personnel) at the Utah Museum of Natural

History at the University of Utah; more and better-compensated staff (plus more work/storage space, better climate controls, a development program, and written policies and procedures) at the Mitchell Indian Museum at Kendall College; and staff development at the Montgomery Gallery at Pomona College, Southwestern Michigan College Museum, and Sheldon Memorial Art Gallery and Sculpture Garden at the University of Nebraska–Lincoln.

## COLLECTION, EXHIBIT, AND PROGRAM NEEDS

Many campus museums, galleries, and related facilities need improvements in collections, exhibits, and/or public programs, according to responses to the author's survey of pressing needs.

In collections, the needs range from acquisitions and computerization to better conservation and storage. Among those institutions giving priority to expanding their collections are the Seton Hall University Museum, Center for Creative Photography at the University of Arizona, University of the Pacific Herbarium, Palmer Museum of Art at Pennsylvania State University, and Founders Gallery at the University of San Diego, which also needs to do more research on its permanent collection.

The Fine Arts Galleries at the University of Arkansas at Little Rock have two priorities—photographic documentation of the permanent collection and computerization of the permanent collection records. The Orton Geological Museum at Ohio State University would like to computerize its cataloging system, while the Schumacher Gallery at Capital University has targeted computerization, preservation, and improved registration procedures (as well as staffing and security) as its greatest needs. The Museum at F.I.T. at the Fashion Institute of Technology needs to do an inventory and put its collections onto a collections management database, while the University of Northern Iowa Gallery of Art lists the development of collection management policies among its needs.

Conservation is the most pressing need at such institutions as the Indiana University Art Museum, University of Maine Museum of Art, and University of Pennsylvania Museum of Archaeology and Anthropology, which would like to fund and implement a major conservation program that would include preventive conservation of collections and a buildingwide renovation of the heating, ventilating, and air cooling systems.

Improved climate control is among the greatest needs at many museums and similar facilities, including the University of New Hampshire Art Gallery, Western New Mexico University Museum, Peabody Museum of Archaeology and Ethnology at Harvard University, Lewis B. Hershey Museum at Tri-State University, Birks Museum at Milliken University, Bayly Art Museum at the University of Virginia, and Robert Hull Fleming Museum at the University of Vermont.

The most pressing need at the Peabody Museum of Natural History at Yale University is "to rehouse the collections under conditions that ensure their pres-

ervation and security while improving access to them for research and teaching," stated its director, Alison F. Richard. The Harvard University Art Museums' primary needs are "renovation and climate control of the Fogg building," Frances Beane, deputy director, explained. At the Yale University Art Gallery, the need is for "renovation of storerooms, stabilization of the environment, and computerization of the collections," according to John McDonald, associate director.

In the exhibit area, the primary needs include renovation of existing exhibits, installation of new exhibits, funds for temporary and traveling exhibitions, additional space, and such basic equipment as exhibit cases.

Among those institutions that include renovation of exhibits among their needs are the University of Nebraska State Museum, Western New Mexico University Museum, and Evergreen House at Johns Hopkins University, where the gardens need to be restored. Exhibit cases are being sought by the Museum of Early Philosophical Apparatus at Transylvania University, Tech Museum at Louisiana Tech University, and Miles Mineral Museum at Eastern New Mexico University.

Funds for new exhibits and/or temporary and traveling exhibitions are needed at the Patrick and Beatrice Haggerty Museum of Art at Marquette University, Birks Museum at Millikin University, Palmer Museum of Art at Pennsylvania State University, and MIT Museum at the Massachusetts Institute of Technology, where the institute does not fund exhibitions or programs. At the Visual Arts Gallery at the University of Alabama at Birmingham, the most pressing needs are more staffing, funding for temporary exhibitions, and expansion of exhibit, preparation, and storage areas. More exhibition space also is needed at the Museum of Art at Bates College and the University of Kentucky Art Museum.

Some museums and similar facilities consider greater funding for public programming—and especially outreach activities—among their principal needs, including the Michell Art Gallery at Saint John's College, Nichols Arboretum at the University of Michigan, West Point Museum at the U.S. Military Academy, Conner Prairie at Earlham College, Krannert Art Museum and Kinkead Pavilion at the University of Illinois at Urbana-Champaign, and Museum of Peoples and Cultures at Brigham Young University.

At the University of California, Berkeley, the Lawrence Hall of Science needs "on-going financial support for public programs and exhibitions," stated Barbara Ando, director of public programs. Gary F. Edson, executive director of the Museum of Texas Tech University, pinpointed his museum's main needs as additional outreach and targeted programming (as well as more personnel and storage space).

## MARKETING AND OTHER NEEDS

University and college museums, galleries, and similar facilities have many other needs, such as master and strategic plans, building improvements, modern

equipment, better security, longer public hours, more parking, improved marketing, and increased attendance.

The University of Alabama Arboretum would like to have a master plan, as well as more funding and personnel; the Connecticut College Arboretum is seeking support for programmatic and landscape master planning, in addition to a full-time volunteer coordinator; and the University of Northern Iowa Gallery of Art has need for strategic planning, staffing, and collection management policies.

The Smith College Museum of Art needs such building improvements as greater accessibility for the disabled and a public elevator. At Glensheen at the University of Minnesota, Duluth, roof replacement and house repairs are among the most pressing needs.

Many planetaria, including the Carr-Fles Planetarium at Muskegon Community College and the Robert J. Novins Planetarium at Ocean County College, list new instruments for sky and related shows as their first priority.

Among those institutions that want more funding of security personnel—usually to permit the museum to be open for longer hours—are the Indiana University Art Museum and the Smith College Museum of Art.

More parking is of greatest need at such museums and galleries as the University of Kentucky Art Museum, University of New Hampshire Art Gallery, Wrather West Kentucky Museum at Murray State University, Jonson Gallery at the University of New Mexico, and Goldstein Gallery at the University of Minnesota, Twin Cities.

An increasing number of institutions see one of their most pressing needs as more visibility and better marketing—hopefully resulting in greater service, attendance, and revenues. The Williams College Museum of Art is one of those seeking "to strengthen efforts to serve the needs of the Museum's public and attract new audiences," according to Marion Goethals, assistant director.

Among the others emphasizing marketing and attendance are the Samuel P. Harn Museum of Art at the University of Florida, Anderson Gallery at Virginia Commonwealth University, Davis Art Gallery at Stephens College, Fine Arts Gallery at Valdosta State University, and California Museum of Photography at the University of California, Riverside.

As was pointed out in a *Museum News* article by contributing editor Tracey Linton Craig in 1988,

museums on campuses across the country have been reaching out to whole new audiences. No longer simply a quiet corner on campus for contemplation or seldom-used teaching resource, museums of both private and public universities and colleges have launched major efforts to offer programming that draws in children, teenagers, adults, and seniors, as well as the handicapped and those who have recently immigrated.

In addition to programming, many museums and similar facilities have marketing, public relations, and/or publications people to send out news releases, produce publications, conduct direct mailings, place advertisements, arrange spe-

cial events, and publicize major donations, building expansions, new collections, research results, exhibit openings, membership activities, fund-raising campaigns, and other efforts to increase visibility, attendance, and support. And when the museums and other museum-like facilities do not have such specialists on their staffs, they often make use of students, volunteers, or university and college offices in those areas.

## NEED FOR SELF-EXAMINATION

What does the future hold for campus museums, galleries, and related facilities? It is difficult to develop a definite path because of the many variables. As Hdiko Heffernan, former director of the Robert Hull Fleming Museum at the University of Vermont, pointed out, ''There are more questions than answers,'' adding that

the basic issues have emerged. Whatever the specific situation, each university museum needs to struggle to redefine its philosophy, its function, its structure, and to solidify its financial base. Each of these areas influences daily operations, and the viability of each campus museum depends upon addressing and resolving these issues.

To resolve such issues, as Heffernan states, it is necessary to begin a process of self-examination—something that an increasing number of museums and similar facilities are undertaking, frequently with grant funds. Such studies can show that a campus museum, gallery, or other facility is not fulfilling its original purpose or a need—in teaching, conducting research, or serving the public—and should be dissolved. Other times the results may indicate that a change in mission or a reorganization is necessary; collections, research, exhibits, programs, facilities, staffing, and/or some other aspect should be strengthened or modified; faculty and/or student involvement should be increased, decreased, or changed in some way; institutional governance, policies, and/or support should be reexamined; greater emphasis should be placed on increasing the attendance, membership, contributions, and/or earned income; new leadership is required; and other such actions that can affect the operations and direction of the facility should be taken.

A self-examination—whether done internally or by a consultant or a campus, peer, or advisory group—certainly would be helpful, but it frequently requires more than studies to bring about change to museums, galleries, and related facilities at universities and colleges. Many museums and similar facilities are underfunded, understaffed, underutilized, and/or underappreciated—and the future is less than encouraging.

Major changes are taking place in society and on the campus—in the composition of the population and student body, government and institutional funding, economic conditions, job market, role of educational and cultural institutions, public expectations, and many other factors. It is becoming more

difficult for universities and colleges to fund activities that are not considered essential to their purposes.

This means that museums and similar facilities must be much more active and effective in convincing academic departments and administrators, institutional presidents and governing boards, faculty members, students, taxpayers, potential donors, and others that they deserve the support necessary to meet the pressing needs mentioned earlier.

## CONFRONTING THE FUTURE

Most campus museums, galleries, and related facilities can do more—often with little or no additional personnel or funding—to satisfy some needs, such as developing a mission statement, operating policies and procedures, goals and strategic plans, collection policies, visitor surveys, evaluation studies, better marketing, and improved relations with academic departments. These are actions that are within the grasp of directors and staff members and that would be extremely useful in improving operations and demonstrating that the facility is viable and being run professionally.

It also should be possible to benefit through informal or formal cooperation with other campus and community museums, galleries, and similar facilities; collaboration on joint programming, traveling exhibitions, and marketing efforts; and formation of advisory committees and support groups, such as volunteer, membership, and friends organizations.

In many instances, museums, galleries, and related facilities need to review their collections, exhibits, and programs to make certain they are serving the needs of the university or college, related academic programs, the professional field, and the campus, community, and other targeted visitors. Some museums and similar facilities need to have a better focus or quality in their collections; improved educational and research opportunities for faculty, students, and visiting scholars; contributions to the advancement of knowledge in their fields; and/or exhibits and programs of greater interest and value to the visiting public.

The key to many problems is increased funding, especially as more universities and colleges cut back in their support. Museums and similar facilities are being asked—and sometimes forced—to seek more funds through donations and grants from outside sources and to produce more earned income from admissions, memberships, publications, gift store and restaurant sales, education program fees, rentals, and other such activities. Although it is not always possible to generate more contributions and earned income with a small facility, staff, and/or budget, greater effort needs to be made in such areas. Assistance often is available through university and college development, public relations, marketing, and other offices and from individuals, companies, and support groups interested in the field or institution.

Many campus museums, galleries, and related facilities have much to offer to the visiting public, but do relatively little to increase their visibility and at-

tendance. Better marketing could have a substantial impact on the number of visitors and thus on admissions revenues. These efforts can be as minimal as issuing announcements, news releases, and/or posters on new exhibitions and programs or as comprehensive as direct mail, newsletters, press conferences, feature stories, paid advertising, special events, and tie-in sponsorship and promotion.

All of the foregoing affect the image of a museum or similar facility—and how it is perceived, appreciated, and supported by the academic community and the general public. They also make it possible to convince the university or college administration, president, and governing board that the museum, gallery, or other facility is essential to the institution and should receive continued or increased funding, have its own staff, play a greater role in instructional and research programs, report to some other office, or have whatever its desired objectives and needs are met.

Campus museums, galleries, and related facilities can do more to help shape their own future, as some have demonstrated with imaginative leadership, revitalized offerings, better marketing, and greater efforts to find funds for improved facilities, expanded collections, more-adequate and better-compensated staffs, and other pressing needs in a period of increasing retrenchment. To do otherwise could mean disaster for some museums and similar facilities and the loss of invaluable campus and cultural resources—many of which are irreplaceable.

# Directory of University and College Museums, Galleries, and Related Facilities

# Agricultural Museums

*Also see Botanical Gardens, Arboreta, and Herbaria and Historical Museums, Houses, and Sites sections.*

## BAYLOR UNIVERSITY
### *Governor Bill and Vara Daniel Historic Village (Strecker Museum)*

(See Natural History Museums and Centers section.)

## BETHEL COLLEGE
### *Kauffman Museum*

(See Archaeology, Anthropology, and Ethnology Museums section.)

## EARLHAM COLLEGE
### *Conner Prairie*

(See Historical Museums, Houses, and Sites section.)

## FERRUM COLLEGE
### *Blue Ridge Institute Farm Museum and Galleries*

The Blue Ridge Institute at Ferrum College in Ferrum, Virginia, seeks to further understanding of the region's history and folklife through study, research,

exhibits, and public programs. Two of its exhibit-oriented facilities are the Blue Ridge Institute Farm Museum and the Blue Ridge Institute Galleries.

The farm museum consists of two re-created farmsteads that illustrate a century of change in the life, architecture, decorative arts, household labor, crafts, and agriculture of German-American settlers in the Blue Ridge Mountains between 1800 and 1900. Costumed interpreters carry out household and farm chores of the two periods.

The institute also has two exhibit galleries dedicated to the presentation of traditional culture. The Jessie Ball du Pont Fund Gallery houses long-term exhibits of folk art and material culture, while the adjacent King Gallery presents smaller rotating exhibitions on the region's folklife.

The Blue Ridge Heritage Archive is the institute's repository for materials related to the history and folklife of Virginia's western Blue Ridge and the state as a whole.

Blue Ridge Institute Farm Museum and Galleries, Ferrum College, Rte. 40, Ferrum, VA 24088-4416. Phone: 703/365-4416. Hours: museum—10–4 Mon.–Sat.; 1–4 Sun. from mid-May through mid-August; closed holidays. Galleries—10–4 Mon.–Sat.; 1–4 Sun. from mid-May through mid-August. Admission: museum—adults, $3; seniors and children 6–15, $2; children under 6, free; galleries—free.

## IOWA STATE UNIVERSITY
### Farm House Museum

The Farm House Museum building is where Iowa State University and its model farm were founded. Located on what is now the central campus, the structure was constructed in 1860 and then restored and opened as a museum in 1975. Furnished in the late Victorian style of 1860–1910, the farm house now is a National Historic Landmark. It is part of the University Museums structure at the university.

Farm House Museum, Iowa State University, Central Campus, 290 Scheman Bldg., Ames, IA 50011. Phone: 515/294-3342. Hours: 11–4 Mon.–Fri.; 1–4 Sat.–Sun.; closed major holidays. Admission: free.

## LOUISIANA STATE UNIVERSITY
### LSU Rural Life Museum

The life styles and cultures of pre-industrial Louisianians are recalled in the LSU Rural Life Museum, located on the Burden Research Plantation, a 450-acre agricultural research experiment station operated by Louisiana State University's Agricultural Center in Baton Rouge.

The outdoor folk museum, which spreads over five acres and includes more than 20 buildings, has extensive collections of tools, household utensils, furniture, and farming implements—many of which are displayed in the original buildings in which rural craftsmen and laborers lived and worked.

The museum was founded in 1970 by the Burden family, which included several long-time employees of the university. It began with a search for a building to house a limited number of artifacts related to eighteenth- and nineteenth-century rural life of Louisiana. From that modest beginning, the museum expanded into a major museum as other buildings and materials have been moved to the site, located five miles from the main LSU campus in Baton Rouge.

The museum is divided into three areas: the Barn, which contains hundreds of artifacts dealing with everyday rural life dating from prehistoric times to the early twentieth century; the Working Plantation, consisting of a complex of buildings (commissary, overseer's house, kitchen, slave cabins, sick house, schoolhouse, blacksmith's shop, sugar house, and grist mill) furnished to reconstruct major activities of life on a typical nineteenth-century working plantation; and Folk Architecture, as exemplified in seven buildings (country church, pioneer's cabin and corncrib, potato house, shotgun house, Acadian house, and dogtrot house) whose divergent construction traits illustrate the various cultures of Louisiana settlers.

Adjacent to the museum are the Burden home and Windrush Gardens, donated separately to the university in 1972 by Ione Burden and her brother, Steele Burden. The five-acre area, containing semiformal gardens with winding paths, includes crepe myrtles, azaleas, camellias, and other plants representative of varieties used in nineteenth-century plantation gardens. The gardens were designed and planted by Mr. Burden.

LSU Rural Life Museum, Louisiana State University, Essen Lane at Interstate 10 (mailing address: 6200 Burden Lane), Baton Rouge, LA 70808. Phone: 504/765-2437. Hours: 8:30 –4 Mon.–Fri.; 9:30–4:30 Sat. (seasonal); closed holidays. Admission: adults, $3; children under 12, $2.

## LOUISIANA STATE UNIVERSITY IN SHREVEPORT
### *Pioneer Heritage Center*

(See Historical Museums, Houses, and Sites section.)

## MICHIGAN STATE UNIVERSITY
### *Kellogg Farm Dairy Center (W.K. Kellogg Biological Station)*

(See Natural History Museums and Centers section.)

## NORTH CAROLINA STATE UNIVERSITY
### *Chinqua-Penn Plantation*

(See Historical Museums, Houses, and Sites section.)

## PENNSYLVANIA STATE UNIVERSITY

Pennsylvania State University in University Park has three agriculturally oriented museums—the Pasto Agricultural Museum, Clark Kerr Apple Variety Museum, and Mascaro/Steiniger Turfgrass Museum.

### Pasto Agricultural Museum

The Pasto Agricultural Museum at Pennsylvania State University's Larson Agricultural Research Center in Rock Springs houses approximately 300 farm and household items dating back to the 1840s. The museum's collection, which began in 1975, can be seen only during the three-day Ag Progress Days trade fair in August and by appointment.

Pasto Agricultural Museum, Pennsylvania State University, Larson Agricultural Research Center, Rock Springs, PA 16865. Phone: 814/865-2541. Hours: 9–5 during Aug. trade fair and by appointment. Admission: free.

### Clark Kerr Apple Variety Museum

Fifty unusual varieties of living apple trees are featured at the College of Agriculture's Clark Kerr Apple Variety Museum at Pennsylvania State University in University Park.

Clark Kerr Apple Variety Museum, Pennsylvania State University, College of Agriculture, 7 Tyson Bldg., University Park, PA 16802. Phone: 814/805-7699. Hours: varies. Admission: free.

### Mascaro/Steiniger Turfgrass Museum

The Mascaro/Steiniger Turfgrass Museum opened in 1994 at Pennsylvania State University in University Park. The 2,800-square-foot museum, part of the Department of Agronomy, features lawn equipment used by professional turf managers. Among the collections and exhibits are such varied items as a horse-drawn soil scoop used to construct a major golf course, a special rake to pick up unsightly dirt trails left by worms without hurting the creatures, and an old tractor similar to the one used by Arnold Palmer in television commercials.

Mascaro/Steiniger Turfgrass Museum, Pennsylvania State University, Dept. of Agronomy, College of Agricultural Sciences, University Park, PA 16802. Phone: 814/865-3970. Hours: 8:30–5 Mon.–Fri.; closed holidays. Admission: free.

## RUTGERS UNIVERSITY
### New Jersey Museum of Agriculture

(See Unaffiliated Museums section.)

## SOUTH DAKOTA STATE UNIVERSITY
### State Agricultural Heritage Museum

(See Unaffiliated Museums section.)

## SWEET BRIAR COLLEGE
### *Sweet Briar Museum*

(See Historical Museums, Houses, and Sites section.)

## TEXAS TECH UNIVERSITY
### *Ranching Heritage Center (Museum of Texas Tech University)*

(See General Museums section.)

## TUSKEGEE UNIVERSITY
### *George Washington Carver Museum*

(See Unaffiliated Museums section.)

## UNIVERSITY OF TEXAS AT AUSTIN
### *Winedale Historical Center*

(See Historical Museums, Houses, and Sites section.)

## UTAH STATE UNIVERSITY
### *Ronald V. Jensen Living Historical Farm*

The Ronald V. Jensen Living Historical Farm in Wellsville, Utah, is an outdoor history museum operated by Utah State University. The 120-acre farm tells the story of agriculture and the role of the university's extension program in assisting farmers in Cache Valley during the World War I era.

The living history museum, founded in 1971, is located at a restored 1917 farm with seven historic buildings (one original from the site, two moved to the site, and four reconstructions). Among the collections are farm implements, wagons, household items, textiles, and other items from the period. The farm also has workhorses, dairy cows, sheep, hogs, poultry, and heritage crops.

Ronald V. Jensen Living Historical Farm, Utah State University, 4025 S. Hwy. 89191, Wellsville, UT 84339-0710. Phone: 801/245-4064. Hours: 10–4 Mon.–Sat. Admission: adults, $2; seniors and university students, $1; children, 50¢.

## VIRGINIA POLYTECHNIC INSTITUTE AND STATE UNIVERSITY
### *Cyrus H. McCormick Memorial Museum*

The Cyrus H. McCormick Memorial Museum is located on the McCormick Farm in Steeles Tavern, Virginia, where the first successful reaping machine— which revolutionized grain harvesting—was developed in 1831. The farm, given

to Virginia Polytechnic Institute and State University by the McCormick family in 1953, now is primarily an agricultural research station.

The museum tells the story of the invention of the McCormick reaper and the history of grain harvesting by machines. It contains a reproduction of the first mechanical grain reaper, models of early grain reapers and mowers, and various related exhibits. The museum also has a ca. 1800 grist mill and a blacksmith shop.

Cyrus H. McCormick Memorial Museum, Virginia Polytechnic Institute and State University, McCormick Farm, Steeles Tavern, VA 24476. Phone: 703/377-2255. Hours: 8–5 daily. Admission: free.

### American Work Horse Museum

The American Work Horse Museum in Paeonian Springs, Virginia, is operated by the College of Agriculture and Life Sciences at Virginia Polytechnic Institute and State University. The museum traces the history of workhorses from 1493 to the present and contains horse-drawn implements, harnesses, blacksmith items, veterinary materials, and other such objects. It was founded in 1971.

American Work Horse Museum, Virginia Polytechnic Institute and State University, PO Box 88, Paeonian Springs, VA 22129. Phone: 703/338-6290. Hours: Apr.–Oct.—9–5 Wed.; other times by appointment. Admission: free.

### Reynolds Homestead

(See Historical Museums, Houses, and Sites section.)

## WEST TEXAS A&M UNIVERSITY
### Panhandle-Plains Historical Museum and T-Anchor Ranch House

(See Historical Museums, Houses, and Sites section.)

# Archaeology, Anthropology, and Ethnology Museums

*Also see Art Museums; Historical Museums, Houses, and Sites; and Natural History Museums and Centers sections.*

## ADAMS STATE COLLEGE
### *Luther E. Bean Museum*

(See General Museums section.)

## ANDERSON UNIVERSITY
### *Gustav Jeeninga Museum of Bible and Near Eastern Studies*

(See Religious Museums section.)

## ANDREWS UNIVERSITY
### *Siegfried H. Horn Archaeological Museum*

The Siegfried H. Horn Archaeological Museum, founded in 1970 at Andrews University in Berrien Springs, Michigan, has collections and exhibits of pottery, tools, textiles, coins, weapons, papyril, and tablets resulting from excavations in the Middle East.

Siegfried H. Horn Archaeological Museum, Andrews University, Berrien Springs, MI 49104. Phone: 616/471-3273. Hours: 9–5 Tues.–Thurs.; 2–5 Sat.–Sun.; closed summer and major holidays. Admission: free.

## ARIZONA STATE UNIVERSITY
### Museum of Anthropology

The Arizona State University Museum of Anthropology in Tempe is primarily a laboratory for graduate students in the museum studies program. It has archaeological, ethnological, and anthropological collections and feature in-house and traveling exhibitions, with temporary exhibits changing as student projects develop. Founded in 1983, the museum is located in a historic register building with the Department of Anthropology.

Museum of Anthropology, Arizona State University, Tempe, AZ 85287-2402. Phone: 602/965-6213. Hours: 9–5 Mon.–Fri.; closed holidays. Admission: free.

### Deer Valley Rock Art Center

The Deer Valley Rock Art Center is a new museum-like information center developed by the Arizona State University Department of Anthropology in collaboration with the U.S. Army Corps of Engineers next to the Adobe Dam flood-control facility in northwest Phoenix. The 7,000-square-foot center, which seeks to show the conjunction of modern work and petroglyphs, resulted from archaeological findings during the dam construction. The rock art is located adjacent to the center.

Deer Valley Rock Art Center, Arizona State University, Dept. of Anthropology, Tempe, AZ 85287-2402. Phone: 602/965-0102. Hours: 8 A.M.–12 noon selected weekdays; 8–5 Sat.–Sun.; closed holidays. Admission: adults, $2.

## AURORA UNIVERSITY
### Schingoethe Center for Native American Cultures

Native American art and cultural materials from prehistoric times to the present are featured at the Schingoethe Center for Native American Cultures, founded in 1989 at Aurora University in Aurora, Illinois. The center's collections include art and cultural materials of North, Central, and South American native peoples. In addition to displaying such artworks and materials, the center presents arts and crafts demonstrations, art festivals, a spring powwow, and an invitational show.

Schingoethe Center for Native American Cultures, Aurora University, Dunham Hall, 347 S. Gladstone, Aurora, IL 60506-4892. Phone: 708/844-5402. Hours: 10–4:30 Mon.–Tues. and Thurs.–Fri.; 1–4 Sun.; closed holidays and Christmas week. Admission: free.

## BACONE COLLEGE
### Ataloa Lodge Museum

The Ataloa Lodge Museum at Bacone College in Muskogee, Oklahoma, was founded in 1932 with Native American art and artifacts donated by staff mem-

bers, students, and their families so that students could preserve their tribal heritage while at college.

The museum, housed in a building patterned after an old hunting lodge, contains permanent exhibits of art and artifacts from throughout North America, as well as some native materials from Central and South America. The collections include San Ildefonso pottery by Maria Martinez, one of the largest collections of kachina dolls, and a land grant signed by Abraham Lincoln.

Ataloa Lodge Museum, Bacone College, 2299 Old Bacone Rd., Muskogee, OK 74403-1597. Phone: 918/683-4581. Hours: 10–12 and 1–4 Mon.–Sat. Admission: free.

## BELOIT COLLEGE
### Logan Museum of Anthropology

The Logan Museum of Anthropology is one of two museums (the other being the Wright Museum of Art) that constitute the Museums of Beloit College in Beloit, Wisconsin. They basically are teaching museums that provide opportunities for Beloit students to learn and work in a professional environment. Students work with the professional staff in every aspect of the operations, including researching collections, designing and installing exhibits, and planning and implementing programs for the community.

The Logan Museum was founded in 1894 with Frank G. Logan's gift of North American Indian materials collected by Horatio N. Rust, who served as an Indian agent in California. This gift of nearly 3,000 artifacts was added to the college's earlier cabinet collection of natural history specimens. Since then, the collections have grown to over 250,000 artifacts.

Among the strengths of the museum's archaeological and ethnographic collections are European and North African paleolithic and neolithic artifacts and the material culture of pre-Columbian and historic North and South American Indians. The museum also has rare aboriginal materials from Japan, Indonesia, Polynesia, Taiwan, and North Africa.

The museum occupies three floors of the 1867 Memorial Hall and part of the attached Anthropology Building. Changing exhibitions, many curated by students, are presented in Memorial Hall.

Logan Museum of Anthropology, Beloit College, Memorial Hall, 700 College St., Beloit, WI 53511. Phone: 608/363-2677. Hours: 11–4 daily; closed holidays and when college not in session. Admission: free.

## BETHEL COLLEGE
### Kauffman Museum

Mennonite cultural history, natural history, and prairie ecology are the focus of the Kauffman Museum at Bethel College in North Newton, Kansas. The museum had its beginnings in South Dakota in 1896 when Charles Kauffman, a farmer and teacher, began collecting Mennonite historical materials and natural

history specimens and practicing taxidermy. He later moved his collections to Bethel College, where they were combined with college collections to form the museum, which opened in 1941.

The museum, currently located in a building erected in the 1980s for the museum, also has four historic buildings moved to the site to re-create a Mennonite farmstead, as well as a tall grass prairie reconstruction plot. The museum's collection now includes approximately 40,000 items pertaining to the natural and cultural history of the Central Plains, Euro-America, Asia, South America, and Africa.

Kauffman Museum, Bethel College, North Newton, KS 67117-9989. Phone: 316/283-1612. Hours: 9:30–4:30 Tues.–Fri.; 1:30–4:30 Sat.–Sun.; closed holidays. Admission: adults, $2; children 6–16, $1.

## BOWDOIN COLLEGE
### Peary-Macmillan Arctic Museum

The Peary-Macmillan Arctic Museum at Bowdoin College in Brunswick, Maine, has collections, exhibits, and archives relating to the exploration, archaeology, anthropology, and ecology of the Arctic region. They include exploration and nautical equipment, prehistoric and historic Inuit artifacts, contemporary Inuit arts and crafts, Arctic flora and fauna, and a photographic collection. The museum, located in Hubbard Hall, was founded in 1967.

Peary-Macmillan Arctic Museum, Bowdoin College, Hubbard Hall, Brunswick, ME 04011. Phone: 207/725-3416. Hours: 10–5 Tues.–Sat.; 2–5 Sun.; closed holidays. Admission: free.

## BRANDEIS UNIVERSITY
### American Jewish Historical Society

(See Unaffiliated Museums section.)

## BRIGHAM YOUNG UNIVERSITY
### Museum of Peoples and Cultures

The Museum of Peoples and Cultures at Brigham Young University in Provo, Utah, began as the Museum of Archaeology and Ethnology in 1961, acquiring its present name and mission in 1980 when it expanded and moved into Allen Hall. Recently, the museum obtained additional exhibition and storage space in the Museum of Art's new state-of-the-art facility.

The museum has more than 100,000 archaeological, anthropological, and ethnographic objects in its collections. Approximately 60 percent were amassed through excavation and have research significance. The most notable materials are artifacts from the Great Basin and Mesoamerica. The museum is strong in ethnographic and prehistoric collections from the American Southwest, Casas

Grandes, Peru, and Polynesia. Exhibits are concerned with prehistoric and ethnographic cultures, including Hohokam, Fremont, Anasazi, Mogollon, Casas Grandes, Maya, Polynesia, Egypt, and the Near East.

Museum of Peoples and Cultures, Brigham Young University, 105 Allen Hall, Provo, UT 84602. Phone: 801/378-6112. Hours: 9–5 Mon.–Fri.; closed holidays and when university not in session. Admission: free.

## BROWN UNIVERSITY
### Haffenreffer Museum of Anthropology

The Haffenreffer Museum of Anthropology at Brown University is located on the shores of Mount Hope Bay in Bristol, Rhode Island, surrounded by 400 acres of woodland. The museum's three galleries present cultural interpretations of native peoples of North, Central, and South America and the traditional arts of Africa, Asia, the Middle East, and Oceania. The museum's collection of more than 100,000 items includes textiles, art, and other ethnographic materials.

Founded as the private museum of Rudolf F. Haffenreffer, the museum and surrounding property were donated to the university upon his death in 1955. The museum grounds are said to be the site of a meeting between Massasoit, sachem of the Wampanoag tribe, and a group from Plimoth Plantation in 1621. It also was at a spring near the museum that Matacomet, Massasoit's son (called King Philip by the English), was killed in 1676, ending the King Philip War.

Haffenreffer Museum of Anthropology, Brown University, Mt. Hope Grant, Bristol, RI 02809-4050. Phone: 401/253-8388. Hours: June–Aug.—10–5 Tues.–Sun.; Mar.–May and Sept.–Dec.—10–5 Sat.–Sun. Admission: adults, $2; seniors and children, $1; Brown University students and faculty, free.

## CALIFORNIA STATE UNIVERSITY, CHICO
### Museum of Anthropology

Archaeological and ethnographic materials from around the world, with emphasis on California prehistory and history, are offered by the Museum of Anthropology at California State University, Chico. The museum, founded in 1969, has a 1,000-square-foot exhibit space.

Museum of Anthropology, California State University, Chico, Dept. of Anthropology, Chico, CA 95929. Phone: 916/898-6192. Hours: 8–5 Mon.–Fri.; closed Jan.–May and holidays. Admission: free.

## CALIFORNIA STATE UNIVERSITY, FULLERTON
### Museum of Anthropology

The Museum of Anthropology at California State University, Fullerton, has a small exhibition area, but extensive collections that include prehistoric artifacts from southern California, the Southwest, and the Midwest; ethnographic speci-

mens from the South Pacific, Near East, Mexico, and South America; and faunal, mineral, and sherd comparative materials. The museum was founded in 1970. Museum of Anthropology, California State University, Fullerton, Fullerton, CA 92634. Phone: 714/773-3626. Hours: academic year—12–6 Mon.–Fri.; 2–5 Sun.; summer—1– 5 Mon.–Fri.; closed vacations. Admission: free.

## CALIFORNIA STATE UNIVERSITY, HAYWARD
### C.E. Smith Museum of Anthropology

Native American artifacts are featured at the C.E. Smith Museum of Anthropology, founded in 1975 at California State University, Hayward. The museum has collections of kachinas and other Southwest artifacts, California Indian baskets, Plains Indians materials, African art, Philippine artifacts, and photographs. C.E. Smith Museum of Anthropology, California State University, Hayward, Hayward, CA 94542. Phone: 510/881-7414. Hours: 10–4 Mon.; 10 A.M.–12 noon Wed.; 10–2 Fri.; closed holidays. Admission: free.

## CENTRAL MICHIGAN UNIVERSITY
### Center for Cultural and Natural History

(See General Museums section.)

## CENTRAL WASHINGTON UNIVERSITY
### Anthropology Museum

The Anthropology Museum at Central Washington University in Ellensburg has a collection of over 2,500 ethnographic materials from New Guinea, the San Blas Islands, Panama, Africa, and the Western Plateau, Southwest, and Northwest Coast of the United States. Founded in 1972, the museum presents rotating exhibitions from its collections. It is located in Farrell Hall with the Department of Anthropology. Anthropology Museum, Central Washington University, Dept. of Anthropology, Farrell Hall, Ellensburg, WA 98920. Phone: 509/963-3201. Hours: by appointment; closed Aug. and holidays. Admission: free.

## COLLEGE OF CHARLESTON
### Avery Research Center for African American History and Culture

(See Historical Museums, Houses, and Sites section.)

## COLLEGE OF EASTERN UTAH
### College of Eastern Utah Prehistoric Museum

(See Geology, Mineralogy, and Paleontology Museums section.)

## COLLEGE OF SOUTHERN IDAHO
### Herrett Museum

The Herrett Museum at the College of Southern Idaho in Twin Falls is a combination archaeological, anthropological, and ethnological museum based largely on artifacts of North, Central, and South American Indians collected by Norman and Lillie Herrett.

Mr. Herrett taught shop at the local high school, operated a jewelry store, and founded a community science center—called the Herrett Arts and Science Center. He and his wife went on expeditions to collect Indian artifacts—usually items to illustrate native stoneworking, pottery making, metal fabricating, casting, and textile and basket weaving. The collection tends to be small ornamental objects from such areas as the valley and west coast of Mexico, the isthmus of Panama, coastal Peru, and the Pacific Northwest Coast. Some of the highlights include an assortment of pre-Inca textiles, Mexican clay figurines, and Peruvian ceramics and metals.

The collection was given to the College of Southern Idaho in 1972 on the condition that the college build a facility to house and display the artifacts and continue to offer the science center hands-on program. The building was completed in 1980 to fulfill the commitment.

Herrett Museum, College of Southern Idaho, 315 Falls Ave., PO Box 1238, Twin Falls, ID 83303-1238. Phone: 208/733-9554. Hours: 9:30–4:30 Mon.–Fri. (also to 8 Tues.); 1–4:30 Sat.–Sun.; closed holidays. Admission: free.

## DePAUW UNIVERSITY
### DePauw University Anthropology Museum

The principal focus of the collections and exhibitions of the DePauw University Anthropology Museum in Greencastle, Indiana, is Africa. The collections concentrate on sculpture from the continent, and the exhibitions usually present different facets of African life, such as artworks, musical instruments, and everyday life. The museum, located on the lower level of St. Asbury Hall, was founded in 1984.

DePauw University Anthropology Museum, 100 Center St., Asbury Hall, Greencastle, IN 46135. Phone: 317/658-4800. Hours: 8–5 Mon.–Fri.; closed major holidays and spring break. Admission: free.

## EASTERN ARIZONA COLLEGE
### Museum of Anthropology

Cultures of the Southwest are featured at the Museum of Anthropology at Eastern Arizona College in Thatcher. The museum, founded in 1977, has collections and exhibits dealing with Mogollon, Anasazi, and Hohokam artifacts; Apache, Navajo, and Hopi ethnographics; the botany of prehistoric peoples; the

Pleistocene period; and such areas as southwestern weaponry, axes, jewelry, and pigment and pottery manufacturing.

Museum of Anthropology, Eastern Arizona College, Thatcher, AZ 85552-0769. Phone: 602/428-8310. Hours: academic year—9–4 Mon.–Fri.; closed summer and holidays. Admission: free.

## EASTERN NEW MEXICO UNIVERSITY
### Blackwater Draw Museum

Eastern New Mexico University's Blackwater Draw Museum, located seven miles north of the Portales campus along Highway 70, was founded in 1969 to display and interpret artifacts and related faunal materials excavated from the Blackwater Draw archaeological site—one of the best-known and most-significant sites in North American archaeology.

Early Blackwater Draw investigations, which began in the 1930s, found evidence of human occupation in association with Late Pleistocene fauna, including the woolly mammoth, camel, horse, bison, sabertooth tiger, and dire wolf. The site—the nation's first multicultural, paleo-Indian archaeological site, is known to have been occupied by humans approximately 11,000 years ago. It is listed on the National Register of Historic Places.

Blackwater Draw Museum, Eastern New Mexico University, Station 9, Portales, NM 88130. Phone: 505/562-2202. Hours: 10–5 Mon.–Sat.; 12–5 Sun.; closed New Year's Day and Christmas. Admission: adults, $2; seniors and children, $1.

## EMORY UNIVERSITY
### Michael C. Carlos Museum

(See Art Museums section.)

## FORT LEWIS COLLEGE
### Center of Southwest Studies Museum

The Center of Southwest Studies at Fort Lewis College in Durango, Colorado, has a museum and an archive in Reed Library in addition to an interdisciplinary academic program in Southwest history, art, anthropology, archaeology, geology, and other fields. The museum, founded in 1964, contains Anasazi pottery, Navajo textiles, Zuni fetishes, kachinas, paintings, and other Southwest artifacts. The archive has over 100 special collections on Native Americans, mining, energy, politics, and other areas in the Southwest, including thousands of historic photographs.

Center of Southwest Studies Museum, Fort Lewis College, Reed Library, 1000 Rim Dr., Durango, CO 81301. Phone: 303/247-7456. Hours: fall/winter—10:30–8 Mon.–Thurs.; 10:30–5 Fri.; 3–7 Sun.; summer—by appointment. Admission: free.

## HARTWICK COLLEGE
### Yager Museum

The Yager Museum, an anthropology museum that is one of the four facilities that comprise the Museums at Hartwick at Hartwick College in Oneonta, New York, has more than 20,000 items and 11 galleries for permanent and special exhibitions and educational programs in recently renovated Yager Hall.

The museum features a collection of over 6,000 Native American artifacts donated by Williard E. Yager, a local amateur archaeologist, in 1928. The materials—which led to the founding of the museum in 1929—relate primarily to people who inhabited the upper Susquehanna region from the paleo-Indian cultures (dating from 9000 B.C. to the Late Woodland period [1000 to 1600 A.D.]). The collection also contains Southwest Indian pottery and baskets from ancient Pueblo sites and trade goods of 1890 Santa Fe.

The museum's other collections include the Furman and Sandell collections, which represent the cultures of the Chimu, Inca, and other Mesoamerican Indians, as well as pre-Columbian and contemporary materials from Ecuador and Peru.

Yager Museum, Hartwick College, Yager Hall, Oneonta, NY 13820. Phone: 607/431-4480. Hours: 10–4 Mon.–Sat.; 1–4 Sun.; closed major holidays. Admission: free.

## HARVARD UNIVERSITY
### Peabody Museum of Archaeology and Ethnology

The Peabody Museum of Archaeology and Ethnology is one of the four museums that comprise the Harvard University Museums of Natural History in Cambridge, Massachusetts. The other three museums, which are described separately in other sections, are the Botanical Museum (Botanical Gardens, Arboritz, and Herbaria), Mineralogical and Geological Museum (Geology, Mineralogy, and Paleontology Museums), and Museum of Comparative Zoology (Zoology Museums). All are located in the same building.

Founded in 1866 with a George Peabody trust fund grant and opened in 1877, the museum houses treasures of prehistoric and historic cultures from throughout the world. In addition to having invaluable collections and serving as a major research resource, the museum seeks to help visitors obtain a sense of human history, cultural diversity, ingenuity, and artistry through its exhibits.

The museum has extensive archaeological and ethnological holdings, especially from the Americas. The strongest collections are the Mesoamerican, Peruvian, Central American, Southwest, Northwest Coast, Subarctic, and Plains collections. It also has African and Oceanic ethnographic collections; archaeological materials from Europe, the Middle East, and southern Asia; a photographic collection with over 500,000 images; and a 180,000-volume library of archaeological, anthropological, and ethnographic books.

More than 2 million objects can found in the museum's collections. They include one of the largest collections of Hopi material culture, with pottery, textiles, and ceremonial objects; one of the finest collections of Mimbres pottery in the world; jades and gold dredged from the Sacred Cenote at Chichén Itzá between 1905 and 1910; carved jade and stone heads from Guatemala and Honduras; African masks, with emphasis on the Guinea Coast culture area, Liberia, and the Ivory Coast; a crested helmet and a cloak of feathers from Hawaii; two of three tapa (mulberry bark cloth) figures known to exist from Easter Island; and a great Benin bronze plaque from the 1500s or early 1600s that shows the Benin chief in a helmet with feathers, carrying a spear and decorated shield, with two Portuguese soldiers in the background.

In 1994–1995, the Peabody Museum had such exhibits as the following on display: first floor—*Ju/wasl: Bushmen of the Kalahari* exhibition, a comprehensive view of the people living in the Kalahari desert of southern Africa, and *Change and Continuity* exhibition in the Hall of the North American Indian, featuring a selection of objects from the permanent collections spanning the North American continent; third floor—*Encounters with the Americas* exhibition, which explored the native cultures of Latin America before and after the first voyage of Christopher Columbus in 1492, and *Worlds in Miniature, Worlds Apart* exhibition, which showed the use of dioramas, models, and mannequins in Peabody Museum exhibits in the late nineteenth and early twentieth centuries; and fourth floor—an exhibit of objects from Melanesia, Micronesia, Polynesia, and Island Southeast Asia in the Oceanic Gallery.

Peabody Museum of Archaeology and Ethnology, Harvard University, 11 Divinity Ave., Cambridge, MA 02138. Phone: 617/495-2248. Hours: 9–4:15 Mon.–Sat.; 1–4:15 Sun.; closed major holidays. Admission: adults, $4; seniors, $3; children, $1; Harvard students, free.

### Semitic Museum

The Semitic Museum at Harvard University in Cambridge, Massachusetts, has served as a center for archaeological exploration, research, and education since it was founded in 1889. Dedicated to promoting ''sound knowledge of Semitic languages and history,'' it has a major collection of over 100,000 archaeological, photographic, and manuscript materials related to the Near East.

The museum pioneered American scientific excavations in the Holy Land at Samaria in 1907–1912 and led important excavations to Nuzi in Iraq and Serabit al-Qedem in the Sinai, where the earliest known alphabet was uncovered. Recent expeditions have investigated seafaring Phoenicians on Cyprus, at Carthage, and off Sardinia. The museum also directs ongoing excavations at the ancient seaport of Ashkelon in Israel. Its collections include cuneiform tablets, ceramic assemblages, ethnographic materials, and other findings from its excavations.

The museum was closed to the public in 1942 because of wartime needs. The collections were stored in the basement, while scholarly work continued. In 1970, the museum's 28,000 nineteenth-century photographs were rediscovered and since have become significant research tools for documenting Near Eastern

cultural heritages. The museum reopened to the public in 1982. It now is open only when special exhibitions are presented.

Semitic Museum, Harvard University, 6 Divinity Ave., Cambridge, MA 02138. Phone: 617/495-4631. Hours: 10–4:30 Mon.–Fri. during scheduled exhibitions. Admission: free.

## HEBREW UNION COLLEGE
### Skirball Museum

Jewish cultural history, Biblical archaeology, and art are the focal point of the Skirball Museum at the Hebrew Union College in Los Angeles. The museum was founded in 1913 by the National Foundation of Temple Sisterhood on the Hebrew Union College campus in Cincinnati. It was moved to the Los Angeles campus in 1972, although branch museums on the Cincinnati and Jerusalem, Israel, campuses of the college share the collections.

Exhibits at the Los Angeles museum change approximately three times a year. The exhibit subjects include Jewish practices, history, ethnographic culture, and arts. Among the museum's most significant collections are the Salli Kirschstein Collection of Jewish ceremonial art, Dr. Nelson Glueck Collection of archaeological artifacts, Joseph Hamburger Collection of numismatics, and I. Soloman and L. Grossman Collection of engravings and photographic prints. Other collections include manuscripts, paintings, sculpture, textiles, decorative arts, graphics, items relating to the American Jewish cultural experience, and prints and drawings by artists of Jewish origins and on Jewish themes.

Skirball Museum, Hebrew Union College, 3077 University Ave., Los Angeles, CA 90007-3796. Phone: 213/749-3424. Hours: 11–4 Tues.–Fri.; 10–5 Sun.; closed national and Jewish holidays (the museum currently is closed and will reopen by 1996 at a new site). Admission: free.

## HEBREW UNION COLLEGE–JEWISH INSTITUTE OF RELIGION
### Skirball Museum, Cincinnati Branch

Hebrew Union College has four campuses (in Cincinnati, Los Angeles, New York, and Jerusalem, Israel). Three of the four have branches of the Skirball Museum (the New York campus has an art gallery). The Jerusalem branch is an archaeological museum, while the Cincinnati and Los Angeles branches contain ceremonial objects relating to Jewish customs, rituals, and life-cycle events; Biblical archaeological objects; and paintings, prints, sculpture, and folk art.

The Skirball Museum originally was founded in Cincinnati as the Union Museum in 1913. A major purchase from the Kirschstein Collection was added in 1926. The museum name was changed to the Gallery of Art and Artifacts and then to the Skirball Museum following a major contribution by Jack Skirball, a former rabbi who became a businessman, in 1972. The collections now are divided among the museum branches.

*An Eternal People: The Jewish Experience* is the core exhibit at the Cincinnati

branch, which is best known for its collections and displays dealing with Jewish immigration to America, Torah ornaments and textiles, life-cycle and holiday-cycle ritual objects, Holocaust materials, Israeli art, and Isaac M. Wise items.
Skirball Museum, Cincinnati Branch, Hebrew Union College–Jewish Institute of Religion, 3101 Clifton Ave., Cincinnati, OH 45220. Phone: 513/221-1875. Hours: 11–4 Mon.–Thurs.; 2–5 Sun.; closed national and Jewish holidays. Admission: free.

## HOWARD UNIVERSITY
### Howard University Museum

Exhibits and artifacts relating to the African-American experience, African culture, and university history can be found at the Howard University Museum at the Moorland-Spingarn Research Center at Howard University in Washington, D.C. The artifacts and related historical materials—such as photographs, manuscripts, tapes, and documents—are from the research center's extensive collections.

The Moorland-Spingarn Research Center is one of the world's largest and most comprehensive repositories for the documentation of the history and culture of people of African descent in Africa, the Americas, and other parts of the world. The center had its beginnings in 1914, with a gift of significant black-related books and other materials from Dr. Jesse E. Moorland, a theologian. It was supplemented by the acquisition of the personal library and other resource materials of Arthur B. Spingarn, an attorney, in 1946. These and related collections became the Moorland-Spingarn Research Center in 1973. The museum opened in 1979, but recently was closed indefinitely.
Howard University Museum, Moorland-Spingarn Research Center, 500 Howard Place, NW, Washington, DC 20059. Phone: 202/806-7239. Hours: closed indefinitely.

## IDAHO STATE UNIVERSITY
### Idaho Museum of Natural History

(See Natural History Museums and Centers section.)

## INDIANA UNIVERSITY
### William Hammond Mathers Museum

The William Hammond Mathers Museum, a museum of world cultures at Indiana University in Bloomington, has archaeological, ethnological, and historical collections and exhibits from North America, Latin America, Europe, Africa, Asia, and Oceania.

The museum, which was opened in 1963, has approximately 20,000 objects and 10,000 photographs in its collections. Two of its most important collections are the Wanamaker Collection of Native American photographs, consisting of over 8,000 images of Native Americans taken between 1908 and 1923, and the

Ethnomusicology Collection, with more than 1,200 non-Western traditional musical instruments from throughout the world.

In addition to the ongoing exhibits, the museum presents changing cultural exhibitions that focus largely on subsistence, ceremony, and ethnological introductions.

William Hammond Mathers Museum, Indiana University, 601 E. Eighth St., Bloomington, IN 47405. Phone: 812/855-6873. Hours: 9–4:30 Tues.–Fri.; 1–4:30 Sat.–Sun.; closed holidays and when university not in session. Admission: free.

## INSTITUTE OF AMERICAN INDIAN ARTS
### Institute of American Indian Arts Museum

(See Art Museums section.)

## JEWISH THEOLOGICAL SEMINARY OF AMERICA
### Jewish Museum

The Jewish Museum in New York City operates under the auspices of—but is governed, staffed, and funded separately from—the Jewish Theological Seminary of America. It is an art, history, and cultural museum that was founded in 1904 and now is housed in the 1908 Felix Warburg Mansion, which was renovated in 1993.

The museum has an extensive Judaica collection spanning 40 centuries. Among the materials in its collections and on display are antiquities, ceremonial objects, paintings, sculpture, prints, drawings, textiles, decorative arts, coins, medals, historic manuscripts, photographs, broadcast material, and other items.

Jewish Museum, 1109 Fifth Ave., New York, NY 10128. Phone: 212/423-3200. Hours: 11–5 Tues.–Fri. and Sun. (also to 8 Thurs.–Fri.); closed Jewish holidays. Admission: adults, $6; seniors and students, $4; children under 12, free.

## JOHNS HOPKINS UNIVERSITY
### Johns Hopkins University Archaeological Collection

The Johns Hopkins University Archaeological Collection in Baltimore began in 1884. It now has approximately 8,000 Egyptian, Near Eastern, Greek, and Roman antiquities from 4000 B.C. to 500 A.D.

Johns Hopkins University Archaeological Collection, Gilman Hall, 3400 N. Charles St., Baltimore, MD 21218. Phone: 410/516-7561. Hours: afternoons Mon.–Fri.; closed holidays and when university not in session. Admission: free.

## KENDALL COLLEGE
### Mitchell Indian Museum

The Mitchell Indian Museum at Kendall College in Evanston, Illinois, resulted from a 1977 gift of John and Betty Mitchell's private collection of art and

ethnographic material from many North American tribes. Since then, it has been expanded to include other contributions and purchases. Mr. Mitchell was an Evanston businessman who collected the artworks and artifacts over 60 years. Permanent exhibits include displays on Illinois prehistory and the historic and modern lifeways of four Native American cultural areas—the western Great Lakes, the Plains, and the Navajo and Pueblo cultures of the Southwest. The exhibits interpret these cultural areas using pottery, basketry, clothing, textiles, beadwork, quillwork, jewelry, musical instruments, dolls, toys, carvings, paintings, and other objects.

Special exhibitions look at a single theme or subject. Past exhibitions have dealt with Pueblo pottery, Northwest Coast Indian art, Native American dolls, and contemporary Native American painting and sculpture.

The museum is on the ground level of a building that also contains classrooms and culinary school facilities.

Mitchell Indian Museum, Kendall College, 2408 Orrington Ave., Evanston, IL 60201. Phone: 708/866-1395. Hours: 9–4:30 Mon.–Fri.; 1–4 Sun.; closed some holidays. Admission: suggested donation—$1.

## LOUISIANA STATE UNIVERSITY
### Museum of Natural Science

(See Natural History Museums and Centers section.)

## LOUISIANA TECH UNIVERSITY
### Louisiana Tech Museum

The Louisiana Tech Museum, which occupies a portion of the Administration Building at Louisiana Tech University in Ruston, contains archaeological, paleontological, and geological collections. Among the diverse exhibits and collections are Native American artifacts, Roman and Egyptian archaeological objects, and pre–World War II weapons.

Louisiana Tech Museum, Louisiana Tech University, Administration Bldg., Ruston, LA 71272. Phone: 318/257-2264. Hours: 1–5 Mon.–Fri.; closed holidays and when university not in session. Admission: free.

## LOUISVILLE PRESBYTERIAN THEOLOGICAL SEMINARY
### Horn Archaeological Museum

(See Religious Museums section.)

## MERRITT COMMUNITY COLLEGE
### Merritt Museum of Anthropology

The Merritt Museum of Anthropology consists of ethnological collections and 12 exhibit cases in several locations on the Merritt Community College campus

in Oakland, California. Wood sculptures from Africa and New Guinea are among its prized possessions. The collections include materials from North and South America, Africa, the Pacific, Asia, and Europe. From 1 to 10 students are trained each semester to select, research, design, and install an exhibit in one of the cases.

Merritt Museum of Anthropology, Merritt Community College, 12500 Campus Dr., Oakland, CA 94619. Phone: 510/436-2610. Hours: cases are always available to be seen, except when college not in session. Admission: free.

## MICHIGAN STATE UNIVERSITY
### Michigan State University Museum

(See Natural History Museums and Centers section.)

## MISSISSIPPI STATE UNIVERSITY
### Lois Dowdle Cobb Museum of Archaeology

Archaeological materials from the Middle East and the southeastern United States are featured at the Lois Dowdle Cobb Museum of Archaeology, which is part of the Cobb Institute of Archaeology, a research and service unit of Mississippi State University in Mississippi State, Mississippi. Among its most significant holdings are the Lloyd Rapport and Gerald and Freida Dunham collections of Middle Eastern artifacts. Annual exhibits focus on the archaeology of the Middle East or Native American materials from the American Southeast.

Lois Dowdle Cobb Museum of Archaeology, Mississippi State University, Cobb Institute of Archaeology, PO Drawer AR, Mississippi State, MS 39762. Phone: 601/325-3826. Hours: 12–4 Tues.–Fri.; closed holidays and when university not in session. Admission: free.

## MONTANA STATE UNIVERSITY
### Museum of the Rockies

(See Natural History Museums and Centers section.)

## MURRAY STATE UNIVERSITY
### Wickliffe Mounds

Block excavations and artifacts of Mississippian culture can be seen at the Wickliffe Mounds in Wickliffe, Kentucky. The archaeological site, which was founded in 1932, is part of Murray State University in Murray.

Wickliffe Mounds, Murray State University, Hwy. 51, Wickliffe, KY 42087. Phone: 502/335-3681. Hours: 9–4:30 daily. Admission: adults, $3.50; seniors, $3.25; children 6–11, $2.50; children under 6, free.

## NEW MEXICO STATE UNIVERSITY
### New Mexico State University Museum

Originally started as a general museum in 1981, the New Mexico State University Museum in Las Cruces shifted its emphasis to archaeology, ethnology, anthropology, and the history of the southwestern United States and northern Mexico in 1986. It now has some 40,000 objects in these areas, including nineteenth-century Mexican retablos, historic photographs, and contemporary prints.

In addition to permanent exhibits from its collections, the museum presents traveling exhibitions, usually with a Native American focus and a southwestern theme. The museum is located in Kent Hall, a two-story Spanish mission–revival building built in 1930 and renovated in the 1980s for use as a museum. It operates under the auspices of the Department of Sociology and Anthropology.
New Mexico State University Museum, Kent Hall, University Ave. at Solano Dr., PO Box 3564, Las Cruces, NM 88003. Phone: 505/646-3739. Hours: 10–4 Mon.–Sat.; 1–4 Sun.; closed some holidays and when university not in session. Admission: free.

## NORTH CAROLINA AGRICULTURAL AND TECHNICAL STATE UNIVERSITY
### Mattye Reed African Heritage Center

Arts and crafts from over 31 African nations, New Guinea, and Haiti are featured at the Mattye Reed African Heritage Center at North Carolina Agricultural and Technical State University in Greensboro. The center was founded in 1968.
Mattye Reed African Heritage Center, North Carolina Agricultural and Technical State University, 312 N. Dudley St., Greensboro, NC 27411. Phone: 910/379-7874. Hours: 9–5 Mon.–Fri.; other times by request. Admission: free.

## NORTHERN ILLINOIS UNIVERSITY
### Anthropology Museum

The Anthropology Museum at Northern Illinois University in DeKalb has archaeological, anthropological, and ethnographic materials from many parts of the world. Collections of the museum, founded in 1964, include ethnographic materials from the Plains, Southwest, and Northwest and from eastern North America, Mexico, South America, Pacific islands, Southeast Asia, Africa, and Greece; archaeological materials from North America; and human and nonhuman primate skeletal materials.
Anthropology Museum, Northern Illinois University, Dept. of Anthropology, DeKalb, IL 60115. Phone: 815/753-0230. Hours: 9–5 Mon.–Fri.; closed major holidays. Admission: free.

## NORTHERN KENTUCKY UNIVERSITY
*Museum of Anthropology*

Ohio Valley archaeological materials and contemporary folk and ethnic arts and crafts are featured at the Northern Kentucky University Museum of Anthropology in Highland Heights. The contemporary items are from Southeast, Southwest, and Northwest Native Americans; West Africa; New Guinea; and elsewhere.

Museum of Anthropology, Northern Kentucky University, Lanorum 200–202, University Dr., Highland Heights, KY 41099-6210. Phone: 606/572-5259. Hours: 9–4 Mon.–Fri.; closed holidays and when university not in session. Admission: free.

## OKLAHOMA STATE UNIVERSITY
*Oklahoma State University Museum of Natural and Cultural History*

(See Natural History Museums and Centers section.)

## OREGON STATE UNIVERSITY
*Horner Museum*

(See General Museums section.)

## OTERO JUNIOR COLLEGE
*Koshare Indian Museum*

(See Unaffiliated Museums section.)

## PACIFIC SCHOOL OF RELIGION
*Bade Institute of Biblical Archaeology and Howell Bible Collection*

(See Religious Museums section.)

## PEMBROKE STATE UNIVERSITY
*Native American Resource Center*

The Native American Resource Center at Pembroke State University in Pembroke, North Carolina, contains Indian artifacts, handicrafts, recordings, and films, with an emphasis on Lumbee culture. Founded in 1979, the museum is housed in the 1923 Old Main Building. A major event annually is the Native American Art Show and Sale in the summer.

Native American Resource Center, Pembroke State University, College Rd., Pembroke, NC 28372. Phone: 910/521-6282. Hours: 8–5 Mon.–Fri.; closed major holidays. Admission: free.

## PENNSYLVANIA STATE UNIVERSITY
### Matson Museum of Anthropology

The Matson Museum of Anthropology at Pennsylvania State University in University Park has collections and exhibits of Afghan folk art, South American Indian artifacts, worldwide folk pottery, Mesoamerican archaeological artifacts, biological anthropology materials, and other such objects. Founded in 1968, the museum moved to the second floor of the Carpenter Building in 1987.

Matson Museum of Anthropology, Pennsylvania State University, Carpenter Bldg., University Park, PA 16802. Phone: 814/865-3853. Hours: 9–4 Mon.–Fri.; 9–12 noon Sat.; 1–3 Sun.; closed holidays and when university not in session. Admission: free.

### Paul Robeson Cultural Center Gallery
(See Art Galleries section.)

## PRINCIPIA COLLEGE
### Principia School of Nations Museum

(See General Museums section.)

## SAINT CLOUD STATE UNIVERSITY
### Evelyn Payne Hatcher Museum of Anthropology

The Evelyn Payne Hatcher Museum of Anthropology at Saint Cloud State University in St. Cloud, Minnesota, has collections and exhibits of archaeological and ethnographic materials, largely from Minnesota. The museum was founded in 1972. It is located in Stewart Hall.

Evelyn Payne Hatcher Museum of Anthropology, St. Cloud State University, 215 Stewart Hall, St. Cloud, MN 56301. Phone: 612/255-2294. Hours: 9–4 Mon.–Fri.; closed holidays and when university not in session. Admission: free.

## SAN FRANCISCO STATE UNIVERSITY
### Treganza Anthropology Museum

The Treganza Anthropology Museum at San Francisco State University originally was a laboratory of California archaeology used as a teaching aid by Professor Adan E. Treganza. After Treganza's death, the facility was converted into a museum of anthropology and archaeology.

The museum is best known for its ethnographic collections of northern California and ethnographic and archaeological collections of Africa and Oceania.

Themes for exhibitions are chosen in association with courses offered by the Department of Anthropology, considering the interest of Bay communities, and upon the acquisition of new collections.

Treganza Anthropology Museum, San Francisco State University, 1600 Holloway Ave., San Francisco, CA 94132. Phone: 415/338-1642. Hours: 9–4 Mon.–Fri.; closed holidays and when university not in session. Admission: free.

## SANTA ROSA JUNIOR COLLEGE
### Jesse Peter Museum

The Jesse Peter Museum at Santa Rosa Junior College in Santa Rosa, California, was founded in 1935 by a WPA grant to display North American Indian traditional art. It still features rotating exhibits of Native American ceramics, basketry, textiles, jewelry, and paintings. The museum is operated through the Behavioral Sciences Department.

Jesse Peter Museum, Santa Rosa Jr. College, Behavioral Sciences Dept., 1501 Mendocino Ave., Santa Rosa, CA 95401-4395. Phone: 707/627-4614. Hours: 12–4 Mon.–Fri.; closed when college not in session. Admission: free.

## SCHOOL OF AMERICAN RESEARCH
### Indian Arts Research Center

The School of American Research—a center for advanced study in anthropology in Santa Fe, New Mexico—has a prized collection of more than 10,000 Southwest Indian paintings, textiles, baskets, pottery, jewelry, and other ethnographic and artistic materials at its Indian Arts Research Center.

Opened in 1978, the center displays historic and contemporary Pueblo, Navajo, and other Native American objects in private open storage for study by scholars, artists, and students. The art and artifacts are stored in two climate-controlled vaults with public access being limited.

Indian Arts Research Center, School of American Research, 660 Garcia St., PO Box 2188, Santa Fe, NM 87504. Phone: 505/982-3583. Hours: 8–5 Mon.–Fri. by appointment; closed holidays. Admission: suggested donations—adults, $15; seniors, $7.

## SETON HALL UNIVERSITY
### Seton Hall University Museum

The ethnography and artifacts of Indians in New Jersey and North America are featured at the Seton Hall University Museum in South Orange, New Jersey. The artifacts are from 10,000 B.C. to 1800 A.D. The museum, which opened in 1960, also has prehistoric materials from Europe.

Seton Hall University Museum, Fahy Hall, S. Orange Ave., South Orange, NJ 07079.

Phone: 201/761-9543. Hours: 8 A.M.–9 P.M. Mon.–Fri.; 8–5 Sat.; closed holidays and when university not in session. Admission: free.

## SHELDON JACKSON COLLEGE
### Sheldon Jackson Museum

(See Unaffiliated Museums section.)

## SOUTHERN BAPTIST THEOLOGICAL SEMINARY
### Joseph A. Callaway Archaeological Museum

(See Religious Museums section.)

## SOUTHERN ILLINOIS UNIVERSITY AT CARBONDALE
### University Museum

(See General Museums section.)

## SPERTUS COLLEGE OF JUDAICA
### Spertus Museum

Nearly 3,000 works spanning 3,500 years of Jewish history, culture, and religion are featured at the Spertus Museum of the Spertus College of Judaica in Chicago. Founded in 1968, the museum contains ceremonial objects, artifacts, textiles, jewelry, coins, costumes, paintings, sculpture, and graphics.

The exhibit portion of the museum includes the *Zell Holocaust Memorial* exhibit and the Paul and Gabriella Rosenbaum Artifact Center, a unique hands-on section that enables children and their families to explore the history of the ancient Near East. The latter has a 32-foot dig site for unearthing artifacts, an open marketplace with five activity stations, a theater/costume area with a television monitor, an illustrated time line, an Israelite house where preschoolers can shake hands with the past, and workshops for children seven years of age and older.

Spertus Museum, Spertus College of Judaica, 618 S. Michigan Ave., Chicago, IL 60605. Phone: 312/922-9012. Hours: 10–5 Mon.–Thurs. and Sun.; 10–3 Fri.; closed national and Jewish holidays. Admission: adults, $3.50; seniors, students, and children, $2; Fridays are free.

## STANFORD UNIVERSITY
### Keesing Museum of Anthropology

The Keesing Museum of Anthropology at Stanford University in Stanford, California, contains a variety of anthropological and archaeological collections

and exhibits. Its holdings include basketry, stone tools, ceramics, and other materials from California, the Pacific, Mexico, the Andes, Africa, Europe, and other regions.

Keesing Museum of Anthropology, Stanford University, Dept. of Anthropology, Bldg. 110, Stanford, CA 94305-2145. Phone: 415/723-3421. Hours: 8–5 Mon.–Fri.; closed holidays. Admission: free.

## SUL ROSS STATE UNIVERSITY
### Museum of the Big Bend

(See Historical Museums, Houses, and Sites section.)

## TRINIDAD STATE JUNIOR COLLEGE
### Louden-Henritze Archaeology Museum

The Louden-Henritze Archaeology Museum at Trinidad State Junior College in Trinidad, Colorado, contains exhibits and collections on the geology, plant and animal fossils, and archaeology of southeastern Colorado and northeastern New Mexico. Among the excavation findings have been a mosasaur skeleton, mammoth tusks, and Indian artifacts. The museum is housed on the ground floor of the library.

Louden-Henritze Archaeology Museum, Trinidad State Junior College, 600 Prospect St., Trinidad, CO 81082. Phone: 719/846-8410. Hours: 10–4 Mon.–Fri.; closed holidays. Admission: free.

## TURABO UNIVERSITY
### Archaeology Museum

Turabo University's Archaeology Museum in Gurabo, Puerto Rico, concentrates on the archaeology of the eastern part of Puerto Rico and features folkloric arts and crafts and the ethnology of the region in the nineteenth century. Founded in 1980, it supplements permanent exhibits with temporary exhibitions.

Archaeology Museum, Turabo University, PO Box 3030, Gurabo, PR 00778. Phone: 809/743-7979, Ext. 4135. Hours: Aug.–May—8–4 daily; closed summer and holidays. Admission: free.

## UNIVERSITY OF ALABAMA
### Moundville Archaeological Park (Alabama Museum of Natural History)

(See Natural History Museums and Centers section.)

## UNIVERSITY OF ARIZONA
*Arizona State Museum*

The cultures of prehistoric and contemporary Native Americans of the Southwest are featured at the Arizona State Museum at the University of Arizona in Tucson. The museum has been collecting, preserving, researching, and interpreting cultural materials of the region since 1893.

The museum—which occupies two campus buildings—has more than 100,000 artifacts from archaeological excavations pertaining to the prehistoric Hohokam, Mogollon, and Anasazi cultures; over 25,000 ethnographic objects that document the lifeways of historic and living American Indians; and in excess of 200,000 photographic images relating to the cultural traditions of the Southwest.

Among the permanent displays is a new exhibit, *Paths of Life: American Indians of the Southwest,* that tells the stories of 10 Indian cultures in Arizona and northern Mexico. The museum also has two temporary exhibition galleries—featuring special topics and collections, ranging from 2,000-year-old pottery to modern southwestern arts and crafts.

Arizona State Museum, University of Arizona, Tucson, AZ 85721. Phone: 602/621-6281. Hours: 10–5 Mon.–Sat.; 12–5 Sun.; closed major holidays. Admission: free.

## UNIVERSITY OF CALIFORNIA, BERKELEY
*Phoebe A. Hearst Museum of Anthropology*

The Phoebe A. Hearst Museum of Anthropology at the University of California, Berkeley, is the largest museum of anthropology west of the Mississippi River. Founded in 1901 with funding from Hearst, the museum occupies more than 70,000 square feet and has over 3.8 million objects in its collections. Until recently, it was known as the Robert H. Lowie Museum of Anthropology. It was renamed for the long-time supporter after receiving a $1 million grant from the Hearst Foundation.

Hearst sponsored expeditions within California (archaeological and ethnographic materials) and to Egypt (ancient artifacts), Peru (archaeological objects), the Mediterranean (classical antiquities), and the Guatemalan highlands (Mayan textiles). Later the museum acquired major collections from the peoples of the Arctic, Africa, and Oceania. The California collections include some 11,000 specimens of human osteology.

The exhibits largely make use of the collections to show the latest theoretical developments in anthropology and often have themes that reflect current research efforts by university faculty members.

Phoebe A. Hearst Museum of Anthropology, University of California, Berkeley, 103 Kroeber Hall, Berkeley, CA 94720. Phone: 510/642-3681. Hours: 10–4:30 Mon.–Fri.; 12–4:30 Sat.–Sun.; closed holidays. Admission: adults, $2; seniors, $1; children under 10, 50¢; university students, free.

## UNIVERSITY OF CALIFORNIA, LOS ANGELES
### Fowler Museum of Cultural History

The Fowler Museum of Cultural History at the University of California, Los Angeles, was created in 1963 to consolidate all the ethnographic collections on the campus and to make them accessible to the university community and the general public. Since then it has established a permanent collection of more than 750,000 artifacts representing prehistoric, historic, and contemporary cultures in Africa, Asia, Oceania, and the Americas.

The museum's archaeology, material culture, art, and related collections are used for teaching, research, exhibits, and public programming. The exhibitions place emphasis on providing cultural context and interpretive perspectives for artifacts, cultures, and focused topics.

The museum's new building, which opened in 1992, provides expanded and improved space for collections, exhibitions, research, laboratory work, seminars, educational activities, offices, an auditorium, a library, and the Center for the Study of Regional Dress.

Fowler Museum of Cultural History, University of California, Los Angeles, CA 90024-1549. Phone: 310/825-4361. Hours: 8:30–5 Mon.–Fri.; closed holidays. Admission: free.

## UNIVERSITY OF CHICAGO
### Oriental Institute Museum

The Oriental Institute Museum at the University of Chicago traces its origin to 1894—3 years after the university was founded and 25 years before the Oriental Institute itself was established. Today it is a major museum of the history, art, and archaeology of the ancient Near East.

The museum began as the Haskell Oriental Museum, with galleries displaying a few plaster-cast reproductions and a number of exhibition cases containing small collections of antiquities. However, the collections and exhibits grew rapidly as a result of private donations and university field expeditions to Egypt, Iraq, and other parts of the Near East.

Since its establishment as a Near East research and study center in 1919, the Oriental Institute has sponsored archaeological and survey expeditions in every country of the region. The results of these excavations have defined the basic chronologies for many ancient Near Eastern civilizations and have helped determine the time when humankind made the transition from hunting-gathering to settled community life. Thousands of antiquities discovered during these expeditions—from ancient Egypt, Mesopotamia, Syria/Palestine, Persia, and Anatolia—now can be seen in the institute's museum.

Among the ancient artifacts on display are statues and relief carvings depicting the people themselves and their gods and goddesses; monumental sculptures reflecting the glory of their kings; clay tablets, papyrus scrolls, and inscriptions

on stone recording the development of their writing systems and documenting many aspects of their lives; and objects of daily life displaying their skill in decorative arts and revealing their aesthetic tastes.

Included among the artifacts are a 16-foot-high, 40-ton Assyrian stone bull found in Iraq, ca. 700 B.C.; a limestone bust of an Egyptian queen or goddess, ca. 300 B.C.; a ceramic pitcher found in Turkey, ca. 1900–1780 B.C.; gypsum human figures from Syria, ca. 1300–1000 B.C.; a gilded bronze Baal statuette found in Israel, ca. 1300 B.C.; a burial mask of an Egyptian woman, ca. 100 B.C.; and a limestone double bull capital to support roof beams found in Iran, ca. 1300–1000 B.C.

A primary concern of the Oriental Institute continues to be the documentation of basic textual information from which interpretive historical and linguistic studies can be derived. These investigations have led to the compilation of dictionaries and the making of accurate copies of ancient texts. Among the dictionaries produced have been Assyrian and Mesopotamian volumes, with work under way on Demotic (Egyptian) and Hittite dictionaries. Oriental Institute expeditions also continue to work in Egypt, Jordan, Syria, Iraq, and Israel.

Oriental Institute Museum, University of Chicago, 1155 E. 58th St., Chicago, IL 60637. Phone: 312/702-9521. Hours: 10–4 Tues.–Sat. (also to 8:30 Wed.); 12–4 Sun.; closed New Year's Day, Thanksgiving, and Christmas. Admission: free.

## UNIVERSITY OF DENVER
### Museum of Anthropology

The University of Denver has a Museum of Anthropology with a small anthropological collection and changing exhibitions on the lower level of the Mary Reed Building.

Museum of Anthropology, University of Denver, Mary Reed Bldg., 2199 S. University Blvd., Denver, CO 80208. Phone: 303/871-2406. Hours: 9–5 Mon.–Fri.; closed holidays and when university not in session. Admission: free.

## UNIVERSITY OF FLORIDA
### Florida Museum of Natural History

(See Natural History Museums and Centers section.)

## UNIVERSITY OF GEORGIA
### University of Georgia Museum of Natural History

(See Natural History Museums and Centers section.)

## UNIVERSITY OF ILLINOIS AT URBANA-CHAMPAIGN
### World Heritage Museum

The World Heritage Museum, also known as Spurlock Museum, at the University of Illinois at Urbana-Champaign is an ethnologically oriented museum

of world history and culture. Founded in 1911, it originally was four separate museums (classical civilization, European culture, art through the ages, and the ancient Orient) operated as adjuncts to academic departments.

The museum has significant collections of ancient Middle Eastern cuneiform clay tablets and cylinder seals; ancient Egyptian artifacts, including a mummy; classical vases and sculpture; Roman glass; Merovingian (early European) grave goods; illuminated manuscripts and early printed manuscripts, including a page of the Gutenberg Bible; Asian textiles; African sculpture and masks; Native American artifacts; and numismatics.

The World Heritage Museum maintains a number of long-term exhibit galleries in such areas as ancient Egyptian, Greek, and Asian history and culture. In addition, it mounts special temporary shows, both in-house and traveling.

The 22,000-square-foot museum is located on the fourth floor of Lincoln Hall, a 1911 university building used primarily for teaching and administration.

World Heritage Museum, University of Illinois at Urbana-Champaign, 484 Lincoln Hall, 702 S. Wright St., Urbana, IL 61801. Phone: 217/333-2360. Hours: 9–5 Mon.–Fri.; 2–5 Sun.; closed June, July, and holidays. Admission: free.

## UNIVERSITY OF KANSAS
### Museum of Anthropology

Collections of prehistoric anthropological materials from the Great Plains and ethnographic materials from throughout the world can be found at the Museum of Anthropology at the University of Kansas at Lawrence.

The museum, founded in 1979, was a part of the University of Kansas Systematics Museums structure until 1994, when it attained independent status in a campus museum reorganization.

The collections cover Great Plains anthropology, Plains Indians, Northwest Coast Indians, Africa, South American Indians, and other cultures. The permanent exhibits deal with the human life cycle in different cultures, while the rotating exhibitions focus on cultural diversity.

Museum of Anthropology, University of Kansas, Lawrence, KS 66045. Phone: 913/864-4245. Hours: 9–5 Mon.–Sat.; 1–5 Sun.; closed holidays. Admission: free.

## UNIVERSITY OF KENTUCKY
### Museum of Anthropology

The cultural history of Kentucky—with an emphasis on prehistoric Native Americans—is the focus of the Museum of Anthropology at the University of Kentucky in Lexington. The museum has approximately 1 million items in its archaeological, ethnographic, and related collections. Many of the artifacts are the result of excavations, which university archaeologists began even before the museum was founded in 1931.

The museum collections and exhibits include paleo-Indian projectile points

from at least 12,000 years ago; Archaic-period scrapers, drills, axes, mortars, cobbles, and atlatl throwing sticks from approximately 7000 B.C.; Woodland-period pottery, copper bracelets, and mica crescents from 2,500 years ago; and ceramic jars, bowls, pans, bottles, and pottery from about 1000 A.D.

Museum of Anthropology, University of Kentucky, 211 Lafferty Hall, Lexington, KY 40506-0024. Phone: 606/257-7112. Hours: 8:30–4:30 Mon.–Fri.; closed holidays and when university not in session. Admission: free.

## UNIVERSITY OF MAINE
### Hudson Museum

The Hudson Museum at the University of Maine in Orono opened in 1986 as a museum of anthropology. It evolved out of a teaching museum based on Professor Richard Emerick's collection, a gift of pre-Columbian artifacts by William P. Palmer III, and funds to build a museum from J. Russell Hudson.

The museum, which occupies a wing of the Maine Center for the Arts, has ethnology collections from Oceania, Africa, Mexico, the Arctic, Asia, and North and South America and archaeological materials from Europe and North, Central, and South America. Among the prized collections are the Palmer Collection of pre-Columbian and Northwest Coast objects and the Nicolas Salgo Collection of Sepik River materials. Selections from the collections are displayed in eight galleries, with changing exhibitions being presented in a temporary gallery.

Hudson Museum, University of Maine, 5746 Maine Center for the Arts, Orono, ME 04469-5746. Phone: 207/581-1906. Hours: 9–4 Tues.–Fri.; 9–3 Sat.; 11–3 Sun.; closed holidays. Admission: free.

## UNIVERSITY OF MEMPHIS
### C.H. Nash Museum–Chucalissa

The C.H. Nash Museum–Chucalissa in Memphis, Tennessee, is an archaeological park, museum, and partially reconstructed fifteenth-century Native American village on an actual site. *Chucalissa* is a Choctaw word meaning "abandoned house."

The site was discovered in 1939 during construction of a state park. It was excavated and preserved, with the reconstructed village and a museum being opened in 1955. In 1962, management of the site and museum was transferred to the University of Memphis and its Department of Anthropology in Memphis.

The site and museum are located in a park-like setting several miles from the university's main campus. The reconstructed village contains Indian mounds and a plaza, a chief's temple, a shaman's house, and a family dwelling from the Mississippian period, while the museum has exhibits on the prehistory of the mid-South, stone tools and pottery, southeastern Indian culture, and a preserved archaeological excavation trench. Among the special events are displays of Choctaw crafts and a Native American Festival.

C.H. Nash Museum–Chucalissa, University of Memphis, 1987 Indian Village Dr., Memphis, TN 38109. Phone: 901/785-3160. Hours: 9–5 Tues.–Sat.; 1–5 Sun.; closed holidays and partly when university not in session. Admission: adults, $3; seniors and children 4–11, $2; university students, free.

## Art Museum
(See Art Museums section.)

# UNIVERSITY OF MICHIGAN
## Kelsey Museum of Archaeology

The Kelsey Museum of Archaeology at the University of Michigan in Ann Arbor was founded in 1927 to house a growing collection of classical antiquities acquired by Francis W. Kelsey, professor of Latin from 1889 to 1927. Professor Kelsey began the collection in 1893 and by the late 1920s brought many thousands of excavated artifacts to the university from North America, the Middle East, and Egypt. These artifacts still form the core of the museum's nearly 100,000 objects from the ancient and early medieval cultures of Egypt, Greece, Rome, and the Middle East.

Since the 1930s, the museum has sponsored excavations in Syria, Libya, and Turkey and currently is exploring sites in Egypt, Tunisia, Israel, and Italy. Highlights of the museum's collections today are textiles, glass, pottery, sculptures, coins, and an array of artifacts of daily life from Roman Egypt.

Almost half of the collections are from the 1924–1935 excavations at Karanis, a Greco-Roman farming town in the Payoum district of Egypt. Scholars often refer to Karanis as "The Pompeii of Egypt" because of the finding of thousands of artifacts that document the daily life of common people of antiquity.

The museum, which occupies Newberry Hall, an 1891 Richardsonian Romanesque structure in the heart of the main campus, is a study center for students and faculty of the university and a research facility for scholars from around the world. It is a unit of the College of Literature, Science, and the Arts.

Plans are under way for the construction of a new museum facility as part of the university's five-year capital campaign launched in 1992. Meanwhile, the museum's current building has undergone a major renovation.

Kelsey Museum of Archaeology, University of Michigan, Newberry Hall, 434 S. State St., Ann Arbor, MI 48109-1390. Phone: 313/763-3559. Hours: 9–4 Mon.–Fri.; 1–4 Sat.–Sun.; closed when university not in session. Admission: free.

## Museum of Anthropology
The University of Michigan Museum of Anthropology in Ann Arbor is a teaching and research facility that does not have exhibits. Opened in 1929, it evolved from a unified collection of materials covering all of the natural sciences. It now is an autonomous department within the university, although the teaching is offered through the Department of Anthropology.

The museum has anthropological and archaeological collections, including

Michigan artifacts, Tibetan tankas, Chinese ceramics, and an ethnobotanical collection. Its research is carried on in a wide range of locations, with the staff having a long-term relationship with archaeologists in the Philippines.

The museum is located primarily in the Ruthven Museums Building, which also houses three other university science-oriented museums. It also has collections stored in a number of other locations.

Museum of Anthropology, University of Michigan, Ruthven Museums Bldg., 1109 Geddes Ave., Ann Arbor, MI 48109-1079. Phone: 813/764-6299. Hours: not open to public.

## UNIVERSITY OF MISSISSIPPI
### University Museums

(See General Museums section.)

## UNIVERSITY OF MISSOURI–COLUMBIA

The University of Missouri at Columbia has two museums in related fields— the Museum of Anthropology and the Museum of Art and Archaeology, which is described in the Art Museums section.

### Museum of Anthropology

The University of Missouri–Columbia has the largest collection of prehistoric Missouri archaeological artifacts in the world at its Museum of Anthropology. Founded in 1949, the museum also has ethnographic materials from native North American cultures of the Arctic, the Northwest Coast, the Southwest, and the Basin and Great Plains areas, as well as the Grayson Collection of archery and archery-related materials from around the world.

Museum of Anthropology, University of Missouri–Columbia, 104 Swallow Hall, Columbia, MO 65211. Phone: 314/882-3573. Hours: 9–4 Mon.–Fri.; scheduled tours, Sat.–Sun.; closed holidays. Admission: free.

### Museum of Art and Archaeology
(See Art Museums section.)

## UNIVERSITY OF NEW MEXICO
### Maxwell Museum of Anthropology

The Maxwell Museum of Anthropology grew out of the expanding collections of the Department of Anthropology at the University of New Mexico in Albuquerque. Since its founding in 1932, the museum has become known as a major resource of Southwest archaeological and ethnological materials.

The museum's collections include Navajo and other southwestern weaving; Mimbres and Pueblo pottery; Native American silver, basketry, and easel art;

musical instruments; Pakistani textiles and jewelry; South American textiles; and Mexican, Australian, and Arctic ethnological materials.

The museum occupies a 30,000-square-foot adobe building in Southwest style, which was built in the 1930s and expanded in the 1960s. It also has satellite storage elsewhere on the campus. The museum has a 12,500-volume library and an active publications program.

Maxwell Museum of Anthropology, University of New Mexico, University and Ash, NE, Albuquerque, NM 87131-1201. Phone: 505/277-4405. Hours: 9–4 Mon.–Fri.; 10–4 Sat.–Sun.; closed holidays. Admission: free.

## UNIVERSITY OF OKLAHOMA
### Oklahoma Museum of Natural History

(See Natural History Museums and Centers section.)

## UNIVERSITY OF OREGON
### Museum of Natural History

(See Natural History Museums and Centers section.)

## UNIVERSITY OF PENNSYLVANIA
### University of Pennsylvania Museum of Archaeology and Anthropology

The University of Pennsylvania Museum of Archaeology and Anthropology in Philadelphia is one of the world's leading archaeological, anthropological, and ethnographic museums. It is noted for its extensive explorations, collections, and exhibits that trace and interpret the life and works of primitive and ancient peoples.

Founded in 1887, the 246,000-square-foot museum has undergone five name changes. Started as the Museum of Archaeology and Paleontology, it became the Free Museum of Science and Art in 1890. In 1913, the name was changed to The University Museum. In more recent years, "of Archaeology and Anthropology" was added in 1989, and "of Pennsylvania" became part of the name in 1993.

The museum has engaged in more than 300 expeditions in 33 countries. The first excavation at Nippur in Iraq in 1888–1890 initiated a continuous program of Near Eastern research covering a period from 5000 B.C. to Roman times. Since then the museum's archaeological and ethnographic investigations have spread to many other parts of the world.

The museum's collections of approximately 1.5 million objects are organized into 10 sections: Africa, America (North, Central, and South American native materials), Asia, Egypt (pre-Islamic), Europe (paleolithic only), Historic America and Europe (currently not active), Mediterranean (Greco-Roman and related

materials), Near East (pre-Islamic), Oceania, and Physical Anthropology (responsible for all human remains except those of ancient Egypt).

The Near East Section holds archaeological materials from numerous sites, including Nippur and the Royal Cemetery of Ur in Iraq; Hasanlu, Hissar, and Islamic Rayy in Iran; and Beth Shan in Israel. It also has ethnographic material from Persia and South Russia. The Babylonian or Tablet Room has approximately 30,000 inscribed objects, predominately clay tablets, from the Near East.

The Egyptian Section has a wide range of materials from the royal tombs of Abydos, the New Kingdom palace of Merneptah at Thebes, the royal city of Memphis, and an early pyramid at Meydum; predynastic materials from Ballas and Naqada; Nubian artifacts from Buhen, Karanog, and Kerma; and Greco-Roman manuscripts from Oxyrhynchus.

Materials from throughout the Greco-Roman world can be found in the Mediterranean Section. Museum excavations have produced objects from Bronze Age Crete, the sites of Kourion and Lapithos on Cyprus, Etruria, Roman Minturnae in Italy, and Leptis Magna in Libya. Several topical collections focus on classical pottery, numismatics, gems, and glass.

The African Section possesses approximately 10,000 ethnographic objects from every major cultural area of the African continent. It is strongest in West Africa and Zaire, but also has a selection of sixteenth- to nineteenth-century Benin bronzes.

The Oceanian Section features ethnographic collections from the Pacific islands (Melanesia, Micronesia, and Polynesia), Australia, and insular Southeast Asia (the Philippines and Indonesia). The Asian Section holds both archaeological and ethnographic materials ranging from Pakistan to India, Southeast Asia, China, and Japan.

Archaeological and ethnographic materials from the whole of the American continents are in the American Section. The major collections include material from Alaskan, Greater Southwest, Great Plains, Mayan, and Peruvian peoples. The Europe Section is responsible for paleolithic materials from Europe and Africa.

The museum has 23 major long-term exhibits and 4 changing exhibition galleries. In general, the long-term exhibits feature inorganic archaeological materials, while the changing exhibitions focus on ethnographic and organic displays as well as traveling exhibitions. Five galleries each are devoted to ancient Egypt (sculpture, architecture, staler, daily life, and mummies) and the Americas (Alaska's native people, Mesoamerica, the Plains Indians, the American Southwest, and South America). The Near East and the Mediterranean are the subject of four galleries each, with the former dealing with the royal tombs of Ur, inscribed tablets, Biblical archaeology, and Islam and the latter with ancient Greece, Roman sculpture, the Bronze Age, and Etruria. Three galleries focus on Asia, including exhibits on India and Southeast Asia, China, and Buddhism. Polynesia and Africa are featured in single galleries.

University of Pennsylvania Museum of Archaeology and Anthropology, 33rd and Spruce Sts., Philadelphia, PA 19104-6324. Phone: 215/898-4000. Hours: 10–4:30 Tues.–Sat.; 1–5 Sun.; closed major holidays and summer Sundays from Memorial Day to Labor Day. Admission: suggested donations—adults, $5; seniors, students, and children, $2.50; university students and children under 6, free.

## UNIVERSITY OF PUERTO RICO
### Museum of Anthropology, History, and Art

The cultural history of Puerto Rico is featured at the Museum of Anthropology, History, and Art at the University of Puerto Rico in Rio Piedras. The museum, which was founded in 1940 and has 4,582 square feet of exhibit space, has collections of seventeenth- to twentieth-century Puerto Rican paintings, sculpture, prints, and drawings; international graphics; and archaeological, ethnographic, and historical materials.

Museum of Anthropology, History, and Art, University of Puerto Rico, Box 21908, UPR Station, Rio Piedras, PR 00931. Phone: 809/764-0000, Ext. 2452. Hours: 9–4:30 Mon.–Wed.; 9–9 Thurs.; 9–3 Sat.; closed holidays. Admission: free.

## UNIVERSITY OF SOUTH CAROLINA
### South Carolina Institute of Archaeology and Anthropology

The South Carolina Institute of Archaeology and Anthropology at the University of South Carolina in Columbia has collections of prehistoric and historic Native American artifacts, African-American and Euro-American archaeological materials, ethnographic objects, and fossil and geological specimens.

Founded in 1963, the institute has a 680-square-foot exhibit space and conducts research on the prehistory and history of South Carolina, French and Spanish presence in South Carolina, Civil War and plantation periods, paleo-Indian and protohistoric Indian fields, shipwrecks, and related areas.

South Carolina Institute of Archaeology and Anthropology, University of South Carolina, 1321 Pendleton St., Columbia, SC 29208. Phone: 803/777-8170. Hours: 8:30–5 Mon.–Fri.; closed major holidays and Christmas recess. Admission: free.

### McKissick Museum
(See General Museums section.)

## UNIVERSITY OF SOUTH DAKOTA
### W.H. Over State Museum

(See Unaffiliated Museums section.)

## UNIVERSITY OF TENNESSEE AT KNOXVILLE
### Frank H. McClung Museum

(See General Museums section.)

## UNIVERSITY OF TEXAS AT AUSTIN
### Texas Memorial Museum

(See Natural History Museums and Centers section.)

## UNIVERSITY OF TEXAS AT EL PASO
### Centennial Museum

(See Natural History Museums and Centers section.)

## UNIVERSITY OF TEXAS AT SAN ANTONIO
### University of Texas Institute of Texan Cultures at San Antonio

(See Historical Museums, Houses, and Sites section.)

## UNIVERSITY OF UTAH
### Utah Museum of Natural History

(See Natural History Museums and Centers section.)

## UNIVERSITY OF VERMONT
### Robert Hull Fleming Museum

(See Art Museums section.)

## UNIVERSITY OF WASHINGTON
### Thomas Burke Memorial Washington State Museum

The Thomas Burke Memorial Washington State Museum is an anthropology and natural history museum at the University of Washington in Seattle. It was founded in 1885 by the Young Naturalists, who received permission to build on the campus. By the end of the century, it had become the university museum and was designated the state museum in 1899. It assumed its present name and location in 1964 with a bequest from Judge Thomas Burke. The museum was part of the Department of Anthropology until recently, when it became an independent university unit.

The museum presents permanent and temporary exhibits in anthropology, archaeology, geology, paleobotany, and zoology, with a geographic focus on the State of Washington, the Pacific Northwest, and the Pacific region, in its 62,000-square-foot building.

The museum has artifact and specimen collections in such fields as anthropology (ethnology, 40,000; archaeology, 1 million); geology (invertebrate paleontology, 45,000; vertebrate paleontology, 2.6 million; paleontology, 17,000;

mineralogy, 19,000); and zoology (mammals, 32,000; birds, 45,000; spiders, 57,000; butterflies, 38,000; mollusks, 20,000).

Thomas Burke Memorial Washington State Museum, University of Washington, Burke Museum DB-10, Seattle, WA 98195. Phone: 206/543-2784. Hours: 10–5 daily. Admission: adults, $3; students, $2; seniors, $1; university students, free.

## UNIVERSITY OF WYOMING
### University of Wyoming Anthropology Museum

The University of Wyoming Anthropology Museum has collections and exhibits relating to ethnology, physical anthropology, human osteology, and archaeology. The ethnographic materials have an American Indian emphasis.

University of Wyoming Anthropology Museum, Anthropology Bldg., 14th and Invinson, Box 3431, Laramie, WY 82071. Phone: 307/776-5136. Hours: academic year—8–5 Mon.–Fri.; summer—7:30–4:30 Mon.–Fri.; closed holidays and when university not in session. Admission: free.

## WAKE FOREST UNIVERSITY
### Museum of Anthropology

Wake Forest University's Museum of Anthropology in Winston-Salem, North Carolina, contains collections and exhibits dealing with archaeology, anthropology, and ethnology. Founded in 1962, it has North and South American Indian artifacts, African art, Oceanic art and technology, and other such objects.

Museum of Anthropology, Wake Forest University, Wake Forest Dr., PO Box 7267, Reynolda Station, Winston-Salem, NC 27109-7201. Phone: 910/759-5282. Hours: 10–4:30 Tues.–Fri.; 2–4:30 Sat.–Sun.; closed major holidays. Admission: free.

## WASHINGTON STATE UNIVERSITY
### Museum of Anthropology

The Museum of Anthropology at Washington State University in Pullman has archaeological and ethnographic collections from western North America, South America, Africa, Asia, and Oceania; basketry from the western United States; and materials from China, South America, West Africa, and New Guinea. The museum was founded in 1966.

Museum of Anthropology, Washington State University, Dept. of Anthropology, Pullman, WA 99164-4910. Phone: 509/335-3441. Hours: Sept.–Apr.—10–4; closed holidays and when university not in session. Admission: free.

## WAYNE STATE UNIVERSITY
### Wayne State University Museum of Anthropology

The Wayne State University Museum of Anthropology in Detroit has archaeology, anthropology, ethnology, and history collections that include West Indian

and military artifacts, glass, ceramics, and manuscripts. The museum was founded in 1958 by the Department of Anthropology.

Wayne State University Museum of Anthropology, Dept. of Anthropology, 6001 Cass Ave., Detroit, MI 48202. Phone: 313/577-2598. Hours: call for hours; closed summer and holidays. Admission: free.

## WESTERN NEW MEXICO UNIVERSITY
### Western New Mexico University Museum

The Western New Mexico University Museum in Silver City began in 1974 when the Grant County Museum Association donated the Eisele Archaeological Collection to the university. It now has the world's largest permanent exhibit of Mimbres pottery. Among the other collections are Casas Grandes and Anasazi pottery, Southwest Native American stone tools and basketry, mining implements, historic photographs, and early physicians' buggies, as well as Editha Watson artwork and archives and the Alvan N. White Memorial archives and memorabilia.

Western New Mexico University Museum, Fleming Hall, 1000 College Ave., Silver City, NM 88061. Phone: 505/538-6386. Hours: 9–4:30 Mon.–Fri.; 10–4 Sat.–Sun.; closed holidays. Admission: free.

## WESTERN OREGON STATE COLLEGE
### Paul Jensen Arctic Museum

The cultural artifacts of the peoples of the Arctic region are collected and exhibited by the Paul Jensen Arctic Museum at Western Oregon State College in Monmouth. The museum, which opened in 1985, has 4,000 square feet of exhibits.

Paul Jensen Arctic Museum, Western Oregon State College, 590 W. Church St., Monmouth, OR 97361. Phone: 503/838-8486. Hours: 10–4 Tues.–Sat.; closed holidays. Admission: free.

## YALE UNIVERSITY
### Peabody Museum of Natural History

(See Natural History Museums and Centers section.)

## YESHIVA UNIVERSITY
### Yeshiva University Museum

The history, art, and culture of the world's Jews over 2,000 years are interpreted at the Yeshiva University Museum in New York City. The museum presents interdisciplinary exhibitions in its two main exhibit halls and changing contemporary art shows in four smaller galleries.

The 18,429-square-foot museum, which shares a building with the university's library and archives, has approximately 2,500 artifacts in it collections. Its holdings are particularly strong in ethnographic material, ephemera, and costume. The fine, decorative, and ceremonial art collections concentrate on the role of Jews as artists, subjects, and patrons, while manuscripts and printed materials reflect historic events, scribal and printing history, graphic art, and Jewish material culture.

A wide variety of domestic and commercial wares and ephemera are collected to show Jewish material culture in various periods and locations. Artifacts are chosen for ethnographic significance and as indicators of Jewish involvement in the decorative arts. Among the divers collection objects are paintings, drawings, graphics, photographs, sculpture, tapestries, architectural models, ceremonial objects, currency, manuscripts, books, furniture, household items, costumes, ephemera, and commercial and professional equipment. Artwork from local public schools, Hispanic artists, Washington Heights artists, and other artists and craftpersons working with Jewish themes are shown in the contemporary art galleries.

Yeshiva University Museum, 2520 Amsterdam Ave., New York, NY 10280. Phone: 212/960-5390. Hours: 10:30–5 Tues.–Thurs.; 12–6 Sun.; closed Jewish holidays. Admission: adults, $3; seniors and children 4–16, $1.50; Yeshiva students, free.

# Art Galleries

*Also see Art Museums; Costume and Textile Museums; Photography Museums; and Sculpture Gardens sections.*

## AGNES SCOTT COLLEGE
### *Dalton Art Gallery*

Contemporary art by local artists is the focus of the Dalton Art Gallery, founded in 1957, at Agnes Scott College in Decatur, Georgia. Among the gallery's holdings are the Harry L. Dalton, Steffan Thomas, Ferdinand Warren, and Clifford Clarke collections.

Dalton Art Gallery, Agnes Scott College, East College Ave., Decatur, GA 30030. Phone: 404/638-6000. Hours: 10–4 Mon.–Fri.; 2–4:30 Sun.; closed holidays and when college not in session. Admission: free.

## ALBERTSON COLLEGE OF IDAHO
### *Rosenthal Gallery of Art*

The Rosenthal Gallery of Art at Albertson College of Idaho in Caldwell schedules a variety of temporary exhibitions.

Rosenthal Gallery of Art, Albertson College of Idaho, 2112 Cleveland Blvd., Caldwell, ID 83605. Phone: 208/459-5426. Hours: 1–4 Tues.–Sat.; closed summer and holidays. Admission: free.

## ALBION COLLEGE
### Bobbitt Visual Arts Center

Albion College's Bobbitt Visual Arts Center in Albion, Michigan, has two art galleries and a print collection.

Bobbitt Visual Arts Center, Albion College, Albion, MI 49224. Phone: 517/629-0246. Hours: 9–5 and 6:30–10 Mon.–Thurs.; 9–5 Fri.; 10–4 Sat.; 2–5 Sun.; closed when college not in session. Admission: free.

## ALBRIGHT COLLEGE
### Freedman Gallery

Changing exhibitions of contemporary art are presented at the Freedman Gallery at Albright College in Reading, Pennsylvania. The gallery, founded in 1976, has 2,800 square feet of exhibition space and a collection of paintings, drawings, prints, photographs, and sculpture by contemporary American artists.
Freedman Gallery, Albright College, 1621 N. 13th St., PO Box 15234, Reading, PA 19612-5234. Phone: 215/921-7616. Hours: academic year—12–4 daily (also to 8 Thurs.); summer—12–4 Mon.–Fri.; closed major holidays. Admission: Free.

## ALLEGHENY COLLEGE
### Allegheny College Art Galleries

Three galleries—Bowman, Penelec, and Megahan galleries—comprise the Allegheny College Art Galleries in Meadville, Pennsylvania. The gallery program, started in 1970, emphasizes twentieth-century prints and photographs in 4,000 square feet of exhibition space.
Allegheny College Art Galleries, N. Main St., Box U, Meadville, PA 16335. Phone: 814/332-4365. Hours: 12:30–5 Tues.–Fri.; 1:30–5 Sat.; 2–4 Sun.; closed major holidays. Admission: free.

## AMERICAN UNIVERSITY
### Watkins Gallery

The Art Department at American University in Washington, D.C., established the Watkins Gallery in 1947 as a memorial to C. Law Watkins, an artist and educator, for the purpose of displaying the Watkins Collection of Fine Art, temporary professional shows, and student exhibitions.

The Watkins Collection, started with donations by 25 Washington artists, has grown to over 1,500 artworks, featuring contemporary paintings, drawings, and prints from the United States and Europe—with many from the Washington area.

Four to five major exhibitions are presented annually in the gallery. They include works of contemporary artists, historical collections, and selections from the Watkins Collection. Student exhibitions are scheduled for the remainder of the year. Funds are being raised for a new $12 million arts facility, which will provide enlarged space for the 725-square-foot gallery.

Watkins Gallery, Art Dept., American University, 4400 Massachusetts Ave., NW, Washington, DC 20016-8004. Phone: 202/885-1064. Hours: 10–4 Mon.–Fri.; 1–5 Sat.; closed holidays. Admission: free.

## ANNA MARIA COLLEGE
### Moll Art Center

The Moll Art Center at Anna Maria College in Paxton, Massachusetts, has a 2,468-square-foot gallery for changing exhibitions. The gallery, founded in 1972, presents exhibitions by students and professional artists.

Moll Art Center, Anna Maria College, Paxton, MA 01612. Phone: 508/849-3300. Hours: 9–4 Mon.–Fri.; closed major holidays and when college not in session. Admission: free.

## ARIZONA STATE UNIVERSITY

Arizona State University in Tempe has three galleries—the Harry Wood Art Gallery, Gallery of Design, and Memorial Union Gallery.

### Harry Wood Art Gallery

The Harry Wood Art Gallery at Arizona State University in Tempe features exhibitions by Master of Fine Arts students. The gallery was started in 1977.

Harry Wood Art Gallery, Arizona State University, School of Art, Tempe, AZ 85287. Phone: 602/965-5044. Hours: 8–5 Mon.–Fri.; closed holidays and when university not in session. Admission: free.

### Gallery of Design

The College of Architecture and Environmental Design at Arizona State University in Tempe presents professional and student work in interior and industrial design, planning and landscape architecture, and architecture in its Gallery of Design. Opened in 1968, the gallery has collections of architectural drawings by Blaine Drake, Alfred Newman Beadle, Paul Schweikert, Paolo Soleri, and Frank Lloyd Wright.

Gallery of Design, Arizona State University, College of Architecture and Environmental Design, Box 1905, Tempe, AZ 85287. Phone: 602/965-6384. Hours: 8–5 Mon.–Fri.; closed holidays and when university not in session. Admission: free.

### Memorial Union Gallery

The Memorial Union Gallery at Arizona State University in Tempe is a 2,400-square-foot student-operated gallery and learning laboratory that has been part of the student union building since 1956.

Memorial Union Gallery, Arizona State University, Memorial Union Bldg., Tempe, AZ 85287. Phone: 602/965-6649. Hours: 8–5 daily; closed when university not in session. Admission: free.

## ARKANSAS STATE UNIVERSITY
### Fine Arts Center Gallery

This Arkansas State University gallery was opened in 1967 when the Fine Arts Center in State University was completed. Its initial collections, consisting largely of twentieth-century artworks, came from corridors and offices throughout the university. The gallery features traveling shows and student works.
Fine Arts Center Gallery, Arkansas State University, PO Box 1920, State University, AR 72467. Phone: 501/972-3050. Hours: 9–4 Mon.–Fri.; closed when university not in session. Admission: free.

## ART INSTITUTE OF BOSTON
### Gallery East and Gallery West

The Art Institute of Boston has two galleries. Gallery East features contemporary works by faculty members and professional artists, while Gallery West displays the works of students.
Gallery East/Gallery West, Art Institute of Boston, 700 Beacon St., Boston, MA 02215. Phone: 617/262-1223. Hours: 9–5:30 Mon.–Fri.; 9–5 Sat.; 12–5 Sun.; closed major holidays. Admission: donation suggested.

## ATLANTA COLLEGE OF ART
### Atlanta College of Art Gallery

Contemporary works are shown at the Atlanta College of Art Gallery, a recently expanded 3,000-square-foot exhibition space, in Atlanta. The college and the gallery are part of the Woodruff Arts Center.
Atlanta College of Art Gallery, Woodruff Arts Center, 1280 Peachtree St., NE, Atlanta, GA 30309. Hours: 10–5 Mon.–Sat.; closed holidays. Admission: free.

## AUGUSTANA COLLEGE
### Augustana College Art Gallery

The Augustana College Art Gallery, operated by the Art and Art History Department, is located in the lobby of the Fine Arts Building auditorium in Rock Island, Illinois. It features changing exhibitions that complement the liberal arts curriculum. The department also has a collection of Swedish-American artworks.
Augustana College Art Gallery, Art and Art History Dept., 3701 Seventh Ave., Rock Island, IL 61201-2296. Phone: 309/794-7231. Hours: 12–4 daily; closed holidays and when college not in session. Admission: free.

## AUSTIN PEAY STATE UNIVERSITY
### Trahern Gallery

Contemporary works by regional artists are featured in the Trahern Gallery at Austin Peay State University in Clarksville, Tennessee. The 2,000-square-foot gallery, which opened in 1974, has collections of contemporary drawings, prints, watercolors, and photographs. The gallery director also manages the Harned Gallery and the university's permanent art collection.

Trahern Gallery, Austin Peay State University, College and Eighth Sts., PO Box 4677, Clarksville, TN 37044. Phone: 615/648-7334. Hours: 9–4 Mon.–Fri.; 10–2 Sat.; 1–4 Sun.; closed holidays and when university not in session. Admission: free.

## AVILA COLLEGE
### Thornhill Gallery

The Thornhill Gallery at Avila College in Kansas City, Missouri, presents temporary and traveling exhibitions of a contemporary nature.

Thornhill Gallery, Avila College, 11901 Wornall Rd., Kansas City, MO 64145. Phone: 816/942-8400. Hours: 1–7 Mon.–Thurs.; 1–5 Fri.; closed major holidays. Admission: free.

## BARTON COLLEGE
### Case Art Gallery

All types of artworks by students and faculty are exhibited at the Case Art Gallery, founded in 1965 at Barton College in Wilson, North Carolina.

Case Art Gallery, Barton College, Whitehead and Gold Sts., Wilson, NC 27893. Phone: 919/399-6477. Hours: 10–4:30 Mon.–Fri.; 1–3 Sat.; closed holidays and when college not in session. Admission: free.

## BAYLOR UNIVERSITY
### University Art Gallery

The Department of Art at Baylor University in Waco, Texas, operates the University Art Gallery, as well as the Martin Museum of Art, in the Hooper-Schaefer Fine Arts Center. The gallery normally presents seven faculty, student, and traveling exhibitions each year.

University Art Gallery, Baylor University, Dept. of Art, Hooper-Schaefer Fine Arts Center, PO Box 97263, Waco, TX 76498-7263. Phone: 817/755-1011. Hours: 10–5 Tues.–Fri.; 2–5 Sat.; closed holidays and when university not in session. Admission: free.

## BEAVER COLLEGE
### Beaver College Art Gallery

Contemporary visual art is shown at the 1,200-square-foot Beaver College Art Gallery in Glenside, Pennsylvania. The gallery is housed in a ca. 1893 historic building.
Beaver College Art Gallery, Church and Easton Rds., Glenside, PA 19038. Phone: 215/572-2900. Hours: 10–3 Mon.–Fri.; 1–4 Sun.; closed Jan., Thanksgiving, and Christmas. Admission: free.

## BEREA COLLEGE
### Doris Ulmann Galleries

Changing exhibitions of contemporary artworks and selections from permanent collections are featured at the Doris Ulmann Galleries in the Rogers Memorial Building at the edge of the Berea College campus in Berea, Kentucky. In 1993–1994, 16 such exhibitions were presented by the Art Department.

In 1977, an extension was added to the 1935 Georgian building to provide more space for the Samuel H. Kress Collection of Renaissance paintings and sculpture, about 5,000 Ulmann photographs, a collection of prints, and African, Oriental, and other paintings, sculpture, crafts, and textiles.

Among the holdings are Stuart's *Portrait of George Washington,* Dürer's *Life of the Virgin,* Blake's *Book of Job,* Goya's *Tauromachia,* Johnson's *Boy Lincoln,* and works by Moran, Inness, and Tanner.
Doris Ulmann Galleries, Berea College, Art Dept., Berea, KY 40404. Phone: 606/986-9341. Hours: 8 A.M.–9 P.M. Mon.–Thurs.; 8–5 Fri.; 1–5 Sun.; closed holidays and when college not in session. Admission: free.

## BETHANY COLLEGE
### Birger Sandzen Memorial Gallery

(See Art Museums section.)

## BLOOMSBURG UNIVERSITY OF PENNSYLVANIA
### Haas Gallery of Art

The Haas Gallery of Art at Bloomsburg University of Pennsylvania in Bloomsburg presents temporary exhibitions on the 8,000-square-foot balcony of the university's auditorium. Founded in 1970, the gallery also has paintings in various university buildings and permanent sculpture throughout the campus in Bloomsburg.

Haas Gallery of Art, Bloomsburg University of Pennsylvania, Auditorium, Bloomsburg, PA 17815. Phone: 717/389-4646. Hours: 8:30–4 Mon.–Fri.; 9–4 Sat.; closed holidays and when university not in session. Admission: free.

# BOSTON UNIVERSITY
## Boston University Art Gallery

Exhibitions featuring the work of major American artists, as well as shows focusing on regional art, can be seen at the Boston University Art Gallery. The gallery was established in 1959.

Boston University Art Gallery, 855 Commonwealth Ave., Boston, MA 02215. Phone: 617/353-4672. Hours: 10–5 Tues.–Fri.; 1–5 Sat.–Sun.; closed holidays and when university not in session. Admission: free.

# BOWLING GREEN STATE UNIVERSITY
## Dorothy Uber Bryan, Hiroko Nakamoto, and School of Art Galleries

Three contemporary art galleries—the Dorothy Uber Bryan, Hiroko Nakamoto, and School of Art galleries—are located in the Fine Arts Center at Bowling Green State University in Bowling Green, Ohio. They present both media- and concept-based exhibitions and have key roles in the annual New Music and Art Festival on the campus.

The 2,400-square-foot School of Art Gallery was founded in 1960 with the construction of the Fine Arts Center. In 1992, the 4,681-square-foot Dorothy Uber Bryan Gallery and 821-square-foot Hiroko Nakamoto Gallery were opened as part of the new addition to the building.

Dorothy Uber Bryan, Hiroko Nakamoto, and School of Art Galleries, Bowling Green State University, Fine Arts Center, Bowling Green, OH 43403. Phone: 419/372-8525. Hours: 9–4:30 Mon.–Fri.; 2–5 Sun.; closed holidays and when university not in session. Admission: free.

# BRENAU UNIVERSITY
## Brenau University Galleries

The Brenau University Galleries in Gainesville, Georgia, offer exhibitions in two locations—in the Simmons Visual Arts Center, a recently renovated 1914 structure, and outside the balcony area of the restored 1880s Pearce Auditorium. The exhibitions feature paintings, drawings, prints, sculpture, and photographs by American artists. The galleries opened in 1983.

Brenau University Galleries, 1 Centennial Cir., Gainesville, GA 30501. Phone: 404/534-6299. Hours: academic year—10–4 Mon.–Fri.; 1–5 Sun.; summer—1–4 Mon.–Thurs.; closed major holidays and Christmas recess. Admission: free.

## BREVARD COLLEGE
### Sims Art Center

Exhibitions of American contemporary art are featured at the Sims Art Center at Brevard College in Brevard, North Carolina.

Sims Art Center, Brevard College, Brevard, NC 28712. Phone: 704/883-8292. Hours: 10–5 Mon.–Fri.; closed holidays and when college not in session. Admission: free.

## BROWN UNIVERSITY
### David Winton Bell Gallery

The David Winton Bell Gallery at Brown University presents five to seven major modern and historical exhibitions, as well as an annual Graduate Exhibition, culminating more than a year's work by second-year students in the History of Art and Architecture Graduate Program.

The museum, opened in 1972 and located on the first floor of the List Art Center on the Providence, Rhode Island, campus, maintains a collection of 3,500 prints, drawings, and photographs from 1500 to the present and a collection of more than 200 twentieth-century paintings and sculptures that includes work by Bannard, Bontecou, Caro, Motherwell, Olitski, Poons, Stella, and Trova.

David Winton Bell Gallery, Brown University, List Art Center, 64 College St., Providence, RI 02912. Phone: 401/863-2932. Hours: Sept.–June—11–4 Mon.–Fri.; 1–4 Sat.–Sun.; closed July–Aug., New Year's Day, and Christmas. Admission: free.

## BUCKNELL UNIVERSITY
### Center Gallery

Exhibitions ranging from Pennsylvania quilts to contemporary art are offered by the Center Gallery at Bucknell University in Lewisburg, Pennsylvania. Opened in 1983, the gallery has a number of collections, including the Samuel Kress Collection of Renaissance paintings and the Andrew Sordoni Collection of Japanese art.

Center Gallery, Bucknell University, Elaine Langone Center, Lewisburg, PA 17837. Phone: 717/524-3792. Hours: 11–6 Mon.–Fri.; 1–4 Sat.–Sun.; closed major holidays. Admission: free.

## BUCKS COUNTY COMMUNITY COLLEGE
### Hicks Art Gallery and Atrium Gallery

The Hicks Art Center at Bucks County Community College in Newton, Pennsylvania, has two galleries—the Hicks Art Gallery for changing contemporary exhibitions and the Atrium Gallery for student work.

Hicks Art Gallery and Atrium Gallery, Bucks County Community College, Hicks Art Center, Swamp Rd., Newton, PA 18940. Phone: 215/968-8432. Hours: academic year— 8:30–4 Mon. and Fri.; 8:30–8 Tues.–Thurs.; 9–1 Sat.; summer—8:30–4 Mon.–Sat.; closed holidays. Admission: free.

### Artmobile

The Division of the Arts at Bucks Community College in Newton, Pennsylvania, operates an Artmobile that travels to elementary and secondary schools in the area during the school year. Started in 1975, the 336-square-foot art van spends from a day to a week at a school. It is accompanied by a staff member who frequently gives art presentations in classes. The exhibits change each year. Artmobile, Bucks County Community College, Hicks Art Center, Swamp Rd., Newton, PA 18940. Phone: 215/960-8432. Hours: by appointment during school year; closed summer and holidays. Admission: $300 per school showing.

## CALIFORNIA COLLEGE OF ARTS AND CRAFTS
### Oliver Art Center Gallery

Contemporary art exhibitions in all media are presented at the Oliver Art Center Gallery at the California College of Arts and Crafts in Oakland.
Oliver Art Center Gallery, California College of Arts and Crafts, 5212 Broadway, Oakland, CA 94618. Phone: 510/653-8118. Hours: 10–4 Mon.–Sat.; closed holidays. Admission: free.

## CALIFORNIA STATE UNIVERSITY, CHICO
### Janet Turner Print Gallery

Historical and contemporary prints are exhibited at the Janet Turner Print Gallery at California State University, Chico. The gallery, founded in 1981, has a collection of original fine arts prints, professional and student prints, and prints from more than 40 countries.
Janet Turner Print Gallery, California State University, Chico, Chico, CA 95929-0820. Phone: 916/898-4476. Hours: 11–4 Mon.–Fri.; closed major holidays and when university not in session. Admission: free.

## CALIFORNIA STATE UNIVERSITY, DOMINGUEZ HILLS
### University Art Gallery

The University Art Gallery in the Humanities and Fine Arts Building at California State University, Dominguez Hills, in Carson focuses on contemporary art and multicultural exhibitions.
University Art Gallery, California State University, Dominguez Hills, 1000 E. Victoria St., Carson, CA 90747. Phone: 310/516-3334. Hours: 9:30–4:30 Mon.–Thurs.; closed holidays and when university not in session. Admission: free.

## CALIFORNIA STATE UNIVERSITY, FULLERTON
### *Art Gallery*

The Art Gallery at California State University, Fullerton, is located in the Visual Arts Center. Founded in 1967 by the Department of Art, it features temporary and traveling exhibitions, usually of contemporary art. The collections include contemporary lithographs and pre-Columbian artifacts.

Art Gallery, California State University, Fullerton, Visual Arts Center, 800 N. State College Blvd., Fullerton, CA 92631. Phone: 714/773-3262. Hours: 12–4 Mon.–Fri.; 2–5 Sun.; closed holidays. Admission: free.

## CALIFORNIA STATE UNIVERSITY, NORTHRIDGE
### *Art Galleries*

The Art Galleries program at California State University, Northridge, includes contemporary, international, and eclectic art. Among the diverse topics of recent exhibitions have been Cypriot vases, recycled art, and the art of fly tying. The gallery, opened in 1959, draws upon the university's collections for some exhibitions. The collections emphasize contemporary American works, such as paintings by Hans Burkhardt and drawings and prints by Mark Tobey and Arshile Gorky. It also has African artifacts and sculpture.

Art Galleries, California State University, Northridge, 18111 Nordhoff St., Northridge, CA 91330. Phone: 818/885-2226. Hours: 12–4 Mon.; 10–4 Tues.–Sat.; closed summer. Admission: free.

## CALIFORNIA STATE UNIVERSITY, SAN BERNARDINO
### *University Art Gallery*

In addition to presenting contemporary art exhibitions, the University Art Gallery at California State University, San Bernardino, has collections of Asian ceramics, African sculpture, and Egyptian art. Gallery space was increased from 2,000 to 8,000 square feet in a new building in 1995.

University Art Gallery, California State University, San Bernardino, 5500 University Pkwy., San Bernardino, CA 92407-2397. Phone: 909/880-5823. Hours: 9–4 Mon.–Fri.; closed holidays and when university not in session. Admission: free.

## CALVIN COLLEGE
### *Center Art Gallery*

The Center Art Gallery at Calvin College in Grand Rapids, Michigan, presents varied exhibitions that change monthly. It is located in the Art Department on the lower level of the Spoelhof Center.

Center Art Gallery, Calvin College, Spoelhof Center, 3201 Burton St., SE, Grand Rapids, MI 49546. Phone: 616/957-6326. Hours: 9–9 Mon.–Thurs.; 9–5 Fri.; 12–4 Sat.; closed holidays and when college not in session. Admission: free.

## CAPITAL UNIVERSITY
### Schumacher Gallery

(See Art Museums section.)

## CAZENOVIA COLLEGE
### Chapman Art Center Gallery

Exhibitions of paintings, sculpture, prints, and photographs are presented at the Chapman Art Center Gallery at Cazenovia College in Cazenovia, New York. Founded in 1978, the gallery features the work of faculty and students, as well as regional and other artists.

Chapman Art Center Gallery, Cazenovia College, Cazenovia, NY 13035. Phone: 315/655-9446. Hours: 1–4 and 7–9 Mon.–Thurs.; 1–4 Fri.; 2–6 Sat.–Sun.; closed major holidays and when college not in session. Admission: free.

## CENTENARY COLLEGE OF LOUISIANA
### Magale Library Gallery and Turner Art Center Gallery

The Department of Art at Centenary College of Louisiana in Shreveport presents exhibitions in two galleries on the campus. The Magale Library Gallery shows artworks from around the world, as well as historical and cultural exhibits, while the Turner Art Center Gallery displays changing contemporary art exhibitions. Student art exhibitions also are scheduled at both locations.

Magale Library Gallery, Centenary College of Louisiana, Woodlawn Ave., Shreveport, LA 71134. Phone: 318/869-5620. Hours: academic year—8 A.M.–10 P.M. Mon.–Thurs.; 8–5 Fri.; 2–5 Sat.; 2–10 Sun.; summer—more limited hours; closed holidays. Admission: free.

Turner Art Center Gallery, Centenary College of Louisiana, Dept. of Art, Turner Art Center, 3000 Centenary Blvd., Shreveport, LA 71104. Phone: 318/869-5260. Hours: 10–8 Mon.–Thurs.; 10–5 Fri.; 1–4 Sat.–Sun.; closed holidays and when university not in session. Admission: free.

## CENTER FOR CREATIVE STUDIES–COLLEGE OF ART AND DESIGN
### Center Galleries

The Center for Creative Studies–College of Art and Design in Detroit presents recent work in all media by local and nationally known artists—as well as students—in its Center Galleries. The exhibition space, which opened in 1989, is located in a building near the campus.

Center Galleries, Center for Creative Studies–College of Art and Design, 15 E. Kirby St., Detroit, MI 48202-4034. Phone: 313/874-1955. Hours: 10–5 Tues.–Sat.; closed Aug. and holidays. Admission: free.

## CENTRAL METHODIST COLLEGE
### Ashby-Hodge Gallery of American Art

A new art gallery—the Ashby-Hodge Gallery of American Art—was opened in 1993 at Central Methodist College in Fayette, Missouri. The gallery, located in the library building, presents changing exhibitions of contemporary art by midwestern artists in addition to selections from its American art collection.
Ashby-Hodge Gallery of American Art, Central Methodist College, Library, Fayette, MO 65248. Phone: 816/248-3391. Hours: 1:30–4:30 Tues.–Thurs.; closed holidays. Admission: free.

## CHAFFEY COMMUNITY COLLEGE
### Wignall Museum/Gallery

The Wignall Museum/Gallery at Chaffey Community College in Rancho Cucamonga, California, features works by emerging artists in southern California. It also schedules traveling exhibitions and sometimes has shows on historical, scientific, anthropological, and other topics. It does not have a permanent collection.
Wignall Museum/Gallery, Chaffey Community College, 5885 Haven Ave., Rancho Cucamonga, CA 91737-3002. Phone: 909/941-2388. Hours: 10–4 Mon.–Fri.; 12–4 Sun.; closed holidays. Admission: free.

## CITY UNIVERSITY OF NEW YORK, BARUCH COLLEGE
### Sidney Mishkin Gallery

The Sidney Mishkin Gallery at Baruch College, part of the City University of New York system, presents small, scholarly oriented loan exhibitions in the College Administrative Center in New York City.
Sidney Mishkin Gallery, Baruch College, City University of New York, 135 E. 22nd St., New York, NY 10010. Phone: 212/387-1006. Hours: 12–5 Mon.–Fri. (also to 7 Thurs.); closed holidays and when college not in session. Admission: free.

## CITY UNIVERSITY OF NEW YORK, BROOKLYN COLLEGE
### Art Gallery of Brooklyn College

The Art Gallery of Brooklyn College of the City University of New York in Brooklyn, New York, presents changing contemporary exhibitions. The gallery, located on the ground floor of LaGuardia Hall, opened in 1987.

Art Gallery of Brooklyn College, City University of New York, Bedford Ave. and Ave. H, Brooklyn, NY 11210. Phone: 718/951-5907. Hours: 12:30–4:30 Mon.–Fri.; closed holidays and when college not in session. Admission: free.

## CITY UNIVERSITY OF NEW YORK, LEHMAN COLLEGE
### Lehman College Art Gallery

Contemporary and urban art of special interest to minorities is featured by the Art Gallery at Lehman College of the City University of New York in the Bronx, New York. The gallery, founded in 1985, has over 4,000 square feet of exhibition space in the Fine Arts Building.
Lehman College Art Gallery, Lehman College, City University of New York, Fine Arts Bldg., 250 Bedford Park Blvd., W., Bronx, NY 10468-1589. Phone: 718/960-8752. Hours: 10–4 Tues.–Sat.; Mon. by appointment; closed holidays. Admission: free.

## CITY UNIVERSITY OF NEW YORK, QUEENS COLLEGE
### Queens College Art Center

The Queens College Art Center at Queens College, City University of New York, in New York City presents exhibitions by emerging artists, arts groups, and Latin American and Spanish artists. The gallery is operated by the Benjamin S. Rosenthal Library, where it occupies the top floor.
Queens College Art Center, Queens College, City University of New York, Benjamin S. Rosenthal Library, 65-30 Kissena Blvd., New York, NY 11367. Phone: 718/997-3770. Hours: 9–5 Mon.–Fri.; closed when college not in session. Admission: free.

## CLARION UNIVERSITY OF PENNSYLVANIA
### Sandford Gallery

Contemporary American art is the focus of the Sandford Gallery at Clarion University of Pennsylvania in Clarion. Founded in 1982, the gallery has collections of nineteenth- and twentieth-century American art and Kuba textiles.
Sandford Gallery, Clarion University of Pennsylvania, Marwick-Boyd Fine Arts Bldg., Clarion, PA 16214. Phone: 814/226-2412. Hours: 10–3 Mon.–Fri.; 2–4 Sun.; closed holidays and when university not in session. Admission: free.

## CLEMSON UNIVERSITY
### Rudolph E. Lee Gallery

Contemporary paintings and graphics and architectural designs and models are featured at the Rudolph E. Lee Gallery in the College of Architecture at Clemson University in Clemson, South Carolina. Student and faculty exhibitions are interspersed with traveling and special shows at the gallery, founded in 1956.

Rudolph E. Lee Gallery, Clemson University, College of Architecture, Lee Hall, Clemson, SC 29634. Phone: 803/656-3084. Hours: 9–4:30 Mon.—Fri.; closed holidays. Admission: free.

## CLEVELAND STATE UNIVERSITY
## Art Gallery

The Cleveland State University Art Gallery in Cleveland, Ohio, presents contemporary and historical exhibitions in a 4,500-square-foot exhibit space. Founded in 1973, the gallery has a collection of mostly nineteenth-century African objects, including masks, sculpture, and decorative utilitarian materials.
Art Gallery, Cleveland State University, 2307 Chester Ave., Cleveland, OH 44114. Phone: 216/687-2103. Hours: 9–5 Mon.–Fri.; 1–4 Sat.; closed holidays. Admission: free.

## COKER COLLEGE
## Cecelia Coker Bell Gallery

The Cecelia Coker Bell Gallery at Coker College in Hartsville, South Carolina, is primarily a teaching gallery that features faculty, student, and alumni art. It was founded in 1983.
Cecelia Coker Bell Gallery, Coker College, 300 E. College Ave., Hartsville, SC 29550. Phone: 803/383-8150. Hours: 10–4:30 Mon.–Fri.; closed major holidays and when college not in session. Admission: free.

## COLGATE UNIVERSITY
## Picker Art Gallery

The Picker Art Gallery was established in 1966 at Colgate University in Hamilton, New York, to ''provide University students and the wider community with visual and intellectual evidence of the world's creative potential.'' It is located in the Charles A. Dana Arts Center and has a diverse collection of paintings, sculpture, prints, drawings, photographs, and posters.

The gallery has three exhibition areas—devoted to antiquities and Asian, African, and Old Master works from the permanent collection; twentieth-century paintings and sculpture; and a changing temporary exhibition program. The collections of over 6,000 works include the Luis de Hoyos Collection of pre-Columbian art, Luther W. Brady Collection of works on paper, Theodore Herman Collection of Asian art, and Japanese Print Series of Tokaido Road.
Picker Art Gallery, Colgate University, Charles A. Dana Arts Center, 13 Oak Dr., Hamilton, NY 13346-1398. Phone: 315/824-7634. Hours: 10–5 daily; closed holidays. Admission: free.

## COLLEGE OF THE ATLANTIC
### Ethel H. Blum Art Gallery

The Ethel H. Blum Art Gallery opened in 1993 in the newly completed Thomas S. Gates Community Center off the central courtyard of the College of the Atlantic campus in Bar Harbor, Maine. It mounts from 8 to 10 landscape, natural history, and student and faculty exhibitions each year.

Ethel H. Blum Art Gallery, College of the Atlantic, 105 Eden St., Bar Harbor, ME 04609-1105. Phone: 207/288-5015. Hours: 11–5 Tues.–Fri.; 11–5 Sat.; closed holidays. Admission: free.

## COLLEGE OF CHARLESTON
### Halsey Gallery

Contemporary art is featured at the Halsey Gallery, founded in 1978 and operated by the School of the Arts at the College of Charleston in Charleston, South Carolina.

Halsey Gallery, College of Charleston, School of the Arts, Charleston, SC 29424. Phone: 803/953-5680. Hours: 11–4 Mon.–Sat.; closed major holidays and when college not in session. Admission: free.

## COLLEGE OF EASTERN UTAH
### Gallery East

Exhibitions of paintings, prints, and other artworks are presented at the College of Eastern Utah's Gallery East in Price. The gallery, opened in 1972, also has a Student Annual and a small collection of sculpture, paintings, prints, ceramics, and drawings.

Gallery East, College of Eastern Utah, 451 E. 400 North, Price, UT 84501. Phone: 801/637-2120. Hours: 8–5 Mon.–Fri.; closed holidays and when college not in session. Admission: free.

## COLLEGE OF THE HOLY CROSS
### Iris and B. Gerald Cantor Art Gallery

The Iris and B. Gerald Cantor Art Gallery at the College of the Holy Cross in Worcester, Massachusetts, presents exhibitions of historical and contemporary art and social issues. The gallery has a collection that includes 10 sculptures by Rodin and others. Founded in 1983, it is located in a late-nineteenth-century building that also houses the central administration and some academic departments.

Iris and B. Gerald Cantor Art Gallery, College of the Holy Cross, 1 College St., Worcester, MA 01610. Phone: 508/793-3356. Hours: 11–4 Mon.–Fri.; 2–5 Sat.–Sun.; closed when college not in session. Admission: free.

## COLLEGE OF MOUNT SAINT JOSEPH
### Studio San Giuseppe Art Gallery

Fine art and craft exhibitions by emerging and established regional artists are presented by the Studio San Giuseppe Art Gallery at the College of Mount Saint Joseph in Cincinnati, Ohio. The gallery opened in 1962 on the first floor of the Dorothy Meyer Ziv Art Building.

Studio San Giuseppe Art Gallery, College of Mount St. Joseph, 5701 Delhi Rd., Cincinnati, OH 45233-1610. Phone: 512/244-4314. Hours: 10–5 Mon.–Fri.; 1:30–4:30 Sat.–Sun.; closed holidays and when college not in session. Admission: free.

## COLLEGE OF NOTRE DAME
### Wiegand Gallery

The Wiegand Gallery at the College of Notre Dame in Belmont, California, is located in the Madison Art Center, which once was a carriage house for the William Ralston estate. The gallery, named for E.L. Wiegand, who provided funds for its renovation, exhibits contemporary art with an emphasis on California artists.

Wiegand Gallery, College of Notre Dame, Madison Art Center, 1500 Ralston Ave., Belmont, CA 94002. Phone: 415/508-3595. Hours: 12–4 Tues.–Sat.; closed holidays and when college not in session. Admission: free.

## COLLEGE OF SAINT BENEDICT
### Benedicta Arts Center

The College of Saint Benedict in St. Joseph, Minnesota, has an art gallery in the Benedicta Arts Center, which opened in 1963. The college has a collection of Oriental and New Guinea artifacts and contemporary prints, drawings, paintings, sculpture, and ceramics, which sometimes are shown in the gallery.

Benedicta Arts Center, College of St. Benedict, 37 S. College Ave., St. Joseph, MN 56374. Phone: 612/363-5777. Hours: 9–4:30 Mon.–Sat.; 1–4:30 Sun.; closed major holidays. Admission: free.

## COLORADO STATE UNIVERSITY

Colorado State University in Fort Collins has four exhibition galleries—three featuring artworks and one specializing in historical costumes and textiles. They are the Curfman Gallery, Duhesa Lounge, Hatton Gallery, and Gustafson Gallery (described in the Costume and Textile Museums section).

### Curfman Gallery and Duhesa Lounge

Two exhibition areas—the Curfman Gallery and the Duhesa Lounge—can be found in the Lory Student Center at Colorado State University in Fort Collins. Opened in 1968, the spaces are used for changing exhibitions, mostly of contemporary art.

Curfman Gallery and Duhesa Lounge, Colorado State University, Lory Student Center, Fort Collins, CO 80523. Phone: 970/491-0423. Hours: 8:30–4:30 and 7–9:30 Mon.–Fri.; 1–4 Sun.; closed Thanksgiving and when university not in session. Admission: free.

### Hatton Gallery

The Hatton Gallery at Colorado State University in Fort Collins presents changing exhibitions of contemporary prints, posters, and other works. Founded in 1970 and located in the Visual Arts Building, the gallery has collections of Japanese prints, Pop movement prints, and graduate student work.

Hatton Gallery, Colorado State University, Visual Arts Bldg., Fort Collins, CO 80523. Phone: 970/491-6774. Hours: 8–12 and 1–4:30 Mon.–Fri.; closed major holidays. Admission: free.

## COLUMBIA COLLEGE CHICAGO
### Columbia College Art Gallery

Contemporary art and designs are presented at the Columbia College Art Gallery in Chicago.

Columbia College Art Gallery, 72 E. 11th St., Chicago, IL 60605. Phone: 312/663-1600. Hours: 10–4 Mon.–Fri.; closed summer and major holidays. Admission: free.

## COLUMBIA UNIVERSITY
### Miriam and Ira D. Wallach Art Gallery

The Miriam and Ira D. Wallach Art Gallery has 2,300 square feet for changing exhibitions in the 1897 Schermerhorn Hall at Columbia University in New York City. The gallery, established in 1986 and located on the eighth floor, presents from two to four exhibitions during the academic year.

Miriam and Ira D. Wallach Art Gallery, Columbia University, 826 Schermerhorn Hall, 116th St. and Broadway, New York, NY 10027. Phone: 212/854-7288. Hours: 1–5 Wed.–Sat.; closed summer and holidays. Admission: free.

## CONCORDIA COLLEGE
### Marxhausen Art Gallery

Contemporary prints, paintings, ceramics, and glass are displayed in the Marxhausen Art Gallery at Concordia College in Seward, Nebraska. The gallery, founded in 1951, previously was known as the Koenig Art Gallery.

Marxhausen Art Gallery, Concordia College, 800 N. Columbus Ave., Seward, NE 68434. Phone: 402/643-3651. Hours: 9–1 Mon.–Fri.; 1–4 Sat.–Sun.; closed major holidays and when college not in session. Admission: free.

## CONCORDIA UNIVERSITY WISCONSIN
### Concordia University Gallery

Eight exhibitions are presented each year by the Concordia University Gallery in Mequon, Wisconsin. They include works by professionals, faculty, and students and selections from a collection that includes religious art, Lanceré and Grachev bronzes, and Seidel porcelains. The gallery opened in 1983.
Concordia University Gallery, Concordia University Wisconsin, N. Lake Shore Dr., Mequon, WI 53092. Phone: 414/243-4242. Hours: 1–4 Tues.–Fri. and Sun (also 5–7 Thurs.); closed summer, holidays, and when university not in session. Admission: free.

## CONVERSE COLLEGE
### Milliken Gallery

Changing exhibitions are presented by the Milliken Gallery, founded in 1971 at Converse College in Spartanburg, South Carolina.
Milliken Gallery, Converse College, 580 E. Main St., Spartanburg, SC 29302. Phone: 803/585-6421. Hours: 11–4 Mon.–Fri.; closed summer and major holidays. Admission: free.

## CORNELL COLLEGE
### Armstrong Gallery

Exhibitions of local, regional, and student artworks are presented at the Armstrong Gallery in the Fine Arts Building at Cornell College in Mount Vernon, Iowa. The gallery was started in 1853 and has been in its present location since 1937.
Armstrong Gallery, Cornell College, Fine Arts Bldg., 600 First St., W., Mount Vernon, IA 52314. Phone: 319/895-4137. 9–4 Mon.–Fri.; 2–4 Sun.; closed holidays and when college not in session. Admission: free.

## DAVIDSON COLLEGE
### William H. Van Every Jr. Gallery

The Davidson College Art Gallery—founded in 1962 as a teaching aid and community service—was renamed the William H. Van Every Jr. Gallery when it moved into the new Visual Arts Center in Davidson, North Carolina, in 1993. It is known for its collection of twentieth-century graphics. Prints and drawings by Goya, Toulouse-Lautrec, Miró, Corinth, Corot, and Hogarth are among its prized artworks. Exhibitions of contemporary art are presented four to six times a year.

William H. Van Every Jr. Gallery, Davidson College, Visual Arts Center, 315 N. Main St., Davidson, NC 28036. Phone: 704/892-2344. Hours: 10–4 Mon.–Fri.; 2–5 Sat.–Sun.; closed holidays and when college not in session. Admission: free.

## DELTA STATE UNIVERSITY
### *Fielding L. Wright Art Center*

The works of Mississippi and southern artists are featured at the Fielding L. Wright Art Center at Delta State University in Cleveland, Mississippi. In addition to such works, the center has a collection of prints by Käthe Kollwitz, Salvador Dali, and G.B. Piranesi; works of Walter Anderson, Marie Hull, and Andrew Bucci; Japanese prints and woodblocks; and sculptured Greek heads from Crete, ca. 600 B.C.

Fielding L. Wright Art Center, Delta State University, Box D2, Cleveland, MS 38733. Phone: 601/846-4720. Hours: 8–8 Mon.–Thurs.; 8–5 Fri.; 3–5 one Sun. a month; closed major holidays and Christmas recess. Admission: free.

## DENISON UNIVERSITY
### *Denison University Gallery*

The Denison University Gallery in Granville, Ohio, presents changing exhibitions of contemporary art and selections from the university's collections. The collections include Eastern, Western, and primitive art and artifacts, European and American nineteenth- and twentieth-century prints, Burmese Buddha images, Chinese Imperial robes, Cuna Indian art, Asian textiles, Baroque drawings, African art, lacquerware, sculpture, rubbings, cartoons, porcelain, bronzes, and contemporary prints. Founded in 1946, the teaching gallery is located in the Burke Hall of Music and Art.

Denison University Gallery, Burke Hall of Music and Art, Granville, OH 43023. Phone: 614/587-6255. Hours: 10:30–4 Mon.–Sat.; 1–4 Sun.; closed summer and holidays. Admission: free.

## DePAUL UNIVERSITY
### *DePaul University Art Gallery*

The DePaul University Art Gallery in Chicago presents three curated exhibitions and one student show each academic year at its main floor location in a classroom building. It also has an additional exhibit space on another campus and maintains the University Collection.

DePaul University Art Gallery, 802 W. Belden Ave., Chicago, IL 60614-3214. Phone: 312/362-5253. Hours: 10–4 Mon.–Fri.; 12–4 Sat.; closed when university not in session. Admission: free.

## DICKINSON COLLEGE
### *Trout Gallery*

The Trout Gallery at Dickinson College in Carlisle, Pennsylvania, presents a diverse program of exhibitions, including temporary shows, student and faculty work, and selections from its permanent collections. Topics of recent temporary exhibitions have included Etruscan pottery, Tibetan tantric art, and imagery created in response to AIDS.

The gallery's collections are the Potamkin Collection of nineteenth- and twentieth-century graphics, Gerofsky Collection of African art, Rilling Collection of non-Western art, Sellers Collection of graphics, and Held Collection of European woodcuts.

Trout Gallery, Dickinson College, Weiss Center for the Arts, PO Box 1773, Carlisle, PA 17013-2896. Phone: 717/245-1709. Hours: 10–4 Tues.–Sat.; closed holidays and when college not in session. Admission: free.

## DREW UNIVERSITY
### *Elizabeth P. Korn Art Gallery*

Six exhibitions—four featuring contemporary and scholarly art and two student shows—are presented each academic year by the Elizabeth P. Korn Art Gallery, established in 1960 at Drew University in Madison, New Jersey.

Elizabeth P. Korn Art Gallery, Drew University, Dept. of Art, Madison, NJ 07940. Phone: 201/408-3331. Hours: 12:30–4 Tues.–Fri.; closed summer and holidays. Admission: free.

## EAST CAROLINA UNIVERSITY
### *Wellington B. Gray Gallery*

Twelve to 15 exhibitions of contemporary and historical art in a variety of media are shown annually at the Wellington B. Gray Gallery in the Jenkins Fine Arts Center at East Carolina University in Greenville, North Carolina.

Wellington B. Gray Gallery, East Carolina University, Jenkins Fine Arts Center, Fifth and Jarvis Sts., Greenville, NC 27858-4353. Phone: 919/757-6336. Hours: 10–5 Mon.–Fri.; 10–5 Sat.; closed holidays and when university not in session. Admission: free.

## EASTERN WASHINGTON UNIVERSITY
### *University Galleries*

Contemporary art exhibitions are offered at the Eastern Washington University Galleries in Cheney. The galleries opened in 1970 in the Art Building.

University Galleries, Eastern Washington University, 140 Art Bldg., Cheney, WA 99004-2495. Phone: 509/359-7070. Hours: 8–5 Mon.–Fri.; closed holidays and when university not in session. Admission: free.

## EAST TENNESSEE STATE UNIVERSITY
### Slocumb Galleries

Revolving monthly exhibitions of all types of art media are offered by the Slocumb Galleries at East Tennessee State University in Johnson City. Founded in 1965, the galleries are part of the Department of Art.
Slocumb Galleries, East Tennessee State University, Dept. of Art, Box 70708, Johnson City, TN 37614-0708. Phone: 615/461-7078. Hours: 8:30–4 Mon.–Fri.; closed holidays. Admission: free.

### Carroll Reece Museum
(See Historical Museums, Houses, and Sites section.)

## EDISON COMMUNITY COLLEGE–LEE COUNTY CAMPUS
### Gallery of Fine Art

Traveling exhibitions of work by such prominent artists as Rauschenberg, Rosenquist, Dufy, and Lichtenstein are presented at the Gallery of Fine Art in Humanities Hall on the Lee County Campus of Edison Community College in Fort Myers, Florida.
Gallery of Fine Art, Edison Community College–Lee County Campus, 8000 College Pkwy., SW, PO Box 06210, Fort Myers, FL 33906-6210. Phone: 813/489-9314. Hours: 10–4 Tues.–Fri.; 11–3 Sat.; 1–5 Sun.; closed holidays and when college not in session. Admission: free.

## EMPORIA STATE UNIVERSITY
### Norman R. Eppink Art Gallery

More than 20 changing exhibitions are presented each year by the Norman R. Eppink Art Gallery at Emporia State University in Emporia, Kansas. They include the annual National Invitational Drawing Exhibition and the Art Faculty Exhibition. Contemporary American drawings and prints are among the most important collections of the gallery, which was founded in 1939 and moved into the new Art Building in 1965.
Norman R. Eppink Art Gallery, Emporia State University, 1200 Commercial St., Emporia, KS 66801-5087. Phone: 316/341-5246. Hours: 9–3 Mon.–Fri.; closed holidays and when university not in session. Admission: free.

## EVERETT COMMUNITY COLLEGE
### Northlight Gallery

The Northlight Gallery at Everett Community College in Everett, Washington, presents changing exhibitions of local, regional, and national artists in all media, as well as a year-end student show.

Northlight Gallery, Everett Community College, 801 Wetmore Ave., Everett, WA 98201. Phone: 206/388-9100. Hours: 9–2 and 5–7 Mon.–Tues.; 9–2 Wed.–Fri.; closed major holidays. Admission: free.

## EVERGREEN STATE COLLEGE
### *Evergreen Galleries*

Changing exhibitions of contemporary art—largely by regional artists—are shown at the Evergreen Galleries at Evergreen State College in Olympia, Washington. The facility opened in 1970.
Evergreen Galleries, Evergreen State College, 2700 Evergreen Pkwy., NW, Olympia, WA 98505-0002. Phone: 206/860-6000. Hours: 12–5 Mon.–Fri.; 1–5 Sat.; closed holidays. Admission: free.

## FAIRFIELD UNIVERSITY
### *Thomas J. Walsh Art Gallery*

The Thomas J. Walsh Art Gallery is part of the multipurpose Regina A. Quick Center for the Arts at Fairfield University in Fairfield, Connecticut. Founded in 1990, it has 2,200 square feet for changing exhibitions.
Thomas J. Walsh Art Gallery, Fairfield University, Regina A. Quick Center for the Arts, N. Benson Rd., Fairfield, CT 06430-4242. Phone: 203/254-4242. Hours: 11–5 Tues.–Sat.; 12–4 Sun.; closed major holidays. Admission: free.

## FERRUM COLLEGE
### *Blue Ridge Institute Farm Museum and Galleries*

(See Agricultural Museums section.)

## FLORIDA COMMUNITY COLLEGE
### *Kent Campus Gallery*

The Kent Campus Gallery of Florida Community College in Jacksonville, Florida, presents a variety of changing exhibitions, including the works of students and local artists and traveling shows. The facility opened in 1978.
Kent Campus Gallery, Florida Community College, 3939 Roosevelt Blvd., Jacksonville, FL 32205. Phone: 904/381-3674. Hours: 10–4 Mon.–Thurs.; 10–2 Fri.; closed holidays and when college not in session. Admission: free.

## FLORIDA SCHOOL OF THE ARTS
### *Florida School of the Arts Gallery*

Works by local to national artists are displayed in changing exhibitions at the Florida School of the Arts Gallery in Palatka. The gallery opened in 1977.

Florida School of the Arts Gallery, 5001 S. John's Ave., Palatka, FL 32177. Phone: 904/328-1571. Hours: varies. Admission: free.

## FORT HAYS STATE UNIVERSITY
### Moss-Thorns Gallery

The Department of Art at Fort Hays State University in Hays, Kansas, operates the Moss-Thorns Gallery, which features faculty, student, and other temporary exhibitions.
Moss-Thorns Gallery, Fort Hays State University, Dept. of Art, Barick Hall, Hays, KS 67601. Phone: 913/628-4247. Hours: 8–4 Mon.–Fri.; closed holidays and when university not in session. Admission: free.

## GEORGETOWN UNIVERSITY
### Fine Arts Gallery

Six to seven exhibitions of contemporary works by art students and artists in the Washington, D.C., area are presented each year in the Fine Arts Gallery in the Walsh Building at Georgetown University in Washington, D.C. The gallery is part of the studio program in the Department of Fine Arts.
Fine Arts Gallery, Georgetown University, Dept. of Fine Arts, Walsh Bldg., Washington, DC 20057. Phone: 202/687-6933. Hours: 10–5 Mon.–Fri.; closed holidays and when university not in session. Admission: free.

## GEORGE WASHINGTON UNIVERSITY
### Dimock Gallery

Two-thirds of the exhibition programming at George Washington University's Dimock Gallery in Washington, D.C., is university related—student, faculty, alumni, and permanent collection shows. Additional exhibitions include those of historical significance, area invitationals, and others reflecting art historical subjects and the Department of Art's curriculum.

Eight to 10 exhibitions are featured each year at the gallery, located on the lower level of Lisner Auditorium. In addition to handling the exhibitions and programs, the gallery's staff maintains the university's permanent collection, which includes paintings, sculpture, and graphic arts from the eighteenth, nineteenth, and twentieth centuries, with special emphasis on American art. Among the highlights are the W. Lloyd Wright Collection of Washingtoniana, works pertaining to George Washington, prints by Joseph Pennell, pre-Columbian artifacts, and the U.S. Grant Collection of photographs, documents, prints, and newspaper clippings.
Dimock Gallery, George Washington University, 730 21st St., NW, Washington, DC 20052. Phone: 202/994-1525. Hours: 10–5 Tues.–Fri.; 12–5 Sat. Admission: free.

## GEORGIA STATE UNIVERSITY
### *Georgia State University Art Gallery*

Contemporary paintings, prints, photographs, and crafts are featured at the Georgia State University Art Gallery in Atlanta. The gallery, which opened in 1970, is part of the School of Art and Design.

Georgia State University Art Gallery, University Plaza, Atlanta, GA 30303. Phone: 404/ 651-3424. Hours: 8–8 Mon.–Fri.; closed major holidays. Admission: free.

## GERTRUDE HERBERT INSTITUTE OF ART
### *Gertrude Herbert Institute of Art Gallery*

The Gertrude Herbert Institute of Art Gallery in Augusta, Georgia, has monthly changing exhibitions of all types of art. The art school and its gallery, which opened in 1937, are located in the 1818 Ware's Folly historic house.

Gertrude Herbert Institute of Art Gallery, 506 Telfair St., Augusta, GA 30901. Phone: 706/722-5495. Hours: 10–5 Tues.–Fri.; 10–2 Sat.; closed major holidays. Admission: adults, $2; seniors and children, $1.

## GONZAGA UNIVERSITY
### *Ad Gallery*

The Ad Gallery—so named because it is located on the lower level of the Administration Building—is an art gallery/museum with a collection of approximately 3,500 works at Gonzaga University in Spokane, Washington. It started in 1971 as an exhibit area for the Department of Art and then became a collecting and exhibition space for the entire university.

The facility has a large print collection of Old Masters, contemporary artists, and student work, as well as a small Rodin sculpture collection. Monthly exhibitions of selections from the print collection and from outside sources are presented.

Ad Gallery, Gonzaga University, E. 502 Boone Ave., Spokane, WA 99258-0001. Phone: 509/328-4220, Ext. 3211. Hours: 10–4 Mon.–Fri.; closed major holidays and when university not in session. Admission: free.

## GOSHEN COLLEGE
### *Goshen College Art Gallery*

Exhibitions of contemporary works by regional artists, ethnic and folk art exhibitions, and student and faculty shows are presented at the Goshen College Art Gallery in Goshen, Indiana. The gallery, which began as exhibitions in the student union in the 1950s, has been located on the basement level of the Harold and Wilma Good Library since 1970.

Goshen College Art Gallery, Harold and Wilma Good Library, 1700 S. Main St., Goshen, IN 46526. Phone: 219/535-7594. Hours: 8–5 Mon.–Fri.; (also 8–10 Wed.); 9–5 Sat.; 12–5 Sun.; closed holidays and when college not in session. Admission: free.

## GOUCHER COLLEGE
### Rosenberg Gallery

Five to six exhibitions of contemporary art are presented each year by the Rosenberg Gallery at Goucher College in Baltimore. The exhibitions typically feature work by regional professional artists, except for a two-week student show. The gallery is in the lobby of the auditorium building.

Rosenberg Gallery, Goucher College, 1021 Dulaney Valley Rd., Baltimore, MD 21204-2794. Phone: 410/337-6073. Hours: 9–5 Mon.–Fri.; open evenings and weekends of auditorium performances; closed when college not in session. Admission: free.

## GREENSBORO COLLEGE
### Irene Cullis Gallery

The Irene Cullis Gallery at Greensboro College in Greensboro, North Carolina, presents changing exhibitions during the academic year.

Irene Cullis Gallery, Greensboro College, 815 W. Market St., Greensboro, NC 27401-1875. Phone: 910/272-7102. Hours: 10:30–4 Mon.–Fri.; 2–5 Sun.; closed summer, holidays, and when college not in session. Admission: free.

## GROSSMONT COLLEGE
### Hyde Gallery

Temporary and traveling exhibitions are shown at the Hyde Gallery at Grossmont College in El Cajon, California. Founded in 1961, the gallery has collections of prints, ceramics, and photographs.

Hyde Gallery, Grossmont College, 8800 Grossmont College Dr., El Cajon, CA 92020-1799. Phone: 619/465-1700. Hours: by appointment; closed holidays. Admission: free.

## GUILFORD COLLEGE
### Guilford College Art Gallery

Rotating theme exhibitions, primarily from the permanent collection, are presented in the Guilford College Art Gallery's two exhibition spaces—Main Gallery and Atrium Galleries—in Greensboro, North Carolina. The gallery, which opened in 1990 in Hege Library, has a collection of arts and crafts representing a variety of periods, styles, and cultures. The collection includes a small, but growing, collection of contemporary Eastern European graphics.

Guilford College Art Gallery, 5800 W. Friendly Ave., Greensboro, NC 27410. Phone: 919/316-2438. Hours: Main Gallery—9–5 Mon.–Fri.; Atrium Galleries—8–6 Mon.–Fri.; 10–6 Sat.–Sun.; closed holidays. Admission: free.

## HAMILTON COLLEGE
*Emerson Gallery*

The Emerson Gallery at Hamilton College in Clinton, New York, is best known for creating, displaying, and circulating exhibitions, mostly of twentieth-century artworks. It has a collection of twentieth-century British art, especially works by Graham Sutherland; the Beiniecke Collection of prints and drawings; and paintings of the Lesser Antilles.

Emerson Gallery, Hamilton College, 198 College Hill Rd., Clinton, NY 13323. Phone: 315/859-4396. Hours: 12–5 Mon.–Fri.; 1–5 Sat.–Sun. Admission: free.

## HAMLINE UNIVERSITY
*Hamline University Galleries*

The Hamline University Galleries in St. Paul, Minnesota, are located in the university's Learning Center. The changing exhibition program relies heavily on the gallery's collection of paintings, sculpture, and graphics from the late nineteenth and the twentieth centuries, but also displays student and other work.

Hamline University Galleries, Learning Center, 1536 Hewitt, St. Paul, MN 55104. Phone: 612/641-2387. Hours: academic year—7 A.M.–10 P.M. Mon.–Fri.; closed holidays and when university not in session. Admission: free.

## HARTNELL COLLEGE
*Hartnell Gallery*

The Hartnell Gallery at Hartnell College in Salinas, California, presents exhibitions of individual artists and historical periods—some drawn from its collections of 1930s WPA art, photographs, netsukes, and Huichol tribal artifacts. The gallery, which began in 1976, is located in the fine arts complex.

Hartnell Gallery, Hartnell College, 156 Homestead Ave., Salinas, CA 93208. Phone: 408/755-6905. Hours: 10–1 Mon.–Thurs.; closed holidays and when college not in session. Admission: free.

## HARTWICK COLLEGE
*Foreman Gallery*

The Foreman Gallery in the Anderson Center for the Arts at Hartwick College in Oneonta, New York, is one of four facilities that comprise the Museums at Hartwick. Exhibitions of paintings, sculpture, photography, prints, graphics, and crafts by regional and nationally known artists, as well as students, are presented throughout the year.

The college's permanent fine arts collection consists of more than 600 works, including prints, drawings, tapestries, ceramics, fibers, and sculpture. Among the

artworks in the collection are the Van Ess group of Renaissance and Baroque works and paintings by nineteenth-century artists Childe Hassam, Rockwell Hunt, John Henry Twactman, and others. The college also has a collection of John Harmon Cassel original political cartoons.

Foreman Gallery, Hartwick College, Anderson Center for the Arts, Oneonta, NY 13820. Phone: 607/431-4480. Hours: 12–3 Wed.–Fri.; closed holidays. Admission: free.

## HAWAII PACIFIC UNIVERSITY
### Hawaii Pacific University Gallery

Six exhibitions of contemporary art are presented each year by the Hawaii Pacific University Gallery in Honolulu.

Hawaii Pacific University Gallery, 1164 Bishop St., Honolulu, HI 96813. Phone: 808/544-0200. Hours: 8–4 Mon.–Fri.; 10–3 Sat.–Sun.; closed major holidays. Admission: free.

## HOBART AND WILLIAM SMITH COLLEGES
### Houghton House Gallery

Contemporary art exhibitions by Northeast artists—as well as faculty, alumni, and students—are presented at the Houghton House Gallery at Hobart and William Smith Colleges in Geneva, New York. The gallery, opened in 1969, is located in a historic Victorian mansion built in the 1880s.

Houghton House Gallery, Hobart and William Smith Colleges, Geneva, NY 14456. Phone: 315/781-3487. Hours: 9–5 Mon.–Sat.; closed mid-June–Aug. and major holidays. Admission: free.

## HOFSTRA UNIVERSITY
### Emily Lowe Gallery (Hofstra Museum)

(See Art Museums section.)

## HOWARD UNIVERSITY
### Howard University Gallery of Art

African-American and American paintings, sculpture, and graphic art are the core of the collections and exhibitions at the Howard University Gallery of Art in Washington, D.C. Among the collections of the gallery, founded in 1928, are the Alain LeRoy Locke African Collection, Irving Gumbel Print Collection, Samuel H. Kress Study Collection of Italian paintings and sculpture, and a collection of European graphic art.

Howard University Gallery of Art, 2455 Sixth St., NW, Washington, DC 20059. Phone: 202/805-7070. Hours: 9:30–4:30 Mon.–Fri.; 1–4 Sun.; closed holidays. Admission: free.

## HUMBOLDT STATE UNIVERSITY
### *Reese Bullen Gallery*

The Reese Bullen Gallery presents changing exhibitions in a 1,600-square-foot space at Humboldt State University in Arcata, California. Founded in 1970, the gallery has a collection of twentieth-century American and African art.

Reese Bullen Gallery, Humboldt State University, Arcata, CA 95521. Phone: 707/826-3819. Hours: 12–5 Tues.–Fri.; closed summer and mid-Dec. through Jan. Admission: free.

## HUNTER COLLEGE
### *Hunter College Art Galleries*

Temporary and traveling exhibitions are presented at the Hunter College Art Galleries in New York City. Founded in 1984, the galleries have a collection that concentrates on American art since 1945.

Hunter College Art Galleries, 695 Park Ave., New York, NY 10021. Phone: 212/772-4991. Hours: 1–6 Mon.–Fri.; closed major holidays. Admission: free.

## INDIANA STATE UNIVERSITY
### *Turman Art Gallery*

Temporary exhibitions of contemporary art are shown at the Turman Art Gallery, located on the first floor of the Fine Arts Building at Indiana State University in Terre Haute, Indiana. Although the gallery does not have a collection, the university maintains a permanent art collection.

Turman Art Gallery, Indiana State University, Fine Arts Bldg., Seventh and Chestnut Sts., Terre Haute, IN 47809. Phone: 812/237-3720. Hours: 12–4:30 Tues.–Fri.; 1–5 Sun.; closed holidays. Admission: free.

## INDIANA UNIVERSITY
### *Fine Arts Gallery*

Student exhibitions are featured at the Fine Arts Gallery, opened in 1987, at Indiana University in Bloomington.

Fine Arts Gallery, Indiana University, 123 Fine Arts Bldg., Bloomington, IN 47405. Phone: 812/855-8490. Hours: 12–4 Tues.–Thurs.; 12–8 Fri.; 1–4 Sat.–Sun.; closed Thanksgiving, Christmas, and spring recess. Admission: free.

## INDIANA UNIVERSITY OF PENNSYLVANIA
### *Kipp Gallery*

The Art Department at Indiana University of Pennsylvania presents changing exhibitions in the Kipp Gallery in Indiana, Pennsylvania.

Kipp Gallery, Indiana University of Pennsylvania, Art Dept., Sprowls Hall, Indiana, PA 15705. Phone: 412/357-7677. Hours: 12–4 and 7–9 Mon.–Fri.; 3–5 Sat.–Sun.; closed holidays and when university not in session. Admission: free.

# JAMES MADISON UNIVERSITY
## Sawhill Gallery

Temporary exhibits from university collections and elsewhere can be seen at the Sawhill Gallery at James Madison University in Harrisonburg, Virginia. Operated by the Department of Art, the gallery was founded in 1967. The collections include the Ernest Staples Collection, Sawhill Collection, Indonesian works, pre-classical and classical items, and modern works of art.

Sawhill Gallery, James Madison University, Main and Grace Sts., Harrisonburg, VA 22807. Phone: 703/568-6407. Hours: academic year—10:30–4:30 Mon.–Fri.; 1:30–4:30 Sat.–Sun.; summer—varies; closed holidays. Admission: free.

### Zirkle House

James Madison University in Harrisonburg, Virginia, has a student-run gallery in Zirkle House on the campus. The gallery shows changing exhibitions of the work of undergraduate and graduate students. It also has a professional photography gallery—called New Image Gallery—which is an extension of the Sawhill Gallery.

Zirkle House, James Madison University, Harrisonburg, VA 22807. Phone: 703/568-6216. Hours: 12–5 Mon.–Sat.; closed summer, holidays, and when university not in session. Admission: free.

# JAMESTOWN COMMUNITY COLLEGE
## Forum Gallery

Contemporary art is featured in the 1,000-square-foot Forum Gallery at Jamestown Community College in Jamestown, New York. The gallery was founded in 1969.

Forum Gallery, Jamestown Community College, 525 Falconer St., Jamestown, NY 14701. Phone: 716/665-9107. Hours: 11–5 Tues.–Sat. (also to 8 Thurs.); closed holidays and spring and winter breaks. Admission: free.

# JOHN C. CALHOUN STATE COMMUNITY COLLEGE
## Art Gallery

The Art Gallery at John C. Calhoun State Community College in Decatur, Alabama, was founded in 1965. Located in the Fine Arts Building, it has a collection of American and European graphics.

Art Gallery, John C. Calhoun State Community College, 31 N-Room 237, Fine Arts Bldg., PO Box 2216, Decatur, AL 35609-2216. Phone: 205/306-2699. Hours: 8–3 Mon.–Fri.; closed holidays. Admission: free.

## JOHNSON COUNTY COMMUNITY COLLEGE
### Gallery of Art

Contemporary art is featured in the 3,000-square-foot Gallery of Art at John-son County Community College in Overland Park, Kansas. The gallery, founded in 1969, has a collection of contemporary American paintings, works on paper, ceramics, and photography.

Gallery of Art, Johnson County Community College, 12345 College Blvd., Overland Park, KS 66210. Phone: 913/459-8500. Hours: 10–5 Mon.–Fri. (also to 7 Tues.–Wed.); 1–5 Sat.–Sun.; closed major holidays. Admission: free.

## KEAN COLLEGE OF NEW JERSEY
### James Howe Gallery

Exhibitions at the James Howe Gallery at Kean College of New Jersey in Union cover a variety of areas in support of teaching. They include artworks by faculty and students and selections from the collections of nineteenth- and twentieth-century artists and 1930–1960 modern furniture and industrial design-ers. More than one-third of the collection artworks are from the Nancy Dryfoos Collection. Founded in 1971, the gallery is located in Vaughn Eames Hall.

James Howe Gallery, Kean College of New Jersey, Vaughn Eames Hall, Morris Ave., Union, NJ 07083. Phone: 908/527-2307. Hours: 10–2 and 5–7 Mon.–Fri.; closed holidays and when college not in session. Admission: free.

## KEENE STATE COLLEGE
### Thorne-Sagendorph Art Gallery

The Thorne-Sagendorph Art Gallery at Keene State College in Keene, New Hampshire, features diversified changing exhibitions of contemporary and his-torical artworks. It has a permanent collection of works reflecting the artistic traditions of the Mount Monadnock region (including artworks by nineteenth-century artists of the Dublin School, a group of artists that flourished in the area) and works by contemporary artists.

Thorne-Sagendorph Art Gallery, Keene State College, 229 Main St., Keene, NH 03401. Phone: 603/358-2719. Hours: 12–4 Sat.–Wed.; 12–8 Fri.; closed holidays. Admission: free.

## KENNESAW STATE COLLEGE
### Sturgis Library Gallery and Fine Arts Gallery

Kennesaw State College in Marietta, Georgia, has two art galleries—the Stur-gis Library Gallery and the Fine Arts Gallery. The former started in 1982 on the lower level of the library, while the latter was opened in 1989 on the first

floor of the Performing Arts Building. Exhibitions have included national shows on timely topics, international exhibitions that coordinate with the year's cultural programs, and faculty, student, and high school juried art shows.

Sturgis Library Gallery and Fine Arts Gallery, Kennesaw State College, PO Box 444, Marietta, GA 30061. Phone: 404/499-3223. Hours: 10–4 Mon.–Fri.; 1–5 Sat.; closed holidays. Admission: free.

## KENT STATE UNIVERSITY
### Kent State University Art Galleries

The Kent State University Art Galleries in Kent, Ohio, consist of two galleries—the Gallery in the School of Art and the William H. Eells Art Gallery at the Blossom Music Center. The galleries, which began in 1950, feature contemporary American art and have collections that include paintings, sculpture, and prints.

Kent State University Art Galleries, School of Art, Kent, OH 44242. Phone: 216/672-7853. Hours: 10–4 Mon.–Fri.; 2–5 Sun.; closed holidays. Admission: free.

## KENTUCKY STATE UNIVERSITY
### Jackson Hall Gallery

Contemporary art exhibitions are the primary focus at the Jackson Hall Gallery at Kentucky State University in Frankfort.

Jackson Hall Gallery, Kentucky State University, Dept. of Art, Frankfort, KY 40461. Phone: 502/227-5995. Hours: 8–4:30 daily; closed summer and holidays. Admission: free.

## LAFAYETTE COLLEGE
### Art Gallery

The Lafayette College Art Gallery, located in the Williams Center for the Arts, presents a wide range of exhibitions covering different time periods, media, and cultures. The Easton, Pennsylvania, college also has an art collection known for its Kirby Collection of nineteenth-century American portraits and historical paintings.

Art Gallery, Lafayette College, Williams Center for the Arts, Easton, PA 18042-1768. Phone: 215/250-5361. Hours: 10–5 Tues.–Fri.; 2–5 Sun.; closed holidays and when college not in session. Admission: free.

## LaGRANGE COLLEGE
### Lamar Dodd Art Center

The Lamar Dodd Art Center at LaGrange College in LaGrange, Georgia, is a three-story building with a gallery featuring contemporary art and selections

from its collections of Lamar Dodd paintings, Southwest Native American art, twentieth-century photographs, and contemporary paintings, prints, drawings, sculpture, and crafts. It opened in 1981.

Lamar Dodd Art Center, LaGrange College, 302 Forrest Ave., LaGrange, GA 30240. Phone: 706/812-7211. Hours: 10–5 Mon.–Fri.; 1–4 Sat.; closed holidays and when college not in session. Admission: free.

## LAKELAND COLLEGE
### Bradley Gallery of Art

The Bradley Gallery of Art is a small gallery at Lakeland College in Sheboygan, Wisconsin. Founded in 1988, it schedules contemporary art exhibitions and selections from its collection of traditional paintings and prints.

Bradley Gallery of Art, Lakeland College, PO Box 359, Sheboygan, WI 53082-0359. Phone: 414/565-1280. Hours: academic year—3–5 Mon.–Fri.; closed summer and major holidays. Admission: free.

## LAKE-SUMTER COMMUNITY COLLEGE
### Art Gallery

Exhibitions of local art associations are featured at the Lake-Sumter Community College Art Gallery in Leesburg, Florida. The gallery opened in 1985 in the lobby of a new multipurpose building on the campus.

Art Gallery, Lake-Sumter Community College, 9501 U.S. Hwy. 441, Leesburg, FL 34788. Phone: 904/365-3598. Hours: 8 A.M.–9 P.M. Mon.–Fri.; 8–12 noon Sat.; closed holidays and when college not in session. Admission: free.

## LAMAR UNIVERSITY
### Dishman Art Gallery

The Dishman Art Gallery at Lamar University in Beaumont, Texas, presents historical and contemporary exhibitions. Founded in 1983 by the Art Department, the gallery has collections of African and New Guinea masks and shields and nineteenth-century paintings and porcelains.

Dishman Art Gallery, Lamar University, Art Dept., Box 10027, Beaumont, TX 77710. Phone: 409/880-8959. Hours: 8–4:30 Mon.–Thurs.; 8–12 noon Fri.; closed major holidays. Admission: free.

## LANE COMMUNITY COLLEGE
### Lane Community College Art Gallery

Paintings, textiles, sculpture, ceramics, jewelry, and other contemporary works are shown in changing exhibitions at the Lane Community College Art Gallery, founded in 1970, in Eugene, Oregon.

Lane Community College Art Gallery, 4000 E. 30th Ave., Eugene, OR 97405. Phone: 503/747-4501. Hours: 8 A.M.–10 P.M. Mon.–Thurs.; 8–5 Fri.; closed holidays. Admission: free.

## LAWRENCE UNIVERSITY
### Wriston Art Center Galleries

Changing exhibitions are featured at the Wriston Art Center Galleries at Lawrence University in Appleton, Wisconsin. Founded in 1989, the galleries have collections of nineteenth- and twentieth-century paintings and prints, German expressionist art, Japanese prints and drawings, and Greek and Roman coins.

Wriston Art Center Galleries, Lawrence University, Box 559, Appleton, WI 54912. Phone: 414/832-6621. Hours: Oct.–May—10–4 Tues.–Fri.; 12–4 Sat.–Sun.; summer— call for hours; closed major holidays. Admission: free.

## LEHIGH UNIVERSITY
### Lehigh University Art Galleries

Twenty exhibitions a year are presented by the Lehigh University Art Galleries at five locations on the campus in Bethlehem, Pennsylvania. The exhibitions—which include selections from an extensive university collection, borrowed works, and traveling exhibitions—are designed to introduce students and the community to current topics in art, architecture, history, science, and technology.

The five galleries are the Ralph L. Wilson Gallery and Hall Gallery in the Alumni Memorial Building, DuBois Gallery in Maginnes Hall, Siegel Gallery in Iacocca Hall, and Study Gallery in Building J. In addition, the university has the Girdler Student Gallery in University Center and the Muriel and Philip Berman Sculpture Gardens in the courtyard of the Mudd, Mart, Whitaker, and Sinclair buildings.

The university's permanent art collection, which began in 1864, is a work/ study collection intended as a resource for students pursuing formal study in the visual arts and/or museum studies, the faculty, and interested residents of the community. It consists of a variety of works by Old Masters and contemporary artists. Among the collection works are American, French, and other European paintings; Old Master prints and drawings; pre-Columbian and contemporary sculpture; contemporary prints; Chinese porcelain; African objects; and photographs. The works of such artists as Gainsborough, Goya, Renoir, Rauschenberg, Calder, and Warhol are part of the collection.

Lehigh University Art Galleries, 17 Memorial Dr., E., Bethlehem, PA 18015-3007. Phone: 610/758-3615. Hours: Wilson and Hall Galleries—9–5 Mon.–Fri.; 9–12 noon Sat.; 2–5 Sun.; DuBois Gallery—9 A.M.–10 P.M. Mon.–Fri.; 9–2 Sat.; Siegel Gallery—

9 A.M.–10 P.M. Mon.–Thurs.; 9–5 Fri.; Girdler Student Gallery—8 A.M.–12 midnight Mon.–Fri.; slightly different summer hours; closed major holidays. Admission: free.

## LOUISBURG COLLEGE
### Louisburg College Art Gallery

The Louisburg College Art Gallery is housed in the 1787 college auditorium theater complex in Louisburg, North Carolina. The gallery, founded in 1957, has collections of Primitive and American Impressionist and contemporary art. Louisburg College Art Gallery, 501 N. Main St., Louisburg, NC 27549. Phone: 919/496-2521. Hours: 8:30–5:30 Mon.–Thurs.; 8:30–1 Fri.; closed summer and holidays. Admission: free.

## LOUISIANA STATE UNIVERSITY
### LSU Union Art Gallery

The LSU Union Art Gallery at Louisiana State University in Baton Rouge presents a series of contemporary art exhibitions during the year.
LSU Union Art Gallery, Louisiana State University, Box 25123, Baton Rouge, LA 70894. Phone: 504/388-5117. Hours: 9–6 Mon.–Fri.; 12–4 Sat.–Sun.; closed major holidays. Admission: free.

## LOWER COLUMBIA COLLEGE
### Art Gallery

Exhibitions of contemporary art, particularly works of Northwest artists, are presented in the Art Gallery at Lower Columbia College in Longview, Washington.
Art Gallery, Lower Columbia College, 1600 Maple, PO Box 3010, Longview, WA 98632-0310. Phone: 206/577-2314. Hours: 10–4 Mon., Tues., and Fri.; 10–8 Wed.–Thurs.; closed holidays and when college not in session. Admission: free.

## LOYOLA MARYMOUNT UNIVERSITY
### Laband Art Gallery

The Laband Art Gallery is part of the Fritz B. Burns Fine Arts Center built in the mid-1980s at Loyola Marymount University in Los Angeles. It features thematic exhibitions dealing with traditional and nontraditional spirituality, social and political issues, and ethnological and/or anthropological subjects.
Laband Art Gallery, Loyola Marymount University, Loyola Blvd. at W. 80th St., Los Angeles, CA 90045-2699. Phone: 310/338-2880. Hours: 11–5 Wed.–Fri.; 12–4 Sat.; closed holidays. Admission: free.

## LUTHER COLLEGE
*Preus Library Fine Arts Collection*

(See Library and Archival Collections and Galleries section.)

## MAINE COLLEGE OF ART
*Baxter Gallery*

Contemporary art is the focus of Baxter Gallery at the Maine College of Art in Portland. The 2,100-square-foot gallery, which opened in 1983, is housed in the 1878 Baxter Building.
Baxter Gallery, Maine College of Art, Baxter Bldg., 619 Congress St., Portland, ME 04101. Phone: 207/775-5152. Hours: academic year—11–4 Tues.–Sun. (also to 9 Thurs.); summer—9–4 Mon.–Fri.; closed holidays. Admission: free.

## MANCHESTER INSTITUTE OF ARTS AND SCIENCES
*Manchester Institute of Arts and Sciences Gallery*

Changing exhibitions of contemporary art are presented at the Manchester Institute of Arts and Sciences Gallery in Manchester, New Hampshire.
Manchester Institute of Arts and Sciences Gallery, 448 Concord St., Manchester, NH 03104. Phone: 603/623-0313. Hours: 10–4:30 Mon.–Sat.; closed holidays. Admission: free.

## MARY BALDWIN COLLEGE
*Hunt Gallery*

The Hunt Gallery at Mary Baldwin College in Staunton, Virginia, presents changing temporary exhibitions, usually of a contemporary nature.
Hunt Gallery, Mary Baldwin College, Hunt Bldg., Staunton, VA 24401. Phone: 703/887-7195. Hours: 9–5 Mon.–Fri.; closed summer, holidays, and when college not in session. Admission: free.

## MARY WASHINGTON COLLEGE
*Mary Washington College Art Galleries*

The Mary Washington College Art Galleries in Fredericksburg, Virginia, consist of two exhibition spaces—the DuPont Gallery and the Ridderhof Martin Gallery. The galleries, founded in 1956, show selections from their permanent collection of mid-twentieth-century American art and Asian art and traveling exhibitions of art of various periods and cultures. The college also has a gallery at Belmont.

Mary Washington College Art Galleries, College Ave. at Seacobeck St., Fredericksburg, VA 22401-5358. Phone: 703/899-4695. Hours: 10–4 Mon., Wed., and Fri.; 1–4 Sat.–Sun.; closed major holidays. Admission: free.

## Belmont, The Gari Melchers Estate and Memorial Gallery

(See Historical Museums, Houses, and Sites section.)

## MARYLAND INSTITUTE
### Decker and Meyerhoff Galleries

The College of Art at the Maryland Institute in Baltimore operates two galleries—the Decker Gallery and the Meyerhoff Gallery—in the 1896 Mt. Royal Railroad Station and the Fox Building, formerly the Cannon Shoe Factory. The galleries present changing exhibitions, have a collection of nineteenth-century paintings, and have sculpture, drawings, and prints on loan to the Baltimore Museum of Art and Walters Art Gallery.

Decker and Meyerhoff Galleries, Maryland Institute, College of Art, 1300 W. Mt. Royal Ave., Baltimore, MD 21217. Phone: 410/225-2280. Hours: 10–5 Mon.–Wed. and Sat.; 12–5 Sun. Admission: free.

## MARYLHURST COLLEGE
### Art Gym at Marylhurst College

The Art Gym at Marylhurst College in Marylhurst, Oregon, features contemporary Northwest artworks. The gallery, founded in 1980, has 2,500 square feet of exhibition space.

Art Gym at Marylhurst College, Marylhurst, OR 97036. Phone: 503/636-8141. Hours: 12–4 Tues.–Sat.; closed major holidays and when college not in session. Admission: free.

## MARYVILLE UNIVERSITY
### Morton May Gallery

Work of emerging and established regional artists is presented at Maryville University's Morton May Gallery in St. Louis. Housed in the Instructional Resource Center, the gallery features crafts and design work as well as art.

Morton May Gallery, Maryville University, 13550 Conway Rd., St. Louis, MO 63141-7922. Hours: 8 A.M.–10 P.M. Mon.–Thurs.; 8–6 Fri.–Sat.; 2–10 Sun.; closed holidays and when university not in session. Admission: free.

## MARYWOOD COLLEGE
### Marywood College Art Galleries

The Marywood College Art Galleries, in Scranton, Pennsylvania, include two facilities—the Contemporary Gallery and the Sucaci Gallery—in the Visual Arts

Center. The Contemporary Gallery, located on the first floor, presents temporary exhibitions by visiting artists, faculty, students, and regional professionals, as well as lectures, concerts, poetry readings, and film showings. The Sucaci Gallery, an art museum on the second floor, displays two loan exhibitions each year and maintains and exhibits a permanent collection of European, American, and Asian fine and decorative arts from the nineteenth and twentieth centuries.

The Sucaci Gallery began as the Lucas Museum in 1924 following a major gift by the Right Rev. George J. Lucas, a local pastor, and was renamed when the new Visual Arts Center opened. The Lucas Collection includes bronze and marble sculptures; French, English, and German ceramics; Chinese cloisonné; English Minton; Wedgewood; and Venetian glass vases. Another collection—the Hoban Collection—consists mainly of Chinese furniture and decorative arts, including ivories, tapestries, and vases.

Marywood College Art Galleries, Visual Arts Center, 2300 Adams Ave., Scranton, PA 18509-1598. Phone: 717/348-6278. Hours: 9–4:30 Mon.–Fri.; 1–4 Sat.–Sun.; closed holidays. Admission: free.

## MASSACHUSETTS INSTITUTE OF TECHNOLOGY
### List Visual Arts Center

Changing exhibitions in contemporary art in all media are presented at three galleries that are part of the List Visual Arts Center at the Massachusetts Institute of Technology in Cambridge. The galleries are the Hayden Gallery, Reference Gallery, and Kakalar Gallery. The List Visual Arts Center was opened in 1950 in the Wiesner Building.

MIT also has an extensive permanent collection of fine art and outdoor sculpture by Alexander Calder, Henry Moore, Louise Nevelson, Tony Smith, Larry Bell, and others. Administered separately, the collection is placed throughout the campus in offices and public areas, rather than in a gallery.

List Visual Arts Center, Massachusetts Institute of Technology, Wiesner Bldg., 20 Ames St., Cambridge, MA 02139. Phone: 617/253-4680. Hours: 12–6 Tues.–Fri. (also to 8 Wed.); 1–5 Sat.–Sun.; closed July–Aug. and holidays. Admission: free.

### Margaret Hutchinson Compton Gallery (MIT Museum)
(See Science and Technology Museums and Centers section.)

## MEMPHIS COLLEGE OF ART
### Frank T. Tobey Memorial Gallery

Changing monthly exhibitions are offered in the Frank T. Tobey Memorial Gallery at the Memphis College of Art in Memphis, Tennessee. The gallery has been part of the college since it opened in 1936.

Frank T. Tobey Memorial Gallery, Memphis College of Art, Overton Park, 1930 Poplar Ave., Memphis, TN 38104. Phone: 901/726-4085. Hours: 8:30–5 Mon.–Fri.; 8:30–3 Sat.; closed holidays and when college not in session. Admission: free.

## METROPOLITAN STATE COLLEGE OF DENVER
### Center for the Visual Arts

The Center for the Visual Arts of the Metropolitan State College of Denver is an off-campus gallery located in the lower downtown historic district. The 10,000-square-foot gallery, which opened in 1990, presents six to seven major exhibitions of the works of national and international artists. Exhibitions featuring regional artists and the works of faculty and students are interspersed in the schedule.

Center for the Visual Arts, Metropolitan State College of Denver, 1701 Wazee St., Denver, CO 80202. Phone: 303/294-5207. Hours: 11–5 Tues.–Thurs.; 11–8 Fri.; 12–4 Sat.; closed holidays. Admission: free.

## MIAMI-DADE COMMUNITY COLLEGE
### Kendall Campus Art Gallery

A wide range of art is presented in exhibitions at the Kendall Campus Art Gallery at Miami-Dade Community College in Miami, Florida. The gallery, which opened in 1970, schedules temporary, loan, and traveling shows. Its collections include contemporary paintings, prints, sculpture, photography, fiber, video and electronic media, and sixteenth- to nineteenth-century engravings, etchings, and lithographs.

Kendall Campus Art Gallery, Miami-Dade Community College, 11011 S.W. 104th St., Miami, FL 33176-3393. Phone: 305/237-2322. Hours: 8–4 Mon., Thurs., and Fri.; 12–7:30 Tues.–Wed.; closed holidays. Admission: free.

### Centre Gallery

Changing exhibitions of contemporary art are scheduled at the Centre Gallery on the Wolfson Campus of Miami-Dade Community College in Miami, Florida. The gallery opened in 1991.

Centre Gallery, Miami-Dade Community College, Wolfson Campus, 300 N.E. Second Ave., Miami, FL 33132. Phone: 305/237-2758. Hours: varies; closed holidays and when college not in session. Admission: free.

## MIDDLE TENNESSEE STATE UNIVERSITY
### Photographic Gallery

(See Photography Museums section.)

## MILLIKIN UNIVERSITY
### Perkinson Gallery

The Perkinson Gallery is part of a large performing and visual arts complex—called the Kirkland Fine Arts Center—at Millikin University in Decatur, Illinois.

Invitational and one-person exhibitions of regional artists—which include a purchase award—are featured. The gallery has a collection of work by contemporary artists.

Perkinson Gallery, Millikin University, 1184 W. Main St., Decatur, IL 62522. Phone: 217/424-6229. Hours: 12–5 Mon.–Fri.; closed holidays and when university not in session. Admission: free.

## MILLS COLLEGE
### Mills College Art Gallery

The Mills College Art Gallery, founded in 1925, presents exhibitions of contemporary art and works related to its extensive collections. Housed in a 1925 Spanish-style campus building in Oakland, California, it devotes more than half of its 10,000 square feet, including a smaller Antonio Prieto Gallery, to exhibitions. The gallery has approximately 6,000 objects in its collections, including European and American paintings, Japanese and Chinese textiles, post-World War II American ceramics, prints and drawings, and sculpture.

Mills College Art Gallery, 5000 MacArthur Blvd., Oakland, CA 94613. Phone: 510/430-2164. Hours: 11–4 Tues.–Sat.; 12–4 Sun.; closed holidays and when college not in session. Admission: free.

## MINNEAPOLIS COLLEGE OF ART AND DESIGN
### MCAD Gallery

The MCAD Gallery is located in a large open space that serves as the main entrance to the Minneapolis College of Art and Design building in Minneapolis. It features changing exhibitions of contemporary art and design by local, regional, national, and international artists in the 4,800-square-foot space. The gallery opened when the building was completed in 1972.

MCAD Gallery, Minneapolis College of Art and Design, 2501 Stevens Ave., S., Minneapolis, MN 55404. Phone: 612/874-3700. Hours: 9–9 Mon.–Fri.; 9–5 Sat.; 12–5 Sun.; closed holidays and when college not in session. Admission: free.

## MONTANA STATE UNIVERSITY
### Haynes Fine Arts Gallery

The Haynes Fine Arts Gallery at Montana State University in Bozeman was founded in 1974 by the School of Art. It presents contemporary art exhibitions and has a collection of prints, crafts, and ceramics.

Haynes Fine Arts Gallery, Montana State University, School of Art, Haynes Hall, Bozeman, MT 59717. Phone: 406/994-2562. Hours: 8–12 and 1–5 Mon.–Fri.; closed holidays. Admission: free.

## *Museum of the Rockies Art Gallery*
(See Natural History Museums and Centers section.)

## MONTANA STATE UNIVERSITY–NORTHERN
## *Northern Gallery*

Contemporary exhibitions are shown at the Northern Gallery, opened in 1989 on the second floor of the Student Union, at Montana State University–Northern in Havre.
Northern Gallery, Montana State University–Northern, Student Union, Havre, MT 59501. Phone: 406/265-3751. Hours: 8–5 Mon.–Fri.; closed summer and holidays. Admission: free.

## MONTCLAIR STATE COLLEGE
## *Montclair State College Art Gallery*

Contemporary works are presented in temporary exhibitions by the Montclair State College Art Gallery in Upper Montclair, New Jersey. The 1,800-square-foot gallery was founded in 1972.
Montclair State College Art Gallery, Valley Rd. and Normal Ave., Upper Montclair, NJ 07043. Phone: 201/655-4000. Hours: 10–4 Mon.–Fri.; 1–5 Sat.; closed major holidays. Admission: free.

## MOORE COLLEGE OF ART AND DESIGN
## *Goldie Paley Gallery, Levy Gallery for the Arts in Philadelphia, and Atrium Gallery*

The Moore College of Art and Design in Philadelphia has three galleries—the Goldie Paley Gallery, featuring traveling exhibitions of the work of national and international artists; Levy Gallery for the Arts in Philadelphia, which displays the works of local artists; and Atrium Gallery, a spillover gallery, which also contains occasional exhibitions of student work.
Goldie Paley Gallery and related galleries, Moore College of Art and Design, 20th St. and The Parkway, Philadelphia, PA 19103. Phone: 215/568-4515. Hours: 10–5 Mon.–Fri. (also to 8 Wed.); 12–4 Sat.; closed major holidays. Admission: free.

## MURRAY STATE UNIVERSITY
## *Clara M. Eagle Gallery*

Murray State University's Clara M. Eagle Gallery in Murray, Kentucky, opened in 1971 as part of the new Price Doyle Fine Arts Center. It was an extension of other campus galleries operating since 1941. The gallery, located on the fourth floor, presents eight major exhibitions per year, as well as continuing baccalaureate exhibitions on the second level of the arts center. Its collec-

tions include WPA prints, the H.L. Jackson Print Collection, the Magic Silver Photographic Collection, and various contemporary artworks.

Clara M. Eagle Gallery, Murray State University, 15th St. and Olive Blvd., Murray, KY 42071. Phone: 502/762-6734. Hours: 8–6 Mon., Wed., and Fri.; 8–7:30 Tues. and Thurs.; 10–4 Sat.; 1–4 Sun.; closed holidays and when university not in session. Admission: free.

## NASSAU COMMUNITY COLLEGE
### Firehouse Art Gallery

The Firehouse Art Gallery at Nassau Community College in Garden City, New York, presents exhibitions from students, regional and other artists, and its collection of more than 450 paintings, prints, and sculpture from the sixteenth century to the present. The gallery was founded in 1965.

Firehouse Art Gallery, Nassau Community College, 1 Education Dr., Garden City, NY 11530. Hours: 11:30–4:30 Mon.–Thurs. (also 7–10 Thurs.); 1–5 Sat.–Sun.; closed holidays and when college not in session. Admission: free.

## NEBRASKA WESLEYAN UNIVERSITY
### Elder Gallery

Nebraska Wesleyan University's Elder Gallery, located in the Rogers Center for Fine Arts in Lincoln, presents temporary exhibitions during the academic year, highlighted by the 12-state Fred Wells Annual Show. The gallery also has responsibility for the university's permanent collection, which includes works by Chagall, Rouault, Utrillo, Matisse, Le Brun, Biddle, Baskin, and Arp.

Elder Gallery, Nebraska Wesleyan University, Rogers Center for Fine Arts, 50th and Huntington Sts., Lincoln, NE 68504-2796. Hours: 10–4 Tues.–Fri.; 1–4 Sat.–Sun.; closed holidays. Admission: free.

## NEW ENGLAND COLLEGE
### New England College Gallery

Contemporary art—including paintings, photographs, and works on paper—is shown at the New England College Gallery in Henniker, New Hampshire. The gallery was founded in 1988.

New England College Gallery, 7 Main St., Henniker, NH 03242. Phone: 608/428-2329. Hours: 4–7 Wed.–Thurs.; 1–4 Fri.–Sun.; closed summer, Thanksgiving week, and Christmas recess. Admission: free.

## NEW MEXICO HIGHLANDS UNIVERSITY
### Arrott Art Gallery

(See Library and Archival Collections and Galleries section.)

## NEW MEXICO STATE UNIVERSITY
### University Art Gallery

The University Art Gallery at New Mexico State University in Las Cruces organizes contemporary exhibitions and schedules traveling exhibitions. The gallery, founded in 1973, is located in Williams Hall. Its collections include nineteenth-century Mexican retablos, contemporary prints, paintings, sculpture, and photographs.

University Art Gallery, New Mexico State University, University Ave., Box 30001, Dept. Box 3572, Las Cruces, NM 88003. Phone: 505/646-2456. Hours: 10–4 Mon.–Fri. (also 7–9 Thurs.); 1–4 Sun.; closed Aug. and holidays. Admission: free.

## NEW YORK UNIVERSITY
### Grey Art Gallery and Study Center

The Grey Art Gallery and Study Center at New York University in New York City presents contemporary exhibitions and has responsibility for the university's 5,000-piece art collection. Founded in 1975, it is located in the Main Building on the campus in historic Washington Square. Among the works in the art collection are nineteenth- and twentieth-century paintings, sculpture, and graphics and the Abby Weed Grey Collection of contemporary Asian and Middle Eastern art.

Grey Art Gallery and Study Center, New York University, Main Bldg., 33 Washington Pl., New York, NY 10003. Phone: 212/998-6780. Hours: academic year—11–6:30 Tues.–Fri. (also to 8:30 Thurs.); 11–5 Sat.; summer—11–6 Mon.–Fri.; closed holidays. Admission: suggested donation—$2.50.

## NORTH CAROLINA STATE UNIVERSITY
### Visual Arts Center

North Carolina State University's 18,000-square-foot Visual Arts Center in Raleigh emphasizes the decorative arts and design in its two gallery spaces. It presents exhibitions of contemporary fiber, clay, folk, and other art and has North Carolina ceramics, Oriental textiles, architectural drawings, and other artworks in its collections.

Visual Arts Center, North Carolina State University, Cates Ave., Box 7306, Raleigh, NC 27695-7306. Phone: 919/515-3503. Hours: 12–8 Tues.–Fri.; 2–8 Sat.–Sun.; closed holidays and when university not in session. Admission: free.

## NORTH DAKOTA STATE UNIVERSITY
### Memorial Union Art Gallery

Exhibitions of contemporary artworks are offered by the North Dakota State University's Memorial Union Art Gallery in Fargo. The gallery, which opened

in 1975, has a collection of contemporary works by American artists.
Memorial Union Art Gallery, North Dakota State University, Memorial Union, PO Box 5476, Fargo, ND 58105. Phone: 701/237-8241. Hours: 10–5 Mon.–Fri.; 1–5 Sat.–Sun.; closed summer and holidays. Admission: free.

## NORTHERN ARIZONA UNIVERSITY
### *Northern Arizona University Art Museum and Galleries*

(See Art Museums section.)

## NORTHERN ILLINOIS UNIVERSITY
### *Northern Illinois University Art Gallery in Chicago*

Northern Illinois University in DeKalb operates a gallery in Chicago that presents contemporary art by professionals, faculty, and students. Known as the Northern Illinois University Art Gallery in Chicago, it functions much like a commercial gallery, with many of the works being for sale. The gallery was opened in 1984.
Northern Illinois University Art Gallery in Chicago, 212 W. Superior St., Suite 306, Chicago, IL 60610. Phone: 312/642-6010. Hours: 11–5 Tues.–Sat.; closed Aug. and major holidays. Admission: free.

## NORTH FLORIDA JUNIOR COLLEGE
### *Art Gallery*

Exhibitions of traditional and contemporary art are presented by the Art Gallery at North Florida Junior College in Madison. Founded in 1975, the gallery displays artworks from its collections and temporary and traveling shows by professional artists and students.
Art Gallery, North Florida Junior College, Turner Davis Dr., Madison, FL 32340. Phone: 904/973-2288. Hours: 10–12 and 1–3 Mon.–Fri.; closed holidays. Admission: free.

## NORTHWESTERN UNIVERSITY
### *Mary and Leigh Block Gallery*

A wide range of experimental and educational visual art exhibitions are presented at the Mary and Leigh Block Gallery at Northwestern University in Evanston, Illinois. The gallery also has a major outdoor sculpture garden containing monumental sculpture by such modernists as Joan Miró, Jean Arp, Barbara Hepworth, Henry Moore, and Jacques Lipchitz. Gallery collections include fif-

teenth- to twentieth-century European prints and drawings, architectural drawings, and contemporary prints and photography.

Mary and Leigh Block Gallery, Northwestern University, 1967 Campus Dr., S., Evanston, IL 60208-2410. Phone: 708/491-4000. Hours: academic year—12–5 Tues.–Wed.; 12–8 Thurs.–Sun.; summer—12–5 Tues.–Sat. Admission: free.

## NORTHWEST MISSOURI STATE UNIVERSITY
### DeLuce Fine Arts Gallery

The DeLuce Fine Arts Gallery at Northwest Missouri State University in Maryville offers changing exhibitions by nationally known artists, faculty members, and graduate art students. Part of the Percival DeLuce Memorial Collection, which features the works of the 1880s portrait painter and book and periodical illustrator, also is displayed.

DeLuce Fine Arts Gallery, Northwest Missouri State University, Olive DeLuce Fine Arts Bldg., 800 University Dr., Maryville, MO 64468. Phone: 816/562-1314. Hours: 6 P.M.–8 P.M. Mon.; 1–3 Tues.–Fri.; 1:30–3:30 Sat.–Sun.; closed holidays and when university not in session. Admission: free.

## OAKLAND UNIVERSITY
### Meadow Brook Art Gallery

Exhibitions of contemporary, Asian, pre-Columbian, African, and Oceanian works are shown in the Meadow Brook Art Gallery at Oakland University in Rochester, Michigan. The gallery, which is located in the same building as a regional professional theater, stays open evenings to accommodate theatergoers, thereby increasing its annual attendance to 35,000. African art and contemporary paintings and prints are among its most important collections. The gallery also has outdoor sculptures.

Meadow Brook Art Gallery, Oakland University, Rochester, MI 48309-4401. Phone: 313/370-3005. Hours: 1–5 Tues.–Fri. (and 7:30–8:30 P.M. when a performance in Meadow Brook Theater); 2–6:30 Sat.–Sun.; closed holidays and when university not in session. Admission: free.

## OCEAN COUNTY COLLEGE
### Ocean County College Gallery

The Ocean County College Gallery displays artworks throughout the college's Fine Arts Center in Toms River, New Jersey.

Ocean County College Gallery, Fine Arts Center, College Dr., Toms River, NJ 08754. Phone: 908/255-0400. Hours: 8 A.M.–10 P.M. Mon.–Thurs.; 8–5 Fri.; 8–1 Sat.; closed when college not in session. Admission: free.

## OHIO STATE UNIVERSITY
### Hopkins Hall Gallery

From 30 to 40 exhibitions are presented each year at the Hopkins Hall Gallery at Ohio State University in Columbus. They include exhibitions featuring the work of regional, national, and international artists; university faculty and students; specially curated shows; and the 48 Hour Turnover Exhibition Series, in which five shows are presented in 10 days, mostly of a multi- and cross-media nature, performance art, and other types of artworks. The gallery, which opened in 1968, is located on the first floor of the building housing the art, art education, and industrial design departments.

Hopkins Hall Gallery, Ohio State University, 128 N. Oval Mall, Columbus, OH 43210-1363. Phone: 614/292-5072. Hours: 8:30–5:30 Mon., Wed., and Fri.; 8:30–7:30 Tues. and Thurs.; closed when university not in session. Admission: free.

### Wexner Center for the Arts

The Wexner Center for the Arts is a contemporary arts center that opened in 1989 at Ohio State University in Columbus. The center has four adjoining galleries, performing arts theaters, and a film/video center. Its collections include paintings, sculpture, photographs, and graphic arts of the 1960s–1970s, as well as subcollections of graphic and Asian arts.

Wexner Center for the Arts, Ohio State University, N. High St. at 15th Ave., Columbus, OH 43210-1393. Phone: 614/292-0330. Hours: 10–6 Tues.–Wed.; 10–8 Thurs.–Sat.; 12–5 Sun.; closed Aug. and major holidays. Admission: free.

## OHIO UNIVERSITY
### Trisolini Gallery

The Trisolini Gallery of Ohio University in Athens presents changing exhibitions of contemporary art. It has a collection of contemporary prints and Southwest Native American works. The gallery, founded in 1974, is part of the College of Fine Arts.

Trisolini Gallery, Ohio University, 48 E. Union St., Athens, OH 45701. Phone: 614/593-1304. Hours: 12–4 Mon.–Sat.; closed holidays. Admission: free.

## OKLAHOMA STATE UNIVERSITY
### Gardiner Art Gallery

The Gardiner Art Gallery at Oklahoma State University in Stillwater exhibits works of art in all media by artists whose work is relevant to contemporary art issues. The exhibitions are primarily regional and traveling shows, with emphasis on contemporary expressions. The gallery, which has a collection consisting largely of prints by American contemporary and WPA artists, began as the

Whitehurst Art Gallery in 1966 and has had its current name and location since 1970.

Gardiner Art Gallery, Oklahoma State University, 107 Bartlett Center for the Studio Arts, Stillwater, OK 74078. Phone: 405/744-6016. Hours: 8–5 Mon.–Fri.; 9–1 Sat.; 1–5 Sun.; closed holidays and when university not in session. Admission: free.

## OLD DOMINION UNIVERSITY
### University Gallery

The University Gallery at Old Dominion University in Norfolk, Virginia, is a storefront exhibition space located off-campus. The gallery, opened in 1971 by the Department of Art, features changing exhibitions of contemporary art.

University Gallery, Old Dominion University, 765 Granby St., Norfolk, VA 23507. Phone: 804/683-4047. Hours: 11–4 Fri.–Sun.; closed holidays and when university not in session. Admission: free.

## OREGON STATE UNIVERSITY
### Memorial Union Concourse Gallery

Changing exhibitions of contemporary art are presented at the Memorial Union Concourse Gallery at Oregon State University in Corvallis.

Memorial Union Concourse Gallery, Oregon State University, Memorial Union, Corvallis, OR 97331-5004. Phone: 503/737-6872. Hours: academic year—7 A.M.–11 P.M. Mon.–Thurs.; 7 A.M.–12 midnight Fri.; 7:30 A.M.–12 midnight Sat.; 8:30 A.M.–11 P.M. Sun.; summer—8–5 Mon.–Fri.; closed holidays. Admission: free.

## OTIS COLLEGE OF ART AND DESIGN
### Otis Gallery

Traveling exhibitions of an educational nature and shows of local contemporary artists are featured in the Otis Gallery at Otis College of Art and Design in Los Angeles.

Otis Gallery, Otis College of Art and Design, 2401 Wilshire Blvd., Los Angeles, CA 90047. Phone: 213/251-0555. Hours: 10–5 Tues.–Sat.; closed holidays. Admission: free.

## PALOMAR COLLEGE
### Boehm Gallery

The Boehm Gallery at Palomar College in San Marcos, California, exhibits the work of local artists and contemporary art. It also has a print collection.

Boehm Gallery, Palomar College, 1140 W. Mission Rd., San Marcos, CA 92069-1487. Phone: 619/744-1150. Hours: 10–4 Tues.; 10–7 Wed.–Thurs.; 10–2 Fri.–Sat.; closed holidays and when college not in session. Admission: free.

## PARKLAND COLLEGE
### Parkland College Art Gallery

The Parkland College Art Gallery in Champaign, Illinois, presents an annual art faculty exhibition, two juried student shows, and exhibitions by regional and national contemporary artists. It also hosts a biennial National Invitational Watercolor Show and an Invitational Show of Ceramic Art. The gallery, which opened in 1981, is located in the central commons area of the community college.

Parkland College Art Gallery, 2400 W. Bradley Ave., Champaign, IL 61821-1899. Phone: 217/351-2485. Hours; 10–3 Mon.–Fri.; 10–12 noon Sat.; closed holidays and when college not in session. Admission: free.

## PASSAIC COUNTY COMMUNITY COLLEGE
### Broadway Gallery and LRC Gallery

Passaic County Community College in Paterson, New Jersey, has two small galleries—the Broadway Gallery and the LRC Gallery—in which loan exhibitions of contemporary art are shown. The galleries opened in 1980.

Broadway Gallery/LRC Gallery, Passaic County Community College, 1 College Blvd., Paterson, NJ 07505-1179. Phone: 201/684-6182. Hours: 9–9 Mon.–Fri.; 9–5 Sat.; closed when college not in session. Admission: free.

## PENNSYLVANIA STATE UNIVERSITY

Pennsylvania State University has seven galleries in various locations on its campus in University Park, in addition to two art museums described in the Art Museums section. They include the Hetzel Union Galleries, Kern Exhibition Area, Paul Robeson Cultural Center, Pattee Library Galleries (see Library and Archival Collections and Galleries section), Zoller Gallery, Photo/Graphics Gallery (see Photography Museums section), and Earth and Mineral Sciences Museum and Art Gallery (see Geology, Mineralogy, and Paleontology Museums section).

### Hetzel Union Galleries

The Hetzel Union Galleries at Pennsylvania State University in University Park include four main gallery areas—the Art Alley Cases, Art Alley Panels, Browsing Gallery, and Formal Gallery—which show the artistic efforts of students and nationally and internationally known artists.

Hetzel Union Galleries, Pennsylvania State University, Hetzel Union Bldg., Pollock Rd., University Park, PA 16802. Phone: 814/865-1878. Hours: 12–8 Tues.–Thurs.; 12–4 Fri.–Sat.; Admission: free.

### Kern Exhibition Area

The Kern Exhibition Area in the Kern Graduate Building at Pennsylvania State University in University Park features changing exhibitions of paintings, sculpture, ceramics, photography, jewelry, and fiber by local and nationally known artists and craftspeople.

Kern Exhibition Area, Pennsylvania State University, Kern Graduate Bldg., University Park, PA 16802. Phone: 814/865-1878. Hours: 7:30 A.M.–11 P.M. Mon.–Fri.; 10 A.M.–11 P.M. Sat.; 12–11 P.M. Sun. Admission: free.

### Paul Robeson Cultural Center Gallery

The Paul Robeson Cultural Center at Pennsylvania State University in University Park presents the art and artifacts of African-descended peoples—and sometimes of other groups—in its gallery. The center is actively building a collection of artworks from African, Caribbean, and African-American artists and regularly shows traveling exhibitions and the works of local artists.

Paul Robeson Cultural Center Gallery, Pennsylvania State University, Shortlidge Rd., University Park, PA 16802. Phone: 814/865-3776. Hours: 8 A.M.–10 P.M. Mon.–Fri.; 11–4 Sat.; 1–4 Sun. Admission: free.

### Zoller Gallery

Contemporary art is featured at the Zoller Gallery in the Visual Arts Building at Pennsylvania State University in University Park. The exhibitions include contemporary paintings, drawings, photographs, sculpture, ceramics, metalwork, graphics, prints, and works in other media by leading artists and university faculty and students.

Zoller Gallery, Pennsylvania State University, 101 Visual Arts Bldg., University Park, PA 16802. Phone: 814/865-0444. Hours: 9–5 Mon.–Fri.; 11–4:30 Sat.; 12–4 Sun. Admission: free.

## PENSACOLA JUNIOR COLLEGE
### Visual Arts Center

Temporary and loan exhibitions are shown at the Visual Arts Center at Pensacola Junior College in Pensacola, Florida. Opened in 1970, the gallery has a collection of contemporary drawings, prints, paintings, photographs, and crafts.

Visual Arts Center, Pensacola Junior College, 1000 College Blvd., Pensacola, FL 32504. Phone: 904/484-2563. Hours: 8 A.M.–9 P.M. Mon.–Thurs.; 8–3:30 Fri.; closed summer and holidays. Admission: free.

## PHILLIPS UNIVERSITY
### Grace Phillips Johnson Gallery

The Grace Phillips Johnson Gallery is a small exhibition space in the Phillips University Art Building in Enid, Oklahoma, that has permanent and temporary exhibitions—usually from its collection of paintings, sculpture, graphic arts,

decorative arts, photographs, and historical documents. The gallery was founded in 1966.

Grace Phillips Johnson Gallery, Phillips University, Art Bldg., PO Box 2000, Enid, OK 73701. Phone: 405/237-4433. Hours: 10–4 Mon.–Fri.; closed holidays and when university not in session. Admission: free.

## PLYMOUTH STATE COLLEGE
### Karl Drerup Fine Arts Gallery

The Karl Drerup Fine Arts Gallery at Plymouth State College in Plymouth, New Hampshire, was founded in 1969 to provide a variety of art exhibitions for the college community and the community at large. It is part of the Department of Fine Arts.

Karl Drerup Fine Arts Gallery, Plymouth State College, Dept. of Fine Arts, Plymouth, NH 03264. Phone: 603/535-2201. Hours: 10–5 Tues.–Fri. (also to 8 Wed.); 12–5 Sat.; closed summer, college recesses, Thanksgiving, and Christmas. Admission: free.

## POMONA COLLEGE
### Montgomery Gallery

Pomona College in Claremont, California, has had an art gallery since the late nineteenth century. It was an extension of the Department of Art until 1958, when it became independent. As Montgomery Gallery, it joined with Lang Gallery at Scripps College in a program called Galleries of the Claremont Colleges in 1974. But the two galleries became separate again in 1993.

The gallery has a changing exhibition program that includes selections from its collection of Renaissance and medieval paintings; nineteenth- and twentieth-century prints, including prints by Goya; Native American baskets, ceramics, and beadwork; and various paintings, drawings, and photographs.

Montgomery Gallery, Pomona College, 330 N. College Ave., Claremont, CA 91711-6344. Phone: 909/621-8283. Hours: 1–5 Wed.–Sun.; closed holidays and when college not in session. Admission: free.

## PRATT INSTITUTE
### Rubelle and Norman Schafler Gallery

Art, design, and architecture are the focus of the Rubelle and Norman Schafler Gallery at the Pratt Institute in Brooklyn, New York. Founded in 1967, the gallery also operates the Pratt Manhattan Gallery, which opened in 1975 in the heart of New York City.

The Brooklyn gallery has a 2,300-square-foot exhibition space, while the Manhattan gallery is a 1,200-square-foot exhibit area. Their changing shows sometimes display selections from the institute's collection of nineteenth- and twentieth-century paintings, sculpture, prints, decorative arts, and graphic arts

by European and American artists. Pratt has 185,000 books, 135,000 photographs, 50,000 slides, 22,000 microforms, and 130,000 government documents pertaining to art, design, and architecture in open stacks.

Rubelle and Norman Schafler Gallery, Pratt Institute, 200 Willoughby Ave., Brooklyn, NY 11205. Phone: 718/636-3517. Hours: academic year—9–5 Mon.–Fri.; summer—9–4 Mon.–Fri.; closed mid-July to mid-Aug. and major holidays. Admission: free. Pratt Manhattan Gallery, Pratt Institute, 295 Lafayette St., Second Fl., New York, NY 10012. Phone: 718/636-3517. Hours: 10–5 Mon.–Fri.; closed major holidays. Admission: free.

## PRESBYTERIAN COLLEGE
### Harper Center Gallery

Presbyterian College in Clinton, South Carolina, opened a new changing exhibition space, called Harper Center Gallery, in 1993. Exhibitions of paintings, sculpture, and graphics are presented in the 2,500-square-foot gallery.

Harper Center Gallery, Presbyterian College, Clinton, SC 29325-9989. Phone: 803/833-8319. Hours: 1–5 Tues.–Sun.; closed when college not in session. Admission: free.

## PRINCETON UNIVERSITY
### Milberg Gallery for the Graphic Arts

(See Library and Archival Collections and Galleries section.)

## PURDUE UNIVERSITY
### Purdue University Galleries

The Purdue University Galleries, located in Creative Arts Building 1 on the campus in West Lafayette, Indiana, were founded in 1978. They present mainly contemporary art exhibitions, but have a collection of American and European paintings, prints, and drawings; contemporary American ceramics; Native American basketry and textiles; and pre-Columbian textiles.

Purdue University Galleries, Creative Arts Bldg. 1, West Lafayette, IN 47907. Phone: 317/494-3061. Hours: 10–5 and 7–9 Mon.–Fri.; 1–5 Sun.; closed holidays. Admission: free.

## QUEENSBOROUGH COMMUNITY COLLEGE
### QCC Art Gallery

The QCC Art Gallery at Queensborough Community College in Bayside, New York, presents exhibitions that reflect the ethnic diversity of the college and community and the role of art in the cultural history of people. The exhibits and collections are based primarily on American artists—particularly women—after 1950. The gallery was founded in 1966.

QCC Art Gallery, Queensborough Community College, 222-05 56th Ave., Bayside, NY 11364-1497. Phone: 718/631-6396. Hours: 9–5 Mon.–Fri.; closed major holidays. Admission: free.

## RADFORD UNIVERSITY
### Radford University Galleries

The Radford University Galleries in Radford, Virginia, have 2,000 square feet of interior space and 16,000 square feet in adjacent exterior space (used largely as a sculpture court) in the Fine Arts Center. Founded in 1985, the facility has a diverse collection of over 600 artworks, representing various styles, periods, cultures, and materials.

The primary focus of the collection is twentieth-century and contemporary paintings and sculpture, with ancillary holdings of Nigerian and Huichol art. Ten exhibitions are presented annually, including selections from the permanent collection, artworks on loan from other museums, and works by the university faculty, students, and alumni.

Radford University Galleries, PO Box 6965, Radford, VA 24142. Phone: 703/831-5754. Hours: 10–4 Tues.–Fri.; 12–4 Sun.; closed holidays and when university not in session. Admission: free.

## RANCHO SANTIAGO COLLEGE
### Rancho Santiago College Art Gallery

Exhibitions of contemporary art from local artists and art with commentary on social issues are presented at the Rancho Santiago College Art Gallery in Santa Ana, California. Opened in 1970, the gallery is off the first floor lobby of Fine Arts Building C.

Rancho Santiago College Art Gallery, 1530 E. 17th St., Santa Ana, CA 92706. Phone: 714/564-5615. Hours: 10–2 Mon.–Thurs. (also 6:30–8:30 Tues.–Wed.); closed holidays and when college not in session. Admission: free.

## REED COLLEGE
### Douglas F. Cooley Memorial Gallery

A wide range of exhibitions is presented by the Douglas F. Cooley Memorial Gallery at Reed College in Portland, Oregon. They include selections from the gallery's collection of 1950s artwork by Pacific Northwest artists.

Douglas F. Cooley Memorial Gallery, Reed College, 3203 S.E. Woodstock, Portland, OR 97202-8199. Phone: 502/771-1112. Hours: 12–5 Tues.–Sun.; closed when college not in session. Admission: free.

## RICE UNIVERSITY
### Sewall Art Gallery

Temporary and traveling exhibitions—as well as student and faculty shows— are presented at the Sewall Art Gallery at Rice University in Houston. Founded

in 1971, the Department of Art and Art History gallery is located in Sewall Hall. It makes extensive use of the university's collection of modern paintings, drawings, and photographs; decorative arts; pre-Columbian, African, and Oriental objects; European art prior to the twentieth century; and medieval wood sculpture.

Sewall Art Gallery, Rice University, Sewall Hall, 6100 S. Main St., Houston, TX 77005. Phone: 713/527-4815. Hours: 12–5 Tues.–Sat. (also to 9 Thurs.); closed summer and holidays. Admission: free.

## RINGLING SCHOOL OF ART AND DESIGN
### Selby Gallery

The contemporary works of regional, national, and international artists and designers are shown by the Selby Gallery at the Ringling School of Art and Design in Sarasota, Florida. The gallery, which opened in 1986, also displays selections from the institution's collection of twentieth-century prints.

Selby Gallery, Ringling School of Art and Design, 2700 N. Tamiami Tr., Sarasota, FL 34234. Phone: 813/359-7563. Hours: 10–4 Mon.–Sat.; closed holidays. Admission: free.

## ROCKFORD COLLEGE
### Rockford College Art Gallery

The Rockford College Art Gallery in Rockford, Illinois, has 1,400 square feet of space for changing exhibitions in the Clark Arts Center. The gallery has a diverse collection of paintings, drawings, sculptures, prints, photographs, decorative arts, ceramics, glass, textiles, and contemporary American, African, and ethnographic art.

Rockford College Art Gallery, Clark Arts Center, 5050 E. State St., Rockford, IL 61108. Phone: 815/226-4034. Hours: 2–5 daily; closed summer. Admission: free.

## ROCKY MOUNTAIN COLLEGE OF ART AND DESIGN
### Philip J. Steele Gallery

The Philip J. Steele Gallery at the Rocky Mountain College of Art and Design in Denver displays the works of the college's students and professional artists and designers.

Philip J. Steele Gallery, Rocky Mountain College of Art and Design, 6875 E. Evans Ave., Denver, CO 80224. Phone: 303/753-6046. Hours: 8–6 Mon.–Fri.; 9–5 Sat.; closed holidays. Admission: free.

## ROWAN COLLEGE OF NEW JERSEY
### Westby Art Gallery

Changing contemporary art and crafts exhibitions are offered by the Westby Art Gallery in Westby Hall at Rowan College of New Jersey—formerly Glassboro State College—in Glassboro.

Westby Art Gallery, Rowan College of New Jersey, Westby Hall, 201 Mullica Hill Rd., Rte. 322, Glassboro, NJ 08028. Phone: 609/256-4520. Hours: 8–4 Mon.–Fri.; closed major holidays. Admission: free.

## RUTGERS UNIVERSITY–CAMDEN
### Stedman Art Gallery

The Stedman Art Gallery on the Camden campus of Rutgers University in New Jersey primarily offers contemporary art exhibitions. Founded in 1975, it has a collection of American and European works on paper, paintings, and sculpture.

Stedman Art Gallery, Rutgers University–Camden, Camden, NJ 08102. Phone: 609/225-6245. Hours: 10–4 Mon.–Sat.; some evenings; closed major holidays and between exhibitions. Admission: free.

## SAINT ANSELM COLLEGE
### Chapel Art Center

The Chapel Art Center at Saint Anselm College in Manchester, New Hampshire, is located in the institution's former chapel building, which first was converted into a general arts center in 1967 and then devoted entirely to the visual arts in the 1980s. The gallery specializes in exhibitions of contemporary painting, sculpture, and decorative arts by artists in New Hampshire and the New England region. Its permanent collection consists primarily of contemporary regional works.

Chapel Art Center, St. Anselm College, 100 St. Anselm Dr., Manchester, NH 03102-1310. Phone: 603/641-7470. Hours: 10–4 Tues.–Sat. (also to 9 Thurs.); closed holidays and when college not in session. Admission: free.

## SAINT BONAVENTURE UNIVERSITY
### University Art Gallery

Old Masters, American art, Chinese porcelain, and other artworks from Saint Bonaventure University's Art Collection are exhibited on a selected, rotating basis in the gallery space in the Fine Arts Center opened in 1994 in St. Bonaventure, New York.

University Art Gallery, St. Bonaventure University, PO Box BB, St. Bonaventure, NY 14778-2356. Hours: undetermined. Admission: free.

## SAINT JOHN'S COLLEGE
### Mitchell Art Gallery

Four temporary and traveling exhibitions are presented each year at the Mitchell Art Gallery at Saint John's College in Annapolis, Maryland. The gallery's

collection includes fourteenth-century Chinese art, sixteenth-century Italian art, seventeenth-century Dutch art, and twentieth-century Japanese art.

Mitchell Art Gallery, St. John's College, 60 College Ave., PO Box 2800, Annapolis, MD 21404-2800. Hours: academic year—12–5 Tues.–Thurs. and Sat.–Sun.; 7–9 P.M. Fri.; closed holidays and when college not in session. Admission: free.

## SAINT JOSEPH COLLEGE
### Art Study Gallery

The Saint Joseph College Art Study Gallery in West Hartford, Connecticut, presents permanent and temporary exhibitions from its collections. The gallery, founded in 1932, has collections that include paintings of early-twentieth-century American artists, fine arts prints by European and American artists from the fifteenth to the twentieth centuries, and works by American photographers.

Art Study Gallery, St. Joseph College, 1678 Asylum Ave., West Hartford, CT 06117. Phone: 203/232-4571. Hours: 10–4 Mon.–Fri.; closed holidays. Admission: free.

## SAINT JOSEPH'S UNIVERSITY
### University Gallery

The University Gallery at Saint Joseph's University presents all types of changing exhibitions in Boland Hall on the campus in Philadelphia.

University Gallery, St. Joseph's University, Boland Hall, 5600 City Line Ave., Philadelphia, PA 19131. Phone: 215/660-1840. Hours: 10–4 Mon.–Fri.; closed major holidays and when university not in session. Admission: free.

## SAINT LAWRENCE UNIVERSITY
### Richard F. Brush Art Gallery

The Richard F. Brush Art Gallery at Saint Lawrence University in Canton, New York, presents changing exhibitions, including selections from the university's permanent collection, in its three exhibition areas. The gallery was founded in 1967. The collections include sixteenth- to twentieth-century European and American paintings, prints, and sculpture; North Country folk art; Frederic Remington Collection; Dorothy Feigin Collection of modern art; Nitechki and Burwash collections of African art; Botkin, von Wicht, Crimi, and Lenney collections; Roman coins; photographs; pre-Columbian pottery; and Makonde sculpture.

Richard F. Brush Art Gallery, St. Lawrence University, Romoda Dr., Canton, NY 13617. Phone: 315/379-5174. Hours: 9–5 Mon.–Fri. and by appointment; closed Easter, Thanksgiving, Christmas, and when university not in session. Admission: free.

## SAINT MARY'S COLLEGE OF MARYLAND
### Dwight Frederick Boyden Gallery

Works by living American artists are featured in the Dwight Frederick Boyden Gallery at Saint Mary's College of Maryland in St. Mary's City. The gallery also has a collection of twentieth-century American paintings, drawings, and prints.

Dwight Frederick Boyden Gallery, St. Mary's College of Maryland, St. Mary's City, MD 20686. Phone: 301/862-0246. Hours: 11–6 Mon.–Thurs.; 11–4 Fri.; closed holidays and when college not in session. Admission: free.

## SALISBURY STATE COLLEGE
### Salisbury State University Galleries

Changing exhibitions are presented in galleries in two buildings by the Salisbury State University Galleries in Salisbury, Maryland. The galleries opened in 1962 and have a collection of regional art, photographs, prints, and sculpture.

Salisbury State University Galleries, 110 Fulton Hall, Salisbury, MD 21801. Phone: 410/543-6271. Hours: 10–5 Tues.–Thurs.; 10–8 Fri.; 12–4 Sat.–Sun.; closed holidays. Admission: free.

## SAN DIEGO STATE UNIVERSITY
### University Art Gallery

The 2,500-square-foot University Art Gallery at San Diego State University in San Diego, California, presents changing exhibitions of contemporary art.

University Art Gallery, San Diego State University, San Diego, CA 92182. Phone: 619/594-4941. Hours: academic year—12–4 Mon., Thurs., and Sat.; 10–4 Tues.–Wed.; closed holidays. Admission: free.

## SAN FRANCISCO ART INSTITUTE
### Walter/McBean Gallery and Diego Rivera Gallery

The San Francisco Art Institute has two galleries—the Walter/McBean Gallery, which presents contemporary art exhibitions, and the Diego Rivera Gallery for displaying student work.

Walter/McBean Gallery, San Francisco Art Institute, 800 Chestnut St., San Francisco, CA 94133. Phone: 415/749-4564. Hours: 10–5 Tues.–Sat. (also to 8 Thurs.); 12–5 Sun. Admission: free. Diego Rivera Gallery hours: 9 A.M.–7 P.M. Mon.–Sat. Admission: free.

## SAN FRANCISCO STATE UNIVERSITY
### San Francisco State University Galleries

San Francisco State University has six galleries, with the two largest and most active being the Art Department's Art Gallery in the Creative Arts and Industry

Building and the Student Center Art Gallery in the Ceaser Chavez Student Center. The former, which opened in 1993, presents five exhibitions each year—three professional shows featuring twentieth-century art and two student exhibitions. The Student Center Art Gallery emphasizes contemporary art and has a small student show at the end of the academic year.

San Francisco State University Art Dept. Art Gallery, Creative Arts and Industry Bldg., 1600 Holloway Ave., San Francisco, CA 94132. Phone: 415/338-2753. Hours: 12–4 Mon.–Sat.; closed summer and holidays. Admission: free. Student Center Art Gallery, San Francisco State University, Ceaser Chavez Student Center, 1650 Holloway Ave., San Francisco, CA 94132. Phone: 415/338-2580. Hours: 10–6 Mon.–Fri.; closed summer and holidays. Admission: free.

## SAN JOSE STATE UNIVERSITY
### Gallery 1

The School of Art and Design at San Jose State University in San Jose, California, presents innovative, content-based contemporary exhibitions and more than 200 student exhibits each year in its Gallery 1.

Gallery 1, San Jose State University, School of Art and Design, 1 Washington Sq., San Jose, CA 95192-0089. Phone: 408/924-4328. Hours: 10–4 Mon.–Fri. (also 6–8 Tues.); closed holidays and when university not in session. Admission: free.

### Union Gallery

The Union Gallery, which has two exhibition spaces on the top floor of the Student Union at San Jose State University in San Jose, California, presents six changing contemporary exhibitions during the academic year.

Union Gallery, San Jose State University, Student Union, San Jose, CA 95192. Phone: 408/924-6330. Hours: 10–3 Mon.–Fri. (also 6–8 Tues.–Wed.); 12–4 Sat.; closed holidays, summer, and when university not in session. Admission: free.

## SANTA FE COMMUNITY COLLEGE
### Santa Fe Gallery

The Santa Fe Gallery at the Santa Fe Community College in Gainesville, Florida, has a 1,000-square-foot exhibition space for changing art shows. It opened in 1978.

Santa Fe Gallery, Santa Fe Community College, 3000 N.W. 83rd St., Gainesville, FL 32606. Phone: 904/395-5621. Hours: varies. Admission: free.

## SCHOOL OF THE ART INSTITUTE OF CHICAGO
### Betty Rymer Gallery and Gallery 2

The School of the Art Institute of Chicago has two galleries—the Betty Rymer Gallery adjacent to institute and Gallery 2 on Chicago's Near North Side. Both are operated by the Department of Exhibitions and Events; contain con-

temporary works by professionals, faculty, and students; and have many of the works for sale. The Betty Rymer Gallery features nationally known artists, while the emphasis is on student and faculty exhibitions and performances at Gallery 2.

Betty Rymer Gallery, School of the Art Institute of Chicago, 280 S. Columbus Dr., Chicago, IL 60603. Phone: 312/443-3703. Hours: 10–5 Tues.–Fri.; closed Aug. and holidays. Admission: free. Gallery 2, School of the Art Institute of Chicago, 1040 W. Huron St., Chicago, IL 60622. Phone: 312/226-1449. Hours: 11–6 Tues.–Sat.; closed Aug. and holidays. Admission: free.

## SCRIPPS COLLEGE
### Ruth Chandler Williamson Gallery

Scripps College's long-established Lang Gallery in Claremont, California, became the Ruth Chandler Williamson Gallery in 1993 and moved into a new facility in 1994. From 1974 to 1993, the gallery was part of a joint program with Montgomery Gallery at Pomona College, known as the Galleries of the Claremont Colleges.

The gallery presents the nation's oldest and largest annual ceramic show as part of its exhibitions program. Among the gallery's collections are the Young Collection of American paintings, Marer Collection of contemporary American and Japanese ceramics, Johnson Collection of Japanese prints, Routh Collection of cloisonné, and Wagner Collection of African sculpture.

Ruth Chandler Williamson Gallery, Scripps College, 1030 Columbia Ave., Claremont, CA 91711-3948. Phone: 909/621-8555. Hours: 1–5 Wed.–Sun.; closed holidays and when college not in session. Admission: free.

## SIENA HEIGHTS COLLEGE
### Klemm Gallery

The Klemm Gallery at Siena Heights College in Adrian, Michigan, presents culturally or historically significant art, one-person shows, and works by alumni.

Klemm Gallery, Siena Heights College, 1247 E. Siena Heights Dr., Adrian, MI 49221-1796. Phone: 517/263-0731. Hours: 9–4 Mon.–Fri. (also 6–9 Tues.); closed holidays and when college not in session. Admission: free.

## SIMPSON COLLEGE
### Farnham Galleries

Six exhibitions are presented each year at Simpson College's Farnham Galleries in Indianola, Iowa, by the Art Department.

Farnham Galleries, Simpson College, 701 N. C St., Indianola, IA 50125. Phone: 515/961-1561. Hours: 8–5 Mon.–Fri.; closed when college not in session. Admission: free.

## SKIDMORE COLLEGE
### Schick Art Gallery

The art gallery at Skidmore College in Saratoga Springs, New York, began in 1926 in a carriage house dating from the nineteenth century when the area was an elegant resort community. It now has a more contemporary home on the campus—and goes by a different name—the Schick Art Gallery (formerly called the Hathorn Gallery).

The gallery presents changing exhibitions, including faculty, student, invitational, and traveling shows, as well as shows from the college art collection. Among the artworks in the collection are prints by Goya, Rembrandt, Whistler, Manet, Kirchner, and Hopper, as well as art pertaining to Saratoga, paintings by such contemporaries as Joan Mitchell and Andy Warhol, and a sculpture by David Smith.

Plans call for the gallery to be converted to an art museum with a new building by 1997.

Schick Art Gallery, Skidmore College, N. Broadway, Saratoga Springs, NY 12866. Phone: 518/584-5000. Hours: Sept.–May—9–5 Mon.–Fri.; 1–3:30 Sat.–Sun.; summer— variable hours; closed holidays. Admission: free.

## SONOMA STATE UNIVERSITY
### University Art Gallery

Twentieth-century American art is featured at the University Art Gallery at Sonoma State University in Rohnert Park, California. The gallery, founded in 1977, has collections of twentieth-century American works on paper, Asian art, and other artworks.

University Art Gallery, Sonoma State University, 1801 E. Cotati Ave., Rohnert Park, CA 94928. Phone: 707/664-2295. Hours: 11–4 Tues.–Fri.; 12–4 Sat.–Sun.; closed summer and holidays. Admission: free.

## SOUTHEAST MISSOURI STATE UNIVERSITY
### Southeast Missouri State University Museum

(See General Museums section.)

## SOUTHERN UTAH UNIVERSITY
### Braithwaite Fine Arts Gallery

Temporary and traveling exhibitions are presented at the Braithwaite Fine Arts Gallery, founded in 1976 and housed in the 1910 Old Administration Building at Southern Utah University in Cedar City. The exhibitions include selec-

tions from the gallery's collection of nineteenth- and twentieth-century American art and eighteenth- and nineteenth-century English art.

Braithwaite Fine Arts Gallery, Southern Utah University, 351 W. Center St., Cedar City, UT 84720. Phone: 801/586-5432. Hours: 10–7:30 Mon.–Fri.; 1–5 Sat.–Sun.; closed major holidays. Admission: free.

## SOUTHERN VERMONT COLLEGE
### Southern Vermont College Art Gallery

Temporary exhibitions are presented by the Southern Vermont College Art Gallery, opened in 1979 and housed in the 1910 Everett Mansion, built in the style of a fourteenth-century English-Norman castle.

Southern Vermont College Art Gallery, Monument Ave., Bennington, VT 05201. Phone: 802/442-5427. Hours: 12–5 daily; closed major holidays. Admission: free.

## STANFORD UNIVERSITY
### Stanford Art Gallery

The Stanford Art Gallery—administered by the Stanford University Museum of Art in Stanford, California—presents changing exhibitions of works from the museum's collections and on loan from other institutions. The gallery, located apart from the museum, was founded in 1917 by Thomas Welton Stanford, brother of Governor Leland Stanford, who founded the art museum. It has three galleries.

Stanford Art Gallery, Stanford University, Serra St., Stanford, CA 94305. Phone: 415/723-2842. Hours: 10–5 Tues.–Fri.; 1–5 Sat.–Sun.; closed major holidays. Admission: free.

## STATE UNIVERSITY OF NEW YORK AT STONY BROOK
### University Art Gallery

Contemporary art is featured in the University Art Gallery at the State University of New York at Stony Brook. The 4,700-square-foot gallery was opened in 1975 as part of the Staller Center for the Arts.

University Art Gallery, State University of New York at Stony Brook, Staller Center for the Arts, Stony Brook, NY 11794-5425. Phone: 516/632-7240. Hours: 12–4 Tues.–Fri.; 5–8 P.M. Sat.; closed holidays and when university not in session. Admission: free.

## STATE UNIVERSITY OF NEW YORK COLLEGE AT BROCKPORT
### Tower Fine Arts Gallery

Seven exhibitions and several arts festivals are offered each year by the Tower Fine Arts Gallery at the State University of New York College at Brockport.

The collections of the gallery, founded in 1964, include the works of e.e. cummings.

Tower Fine Arts Gallery, State University of New York College at Brockport, Tower Fine Arts Bldg., Brockport, NY 14420. Phone: 716/495-5253. Hours: 12–5 Mon.–Sat. (also 7–9 Tues.–Wed.); closed major holidays and when college not in session. Admission: free.

## STATE UNIVERSITY OF NEW YORK COLLEGE AT CORTLAND
### Dowd Fine Arts Gallery

Historical exhibitions, contemporary works, and theme shows are among the offerings each year by the Dowd Fine Arts Gallery at the State University of New York College at Cortland. The gallery's most-prized collections are nineteenth- and twentieth-century European and American works on paper.

Dowd Fine Arts Gallery, State University of New York College at Cortland, Box 2000, Cortland, NY 13045. Phone: 607/753-4216. Hours: 11–4 Tues.–Sat.; closed holidays and when college not in session. Admission: free.

## STATE UNIVERSITY OF NEW YORK COLLEGE AT FREDONIA
### Michael C. Rockefeller Arts Center Gallery

The Michael C. Rockefeller Arts Center Gallery at the State University of New York College at Fredonia was included as part of the arts center when it opened in 1970. It displays changing exhibitions of contemporary paintings, sculpture, prints, and drawings.

Michael C. Rockefeller Arts Center Gallery, State University of New York College at Fredonia, Fredonia, NY 14063. Phone: 716/673-3538. Hours: 4–8 Thurs.–Sun.; closed holidays and when college not in session. Admission: free.

## STATE UNIVERSITY OF NEW YORK COLLEGE AT GENESEO
### Bertha V.B. Lederer Fine Arts Gallery

Exhibitions of contemporary artworks are presented at the Bertha V.B. Lederer Fine Arts Gallery at the State University of New York College at Geneseo. The gallery, founded in 1967, has a collection of paintings, graphics, sculpture, ceramics, and furniture.

Bertha V.B. Lederer Fine Arts Gallery, State University of New York College at Geneseo, Dept. of Art, Fine Arts Bldg., 1 College Cir., Geneseo, NY 14454. Phone: 716/245-5814. Hours: announced for individual exhibitions. Admission: free.

## STATE UNIVERSITY OF NEW YORK COLLEGE AT NEW PALTZ
### College Art Gallery

The College Art Gallery at the State University of New York College at New Paltz became the first museum-like gallery to be built in the state university

system when it opened as part of the new fine arts complex in 1964. The gallery produces temporary exhibitions of both contemporary and historical nature. Its collection includes twentieth-century American prints, Japanese woodblock prints, and pre-Columbian artifacts.

College Art Gallery, State University of New York College at New Paltz, 75 S. Manheim Blvd., New Paltz, NY 12561. Phone: 914/257-3844. Hours: 10–4 Mon.–Thurs.; 1–4 Sat.–Sun.; closed holidays and when college not in session. Admission: free.

## STATE UNIVERSITY OF NEW YORK COLLEGE AT OSWEGO
### Tyler Art Gallery

The Tyler Art Gallery at the State University of New York College at Oswego presents temporary and traveling exhibitions. It has teaching collections of nineteenth- and twentieth-century European and American drawings, prints, paintings, and sculpture.

Tyler Art Gallery, State University of New York College at Oswego, College of Arts and Science, Oswego, NY 13126. Phone: 315/341-2113. Hours: academic year—9:30–4:30 Mon.–Fri.; 12:30–4:30 Sat.–Sun.; summer—12–4 Mon.–Fri.; closed holidays and when college not in session. Admission: free.

## STATE UNIVERSITY OF NEW YORK COLLEGE AT PLATTSBURGH
### SUNY Plattsburgh Art Museum

(See Art Museums section.)

## STATE UNIVERSITY OF NEW YORK COLLEGE AT POTSDAM
### Roland Gibson Gallery

The Roland Gibson Gallery at the State University of New York College at Potsdam has collections and exhibitions of contemporary paintings, prints, drawings, sculpture, and ceramics. The gallery was founded in 1968.

Roland Gibson Gallery, State University of New York College at Potsdam, Potsdam, NY 13676. Phone: 315/267-2250. Hours: 12–5 Mon.–Fri. (also 7–9 Mon.–Thurs.); 12–4 Sat.–Sun.; closed holidays. Admission: free.

## STEPHENS COLLEGE
### Davis Art Gallery

The exhibition program at Stephens College's Davis Art Gallery in Columbia, Missouri, emphasizes contemporary and regional art—usually by woman artists. The gallery is housed in the Webb Art Studios.

Davis Art Gallery, Stephens College, Box 2012, Columbia, MO 65215. Phone: 314/876-7173. Hours: 10–4 Mon.–Fri.; closed holidays and when college not in session. Admission: free.

## STETSON UNIVERSITY
### Pope and Margaret Duncan Gallery of Art

Exhibits of contemporary art with a focus on artists of the Southeast are presented at the Pope and Margaret Duncan Gallery of Art at Stetson University in DeLand, Florida. The gallery has a permanent collection of a diverse group of works, including paintings, drawings, prints, sculpture, photographs, and ceramics.

Pope and Margaret Duncan Gallery of Art, Stetson University, Sampson Hall, Campus Box 8252, DeLand, FL 32720-3757. Phone: 904/822-7386. Hours: 10–4 Mon.–Fri.; 1–4 Sat.–Sun.; closed holidays and when university not in session. Admission: free.

## SWARTHMORE COLLEGE
### List Gallery

The List Gallery at Swarthmore College presents month-long exhibitions of contemporary art and exhibits of faculty and student artworks in Swarthmore, Pennsylvania. The gallery's collections include paintings and more than 200 drawings by Benjamin West. In 1991, the gallery replaced a one-room gallery from the early 1960s. It now is located in the Eugene M. and Theresa Lang Performing Arts Center.

List Gallery, Swarthmore College, Dept. of Art, 500 College Ave., Swarthmore, PA 19081. Phone: 215/328-8116. Hours: 12–1 and 3–6 Wed.–Fri.; 2–6 Sat.–Sun.; closed holidays and when college not in session. Admission: free.

## SWEET BRIAR COLLEGE
### Sweet Briar College Art Gallery

The Sweet Briar College Art Gallery consists of three exhibition spaces—the main gallery in Pannell Center, a renovated refectory building, and satellite spaces in the performing arts and humanities buildings in Sweet Briar, Virginia. Gallery exhibitions include traveling shows and selections from its collection of European, American, and Japanese works on paper.

Sweet Briar College Art Gallery, Pannell Center, Sweet Briar, VA 24595-1115. Phone: 804/381-6248. Hours: 12–5 Tues.–Sun. (also 7:30–9:30 Tues. and Thurs.); closed holidays and when college not in session. Admission: free.

## SYRACUSE UNIVERSITY
### Joe and Emily Lowe Art Gallery

The Joe and Emily Lowe Art Gallery at Syracuse University was founded in 1952 as part of a campus art center in Syracuse, New York. By 1975, it had outgrown its facilities and was relocated to an expanded space in Sims Hall—

between the University Art Collection and a major School of Art and Design facility.

The gallery museum cooperates with the University Art Collection, Bird Library Special Collections, and Light Work (an artists' photography and exhibition organization) in presenting exhibitions—which usually spring from the demands of the School of Art and Design and the Graduate Program in Museum Studies. The exhibitions include shows from the university collections and traveling exhibitions on nineteenth- and twentieth-century American paintings, sculpture, and graphics; African and Indian sculpture, textiles, and decorative arts; photography; and other areas. It also presents student exhibits.

Joe and Emily Lowe Art Gallery, Syracuse University, Shaffer Art Bldg., Syracuse, NY 13244. Phone: 315/443-4098. Hours: 12–5 Tues.–Sun. (also to 8 Wed.); closed holidays. Admission: free.

## TEIKYO WESTMAR UNIVERSITY
### Teikyo Westmar Gallery

Changing exhibitions are presented at the Teikyo Westmar Gallery at Teikyo Westmar University in Le Mars, Iowa. The gallery, operated by the Department of Art and located in the library, has an extensive Haitian art collection.

Teikyo Westmar Gallery, Teikyo Westmar University, 1002 Third Ave., SE, Le Mars, IA 51031. Phone: 712/546-7081. Hours: 8 A.M.–10 P.M. Mon.–Fri.; closed when university not in session. Admission: free.

## TEMPLE UNIVERSITY
### Tyler Galleries

The Tyler School of Art at Temple University operates four galleries known collectively as the Tyler Galleries. They include the Temple Gallery in downtown Philadelphia and three galleries on the Elkins Park, Pennsylvania, campus. The latter galleries opened in 1934 and consist of two galleries for student work and one for changing exhibitions of all types of art. The Temple Gallery, founded in 1985, presents changing exhibitions of contemporary work.

Tyler Galleries, Tyler School of Art, Temple University, Beech and Penrose Aves., Elkins Park, PA 19027. Phone: 215/782-2776. Hours: 10–5 Tues.–Sat.; closed summer and major holidays. Admission: free. Temple Gallery, Tyler School of Art, Temple University, 1619 Walnut St., Philadelphia, PA 19103. Phone: 215/204-5041. Hours: 10–5 Tues.–Sat.; closed major holidays. Admission: free.

## TEXAS A&M UNIVERSITY
### J. Wayne Stark University Center Galleries

The J. Wayne Stark University Center Galleries at Texas A&M University in College Station provides a rotating program of exhibitions in three galleries

occupying 20,000 square feet in the Memorial Student Center. The gallery collection consists of works of Texas artists and artworks created in or with the subject of Texas.

J. Wayne Stark University Center Galleries, Texas A&M University, Memorial Student Center, PO Box J-3, College Station, TX 77844-9083. Phone: 409/845-8501. Hours: 9–8 Tues.–Fri.; 12–6 Sat.–Sun.; closed holidays and when university not in session. Admission: free.

## *MSC Forsyth Center Galleries*

The MSC Forsyth Center Galleries opened in 1989 at the Memorial Student Center at Texas A&M University in College Station. The galleries present changing exhibitions—including selections from collections of nineteenth-century English cameo glass, nineteenth- and early-twentieth-century American art glass, and 1850–1950 American paintings.

MSC Forsyth Center Galleries, Texas A&M University, Memorial Student Center, Joe Routt Blvd., PO Box J-1, College Station, TX 77844-9081. Phone: 409/845-9251. Hours: 9–8 Mon.–Fri.; 12–6 Sat.–Sun.; closed major holidays. Admission: free.

## TEXAS CHRISTIAN UNIVERSITY
### *Moudy Gallery*

Works by fine arts students dominate the changing exhibitions schedule of the Moudy Gallery at Texas Christian University in Fort Worth. The gallery, which opened in 1982, has a collection of works on paper by contemporary and traditional artists.

Moudy Gallery, Texas Christian University, University Dr. and Cantey, PO Box 30793, Fort Worth, TX 76129. Phone: 817/921-7643. Hours: 11–4 Mon.–Fri.; 11–6 Sat.–Sun.; closed Easter, Christmas, and when university not in session. Admission: free.

## TEXAS WOMAN'S UNIVERSITY
### *Texas Woman's University Art Galleries*

The Texas Woman's University Art Galleries in Denton consist of two teaching galleries—the East Gallery and the West Gallery—in the Fine Arts Building. Changing exhibitions are presented in the Department of Visual Arts, which opened in 1927.

Texas Woman's University Art Galleries, Dept. of Visual Arts, Fine Arts Bldg., Box 22995, TWU Station, Denton, TX 96204. Phone: 817/898-3198. Hours: academic year—9–4 Mon.–Thurs.; summer—9–4 Mon.–Fri.; closed major holidays. Admission: free.

## THOMAS COLLEGE
### *Thomas College Art Gallery*

The Thomas College Art Gallery, housed in the Administration Building on the campus in Waterville, Maine, offers a varied changing exhibition program—often of paintings and photographs relating to Maine.

Thomas College Art Gallery, 180 West River Rd., Waterville, ME 04901. Phone: 207/873-0771. Hours: varied hours daily. Admission: free.

## TOUGALOO COLLEGE
### Warren Hall Art Gallery

The Warren Hall Art Gallery at Tougaloo College in Tougaloo, Mississippi, presents exhibitions of African, African-American, student, and other artworks. The college is located on the site of a former cotton plantation with an antebellum mansion.

Warren Hall Art Gallery, Tougaloo College, Tougaloo, MS 39174. Phone: 601/977-7700. Hours: 3–5 Mon.–Fri.; closed summer and major holidays. Admission: free.

## TOWSON STATE UNIVERSITY
### Roberts Gallery

The Roberts Gallery, located at the Asian Arts Center in the Fine Arts Building at Towson State University in Towson, Maryland, presents three to four temporary exhibitions on contemporary Asian art each year. The Asian Arts Center was established in 1971 when a local businessman donated his collection of Chinese and Japanese ivory sculpture. Since then the collection has been expanded to include other ivories, ceramics, textiles, paintings, prints, and sculpture from India, Tibet, China, Japan, Korea, and Southeast Asia. Many of the objects are on permanent display.

Roberts Gallery, Towson State University, Asian Arts Center, Fine Arts Bldg., Towson, MD 21204. Phone: 410/830-2807. Hours: 10–4 Mon.–Fri.; closed holidays and when university not in session. Admission: free.

## TRINITY COLLEGE
### Widener Gallery

The Widener Gallery at Trinity College in Hartford, Connecticut, has primarily teaching collections, including the Samuel H. Kress Collection. The gallery, founded in 1964, is located in the Austin Arts Center.

Widener Gallery, Trinity College, 300 Summit St., Hartford, CT 06106. Phone: 203/297-2498. Hours: 1–5 Mon.–Fri.; closed holidays and when college not in session. Admission: free.

## TUFTS UNIVERSITY
### Tufts University Art Gallery

The Tufts University Art Gallery is located in the new Aidekman Arts Center on the campus in Medford, Massachusetts. It opened in 1990, replacing a smaller gallery—Gallery 11—founded in 1955. The gallery presents exhibitions from

the university's art collection, traveling shows, and senior thesis exhibits from the Boston Museum School.

Tufts University Art Gallery, Aidekman Arts Center, Medford, MA 02155. Phone: 617/ 625-3518. Hours: 11–5 Tues.–Sun. (also to 9 Thurs.); closed when university not in session. Admission: free.

## TULANE UNIVERSITY
### Newcomb Art Gallery

The Newcomb Gallery of Newcomb College at Tulane University in New Orleans presents seven historical and contemporary exhibitions a year in its 1,100-square-foot gallery. Four of the shows display faculty or student works, while the other three are organized by the staff or are traveling exhibitions. Some pieces from the gallery's collection of Newcomb pottery are always on display. The present gallery space of the women's coordinate college has been used since 1917.

Newcomb Art Gallery, Newcomb College, Tulane University, 39 Newcomb Pl., New Orleans, LA 70118. Phone: 504/865-5327. Hours: 9–4:30 Mon.–Fri.; closed major holidays and when university not in session. Admission: free.

## UNITY COLLEGE
### Unity College Art Gallery

Maine artists are featured in the Unity College Art Gallery in Unity, Maine. The gallery is located in the South Coop Building.

Unity College Art Gallery, Quaker Hill Rd., Unity, ME 04988. Phone: 207/948-3131. Hours: 10–4 Mon.–Fri.; closed major holidays and when college not in session. Admission: free.

## UNIVERSITY OF ALABAMA
### Moody Gallery of Art

The Moody Gallery of Art is housed in Garland Hall, built in 1886 in the old quadrangle of the University of Alabama at Tuscaloosa. A portion of the building became the gallery in 1967. The changing exhibitions include works from the gallery's collection of predominately modern paintings, drawings, and prints.

Moody Gallery of Art, University of Alabama, 103 Garland Hall, PO Box 870270, Tuscaloosa, AL 35487-0270. Phone: 205/348-1890. Hours: 8:30–4:30 Mon.–Fri.; 2–5 Sun.; closed holidays and when university not in session. Admission: free.

## UNIVERSITY OF ALABAMA AT BIRMINGHAM
### Visual Arts Gallery

The Department of Art's Visual Arts Gallery at the University of Alabama at Birmingham features temporary exhibitions of international, national, and

regional art; artists' movements; and faculty and student work. The gallery's collection includes works on paper since 1750, contemporary art and photography, and faculty and student artworks.

Visual Arts Gallery, University of Alabama at Birmingham, 101 Humanities Bldg., 900 13th St. S., Birmingham, AL 35294-1260. Phone: 205/934-4941. Hours: 1–6 Mon.–Thurs.; 2–6 Sun.; closed holidays and when university not in session. Admission: free.

## UNIVERSITY OF ALABAMA IN HUNTSVILLE
### Church Gallery

The Department of Art and Art History presents changing exhibitions of student, faculty, and regional professional artists at the Church Gallery at the University of Alabama in Huntsville. Founded in 1975, the gallery is located in the 1840s Greek Revival Presbyterian Chapel on the campus.

Church Gallery, University of Alabama in Huntsville, Dept. of Art and Art History, Huntsville, AL 35889. Phone: 205/895-6114. Hours: 11–4 Mon.–Fri.; closed holidays and when university not in session. Admission: free.

### University Center Gallery

Exhibitions of art in all media by southeastern artists are offered at the University Center Gallery at the University of Alabama in Huntsville. The gallery, administered by the Department of Art and Art History, opened in 1982 upon completion of the University Center Building.

University Center Gallery, University of Alabama in Huntsville, University Center, Dept. of Art and Art History, Huntsville, AL 35899. Phone: 205/895-6114. Hours: 9–6 daily; closed holidays and when university not in session. Admission: free.

## UNIVERSITY OF ARIZONA
### Student Union Galleries

Contemporary exhibitions are presented by the University of Arizona Student Union Galleries in Tucson. The Student Union has two galleries—the Main Gallery and the Open Lounge Gallery—and a collection of works by regional and national artists.

Student Union Galleries, University of Arizona, Student Union, SUPO Box 10,000, Tucson, AZ 85720-0001. Phone: 602/621-3546. Hours: Main Gallery—11–4 Mon.–Fri.; 11–3 Sun.; Open Lounge Gallery—8 A.M.–10 P.M. daily (both from mid-Jan. to mid-Dec.). Admission: free.

## UNIVERSITY OF ARKANSAS AT LITTLE ROCK
### Fine Art Galleries

The Fine Art Galleries at the University of Arkansas at Little Rock consist of three exhibition spaces in the Fine Arts Building—two downstairs and another on the second floor. Approximately 28 temporary exhibitions are presented

each year, usually featuring regional contemporary art and faculty and student work in invitational and competitive shows. Collection highlights include twentieth-century American photography, historic prints, and medieval manuscripts. Fine Art Galleries, University of Arkansas at Little Rock, Fine Arts Bldg., 2801 S. University, Little Rock, AR 72204-1099. Phone: 501/569-3182. Hours: 9–5 Mon.–Fri. (also to 8 Thurs.); 2–5 Sun.; closed holidays and when university not in session. Admission: free.

# UNIVERSITY OF THE ARTS
## Rosenwald-Wolf Gallery

A diverse presentation of contemporary art—including paintings, drawings, sculpture, crafts, architecture, and design—can be found at the Rosenwald-Wolf Gallery at the University of the Arts in Philadelphia. The gallery is located on the street level of a nine-story building.
Rosenwald-Wolf Gallery, University of the Arts, Broad and Pine Sts., Philadelphia, PA 19102. Phone: 215/875-1116. Hours: 10–5 Mon.–Fri. (also to 9 Wed.); 12–5 Sat.–Sun.; closed holidays. Admission: free.

# UNIVERSITY OF BRIDGEPORT
## Carlson Gallery

The Carlson Gallery's two exhibition spaces are used for contemporary art shows at the University of Bridgeport in Bridgeport, Connecticut. The gallery, which opened in 1972, is located in the Bernhard Arts and Humanities Center. Carlson Gallery, University of Bridgeport, Bernhard Arts and Humanities Center, Bridgeport, CT 06601. Phone: 203/576-4402. Hours: 11–5 Tues.–Sat. (also to 8 Thurs.); closed summer, holidays, and when university not in session. Admission: free.

# UNIVERSITY OF CALIFORNIA, DAVIS
## Richard L. Nelson Gallery and Fine Arts Collection

Contemporary art by northern California artists is featured at the Richard L. Nelson Gallery at the University of California, Davis. The gallery, which opened in 1976, also makes use of its Fine Arts Collection, which includes paper, prints, drawings, and paintings from the sixteenth century to the present; contemporary art; Chinese and Asian art; European and American art; and ceramics.
Richard L. Nelson Gallery and Fine Arts Collection, University of California, Davis, Dept. of Art, Davis, CA 95616. Phone: 916/752-8500. Hours: 12–5 Mon.–Fri.; 2–5 Sun.; closed Aug. and major holidays. Admission: free.

## Memorial Union Art Gallery
Contemporary art exhibitions can be seen at the Memorial Union Art Gallery at the University of California, Davis. The gallery opened in 1967 on the second floor of the student union building.

Memorial Union Art Gallery, University of California, Davis, Memorial Union Bldg., Davis, CA 95616. Phone: 916/752-2885. Hours: 9–5 Mon.–Fri.; closed holidays. Admission: free.

## UNIVERSITY OF CALIFORNIA, IRVINE
### Fine Arts Gallery

The Fine Arts Gallery at the University of California, Irvine, was founded in 1965. It presents changing exhibitions and has a collection of lithographs by Jasper Johns, Roy Lichtenstein, Alic Neal, Robert Bechtle, and Paul Jenkins.
Fine Arts Gallery, University of California, Irvine, Irvine, CA 92717. Phone: 714/856-4912. Hours: 12–5 Tues.–Sun.; closed major holidays and when university not in session. Admission: free.

## UNIVERSITY OF CALIFORNIA, LOS ANGELES
### Wight Art Gallery and Grunwald Center for the Graphic Arts

(See Art Museums section.)

## UNIVERSITY OF CALIFORNIA, RIVERSIDE
### University Art Gallery

Contemporary art exhibitions are presented at the University Art Gallery in Watkins House at the University of California, Riverside. The gallery was founded in 1963.
University Art Gallery, University of California, Riverside, Watkins House, 3701 Canyon Crest Dr., Riverside, CA 92521. Phone: 909/787-3755. Hours: 11–4 Tues.–Sat.; 12–4 Sun.; closed major holidays. Admission: free.

## UNIVERSITY OF CALIFORNIA, SAN DIEGO
### University Art Gallery

Changing contemporary art exhibitions are featured at the University Art Gallery, opened in 1974, at the University of California, San Diego, in La Jolla. It formerly was called the Mandeville Gallery.
University Art Gallery, University of California, San Diego, 9500 Gilman Dr., La Jolla, CA 92093-0327. Phone: 619/534-2864. Hours: 11–4 Tues.–Sat.; closed summer and holidays. Admission: free.

## UNIVERSITY OF CHICAGO
### Renaissance Society

The Renaissance Society at the University of Chicago is the oldest continuously operated gallery in Chicago devoted exclusively to temporary exhibitions

of avant-grade art. The gallery, founded in 1915, is located on the university's main quadrangle in a landmark building designed by Henry Ives Cobb.

It is a noncollecting gallery that emphasizes the investigation of new ideas and methods, presenting five temporary exhibitions of avant-garde art each year. Over the years, it has shown the early work of such artists as Picasso, Matisse, Rounault, Naguchi, Calder, Moholy-Nagy, Miró, Klee, Kandinsky, Magritte, Moore, and Shahn.

Renaissance Society, University of Chicago, 5811 S. Ellis Ave., Chicago, IL 60637. Phone: 312/702-8670. Hours: 10–4 Tues.–Fri.; 12–4 Sat.–Sun.; closed summers and major holidays. Admission: free.

## UNIVERSITY OF COLORADO AT BOULDER
### University of Colorado Art Galleries

The University of Colorado Art Galleries in Boulder consist of three adjoining galleries in the Sibell Wolfe Fine Arts Building. Changing contemporary art exhibitions are the primary focus of the galleries, which also have collections of nineteenth- and twentieth-century paintings and prints; fifteenth- to twentieth-century drawings, watercolors, sculptures, and ceramics; and twentieth-century photographs.

University of Colorado Art Galleries, Sibell Wolfe Fine Arts Bldg., Campus Box 318, Boulder, CO 80309-0318. Phone: 303/492-8300. Hours: 10–4 Mon.–Fri. (also to 8 Tues.); 12–5 Sat.; closed major holidays. Admission: free.

### UMC Art Gallery

The UMC Art Gallery presents a wide variety of contemporary art exhibitions in the University Memorial Center at the University of Colorado at Boulder. The exhibitions range from paintings and sculpture to multimedia shows.

UMC Art Gallery, University of Colorado at Boulder, University Memorial Center, Campus Box 207, Boulder, CO 80309-0207. Phone: 303/492-7465. Hours: 9 A.M.–10 P.M. Mon.–Thurs.; 9–5 Fri.; closed holidays. Admission: free.

## UNIVERSITY OF COLORADO AT COLORADO SPRINGS
### Gallery of Contemporary Art

International, national, and regional exhibitions; annual student shows; and biennial faculty exhibitions on themes or particular media are presented by the Gallery of Contemporary Art at the University of Colorado at Colorado Springs.

Gallery of Contemporary Art, University of Colorado at Colorado Springs, 1420 Austin Bluffs Pkwy., PO Box 7150, Colorado Springs, CO 80933-7150. Phone: 719/593-3567. Hours: 10–4 Mon.–Fri.; 1–4 Sat.; closed holidays. Admission: adults, $1; seniors and students, 50¢; university students, faculty, and staff, free.

## UNIVERSITY OF DELAWARE
### University Gallery

The University Gallery at the University of Delaware in Newark places emphasis on its teaching mission, working closely with the art history and museum studies departments and the Winterthur art conservation and early American culture programs. It primarily exhibits art, although it also presents material and popular culture exhibitions.

The gallery occupies part of an 1832 Greek Revival building—the first major structure of its type in the state. Its collections include Gertrude Kasebier photographs, Abraham Walkowitz drawings, pre-Columbian and Native American ceramics, African art objects, and nineteenth- and twentieth-century American and European graphics.

University Gallery, University of Delaware, 114 Old College, Newark, DE 19716. Phone: 302/831-8242. Hours: 11–5 Mon.–Fri.; 1–5 Sat.–Sun.; closed holidays. Admission: free.

## UNIVERSITY OF FLORIDA
### University Galleries

Three galleries—the University Gallery, Focus Gallery, and Grinter Gallery—comprise the University Galleries at the University of Florida in Gainesville. All three present art exhibitions with a wide range of styles, both historical and contemporary.

The University Gallery, designed to function as a professional art gallery, serves as a teaching adjunct to the Department of Art and as a community outreach program, exhibiting contemporary art of national and international merit. It is located in a separate building within the fine art complex of four buildings.

The Focus Gallery, housed within the offices of the Department of Art, exhibits the work of emerging artists, Master of Fine Art candidates, and senior faculty members. The Grinter Gallery occupies first-floor space in the Grinter Building complex and presents exhibitions in conjunction with the study programs of the Center for Latin American Studies and the Center for African Studies.

University Galleries, University of Florida, PO Box 115803, Gainesville, FL 32611-5803. Phone: 904/392-0201. Hours: University Gallery—10–8 Tues.–Fri.; 1–5 Sat.–Sun.; Focus Gallery—8–11:45 and 1–4:45 Mon.–Fri.; Grinter Gallery—10–4 Mon.–Fri.; all are closed holidays and when university not in session. Admission: free.

## UNIVERSITY OF GUAM
### Isla Center for the Arts

The Isla Center for the Arts at the University of Guam in Mangilao presents exhibitions on Pacific artifacts, prints, paintings, and sculpture. Opened in 1980, it has 1,000 square feet of exhibit space.

Isla Center for the Arts, University of Guam, 15 Dean's Cir., Mangilao GU 06923. Phone: 671/734-2786. Hours: 12–6 Mon.–Fri. (also to 9 Thurs.); closed holidays. Admission: free.

## UNIVERSITY OF HARTFORD
### Joseloff Gallery

The Joseloff Gallery at the University of Hartford in West Hartford, Connecticut, presents contemporary art exhibitions in its 3,500-square-foot space in the Harry Jack Gray Center. The gallery was founded in 1970.

Joseloff Gallery, University of Hartford, Harry Jack Gray Center, 200 Bloomfield Ave., West Hartford, CT 06117. Phone: 203/768-4090. Hours: 11–4 Mon.–Fri.; 12–4 Sat.; closed major holidays. Admission: free.

## UNIVERSITY OF HAWAII AT MANOA
### Art Gallery

Temporary exhibitions of contemporary and historical art are displayed at the Art Gallery at the University of Hawaii at Manoa. The gallery was opened in 1976 by the Department of Art.

Art Gallery, University of Hawaii at Manoa, Dept. of Art, 2535 The Mall, Honolulu, HI 96822. Phone: 808/956-6888. Hours: 10–4 Mon.–Fri.; 12–4 Sun.; closed holidays. Admission: free.

## UNIVERSITY OF HOUSTON
### Sarah Campbell Blaffer Gallery

The Sarah Campbell Blaffer Gallery, built as part of a new fine arts complex at the University of Houston in 1973, presents contemporary art exhibitions. It occupies 10,000 square feet in the complex and has collections that include pre-Columbian artifacts, modern Mexican graphics, contemporary prints, and sculpture.

Sarah Campbell Blaffer Gallery, University of Houston, Fine Arts Bldg., Houston, TX 77204-4891. Phone: 713/743-9521. Hours: 10–5 Tues.–Fri.; 1–5 Sat.–Sun. Admission: free.

## UNIVERSITY OF ILLINOIS AT CHICAGO
### Gallery 400

Gallery 400 at the University of Illinois at Chicago features changing exhibitions of contemporary art, design, and architecture. Founded in 1983 by the School of Art and Design, it serves as an alternative gallery with exhibitions and programs to foster an interdisciplinary understanding of the visual arts. The gallery is located in a renovated warehouse building on campus.

Gallery 400, University of Illinois at Chicago, 400 S. Peoria St., Chicago, IL 60607. Phone: 312/996-6114. Hours: 9–5 Mon.–Fri.; 12–4 Sat.; closed holidays. Admission: free.

## UNIVERSITY OF LOUISVILLE
### Morris B. Belknap Jr. Gallery and Dario A. Covi Gallery

The Morris B. Belknap Jr. Gallery and the Dario A. Covi Gallery are adjoining galleries of the Allen R. Hite Art Institute at the University of Louisville. Traveling, independent artist, and student exhibitions are shown in the galleries. The collections consist of European and American prints, drawings, and paintings from the fifteenth to the twentieth centuries.
Morris B. Belknap Jr. Gallery/Dario A. Covi Gallery, University of Louisville, Allen R. Hite Art Institute, 104 Schneider Hall, Belknap Campus, Louisville, KY 40292. Phone: 502/588-6794. Hours: 8:30–4:30 Mon.–Fri.; closed holidays and when university not in session. Admission: free.

## UNIVERSITY OF MARYLAND AT COLLEGE PARK
### Art Gallery at the University of Maryland at College Park

The Art Gallery at the University of Maryland at College Park hosts four to five exhibitions of historical and contemporary art each academic year. The gallery, located in the Art-Sociology Building, has collections of 1950–1980 Japanese prints, traditional African sculptures, and 1930s studies for WPA murals.
Art Gallery at the University of Maryland at College Park, Art-Sociology Bldg., College Park, MD 20742. Phone: 301/405-2763. Hours: 12–4 Mon.–Fri.; 1–5 Sat.–Sun.; closed holidays. Admission: free.

## UNIVERSITY OF MASSACHUSETTS, AMHERST
### University Gallery

The University Gallery at the University of Massachusetts, Amherst, houses the university's permanent art collection and mounts a continuing series of exhibitions of contemporary art by established and emerging artists of national and international stature. Located in the Fine Arts Center, it is the primary venue for professional visual arts on the campus. Five additional galleries show student, faculty, and regional art.

The art collection is strong in contemporary prints, drawings, and photographs. It includes the Class of 1928 Photography Collection, WPA prints and drawings, Hollister Collection of Southwest American Indian pottery, and public sculpture by Stephen Antonakos, Richard Fleischner, Robert Irwin, Robert Murray, Jeffrey Schiff, and George Trakas.

University Gallery, University of Massachusetts, Amherst, 35 Fine Arts Center, Amherst, MA 01003. Phone: 413/545-3670. Hours: 11–4:30 Tues.–Fri.; 2–5 Sat.–Sun.; closed holidays and when university not in session. Admission: free.

## UNIVERSITY OF MASSACHUSETTS, DARTMOUTH
### University Art Gallery

The University Art Gallery at the University of Massachusetts, Dartmouth, in North Dartmouth features contemporary art in its 2,600 square feet of exhibition space.
University Art Gallery, University of Massachusetts, Dartmouth, North Dartmouth, MA 02747. Phone: 508/999-8555. Hours: 1–5 Mon.–Sat.; closed summer and major holidays. Admission: free.

## UNIVERSITY OF MICHIGAN
### Jean Paul Slusser Gallery

The School of Art at the University of Michigan in Ann Arbor has the Jean Paul Slusser Gallery for student, faculty, alumni, and other art and design exhibitions.
Jean Paul Slusser Gallery, University of Michigan, School of Art, 2000 Bonisteel Blvd., Ann Arbor, MI 48109-2069. Phone: 313/936-2082. Hours: academic year—10–5 Mon.–Fri.; 1–5 Sat.; summer—varies. Admission: free.

## UNIVERSITY OF MISSOURI–COLUMBIA
### State Historical Society of Missouri Gallery

(See Unaffiliated Museums section.)

## UNIVERSITY OF MISSOURI–KANSAS CITY
### University of Missouri–Kansas City Gallery of Art

The University of Missouri–Kansas City Gallery of Art, part of the Department of Art and Art History in the Fine Arts Building, exhibits twentieth-century European and American art.
University of Missouri–Kansas City Gallery of Art, 204 Fine Arts Bldg., 5100 Rockhill Rd., Kansas City, MO 64110-2499. Phone: 816/235-1502. Hours: 12–5 Mon.–Fri.; 1–5 Sat.–Sun.; closed holidays and when university not in session. Admission: free.

## UNIVERSITY OF MONTANA
### Paxson Gallery

The Paxson Gallery presents changing exhibitions at the University of Montana Performing Arts Center in Missoula. The gallery, part of the School of Fine Arts, opened when the center was built in 1984. Its collections include WPA

prints from the 1930s, contemporary prints, Daumier lithographs, and other artworks.

Paxson Gallery, University of Montana, School of Fine Arts, Performing Arts Center, Missoula, MT 59802-1220. Phone: 406/234-2019. Hours: 11–3 Mon.–Sat.; closed holidays and when university not in session. Admission: free.

## UNIVERSITY OF NEVADA AT LAS VEGAS
### Donna Beam Fine Art Gallery

Contemporary art in all media can be seen in changing exhibitions at the Donna Beam Fine Art Gallery at the University of Nevada at Las Vegas. The gallery, which opened in 1981, was an outgrowth of an earlier gallery established in 1960.

Donna Beam Fine Art Gallery, University of Nevada at Las Vegas, 4505 Maryland Pkwy., PO Box 455002, Las Vegas, NV 89154-5002. Phone: 702/895-3893. Hours: 9–5 Mon.–Fri.; closed holidays and when university not in session. Admission: free.

## UNIVERSITY OF NEVADA AT RENO
### Sheppard Fine Arts Gallery

The Department of Art at the University of Nevada at Reno operates the Sheppard Fine Arts Gallery in the Church Fine Arts Building. The gallery, which opened in 1960, presents contemporary art exhibitions and has a collection of prints, drawings, and sculpture.

Sheppard Fine Arts Gallery, University of Nevada at Reno, Dept. of Art, Church Fine Arts Bldg., Reno, NV 89577-0007. Phone: 702/784-6682. Hours: 9–5 Mon.–Fri. (also to 9 Thurs.); closed holidays. Admission: free.

## UNIVERSITY OF NORTHERN COLORADO
### Mariani Gallery

The Mariani Gallery, a part of the Department of Visual Arts at the University of Northern Colorado in Greeley, presents regional and student exhibitions.

Mariani Gallery, University of Northern Colorado, Dept. of Visual Arts, Eighth Ave. and 18th St., Greeley, CO 80639. Phone: 303/351-2184. Hours: 9–4 Mon.–Fri. (also 7–9 Mon. and Wed.); closed holidays and when university not in session. Admission: free.

## UNIVERSITY OF NORTHERN IOWA
### Gallery of Art

The University of Northern Iowa Gallery of Art in Cedar Falls evolved from a hallway display into a 6,000-square-foot gallery in the Kamerick Art Building. Founded in 1978, the gallery presents a faculty exhibition, a student competition show, and an exhibition of national significance each year. Its collection features twentieth-century American and European art, including works by such artists

as Calder, Cassatt, Cézanne, Chagall, Dali, Daumier, Degas, Goya, Matisse, Picasso, Renoir, and Wood.

Gallery of Art, University of Northern Iowa, Kamerick Art Bldg., Cedar Falls, IA 50614-0362. Phone: 319/273-2077. Hours: 9–9 Mon.–Thurs.; 9–5 Fri.; 12–5 Sat.–Sun.; closed holidays and when university not in session. Admission: free.

## UNIVERSITY OF NORTH TEXAS
### University of North Texas Art Gallery

Contemporary exhibitions are presented at the University of North Texas Art Gallery and two branch galleries—the Cora Stafford Gallery and the Lightwell Gallery—in Denton. Founded in 1972, the university gallery and the adjacent Lightwell Gallery are located in the Visual Arts Building, while the Cora Stafford Gallery is in Oak Street Hall. The gallery's collections include paintings, ceramics, prints, graphics, and sculpture—some by former students and faculty and others donated by patrons and artists, such as DeKooning and Motherwell.

University of North Texas Art Gallery, School of Visual Arts, Mulberry at Welch, PO Box 5098, Denton, TX 76203. Phone: 817/565-4005. Hours: 11–8 Mon.–Tues.; 11–4 Wed.–Sat.; closed holidays and when university not in session. Admission: free.

## UNIVERSITY OF PENNSYLVANIA
### Institute of Contemporary Art

Contemporary art is the focus of the Institute of Contemporary Art at the University of Pennsylvania in Philadelphia. The gallery, founded in 1963, presents changing exhibitions, maintains a registry of Philadelphia artists, and has archives of videotapes and statements and notes by artists exhibited at the institute.

Institute of Contemporary Art, University of Pennsylvania, 118 S. 36th St., Philadelphia, PA 19104-3289. Phone: 215/898-7108. Hours: 10–5 Wed.–Sun. (also to 7 Wed.); closed New Year's Day, Easter, Thanksgiving, and Christmas. Admission: adults, $3; students, $1; discounts to seniors and artists.

### Arthur Ross Gallery

The 1,900-square-foot Arthur Ross Gallery, founded in 1983, is housed in the 1891 Furness Building, originally built for the main library, at the University of Pennsylvania in Philadelphia. The gallery presents all types of historical and contemporary art exhibitions.

Arthur Ross Gallery, University of Pennsylvania, Furness Bldg., 220 S. 34th St., Philadelphia, PA 19104-6308. Phone: 215/898-4401. Hours: 10–5 Tues.–Fri.; 12–5 Sat.–Sun.; closed major holidays. Admission: free.

## UNIVERSITY OF PITTSBURGH
### University Art Gallery

Changing exhibitions are presented at the University Art Gallery in the Frick Fine Arts Building at the University of Pittsburgh in Pennsylvania. Opened in

1966, the gallery has a collection with an emphasis on western Pennsylvania, as well as examples of Baroque drawings, Callot prints, and Asian decorative arts.

University Art Gallery, University of Pittsburgh, 104 Frick Fine Arts Bldg., Pittsburgh, PA 15260. Phone: 412/648-2400. Hours: 10–4 Tues.–Sat.; 2–5 Sun.; closed Easter and Christmas. Admission: free.

## UNIVERSITY OF PITTSBURGH AT JOHNSTOWN
### Southern Alleghenies Museum of Art at Johnstown

(See Saint Francis College in Art Museums section.)

## UNIVERSITY OF PUGET SOUND
### Kittredge Gallery

The Kittredge Gallery at the University of Puget Sound in Tacoma, Washington, offers one- or two-person exhibitions of local and regional artists. The gallery, which opened in 1954 in Kittredge Hall, has a contemporary ceramics collection and the Abby Williams Hill Collection.

Kittredge Gallery, University of Puget Sound, Kittredge Hall, 1508 N. Lawrence, Tacoma, WA 98416. Phone: 206/756-3348. Hours: 10–4 Mon.–Fri.; 1–4 Sun.; closed holidays and when university not in session. Admission: free.

## UNIVERSITY OF REDLANDS
### Peppers Art Gallery

The Peppers Art Gallery at the University of Redlands in Redlands, California, mounts six shows a year—one faculty exhibition, one student show, and four exhibitions of contemporary art in all media by southern California artists. The gallery was founded as part of a new art building in 1964.

Peppers Art Gallery, University of Redlands, 1200 E. Colton, PO Box 3080, Redlands, CA 92373-0999. Phone: 909/793-2121. Hours: 12–4 Tues.–Fri.; 2–5 Sat.–Sun.; closed holidays and when university not in session. Admission: free.

## UNIVERSITY OF RHODE ISLAND
### Fine Arts Center Galleries

The Fine Arts Center Galleries at the University of Rhode Island in Kingston offer a constantly changing program of contemporary art in all media by nationally and internationally recognized and emerging artists, as well as by resident and visiting faculty. All of its exhibitions are generated internally, with many traveling to other galleries.

The galleries consist of main, photography, and corridor exhibition spaces. They increasingly have gained a reputation for mounting multicultural programs

in all media, from film and video through painting, sculpture, printmaking, photography, and mixed-media works. Monographic and group exhibitions have featured African-Americans, Asian Americans, Native Americans, expatriate Chinese, and former Soviet Union artists.

Fine Arts Center Galleries, University of Rhode Island, Upper College and Bills Rds., Kingston, RI 02881-0820. Phone: 401/792-2131. Hours: 12–4 and 7:30–9:30 Tues.–Fri.; 1–4 Sat.; closed holidays and when university not in session. Admission: free.

## UNIVERSITY OF RICHMOND
### Marsh Art Gallery

(See Art Museums section.)

## UNIVERSITY OF SAN DIEGO
### Founders Gallery

Diverse exhibitions are offered by the Founders Gallery at the University of San Diego in California. The gallery, located in Founders Hall, was established in 1971 by Therese T. Whitcomb, professor of art history, as a working laboratory for art historical research at the university. Its collections include religious paintings and statuary, nineteenth- and twentieth-century bronzes, and American art.

Founders Gallery, University of San Diego, Founders Hall, 5998 Alcalá Park, San Diego, CA 92110-2492. Phone: 619/260-4600. Hours: 12:30–4:30 Mon.–Fri.; closed holidays. Admission: free.

## UNIVERSITY OF THE SOUTH
### University Gallery

The University Gallery at the University of the South in Sewanee, Tennessee, is part of a performing arts complex on the campus. The gallery was founded in 1954 to care for numerous donations of art objects and to present changing contemporary art exhibitions. It is best known for its photographic collections and exhibitions.

University Gallery, University of the South, 735 University Ave., Sewanee, TN 37375. Phone: 615/598-1223. Hours: 12–5 daily; closed holidays and when university not in session. Admission: free.

## UNIVERSITY OF SOUTH DAKOTA
### University Art Galleries

The University Art Galleries at the University of South Dakota in Vermillion consist of two galleries in the Warren M. Lee Center for the Fine Arts, which present contemporary art shows. The galleries, which also serve two other ex-

hibition spaces on the campus, have works by Native American artist Oscar Howe in their collections.

University Art Galleries, University of South Dakota, 414 E. Clark St., Vermillion, SD 57069-2390. Phone: 605/677-5481. Hours: 10–5 Mon.–Fri.; 1–5 Sat.–Sun.; closed holidays. Admission: free.

## UNIVERSITY OF SOUTHERN INDIANA
### New Harmony Gallery of Contemporary Art

The New Harmony Gallery of Contemporary Art—a part of the University of Southern Indiana—is located at Historic New Harmony, an open-air museum on the site of two early-nineteenth-century utopian experimental communities. The storefront gallery presents exhibitions of regional contemporary art.

New Harmony Gallery of Contemporary Art, University of Southern Indiana, 506 Main St., New Harmony, IN 47631. Phone: 812/682-3156. Hours: 9–5 Tues.–Sat.; 1–5 Sun.; closed holidays. Admission: free.

## UNIVERSITY OF SOUTHERN MAINE
### Art Gallery

Exhibitions of paintings, sculpture, graphics, and photographs are shown at the University of Southern Maine's Art Gallery in Gorham. The gallery was founded in 1965.

Art Gallery, University of Southern Maine, 17 College Ave., Gorham, ME 04038. Phone: 207/780-5409. Hours: 12–4 Sun.–Thurs. during scheduled exhibitions only. Admission: free.

## UNIVERSITY OF TAMPA
### Lee Scarfone Gallery and Hartley Gallery

Art in all media—including dance, music, and theater—are part of the overall experience at the Lee Scarfone Gallery on the downtown campus of the University of Tampa in Tampa, Florida. The main gallery serves as a teaching gallery and exhibits works of art as an extension of the classroom. Exhibitions feature the works of regional and national artists, as well as annual shows by students and faculty. The Hartley Gallery, a wing of the Lee Scarfone Gallery, exhibits other artworks as well as senior portfolios throughout the year.

Lee Scarfone Gallery/Hartley Gallery, University of Tampa, 401 W. Kennedy Blvd., Tampa, FL 33606-1490. Phone: 813/253-6217. Hours: 10–4 Mon.–Sat.; closed holidays. Admission: free.

## UNIVERSITY OF TENNESSEE AT CHATTANOOGA
### George Ayers Cress Gallery of Art

The Department of Art at the University of Tennessee at Chattanooga operates the George Ayers Cress Gallery of Art, a contemporary art gallery founded in 1952 that formerly was known as the University Gallery.

George Ayers Cress Gallery of Art, University of Tennessee at Chattanooga, Dept. of Art, Fine Arts Center, Chattanooga, TN 37403. Phone: 615/755-4178. Hours: 9–4 Mon.–Fri.; closed major holidays and when university not in session. Admission: free.

## UNIVERSITY OF TEXAS AT ARLINGTON
### Center for Research in Contemporary Art

The Center for Research in Contemporary Art at the University of Texas at Arlington has a 4,000-square-foot gallery in the Fine Arts Building. Opened in 1986, the gallery presents exhibitions of contemporary art.

Center for Research in Contemporary Art, University of Texas at Arlington, Fine Arts Bldg., 700 W. Second St., PO Box 19089, Arlington, TX 76019. Phone: 817/273-2790. Hours: 10–6 Mon.–Fri. (also to 9 Tues.–Wed.); 12–5 Sat.–Sun.; closed holidays and when university not in session. Admission: free.

## UNIVERSITY OF TEXAS AT SAN ANTONIO
### Art Gallery

Contemporary art is exhibited by the Art Gallery at the University of Texas at San Antonio. The exhibitions feature local and nationally known artists. The gallery opened in 1982.

Art Gallery, University of Texas at San Antonio, 6900 North Loop 1604, W., San Antonio, TX 78249. Phone: 210/691-4391. Hours: 10–4 Mon.–Fri.; 2–4 Sun.; closed holidays and when university not in session. Admission: free.

## UNIVERSITY OF VERMONT
### Francis Colburn Gallery

The Department of Art at the University of Vermont in Burlington operates the Francis Colburn Gallery as a teaching gallery featuring 12 to 14 contemporary exhibitions a year. Founded in 1975, the gallery is housed in Williams Hall, an 1896 campus building.

Francis Colburn Gallery, University of Vermont, Dept. of Art, Williams Hall, Burlington, VT 05405. Phone: 802/656-2014. Hours: 9–5 Mon.–Fri.; closed summer and major holidays. Admission: free.

## UNIVERSITY OF WEST FLORIDA
### University of West Florida Art Gallery

The University of West Florida Art Gallery in Pensacola exhibits contemporary art and the works of students and faculty.

University of West Florida Art Gallery, 11000 University Pkwy., Pensacola, FL 32514-5751. Phone: 904/474-2696. Hours: 10–5 Mon.–Fri.; 10–1 Sat.–Sun.; closed holidays and when university not in session. Admission: free.

## UNIVERSITY OF WISCONSIN–EAU CLAIRE
### Foster Gallery

Contemporary art in all media is exhibited by Foster Gallery at the University of Wisconsin–Eau Claire. The gallery, which opened in 1980, is best known for its contemporary shows of nonregional works and strong visiting artist program. Foster Gallery, University of Wisconsin–Eau Claire, 121 Water St., Eau Claire, WI 54702-4004. Phone: 715/836-3277. Hours: 10–4:30 Mon.–Fri.; 1–4:30 Sat.–Sun.; closed holidays and when university not in session. Admission: free.

## UNIVERSITY OF WISCONSIN–MADISON
### Wisconsin Union Art Galleries

One of the largest collections of original Wisconsin art is on view in the galleries, hallways, offices, and meeting rooms of the Wisconsin Memorial Union and Union South Building at the University of Wisconsin–Madison. Over 800 works by more than 500 artists with Wisconsin roots make up the collection of the Wisconsin Union Art Galleries. The main gallery, which opened in 1928, was renamed the Porter Butts Gallery in 1992. It presents changing exhibitions from a varied collection and elsewhere.
Wisconsin Union Art Galleries, University of Wisconsin–Madison, Wisconsin Memorial Union, 800 Langdon St., Madison, WI 53706. Phone: 608/262-2263. Hours: 7 A.M.–11 P.M. Mon.–Fri.; 8 A.M.–12 noon Sat.; 9 A.M.–11 P.M. Sun.; closed Christmas. Admission: free.

## UNIVERSITY OF WISCONSIN–MILWAUKEE
### Union Art Gallery

Changing exhibitions of artworks by professionals and students are shown at the Union Art Gallery at the University of Wisconsin–Milwaukee. The gallery, opened in 1972 in the student union, also has a collection of works in various media.
Union Art Gallery, University of Wisconsin–Milwaukee, 2200 E. Kenwood Blvd., Milwaukee, WI 53201. Phone: 414/229-6310. Hours: 11–4 Mon.–Wed.; 11–7 Thurs.; 11–3 Fri.; closed summer, holidays, and when university not in session. Admission: free.

## UNIVERSITY OF WISCONSIN–RIVER FALLS
### Gallery 101

Changing exhibitions of regional contemporary artists can be seen at Gallery 101 at the University of Wisconsin–River Falls. The gallery opened in 1973.
Gallery 101, University of Wisconsin–River Falls, River Falls, WI 54022. Phone: 715/425-4487. Hours: 9–5 and 7–9 Mon.–Fri.; 2–4 Sat.–Sun.; closed when university not in session. Admission: free.

## UNIVERSITY OF WISCONSIN–STOUT
### John Furlong Gallery

The John Furlong Gallery at the University of Wisconsin–Stout in Menominie presents changing exhibitions of a diverse nature. Founded in 1966, the gallery will be moving from its present space to a new facility in 1996.

John Furlong Gallery, University of Wisconsin–Stout, Menominie, WI 54751. Phone: 715/232-2261. Hours: 10–4 Mon.–Fri.; 12–3 Sat.; closed holidays. Admission: free.

## UNIVERSITY OF WISCONSIN–WHITEWATER
### Crossman Gallery

The Crossman Gallery at the University of Wisconsin–Whitewater is a teaching gallery that has changing exhibitions by established studio and emerging artists. Founded in 1971, it is located in the Center for the Arts, which houses music, theater, dance, and visual/studio art activities.

Crossman Gallery, University of Wisconsin–Whitewater, Center for the Arts, 800 W. Main St., Whitewater, WI 53190. Phone: 414/472-1207. Hours: 10–5 Mon.–Fri.; 1–5 Sun.; closed holidays and when university not in session. Admission: free.

## VALDOSTA STATE UNIVERSITY
### Fine Arts Gallery

A variety of art forms can be seen at the Fine Arts Gallery in the School of Fine Arts Building at Valdosta State University in Valdosta, Georgia.

Fine Arts Gallery, Valdosta State University, School of Fine Arts Bldg., Valdosta, GA 31698. Phone: 912/333-5833. Hours: 10–4 Mon.–Thurs.; 10–3 Fri.; closed when university not in session. Admission: free.

## VALENCIA COMMUNITY COLLEGE
### East Campus Galleries

The Valencia Community College East Campus Galleries in Orlando, Florida, present innovative contemporary group exhibitions and works from an annual juried competition. The gallery program was started on the West Campus in 1967 and then moved to new facilities on the East Campus in 1982.

East Campus Galleries, Valencia Community College, 701 N. Econlockhatchee Trail, PO Box 3028, Orlando, FL 32802-3028. Phone: 407/299-5000. Hours: 12:30–4:30 Mon.–Fri.; closed holidays and when college not in session. Admission: free.

## VANDERBILT UNIVERSITY
### Vanderbilt Fine Arts Gallery

The Vanderbilt Fine Arts Gallery at Vanderbilt University in Nashville, Tennessee, presents six to seven temporary exhibitions each year from a Department

of Fine Arts and gallery collection and artworks from other sources. The collection consists of approximately 7,000 works of Asian art, Old Masters and modern art, Renaissance paintings, prints, sculpture, graphics, ceramics, and photographs. The 1,500-square-foot gallery, located in a renovated 1880 gymnasium, opened in 1961, while the collection started in 1955 with a gift of Old Masters and modern works from Anna C. Hoyt.

Vanderbilt Fine Arts Gallery, Vanderbilt University, 23rd at West End Ave., Box 1801, Station B, Nashville, TN 37325. Hours: academic year—1–4 Mon.–Fri.; 1–5 Sat.–Sun.; summer—1–4 Mon.–Fri; closed holidays and when university not in session. Admission: free.

## VERMONT COLLEGE
### Wood Art Gallery

Founded in 1891, the Wood Art Gallery at Vermont College in Montpelier has permanent and changing exhibitions. Its collections consist of 438 oils, watercolors, and drawings by Thomas Waterman Wood and his contemporaries, including A.H. Wyant, A.B. Durand, and J.G. Brown; American artists of the 1920s and 1930s; and 60 works in a WPA collection.

Wood Art Gallery, Vermont College, Montpelier, VT 05602. Phone: 802/828-8743. Hours: 12–4 Tues.–Sun.; closed major holidays. Admission: adults, $2.

## VIRGINIA COMMONWEALTH UNIVERSITY
### Anderson Gallery

(See Art Museums section.)

## WAKE FOREST UNIVERSITY
### Fine Arts Gallery

The Wake Forest University Fine Arts Gallery in Winston-Salem, North Carolina, presents contemporary and historical exhibitions in various media. Founded in 1976, the gallery schedules loan and traveling exhibitions to supplement shows curated by its staff.

Fine Arts Gallery, Wake Forest University, Dept. of Art, Box 7232, Winston-Salem, NC 27109. Phone: 910/759-5795. Hours: 10–5 Mon.–Fri.; 1–5 Sat.–Sun.; closed holidays and when university not in session. Admission: free.

## WASHINGTON AND JEFFERSON COLLEGE
### Olin Fine Arts Gallery

The Olin Fine Arts Gallery at Washington and Jefferson College in Washington, Pennsylvania, presents monthly exhibitions during the academic year for students, faculty, and the local community. Located in the Arts Center, the

gallery has a collection of local and college historical works and modern American paintings.

Olin Fine Arts Gallery, Washington and Jefferson College, E. Wheeler St., Arts Center, Washington, PA 15301. Phone: 412/222-4400. Hours: 12–7 daily; closed when college not in session. Admission: free.

## WASHINGTON AND LEE UNIVERSITY
### Du Pont Gallery

The Du Pont Gallery at Washington and Lee University in Lexington, Virginia, contains changing exhibitions of regional artists. The gallery, opened in 1952, is in the center of Du Pont Hall, an academic building housing the art and music departments.

Du Pont Gallery, Washington and Lee University, Du Pont Hall, Lexington, VA 24450. Phone: 703/463-8861. Hours: 8–5 Mon.–Fri.; closed holidays and when university not in session. Admission: free.

## WATKINS INSTITUTE
### Watkins Institute Art Gallery

The Watkins Institute Art Gallery is part of the art school in Nashville, Tennessee. It is known for its Tennessee All-State Art Collection of paintings, graphics, and sculpture. The gallery also has 50 etchings by Nahum Tschachbasov, 7 paintings by Elihu Vedder, and 9 antique hand-colored prints of classical interiors and artifacts.

Watkins Institute Art Gallery, 601 Church, Nashville, TN 37219. Phone: 615/242-1851. Hours: 9–9 Mon.–Thurs.; 9–1:30 Fri.; closed major holidays. Admission: free.

## WAYNE STATE UNIVERSITY
### Wayne State University Community Arts Gallery

Student and faculty exhibitions of paintings, sculpture, ceramics, photography, fibers, and other artworks are the primary focus at the Wayne State University Community Arts Gallery in Detroit, Michigan. The Department of Art gallery, founded in 1958, is located in the Community Arts Building.

Wayne State University Community Arts Gallery, Dept. of Art, 150 Community Arts Bldg., Detroit, MI 48202. Phone: 313/577-2985. Hours: 10–5 Mon.–Fri. Admission: free.

## WEBER STATE UNIVERSITY
### Art Gallery

Exhibitions of contemporary paintings, prints, drawings, photographs, and ceramics by emerging artists are offered by the Weber State University Art Gallery

in Ogden, Utah. The gallery is located in the Department of Visual Arts building opened in 1968.

Art Gallery, Weber State University, Dept. of Visual Arts, Ogden, UT 84408-2001. Phone: 801/626-6762. Hours: 9–9 Mon.–Fri.; closed holidays and when university not in session. Admission: free.

## WEBSTER UNIVERSITY
### Hunt Gallery

Six exhibitions by regional, national, and international artists are presented each year by the Hunt Gallery at Webster University in St. Louis, Missouri. Most of the shows are contemporary, with an occasional historical exhibition. The gallery first opened in 1980 and expanded its scope and moved to its present location in the Visual Arts Studios in 1989.

Hunt Gallery, Webster University, Visual Arts Studios, 8342 Big Bend Blvd., St. Louis, MO 63119. Phone: 314/968-7171. Hours: 10–4 Mon.–Fri.; 10–2 Sat.; closed summer and holidays. Admission: free.

## WENATCHEE VALLEY COLLEGE
### Gallery '76

Six to nine changing exhibitions are shown each year at Gallery '76—founded during the 1976 bicentennial year—at Wenatchee Valley College in Wenatchee, Washington. They consist of exhibitions of works by regional and national artists, as well as student shows.

Gallery '76, Wenatchee Valley College, 1300 Fifth St., Wenatchee, WA 98801. Phone: 509/662-1651. Hours: 1–4 Mon.–Fri. (also 7–9 Wed.–Thurs.); closed summer and holidays. Admission: free.

## WESLEYAN UNIVERSITY
### Ezra and Cecile Zilkha Gallery

Exhibitions of contemporary art are offered by the Ezra and Cecile Zilkha Gallery at Wesleyan University's Center for the Arts in Middletown, Connecticut.

Ezra and Cecile Zilkha Gallery, Wesleyan University, Center for the Arts, Middletown, CT 06459-0442. Phone: 203/344-8544. Hours: 12–4 Tues.–Fri.; 2–5 Sat.–Sun.; closed holidays. Admission: free.

## WEST CHESTER UNIVERSITY
### McKinney Gallery

Changing exhibitions by local, regional, and national artists are presented by the McKinney Gallery at West Chester University in West Chester, Pennsylvania. The gallery, located in Mitchell Hall, opened in 1973.

McKinney Gallery, West Chester University, Dept. of Art, Mitchell Hall, West Chester, PA 19383. Phone: 610/436-2755. Hours: 9–4 Mon.–Fri.; closed Christmas recess. Admission: free.

# WESTERN ILLINOIS UNIVERSITY
## Western Illinois University Art Gallery/Museum

(See Art Museums section.)

# WESTERN KENTUCKY UNIVERSITY
## Western Kentucky University Gallery

Contemporary works are displayed at the Western Kentucky University Gallery in the Ivan Wilson Center for Fine Arts on the campus in Bowling Green. Western Kentucky University Gallery, 200 Ivan Wilson Center for Fine Arts, Bowling Green, KY 42101. Phone: 502/745-3944. Hours: 8:30–4:30 Mon.–Fri.; closed between exhibitions. Admission: free.

# WESTERN MICHIGAN UNIVERSITY
## Western Michigan University Art Galleries

The Department of Art at Western Michigan University in Kalamazoo offers exhibitions in five galleries—in the Gallery II in Sangren Hall, Space Gallery in Knauss Hall, and Rotunda and South galleries (which constitute the Student Art Gallery) in East Hall and sometimes in the Multimedia Room in Dalton Center.

The gallery program, which began in 1975, features changing exhibitions of contemporary artists, student art, and occasionally pieces from a university/departmental collection of prints by European and American contemporary and younger avant-garde artists and of nineteenth- and twentieth-century American and European fine and decorative arts.

Western Michigan University Art Galleries, Dept. of Art, College of Fine Arts, Kalamazoo, MI 49008. Phone: 616/387-2455. Hours: Gallery II and Student Art Gallery—10–4 Mon.–Fri.; Space Gallery—10–4 Mon.–Thurs.; Multimedia Room—10–4 Mon.–Sat.; closed summer and holidays. Admission: free.

# WESTERN MONTANA COLLEGE
## Western Montana College Gallery-Museum

The Western Montana College Gallery-Museum in Dillon is a combination art gallery and natural history museum, founded in 1986. Housed in the college's 1893 main building, the gallery-museum presents changing exhibitions and has

a collection of wildlife specimens and examples of works by Edgar Paxson, Charles Russell, Pierre Auguste Renoir, and Salvador Dali.
Western Montana College Gallery-Museum, 710 S. Atlantic St., Dillon, MT 59725. Phone: 406/683-7126. Hours: 12–4 Mon.–Fri. (also 7–9 Tues. and Thurs.); 1–4 Sun.; closed major holidays and breaks. Admission: free.

## WESTERN NEW MEXICO UNIVERSITY
### Francis McCray Galleries

Contemporary regional art exhibitions and exceptional art on loan from private collections in the area are presented at the Francis McCray Galleries at Western New Mexico University in Silver City. The gallery also has a collection of contemporary American prints and 1600–1960 Japanese prints.
Francis McCray Galleries, Western New Mexico University, PO Box 680, Silver City, NM 88062. Phone: 505/538-6614. Hours: 9–12 and 1–4 Mon.–Fri.; closed holidays and when university not in session. Admission: free.

## WESTERN WASHINGTON UNIVERSITY
### Western Gallery

Seven exhibitions of contemporary, historical, and/or experimental art are presented each year by the Western Gallery at Western Washington University in Bellingham. The gallery's collections include prints and drawings by Helen Loggie and the Outdoor Sculpture Collection, consisting of more than 20 works throughout the campus, such as Isamu Noguchi's painted steel creation, *Skyviewing Sculpture.*
Western Gallery, Western Washington University, Fine Arts Complex, Bellingham, WA 98225. Phone: 206/650-3963. Hours: 10–4 Mon.–Fri.; 12–4 Sat.; closed holidays and when university not in session. Admission: free.

### Viking Union Gallery
Changing exhibitions of student and local professional art are shown in the Viking Union Gallery at Western Washington University in Bellingham. The gallery opened in 1950.
Viking Union Gallery, Western Washington University, 202 Viking Union, Bellingham, WA 98225-9106. Phone: 206/650-6534. Hours: 11–5 Mon.–Sat.; closed holidays. Admission: free.

## WEST VIRGINIA UNIVERSITY
### Creative Arts Center Galleries

The Creative Arts Center Galleries on the Evansdale Campus of West Virginia University in Morgantown present changing exhibitions in 22,000 square feet of exhibit space. The galleries were opened in 1968.

Creative Arts Center Galleries, West Virginia University, Evansdale Campus, Morgantown, WV 26506-6111. Phone: 304/293-4642. Hours: 1–5 Mon.–Fri. (also 7–9:30 three nights a week); closed summer and winter breaks. Admission: free.

## WHEATON COLLEGE
### Watson Gallery

The Watson Gallery, located on the main level of the Watson Arts Center at Wheaton College in Norton, Massachusetts, presents six historical and contemporary exhibitions during the academic year. They are loan exhibitions or drawn from the gallery's collections of antiquities, Native American baskets, decorative arts, paintings, drawings, and prints.

Watson Gallery, Wheaton College, Watson Arts Center, Norton, MA 02766. Phone: 528/285-8200. Hours: 12:30–4:30 Mon.–Sun.; closed holidays and when college not in session. Admission: free.

## WHITMAN COLLEGE
### Donald H. Sheehan Gallery

Six exhibitions are presented each year by the Donald H. Sheehan Gallery at Whitman College in Walla Walla, Washington. The gallery, founded in 1972 in Olin Hall, has collections of Asian art—primarily from Japan, China, Korea, and Thailand—and paintings and prints from the Pacific Northwest.

Donald H. Sheehan Gallery, Whitman College, Olin Hall, 900 Isaacs, Walla Walla, WA 99362. Phone: 509/527-5249. Hours: 10–5 Tues.–Fri.; 1–4 Sat.–Sun.; closed when college not in session. Admission: free.

## WILKES UNIVERSITY
### Sordoni Art Gallery

The Sordoni Art Gallery at Wilkes University in Wilkes-Barre, Pennsylvania, emphasizes nineteenth- and twentieth-century American art in its collections and exhibitions. The 1,200-square-foot gallery opened in 1973.

Sordoni Art Gallery, Wilkes University, 150 S. River St., Wilkes-Barre, PA 18766. Phone: 717/831-4325. Hours: 12–5 daily (also to 9 Thurs.); closed major holidays. Admission: free.

## WILLIAM PATERSON COLLEGE OF NEW JERSEY
### Ben Shahn Galleries

The Ben Shahn Galleries at William Paterson College of New Jersey in Wayne present one-person exhibitions and group thematic shows of contemporary artworks. Collections of the 6,000-square-foot facility, opened in 1970, include paintings from the nineteenth century and drawings from the 1950s. The gallery is located in the Ben Shahn Center for the Visual Arts.

Ben Shahn Galleries, William Paterson College of New Jersey, Ben Shahn Center for the Visual Arts, 300 Pompton Rd., Wayne, NJ 07470. Phone: 201/595-2654. Hours: 10–5 Mon.–Thurs.; closed holidays and when college not in session. Admission: free.

## WINSTON-SALEM STATE UNIVERSITY
### Diggs Gallery

Changing exhibitions on black culture from around the world—with the emphasis on African-American and African art—are featured at the Diggs Gallery at Winston-Salem State University in Winston-Salem, North Carolina. The gallery, which opened in 1990 on the lower level of the library, is part of the university's growing art offerings, which include a sculpture garden, two large murals by John Biggers, and a number of paintings, prints, and sculptures.

Diggs Gallery, Winston-Salem State University, 601 Martin Luther King Jr. Dr., Winston-Salem, NC 27110. Phone: 910/750-2458. Hours: 11–5 Tues.–Sat.; closed holidays. Admission: free.

## WOFFORD COLLEGE
### Sandor Teszler Library Gallery

(See Library and Archival Collections and Galleries section.)

## WRIGHT STATE UNIVERSITY
### Wright State University Galleries

The Wright State University Galleries in Dayton, Ohio, consist of four galleries devoted to contemporary art. The collection includes paintings, sculpture, and works on paper. Founded in 1974, the galleries began as the Dayton Art Institute Museum of Contemporary Art at Wright State University.

Wright State University Galleries, 3640 Colonel Glenn Hwy., Dayton, OH 45435. Phone: 513/873-2978. Hours: 10–4 Mon.–Fri.; 12–4 Sat.–Sun.; closed holidays. Admission: free.

## XAVIER UNIVERSITY
### Xavier University Art Gallery

Regional and local art is shown at the Xavier University Art Gallery, an extension of the Department of Art's studio art program, in Cincinnati, Ohio.

Xavier University Art Gallery, 3800 Victory Pkwy., Cincinnati, OH 45207-7311. Phone: 513/745-3811. Hours: 1–5 Mon.–Fri.; closed holidays and when university not in session. Admission: free.

## YAKIMA VALLEY COMMUNITY COLLEGE
### Larson Gallery

The Larson Gallery at Yakima Valley Community College in Yakima, Washington, schedules 10 exhibitions a year of contemporary art, ethnic arts, and

juried shows, with the emphasis on Northwest artists. The gallery—originally known as the Larson Museum and Gallery—was founded in 1949.

Larson Gallery, Yakima Valley Community College, S. 16th Ave. and Nob Hill Rd., PO Box 1647, Yakima, WA 98907. Phone: 509/575-2402. Hours: 10–5 Tues.–Fri.; 1–5 Sat.–Sun.; closed Aug. and major holidays. Admission: free.

## YESHIVA UNIVERSITY
### Yeshiva University Museum

(See Archaeology, Anthropology, and Ethnology Museums section.)

## YOUNGSTOWN STATE UNIVERSITY
### John J. McDonough Museum of Art

The John J. McDonough Museum of Art, which opened in a new 9,000-square-foot building in 1991, displays student, faculty, alumni, and experimental artworks at Youngstown State University in Youngstown, Ohio. It does not have collections.

John J. McDonough Museum of Art, Youngstown State University, 410 Wick Ave., Youngstown, OH 44555-0001. Phone: 216/742-1400. Hours: 11–8 Wed.; 11–4 Tues. and Thurs.–Sat.; closed Aug. and holidays. Admission: free.

# Art Museums

*Also see Art Galleries; Costume and Textile Museums; Photography Museums; and Sculpture Gardens sections.*

## ACADEMY OF THE NEW CHURCH
### Glencairn Museum

(See Historical Museums, Houses, and Sites section.)

## ALFRED UNIVERSITY
### Museum of Ceramic Art at Alfred

The New York State College of Ceramics at Alfred University has the only university art museum in the nation devoted to ceramic art. It started as a study collection in 1900 and became the Museum of Ceramic Art at Alfred in 1991. The museum's collections include ancient pottery, pre-Columbian ceramics, European porcelain, contemporary American ceramics, and works by Alfred-trained ceramists and graduate students.

Museum of Ceramic Art at Alfred, New York State College of Ceramics at Alfred University, Harder Hall, Alfred, NY 14802. Phone: 607/871-2421. Hours: 1–4 Tues.–Sun.; closed holidays and when university not in session. Admission: free.

## AMHERST COLLEGE
### Mead Art Museum

The Mead Art Museum at Amherst College in Amherst, Massachusetts, originated in 1950 as the Mead Art Building, built to house the college's diverse

art collections and to provide related facilities. Today the museum occupies 30,454 square feet in the building, which contains collections, galleries, a print study room, a period Tudor room, a slide library, and an auditorium.

The museum is best known for its collections of nineteenth- and early-twentieth-century American fine and decorative arts and eighteenth-century British paintings. They include the works of John Copley, Gilbert Stuart, Charles Willson Peale, Thomas Cole, Rembrandt Peale, and Benjamin West. The museum also has an extensive print collection as well as ancient Syrian reliefs, Elizabethan furnishings, and ethnographic materials.

The Mead Art Museum presents from six to eight changing exhibitions each year, including selections from its permanent collections, faculty and student shows, and exhibitions from other institutions.

Mead Art Museum, Amherst College, Mead Art Bldg., Amherst, MA 01002. Phone: 413/542-2335. Hours: 10–4:30 Mon.–Fri.; 1–5 Sat.–Sun.; closed holidays and open only limited hours when college not in session. Admission: free.

# ARIZONA STATE UNIVERSITY
## Arizona State University Art Museum

The Arizona State University Art Museum in Tempe was founded in 1950 following the gift of approximately 130 major American works of art by Phoenix attorney Oliver B. James. The museum now holds more than 5,000 works ranging from Rembrandt to Remington and Orozco to O'Keeffe.

The museum occupies 56,212 square feet in parts of two buildings. Most of the collections are housed and exhibited in a new structure that is part of the Nelson Fine Arts Center. Ceramics and other parts of the collections are in the Matthews Center, which was the only museum facility from 1950 to 1989.

The museum's collections and exhibitions feature American art, contemporary crafts (especially ceramics and turned wood), and American and European historical and contemporary prints. It also has an experimental gallery, which presents cutting-edge works and offers changing exhibitions from its collections by local and regional artists and from works on loan from other institutions.

Arizona State University Art Museum, Nelson Fine Arts Center, 10th St. and Mill Ave., Box 872911, Tempe, AZ 85287-2911. Phone: 602/965-2787. Hours: 10–5 Tues.–Sat. (also to 9 Tues.); 1–5 Sun.; closed holidays. Admission: free.

## Deer Valley Rock Art Center
(See Archaeology, Anthropology, and Ethnology Museums section.)

# BALL STATE UNIVERSITY
## Ball State University Museum of Art

Paintings, sculpture, prints, and decorative arts—with objects from antiquity to the present—are featured at the Ball State University Museum of Art in Muncie, Indiana. Founded in 1935, the museum has more than 9,200 works in

its collections and occupies approximately 30 percent of the 76,000-square-foot Fine Art Building.

The museum's strengths are fifteenth- through nineteenth-century European paintings, nineteenth- and twentieth-century American works, and a range of decorative arts. The collections also include examples of Native African, Oceanic, Asian, and pre-Columbian objects. Among the artists represented are Rembrandt, Jean Honoré Fragonard, Edgar Degas, Winslow Homer, Childe Hassam, and Alexander Calder.

Ball State University Museum of Art, 2000 University Ave., Muncie, IN 47306. Phone: 317/285-5242. Hours: 9–4:30 Tues.–Fri.; 1:30–4:30 Sat.–Sun.; closed major holidays. Admission: free.

## BARD COLLEGE
### Bard Graduate Center for Studies in the Decorative Arts

Bard College opened a decorative arts museum as part of the Bard Graduate Center for Studies in the Decorative Arts in New York City in 1992.

Bard Graduate Center for Studies in the Decorative Arts, Bard College, 18 W. 86th St., New York, NY 10024. Phone: 212/501-3000. Hours: 11–5 Tues.–Fri. and Sun (also to 8:30 Thurs.); closed holidays. Admission: adults, $2; seniors and students, $1; children under 12, free.

## BATES COLLEGE
### Museum of Art

The Museum of Art at Bates College in Lewiston, Maine, began as Treat Gallery in 1955. In 1986, the college's collections were combined to form the Museum of Art as a wing of the newly constructed Olin Arts Center. The museum is best known for its collection of works by Marsden Hartley, a Lewiston native. Its collections also include nineteenth- and twentieth-century American and European works on paper, Chinese art objects, and American and European paintings and photographs.

Museum of Art, Bates College, Olin Arts Center, Lewiston, ME 04240. Phone: 207/786-6158. Hours: 10–5 Mon.–Sat.; 1–5 Sun.; closed holidays. Admission: free.

## BAYLOR UNIVERSITY
### Martin Museum of Art

The Martin Museum of Art opened in 1980 as part of the new Hooper-Schaefer Fine Arts Center at Baylor University in Waco, Texas. The collections and exhibits include such works as New Guinea figurines, African sculpture, and paintings from the region. The museum, part of the Department of Art, also presents changing exhibitions.

Martin Museum of Art, Baylor University, Dept. of Art, Hooper-Schaefer Fine Arts Center, PO Box 97263, Waco, TX 76498-7263. Phone: 817/755-1867. Hours: 10–5 Tues.–Fri.; 12–5 Sat.; closed holidays and when university not in session. Admission: free.

# BELOIT COLLEGE
## Wright Museum of Art

The Wright Museum of Art is one of two "teaching museums" that comprise the Museums of Beloit College in Beloit, Wisconsin. The other is the Logan Museum of Anthropology (described in the Archaeology, Anthropology, and Ethnology Museums section). Both were founded with major gifts in the latter part of the nineteenth century and provide opportunities for students to learn and work in a professional environment.

The art museum was founded in 1892 when large donations of prints, drawings, photographs, and plaster casts of Greek sculpture were received, primarily from Helen Brace Emerson. The collections now include extensive holdings of nineteenth-century photographs; European and American graphics, paintings, and sculpture; and Asian decorative arts, including porcelains, sculpture, jewelry, Chinese imperial robes, Korean celadon ceramics, and Japanese sagemono.

The museum occupies 17,000 square feet in Wright Art Hall, which it shares with the Department of Art and Art History. Plans call for the museum space to be expanded to 25,000 square feet.

Wright Museum of Art, Beloit College, Wright Art Hall, 700 College St., Beloit, WI 53511. Phone: 608/363-2677. Hours: 9–5 Mon.–Fri.; 11–4 Sat.–Sun.; closed holidays and when college not in session. Admission: free.

# BETHANY COLLEGE
## Birger Sandzen Memorial Gallery

Swedish artist Birger Sandzen came to Bethany College in Lindsborg, Kansas, to teach for two years, but stayed for the rest of his life. The Birger Sandzen Memorial Gallery, founded in 1957, honors his memory as an artist, teacher, and early practitioner of outreach programs.

The gallery has collections of oils, watercolors, and prints by Sandzen; paintings by Kansas native Henry Varnam Poor, Marsden Hartley, B.J.O. Nordfelt, and others; sixteenth-century tapestries; Japanese bronzes; and other paintings, ceramics, sculpture, and graphics. A fountain, *The Little Triton,* by Carl Milles dominates the building's courtyard. Exhibitions are based on the collections and artworks on loan.

Birger Sandzen Memorial Gallery, Bethany College, 401 N. First St., Box 348, Lindsborg, KS 67456-0348. Phone: 913/227-2220. Hours: 1–5 Wed.–Sun.; closed major holidays. Admission: adults, $2, children in grades 1–12, 50¢.

## BOB JONES UNIVERSITY
### Bob Jones University Collection of Sacred Art

(See Religious Museums section.)

## BOSTON COLLEGE
### Boston College Museum of Art

The Boston College Museum of Art in Chestnut Hill, Massachusetts, has a collection that spans the history of art from Europe, Asia, and the Americas. It includes Gothic and Baroque tapestries, Italian paintings of the sixteenth and seventeenth centuries, American landscape paintings of the nineteenth and early twentieth centuries, and Japanese prints.

The collection is displayed on a rotating basis. The Micro Gallery features an interactive computer that enables visitors to obtain information and see images from the collection. The museum also maintains an active special exhibition program that brings outstanding works from around the world to its galleries. Founded in 1976, the museum occupies two floors of Devlin Hall, a neo-Gothic building completed in 1924 and renovated in 1993.

Boston College Museum of Art, Devlin Hall, 140 Commonwealth Ave., Chestnut Hill, MA 02167. Phone: 617/552-8587. Hours: academic year—11–4 Mon.–Fri.; 12–5 Sat.–Sun.; summer—11–4 Mon.–Fri.; closed major holidays. Admission: free.

## BOWDOIN COLLEGE
### Bowdoin College Museum of Art

The collections of the Bowdoin College Museum of Art in Brunswick, Maine, originated in 1881 through the bequest of James Bowdoin III, but it was not until 1894 that the museum was formalized and occupied its present building—a Beaux Arts structure designed by Charles Follen McKim and named the Walker Art Building for an early benefactor.

Bowdoin bequeathed 70 paintings collected in Europe and 142 drawings, giving the institution one of the nation's earliest collegiate collections of fine arts. In the years that followed, numerous other artworks were added. The museum now has approximately 12,000 works, including the oldest extant collection of Old Master drawings in a collegiate museum and an excellent encyclopedic collection of fine arts.

Among the museum's holdings are Colonial and Federal portraits, including works by Smibert, Feke, Copley, and Stuart; ancient Greek works; Asian art; Assyrian reliefs; Old Master drawings and prints; Warren Collection of classical antiquities; Winslow Homer Collection of wood engravings, watercolors, drawings, and memorabilia; Molinare Collection of medals and plaquettes; and works by such nineteenth- and twentieth-century artists as Thomas Eakins, Martin

Johnson Heade, George Inness, Robert Henri, John Sloan, and Leonard Baskin. Many of these works are on exhibit. In addition, the museum presents 18 temporary exhibitions each year.
Bowdoin College Museum of Art, Walker Art Bldg., Brunswick, ME 04011. Phone: 207/725-3275. Hours: 10–5 Tues.–Sat.; 2–5 Sun.; closed holidays. Admission: free.

# BRANDEIS UNIVERSITY
## Rose Art Museum

Twentieth-century American and European painting and sculpture are featured in the Rose Art Museum's collection of 9,000 works at Brandeis University in Waltham, Massachusetts. Launched in a new contemporary glass and concrete building in 1961, the museum was a gift of Edward and Bertha Rose of Boston to house artworks that had been accumulating at the university since it opened in 1948.

The museum's collections include contemporary paintings, sculptors' drawings, and photography, as well as such diverse works as Tibetan art related to Tantric Buddhism, pre-modern art (before 1800), Oceanic art, early ceramics, Japanese prints, Native American art, pre-Columbian art, and African art.

The museum also operates exhibition spaces in three other campus buildings—the Dreitzer Gallery, Schwartz Hall, and Farber Library. The Helen S. Slosberg Collection of Oceanic art is displayed in the Schwartz Hall reception area, while changing exhibitions are presented in the other two locations. The museum also has responsibility for sculptures located throughout the university grounds.
Rose Art Museum, Brandeis University, 415 South St., Waltham, MA 02254-9110. Phone: 617/736-3434. Hours: 1–5 Tues.–Sun. (also to 9 Thurs.); closed major holidays. Admission: free.

# BRIGHAM YOUNG UNIVERSITY
## Museum of Art

The Museum of Art at Brigham Young University in Provo, Utah, moved into its new 100,000-square-foot building in 1993 after being founded as a gallery and operating for nearly three decades in the Harris Fine Arts Center. The museum now has more than 14,000 artworks in its collections and is noted for its American art.

The collections include extensive works by nineteenth- and twentieth-century American artists, including Albert Bierstadt, Thomas Moran, George Inness, and Maynard Dixon, and such Utah artists as J.T. Harwood, Edwin Evans, and John Hafen. The exhibits feature such works as 7 × 10-foot murals by pioneer artist C.C.A. Christensen.

The museum's holdings were broadened in 1959 with the acquisition of thousands of art pieces from the J. Alden Weir and Mahonri M. Young collec-

tions. They include etchings by Rembrandt, a Monet sketch, paintings by Weir, and sculptures by Young.

The museum also has eighteenth- and nineteenth-century English art and Japanese prints, antique and modern European prints and drawings, ivory and Ch'ing jade carvings, ancient musical instruments, and an outdoor sculpture garden containing 20 works in bronze. A massive bronze by Reuben Nakian stands at the museum's east entrance.

An exhibition of 73 masterworks by American artists, titled *150 Years of American Painting, 1794–1944,* was the first major exhibition from the museum's collections presented in the new building. It included landscapes, portraits, seascapes, still lifes, and history paintings by 56 artists, including Frederic Church, Asher B. Durand, Albert Bierstadt, Thomas Moran, and Childe Hassam. Museum of Art, Brigham Young University, N. Campus Dr., Provo, UT 84602. Phone: 801/378-2787. Hours: 9–5 Mon.–Sat.; closed major holidays. Admission: free.

## BROWN UNIVERSITY
### Annmary Brown Memorial

(See Historical Museums, Houses, and Sites section.)

### David Winton Bell Gallery
(See Art Galleries section.)

### Haffenreffer Museum of Anthropology
(See Archaeology, Anthropology, and Ethnology Museums section.)

## CALIFORNIA STATE UNIVERSITY, LONG BEACH
### University Art Museum

The University Art Museum at California State University, Long Beach, was founded as a gallery in 1949 when the university was begun. It became a museum in 1973 when the first full-time director was hired. The museum features modern and contemporary works of art on paper from throughout the world and site-specific sculpture. It occupies 10,000 square feet in a renovated building shared with an auxiliary library.
University Art Museum, California State University, Long Beach, 1250 Bellflower Blvd., Long Beach, CA 90840-1901. Phone: 310/985-5761. Hours: 12–8 Tues.–Thurs.; 12–5 Fri.–Sun.; closed holidays and when university not in session. Admission: free.

## CAPITAL UNIVERSITY
### Schumacher Gallery

The Schumacher Gallery is Capital University's art museum in Columbus, Ohio. Founded in 1972, it has over 2,000 artworks in its collections, including

Asian art, ethnic art, graphics, period works, sculpture, and works by contemporary artists, including many from Ohio. Among the museum's holdings are woodcuts by Albrecht Dürer, a sixteenth-century Pieta by Willem Key, a landscape by George Wesley Bellows, and watercolors by Reginald Marsh, William Zorach, and others. Selections from the collections and temporary exhibitions are displayed in eight gallery spaces on the fourth floor of the library building.
Schumacher Gallery, Capital University, Library Bldg., 2199 E. Main St., Columbus, OH 43209. Phone: 614/236-7108. Hours: academic year—1–5 Mon.–Fri.; 2–5 Sat.–Sun.; closed holidays and when university not in session. Admission: free.

## CARNEGIE MELLON UNIVERSITY
### Hunt Institute for Botanical Documentation Art Collection

(See Botanical Gardens, Arboreta, and Herbaria section.)

## CENTENARY COLLEGE OF LOUISIANA
### Meadows Museum of Art

The Meadows Museum of Art opened in 1976 at Centenary College of Louisiana in Shreveport as the permanent home for the Jean Despujols Collection of paintings and drawings of Indochina—a gift from alumnus Algur H. Meadows. Despujols was a French artist who was commissioned in 1936 to record the lives and environment of the people of French Indochina. He created a remarkable documentary record of the remote areas of Vietnam, Laos, and Cambodia in the 1930s.

The unique collection encompasses 360 works in a variety of media, ranging from oils and watercolors to pencil sketches, arranged in eight groups by regions and ethnic divisions. An award-winning film, *Indochina Revisited,* is shown with the works. It contains excerpts from Despujols' personal journals, photographs of the artist, and selections from his work.
Meadows Museum of Art, Centenary College of Louisiana, 2911 Centenary Blvd., PO Box 41188, Shreveport, LA 71134-1188. Phone: 318/869-5169. Hours: 1–5 Tues.–Fri.; 1–4 Sat.–Sun.; closed holidays. Admission: free.

## CENTRAL CONNECTICUT STATE UNIVERSITY
### Museum of Central Connecticut State University

The Museum of Central Connecticut State University in New Britain is an art museum located in the Samuel S.T. Chen Art Center. Founded in 1965, it has collections of paintings, sculpture, graphics, decorative arts, textiles, and architectural drawings and models, as well as anthropological, archaeological, and industrial materials. The museum's resources are used primarily in undergraduate and graduate programs.

Museum of Central Connecticut State University, Art Dept., Samuel S.T. Chen Art Center, New Britain, CT 06050. Phone: 203/827-7322. Hours: by appointment only. Admission: free.

## CITY UNIVERSITY OF NEW YORK, QUEENS COLLEGE
### Frances Godwin and Joseph Ternbach Museum

The Frances Godwin and Joseph Ternbach Museum is an art museum at Queens College of the City University of New York in Flushing. Its collections include paintings, prints, graphics, sculpture, glass, and other works and range from Near Eastern and Asian art to Western and contemporary works. The museum was founded in 1957.

Frances Godwin and Joseph Ternbach Museum, Queens College, City University of New York, 65-30 Kissena Blvd., Flushing, NY 11367. Phone: 718/997-4747. Hours: by appointment. Admission: free.

## COLBY COLLEGE
### Colby College Museum of Art

American art from the eighteenth century to the present is the primary focus of the Colby College Museum of Art in Waterville, Maine. Opened in 1959, the small (8,500 square feet), but important, museum is located in the Bixler Art and Music Center.

Among the museum's notable holdings are 14 paintings by Winslow Homer; 25 works by John Marin; American impressionist paintings by such nineteenth-century artists as Thomas Cole, John Frederick Kensett, Thomas Doughty, and George Inness of the Hudson River School; Colonial portraits by Joseph Badger, Joseph Blackburn, John Singleton Copley, John Smibert, and others; and 78 canvases of American folk art, consisting largely of New England primitives of the 1800–1869 period.

The Colby museum also has a variety of other materials, including pre-Columbian objects, European art, Far Eastern ceramics, American and European prints and drawings, and an archive of Maine art. It also presents a variety of temporary exhibitions.

Colby College Museum of Art, Mayflower Hill Dr., Waterville, ME 04901. Phone: 207/872-3228. Hours: 10–4:30 Mon.–Sat.; 2–4:30 Sun.; closed holidays. Admission: free.

## COLGATE UNIVERSITY
### Picker Art Gallery

(See Art Galleries section.)

## COLLEGE OF WILLIAM AND MARY
### Joseph and Margaret Muscarelle Museum of Art

The College of William and Mary in Williamsburg, Virginia, has been acquiring artworks since the early eighteenth century, but it was not until 1983

that private funding made it possible to build a structure to house the collections and special loan exhibitions. In 1987, the size of the building was doubled, resulting in today's Joseph and Margaret Muscarelle Museum of Art.

The museum has a diverse collection of over 3,000 works. It includes English and American portraits of the seventeenth, eighteenth, and nineteenth centuries; American abstract expressionist paintings, drawings, and watercolors; a survey collection of approximately 1,800 European, Asian, and American prints and drawings from the fifteenth through the twentieth centuries; and Native American, Asian, Islamic, and African collections.

The museum also is known for what is called "the world's first solar painting"—a 65 × 13-foot passive solar wall on the south facade of the museum's building. The work—called *Sun Sonata*—contains 124 reinforced fiberglass tubes, each filled with dyed water and illuminated by fluorescent lights from behind. Designed by the late Gene Davis, the vertical-tubed wall collects solar energy by day and glows as colorful stripes at night.

Joseph and Margaret Muscarelle Museum of Art, College of William and Mary, PO Box 8795, Williamsburg, VA 23187-8795. Phone: 804/221-2700. Hours: 10–4:45 Mon.–Fri.; 12–4 Sat.–Sun.; closed or 12–4 on holidays. Admission: free.

## COLLEGE OF WOOSTER
### College of Wooster Art Museum

The College of Wooster Art Museum in Wooster, Ohio, began as a small gallery in the 1950s and moved into its present larger quarters in a renovated vacant library building in 1968. Plans now call for the museum and the Department of Art History to be moved into new facilities in the near future.

The museum is known for its exceptional John Taylor Arms Collection of approximately 5,000 prints, ranging from Dürer to Dali. Its holdings also include Chinese bronzes, African sculpture, and ceramics. In addition, the museum has an extensive temporary exhibition schedule. In recent years, the museum has emphasized the organization of exhibitions of contemporary women and minority artists, such as Miriam Shapiro, Faith Ringgold, Michelle Stuart, and Emma Amos.

College of Wooster Art Museum, E. University St., Wooster, OH 44691. Phone: 216/ 263-6710. Hours: 9–12 and 1–5 Mon.–Fri.; 2–5 Sun.; closed holidays and when college not in session. Admission: free.

## CORNELL UNIVERSITY
### Herbert F. Johnson Museum of Art

The Herbert F. Johnson Museum of Art's 10-floor building occupies a knoll overlooking the campus, Cayuga Lake, downtown Ithaca, and the surrounding New York countryside. It was here that founder Ezra Cornell stood and declared his intention to build a great university and that architect I.M. Pei designed a

spectacular concrete home of varying juxtaposed rectangular shapes for the museum.

The museum, founded in 1953 in Andrew Dixon White's house (which had been the residence of Cornell's presidents since 1872) moved into its present structure—a gift of alumnus Herbert F. Johnson of Johnson's Wax—in 1973. The 61,000-square-foot building has wide corridor galleries with large windows that display sculpture and decorative arts impervious to sunlight, while paintings and prints are exhibited in controlled-light galleries that fold inward.

The museum's collections are rich in Asian art and prints, but also extensive in nineteenth- and twentieth-century American paintings, European paintings and graphic arts. Other holdings include sculpture, drawings, photographs, and pre-Columbian, African, Oceanic, and Americas art.

The Asian art collections range from a wide variety of ceramics from China, Japan, Korea, and Southeast Asia to examples of paintings, sculpture, bronzes, prints, and scrolls. The superb print collection includes works by Dürer, Mantegna, Whistler, Goya, Hogarth, and Toulouse-Lautrec.

Among the artists represented in the American painting collection are Marin, Davis, Dove, O'Keeffe, Sheeler, Rattner, and Lawrence, while the European collection includes seventeenth-century Dutch works, French paintings before impressionism, twentieth-century art, and other works.

Many of the pieces in the collections are on permanent display in the galleries, supplemented by 20 changing exhibitions featuring a full range of world art.

Herbert F. Johnson Museum of Art, Cornell University, Ithaca, NY 14852. Phone: 607/255-6464. Hours: 10–5 Tues.–Sun. (also to 8 Wed.); closed major holidays and Christmas recess. Admission: free.

## CRANBROOK ACADEMY OF ART
### Cranbrook Academy of Art Museum

The Cranbrook Academy of Art Museum in Bloomfield Hills, Michigan, was founded in 1930 as an extension of the academy, which began in the 1920s. It originally consisted of the private collection of George and Ellen Booth, who started the Cranbrook Educational Community, which includes the Cranbrook Schools, Cranbrook Institute of Science, and Cranbrook Academy of Art and Museum in a setting of formal and informal gardens with sculptures, fountains, and tree-lined walks. Mr. Booth was the long-time publisher of the *Detroit News,* and Mrs. Booth was a member of the Scripps newspaper family.

Over the years, the museum's holdings—known as the Cranbrook Collection—have been expanded to include the works of the academy's faculty and students. It now features sculpture, paintings, furniture, ceramics, textiles, and metalwork by such artists and designers as Harry Bertoia, Ray and Charles Eames, Marshall Fredericks, Maija Grotell, Donald Lipski, Eero Saarinen, and John Torreano, who have been attracted to the innovative community.

The 1941 museum building was designed by the noted Finnish architect Eliel

Saarinen, first president of the academy, whose architecture, drawings, furniture, and decorative arts are featured at the museum. Swedish-born sculptor Carl Milles, who came to Cranbrook as a faculty member in 1931, left approximately 70 works. Eight of the sculptures form the beautiful *Orpheus Fountain* at one corner of the museum.

Some of the Booths' collection still remains in the 1908 former residence at the cultural complex. The 1930 home and studio of Eliel and Loja Saarinen also can be seen on the grounds.

Cranbrook Academy of Art Museum, 1221 Woodward Ave., Box 801, Bloomfield Hills, MI 48303-0801. Phone: 313/645-3323. Hours: 1–5 Wed.–Sun.; closed major holidays. Admission: adults, $3; seniors and students, $2; children under 7, free.

## CROWDER COLLEGE
### Longwell Museum

The Longwell Museum in the Elsie Plaster Community Center at Crowder College in Neosho, Missouri, is an art museum with collections and exhibits featuring regional artists. Founded in 1970, the museum collections include oil paintings by Ozark artist Daisy Cook and original prints by Grant Wood, Birger Sandzen, John Steuart Curry, Peter Hurd, and Thomas Hart Benton. The museum also has Japanese woodblock prints, Chinese paper cuts, and items from the Camp Crowder Collection, containing historical items from the World War II signal training center located on the college site.

Longwell Museum, Crowder College, Elsie Plaster Community Center, Neosho, MO 64850. Phone: 417/451-3223. Hours: 10–4 Mon.–Fri.; 1–4 Sun.; closed holidays. Admission: free.

## DARTMOUTH COLLEGE
### Hood Museum of Art

Dartmouth College in Hanover, New Hampshire, began collecting in 1772, but it was not until 1974 that the separate collections were consolidated and displayed on a rotating basis in the Hopkins Center for the Creative and Performing Arts, Carpenter Hall, Wilson Hall, and other campus buildings. In 1985, a 41,535-square-foot facility was completed to house the new Hood Museum of Art and its collections, galleries, and offices.

The museum now has a large and diverse collection of approximately 60,000 objects that is strong in Old Master prints, American art, and African, Oceanian, and Native American art. A broad-based exhibitions program ranges from ancient Greek art to contemporary art.

The museum's holdings include an impressive collection of nineteenth- and twentieth-century American and European paintings, drawings, prints, and sculpture. Among the artists represented are Picasso, Goya, Sloan, Remington, Zurbaran, Gris, Rattner, Eakins, Rothko, and Zox.

Among the other works are Assyrian reliefs, early Christian mosaics, classical icons, Chinese art, pre-Columbian stone sculpture and ceramics, Melanesian art, decorative arts, costumes, photographs, coins, and even scientific instruments. A number of outdoor sculptures on the campus also are part of the holdings.
Hood Museum of Art, Dartmouth College, Wheelock St., Hanover, NH 03755-3591. Phone: 603/646-2808. Hours: 10–5 Tues.–Sat. (also to 9 Wed.); 12–5 Sun.; closed major holidays. Admission: free.

## DE ANZA COLLEGE
### Euphrat Museum of Art

The Euphrat Museum of Art at De Anza College in Cupertino, California, has collections and exhibits of contemporary paintings, prints, and photographs, as well as works by Agnes Pelton and Tom Holland. Founded in 1971, the museum has 1,470 square feet of exhibit space.
Euphrat Museum of Art, De Anza College, Cupertino, CA 95014. Phone: 408/864-8836. Hours: 11–4 Tues.–Thurs. (also 6–8 Wed.); 11–2 Sat.; closed summer. Admission: free.

## DREXEL UNIVERSITY
### Drexel University Museum

When Anthony Drexel founded Drexel University in Philadelphia in 1890, he included a museum collection in his plans as a means to support the academic offerings of an institute of art, science, and industry. This eventually led to the founding of a museum of art, but it did not result in similar collections or a museum in science and industry.

Drexel and his brother-in-law, John D. Lankenau, provided the original art collection, which constituted a survey of European and American art trends in the nineteenth century. Today the Drexel University Museum, located in the Main Building, still focuses on nineteenth-century European and American art, with paintings, sculpture, costumes, and a wide range of decorative arts of the era in its collections and exhibits.
Drexel University Museum, Main Bldg., 32nd and Chestnut Sts., Philadelphia, PA 19104. Phone: 215/895-1637. Hours: 2–5 Wed.; closed holidays. Admission: free.

## DUKE UNIVERSITY
### Duke University Museum of Art

In 1966, Duke University in Durham, North Carolina, purchased a collection of 275 pieces of Romanesque and Gothic sculpture. Three years later, the 27,000-square-foot science building on East Campus was converted to house the art, resulting in the founding of the Duke University Museum of Art.

The museum's collections now include medieval sculpture and decorative art; pre-Columbian Andean and Mesoamerican pottery and textiles; African sculp-

ture; Greek and Roman antiquities; Chinese jade and porcelain; American and European paintings, drawings, and sculpture; and contemporary art. The museum also presents changing exhibitions from its holdings and exhibitions on loan from other institutions.

Duke University Museum of Art, Buchanan Blvd. at Trinity, Box 90732, Durham, NC 27708-0732. Phone: 919/684-5135. Hours: 9–5 Tues.–Fri.; 11–2 Sat.; 2–5 Sun.; closed holidays. Admission: free.

## EASTERN ILLINOIS UNIVERSITY
### Tarble Arts Center

The Tarble Arts Center replaced a small 1950 gallery at Eastern Illinois University in Charleston in 1982. It serves as the campus art museum and a regional arts resource in a predominately rural area in eastern Illinois. The emphasis is on indigenous contemporary folk arts, watercolors, prints, and sculpture. In addition, it has a collection of American scene prints and Paul T. Sargent oils, as well as changing exhibitions.

Tarble Arts Center, Eastern Illinois University, S. Ninth St. at Cleveland Ave., Charleston, IL 61920-3099. Phone: 217/581-2787. Hours: 10–5 Tues.–Fri.; 10–4 Sat.; 1–4 Sun.; closed major holidays. Admission: free.

## EMORY UNIVERSITY
### Michael C. Carlos Museum

The Michael C. Carlos Museum at Emory University in Atlanta was founded in 1919 to preserve and display collections of ethnographic, biological, geological, archaeological, and historical materials. Today it is a major campus museum of antiquities and fine arts with over 15,000 objects, including art from Egypt, Greece, Rome, the Near East, the Americas, Asia, Africa, and Oceania and artworks on paper ranging from the Middle Ages to the twentieth century. It also offers temporary exhibitions from its own holdings and from other institutions, both nationally and internationally.

The museum, which occupies a 45,000-square-foot building on the university's historic main quadrangle, originally was called the Emory University Museum and then changed to the Emory University Museum of Art and Archaeology in 1985 before being renamed the Michael C. Carlos Museum for a major benefactor in 1991.

The antiquities collection has approximately 6,000 objects, consisting largely of Egyptian, Near Eastern, classical, and ancient American art. The museum also owns over 158,000 pottery samples from the ancient Moab region of Jordan. The ethnographic collection totals over 3,000 objects, including Asian, African, and Oceanic art. The works on paper collection, which numbers more than 3,000 objects, includes drawings, photographics, paintings, lithographs, and etchings from Europe, America, and Asia, ranging from the Middle Ages to the present.

The museum is involved in an innovative multimedia project, funded by the Lila Wallace–Reader's Digest Fund, to expand the educational experience of museum visitors. Interactive programs will be available to visitors at seven kiosks linked to a hypermedia authoring station. Images and information about objects in the permanent collections will become available through sound, video, graphics, photography, hypertext, and computer animation. The system also will make it possible to create "virtual exhibitions," using images downloaded from the museum's database and placed in a three-dimensional "exhibit" created with CAD software. In addition, the project will link all museum departments through Ethernet.

Michael C. Carlos Museum, Emory University, 571 S. Kilgo St., Atlanta, GA 30322. Phone: 404/727-4282. Hours: 10–5 Mon.–Sat. (also to 9 Fri.); 12–5 Sun.; closed major holidays. Admission: suggested donation—$3.

## FISK UNIVERSITY
### University Galleries

The University Galleries at Fisk University in Nashville, Tennessee, consist of two major galleries—the Carl Van Vechten Gallery and the Aaron Douglas Gallery—both housed in the 1888 Van Vechten building, located on the site of a former Civil War fort.

The museum's collections feature African-American paintings, sculpture, graphics, and traditional and contemporary African works and include the James Collection of African-American folk art, Liff Collection of African art, Cyrus Baldridge Collection of drawings, Alfred Stieglitz Collection of early European and American modern art, and Carl Van Vechten Collection of photographs.

University Galleries, Fisk University, 1000 17th Ave., N., Nashville, TN 37208-3051. Phone: 615/329-8720. Hours: 10–5 Tues.–Fri.; 1–5 Sat.–Sun.; closed holidays. Admission: free.

## FLORIDA INTERNATIONAL UNIVERSITY
### Art Museum at Florida International University

The Art Museum at Florida International University in Miami has diverse collections and exhibits, including the ArtPark outdoor sculpture park. It also has an extensive program of temporary and traveling exhibitions. Collections of the museum, founded in 1977, include paintings, drawings, prints, and sculpture from North and South America and Europe; artifacts from Africa, the Orient, and the pre-Columbian period; and works by contemporary Cuban-American artists.

Art Museum at Florida International University, University Park, PC 110, Miami, FL 33199. Phone: 305/348-2890. Hours: 10–9 Mon.; 10–5 Tues.–Fri.; 12–4 Sat.; closed major holidays. Admission: free.

## FLORIDA STATE UNIVERSITY
### Florida State University Museum of Fine Arts

The Florida State University Museum of Fine Arts in Tallahassee began as a gallery with a small collection of paintings and prints in 1950. Today its collections and exhibits have expanded to include Peruvian art, European art, Asian art, contemporary art, glass, graphics, photography, basketry, and Remington bronzes. The museum, located in the Fine Arts Building, also presents a variety of temporary exhibitions.

Florida State University Museum of Fine Arts, 250 Fine Arts Bldg., Copeland and Tennessee Sts., Tallahassee, FL 32306-2055. Phone: 904/644-6836. Hours: academic year—10–4 Mon.–Fri.; 1–4 Sat.–Sun.; summer—10–4 Mon.–Fri.; closed major holidays. Admission: free.

## FLORIDA STATE UNIVERSITY AND CENTRAL FLORIDA COMMUNITY COLLEGE
### Appleton Museum of Art

The Appleton Museum of Art in Ocala, Florida, was a gift of Arthur I. and Edith-Marie Appleton to Florida State University and Central Florida Community College in 1987. The 45,000-square-foot facility, jointly owned by the foundations of the two institutions, is located on a 44-acre wooded site, donated by the City of Ocala, along a major thoroughfare, rather than on either campus.

The museum has a diversified collection of over 6,000 pieces covering 5,000 years of cultural history. Its most important holdings are pre-Columbian artifacts, nineteenth-century paintings, and bronze sculptures. Other works include American, European, Oriental, African, and Islamic art and antiquities.

The collection includes works by Barbizon and academic painters Rousseau, Diaz, Jacque, Monticelli, Bougoereau, and Cot; a number of significant bronzes, including an early cast of *The Thinker* by Rodin; five nineteenth-century sculptures; and Indian stone reliefs dating to the tenth and twelfth centuries.

Appleton Museum of Art, Florida State University/Central Florida Community College, 4333 E. Silver Springs Blvd., Ocala, FL 34470-5000. Phone: 904/236-5050. Hours: 10–4 Tues.–Sat.; 1–5 Sun.; closed major holidays. Admission: adults, $3; students, $2; FSU/CFCC students, $1.

## FRAMINGHAM STATE COLLEGE
### Danforth Museum of Art

The Danforth Museum of Art at Framingham State College in Framingham, Massachusetts, is a community museum founded in 1975 as a joint project of the college, the Town of Framingham, and the private Danforth Museum Corporation. Housed in Framingham's old downtown high school, the museum has

approximately 1,700 paintings, lithographs, etchings, drawings, photographs, and other works, with the emphasis on late-nineteenth- and twentieth-century American art from New England.

Danforth Museum of Art, Framingham State College, 123 Union Ave., Framingham, MA 01701. Phone: 617/620-0050. Hours: 12–5 Wed.–Sun.; closed major holidays. Admission: adults, $3; seniors, $2; children, free.

## GEORGETOWN UNIVERSITY
### Georgetown University Collection

The Georgetown University Collection, which began in 1789, consists of artworks, decorative arts, and historical objects, including works by Van Dyck and Stuart and collections of paintings, sculpture, portraits, graphics, and religious objects. The collection, which is used primarily for research, is housed in the 1879 Healy Hall on the Georgetown campus in Washington, D.C. Special exhibitions are presented in the Carroll Parlour.

Georgetown University Collection, 36th St., NW, Box 2269, Hoya Station, Washington, DC 20057. Phone: 202/687-4406. Hours: by appointment; closed holidays and when university not in session. Admission: free.

## GONZAGA UNIVERSITY
### Ad Gallery

(See Art Galleries section.)

## HAMPTON UNIVERSITY
### Hampton University Museum

(See General Museums section.)

## HARVARD UNIVERSITY
### Harvard University Art Museums

The Harvard University Art Museums in Cambridge, Massachusetts, consist of three museums—the Fogg Art Museum, Busch-Reisinger Museum, and Arthur M. Sackler Museum—each with its own distinct history and collections. The Fogg is the oldest and largest of the museums, which adopted the name "Harvard University Art Museums" to reflect their unified administration in the early 1980s. Together the three museums have more than 130,000 works in their collections, occupy approximately 200,000 square feet of space, and have an annual attendance of over 240,000. They are organized under a single director and are located in a complex of buildings at Quincy Street and Broadway.

The Center for Conservation and Technical Studies, established in 1928 to provide professional care in the conservation of artistic and historical works and

to train conservation professionals, also is associated with the museums. The center is located on the fourth floor of the Fogg Art Museum and has three specialized conservation laboratories and four unique reference collections (pigments and other materials of the artist, aged pigments and media, extensive documentation of British artists' materials, and over 4,000 X-radiographs of works of art in Europe and America).

## Fogg Art Museum

The history of art museums at Harvard University began in 1891 when the university received a bequest of $220,000 from Mrs. William Hayes Fogg. This led to the founding of the original Fogg Art Museum, which opened in 1895 and housed mostly reproductions. The content and mission of the museum changed under the leadership of Edward Forbes (director, 1909–1944) and Paul Sacks (assistant director/associate director/professor of fine arts, 1915–1944), who saw the museum as a "laboratory for the fine arts" with "original art works of the highest quality" for teaching the young about art.

The focus of the new thrust was to train professionals in the rapidly expanding new field of art museum administration, to provide resources for the teaching of college and university instructors in art history, and to expose undergraduate students to the importance of art in all human cultures. The application of science to the study of art and art conservation also began under Forbes, who established what became the Center for Conservation and Technical Studies.

The Fogg Art Museum came to specialize in the art of Europe and North America in all media from the Middle Ages to the present. Among its collections are nearly 2,000 Western paintings, approximately 50,000 prints, 10,000 European and American drawings, over 1,000 works of sculpture, 7,000 photographs, and nearly 4,000 works of decorative arts.

The paintings collection is considered among the finest at campus art museums, with particular strengths in the early Italian Renaissance, nineteenth-century French and British works, and American paintings. It contains important works by Degas, Picasso, Renoir, Ingres, Monet, Cézanne, Whistler, Giotto, Rembrandt, Rothko, Van Gogh, Poussin, Fra Angelico, Duccio, Kandinsky, Pollock, Stella, Louis, Moreau, Rossetti, and Copley.

The print collection is said to be the largest and best at any American university. It is especially strong in Old Master etchings, engravings, and woodcuts, with extensive representation of early Italian engravers, Schongauer, Dürer, Rembrandt, Ostade, Castiglione, Ribera, Testa, Canaletto, and Goya. The collection also includes reproductive engravings of the sixteenth through nineteenth centuries and nineteenth- and twentieth-century works by such artists as Blake, Turner, Constable, Daumier, Manet, Degas, Toulouse-Lautrec, Picasso, Munch, Kirchner, Nolde, Heckel, and Schmidt-Rottloff.

The museum also has one of the most comprehensive collections of drawings from the fourteenth century to the present. Major strengths include French works of the seventeenth and early nineteenth centuries, sixteenth-century Italian and

eighteenth-century Venetian drawings, German drawings of the eighteenth and nineteenth centuries, and nineteenth-century American and English works. Among the holdings are extensive collections of works by Ingres, Gericault, David, Blake, Beardsley, Homer, Sargent, Whistler, Fragonard, Courbet, Degas, Picasso, Tiepolo, and Rubens.

The sculpture collection contains significant French and Spanish Romanesque stone pieces, Italian Renaissance plaquettes, seventeenth-century Roman terra-cotta studies, nineteenth-century French sculpture, and varied twentieth-century holdings. Among the notable works are sculptures by Bernini, Rodin, Barye, and David Smith.

Three hundred artists are represented in the museum's twentieth-century photography collection and 44 in the nineteenth-century collection. Approximately half of the photographs are in the Ben Shahn Collection.

In the decorative arts, the museum is strongest in seventeenth- and eighteenth-century American and French silver, eighteenth-century Wedgewood pottery, seventeenth- and eighteenth-century clocks, Renaissance Limoges enamels, tapestries, and European and American furniture.

The Fogg Art Museum began in Hunt Hall and has been housed since 1927 in a Georgian brick structure with a large interior Renaissance-style courtyard.

### Busch-Reisinger Museum

The Busch-Reisinger Museum—located in Werner Otto Hall attached to the Fogg Art Museum—was founded at Harvard University in 1901. Specializing in the art of German-speaking Europe, it originally was called the Germanic Museum and operated as a branch of the Germanic Languages Department. It became affiliated with Fogg in 1930 and moved into its present building in 1991. Plans call for the museum's former home, Adolphus Busch Hall, to be renovated to house Harvard's collections of medieval art.

The museum is the only institution in the Americas devoted exclusively to the arts of Central and Northern Europe. The collection of nearly 5,000 items ranges from the Romanesque period to the present, with special emphasis on art after 1880. It contains North America's leading collection of German expressionist drawings, sculpture, prints, and paintings, including major works by Beckmann, Klee, Nolde, and Kandinsky.

The museum also is strong in late Middle Ages work, eighteenth-century porcelains, and work from the late nineteenth century, Austrian Secession, Bauhaus, and 1945 to the present. The museum holds the largest collection of Bauhaus materials outside Germany, as well as the archives of Walter Gropius and Lyonel Feininger.

### Arthur M. Sackler Museum

The Arthur M. Sackler Museum is the newest of Harvard University's art museums. Opened in 1985 in a modern limestone and porcelain building near the Fogg Art Museum, it houses the university's collections of ancient, Asian, and Islamic art. The museum has one of the world's most important collections

of ancient Chinese jades, rare groups of Persian and Indian miniatures, Japanese prints and ceramics, Roman portrait sculpture, and Greek vases.

The museum has nearly 19,000 items in its highly regarded Asian collection. The greatest strength is in Chinese art, especially early Chinese art. In addition to its superb collection of Chinese jade, it has ritual bronze vessels, ceremonial weapons, mirrors, chariot fittings, stone and gilt bronze sculptures, clay bodhi-sattva, wall-painting fragments from Tun-Haung, Liang-chu culture pottery, Sung- and Yuan-period Chum and Temmoku wares, late Ming enameled porcelains, rhinoceros horn carvings, and paintings that include 30 masterworks.

The museum also possesses Asian collections of Korean ceramics and archaeological materials; Japanese surimono and other prints, woodblock-printed books, calligraphy, and paintings; Thai and other Southeast Asian illustrated books; and Indian and other Southeast Asian sculptures.

The ancient art collection of approximately 24,000 objects consists of Greek, Roman, Etruscan, Egyptian, and Near Eastern art and includes vases, stone sculptures, metalwork, terracottas, glass, glyptics, wood, ivory, bone, and coins. It is noted for its Greek red and black figure vases of the Classical period, Greek and Roman bronzes, stone sculptures, and more than 14,000 ancient coins.

The museum's collection of Islamic and later Indian art has approximately 2,100 items, mostly of works on paper in three major groupings—Safavid (primarily seventeenth-century Iran), Ottoman (seventeenth-century and later Turkey and empire), and Indian (contemporary Mughal empire). They include such outstanding works as miniatures from the fourteenth-century Tabriz *Book of Kings* (Shahnama), Persian paintings and drawings from the Safavid and Uzbek periods, and calligraphies, illuminations, marbling, and Deccani paintings.

Harvard University Art Museums, 32 Quincy St. (485 Broadway for Sackler Museum), Cambridge, MA 02138. Phone: 617/495-9400. Hours: 10–5 daily; closed major holidays. Admission: adults, $5; seniors, $4; non-Harvard students, $3; Harvard students, high school students under 18, and children, free.

## HEBREW UNION COLLEGE
### Skirball Museum

(See Archaeology, Anthropology, and Ethnology Museums section.)

## HEBREW UNION COLLEGE–JEWISH INSTITUTE OF RELIGION
### Skirball Museum, Cincinnati Branch

(See Archaeology, Anthropology, and Ethnology Museums section.)

## HOFSTRA UNIVERSITY
### Hofstra Museum

The Hofstra Museum at Hofstra University in Hempstead, New York, is a decentralized facility with five principal indoor exhibition areas and outdoor

sculpture throughout the 238-acre campus. The museum began in 1963 as the Emily Lowe Gallery and became formalized as the Hofstra Museum in the 1980s. The Lowe Gallery remains as the focus of the museum's program, housing the museum's offices and many of the exhibitions. Principal exhibition areas are the Filderman and Lowenfeld galleries.

The museum is best known for its 42 permanent and 6 loan sculptures scattered around the campus and its collections of modern, ethnographic, and contemporary works. Among the collections are European and American paintings, prints from seventeenth-century Japan and twentieth-century America, photographs from twentieth-century Europe and America, and sculpture from Africa, India, Japan, Oceania, Puerto Rico, South America, and the United States. Highlights include such works as *Retreat from the Storm* by Jean-François Millet, *Portrait of a Woman* by Paul Gauguin, and *Otarie Rouse et Juane* by Alexander Calder.

Hofstra Museum, Hofstra University, 112 Hofstra, Hempstead, NY 11500-1090. Phone: 516/463-5672. Hours: academic year—10–5 Tues.–Fri. (also to 8 Tues.); 1–5 Sat.–Sun.; summer—10–4 Tues.–Fri.; closed major holidays. Admission: free.

## HOUSATONIC COMMUNITY-TECHNICAL COLLEGE
### Housatonic Museum of Art

The Housatonic Museum of Art began as a college art collection at the Housatonic Community-Technical College in Bridgeport, Connecticut, in 1967. It became a museum in 1991, with the opening of a museum gallery. The museum's collections of approximately 3,000 works consist primarily of contemporary prints and sculpture; works by Connecticut and Latin American artists; ethnographic artifacts from Africa, Asia, and the South Seas; and nineteenth- and twentieth-century European and American art. Selections from the collections are displayed largely in administrative and faculty offices, hallways, and stairwells.

Housatonic Museum of Art, Housatonic Community-Technical College, 510 Barnum Ave., Bridgeport, CT 06608. Phone: 203/579-6550. Hours: academic year—10–3 Mon.–Fri. (also to 8 Wed.); summer—10–2 Tues., Wed., and Fri.; closed major holidays and college vacations. Admission: free.

## INDIANA UNIVERSITY
### Indiana University Art Museum

The Indiana University Art Museum in Bloomington began as a gallery in 1941 and evolved into a major university museum with more than 25,000 paintings, prints, drawings, photographs, textiles, and jewelry representing nearly every art-producing culture throughout history. It now occupies an eye-catching 105,000-square-foot triangular building designed by I.M. Pei that was completed in 1982.

The museum is known for its collections of the arts of Africa, Oceania, and the Americas; ancient gold jewelry; works on paper; and textiles. Among its other collections are ancient Egyptian, Greek, and Roman sculptures and four-teenth- through twentieth-century European and American paintings, sculpture, prints, drawings, decorative arts, and photographs.

Included in the collections are such works as rare medieval and Renaissance altarpieces, seventeenth-century religious paintings, eighteenth-century romantic works, nineteenth-century landscape art, and twentieth-century paintings and sculptures by such artists as Pablo Picasso, Stuart Davis, Jackson Pollock, Frank Stella, Marcel Duchamp, Louis Nevelson, and Claes Oldenburg.

Three permanent collection galleries display the art of the Western world through Byzantine to modern times, Asian and ancient art, and the art of Africa, the Pacific, and the pre-Columbian period. In addition, one major exhibition and numerous smaller shows are presented each year in two temporary exhibition halls.

Indiana University Art Museum, Bloomington, IN 47405. Phone: 812/855-5445. Hours: 10–5 Wed.–Sat. (also to 8 Fri.); 12–5 Sun.; closed major holidays. Admission: free.

## INDIANA UNIVERSITY OF PENNSYLVANIA
### *University Museum*

(See General Museums section.)

## INSTITUTE OF AMERICAN INDIAN ARTS
### *Institute of American Indian Arts Museum*

The Institute of American Indian Arts Museum in Santa Fe, New Mexico, is a museum of contemporary American Indian and Alaskan native arts. Founded in 1962, the museum has collections and exhibits of Native American artifacts and contemporary Indian arts and crafts. It also has an archive of 800 Native American videotapes.

Institute of American Indian Arts Museum, 108 Cathedral Pl., Santa Fe, NM 87501. Phone: 505/988-6281. Hours: 10–5 Mon.–Sat.; 12–5 Sun.; closed major holidays. Admission: adults, $4; students and seniors, $2.

## IOWA STATE UNIVERSITY
### *Brunnier Art Museum*

The Brunnier Art Museum is one of three parts of the University Museums program at Iowa State University in Ames. It is its decorative and fine arts museum, established in 1975, which has collections of glass, dolls, ceramics, and jade; paintings by leading Iowa artists; and Japanese prints from the nine-teenth and twentieth centuries.

The two other branches of the University Museums are the Farm House Mu-

seum, an 1860 structure on the central campus, which opened as a museum in 1975 (described separately in the Historical Museums, Houses, and Sites section), and the Art on Campus Program, which includes approximately 200 works of art in university buildings and on the grounds.

Brunnier Art Museum, Iowa State University, Scheman Bldg., Ames, IA 50011. Phone: 515/294-3342. Hours: 11–4 Tues.–Sun.; other times by request; closed major holidays. Admission: free.

## JACKSONVILLE UNIVERSITY
### Alexander Brest Museum and Gallery

Decorative arts are the focus of the Alexander Brest Museum and Gallery at Jacksonville University in Jacksonville, Florida. The museum is best known for its antique ivory collection, but also has collections of pre-Columbian artifacts, Steuben glass, Tiffany glass, and Asian, European, and American porcelains. The museum was founded in 1967 and is housed in the Phillips Fine Arts Building.

Alexander Brest Museum and Gallery, Jacksonville University, Phillips Fine Arts Bldg., 2800 University Blvd., N., Jacksonville, FL 32211. Phone: 904/745-7371. Hours: 9–4:30 Mon.–Fri.; 12–5 Sat.; closed holidays. Admission: free.

## JEWISH THEOLOGICAL SEMINARY OF AMERICA
### Jewish Museum

(See Archaeology, Anthropology, and Ethnology Museums section.)

## JOHNS HOPKINS UNIVERSITY
### Evergreen House

(See Historical Museums, Houses, and Sites section.)

## KALAMAZOO INSTITUTE OF ARTS
### Kalamazoo Institute of Arts

The Kalamazoo Institute of Arts functions as an art museum and school in Kalamazoo, Michigan. Founded in 1924, it has five galleries and presents approximately 25 exhibitions a year. The collections include nineteenth- and twentieth-century American art, twentieth-century European art, fifteenth- to twentieth-century graphics, ceramics, sculpture, photography, and works on paper.

Kalamazoo Institute of Arts, 314 S. Park St., Kalamazoo, MI 49007-5102. Phone: 616/ 349-7775. Hours: 10–5 Tues.–Sat.; 1–5 Sun.; closed major holidays. Admission: free.

## KANSAS CITY ART INSTITUTE
### *Kemper Museum of Contemporary Art and Design*

The Kemper Museum of Contemporary Art and Design—part of the Kansas City Art Institute in Kansas City, Missouri—opened in a new 23,200-square-foot building in 1994 as the result of a $6.6 million gift from R. Crosby and Bebe Kemper. The museum, founded in 1990, features the works of contemporary artists and designers.

The museum's permanent collection, which numbers more than 700 works, encompasses a broad range of media, including paintings, sculpture, drawings, prints, photographs, textiles, ceramics, videos, designs, and illustrations. The core of the collection is the Bebe and Crosby Kemper Collection, which includes works by such artists as Georgia O'Keeffe, Jasper Jones, Helen Frankenthaler, Robert Rauschenberg, David Hockney, Frank Stella, Robert Motherwell, Nancy Graves, Wayne Thiebaud, Grace Hartigan, William Wedman, and Red Grooms.

A growing design collection contains modern furnishings by Harry Bertoia, Charles and Ray Eames, Russell Wright, George Nelson, and Herman Miller. Thirty etchings and lithographs by Childe Hassam also are part of the permanent collection. In addition, the museum has an extensive program of temporary exhibitions in the contemporary art and design fields.

Kemper Museum of Contemporary Art and Design, Kansas City Art Institute, 4420 Warwick Blvd., Kansas City, MO 64111-1874. Phone: 816/561-4852. Hours: 10–4 Tues.–Fri. (also to 9 Fri.); 10–5 Sat.; 10–5 Sun. Admission: free.

## KANSAS STATE UNIVERSITY
### *Marianna Kistler Beach Museum of Art*

Kansas State University in Manhattan has a new art museum—the Marianna Kistler Beach Museum of Art, which opened in 1994. It houses the university's art collection, started in 1928, and features rotating exhibitions of selections from the collections and elsewhere and traveling shows.

The collection of approximately 1,500 works is comprised largely of graphic art and paintings, but also includes photography, sculpture, ceramics, and other works. The primary focus is on twentieth-century regional American art, featuring the works of such artists as Thomas Hart Benton, John Steuart Curry, Birger Sandzen, and Grant Wood.

Among the other holdings are works by such Kansas artists as John Noble, Henry Varnum Poor, and William Dickerson; 125 photographs by photojournalist Gordon Parks; and a collection of 61 contemporary prints by East Indian artists.

The 28,000-square-foot museum is located in a new building constructed near the entrance to the university. It was made possible through private donations,

including a major leading gift from Ross and Marianna Beach. Two of the museum's four galleries are specifically designated for temporary exhibitions.
Marianna Kistler Beach Museum of Art, Kansas State University, Manhattan, KS 66502-2912. Phone: 913/532-7718. Hours: 10–4:30 Tues.–Fri.; 1–4 Sat.–Sun.; closed holidays. Admission: free.

## KENDALL COLLEGE
### Mitchell Indian Museum

(See Archaeology, Anthropology, and Ethnology Museums section.)

## KENT STATE UNIVERSITY
### Kent State University Museum

The Kent State University Museum in Kent, Ohio, is a costume and decorative arts museum housed in a 1927 building that formerly was the university's first library. The museum, founded in 1981, has nine galleries and collections of Western dress from 1750 to the present, nineteenth- to twentieth-century American glass, Asian and African regional dress, eighteenth- to twentieth-century ceramics, and seventeenth to twentieth-century furniture.
Kent State University Museum, Rockwell Hall, PO Box 5190, Kent, OH 44242-0001. Phone: 216/672-3450. Hours: 10–5 Wed.–Sat. (also to 9 Thurs.); 12–5 Sun.; closed holidays. Admission: suggested donation—$2.

## LaGRANGE COLLEGE
### Lamar Dodd Art Center

(See Art Galleries section.)

## LA SALLE UNIVERSITY
### La Salle University Art Museum

European and American paintings, drawings, and Old Master prints from the fifteenth century to the present are featured at the La Salle University Art Museum in Philadelphia. The artworks are displayed in seven period galleries. The museum, opened in 1976, evolved from a study collection. In addition to showing selections from the permanent collections, it presents four to five temporary exhibitions each year. The museum is located in the renovated lower level of Olney Hall, the main humanities classroom building.
La Salle University Art Museum, Olney Hall, 1900 Olney Ave., Box 845, Philadelphia, PA 19141-1199. Phone: 215/951-1221. Hours: 11–4 Tues.–Fri.; 2–4 Sun.; closed holidays, vacation periods, and Aug. Admission: free.

## LONG ISLAND UNIVERSITY, C.W. POST CAMPUS
### *Hillwood Art Museum*

The Hillwood Art Museum on the C.W. Post Campus of Long Island University in Brookville, New York, has a collection of lithographs, paintings, photographs, and sculpture and normally presents eight temporary exhibitions each year. Opened in 1974, the museum is located on the second floor of the student union building.

Hillwood Art Museum, Long Island University, C.W. Post Campus, Hillwood Commons, Brookville, NY 11548. Phone: 516/299-2788. Hours: 10–5 Mon.–Fri.; 1–5 Sat.–Sun.; closed major holidays. Admission: free.

## LONGWOOD COLLEGE
### *Longwood Center for the Visual Arts*

The Longwood Center for the Visual Arts at Longwood College in Farmville, Virginia, is located at an interim site while awaiting construction of a new facility planned for 1997. The museum/gallery, established in 1978, has collections of the works of Thomas Sully and his contemporaries and contemporary Virginia artists, as well as portraits of Longwood administrators and faculty and study collections.

Longwood Center for the Visual Arts, Longwood College, 129 N. Main St., Farmville, VA 23901. Phone: 804/395-2206. Hours: 9–12 and 1–5 Mon.–Fri.; 2–5 Sun.; closed major holidays. Admission: free.

## LOUISIANA STATE UNIVERSITY
### *LSU Museum of Art*

The LSU Museum of Art at Louisiana State University in Baton Rouge was established in 1959 as the Anglo-American Art Museum by an anonymous donor interested in showing the influence of British culture on the United States through the arts. The museum opened in 1962. The name was changed in 1992.

The museum's collections, which are divided into English and American wings, include paintings, prints, drawings, and decorative arts, with a strong emphasis on portraiture. They are displayed primarily in period rooms—spanning the early seventeenth century to the present.

The Long Gallery contains eighteenth- and nineteenth-century British portraits by Thomas Gainsborough, Nathaniel Dance, John Hoppner, and Sir Henry Raeburn, as well as a portrait by Anglo-American artist Benjamin West and a bas-relief sculpture by Irish-American sculptor Augustus Saint-Gaudens.

Other galleries with period furnishings and artworks include the Jacobean Room, an early seventeenth-century sitting room from a townhouse in Ware, Hertfordshire; Hacton Drawing Room, a ca. 1745–1755 room from a middle-

sized country house built on commission from William Braund in Essix County; Colonial Room, which contains a paneled overmantel and dentil cornice from a 1750–1765 farmhouse in eastern Pennsylvania; Shepherd-Salisbury Plantation Drawing Room, representing the Federal or Early Republican period (ca. 1790–1830); and Greek Revival Room, which has elements from a double parlor of an 1840–1842 New Orleans house designed and built by William L. Atkinson for the family of John Leslie.

The museum's holdings also include the largest collection of the work of Adrien Persac, the Franco-American cartographer-artist who did meticulous gouaches of Louisiana plantations and public buildings in the pre–Civil War period, the largest public collection of nineteenth-century silver made in New Orleans, and nearly every print made since 1930 by prominent Louisiana artist Caroline Durieux.

LSU Museum of Art, Louisiana State University, Memorial Tower, Baton Rouge, LA 70803-3403. Phone: 504/388-4003. Hours: 9–4 Mon.–Fri.; 10–12 and 1–4 Sat.; 1–4 Sun.; closed holidays. Admission: free.

## LOYOLA UNIVERSITY CHICAGO
### Martin D'Arcy Gallery of Art

The Martin D'Arcy Gallery of Art at Loyola University Chicago is a museum of medieval, Renaissance, and Baroque art. Founded in 1969, it was named for the noted British theologian and scholar and modeled after the collection he amassed for the Jesuit college at Oxford University.

The collection features liturgical objects, jewelry, paintings, and sculpture from 1100 to 1750. It has over 300 major works, including paintings by Bellini, Tintoretto, and Bassano; German and Flemish sculpture; French and Italian furniture and jewelry; ecclesiastical texts from England and Flanders; liturgical vessels; and architectural elements from the period.

Martin D'Arcy Gallery of Art, Loyola University Chicago, 6525 N. Sheridan Rd., Chicago, IL 60626. Phone: 312/508-2679. Hours: 12–4 Mon.–Fri.; closed summer and holidays. Admission: free.

## MARQUETTE UNIVERSITY
### Patrick and Beatrice Haggerty Museum of Art

The Patrick and Beatrice Haggerty Museum of Art at Marquette University in Milwaukee, Wisconsin, opened in 1984 in a new 20,000-square-foot building. It succeeded a library gallery founded in 1955 to house the university's expanding collections.

The museum's offerings—many of which are religious in nature—include European and American paintings from the fifteenth to the twentieth centuries; works by major twentieth-century international artists; modern paintings, prints, drawings, and photography; decorative arts; and Asian and African art.

Among the collections are Flemish and Italian paintings of the Renaissance, French tapestries of the seventeenth to the nineteenth centuries, Dürer prints, and works by Reynolds, Matisse, and Dali. The museum presents from 10 to 12 exhibitions each year of works ranging from Old Masters to contemporary art.

Patrick and Beatrice Haggerty Museum of Art, Marquette University, 13th and Clybourn, Milwaukee, WI 53233. Phone: 414/288-7290. Hours: 10–4:30 Mon.–Sat. (also to 8 Thurs.); 12–5 Sun.; closed New Year's Day, Easter, and Christmas. Admission: free.

## MARY WASHINGTON COLLEGE
### Mary Washington College Art Galleries

(See Art Galleries section.)

## MARYWOOD COLLEGE
### Suraci Gallery (Marywood College Art Galleries)

(See Art Galleries section.)

## MIAMI UNIVERSITY
### Miami University Art Museum

The Miami University Art Museum in Oxford, Ohio, has a growing collection of over 16,000 artworks and houses five galleries of changing exhibitions in its nearly 24,000-square-foot building opened in 1978. Many of the works—collected since the university's founding—had been displayed in a temporary art center since 1969.

The museum has a broad and diverse collection, including ancient, pre-Columbian, African, Native American, Oceanic, Chinese, and nineteenth- and twentieth-century European and American art, as well as international folk art and textiles. It is especially strong in paintings by American artists, including works by Charles Willison Peale, Ralph Albert Blakelock, Charles Burchfield, Hans Hofmann, and Robert Indiana.

Among the other holdings are eighteenth- and nineteenth-century British paintings, including works by John Hoppner, George Morland, and Sir John Everett Millais; Middle Eastern, Greek, Roman, and Egyptian stone, ceramic, glass, and metal works; African wood sculpture, masks, textiles, and metal work; pre-Columbian ceramics, jewelry, stone sculpture, and textiles; prints by Dürer, Rembrandt, Goya, Whistler, Rouault, Gauguin, and others; eighteenth- and nineteenth-century American and European decorative arts; nineteenth-century bronzes and twentieth-century sculpture; and folk art from approximately 30 countries.

Exhibitions include selections from the permanent collections and special temporary shows organized by the museum and traveling exhibitions from other

institutions. The museum also uses the William Holmes McGuffey House and Museum, a branch site, to display its nineteenth-century decorative arts and furnishings (see Historical Museums, Houses, and Sites section).

Miami University Art Museum, Patterson Ave., Oxford, OH 45056. Phone: 513/529-2232. Hours: 11–5 Tues.–Sun.; closed holidays and when university not in session. Admission: free.

## MICHIGAN STATE UNIVERSITY
### Kresge Art Museum

The Kresge Art Museum at Michigan State University in East Lansing has a permanent collection of more than 4,000 works of art ranging from the prehistoric to contemporary periods and presents 12 changing exhibitions each year.

The 6,000-square-foot museum, founded in 1959 as a component of the Kresge Art Center, has a strong twentieth-century modern collection, as well as many works on paper and fifteenth- through twentieth-century European art. Other collections include Asian, African, and South American works.

Kresge Art Museum, Michigan State University, Kresge Art Center, Auditorium Rd., East Lansing, MI 48824-9834. Phone: 517/353-9834. Hours: academic year—9:30–4:30 Mon.–Wed. and Fri.; 12–8 Thurs.; 1–4 Sat.–Sun.; summer—11–4 Mon.–Fri.; 1–4 Sat.–Sun.; closed holidays. Admission: free.

## MIDDLEBURY COLLEGE
### Middlebury College Museum of Art

The Middlebury College Museum of Art was inaugurated in 1992 as part of the college's new Center for the Arts in Middlebury, Vermont. It is one of five components of the center, which also includes practice and performance spaces for music, dance, and theater, as well as a music library. The Christian A. Johnson Memorial Gallery, which formerly housed the collection, now is used to display traveling exhibitions.

The museum's collection of several thousand works ranges from the antique through contemporary art and includes nineteenth-century European and American sculpture, Cypriot pottery, and contemporary prints and photography. Twelve changing exhibitions are presented during the year.

Middlebury College Museum of Art, Center for the Arts, Rte. 30, Middlebury, VT 05753. Phone: 802/388-3711, Ext. 5007. Hours: 10–5 Tues.–Fri. (also to 8 Thurs. during academic year); 12–5 Sat.–Sun.; closed major holidays and Christmas recess. Admission: free.

## MILLIKIN UNIVERSITY
### Birks Museum

The Birks Museum specializes in the decorative arts at Millikin University in Decatur, Illinois. It was opened in 1981 in Gorin Hall, being established from

a personal collection and endowed by Florence and Jenna Birks. The museum has approximately 1,300 items in its collections, including Steuben glassware, Belleek and Beehm porcelain, Cameo glass, and a paperweight collection.
Birks Museum, Millikin University, Gorin Hall, 1184 W. Main St., Decatur, IL 62522. Phone: 217/424-6337. Hours: 1–3:30 Mon.–Thurs.; 2–4 Sun.; closed holidays and when university not in session. Admission: free.

## MILLS COLLEGE
### Mills College Art Gallery

(See Art Galleries section.)

## MOREHEAD STATE UNIVERSITY
### Folk Art Center

Contemporary folk art from eastern Kentucky is featured at the Folk Art Center at Morehead State University in Morehead, Kentucky. The folk art museum, which was founded in 1985, has a 4,000-square-foot facility, with 900 square feet being exhibit space.
Folk Art Center, Morehead State University, 119 W. University Blvd., Morehead, KY 40351. Phone: 606/783-2760. Hours: 8:30–4:30 Mon.–Fri.; closed major holidays and Christmas recess. Admission: free.

## MORGAN STATE UNIVERSITY
### James E. Lewis Museum of Art

The James E. Lewis Museum of Art at Morgan State University in Baltimore, Maryland, has collections and exhibits relating to African-American history from ancient Africa to the present. Founded in 1955, the museum has three galleries in the Carl Murphy Arts Center. Its collections include African and New Guinean sculpture, nineteenth- and twentieth-century American and European sculpture, and various paintings, graphics, and decorative arts.
James E. Lewis Museum of Art, Morgan State University, Carl Murphy Arts Center, Coldspring Lane and Hillen Rd., Baltimore, MD 21239. Phone: 410/444-3835. Hours: 9–5 Mon.–Fri.; weekends and holidays by appointment; closed Easter, Thanksgiving, and Christmas. Admission: free.

## MOUNT HOLYOKE COLLEGE
### Mount Holyoke College Art Museum

The collections of the Mount Holyoke College Art Museum in South Hadley, Massachusetts, began in 1976 with gifts of paintings by Albert Bierstadt and George Inness. The museum now has over 15,000 artworks in its collections and occupies the first floor of a three-story art building dedicated in 1971.

The museum's collections are broad based, with highlights being early Italian Renaissance panel paintings; Greek, Roman, and Egyptian classical objects; nineteenth-century American paintings; and Asian art. The museum also has a sculpture court and presents changing exhibitions.

The art museum also administers the college's historic museum, Skinner Museum (see Historical Museums, Houses, and Sites section).

Mount Holyoke College Art Museum, Art Bldg., South Hadley, MA 01075-1499. Phone: 413/538-2245. Hours: 11–5 Tues.–Fri.; 1–5 Sat.–Sun.; closed holidays and vacation periods. Admission: free.

## NIAGARA UNIVERSITY
### Castellani Art Museum

The Castellani Art Museum at Niagara University in Niagara University, New York, has a collection of over 4,000 artworks, featuring pre-Columbian pottery and paintings, sculpture, prints, and drawings by nineteenth- and twentieth-century artists. The museum was founded in 1973.

Castellani Art Museum, Niagara University, Niagara University, NY 14109. Phone: 716/256-8200. Hours: 11–5 Wed.–Sat.; 1–5 Sun.; closed major holidays. Admission: free.

## NORTH CAROLINA AGRICULTURAL AND TECHNICAL STATE UNIVERSITY
### Mattye Reed African Heritage Center

(See Archaeology, Anthropology, and Ethnology Museums section.)

## NORTH CAROLINA CENTRAL UNIVERSITY
### NCCU Art Museum

The works of emerging and established African-American artists and art by others dealing with the black experience are featured at the NCCU Art Museum at North Carolina Central University in Durham. The museum, which opened in 1972, also has collections of traditional African and Oceanian art and works by European, Native American, and other American artists.

Among the museum's most prized possessions are the works of Harlem Renaissance artists. The collections include paintings by Robert S. Duncanson, Henry O. Tanner, and William H. Johnson and sculptures by Selma H. Burke and Richard Hunt. Five temporary exhibitions, often featuring the work of black artists, also are presented each year.

NCCU Art Museum, North Carolina Central University, PO Box 19555, Durham, NC 27707. Phone: 919/560-6211. Hours: 9–5 Tues.–Fri.; 2–5 Sun.; closed holidays and when university not in session. Admission: free.

## NORTH CAROLINA STATE UNIVERSITY
*Visual Arts Center*

(See Art Galleries section.)

## NORTHERN ARIZONA UNIVERSITY
*Northern Arizona University Art Museum and Galleries*

The Northern Arizona University Art Museum and Galleries in Flagstaff has collections and exhibitions in two locations—Old Main and the Creative and Communication Arts Building. The original museum in Old Main features contemporary exhibitions and the Marguerite Hettel Weiss Collection of paintings, furniture, and other materials, while the recently opened Richard E. Beasley Museum and Gallery in the arts building contains examples of the artist's paintings, weavings, and ceramics, as well as student, faculty, and local artworks. The museum, founded in 1961, has collections of paintings, graphics, ceramics, and sculpture.
Northern Arizona University Art Museum and Galleries, Box 6021, Flagstaff, AZ 86011-6021. Phone: 802/523-3471. Hours: 8–5 Mon.–Fri.; 1–4 Sun.; closed holidays. Admission: Free.

## NORTHERN ILLINOIS UNIVERSITY
*NIU Art Museum*

The NIU Art Museum at Northern Illinois University in DeKalb operates a museum in the 1895 Algeld Hall on the campus and a gallery branch in Chicago (which is described separately in the Art Galleries section). The museum, founded in 1970, has modern and contemporary drawings, original prints, paintings, Burmese art, original etchings and lithographs by nineteenth- and early-twentieth-century European artists, and early backdrops and maquettes from the Chicago Lyric Opera.
NIU Art Museum, Northern Illinois University, DeKalb, IL 60115. Phone: 815/753-1936. Hours: 9–6 Mon.–Fri.; closed summer and major holidays. Admission: free.

## NORTHERN KENTUCKY UNIVERSITY
*Northern Kentucky University Art Museum*

The Northern Kentucky University Art Museum in Highland Heights emphasizes regional and national artists and varied media in its collections and exhibitions. Founded in 1968, it has a 2,700-square-foot exhibition area.
Northern Kentucky University Art Museum, Nunn Dr., Highland Heights, KY 41099. Phone: 606/572-5566. Hours: 9–9 Mon.–Fri.; 1–5 Sat.–Sun.; closed holidays, spring break, and mid-Dec.–mid-Jan. Admission: free.

## NORTHWESTERN MICHIGAN COLLEGE
### Dennos Museum Center

The Dennos Museum Center of Northwestern Michigan College in Traverse City was founded as an art museum in 1991. Its collections and exhibits include contemporary Inuit sculpture and prints, Canadian Indian and Great Lakes Indian art, Japanese prints, nineteenth- and twentieth-century American and European prints, contemporary German prints, and sculpture.

Dennos Museum Center, Northwestern Michigan College, 1701 E. Front St., Traverse City, MI 49684. Phone: 616/922-1055. Hours: academic year—10–5 Mon.–Sat.; 1–5 Sun.; summer—5–8 Tues.–Sat.; closed major holidays. Admission: adults and seniors, $2; students and children, $1.

## OBERLIN COLLEGE
### Allen Memorial Art Museum

More than 14,000 objects from ancient Egypt to contemporary America are part of the Allen Memorial Art Museum collections at Oberlin College in Oberlin, Ohio. The museum has particular strength in Dutch and Flemish paintings of the seventeenth century, European art of the late nineteenth and twentieth centuries, and contemporary American art.

The museum, the first college museum west of the Alleghenies, opened in 1917 with funding from Dr. Dudley Peter Allen. It is located in an Italianate structure, designed by Cass Gilbert. In 1977, the original building was renovated, and a large addition, designed by Robert Venturi, was completed to house the modern and contemporary art collection.

Among the museum's collections are the Mary A. Ainsworth Collection of Japanese woodblock prints, Charles Martin Hall Collection of Islamic carpets, Joseph and Enid Bissett Collection of modern European paintings, and a comprehensive collection of Old Master prints, including works by Rembrandt and Dürer. In addition to the works in its galleries, the museum has a number of sculptures on the grounds around the building. It also presents a variety of special exhibitions from its own collections, as well as loan exhibitions organized by its staff or by other institutions.

Allen Memorial Art Museum, Oberlin College, 87 N. Main St., Oberlin, OH 44074. Phone: 216/775-8665. Hours: 10–5 Tues.–Sat.; 1–5 Sun.; closed holidays. Admission: free.

## PALM BEACH COMMUNITY COLLEGE
### Palm Beach Community College Museum of Art

The Palm Beach Community College Museum of Art in Lake Worth, Florida, was founded in 1989 in a 1939 art deco movie theater. It exhibits selections from its contemporary collection and temporary and traveling shows.

Palm Beach Community College Museum of Art, 601 Lake Ave., Lake Worth, FL 33460. Phone: 407/582-0006. Hours: 12–5 Tues.–Sun.; closed major holidays. Admission: free.

# PENNSYLVANIA ACADEMY OF THE FINE ARTS
## Museum of American Art

The nation's first art school and art museum—part of the Pennsylvania Academy of the Fine Arts—were founded in 1805 by Philadelphia artists and business leaders to provide classical training for artists. The Museum of American Art initially was designed to give students an opportunity to study the Old Masters. Over the years, however, the mission broadened to include the public.

The museum—located in an 1876 historic landmark building that was completely renovated in 1976—has one of the nation's finest collections of American art. The collection of eighteenth- through twentieth-century American art now numbers over 17,000 paintings, 14,000 works on paper, and 300 sculptures. The academy and the museum have a library and archives with substantial material on the cultural history of the nation and the academy's role in the development of American art.

The museum has works by such noted artists as Washington Allston, Benjamin West, the Peale Family, Gilbert Stuart, Winslow Homer, Frank Duveneck, William Merritt Chase, William Sidney Mount, Cecilia Beaux, Thomas Sully, William Rush, John Sloan, Robert Henri, Arthur B. Carles, Edward Hopper, Childe Hassam, Thomas Elkins, Mary Cassatt, Philip Pearlstein, Alex Katz, Frank Stella, Nancy Graves, Horace Pippin, Ray Saunders, Janet Fish, Jennifer Bartlett, Rafael Ferrer, Cynthia Carlson, Stuart Davis, Robert Motherwell, and Katherine Porter.

Museum of American Art, Pennsylvania Academy of the Fine Arts, 118 N. Broad St., Philadelphia, PA 19102. Phone: 215/972-7600. Hours: 10–5 Tues.–Fri.; 11–5 Sun.; closed New Year's Day, Thanksgiving, and Christmas. Admission: adults, $5; seniors, $3; students, $2; children under 5, free.

# PENNSYLVANIA STATE UNIVERSITY
## Palmer Museum of Art

The Palmer Museum of Art at Pennsylvania State University in University Park was founded in 1972 and expanded to 50,000 square feet and given its present name in 1993. Its 10 galleries present selections from a permanent collection of paintings, sculpture, ceramics, and works on paper from the United States, Europe, Asia, and South America, as well as diverse special exhibitions of media, cultures, and time periods.

The museum's collections include American and European paintings, drawings, prints, photographs, and sculpture, with an emphasis on Pennsylvania artists; Chinese export porcelain; contemporary European and Japanese ceramics;

European posters from 1890 to 1930; ancient Peruvian ceramics; and works on paper.

Palmer Museum of Art, Pennsylvania State University, Curtin Rd., University Park, PA 16802-2507. Phone: 814/865-7672. Hours: 10–4:30 Tues.–Sat.; 12–4 Sun.; closed holidays and Christmas recess. Admission: free.

## Materials Research Laboratory Museum of Art and Science

The Materials Research Laboratory Museum of Art and Science at Pennsylvania State University in University Park is a small specialized museum of art that promotes the interaction between the physical sciences and the arts. Forms, patterns, and spatial relationships that originate in science and technology result in works of art that are displayed in the museum.

The museum's collections and exhibitions include computer-generated artworks, works from an annual Science in Art Competition, major sculptures by English sculptor Barbara Hepworth and Swiss artist Max Bill, photographs of crystals, and reproductions of drawings by graphic artist M.C. Escher.

Materials Research Laboratory Museum of Art and Science, Pennsylvania State University, Hastings Rd., University Park, PA 16802. Phone: 814/865-3422. Hours: 8–5 Mon.–Fri.; closed holidays. Admission: free.

## POMONA COLLEGE
### Montgomery Gallery

(See Art Galleries section.)

## PRINCETON UNIVERSITY
### The Art Museum

The Art Museum at Princeton University in Princeton, New Jersey, goes back to 1882 when Professor Allan Marquand developed a history of art curriculum and the introduction of original works of art seemed a necessary component of such study. The belief was shared by alumnus William Cowper Prime, who promised to give his extensive collection of pottery and porcelain upon the completion of a fireproof building. This resulted in a museum that opened in 1890 in a Romanesque Revival building. The building later was razed and replaced by McCormick Hall and several additions.

Over the last century, the Princeton museum has become a leading university art museum with a full-time staff of 30, collections totaling over 35,000, and a building with 65,592 square feet. The museum's holdings range from ancient to contemporary art, with a geographical focus on the Mediterranean regions, Western Europe, China, Latin America, and the United States.

The museum has an exceptional collection of Greek and Roman antiquities, including ceramics, marbles, bronzes, and Roman mosaics. Medieval Europe is represented by sculpture, metalwork, and stained glass, while a collection of

Western European paintings includes examples from the early Renaissance through the twentieth century.

Among the greatest strengths are the collections of Chinese and pre-Columbian art. The Chinese collection has important holdings in bronzes, tomb figures, painting, and calligraphy, and the pre-Columbian collection features the art of the Maya.

Among the other significant collections are Old Master prints and drawings, photographs, African art, Northwest Coast Indian art, and the John B. Putnam Jr. Memorial Collection of twentieth-century sculpture, located throughout the campus and containing works by such modern masters as Henry Moore, Alexander Calder, Pablo Picasso, and Jacques Lipchitz.

Many of the museum's exhibitions are drawn from the collections and organized in conjunction with the Department of Art and Archaeology and other academic programs. The museum also originates temporary exhibitions that frequently rely upon loans from other institutions and are circulated to other museums.

The Art Museum, Princeton University, McCormick Hall, Princeton, NJ 08544-1018. Phone: 609/258-3788. Hours: 10–5 Tues.–Sat.; 1–5 Sun.; closed major holidays. Admission: suggested donation—$3.

## RADFORD UNIVERSITY
### Radford University Galleries

(See Art Galleries section.)

## RANDOLPH-MACON WOMAN'S COLLEGE
### Maier Museum of Art

The Maier Museum of Art at Randolph-Macon Woman's College in Lynchburg, Virginia, has five galleries for permanent collections and one for changing exhibitions. The present museum, built in 1952, began its collections of American paintings and European and American graphics in 1920.

Maier Museum of Art, Randolph-Macon Woman's College, Quinlan St., Lynchburg, VA 24504. Phone: 804/947-8136. Hours: 1–5 Tues.–Sat.; closed summer, holidays, and when college not in session. Admission: free.

## RHODE ISLAND SCHOOL OF DESIGN
### Museum of Art

The Museum of Art was founded as part of the Rhode Island School of Design in Providence, Rhode Island, in 1877 by Mrs. Jesse Metcalf and the Women's Centennial Committee. With the $1,675 left after expenses from the Centennial Exposition in Philadelphia in 1876, the committee established the design school to train artisans and art students and to further public art education. The insti-

tution has since grown to be one of the nation's leading schools of art and design, with over 1,900 students and 250 faculty members.

The museum—located in a six-story complex covering 72,650 square feet—has over 100,000 works of art and 47 exhibition galleries on three floors, of which 36 are used for the exhibition and rotation of its permanent collection and the others primarily for temporary exhibitions.

The museum's greatest strengths are in the areas of classical Greek, Roman, and Etruscan art; medieval and Renaissance sculpture; nineteenth-century European paintings and sculpture; early twentieth-century American paintings; American Indian and pre-Columbian sculpture and artifacts; and nineteenth- and twentieth-century American and European costumes and textiles.

The history of Western art from antiquity to the twentieth century is featured on the main floor. The galleries begin with ancient Greek and Roman art and continue through medieval, Renaissance, Baroque, Rococo, nineteenth-century, and modern art. The Egyptian, pre-Columbian, Japanese, Chinese, Indian, African, and Melanesian galleries are on the upper level, while a print and photography gallery, a sculpture garden, and temporary exhibitions are on the lower level. Contemporary art is the focus of the new Daphne Farago Wing.

The museum has the earliest example of an American wing in any museum in Pendleton House, which features a major collection of eighteenth-century American furniture, silver, painting, and decorative arts in period rooms constructed in 1906.

Museum of Art, Rhode Island School of Design, 224 Benefit St., Providence, RI 02903-2723. Phone: 401/454-6500. Hours: academic year—10:30–5 Tues.–Sat. (also to 8 Thurs.); 2–5 Sun. and some holidays; summer—12–5 Wed.–Sat.; closed New Year's Day, Fourth of July, Thanksgiving, and Christmas. Admission: adults, $2; seniors, $1; children (5–18) and college students, 50¢.

# ROLLINS COLLEGE
## George D. and Harriet W. Cornell Fine Arts Museum

European and American art from the Italian Renaissance to contemporary American sculpture are featured at the George D. and Harriet W. Cornell Fine Arts Museum at Rollins College in Winter Park, Florida. It is one of the largest such campus collections.

The museum, which opened in 1978 and incorporated the Morse Gallery of Art (founded in 1941), has paintings, bronzes, sculptures, prints, drawings, posters, photographs, decorative arts, furniture, glass, ceramics, and keys (the Smith Watch Key Collection of over 1,200 keys from the mid-sixteenth to mid-nineteenth centuries is the most complete of its type in the world.)

Among the artists represented in the collections are Albert Bierstadt, W.L. Sonntag, Herman Herzog, Robert Henri, Childe Hassam, John F. Kensett, William-Adolphe Bouguereau, Jean-Baptiste Leprince, Adolphe Monticelli, Pietro Liberi, Lavinia Fontana, and Sir John Lavery.

The changing exhibitions include shows of contemporary photography, Old Master prints, contemporary paintings and sculptures, and selections from the Renaissance and other collections.

George D. and Harriet W. Cornell Fine Arts Museum, Rollins College, Winter Park, FL 32789-4499. Phone: 407/646-2526. Hours: 10–5 Tues.–Fri.; 1–5 Sat.–Sun.; closed major holidays. Admission: free.

# RUTGERS UNIVERSITY
## Jane Voorhees Zimmerli Art Museum

The Jane Voorhees Zimmerli Art Museum at Rutgers University in New Brunswick, New Jersey, began in 1966 as an art gallery organized to house the university's fine arts collection assembled over a 200-year period.

The collection—which now numbers over 40,000—includes paintings, prints, drawings, sculpture, and decorative arts. Among the most significant collections are the Riabov Collection of Russian art, Dodge Collection of Soviet nonconformist art, and Rutgers Archives of Printmaking Studios.

The museum is best known for its nineteenth- and twentieth-century Japonisme graphic arts, Russion icons through Soviet nonconformist art, and mid-twentieth-century American surrealism and abstraction art. Changing exhibitions highlight the strengths of the collection and include other temporary and traveling shows.

Jane Voorhees Zimmerli Art Museum, Rutgers University, George and Hamilton Sts., New Brunswick, NJ 08903. Phone: 908/932-7237. Hours: 10–4:30 Tues.–Fri.; 12–5 Sat.–Sun.; closed major holidays. Admission: free.

# SAINT FRANCIS COLLEGE
## Southern Alleghenies Museum of Art

The Southern Alleghenies Museum of Art at Saint Francis College in Loretto, Pennsylvania, started as a single facility in 1975, but later added branches in Hollidaysburg and Johnstown. The museum, located on the college mall, specializes in American art. It has a collection of nineteenth- and twentieth-century American art.

Southern Alleghenies Museum of Art, St. Francis College, Mall, PO Box 8, Loretto, PA 15940. Phone: 814/472-6400. Hours: 10–4 Mon.–Fri.; 1:30–4:30 Sat.–Sun.; closed holidays. Admission: free.

## Southern Alleghenies Museum of Art at Altoona

The Southern Alleghenies Museum of Art in Altoona, Pennsylvania, is a new branch of the Southern Alleghenies Museum of Art at Saint Francis College in Lorreto. It replaced the branch—known as the Blair Art Museum—in Hollidaysburg in 1995. The facility has collections and exhibitions of American paintings, photographs, and graphic works.

Southern Alleghenies Museum of Art at Altoona, 1216 11th Ave., Altoona, PA 16602. Phone: 814/472-6400. Hours: 10–4 Mon.–Fri.; 1:30–4:30 Sat.–Sun.; closed holidays. Admission: free.

## Southern Alleghenies Museum of Art at Johnstown

Changing exhibitions of contemporary American art are presented at the Southern Alleghenies Museum of Art at Johnstown, Pennsylvania. The satellite facility, originally opened downtown in 1982, was relocated to the Pasquerilla Performing Arts Center of the University of Pittsburgh at Johnstown in 1993. However, it still operates as an extension of the Saint Francis College museum. Southern Alleghenies Museum of Art at Johnstown, University of Pittsburgh at Johnstown, Pasquerilla Performing Arts Center, Johnstown, PA 15904. Phone: 814/535-1803. Hours: 10–5 Mon.–Fri.; 12–4 Sat.; closed major holidays. Admission: free.

## SAINT GREGORY'S COLLEGE
### Mabee-Gerrer Museum of Art

Saint Gregory's College in Shawnee, Oklahoma, began its art collections toward the end of the nineteenth century, but it was not until 1979 that the Mabee-Gerrer Museum of Art was built (and then expanded in 1991). The museum now has extensive medieval, Renaissance, Egyptian, African, and Native American collections in a 16,400-square-foot facility.

Among the works in the collections are eighteenth- and nineteenth-century European and American oil paintings; Egyptian, Babylonian, pre-Columbian, African, South Pacific, and North, South, and Central American Indian artifacts; Persian and Chinese Oriental rugs; bronze, ivory, marble, and Romanesque wood sculpture; and engravings, serigraphs, lithographs, drawings, and watercolors. The European art is displayed in a permanent gallery, while rotating exhibitions of art and artifacts are shown in two other galleries. Mabee-Gerrer Museum of Art, St. Gregory's College, 1900 W. MacArthur, Shawnee, OK 74801-2499. Phone: 403/898-5300. Hours: 1–4 Tues.–Sun.; closed major holidays. Admission: free.

## SAINT MARY'S COLLEGE OF CALIFORNIA
### Hearst Art Gallery

The Hearst Art Gallery at Saint Mary's College of California in Moraga offers a combination of short-term changing exhibitions and long-term selections from its permanent collection. The college, which has been acquiring art since the 1920s, opened the Hearst Art Gallery in 1977, replacing a smaller William Keith Gallery.

The art museum always has paintings on display from its extensive William Keith Collection. Keith was a leading figure in the history of California art. It also actively collects and exhibits nineteenth- and twentieth-century California landscapes by other artists and in other media.

Christian imagery in art is another focus of the museum's collection and of occasional exhibitions. The collection includes fifteenth-century German carved-wood Madonnas, Russian and Greek icons, and contemporary artists' responses to traditional Christian themes.

Other parts of the museum collection include such other types of art as ancient ceramics, Morris Graves drawings, European satirical prints, and paintings by such modern artists as Emile Bernald, Rosa Bonheum, Maurice de Vlaminck, Albert Bierstadt, William Coulter, and George Inness.

Hearst Art Gallery, St. Mary's College of California, PO Box 5110, Moraga, CA 94575. Phone: 510/631-4379. Hours: 11–4:30 Wed.–Sun.; closed on holidays. Admission: free.

## SAINT OLAF COLLEGE
### Steensland Art Museum

Norwegian-American landscape paintings of the late eighteenth and early nineteenth centuries and contemporary British prints are featured at the Steensland Art Museum at Saint Olaf College in Northfield, Minnesota. The museum's collections include historic and contemporary prints, paintings, and sculpture; Albert Christ-Janer prints and paintings; Kaare Nygaard sculpture; and works by Scandinavian immigrant painters. Founded in 1976, the museum is housed in a 1905 Classical Revival building originally used as the library.

Steensland Art Museum, St. Olaf College, Northfield, MN 55057. Phone: 507/646-3556. Hours: 12–5 Mon.–Fri. (also to 8 Thurs.); 2–5 Sat.–Sun.; closed major holidays and when college not in session. Admission: free.

## SAGINAW VALLEY STATE UNIVERSITY
### Marshall M. Fredericks Sculpture Gallery

(See Sculpture Gardens section.)

## SANTA CLARA UNIVERSITY
### de Saisset Museum

A bequest by Isabel de Saisset in memory of her brother, Ernest, resulted in the founding of the de Saisset Museum at Santa Clara University in Santa Clara, California, in 1955. A museum building was constructed adjacent to the Mission Santa Clara de Asis to house paintings by Ernest de Saisset and works of many eras and styles.

Among the museum's diverse holdings are seventeenth-century Dutch-Flemish and Spanish art; nineteenth-century American and English works; an Oriental collection from the seventh century to the present; African artifacts; sculpture, photographs, and video art from the nineteenth and twentieth centuries; Native American art and artifacts; and collections of tapestries, porcelain,

and other works. The museum has an exceptional collection of WPA art that includes paintings, drawings, sculpture, and photographs of the period.

The museum has a permanent exhibit on California history, consisting of Native American, mission, and early university materials, and presents changing exhibitions of selections from its collections and on loan from other institutions. de Saisset Museum, Santa Clara University, 500 El Camino Real, Santa Clara, CA 95053. Phone: 408/554-4528. Hours: 11–4 Tues.–Sun.; closed major holidays and between exhibitions. Admission: free.

## SCHOOL OF AMERICAN RESEARCH
### Indian Arts Research Center

(See Archaeology, Anthropology, and Ethnology Museums section.)

## SCRIPPS COLLEGE
### Ruth Chandler Williamson Gallery

(See Art Galleries section.)

## SMITH COLLEGE
### Smith College Museum of Art

When Smith College opened in 1875 in Northampton, Massachusetts, a gallery of reproductions of the great works of art for the students to study was included in the first building. Shortly thereafter, the college began collecting original works from contemporary American artists. It was not until 1926, however, that the various collections owned by the college were formally designated the Smith College Museum of Art.

Today, the museum is located in its fourth home (Tryon Hall, completed in 1972) and has a collection of approximately 24,000 objects from a variety of cultures and in a wide spectrum of media, dating from 2500 B.C. to the present.

The museum's collection is centered around seventeenth- through twentieth-century European and American paintings, sculpture, prints, drawings, photographs, and decorative arts and is especially rich in nineteenth- and early-twentieth-century painting and sculpture.

Some of the highlights include *Daughter of Jephthah* by Degas, study for *La Grande Jatte* by Seurat, *Preparation of the Dead Girl* by Courbet, *Rolling Power* by Charles Sheeler, *Portrait of Edith Mahon* by Thomas Eakins, and *La Table* by Pablo Picasso. The museum also has paintings by Monet, Renoir, Cézanne, Gauguin, Vuillard, Gris, Kirchner, Bierstadt, Inness, Homer, Sargent, and Whistler and sculptures by Barye, Rodin, Arp, Giacometti, Calder, and Rickey.

The changing exhibitions range from historical to contemporary art and include site-specific installations by artists of multicultural backgrounds.

Smith College Museum of Art, Elm St. at Bedford Ter., Northampton, MA 01063. Phone: 413/585-2770. Hours: academic year—12–4 Tues.–Sun. (also to 8 Thurs.); Jan. and June–July—12–4 Wed., Sat., and Sun.; Aug.—12–4 Tues.–Sun.; closed major holidays. Admission: free.

## SOUTH CAROLINA STATE UNIVERSITY
### *I.P. Stanback Museum and Planetarium*

The I.P. Stanback Museum and Planetarium at South Carolina State University in Orangeburg is an unusual combination of an art museum, science exhibits, and a planetarium. The facility, which opened in 1980, features collections and exhibits of African and African-American art and offers planetarium shows and some science-oriented exhibits.

Among the museum's permanent art collections are African tribal art by the Mende, Bambara, and Yoruba peoples, among many other African ethnic groups; the photographic works of Gordon Parks, James Vanderzee, Lloyd Yearwood, and Addison Scurlock; prints and paintings by Romare Bearden, Jacob Lawrence, Ellis Wilson, and William H. Johnson; and sculptural works by Phillip Simmons.

Science collections and exhibits include African gemstones, meteor fragments, and replicas of communications satellites. The planetarium shows are presented in a 44-foot domed theater, with a Minolta IIB projector and 82-seat capacity. I.P. Stanback Museum and Planetarium, South Carolina State University, 300 College St., NE, Orangeburg, SC 29115. Phone: 803/536-7174. Hours: 9–4:30 Mon.–Fri.; 3–5 selected Sun.; closed holidays. Admission: museum—free; planetarium—adults, $1; seniors and children, 50¢.

## SOUTH DAKOTA STATE UNIVERSITY
### *South Dakota Art Museum*

The South Dakota Art Museum at South Dakota State University in Brookings features the works of South Dakota artists. The museum was founded as the South Dakota Memorial Art Center in 1970 to house the university's collections, exhibitions, and other arts activities. The name was changed in 1989 to better reflect the nature of the institution.

The South Dakota collection includes nearly 100 paintings and drawings by Harvey Dunn, noted illustrator, combat artist, and painter of pioneer life on the Dakota prairies; 23 works by Oscar Howe, a Yanktonai Sioux; approximately 1,800 embroidered linens by Vera May Marghab; and an extensive collection of Native American artifacts. The museum also has a growing collection of American art with works by such artists as Karl Bodmer, Rockwell Kent, Reginald Marsh, and Thomas Hart Benton. South Dakota Art Museum, South Dakota State University, Medary Ave. at Harvey Dunn St., PO Box 2250, Brookings, SD 57007. Phone: 605/688-5423. Hours: 8–5 Mon.–Fri.;

10–5 Sat.; 1–5 Sun. and holidays; closed New Year's Day, Thanksgiving, and Christmas. Admission: free.

## SOUTHERN ILLINOIS UNIVERSITY AT CARBONDALE
### University Museum

(See General Museums section.)

## SOUTHERN METHODIST UNIVERSITY
### Meadows Museum

Spanish art from the fourteenth to the twentieth centuries is the focus of the Meadows Museum at Southern Methodist University in Dallas. The museum, which began in 1965 with the collection of Algur H. Meadows, has paintings, prints, drawings, and a sculpture garden largely reflecting Spanish culture. In addition, the museum's collections include works by Latin American and twentieth-century American and Texas artists.

The museum, located in the Owens Art Center, has the largest collection of nineteenth-century Spanish paintings in America. Among the museum highlights are *Portrait of King Philip IV* by Velázquez, *Mystical Marriage of St. Catherine* by Zurbarán, *Jacob Laying the Peeled Rods Before the Flocks of Laban* by Murillo, *Still Life in a Landscape* by Picasso, and *The Madhouse of Saragossa* and *Los Caprichos, Disasters of War* by Goya. The museum also has works by Juan de Sevilla, Valdes Leal, Juan de Borgoña, Francesco Gallego, Juan Gris, Joan Miró, and Diego Rivera.

Meadows Museum, Southern Methodist University, Owen Arts Center, Dallas, TX 75275-0356. Phone: 214/768-2516. Hours: 10–5 Mon.–Tues. and Thurs.–Sat. (also to 8 Thurs.); 1–5 Sun.; closed major holidays. Admission: free.

## SOUTHERN OREGON STATE COLLEGE
### Schneider Museum of Art

The Schneider Museum of Art at Southern Oregon State College in Ashland has examples of various media, styles, and cultures for exhibition and research purposes in its collection, which includes medieval illuminated manuscripts, Renaissance etchings, engravings of Shakespearean characters and plays, early printed typography, Northwest Native American baskets and ceremonial objects, Japanese prints, and American and European paintings. The exhibition schedule always includes works by an artist of the Northwest and a non-Western culture. The museum opened in 1986.

Schneider Museum of Art, Southern Oregon State College, 1250 Siskiyou Blvd., Ashland, OR 97520. Phone: 503/552-6245. Hours: academic year—11–5 Tues.–Fri.; 1–5 Sat.; summer—1–5 Wed.–Sun.; closed holidays. Admission: free.

## SPERTUS COLLEGE OF JUDAICA
### Spertus Museum

(See Archaeology, Anthropology, and Ethnology Museums section.)

## STANFORD UNIVERSITY
### Stanford University Museum of Art

When the Stanford University Museum of Art in Stanford, California, opened in 1894, it was the largest private museum in the world. It no longer holds that distinction, but it remains one of the nation's leading university art museums.

The university and the museum were founded (in 1885 and 1891, respectively) by Governor Leland and Jane Lathrop Stanford, who were enriched by the completion of the transcontinental railroad in 1869. The Stanfords originally were thinking of establishing an art museum—in memory of their only child, 15-year-old Leland, Jr., who died of typhoid fever in Florence and had a great interest in collecting art. When the university idea surfaced and was implemented, the museum quickly followed.

The museum has had its difficulties with earthquakes. The 1906 San Francisco area quake badly damaged its building and destroyed much of its collections, and the 1989 Loma Prieta earthquake caused an eight-year closure while the museum building was being repaired. But the museum has managed to overcome such natural disasters. It has been presenting exhibitions in the Stanford Art Gallery during the most recent rehabilitation of its building (see Art Galleries section).

The museum is best known for its sculpture collection of approximately 150 pieces by August Rodin. Twenty of the sculptures are displayed in the outdoor B. Gerald Cantor Rodin Sculpture Garden on the campus, and others can be seen in the Rodin Rotunda of the museum.

The museum's collections range from ancient and classical pieces to Asian, European, and American works. Among its outstanding collections are eighteenth- and nineteenth-century French and English prints and drawings, paintings from the Ming Dynasty, and bronzes from the Chou Dynasty. It also has ancient art from Greece, Rome, and Egypt; Oriental, pre-Columbian, African, Native American, and Melanesian art; and Western art from the Renaissance to the present.

Stanford University Museum of Art, Lomita Dr. and Museum Way, Stanford, CA 94305-5060. Phone: 415/725-0460. Hours: closed temporarily but normally 10–5 Tues.–Fri.; 1–5 Sat.–Sun. Admission: free.

## STATE UNIVERSITY OF NEW YORK AT ALBANY
### University Art Museum

Contemporary paintings, prints, and photographs are the focus of collections and exhibitions at the University Art Museum at the State University of New

York at Albany. The 14,000-square-foot museum evolved from a gallery in the Fine Arts Building when the university's new campus was built in 1967.
University Art Museum, State University of New York at Albany, 1400 Washington Ave., Albany, NY 12222. Phone: 518/442-4035. Hours: 10–5 Tues.–Fri.; 12–4 Sat.–Sun.; closed major holidays and when exhibitions are being installed. Admission: free.

## STATE UNIVERSITY OF NEW YORK AT BINGHAMTON
### University Art Museum

The University Art Museum at the State University of New York at Binghamton began as a gallery in 1967. It now has collections and exhibits of paintings, sculpture, graphics, decorative arts, pottery, and Chinese art in the Fine Arts Building.
University Art Museum, State University of New York at Binghamton, Fine Arts Bldg., Vestal Pkwy., E. Binghamton, NY 13902-6000. Phone: 607/777-2634. Hours: 10–4 Tues.–Fri. (also 6–8 Thurs.); 1–4 Sat.–Sun.; closed summer and holidays. Admission: free.

## STATE UNIVERSITY OF NEW YORK AT BUFFALO
### Burchfield Penney Art Center

The Burchfield Penney Art Center is a regional arts museum for western New York located at the State University of New York at Buffalo. It is dedicated to works by and archival material about significant artists who live or have practiced in the western section of the state and to graphic media illustrating and documenting the career of Charles E. Burchfield, a noted American watercolorist who spent most of his life in the region.

The center, located in Rockwell Hall, began as a small gallery in 1966 with donated paintings and archival materials from Burchfield, who was a consulting artist at the institution at the time. In 1987, the center moved into an expanded and renovated 25,000-square-foot space as it acquired additional Burchfield materials and enlarged the scope of its activities. The center now has 70 paintings, 263 drawings, 33 prints, 84 wallpapers, 10 commercial designs, and 30 doodles by Burchfield, as well as work by contemporaries Reginald Marsh, Marsden Hartley, and others.

Among the other additions are a photography collection that extends from the photo-pictorialist movement through contemporary work; works by late-nineteenth- and early-twentieth-century artists, such as painters Lars Sellstedt and Alexis Jean Fournier; twentieth-century works by Robert N. Blair, Edwin Dickinson, Arnold Mesches, Bruce Shanks, and Charles Clough; and the Charles Rand Penney Collection of western New York art, featuring works by Russell Drisch, Joseph Piccillo, and Milton Rogovin. The collections now include more than 4,300 artworks from 1875 to the present.

Burchfield Penney Art Center, State University of New York at Buffalo, 1300 Elmwood Ave., Buffalo, NY 14222-1095. Phone: 716/878-6011. Hours: 10–5 Tues.–Sat.; 1–5 Sun.; closed holidays. Admission: free.

## STATE UNIVERSITY OF NEW YORK COLLEGE AT NEW PALTZ
### College Art Gallery

(See Art Galleries section.)

## STATE UNIVERSITY OF NEW YORK COLLEGE AT PLATTSBURGH
### SUNY Plattsburgh Art Museum

The SUNY Plattsburgh Art Museum at the State University of New York College at Plattsburgh consists of three galleries and a collection that features the works of Rockwell Kent. Founded in 1952, the museum also has the Nina Winkel Collection of sculptures, Millet Asian Collection, and Ackerman Collection of modern art.

The Rockwell Kent Collection includes 19 paintings, 39 prints, 41 drawings, and hundreds of sketches, proofs, and designs, as well as the artist's books, first editions written or illustrated by Kent, and other personal materials. The museum operates a gallery in the Feinberg Library and two galleries in the Myers Fine Arts Building and presents 24 changing exhibitions each year.

SUNY Plattsburgh Art Museum, State University of New York College at Plattsburgh, Rugar St., Plattsburgh, NY 12001-2697. Phone: 518/564-2474. Hours: 12–4 daily (also to 8 Thurs.); closed major holidays. Admission: free.

## STATE UNIVERSITY OF NEW YORK COLLEGE AT PURCHASE
### Neuberger Museum of Art

Nineteenth- and twentieth-century American art and primitive art from Africa are featured at the Neuberger Museum of Art, which opened in 1974 in a 78,000-square-foot building designed by Philip Johnson and John Burgee at the State University of New York College at Purchase.

More than 5,000 works of art in various media can be found in the museum's collections, comprised mainly of works donated by art patron Roy R. Neuberger. Among the artworks on permanent display are major works by such modern artists as Milton Avery, Romare Bearden, Willem de Kooning, Helen Frankenthaler, Nancy Graves, Edward Hopper, Jacob Lawrence, Georgia O'Keeffe, and Jackson Pollack.

The museum's holdings also encompass the George and Edith Rickey Collection of constructivist art, the Hans Richter Bequest of dada and surrealist works, and the Aimee Hirshberg Collection of African art, consisting of African masks, carvings, sculpture, and other objects of ceremonial and daily use. Six-

teen changing exhibitions of contemporary art are presented each year by the museum.

Neuberger Museum of Art, State University of New York College at Purchase, 735 Anderson Hill Rd., Purchase, NY 10577-1400. Phone: 914/251-6100. Hours: 10–4 Tues.– Fri.; 11–5 Sat.–Sun.; closed major holidays. Admission: free, but donation suggested.

## SWARTHMORE COLLEGE
### List Gallery

(See Art Galleries section.)

## SYRACUSE UNIVERSITY
### Syracuse University Art Collection

Once the School of Art Collection, the renamed Syracuse University Art Collection was established as an autonomous department in 1973. It now occupies a renovated 10,000-square-foot space between the art school's main building and a classroom building. It presents traveling exhibitions and rotating showings from its collection of twentieth-century American prints, paintings, illustrations, and cartoons and nineteenth-century European academic paintings.

Syracuse University Art Collection, Sims Hall, Syracuse, NY 13244-1230. Phone: 315/ 443-4097. Hours: 9–5 Mon.–Fri.; closed holidays. Admission: free.

## TENNESSEE TECH UNIVERSITY
### Appalachian Center for Crafts

The Appalachian Center for Crafts, which serves as an arts and crafts museum as well as an education center, is operated by the Department of Music and Art at Tennessee Tech University in Smithville. The center, founded in 1979, has 1,500 square feet of exhibition space and fiber, metal, wood, glass, and clay studios for educational programs.

Appalachian Center for Crafts, Tennessee Tech University, Rte. 3, Box 430, Smithville, TN 37166. Phone: 615/597-6801. Hours: 9–5 daily; closed major holidays. Admission: free.

## UNIVERSITY OF ALASKA FAIRBANKS
### University of Alaska Museum

(See Natural History Museums and Centers section.)

## UNIVERSITY OF ARIZONA
### University of Arizona Museum of Art

The University of Arizona Museum of Art in Tucson opened in an 18,200-square-foot building in 1955 following the gift of 50 European paintings span-

ning the mid-fourteenth through the nineteenth centuries from Samuel H. Kress. Before then, a collection of modern American paintings donated to the university by C. Leonard Pfeiffer had been exhibited in a small room in the campus library since 1943.

The museum's permanent collection now consists of more than 3,000 paintings, sculptures, drawings, and prints. It has one of the most comprehensive university collections in the Southwest of Renaissance and later European and American art, including works by Rembrandt, Piranesi, Picasso, O'Keeffe, and Rothko.

Among the holdings are 26 panels of the fifteenth-century Spanish altarpiece of the Cathedral of Ciudad Rodrigo by Fernando Gallego and his assistants; 61 clay and plaster models and sketches by twentieth-century sculptor Jacques Lipchitz; more than 60 works on paper by Maynard Dixon and Paul Landacre, early Southwest artists; a concentration of American paintings and prints of the 1930s and Modernist paintings from 1920 to 1970; and over 2,000 prints from the last five centuries.

In addition to its collection of contemporary art, the museum presents approximately 20 changing exhibitions—mostly of contemporary art—each year. University of Arizona Art Museum, Park and Speedway, Tucson, AZ 85721. Phone: 602/ 621-7567. Hours: academic year—9–5 Mon.–Fri.; 12–4 Sun.; summer—10–3:30 Mon.– Fri.; 12–4 Sun.; closed holidays. Admission: free.

# UNIVERSITY OF CALIFORNIA, BERKELEY
*University Art Museum and Pacific Film Archive*

The University Art Museum at the University of California in Berkeley was founded in 1963 following a bequest from abstract expressionist Hans Hofmann and a university study that identified the need for a large, versatile exhibition space. The museum building opened in 1970, and the Pacific Film Archive began showing films daily in 1971.

The museum's striking reinforced-concrete building—designed in brutalist style by Mario Ciampi—has 95,000 square feet, with a dramatic central atrium, 11 galleries, a 234-seat theater, and a film study center.

The Hofmann bequest gave the university 45 of his paintings and $250,000 to help build a gallery to house them. His works still remain among the museum's highlights. It is the world's largest collection of Hofmann paintings. The museum also has significant collections of other abstract expressionist art, German expressionist works on paper, and Chinese paintings, while the Pacific Film Archive has important Japanese and contemporary avant-garde films as part of its impressive collection of films, photographs, videotapes, film posters, movie stills, prints, and related materials.

Among the artworks are sixteenth-century masterworks by Rubens, Carracciolo, and Savoldo; nineteenth-century paintings by Cézanne, Rosso, Carpeaux, Blakelock, Bierstadt, and Ensor; modern works by Americans Rothko, de Koo-

ning, Bearden, Reinhardt, Still, Frankenthaler, Gottlieb, Mitchell, Wiley, Clarke, and Francis and Europeans Bacon, Miró, Léger, and Margritte; and sculptures by Calder, Maillot, Smith, Pomodoro, Paolozzi, Lye, Voulkos, and Cornell.

The museum, which has an annual attendance of approximately 250,000, also has extensive changing exhibition and film programs.

University Art Museum and Pacific Film Archive, University of California, Berkeley, 2626 Bancroft Way, Berkeley, CA 94704. Phone: 510/642-1207. Hours: 11–5 Wed.– Sun. (also to 9 Thurs.); closed holidays. Admission: adults, $6; seniors and non–UC Berkeley students; children 12–17, $4; UC Berkeley students, free.

## UNIVERSITY OF CALIFORNIA, LOS ANGELES
### UCLA at the Armand Hammer Museum of Art and Cultural Center

In an unusual move in 1994, the University of California, Los Angeles signed a 99-year operating agreement under which it assumed management of the Armand Hammer Museum of Art and Cultural Center, with the university's Wight Art Gallery and Grunwald Center for the Graphic Arts moving into the museum.

The Hammer museum was founded by Dr. Armand Hammer, the late physician-turned-industrialist who controlled Occidental Petroleum Corporation for more than three decades, and largely funded by the Armand Hammer Foundation and the corporation. It opened in 1990 in a $60 million, 76,000-square-foot building adjacent to the Occidental Petroleum headquarters in the Westwood section of Los Angeles. However, it had operating, financial, and legal problems from the beginning.

The Hammer museum has the nation's most extensive collection of works by nineteenth-century French artist Honoré Daumier, consisting of approximately 10,000 lithographs and other works; about 100 impressionist and Old Master paintings; prints and drawings by Daumier's contemporaries; and an 18-page manuscript with 365 drawings by Leonardo da Vinci, known as the Codex Hammer.

Under the new arrangement, the Wight Art Gallery and the Grunwald Center for the Graphic Arts have moved their staffs, collections, and exhibitions into the Hammer museum from their prior campus sites. Henry Hopkins, director of the Wight Gallery, has become director of the museum, which now has a new nine-member board of directors (consisting of three representatives from UCLA, three from Occidental Petroleum, one from the Armand Hammer Foundation, and two from the community at large).

See the following separate listings for descriptions of the Wight Art Gallery and the Grunwald Center for the Graphic Arts.

UCLA at the Armand Hammer Museum of Art and Cultural Center, University of California, Los Angeles, 10889 Wilshire Blvd., Los Angeles, CA 90024. Phone: 310/443-7000. Hours: 11–7 Tues.–Sat.; 11–6 Sun.; closed major holidays. Admission: adults, $4.50; seniors and students, $3.

## Wight Art Gallery and Franklin D. Murphy Sculpture Garden

The Wight Art Gallery of the University of California, Los Angeles—now located at the UCLA at the Armand Hammer Museum of Art and Cultural Center—presents exhibitions of paintings, sculpture, prints, drawings, architecture, and design. The exhibitions often are in close collaboration with UCLA's Fowler Museum of Cultural History and the Grunwald Center for the Graphic Arts.

Founded in 1952 and named for former director Frederick S. Wight, the gallery was located in the Dickson Art Center on the university campus before its move to the Hammer museum. It has a collection of pre-Columbian, African, Oceanian, and fifteenth- to twentieth-century European paintings. It is best known for its extensive outdoor sculpture collection—the Franklin D. Murphy Sculpture Garden, named for a former chancellor who conceived the idea, on the UCLA campus.

The sculpture garden, designed by landscape architect Ralph D. Cornell, contains 59 works by some of the world's leading sculptors, including Auguste Rodin, Alexander Calder, Henry Moore, Isamu Noguchi, Henri Matisse, David Smith, Jacques Lipchitz, Lynn Chadwick, Henri Laurens, Barbara Hepworth, Pietro Consagra, Tony Rosenthal, Alexander Archipenko, Peter Voulkos, George Rickey, Aristide Maillol, and Jean Arp.

The initial core of the collection was a 1967 gift of 14 sculptures by David and Dolly Bright. The UCLA Art Council has since made contributions of significant works to the still growing collection, which also includes 10 other sculptures at other campus sites and in storage. The sculpture garden is open 24 hours without an admission charge.

## Grunwald Center for the Graphic Arts

The Grunwald Center for the Graphic Arts at the University of California, Los Angeles, has a works-on-paper gallery as part of its extensive study center— now located at the UCLA at the Armand Hammer Museum of Art and Cultural Center. Founded in 1956, the center has a collection of over 35,000 prints, drawings, photographs, and books and presents changing exhibitions relating to graphic arts.

The center's collection contains prints dating from the fifteenth century, including the works of German expressionists and French impressionists, Japanese woodblocks, and Tamarind lithography workshop impressions. Among the artworks are nearly all of Renoir's prints and representative prints from Matisse, Rouault, and Picasso.

The Grunwald center was located on the upper level of the Wight Art Gallery in the Dickson Art Center before its move to the Hammer museum. It now is open from 11 A.M. to 7 P.M. during the academic year at no charge at its new location.

## UNIVERSITY OF CALIFORNIA, SAN DIEGO
*Stuart Collection*

(See Sculpture Gardens section.)

## UNIVERSITY OF CALIFORNIA, SANTA BARBARA
*University Art Museum*

The University Art Museum at the University of California, Santa Barbara, has collections and exhibits ranging from pre-Columbian art to contemporary works. It also presents temporary exhibitions by the studio faculty and students, as well as from outside sources.

Founded in 1959, the museum has extensive collections, including the Morgenroth Collection of medals and plaquettes; Sedgwick Collection of Old Master drawings; Dreyfus Collection of Luristan bronzes, Near Eastern ceramics, and pre-Columbian art; Ala Story Graphic Arts Collection (fifteenth to eighteenth centuries); Ruth S. Shaffner Collection of contemporary art; Fernand Lungren paintings and drawings; and various other paintings, sculpture, drawings, prints, photographs, and ceramics, with emphasis on the contemporary. It also has a separately housed collection of over 350,000 architectural drawings and related materials that are largely the work of California architects.

University Art Museum, University of California, Santa Barbara, Santa Barbara, CA 93106. Phone: 805/893-2951. Hours: 10–4 Tues.–Sat.; 1–5 Sun. and holidays; closed New Year's Day, Easter, Thanksgiving, and Christmas. Admission: free.

## UNIVERSITY OF CHICAGO
*David and Alfred Smart Museum of Art*

The David and Alfred Smart Museum of Art and its adjacent Vera and A. Elden Sculpture Garden were established in 1974 through a major gift to the University of Chicago by the Smart Family Foundation. David and Alfred Smart were the founders and publishers of *Esquire* magazine.

The museum, located in a 29,200-square-foot building designed by Edward Larrabee Barnes, has over 7,000 works in its collections. The works include paintings, sculpture, decorative arts, drawings, prints, photography, and East Asian art, ranging from ancient to modern times.

Among the collections are modern sculpture by Degas, Matisse, Rodin, and Moore; Tarbell Collection of ancient Greek vases, including a rare example of Euphronios; Kress Collection of Old Master paintings; Old Master prints from the Epstein Archive with significant impressions by Dürer, Rembrandt, and Delacroix; medieval sculpture from the French Romanesque church of Cluny III; and Frank Lloyd Wright furniture from the Robie House (also located on the campus).

From its inception, the Smart Museum has organized a variety of ground-

breaking exhibitions, including *Kandinsky Watercolors; Blue and White: Chinese Porcelain and Its Impact on the Western World;* and *The Chicago Imagist Print.*

David and Alfred Smart Museum of Art, University of Chicago, 5550 S. Greenwood Ave., Chicago, IL 60637. Phone: 312/702-0200. Hours: 10–4 Tues.–Fri.; 12–6 Sat.–Sun.; closed holidays. Admission: free.

## UNIVERSITY OF CONNECTICUT
### *William Benton Museum of Art*

The William Benton Museum of Art at the University of Connecticut in Storrs is the state art museum. It opened in 1966 in a 1920 Gothic building that formerly was a dining hall for faculty and students and that recently was doubled in size.

The museum's original collection of 200 has grown to more than 4,000 European and American works in various media from the sixteenth century to the present. They include major collections of prints by Käthe Kollwitz and Reginald Marsh, as well as paintings by Benjamin West, George Bellows, Ernest Lawson, and Mary Cassatt. The museum also has a broad-based temporary exhibition program.

William Benton Museum of Art, University of Connecticut, 245 Glenbrook Rd., U-140, Storrs, CT 06269-2140. Phone: 203/486-4520. Hours: 10–4:30 Tues.–Fri.; 1–4:30 Sat.–Sun.; closed Aug. and major holidays. Admission: free.

## UNIVERSITY OF FLORIDA
### *Samuel P. Harn Museum of Art*

The Samuel P. Harn Museum of Art opened in 1990 in a new 62,000-square-foot contemporary structure on the campus of the University of Florida in Gainesville. It is named for a local alumnus whose family made a $3 million founding gift, which was supplemented by other private contributions and $4 million from the state.

Strengths of the museum's collections are in works from the varied cultures of the Americas, Asia, Africa, Melanesia, and Europe. The holdings include the William and Eloise Chandler Collection of American paintings, featuring works by such figurative artists as Francis Criss, Leon Kroll, Jack Levine, Jonas Lie, John Marin, and Paul Sample, and the Marion and Samuel Spring Collection, containing nearly 150 examples of the art of Papua New Guinea.

Among the museum's other works are a group of pre-Columbian sculptures and vessels, ranging from Mesoamerica to the Andean region of South America; sculptures and paintings from India; woodblock prints from Japan; ceramics from China and Korea; and tribal art of many cultures in sub-Sahara Africa. The temporary exhibition program includes traveling exhibitions.

Samuel P. Harn Museum of Art, University of Florida, PO Box 112700, Gainesville, FL 32611-2700. Phone: 904/392-9826. Hours: 11–5 Tues.–Fri.; 10–5 Sat.; 1–5 Sun.; closed holidays. Admission: free.

## UNIVERSITY OF GEORGIA
### Georgia Museum of Art

In 1996, the Georgia Museum of Art moved into a 45,000-square-foot building that is part of the new Performing and Visual Arts Triangle complex at the University of Georgia in Athens—and plans call for a similar addition as part of the second phase (scheduled to begin as soon as the first phase of the complex is completed). The museum previously was located in a 1907 building of 16,500 square feet that originally served as the university library.

The museum—now designated as the official state art museum—was founded in 1945 following a gift of 100 American paintings from 1840–1940 to the university by Alfred H. Holbrook, a 70-year-old New York lawyer who retired to Athens. Holbrook then became the director of the new museum when it opened in 1948 in the lower level of the library (later taking over the entire building when a larger library was constructed). By the time Holbrook died at the age of 99 in 1974, his gifts to the museum came to approximately 800 paintings, drawings, and sculptures.

The museum's collection, which now totals over 7,000 works, includes nineteenth- and twentieth-century American paintings; European, American, and Oriental prints and drawings; and a Kress Study Collection of Italian Renaissance paintings. The museum has a comprehensive collection of approximately 5,000 works on paper, including many by Rembrandt; a number of significant American impressionist paintings; and one of only three complete sets of L'Estampe Originale in the nation. The temporary exhibition programs feature selections from the collections and traveling exhibitions.

Georgia Museum of Art, University of Georgia, Athens, GA 30602-1719. Phone: 706/542-3255. Hours: 9–5 Mon.–Sat.; 1–5 Sun.; closed holidays. Admission: free.

## UNIVERSITY OF HOUSTON
### Sarah Campbell Blaffer Gallery

(See Art Galleries section.)

## UNIVERSITY OF ILLINOIS AT URBANA-CHAMPAIGN
### Krannert Art Museum and Kinkead Pavilion

The permanent collection of 8,000 objects at the Krannert Art Museum and Kinkead Pavilion at the University of Illinois at Urbana-Champaign spans much of the history of art. It includes art from Greece, Iran, and Egypt; European and American paintings from the late fifteenth to the early twentieth centuries; me-

dieval and Near Eastern paintings; sculpture, glass, and ceramics; Chinese, African, Japanese, and Indian art; and twentieth-century paintings, sculpture, prints, drawings, and photography.

The Krannert Art Museum opened in 1961 after Mr. and Mrs. Herman Krannert, an Indianapolis industrialist and his wife, provided the funds for the building and $1 million for the purchase of artworks. The museum was expanded in 1967, and the Kinkead Pavilion was added in 1988, increasing the size to 48,000 square feet.

Some of the most recognized works in the collection are European and American paintings by such artists as Bartolomé Esteban Murillo, François Boucher, Frans Hals, Winslow Homer, Camille Pissarro, Charles Daubigny, and David Teniers. The museum's twentieth-century art includes works by Hans Hofmann, Yves Tanguy, Roberto Matta, Philip Guston, Max Beckmann, Leon Golub, Andy Warhol, and Milton Avery.

From 14 to 16 temporary exhibitions are presented each year in three galleries, covering 7,500 of the museum's 25,000 square feet of exhibition space.

Krannert Art Museum and Kinkead Pavilion, University of Illinois at Urbana-Champaign, 500 E. Peabody Dr., Champaign, IL 61820. Phone: 217/333-1860. Hours: 10–5 Tues.–Sat. (also to 8 Wed.); 2–5 Sun.; closed holidays. Admission: free.

# UNIVERSITY OF IOWA
## *University of Iowa Museum of Art*

The University of Iowa Museum of Art in Iowa City resulted from the gift to the university of a major collection of paintings, prints, silver, and jade by Owen and Leone Elliott of Cedar Rapids with the proviso that a museum be built to house it. A successful fund-raising campaign was conducted, and the museum building was opened in 1969.

The museum now has a permanent collection of over 8,000 items in its 48,000-square-foot building. It includes extensive collections of twentieth-century European and American paintings and African art, as well as silver, graphic art, and a broad range of ethnographic material, especially pre-Columbian and South Pacific material.

The Elliott Collection included large groups of prints and jades, approximately 60 French paintings from after 1904, and a number of important expressionist paintings. Among the paintings were landscapes by Munch and Kokoschka, major portraits by Jawlensky and Soutine, Fauve paintings by Vlaminck, still lifes by Morandi and Villon, and works by Mare, Feininger, Delaunay, Braque, Gris, Kandinsky, Picasso, Utrillo, Matisse, and Gauguin.

Other museum holdings include works by such twentieth-century artists as Pollock, Davis, Harley, Levine, Guston, Diebenkorn, Motherwell, Gilliam, Rickey, di Suvero, and Beckmann. The varied temporary exhibitions range from African to contemporary art.

University of Iowa Museum of Art, 150 N. Riverside Dr., Iowa City, IA 52242-1789. Phone: 319/335-1727. Hours: 10–5 Tues.–Sat.; 12–5 Sun.; closed New Year's Day, Thanksgiving, and Christmas. Admission: free.

## UNIVERSITY OF KANSAS
### Spencer Museum of Art

The University of Kansas Museum of Art—founded in 1928 on the Lawrence campus when Sallie Casey Thayer gave her eclectic collection of approximately 9,000 objects to the university—was renamed the Helen Foresman Spencer Museum of Art when it moved into a new neoclassical building in 1978.

Mrs. Spencer and her husband, Kenneth, were Kansas City alumni who provided the funds to build the museum and the Kenneth Spencer Research Library, a separate facility. The museum occupies 43,813 square feet of its 95,000-square-foot building, which also houses the Department of Art History and a 90,000-volume library of art and architecture.

The museum has a permanent collection of more than 17,000 works that include medieval sculpture, early Renaissance paintings, German and Austrian Baroque works, nineteenth-century paintings, Old Master prints, photography, decorative arts, textiles, Japanese Edo-period paintings, Japanese woodblock prints, modern Chinese paintings, Korean ceramics, and contemporary art.

Among the important works in the collection are sculptures by Tilman Riemenschneider, Giovanni Bologna, and Don Judd; paintings by Guercino, Sebastiano Ricci, Winslow Homer, Dante Gabriel Rossetti, and James Rosenquist; and graphics by Andrea Mantegna, Dürer, Rembrandt, and Jasper Johns.

Six galleries are used to show works from the collection chronologically, except for Asian art, which is displayed in a separate gallery. The museum also presents rotating exhibitions of prints, drawings, and photographs among 10 to 12 special exhibitions per year in two changing galleries.

Spencer Museum of Art, University of Kansas, 1301 Mississippi St., Lawrence, KS 66045. Phone: 913/864-4710. Hours: 8:30–5 Tues.–Sat. (also to 9 Thurs.); 12–5 Sun.; closed holidays. Admission: free.

## UNIVERSITY OF KENTUCKY
### University of Kentucky Art Museum

The University of Kentucky Art Museum in Lexington evolved from a gallery started in 1918 as an adjunct to art instruction. The 20,000-square-foot museum was founded in 1975 as part of the new Singletary Center for the Arts, which it shares with the performance arts concert halls.

The museum has a varied collection, with a focus largely on painting and sculpture of the nineteenth and twentieth centuries. Among the select European and American paintings are works by Agostino Carracci, El Greco, Julian Dupre, J-L Gerome, Maurice Denis, W.L. Metcalf, Frank Duveneck, Milton Avery, Ben

Shahn, and Joan Mitchell. Other works in the collection include Oriental art; textiles, ceramics, and metalwork from Africa and pre-Columbian America; European Old Master prints; paintings, drawings, cartoons, and prints from WPA projects; photography; contemporary art; Native American materials; and works by Kentucky artists. Approximately 15 changing exhibitions are presented each year, with about half being generated from the permanent collection.

University of Kentucky Art Museum, Singletary Center for the Arts, Rose St. and Euclid Ave., Lexington, KY 40506-0241. Phone: 606/257-5716. Hours: 12–5 Tues.–Sun.; closed holidays. Admission: free.

## UNIVERSITY OF MAINE
### University of Maine Museum of Art

For more than 30 years, Professor Vincent Hartgen collected works of art by Maine and other artists for the University of Maine's Art Collection in Orono. In 1988, the collection was developed into the Museum of Art, with exhibitions, programs, and services in a 1904 neoclassical granite structure originally used for the university's library.

The collection now contains more than 5,400 works of art, including paintings, watercolors, prints, drawings, photographs, sculpture, and other media. The artists represented are primarily early- and mid-twentieth-century American. The collection strengths reflect the two-fold founding mission of the museum program—to provide a visual resource for teaching and to place original art on public view on the campus, in nearby community centers, and in elementary and secondary public schools throughout the state.

The collection's works are in continual rotation in over 70 campus and community locations. Maine artists and collectors also have donated hundreds of works on paper to create 153 exhibits circulated under the museum's Museums by Mail program. Up to 150 classrooms are served each year, and over 300 schools currently are involved in the program that provides exhibits and original art and classroom materials to teachers.

The museum's collection is rich in works by artists who lived or spent a portion of their artistic careers in Maine, such as Waldo Peirce, Carl Sprinchorn, Edmund Schildknecht, Caroll Thayer Berry, Cadwallader Washburn, Winslow Homer, William Gropper, Marsden Hartley, John Marin, Emily Muir, Laurence Sisson, Will Barnet, Stow Wengrenroth, Fairfield Porter, and Neil Welliver.

The museum also has a teaching collection of historic and contemporary works in a variety of print techniques by such artists as Albers, Picasso, Calder, Braque, Goya, Piranesi, Hogarth, Daumier, Arp, Ernst, Morisot, Severini, Kollwitz, Whistler, Rouault, Tschabasov, Bolotowsky, Neel, Riley, Lichtenstein, and Dine.

University of Maine Museum of Art, 5712 Carnegie Hall, Orono, ME 04469-5712. Phone: 207/581-3255. Hours: 9–4:30 Mon.–Fri.; Sat. by appointment; closed major holidays. Admission: free.

## UNIVERSITY OF MEMPHIS
### Art Museum

Memphis State University and its University Gallery in Memphis, Tennessee, changed their names in 1994. The institution became the University of Memphis, and the gallery was renamed the Art Museum. Founded in 1981, the art facility is known for its collections and exhibits of Egyptian and West African art and artifacts.

The museum—administered through the Department of Art—occupies 12,000 square feet in the College of Communications and Fine Arts Building. It works with the Institute of Egyptian Art and Archaeology, which also is a component of the art department.

The Egyptian Collection consists of more than 150 antiquities from the 3500 B.C. to 700 A.D. period, including mummies, jewelry, and religious and funerary items. Among the other collections are the Neil Nokes Collection of African masks, wooden figures, and textiles; the Paul Gruenberg Miniature Collection of eighteenth-century American interiors; and a collection of nineteenth- and twentieth-century prints.

In addition to the permanent galleries containing Egyptian and West African art and artifacts and interior miniatures, the museum has three galleries for changing exhibitions, used mostly for contemporary art showings.

Art Museum, University of Memphis, Dept. of Art, 142 Communications and Fine Arts Bldg., 3750 Norriswood Ave., Memphis, TN 38152. Phone: 901/678-2224. Hours: 9–5 Tues.–Fri.; 1–5 Sat.–Sun.; closed holidays and when university not in session. Admission: free.

## UNIVERSITY OF MIAMI
### Lowe Art Museum

The Lowe Art Museum at the University of Miami in Coral Gables, Florida, keeps expanding its facilities and collections. The museum, which developed from two gallery spaces in a classroom in 1948, opened in its own building in 1952; had additions in 1953, 1956, and 1961; and now is building a 10,000-square-foot addition to its 23,000-square-foot structure.

During this growth period, the museum continued to enlarge its holdings. Its collections—best known for their emphasis on non-Western art—now include the Samuel H. Kress Study Collection of Renaissance and Baroque art; Alfred I. Barton Collection of North American Indian art; Samuel K. Lothrop Collection of Guatemalan textiles; Cintas Collection of Spanish paintings; collections of pre-Columbian art; Asian sculpture, bronzes, ceramics, and paintings; African art; and European and American paintings, sculpture, and works on paper.

The museum's changing exhibitions are varied, ranging from the decorative arts to contemporary art.

Lowe Art Museum, University of Miami, 1301 Stanford Dr., Coral Gables, FL 33124-6310. Phone: 305/284-3535. Hours: 10–5 Tues.–Sat.; 12–5 Sun.; closed major holidays. Admission: adults, $4; seniors, $3; students, $2; children 6–12, $1, children under 6, free.

# UNIVERSITY OF MICHIGAN
## University of Michigan Museum of Art

The University of Michigan at Ann Arbor began collecting art in 1855 with the purchase of engravings to illustrate lectures on classical antiquity. But it was not until 1946 that the University of Michigan Museum of Art was established as a separate administrative unit in Alumni Memorial Hall.

The museum now has a permanent collection of over 13,000 works of art. Among the most important collections are works on paper from 1600 to the present and Chinese and Japanese paintings and ceramics. Other holdings include Western art from the sixth century to the present, African and Oceanian art, objects from the Islamic world, twentieth-century sculpture, and photography.

Among the artworks are *Esther Before Ahasuerus* by Guercino, *The Annunciation* by Juan Valdes de Leal, *Begin the Beguine* by Max Beckmann, *Pre-Adamic Fruit* by Jean Arp, and more than 150 etchings and lithographs by J.M. Whistler.

From 13 to 18 special exhibitions are presented each year in five changing galleries. They include selections from the museum's collection and loan shows from other institutions.

University of Michigan Museum of Art, 525 S. State St., Ann Arbor, MI 48109-1354. Phone: 313/764-0395. Hours: academic year—10–5 Tues.–Sat.; 12–5 Sun.; summer—11–5 Tues.–Sat.; 12–5 Sun.; closed major holidays. Admission: free.

# UNIVERSITY OF MINNESOTA, DULUTH
## Tweed Museum of Art

The Tweed Museum of Art at the University of Minnesota, Duluth, opened in 1950 as the Tweed Gallery in the George P. Tweed mansion, but moved to the campus in 1958 and has been expanded several times. The building and major portions of the permanent collection were gifts from the Tweed family. The Alice Tweed Tuohy Foundation continues to support the museum program.

The museum now has eight galleries, a sculpture conservatory and courtyard, and over 3,000 works in its collections. The George P. Tweed Memorial Art Collection is best known for its large number of French Barbizon paintings, but also has a fine selection of nineteenth-century American paintings.

Among the other collections are the Simon, Milton, and Jonathan Sax Purchase Fund Collection of twentieth-century American paintings and sculpture; the Potlatch Collection of more than 300 illustrations of Northwest Mounted

Police; and an extensive print collection featuring twentieth-century American artists.

Tweed Museum of Art, University of Minnesota, Duluth, 10 University Dr., Duluth, MN 55812. Phone: 218/726-8222. Hours: 9–4:30 Tues.–Fri. (also to 8 Tues.); 1–5 Sat.–Sun.; closed holidays. Admission: suggested donation—adults, $3; children, $1; families, $5.

## UNIVERSITY OF MINNESOTA, TWIN CITIES
### Frederick R. Weisman Art Museum

The University Art Museum at the University of Minnesota, Twin Cities in Minneapolis opened with a new name and a new building in 1993. The museum, which began as "The Little Gallery" in 1934 and evolved into the University Art Museum in the 1970s, now is the Frederick R. Weisman Art Museum, housed in a striking $10.3 million, 47,300-square-foot facility designed by noted architect Frank O. Gehry.

The museum has approximately 13,000 works in its permanent collections. It possesses a significant collection of American art from the first half of the twentieth century, including the world's largest collection of work by Marsden Hartley, Alfred H. Maurer, and B.J.O. Nordfeldt. The museum also has strong collections of Asian, American, European, and Native American ceramics, as well as Korean furniture.

The museum presents exhibitions that place art within relevant cultural, social, and historical contexts. Several major exhibitions are offered each year.

Frederick R. Weisman, a Minnesota native who became a California philanthropist, art patron, and entrepreneur, provided the pivotal gift of $3 million, which gave the art museum a new home.

Frederick R. Weisman Art Museum, University of Minnesota, Twin Cities, 333 E. River Rd., Minneapolis, MN 55455. Phone: 612/625-9494. Hours: 10–5 Tues.–Fri. (also to 8 Thurs.); 11–5 Sat.–Sun.; closed holidays. Admission: free.

## UNIVERSITY OF MISSOURI–COLUMBIA
### Museum of Art and Archaeology

The Museum of Art and Archaeology at the University of Missouri–Columbia has a dual purpose—serving both the teaching and research missions of the university and the educational and aesthetic needs of the general public. The study collections for art history and archaeology were organized in 1957 to make available a modest group of archaeological artifacts and artworks. With the addition of 14 Kress Study Collection paintings in 1961, the collections became the Museum of Art and Archaeology. In 1976, the museum moved from the university library to its present home in Pickard Hall on the historic campus quadrangle.

The museum, which has become a regional museum for central Missouri, has its major strength in the art and archaeology of the ancient Mediterranean and

West Asia, which comprise more than half of the 13,000-plus objects in its collections. They include Egyptian predynastic to Roman pottery and wood and stone sculpture; fifth to first millennia B.C. pottery and Luristan bronzes from Iran; Mesopotamian pottery, cuneiform tablets, and sealstones; Anatolian objects in a variety of media from Neolithic through Byzantine; pottery and lamps from Syria; Palestinian pottery, metalwork, glass, and other media, Paleolithic to Byzantine; Cypriote pottery and metalwork; Greek pottery, metalwork, glass, jewelry, and stone and terracotta sculpture, Cycladic, Minoan/Mycenaean, and Geometric through Hellenistic; Villanovan, Etruscan, and Roman pottery, small bronzes, terracotta figurines, stone sculpture, jewelry, glass, and lamps; early Christian and Byzantine glass, jewelry, metalwork, lamps, stone sculpture, and Coptic textiles; and ancient Greek, Roman, and Byzantine coins from the seventh century B.C. to the fourteenth century A.D.

A secondary area of strength is a collection of European and American prints, drawings, and photographs from the fifteenth to the twentieth centuries, complemented by a collection of Old Master and nineteenth- and twentieth-century paintings, sculpture, and collages. The museum also has an extensive collection of terracotta and stone sculptures, bronzes, pottery, and paintings from India and Pakistan. Other collections include pre-Columbian, Central and South American, African, Oceanian, Chinese, Japanese, and Korean artworks and/or archaeological artifacts.

The museum's permanent exhibits occupy nine galleries on the second floor and feature a selection of artworks and archaeological artifacts from its collections. They are supplemented by temporary and traveling exhibitions.

Museum of Art and Archaeology, University of Missouri–Columbia, Pickard Hall, Columbia, MO 65211. Phone: 314/882-3591. Hours: 9–5 Tues.–Fri.; 12–5 Sat.–Sun.; closed holidays. Admission: free.

## UNIVERSITY OF MONTANA
### Museum of Fine Arts

The Museum of Fine Arts at the University of Montana in Missoula was founded in 1956. Part of the School of Fine Arts, it has two galleries and collections of such western artists as Sharp, Paxson, Mauer, and Chase; American artists, including Krasner and Motherwell; ceramic sculpture; and Montana area artifacts.

Museum of Fine Arts, University of Montana, School of Fine Arts, Missoula, MT 59812. Phone: 406/243-0211. Hours: 11–3 Mon.–Sat.; closed state holidays. Admission: free.

## UNIVERSITY OF NEBRASKA–KEARNEY
### Museum of Nebraska Art

The Museum of Nebraska Art is a partnership between the University of Nebraska–Kearney and the Nebraska Art Collection Foundation. It was created

to house the Nebraska Art Collection, the official visual art collection of the State of Nebraska. The museum opened in 1986 in the old Kearney Post Office Building, which was expanded to 37,500 square feet in 1993.

The museum's collections—which consist of nearly 4,000 works—feature art and artists associated with Nebraska from 1819 to the present. Among the highlights are works by such artist-explorers as Titian Ramsay Peale, Karl Bodmer, George Catlin, and Worthington Whittredge; such pioneer Nebraska artists as Robert Henri, William Henry Jackson, and Augustus Dunbier; and the Grant Reynard Collection. The museum also has a sculpture garden and maintains an archive on all artists associated with Nebraska.

Selections from the collections are presented on a rotating basis. At least two of the museum's 12 galleries are used for temporary exhibitions from other museums, private collections, or individual contemporary artists.

Museum of Nebraska Art, University of Nebraska–Kearney, 2401 Central Ave., PO Box 1667, Kearney, NE 68848-1667. Phone: 308/234-8559. Hours: 11–5 Tues.–Sat.; 1–5 Sun.; closed major holidays. Admission: free.

## UNIVERSITY OF NEBRASKA–LINCOLN
### Sheldon Memorial Art Gallery and Sculpture Garden

The Sheldon Memorial Art Gallery and Sculpture Garden at the University of Nebraska–Lincoln is known for its twentieth-century American art and its travertine marble building designed by noted architect Philip Johnson and flanked by a sculpture garden. The museum and the building opened in 1963, consolidating a collection and exhibit spaces scattered in various buildings on the campus.

The 60,000-square-foot museum has over 12,000 artworks, consisting mainly of nineteenth- and twentieth-century American art. They include collections of early American modernism, American impressionism, geometric abstraction, American photography, and post–World War II American sculpture.

Among the twentieth-century American artists represented in the collections are Walt Kuhn, Max Weber, Stuart Davis, Edward Hopper, Mark Rothko, Morris Louis, James Brooks, Helen Frankenthaler, Conrad Marca-Relli, and Robert Motherwell. Nineteenth-century American painters include Ralph Blakelock, Thomas Eakins, Albert Ryder, and Thomas Moran. The 15-acre sculpture garden contains works by Gaston Lachaise, Jacques Lipchitz, Bruno Lucchesi, Elie Nadelman, Reuben Nakian, Julius Schmitt, David Smith, Tony Smith, William Zorach, and others.

The museum's exhibition program consists of three parts—exhibits from its permanent collections, exhibitions obtained from other institutions, and shows organized by the Sheldon staff from outside sources.

Sheldon Memorial Art Gallery and Sculpture Garden, University of Nebraska–Lincoln, 12th and R Sts., PO Box 880300, Lincoln, NE 68588-0300. Phone: 402/472-2461. Hours: 10–5 Tues.–Sat. (also 7–9 Thurs.–Sat.); 2–9 Sun.; closed holidays. Admission: free.

### Center for Great Plains Studies Art Collection

The Center for Great Plains Studies Art Collection at the University of Nebraska–Lincoln was founded in 1980 when Dr. John and Elizabeth Christlieb gave their collection of western art and library of western Americana to the center. The gift of 175 bronze sculptures, 160 paintings, 300 works of art on paper, and a 2,000-volume library still forms the core of the collection.

The center's collection, which now includes approximately 750 works of art and 4,000 volumes, occupies nearly 5,500 square feet in the university's main library building. Most of the five exhibitions presented each year draw upon the permanent collection.

The Christlieb Collection includes sculptures by Charles M. Russell and Frederick S. Remington and photographs by William Henry Jackson. The center also has a growing collection of paintings by Native American artists made possible by donors Patricia J. and Stanley H. Broder.

Center for Great Plains Studies Art Collection, University of Nebraska–Lincoln, 205 Love Library, PO Box 880475, Lincoln, NE 68588-0475. Phone: 402/472-6220. Hours: 9:30–5 Mon.–Fri.; 10–5 Sat.; 1:30–5 Sun.; closed major holidays and between semesters. Admission: free.

## UNIVERSITY OF NEW HAMPSHIRE
### The Art Gallery

The Art Gallery at the University of New Hampshire in Durham was founded in 1960 with the opening of the Paul Creative Arts Center, which also houses the Departments of the Arts, Music, and Theater and Dance. It operates as an adjunct of the Department of the Arts, which mounted exhibitions in the library for 20 years before the museum became a reality.

The Art Gallery has a collection of approximately 1,000 works that emphasizes nineteenth- and twentieth-century prints and drawings. The prized works include nearly 200 Japanese woodblock prints from the nineteenth century, as well as twentieth-century works on paper.

From six to eight changing exhibitions, ranging from historical to contemporary, are presented each year. They feature selections from the permanent collection and the work of faculty and senior art students. A series of major exhibitions with scholarly catalogs has documented New Hampshire's cultural and historic heritage.

The Art Gallery, University of New Hampshire, Paul Creative Arts Center, 30 College Rd., Durham, NH 03824-3538. Phone: 603/862-3712. Hours: 10–4 Mon.–Thurs. (also to 8 Thurs.); 1–5 Sat.–Sun.; closed summer and major holidays. Admission: free.

## UNIVERSITY OF NEW MEXICO
### University Art Museum

The University Art Museum at the University of New Mexico in Albuquerque consists of two facilities—the main museum located in the Fine Arts Center and

the Jonson Gallery in the former residence/studio of artist Raymond Jonson across campus (described separately).

Founded in 1963, the University Art Museum has approximately 25,000 works in its collections. It possesses one of the nation's best university museum collections of photography and a strong collection of prints, with special emphasis on the history of lithography. The museum is the archive for all works produced by the Tamarind Institute. It also has collections of Latin American art, works of Modernism, Old Master paintings and sculpture, Spanish Colonial art, and nineteenth- and twentieth-century art.

The superb collection of daguerreotypes, ambrotypes, tintypes, and photographs includes the work of many of the pioneering photographers, including Roger Fenton, Paul Martin, Francis Firth, David O. Hill, Gertrude Kasebier, Felice Beato, Eduard-Denis Baldus, P.H. Emerson, Giorgio Sommer, and Alfred Steiglitz. Among the artists represented are Theophile Steinlen, with one of the largest known nineteenth-century lithographs; Gaston Lachaise, a larger-than-life bronze figure; and Georgia O'Keeffe, the ca. 1913 *Tent Door at Night* watercolor.

University Art Museum, University of New Mexico, Fine Arts Center, Cornell and Central, NE, Albuquerque, NM 87131-1416. Phone: 505/277-4001. Hours: 9–4 Tues.–Fri. (also 5–8 Thurs.); 1–4 Sun.; closed holidays. Admission: free.

### Jonson Gallery

The Jonson Gallery, now a branch of the University of New Mexico Art Museum in Albuquerque, was founded in 1950 by Professor Raymond Jonson in his residence/studio to preserve and exhibit his own and other modernist artists' work. It was the only modernist exhibition space in New Mexico until the mid-1960s. After Jonson's death, his collections and the space went to the university to become a museum focusing on modernism in New Mexico and experimental work. The museum continues to present revolving exhibitions from the Jonson collection of over 700 works and a collection of more than 500 works by other artists, with an emphasis on New Mexico art. Most of the exhibitions, however, present changing shows of work by living artists.

Jonson Gallery, University of New Mexico, 1909 Las Lomas, NE, Albuquerque, NM 87131. Phone: 505/277-4697. Hours: 9–4 Tues.–Fri. (also 5–8 Tues.); weekends by appointment; closed holidays. Admission: free.

### Harwood Foundation Museum

The Harwood Foundation Museum in Taos, New Mexico, was started in 1923 by Lucy Case Harwood and transferred to the University of New Mexico in 1935. It has a collection of works in all media by Taos artists from the early twentieth century to the present and a Hispanic traditions collection of retablos, tinwork, and furniture.

The museum, located in a Pueblo Revival building dating from the mid-nineteenth century that is on the National Register of Historic Places, also has old New Mexico santos, Persian miniatures, primitive carvings, and books on the art and literature of the Southwest.

Harwood Foundation Museum, University of New Mexico, 238 Ledoux St., PO Box 4080, Taos, NM 87571. Phone: 505/758-9826. Hours: 12–5 Mon.–Fri.; 10–4 Sat.; closed major holidays. Admission: adults, $2.

## UNIVERSITY OF NORTH CAROLINA AT CHAPEL HILL
### Ackland Art Museum

The Ackland Art Museum at the University of North Carolina at Chapel Hill is the only museum in the United States where the donor's remains actually lie within the building his generosity made possible. William Hayes Ackland was a Tennesseean who willed a substantial sum to be used to establish an art museum in a major university in the South. After years of litigation over the site, the courts awarded the bequest to the University of North Carolina. Ackland's remains are entombed in a marble sarcophagus overlaid with his reclining bronze figure.

The museum building, which opened in 1958, contains a wide range of artworks—from ancient Greek bronzes to Renaissance altar panels and from Han Dynasty ceramics to twentieth-century abstract paintings. It has representative works of such masters as Rubens, Delacroix, Degas, and Pissarro, as well as one of the strongest collections of Indian art and western prints, drawings, and photographs in the Southeast.

Among the holdings are a second-century B.C. Greek bronze female head, *Blessing Christ* frescoe by Francesco Traini (ca. 1335), *Posthumous Portrait of Louis II de Bourbon, Prince of Conde* Baroque bust by Antoine Coysevox (commissioned in 1688), *Cleopatra and the Servant* oil on canvas by Eugen Delacroix (1838), *View of the Ile St. Louis* oil on canvas by Henri Rousseau (1888), *Composition with Three Figures* gouache by Max Weber (1910), and *Sculpture-Seuil* bronze by Jean (Hans) Arp (1959).

Ackland Art Museum, University of North Carolina at Chapel Hill, Columbia and Franklin Sts., Campus Box 3400, Chapel Hill, NC 27599-3400. Phone: 919/966-5736. Hours: 10–5 Wed.–Sat.; 1–5 Sun.; closed major holidays. Admission: free.

## UNIVERSITY OF NORTH CAROLINA AT GREENSBORO
### Weatherspoon Art Gallery

The Weatherspoon Art Gallery at the University of North Carolina at Greensboro was founded by the Department of Art in 1942 when the institution was still the Women's College of the University of North Carolina. The museum now is located in the Anne and Benjamin Cone Building, constructed in 1989, which also houses the art history program of the Department of Art.

The gallery—which has over 4,500 objects in its collections—is known for its collection of twentieth-century American art, with one of its most prized collections being the Etta Cone Collection of 67 lithographs and 6 bronzes by Henri Matisse. The gallery's exhibition program features selections from the

Weatherspoon collections; contemporary shows by faculty, students, and visiting artists; and traveling exhibitions.

Weatherspoon Art Gallery, University of North Carolina at Greensboro, Spring Garden and Tate Sts., Greensboro, NC 27412-5001. Phone: 910/334-5770. Hours: 10–5 Tues.–Fri. (also to 8 Wed.); 1–5 Sat.–Sun.; closed holidays. Admission: free.

## UNIVERSITY OF NORTH DAKOTA
### North Dakota Museum of Art

Contemporary art is the focus of the North Dakota Museum of Art at the University of North Dakota in Grand Forks. Founded in 1970, the museum moved into a renovated 1907 historic and more spacious campus building, once used as a gymnasium, in 1989.

The museum has collections of regional art, folk art, and aerial photography and presents both contemporary and historical exhibitions. The emphasis, however, is clearly on contemporary art. Many of the exhibitions are curated internally, while others are traveling exhibitions.

North Dakota Museum of Art, University of North Dakota, Centennial Dr., PO Box 7305, Grand Forks, ND 58202. Phone: 701/777-4195. Hours: 9–5 Mon.–Fri. (also to 9 Thurs.); 1–5 Sat.–Sun.; closed New Year's Day, Thanksgiving, and Christmas. Admission: free.

## UNIVERSITY OF NOTRE DAME
### Snite Museum of Art

The Snite Museum of Art at the University of Notre Dame in Notre Dame, Indiana, contains approximately 19,000 works from antiquity to the twentieth century. The majority of the 68,000-square-foot museum, which opened in 1980, is devoted to its permanent collection.

Among the museum's important works are those by Ridolfo Ghirlandaio, Claude Lorrain, Abraham Bloemaert, François Boucher, Thomas Eakins, Frederic Remington, Georgia O'Keeffe, George Rickey, Joseph Stella, Milton Avery, and Jim Dine.

Notable collections include the Feddersen Collection of Rembrandt etchings, Noah L. Burkin bequest of nineteenth-century French paintings, Reilly Collection of Old Master drawings, Janos Scholz Collection of nineteenth-century European photographs, Mary Lou and Judd Leighton Collection of pre-classical figurines, and Kress Study Collection. The museum also has a collection and study center of sculpture and drawings by Ivan Meštrović, the noted Yugoslav sculptor who spent his last days at the university.

The museum's galleries are designed chronologically. The first level contains the Alsdorf Gallery of ancient, medieval, and Renaissance art and the Knott-Beckman Gallery of sixteenth- and seventeenth-century art. The Meštrović Gal-

lery and the O'Shaughnessy Galleries, used for larger temporary exhibitions, also are on this floor.

On the second level are the eighteenth-, nineteenth-, and twentieth-century galleries. The Print, Drawing, and Photography Gallery is located between the two levels. It also is the site of smaller temporary exhibitions. The lower level features ethnographic, decorative, and American art.

The museum also has an outdoor sculpture garden that features *Griffon,* a 27-foot steel sculpture by David Hayes, and a kinetic sculpture by George Rickey.

Snite Museum of Art, University of Notre Dame, Notre Dame, IN 46566. Phone: 219/631-5466. Hours: 10–4 Tues.–Sat. (also to 6 Thurs. when classes in session); 1–4 Sun.; closed major holidays. Admission: suggested donation—$2.

## UNIVERSITY OF OKLAHOMA
### Fred Jones Jr. Museum of Art

The Fred Jones Jr. Museum of Art at the University of Oklahoma in Norman is best known for its contemporary art, but it also has a variety of other holdings, including Oriental paintings and sculpture, Flemish and Dutch paintings, and Native American art.

The museum, founded in 1936 as the University of Oklahoma Museum of Art, has a collection of over 5,000 works. Its strongest areas are post–World War II American paintings, graphics, and photography. The museum occupies 20,000 square feet in the Fred Jones Jr. Memorial Art Center, which also houses the School of Art.

Fred Jones Jr. Museum of Art, University of Oklahoma, 410 W. Boyd St., Norman, OK 73070-0525. Phone: 405/325-3272. Hours: 10–4:30 Tues.–Sun. (also to 9 Thurs.); closed holidays. Admission: free.

## UNIVERSITY OF OREGON
### University of Oregon Museum of Art

The University of Oregon Museum of Art in Eugene was founded in 1930 as a result of a major gift of Asian art in 1921. State legislators and private individuals were so inspired by the Murray Warner Collection of Oriental art that they provided the funds for the museum's 24,000-square-foot building, which opened in 1933.

The Asian collection—later supplemented by Warner's bequest and other acquisitions—primarily features works from China and Japan, but also has works from Cambodia, Korea, Mongolia, Tibet, India, and Russia, as well as American and British works that show Oriental influence. It includes Chinese jade, ceramics, and imperial textiles; Japanese arts and crafts; Ghandaran and Indian sculpture; Persian miniatures and ceramics; and a 70-inch-high Imperial Jade Memorial Pagoda commissioned by Chinese Emperor K'ang Hsi, ca. 1709.

The museum also has a rich collection of twentieth-century art of the Pacific

Northwest, which began with a gift by the Haseltine family. It includes major paintings by Oregon-born Morris Graves and a Graves archival collection of nearly 500 drawings, sketches, prints, and other objects. Other Northwest artists represented include Louis Bunce, Kenneth Callahan, Tom Hardy, James Mc-Garrell, Carl and Hilda Morris, C.S. Price, and Mark Tobey.

Other museum collections include American and European contemporary art, West African art, Syrian glass, decorative arts, graphics, prints, and photographs. The changing exhibition program consists primarily of contemporary art.

University of Oregon Museum of Art, 1430 Johnson Lane, 1223 University of Oregon, Eugene, OR 97403-1223. Phone: 503/346-3027. Hours: 12–5 Wed.–Sun.; closed holidays. Admission: free.

## UNIVERSITY OF PUERTO RICO
### Museum of Anthropology, History, and Art

(See Archaeology, Anthropology, and Ethnology Museums section.)

## UNIVERSITY OF PITTSBURGH AT JOHNSTOWN
### Southern Alleghenies Museum of Art at Johnstown

(See Saint Francis College in this section.)

## UNIVERSITY OF RICHMOND
### Marsh Art Gallery

The Marsh Art Gallery on the Weshampton Campus of the University of Richmond in Richmond, Virginia, is undergoing growing pains. It has occupied 3,000 square feet in the Modlin Fine Arts Center since it was founded in 1967, but will expand to 9,000 square feet when a new $16 million arts complex is completed in the fall of 1996. The gallery has a small collection, primarily of Western contemporary art, and presents changing exhibitions by established and emerging contemporary artists and exhibitions of national and international historical art.

Marsh Art Gallery, University of Richmond, Modlin Fine Arts Center, University of Richmond, Richmond, VA 23173. Phone: 804/289-8276. Hours: academic year—1–5 Tues.–Sun.; summer—1–5 Fri.–Sun.; closed holidays and recesses. Admission: free.

### Lora Robins Gallery of Design from Nature

The Lora Robins Gallery of Design from Nature at the University of Richmond in Richmond, Virginia, is a unique museum of geology, mineralogy, natural history, and art. It was founded in 1977 following the gift of a large collection of minerals, fossils, and sea shells by Mrs. Lora M. Robins. It seeks to further ''an awareness, appreciation, and understanding of the handicraft of nature and its role in the development of culture through its application by mankind.''

The gallery, which moved into a new 25,000-square-foot facility in 1989, now has a collection of more than 20,000 specimens, artworks, and artifacts. Central in the gallery is the Boehm Atrium, featuring an impressive collection of over 100 Boehm porcelains. Extending from this core are corridors of displays with collections of gems and jewels, minerals, sea shells and corals, fossils, and cultural artifacts relating nature's art to human culture.

Among the exhibit highlights are a meter-square model of the Taj Mahal, made in Agra, India, of alabaster from the same quarry as the Taj Mahal itself was cut over 350 years ago; over 10,000 sea shells; a fluorescent mineral room with minerals changing colors with different wavelengths of ultraviolet lights; beautiful Chinese porcelains and jade carvings; and mineral specimens of exceptional quality.

Lora Robins Gallery of Design from Nature, University of Richmond, Richmond Way, Richmond, VA 23713. Phone: 804/289-8460. Hours: 9–4 Mon.–Fri.; 1–5 Sat.–Sun.; closed holidays. Admission: free.

# UNIVERSITY OF ROCHESTER
## Memorial Art Gallery

The Memorial Art Gallery of the University of Rochester in Rochester, New York, offers a panorama of the world's art—from the relics of antiquity to contemporary works. It is best known for its medieval treasures, but it has other strengths, such as seventeenth-century art, nineteenth- and twentieth-century French and American paintings, American folk art, and European and American prints and drawings.

The museum opened with a small collection of paintings and sculpture in its Italian Renaissance–style home in 1913. As the collections grew, the building was expanded in 1926, 1968 (when an outdoor sculpture garden also was added), and 1987.

The museum's rich medieval collection includes capitals, ivories, illuminated manuscripts, enamels, sculpture, stained glass, tapestries, and a frescoed apse from a chapel in Auvergne. One of the collection highlights is a thirteenth-century French limestone capital, consisting of three of Christ's apostles looking on as Christ shows his wound to Doubting Thomas, called *Doubting Thomas, Christ and Apostles.*

The works of Egyptians, Mesopotamians, Greeks, Etruscans, and Romans are featured in the ancient art collection. Among the objects are a sphinx from Karnak, a little figure from Babylon, and rare jars decorated with warriors from the Aegean. The Asian art and primitive arts collections contain examples from North America, Africa, Colombia, Guatemala, Mexico, Peru, and other parts of the world. Panel paintings such as *Madonna and Child Enthroned* by the Master of the St. Ursula Legend and *St. Margaret with Donor* by Vrancke van der Stockt are part of the Renaissance collection.

Among the artworks from the seventeenth to the twentieth centuries are *Rec-*

onciliation Between Henri III and Henri of Navarre by Peter Paul Rubens (ca. 1630) and Waterloo Bridge, Soleil Voile by Claude Monet (1903). Others represented in the collection are Rembrandt, Van Dyck, Boucher, Delacroix, Coubet, Degas, Matisse, Picasso, and Cézanne.

The American works include The Artist's Studio in an Afternoon Fog by Winslow Homer (1894) and Boom Town by Thomas Hart Benton (1928). Among others in the collection are George Catlin, Thomas Eakins, Albert Pinkham Ryder, Max Weber, Hans Hofmann, Stuart Davis, and Andy Warhol.

Henry Moore's Vertebrae can be seen in the sculpture garden. Other museum sculptures include the works by Maillol, Smith, Nadelman, Noguchi, Lachaise, and Sellers.

Memorial Art Gallery, University of Rochester, 500 University Ave., Rochester, NY 14607. Phone: 716/473-7720. Hours: 12:30–9 Tues.; 10–4 Wed.–Fri.; 10–5 Sat.; 12–5 Sun.; closed major holidays. Admission: adults, $4; seniors and college students, $3; children 6–18; $2; children under 6, free; 5–9 Tues, $2.

## UNIVERSITY OF THE SOUTH
### University Gallery

(See Art Galleries section.)

## UNIVERSITY OF SOUTH CAROLINA
### McKissick Museum

(See General Museums section.)

## UNIVERSITY OF SOUTHERN CALIFORNIA
### Fisher Gallery

The Fisher Gallery at the University of Southern California in Los Angeles was established in 1939 with a gift of paintings and funds from Elizabeth Holmes Fisher. The gallery's collections were enhanced in subsequent years by other donations, including the Armand Hammer Collection.

The gallery's most prized artworks today still are the American, British, and French paintings from Fisher and the seventeenth- and eighteenth-century northern European works from Hammer.

A large portion of the collection consists of Dutch and Flemish works, including two Rubens paintings, Venus Wounded by a Thorn and The Nativity. Other works include Barbizon and Hudson River school paintings, Oriental porcelains, Chinese bronze mirrors, Georgian silver, and prints from the eighteenth and nineteenth centuries.

The 7,000-square-foot gallery, which is used primarily as a teaching aid in art, museum studies, and other courses, exhibits works by contemporary and Old Master artists.

Fisher Gallery, University of Southern California, University Park, Los Angeles, CA 40089-0292. Phone: 213/740-4561. Hours: 12–5 Mon.–Fri.; 11–3 Sat.–Sun. Admission: free.

# UNIVERSITY OF SOUTH FLORIDA
## Contemporary Art Museum

A gallery program started in 1968 developed into the Contemporary Art Museum at the University of South Florida in Tampa in 1989 with the opening of a 13,000-square-foot separate facility. The museum now has a collection of approximately 3,000 contemporary works, consisting largely of graphics, photography, and public art commissions.

Among the holdings are the graphics of such contemporary artists as Anuszkiewicz, Calder, Dine, Rauschenberg, and Rosenquist and photographs by Caponigro, Hine, Minor, Velsmann, and White. The museum also has paintings, sculpture, and ceramics, including a pre-Columbian collection from Mexico and Costa Rica, folk art from Guatemala, and masks and sculpture from West Africa. The museum frequently features contemporary art with an international perspective in its two galleries.

Contemporary Art Museum, University of South Florida, 4202 Fowler Ave., Tampa, FL 33620. Phone: 813/974-2849. Hours: 10–5 Mon.–Fri.; 1–4 Sat.; closed holidays. Admission: free.

# UNIVERSITY OF SOUTHWESTERN LOUISIANA
## University Art Museum

The University Art Museum at the University of Southwestern Louisiana in Lafayette has a permanent collection of primarily nineteenth- and twentieth-century works of art and a continuous program of changing exhibitions of both a historical and a contemporary nature. It operates out of two sites—one featuring the collection and the other (historic Fletcher Hall) presenting changing exhibitions.

The museum, which was founded in 1968, has approximately 1,500 works in its collections, including the Louisiana Collection of nineteenth- and twentieth-century paintings, drawings, sculpture, and photographs of Louisiana; Henry Botkin Collection of paintings, drawings, and collages from 1928–1981; and Heymann-Cohn Collection of Japanese prints from the nineteenth and twentieth centuries. Among the most notable holdings are nineteenth-century portraits by American and French artists who worked in New Orleans between 1795 and 1861.

University Art Museum, University of Southwestern Louisiana, E. Lewis and Girard Park Cir., USL Drawer 42571, Lafayette, LA 70504. Phone: 318/231-5326. Hours: 9–4 Mon.–Fri.; 2–5 Sun.; closed holidays. Admission: adults, $2; seniors, $1; children 18 and under, free.

## UNIVERSITY OF TEXAS AT AUSTIN
### Archer M. Huntington Art Gallery

The Archer M. Huntington Art Gallery, which functions as the art museum and a teaching and research facility at the University of Texas at Austin, operates out of two campus locations—with changing contemporary art exhibitions being presented in the Art Building and the gallery collections being stored and exhibited at the Harry Ransom Humanities Research Center.

The gallery was founded in the then-new Art Building in 1963 after two decades of exhibitions in various university buildings and was later expanded to the Harry Ransom Center as the collections grew. The collections now contain over 10,000 pieces.

Among the artworks on display on the first and second floors of the Harry Ransom Center are selections from the Mari and James Michener Collection of twentieth-century American painting (375 works), the C.R. Smith Collection of western art (approximately 100 works), the Contemporary Latin American Art Collection (over 1,500 works), the William T. Battle Collection of 80 nineteenth-century plaster casts of Greek and Roman sculpture, a collection of more than 8,500 prints and drawings, and collections of ancient, medieval, European, and Australian art.

Archer M. Huntington Art Gallery, University of Texas at Austin, Art Bldg. (at 23rd and San Jacinto Sts.) and Harry Ransom Center (at 21st and Guadalupe Sts.), Austin, TX 78712-1205. Phone: 512/471-7324. Hours: 9–5 Mon.–Sat.; 1–5 Sun.; closed major holidays. Admission: free.

## UNIVERSITY OF UTAH
### Utah Museum of Fine Arts

The Utah Museum of Fine Arts at the University of Utah in Salt Lake City offers a broad overview of the principal artistic styles and periods of art history. Founded in 1951 after two major gifts of art, the museum occupies a 35,000-square-foot building constructed in 1972.

The museum's collections, which total over 15,000 works, include the Val A. Browing Collection of Old Master paintings, Natacha Rambova Collection of Egyptian antiquities, European paintings and decorative arts, contemporary American works on paper, and traditional arts of Africa, Indonesia, Oceania, and the Americas.

Among the highlights are nineteenth-century American and French landscapes, seventeenth- and eighteenth-century English furniture and paintings, eighteenth-century French tapestries and decorative arts, Italian Renaissance paintings, Egyptian antiquities, objects from various Buddhist cultures, Ch'ing Dynasty porcelains, Navajo weavings, and contemporary graphics.

Utah Museum of Fine Arts, University of Utah, 101 Art and Architecture Center, Salt Lake City, UT 84112. Phone: 801/581-7049. Hours: 10–5 Mon.–Fri.; 2–5 Sat.–Sun.; closed major holidays. Admission: free.

## UNIVERSITY OF VERMONT
### Robert Hull Fleming Museum

The Robert Hull Fleming Museum at the University of Vermont in Burlington is an art/anthropology museum with more than 17,000 objects from many of the world's past and present cultures. The museum, which opened in 1931 in a neoclassical building, was made possible largely by a gift from Katherine Wolcott, niece of Fleming, who was an 1862 alumnus. They were art collectors and world travelers whose collections were presented to the university, which built the museum to house their and other university collections.

The museum's permanent collection now includes American and European paintings; medieval to modern sculpture, prints, and drawings; ancient pre-Columbian, African, Oceanian, and Oriental art and objects; Native American materials; decorative arts; costumes; textiles; and archaeological and anthropological materials.

Among the exceptional holdings are a large collection of works on paper, an ancient Egyptian collection, American art from the first half of the twentieth century, and the Ogden Benedict Read Collection of Northern Plains Indian art. Other works of great interest include paintings by Vermont artists, including Francis Colburn and Ronald Slayton; unusual examples of Rookwood pottery; and a variety of Asian and Middle Eastern objects.

The museum presents temporary exhibitions from its collections and major traveling shows.

Robert Hull Fleming Museum, University of Vermont, Colchester Ave., Burlington, VT 05405. Phone: 802/656-0750. Hours: academic year—9–4 Tues.–Fri.; 1–5 Sat.–Sun.; summer—12–4 Tues.–Fri.; 1–5 Sat.–Sun.; closed holidays. Admission: free.

## UNIVERSITY OF VIRGINIA
### Bayly Art Museum

In 1929, the University of Virginia at Charlottesville received a $100,000 bequest from Evelyn Bayly Tiffany to establish an art museum on the beautiful campus founded and planned by Thomas Jefferson. It resulted in a 10,000-square-foot Palladian-style university museum in 1935 that later was renamed the Bayly Art Museum.

The museum now has a collection of approximately 7,000 artworks, including American and European art in the age of Jefferson, as well as pre-Columbian, Asian, African, and Native American art; nineteenth-century French prints; and nineteenth- and twentieth-century American paintings, prints, drawings, sculp-

ture, and photographs. The museum has seven galleries for its permanent collection and the 8 to 10 temporary exhibitions presented each year.

Bayly Art Museum, University of Virginia, Rugby Rd., Charlottesville, VA 22901. Phone: 804/924-3592. Hours: 1–5 Tues.–Sun.; closed major holidays and Christmas recess. Admission: free.

## UNIVERSITY OF WASHINGTON
### Henry Art Gallery

Nineteenth- and early-twentieth-century European and American paintings, drawings, and prints are featured at the Henry Art Gallery at the University of Washington in Seattle. It also has an extensive collection of works by Pacific Northwest artists, contemporary Japanese folk art, photographs spanning the history of the medium, and ethnic textiles and costumes from 131 countries.

The museum, which opened in 1927, was a gift of Horace C. Henry, a Seattle railroad and timber magnate. He gave the university a collection of 126 predominately nineteenth-century paintings from the Barbizon School, landscapes from the Hudson River School, and academic works from the Paris Salon, as well as $100,000 for the construction of a building, which is a modified Tudor Gothic structure with the varied patterns of its brick exterior being divided by ornamented stone in low relief. A major expansion is now under way, which will add approximately 35,000 square feet to the 10,000-square-foot facility.

Among the Henry Art Gallery's collections are paintings and drawings by Morris Graves and Mark Tobey of the Pacific Northwest; drawings and prints of Georges Rouault of France, William Hogarth of Britain, and Giovanni Battista Piranesi of Italy; and works by Homer, Inness, Blakelock, and Rauschenberg. It also has numerous special exhibitions, usually with an emphasis on selections from its collections and the work of living artists.

Henry Art Gallery, University of Washington, 15th Ave., NE and N.E. 41st St., Seattle, WA 98105. Phone: 206/543-2281. Hours: 11–5 daily. Admission: adults, $3.50; seniors and non-university students, $2; University of Washington students, faculty, and staff, free.

## UNIVERSITY OF WISCONSIN–MADISON
### Elvehjem Museum of Art

The Elvehjem Museum of Art at the University of Wisconsin–Madison evolved from the assembling of artworks for teaching purposes beginning in the 1940s. By 1958, the need for a facility for the collections became apparent, and when President Conrad A. Elvehjem sought the opinion of the faculty, the vote was unanimous to make the construction of an art museum a priority. As a result, the museum was founded in 1962 and opened in 1970.

The museum occupies a 90,000-square-foot building adjacent to the Humanities Building and Vilas Communication Hall, making the complex the center

of cultural activities on the campus. Its collections have grown to over 15,000 paintings, prints, drawings, sculpture, decorative arts, photographs, artifacts, and other objects.

Holdings of special note include the Edward Burr Van Vleck Collection of Japanese prints, Earnest C. Watson and Jane Werner Watson Collection of Indian miniature paintings, Vernon Hall Collection of European medals, Joseph E. Davies Collection of Russian and Soviet paintings, Richard E. Stockwell Collection of Oriental decorative arts, and Liebman Collection of Chinese export porcelain.

Among the collections are Egyptian, Greek, and Roman art; Near Eastern artifacts; medieval, Renaissance, and Baroque art; Asian sculpture, paintings, prints, and decorative art; eighteenth- through twentieth-century art; and more than 7,500 prints, drawings, photographs, and miniature paintings in the Mayer Print Center. Over 110,000 volumes also can be found in the Kohler Art Library on the ground level.

Eighty percent of the museum's 26,637 square feet of gallery space is devoted to permanent installation, with the remainder being used for temporary exhibitions from the collections and elsewhere.

Elvehjem Museum of Art, University of Wisconsin–Madison, 800 University Ave., Madison, WI 53706-1479. Phone: 608/263-2246. Hours: 9–5 daily; closed New Year's Day, Thanksgiving, and Christmas Eve and Day. Admission: free.

## UNIVERSITY OF WISCONSIN–MILWAUKEE
### UWM Art Museum

The UWM Art Museum at the University of Wisconsin–Milwaukee consists of three parts—the main museum in Vogel Hall, the Fine Arts Gallery in the Fine Arts Center, and the Art History Gallery in Mitchell Hall. The museum was founded in 1982.

The collections and principal exhibits—in such areas as contemporary art, folk art, and sculpture—are located in the main art museum. The collections contain contemporary and historic works from the United States, Europe, Africa, and Asia, including paintings, graphics, sculpture, Greek and Russian icons, European liturgical items, and artworks by Wisconsin artists.

Student and faculty shows are presented in the Fine Arts Gallery, while the Art History Gallery features changing exhibitions of more traditional art.

UWM Art Museum, University of Wisconsin–Milwaukee, 3253 N. Downer Ave., Box 413, Milwaukee, WI 53211. Phone: 414/229-6509. Hours: 10–4 Tues.–Fri. (also to 8 Wed.); 1–4 Sat.–Sun.; closed holidays. Admission: free.

## UNIVERSITY OF WYOMING
### University of Wyoming Art Museum

The University of Wyoming Art Museum in Laramie is located in the new Centennial Complex, a dramatic conical structure completed in 1993, which also

houses the university's American Heritage Center and archives. The museum has nine expansive galleries and an outdoor sculpture terrace, which offer a variety of exhibition experiences.

The art museum, founded in 1968 and formerly in the Fine Arts Center, has a diverse collection of over 6,000 objects, including European and American paintings, prints, and drawings; nineteenth-century Japanese prints; eighteenth- and nineteenth-century Persian and Indian miniature paintings; twentieth-century photography; decorative art; crafts; and African and Native American artifacts.

It has works by Frederic Remington, Alfred Jacob Miller, Albert Bierstadt, Thomas Moran, Thomas Hart Benton, George B. Luks, Charles E. Burchfield, Yasuo Kuniyoski, Theodor Rombouts, Alfred Stevens, Jules Dupré, and many other artists.

The permanent collection is the primary source for exhibits. Exhibitions also are obtained on loan from other institutions, galleries, and artists. In addition, the museum organizes traveling exhibitions and operates an Art Mobile Program, which provides exhibitions and hands-on art activities throughout the state in traditional and nontraditional settings.

University of Wyoming Art Museum, Centennial Complex, 2111 Willet Dr., PO Box 3807, Laramie, WY 87071-3807. Phone: 307/766-6622. Hours: 10–5 Tues.–Fri.; 2–5 Sat.–Sun.; closed major holidays. Admission: adults, $3.50; seniors and children 6–17, $1.50; university students and children 5 and under, free.

### American Heritage Center

(See Library and Archival Collections and Galleries section.)

## URSINUS COLLEGE
### Philip and Muriel Berman Museum of Art

The Philip and Muriel Berman Museum of Art at Ursinus College in Collegeville, Pennsylvania, was founded in 1987 by the college and a couple who wanted to share their large collection of art for study and enjoyment. The Bermans endowed the directorship, gave over 3,000 works of art, and continue to be partners in strengthening the program.

The museum is housed in a renovated 17,000-square-foot former library building and has an impressive outdoor contemporary sculpture collection. Among the significant holdings are nineteenth- and early-twentieth-century American landscape and impressionist paintings and watercolors; eighteenth- and nineteenth-century European and American portraits; Old Master and contemporary Japanese woodcuts, watercolors, and artifacts; twentieth-century American pop, op, and contemporary paintings and prints; Pennsylvania German art and artifacts; and a comprehensive survey of the work of British sculptor Lynn Chadwick, containing 140 pieces.

Ten to 12 exhibitions are presented each year, covering a variety of historical periods and mediums, such as archaeology, folk art, contemporary painting and sculpture, Old Master drawings, ceramics, and works on paper.

Philip and Muriel Berman Museum of Art, Ursinus College, Main St., PO Box 1000, Collegeville, PA 19426. Phone: 215/489-4111, Ext. 2354. Hours: 10–4 Tues.–Fri.; 12–4:30 Sat.–Sun.; closed holidays. Admission: free.

## UTAH STATE UNIVERSITY
### Nora Eccles Harrison Museum of Art

The Nora Eccles Harrison Museum of Art was founded in 1982 to house artworks collected over a century at Utah State University in Logan. The 24,000-square-foot museum now is part of the university's Chase Fine Arts Center Complex.

The museum is best known for its collections and exhibitions of contemporary art by artists who have either lived or worked in the western region of the United States from 1900 to the present. The museum's various collections include over 1,000 ceramic objects, 600 prints, 600 photographs, and 400 Southwest American materials. Thematic and chronological exhibitions in all media are presented in the changing exhibition program.

Nora Eccles Harrison Museum of Art, Utah State University, 650 N. 1100 E., Logan, UT 84332-4020. Phone: 801/750-1412. Hours: 10:30–4:30 Tues.–Fri. (also to 9 Wed.); 2–5 Sat.–Sun.; closed holidays. Admission: free.

## VALPARAISO UNIVERSITY
### Museum of Art

The Valparaiso University Museum of Art moved into a new 14,000-square-foot home in 1995 that is part of the university's Center for the Arts in Valparaiso, Indiana. The new arts complex also houses the art, music, and theater academic programs and related facilities.

The museum began as a gallery in 1953 with a gift of the American paintings and drawings of Junius R. Sloan. The collection has grown to over 1,600 pieces and now includes landscapes and other works from the mid-nineteenth century to the present by such artists as Charles Burchfield, Frederick Edwin Church, William Glackens, Childe Hassam, Eastman Johnson, John Marin, Georgia O'Keeffe, and John Sloan.

The museum, formerly located in Moellering Library, has been presenting exhibitions in three campus gallery locations.

Museum of Art, Valparaiso University, Center for the Arts, Valparaiso, IN 46383. Phone: 219/464-5365. Hours: varies. Admission: free.

## VASSAR COLLEGE
### Frances Lehman Loeb Art Center

Vassar College opened its $15.6 million Frances Lehman Loeb Art Center on its Poughkeepsie, New York, campus in 1993—incorporating a new 30,200-

square-foot building with 29,500 square feet of renovated space from the former Vassar College Art Gallery. The museum-teaching facility also includes an 8,600-square-foot sculpture garden.

Vassar College, founded in 1861, was the nation's first college to include an art museum for the display of its teaching collection, which now numbers more than 12,500 works of art. The initial museum was established in 1864 following the purchase of the Elias Lyman Magoon Collection by the college's founder, Matthew Vassar.

The new art center, designed by architect Cesar Pelli, was made possible largely through a major leadership gift by Frances Lehman Loeb, a Vassar alumna and trustee. Its 59,700 square feet include approximately 20,000 square feet of art galleries, as well as support facilities, classrooms, and conference rooms.

The Vassar collection—which spans the history of art from ancient Egyptian to contemporary American works—includes paintings, sculpture, prints, drawings, and photographs. In addition to important Hudson River School printings by such artists as Frederic E. Church and Thomas Cole from the founding Magoon collection, the Vassar collection features European and American works by Paul Cézanne, Arshile Gorky, Marsden Hartley, Henri Matisse, Joan Miró, Edvard Munch, Georgia O'Keeffe, Pablo Picasso, Jackson Pollock, and J.M.W. Turner and an important group of Old Master prints. It also has Old Master paintings, Greek and Roman sculpture, coins, nineteenth-century drawings, watercolors, and photographs.

Frances Lehman Loeb Art Center, Vassar College, Box 23, Raymond Ave., Poughkeepsie, NY 12601. Phone: 914/437-5237. Hours: 10–5 Wed.–Sat.; 1–5 Sun.; closed holidays. Admission: free.

# VIRGINIA COMMONWEALTH UNIVERSITY
## Anderson Gallery

A 16,000-square-foot new home is being constructed for the Anderson Gallery at Virginia Commonwealth University in Richmond. The gallery was founded in 1925 by the School of the Arts, but closed in 1935 to provide space for the university library. It reopened in 1970 in a former carriage house built in the 1880s. The new building is scheduled to open in 1997.

Temporary exhibitions of contemporary works by regional, national, and international artists are featured at the gallery, which also has student and faculty shows. The gallery has a collection of more than 2,000 artworks, with the emphasis on works on paper from the sixteenth through the twentieth centuries and works by twentieth-century photographers. Among the gallery prints are *Portrait of Dr. Gachet* by Van Gogh, *Eight Bells* by Homer, *La Petite Liseuse* by Matisse, and *Bouboules* by Calder. The present focus is on acquisitions of contemporary works by national and international artists.

Anderson Gallery, Virginia Commonwealth University, 907½ W. Franklin St., PO Box 842514, Richmond, VA 23784-2514. Phone: 804/828-1522. Hours: 10–5 Tues.–Fri.; 1–5 Sat.–Sun.; closed major holidays. Admission: free.

## WASHBURN UNIVERSITY
### Mulvane Art Museum

The Mulvane Art Museum at Washburn University in Topeka, Kansas, began in 1924 with a gift of American, European, and Asian works, largely on paper, by Joab Mulvane. The museum building has since become part of the adjacent Garvey Fine Arts Center, which houses the art, music, and theater programs and facilities.

The museum has approximately 2,000 works, which include art of Kansas, the mountain-plains region, and other areas, with strengths in American works since 1945, German expressionism, prints of Georges Rouault, and Japanese woodcuts. Temporary exhibitions focus on art from the region, ranging from solo to group showings.

Mulvane Art Museum, Washburn University, 17th and Jewell Sts., Topeka, KS 66621-1150. Phone: 913/231-1089. Hours: 10–4 Tues.–Fri. (also to 9 Tues. during academic year); 1–4 Sat.–Sun.; closed holidays and during exhibit installation. Admission: free.

## WASHINGTON AND LEE UNIVERSITY
### Reeves Center for Research and Exhibition of Porcelain and Paintings

The Reeves Center for Research and Exhibition of Porcelain and Paintings has more than 4,000 ceramic works and paintings from the eighteenth through the twentieth centuries in its collections at Washington and Lee University in Lexington, Virginia. The holdings are especially rich in Chinese export porcelain.

Most of the pieces were collected by Mr. and Mrs. Euchlin D. Reeves of Providence, Rhode Island, and supplemented by gifts of friends. The couple gave their collection to the university in 1967. The center, housed in a restored 1840 Greek Revival house on the campus, was opened in 1982.

In addition to the Chinese export porcelain, the center has English, European, and Japanese ceramics and nineteenth- and twentieth-century paintings, including paintings and watercolors by Mrs. Reeves, who signed her works with her maiden name of Louise Herreshoff.

The Reeves Center displays much of its collections in seven exhibition rooms and the nearby Watson Pavilion for Asian Arts. The Watson Pavilion opened in 1993 in a Palladian-style building that houses Asian ceramics, jades, ivory, silver, and bronzes. Its collections include popular and imperial porcelain from the Ming and Qing dynasties; Chinese paintings, furniture, and accessories; and Chinese, Japanese, and Korean ceramics.

Reeves Center for Research and Exhibition of Porcelain and Paintings, Washington and Lee University, Lexington, VA 24450. Phone: 703/463-8744. Hours: 9–4 Mon.–Fri.; by appointment Sat.–Sun.; closed major holidays. Admission: free.

## Lee Chapel and Museum
(See Historical Museums, Houses, and Sites section.)

## WASHINGTON STATE UNIVERSITY
### Museum of Art

The Museum of Art at Washington State University in Pullman has a small, but impressive, collection of modern art, with approximately 250 paintings and 1,350 prints. The core of the collection once belonged to President E.O. Holland, who donated them to the university 40 years before the museum was created in 1974.

Among the holdings are late-nineteenth- and early-twentieth-century American paintings, including major works by Inness, Chase, Duveneck, Glackens, Lawson, Henri, and Prendergast; twentieth-century Northwest regional paintings by such artists as Mark Tobey, Kenneth Callahan, and Margaret Tomkins; etchings by Goya, Hogart, and Daumier; and contemporary prints by British and American artists, among them Stella, Hockney, Kitaj, Motherwell, Rauschenberg, Golub, Warhol, Henry Moore, and William Hayter.

The museum has two galleries to display selections from its collection and present other temporary shows in its two small galleries in the 10,309-square-foot wing it occupies in the Fine Arts Center.

The Museum of Art is a founding member and co-owner of the Washington Art Consortium, formed through a partnership of six museums in Tacoma, Seattle, Bellingham, Spokane, and Pullman. It was formed in 1975 to acquire and administer a collection of works on paper by twentieth-century American artists. A second collection of American photographs was initiated in 1978.

Museum of Art, Washington State University, Fine Arts Center, Pullman, WA 99164-7460. Phone: 509/335-1910. Hours: 10–4 Mon.–Fri. (also 7–10 Tues.) mid-Jan. to early July and late Aug. through mid-Dec.; closed when university not in session. Admission: free.

## WASHINGTON UNIVERSITY
### Washington University Gallery of Art

The history of the Washington University Gallery of Art goes back to 1881 when its collections were housed in the St. Louis Art Museum, the first museum west of the Mississippi. Since 1960, the collections—among the oldest university art collections in the nation—have been part of the Gallery of Art, which occupies the two lower floors of Steinberg Hall on the campus.

The museum has over 3,000 objects in its collections, ranging from Egyptian mummies and Greek vases to paintings and contemporary mixed media con-

structions. It is best known for its collection of nineteenth- and twentieth-century European and American art.

The collections include European paintings by Barbizon, realist, and academic masters and American paintings by artists of the Hudson River School. Works by Jules Dupré, Honoré Daumier, Frederic E. Church, and Sanford Gifford are highlights of the collection established at the turn of the century. The revolutions in twentieth-century art are shown by major works of cubist and surrealist artists such as Pablo Picasso, Max Ernst, and Joan Miró, while the post-World War II American School is represented by the works of Jackson Pollock, Willem de Kooning, Arshile Gorky, and others.

The museum's exhibit program offers contemporary and historical art, including special loan exhibitions, faculty and student shows, and installations from the permanent collection.

Washington University Gallery of Art, 1 Brookings Dr., Campus Box 1214, St. Louis, MO 63130-4899. Phone: 314/935-5490. Hours: 10–5 Mon.–Fri.; 1–5 Sat.–Sun.; closed holidays and on Mondays from May through Aug. Admission: free.

# WELLESLEY COLLEGE
## *Davis Museum and Cultural Center*

One of the nation's newest and most eye-catching art museums opened in 1993 at Wellesley College in Wellesley, Massachusetts—more than a century after the college's first art museum was established in 1889. The 61,000-square-foot facility, designed by noted Spanish architect Rafael Moneo, provides elegant galleries for exhibitions and much-improved space for the institution's art collection.

The museum is a four-story building west of the Jewett Arts Center, where the college's art collection and galleries formerly were located. The galleries are stacked vertically with a central stair that scissors back and forth and allows visitors to view the gallery spaces. A sculpture garden can be found on the top floor.

The art collection has grown to nearly 5,000 objects since the last century. The holdings include Greek and Roman vases and sculpture; pre-conquest Mesoamerican objects; Asiatic ceramics and porcelains; medieval architectural sculpture and panel paintings; paintings and sculpture from the Renaissance and Baroque periods by Giordano, Strozzi, Domenichino, and the workshop of Vasari; nineteenth-century French sculpture by Falguière, Carrier-Belleuse, and Rodin; early modernist works by Kokoschka, Léger, and Moholy-Nagy; vintage and contemporary photographs from Fox Talbot to Jan Groover; Benin, Dan, Nigerian, and Bamana bronze, wood, and ivory objects; and contemporary paintings and sculpture by Noland, Nevelson, Abakanowicz, Wilmarth, Martin, and others.

The museum's special exhibitions, which are accompanied by programs and

publications, deal with new scholarship, alternative methodological approaches, new work, and diverse cultures and communities.

Davis Museum and Cultural Center, Wellesley College, 106 Central St., Wellesley, MA 02181-8257. Phone: 617/283-2051. Hours: 11–5 Tues.–Sat. (also to 8 Wed.–Thurs.); 1–5 Sun.; closed major holidays. Admission: free.

## WESLEYAN UNIVERSITY
### Davison Art Center

The Davison Art Center at Wesleyan University in Middletown, Connecticut, has more than 20,000 prints from 1450 to the present and approximately 10,000 other drawings, paintings, photographs, and other works. Selections from the collections are presented in exhibitions several times a year. In addition, exhibitions from outside sources are scheduled. The 3,742-square-foot museum, founded in 1953, is located in a wing attached to the 1838 Alsop House.

Davison Art Center, Wesleyan University, 301 High St., Middletown, CT 06459-0487. Phone: 203/347-9411. Hours: 12–4 Tues.–Fri.; 2–5 Sat.–Sun.; closed holidays and when university not in session. Admission: free.

## WESTERN ILLINOIS UNIVERSITY
### Western Illinois University Art Gallery/Museum

The Western Illinois University Art Gallery/Museum in Macomb has three galleries for showing predominately contemporary artworks. The collections include contemporary graphics, paintings, sculpture, glass, jewelry, and ceramics; Native American pottery; and WPA graphics and paintings. The museum also has annual faculty and student exhibitions.

Western Illinois University Art Gallery/Museum, Macomb, IL 61455. Phone: 309/298-1587. Hours: 9–4 Mon.–Fri. (also 6–8 Tues.); closed holidays and when university not in session. Admission: free.

## WICHITA STATE UNIVERSITY
### Edwin A. Ulrich Museum of Art

In addition to its own collections and exhibitions, the Edwin A. Ulrich Museum of Art at Wichita State University in Wichita, Kansas, administers a major university outdoor collection of 54 sculptures placed around the campus. The sculpture collection was established in 1972 and includes the work of many of the twentieth-century's leading sculptors, including Auguste Rodin, Joan Miró, Henry Moore, Lynn Chadwick, Jo Davidson, and Louise Nevelson.

The museum, which opened in 1974 and recently underwent a major renovation, is a component part of the multifaceted McKnight Art Center. The core of its collections is the Ulrich Collection of American art, which has been augmented to include European, African, pre-Columbian, and other American

works. Among the significant collections are the studio collection of Charles Grafly and the paintings and drawings of Frederick Waugh. The museum also is known for its exhibitions of experimental art and the large Miró mural at its entrance.

Edwin A. Ulrich Museum of Art, Wichita State University, 1845 Fairmount, Campus Box 46, Wichita, KS 67260-0046. Phone: 306/689-3664. Hours: 10–5 Tues.–Fri.; 1–5 Sat.–Sun.; closed major holidays. Admission: free.

# WIDENER UNIVERSITY
## Widener University Art Museum

The Widener University Art Museum in Chester, Pennsylvania, was founded in 1970 and moved into its present home—a renovated ca. 1905 Georgian-style mansion at the edge of the campus—in 1984. Its collections include the Alfred O. Deshong Collection of nineteenth-century American and European genre paintings and eighteenth- and nineteenth-century Oriental art and a collection of American impressionist paintings.

Among the works in the Deshong Collection are paintings by Rudolf Epp, Louis Adan, Charles Hoguet, Lilly Martin Spencer, and George Washington Nicholson; Japanese ivory figures and cloisonné enameled vases; Japanese Meiji period bronze vessels; and Chinese and Japanese lacquerware. American impressionists represented at the museum include Paul Cornoyer, Charles H. Davis, George L. Noyes, Edward Redfield, and Robert Spencer.

Widener University Art Museum, 1300 Potter St., Chester, PA 19013. Phone: 610/499-1189. Hours: 10–4 Tues–Sat.; closed July and holidays. Admission: free.

# WILLIAMS COLLEGE
## Williams College Museum of Art

The Williams College Museum of Art in Williamstown, Massachusetts, was founded in 1926 as the Lawrence Art Museum by Karl Weston, the first director, to provide Williams students with an opportunity to observe the fine works of art. During his 22-year tenure, Weston established a diverse and noteworthy collection through purchase and gifts from alumni and townspeople.

The museum, located in the renovated and expanded 1846 Lawrence Hall in which it was founded, is best known for its emphasis on American art, modern and contemporary art, and the art of non-Western peoples in its collections, exhibitions, and programs and for its Prendergast Archive and Study Center.

The collections include eighteenth- and nineteenth-century American art; American and European modern and contemporary art; Dutch, Flemish, and Spanish Baroque art; fifteenth- to eighteenth-century Spanish painting and furniture; Italian Renaissance painting and sculpture; European and American prints and drawings; twentieth-century American photography; ninth- to eleventh-century South Asian sculpture; fifteenth- to nineteenth-century Indian painting

and sculpture; Assyrian relief sculptures; African art; and art by Charles and Maurice Prendergast.

Williams College Museum of Art, Lawrence Hall, Main St., Williamstown, MA 01267-2566. Phone: 413/597-2429. Hours: 10–5 Tues.–Sat.; 1–5 Sun.; closed New Year's Day, Thanksgiving, and Christmas. Admission: free.

## YALE UNIVERSITY

Yale University in New Haven, Connecticut, has two major art museums—the Yale University Art Gallery and the Yale Center for British Art. The art gallery was founded in 1832 and has diversified holdings of nearly 100,000 objects that span the ancient and the contemporary worlds, while the British art center, which opened in 1977, contains masterpieces by all the leading artists who worked in Great Britain from the sixteenth century to the present. The two institutions, located across the street on the campus, are distinct from, but complementary to, each other.

### *Yale University Art Gallery*

The Yale University Art Gallery in New Haven, Connecticut, is one of the nation's oldest, largest, and most comprehensive university art museums. It began in 1832 after Colonel John Trumbull, the Revolutionary War patriot-artist, gave more than 100 of his paintings to Yale in return for an annuity. The agreement called for a separate gallery structure that became the first university art museum in the Western Hemisphere.

In 1864, the gallery moved from its original building on the Old Campus to neoclassical Street Hall, which also housed the Yale School of Art. The growth of painting collections—including James Jackson Jarves's Italian Renaissance panel paintings—resulted in the construction of Swartwout Building, a Tuscan Romanesque structure, which opened in 1928. After the gift of over 10,000 works in the Mabel Brady Garvan Collection of American decorative arts in the 1930s, areas of the building were set aside for American decorative arts and period rooms.

The continued expansion of collections led to the construction of the first modern building at Yale, designed by Louis I. Kahn and completed in 1953, to supplement the space in Swartwout. The gallery's collections in the two adjacent buildings now occupy 100,123 square feet and contain approximately 100,000 works of Asian, African, and pre-Columbian art, as well as American and European art. The annual attendance is 150,000.

The Yale University Art Gallery has extensive collections of American paintings, furniture, silver, sculpture, and other works. In addition to Trumbull's Revolutionary-period paintings and miniatures, it has early portraits by John Smibert, John Singleton Copley, Ralph Earl, and Charles Willson Peale; landscapes by Frederic E. Church, Martin J. Heade, and Worthington Whitteredge; and works by Winslow Homer, Thomas Eakins, John Singer Sargent, Robert Henri, William Metcalf, Edward Hopper, and George Bellows.

Among the other holdings are the Hobart and Edward Small Moore Memorial Collection of Chinese bronzes, jades, ceramics, paintings, and sculpture; Rebecca Darlington Stoddard Collection of Greek and Roman vases; Griggs Collection of Italian paintings and medieval art; Linton Collection of African sculpture; Olsen Collection of pre-Columbian art; Rabinowitz and Stephen Clark collections of master paintings; ancient material from Yale's excavations at the site of Dura Europos on the Euphrates; and collections of Old Master prints and drawings and contemporary photographs. The permanent exhibit installations emphasize European, American, and modern painting; American silver, furniture, and painting; and ancient, pre-Columbian, and classical art. Rotating displays of works on paper and Asian ceramics and paintings also are presented.

Among the best known works normally on view are Trumbull's *The Declaration of Independence,* Copley's *Portrait of Isaac Smith,* Van Gogh's *Night Cafe,* Stella's *Brooklyn Bridge,* and Antonio Pollaiuolo's *Hercules and Deianira.*

Yale University Art Gallery, 201 York St., New Haven, CT 06520. Phone: 203/432-0660. Hours: 10–5 Tues.–Sat.; 2–5 Sun.; closed major holidays. Admission: free.

## Yale Center for British Art

The Yale Center for British Art houses the most comprehensive collection of English paintings, prints, drawings, sculpture, and rare books outside Great Britain. The museum and its original artworks were gifts of alumnus Paul Mellon. It opened in 1977 in a four-story concrete, steel, and glass structure built on a double courtyard plan and designed by Louis I. Kahn, who also was the architect for the Yale University Art Gallery building across the street.

The museum's collections illustrate British life and culture from the sixteenth century to the present, with emphasis on the period between the birth of William Hogarth in 1697 and the death of Joseph Mallord William Turner in 1851—considered to be the "golden age" of English art. The Paul Mellon Collection displays a preference for the more informal aspects of British art—genre scenes, sporting art, unofficial portraiture, and small landscape paintings.

The center's collections now number more than 1,300 paintings, 17,000 drawings, 30,000 prints, and 22,000 rare books, as well as over 13,500 volumes of reference books, 10,000 microfiches, and 75,000 photographs of British art.

Among the paintings are Hogarth's *Beggars' Opera,* Turner's *Dort,* Peter Paul Rubens's *Peace Embracing Plenty,* John Constable's *Hadleigh Castle,* George Stubb's *A Lion Attacking a Horse,* and Sir Anthony Van Dyck's *Mountjoy Blount, Earl of Newport.*

Temporary exhibitions also play an important role in the center's programs. They range from exhibitions featuring aspects of the permanent collection to international loan shows.

Yale Center for British Art, Yale University, 1080 Chapel St., PO Box 208280, New Haven, CT 06520-8280. Phone: 203/432-2800. Admission: free.

## YESHIVA UNIVERSITY
### Yeshiva University Museum

(See Archaeology, Anthropology, and Ethnology Museums section.)

# Botanical Gardens, Arboreta, and Herbaria

*Also see Natural History Museums and Centers section.*

## BALL STATE UNIVERSITY
### *Biology Teaching Museum and Nature Center*

The Biology Teaching Museum and Nature Center at Ball State University in Muncie, Indiana, consists of a teaching museum, a nature center, and an arboretum. It was founded in 1918 and has collections of orchids, cacti, tropical plants, ferns, herbaceous plants, amphibians, fish, fossils, insects, shells, and African birds.

Biology Teaching Museum and Nature Center, Ball State University, Dept. of Biology, 2000 University Ave., Muncie, IN 47306. Phone: 317/285-8820. Hours: arboretum— 7:30–4:30 Mon.–Fri.: 8–4 Sat.; Apr.–Nov.—1–4 Sun.; teaching museum—open when classes are in session. Admission: free.

## BRIGHAM YOUNG UNIVERSITY
### *Monte L. Bean Life Science Museum Herbarium*

(See Natural History Museums and Centers section.)

## CALIFORNIA POLYTECHNIC STATE UNIVERSITY
### *Robert F. Hoover Herbarium*

Dried plant specimens from San Luis Obispo County and California, the West and the Midwest, and Africa are among the offerings at the Robert F. Hoover

Herbarium at California Polytechnic State University in San Luis Obispo. The herbarium, which was founded by Dr. Hoover in 1946, is part of the Department of Biological Sciences and occupies three rooms in two adjacent buildings.

Robert F. Hoover Herbarium, California Polytechnic State University, Dept. of Biological Sciences, 309 Science North, San Luis Obispo, CA 93407. Phone: 805/756-2043. Hours: by appointment; closed when university not in session. Admission: free.

## CALIFORNIA STATE UNIVERSITY, FULLERTON
### Fullerton Arboretum

The Fullerton Arboretum is operated under a joint-powers agreement between California State University, Fullerton, and the City of Fullerton. The 26-acre arboretum, which opened to the public in 1979, is located on the site of the old Gilman Ranch, where the first Valencia oranges in Orange County were planted.

Twenty acres of the arboretum have been developed. The arboretum has approximately 3,500 accessions, with the emphasis on drought-tolerant plants suitable to the coastal plain of southern California. It also has a historical collection that includes a house, outbuildings, and artifacts such as musical instruments, family memorabilia, Victorian furniture and furnishings, and medical and pharmaceutical equipment. The 1894 home and office of Dr. George Clark was relocated from downtown to the site.

Fullerton Arboretum, California State University, Fullerton, Yorba Linda Blvd. and Associated Rd., Fullerton, CA 92634. Phone: 714/773-3579. Hours: arboretum—8–4:45 daily; Heritage House—2–4 Sun.; closed New Year's Day, Thanksgiving, and Christmas. Admission: free.

## CARNEGIE MELLON UNIVERSITY
### Hunt Institute for Botanical Documentation

Extensive collections of botanical literature, art, and archival materials are the focus of the Hunt Institute for Botanical Documentation at Carnegie Mellon University in Pittsburgh. The institute, a gift of Mr. and Mrs. Roy A. Hunt, serves international plant science through research and documentation of all aspects of botanical history, both past and current, including bibliography, biography, and graphic communication.

The institute was founded in 1961 as the Rachel McMasters Miller Hunt Botanical Library, an academic institute that conducted its own program of research and service and made its collections available to others. By 1971, these activities were so diversified that the name was changed to the Hunt Institute for Botanical Documentation.

The institute now acquires and conserves collections of books, plant images, manuscript materials, and portraits; compiles authoritative data files; produces publications; and provides other information services to assist current research in botanical systematics, history, and biography and to meet the reference needs

of biologists, historians, conservationists, librarians, bibliographers, and the public at large.

The collections include over 23,000 library volumes, with the main strength in primary source material published between 1550 and 1850; more than 30,000 botanical watercolors, drawings, and original prints from the Renaissance to the present; approximately 2,000 botanists' letters dating from the eighteenth to the twentieth centuries and 280 sets of botanists' collected private papers, primarily from the nineteenth and twentieth centuries; and in excess of 22,000 prints, paintings, drawings, and photographs representing approximately 19,000 botanists, botanical artists, horticulturists, and others in related fields.

The institute also has bibliographical references that include data on more than 34,000 plant science books published between 1730 and 1840 and over 120,000 references to contemporary reviews and announcements and a master biographical file with information on past and present botanists, including citations of 200,000 published biographical accounts.

Among the significant possessions are the Torner Collection of nearly 2,000 botanical and zoological illustrations made during the Spanish royal expedition of 1787–1803 to New Spain, Hitchcock-Chase Collection of over 4,700 ink drawings of grasses, and U.S. Department of Agriculture Forest Service Collection of more than 2,800 ink drawings of woody species.

Hunt Institute for Botanical Documentation, Carnegie Mellon University, Hunt Library, Pittsburgh, PA 15213-3890. Phone: 412/268-2434. Hours: 9–5 Mon.–Fri.; closed holidays. Admission: free.

## CLEMSON UNIVERSITY
### South Carolina Botanical Garden

Clemson University's South Carolina Botanical Garden is located on a 256-acre site—part of which was the original John C. Calhoun Plantation Estate—near Clemson. It resulted from the expansion of a teaching collection of plants for horticulture and forestry into a botanical garden in 1959.

The garden's plant collections include holly, camellia, and 250,000 daffodils. There are a number of specific garden areas, such as the wildflower garden. Among the other exhibits are period farm implements, a grist mill, and a liquor still. Approximately 125,000 persons visit the botanical garden each year.

South Carolina Botanical Garden, Clemson University, Dept. of Horticulture, Box 340375, Clemson, SC 29634-0375. Phone: 803/656-3405. Hours: dawn–dusk daily. Admission: free.

## COLLEGE OF THE DESERT
### Moorten Botanic Garden and Cactarium

More than 3,000 varieties of desert plants from throughout the world are featured at the Moorten Botanic Garden and Cactarium at the College of the

Desert in Palm Springs, California. Founded in 1938, the botanical garden has many rare and endangered species. A 1915 historic house, called Cactus Castle, can be seen on the grounds.

Moorten Botanic Garden and Cactarium, College of the Desert, 1701 S. Palm Canyon Dr., Palm Springs, CA 92264. Phone: 619/327-6555. Hours: 9–4:30 Mon.–Sat.; 10–4 Sun. Admission: adults, $2; children 5–15, 75¢; children under 5, free.

## CONNECTICUT COLLEGE
### Connecticut College Arboretum

Woody plants native to New England are featured at the Connecticut College Arboretum in New London. The arboretum, opened in 1931, has 440 acres, of which 25 acres are traditional plant collections.

Connecticut College Arboretum, 270 Mohegan Ave., Box 5625, New London, CT 06320-4196. Phone: 203/439-2140. Hours: dawn–dusk daily. Admission: free.

## CORNELL UNIVERSITY
### Cornell Plantations

The Cornell Plantations of Cornell University in Ithaca, New York, include 2,700 acres of natural areas, a 200-acre arboretum, and 14 separate gardens as part of a botanical garden. Founded in 1935, the plantations have maple, oak, conifer, rhododendron, herb, peony, groundcover, and other collections, as well as such diverse natural areas as bogs, fens, swamps, ponds, and woodlands. The annual attendance is approximately 150,000.

Cornell Plantations, Cornell University, 1 Plantations Rd., Ithaca, NY 14850-2799. Phone: 607/255-3020. Hours: dawn–dusk. Admission: free.

### L.H. Bailey Hortorium

The L.H. Bailey Hortorium at Cornell University in Ithaca, New York, is an herbarium with a worldwide collection of over 800,000 plants. It is strong in flora of New York and cultivated plants.

L.H. Bailey Hortorium, Cornell University, 462 Mann Library, Ithaca, NY 14850. Phone: 607/255-7981. Hours: 8–4:30 Mon.–Fri.; closed holidays. Admission: free.

## CRANBROOK ACADEMY OF ART
### Cranbrook Academy of Art Museum Gardens

(See Art Museums section.)

## DIABLO VALLEY COLLEGE
### Diablo Valley College Museum Botanical Garden

(See Natural History Museums and Centers section.)

# FORT HAYS STATE UNIVERSITY
## Sternberg Museum of Natural History Herbarium

(See Natural History Museums and Centers section.)

# FRANKLIN AND MARSHALL COLLEGE
## North Museum of Natural History and Science Herbarium

(See Natural History Museums and Centers section.)

# HARTWICK COLLEGE
## Hoysradt Herbarium

The Hoysradt Herbarium, located in Hartwick College's Miller Science Hall in Oneonta, New York, has over 20,000 specimens of flowering plants, ferns, and fern allies. The nucleus of the collection initially came from the personal herbarium of Lyman Henry Hoysradt, who began collecting plant specimens in 1870. Most of the specimens are from the Pine Plains area of the state. Additional specimens were acquired in exchanges with botanists in more than 40 states and a number of foreign countries. The herbarium is one of four facilities that comprise the Museums at Hartwick.

Hoysradt Herbarium, Hartwick College, Miller Science Hall, Oneonta, NY 13820. Phone: 607/431-4480. Hours: by appointment; closed holidays. Admission: free.

# HARVARD UNIVERSITY

Harvard University has five major facilities of a botanical nature. They include the Botanical Museum, Harvard University Herbaria, Arnold Arboretum of Harvard University, Harvard Forest and Fisher Museum, and Dumbarton Oaks Research Library and Collection grounds (described in the Library and Archival Collections and Galleries section.)

## Botanical Museum

The Botanical Museum of Harvard University in Cambridge, Massachusetts, is known as the Garden of Glass Flowers because of its more than 3,000 models of some 850 plant species created by Leopold Blaschka and his son, Rudolph, between 1887 and 1936. The exquisite models are part of the highly popular Ware Collection of Glass Models of Plants at the museum.

The museum, which was founded in 1858, is one of five Harvard institutions devoted to the plant sciences and one of the four museums that comprise the Harvard University Museums of Natural History.

The Ware Collection models, originally commissioned as a useful adjunct to teaching biology, are made entirely of blown or shaped glass, reinforced by wire

in some places. A varnish-like suspension of ground colored glass or oxides was applied to the glass in early models, while colored glass, often enameled, was used to make later models.

Among the other collections are the Hankins Collection of fossil woods, Tina and Gordon Wasson Ethnomycological Collection, Oakes Ames Collections of orchids and economic botany, a manuscript collection, and examples of narcotic and medicinal plants, rubber-yielding plants, and pre-Columbian ethnobotany and paleobotany. The mansion also has a library and archives.

Botanical Museum, Harvard University, 24 Oxford St., Cambridge, MA 02138. Phone: 617/495-2326. Hours: 9–4:30 Mon.–Sat.; 1–4:30 Sun.; closed major holidays. Admission: adults, $4; seniors and students, $3; children 3–13, $1; Harvard students, free.

## Harvard University Herbaria

The Harvard University Herbaria in Cambridge have approximately 5 million specimens, comprising one of the largest and most significant collections of dried, pressed plants for teaching and research. The collection began in 1864 through the gift of Asa Gray's personal herbarium.

The herbaria also serve as an umbrella administrative agency for the university's various herbarium collections—Herbarium at Arnold Arboretum, Farlow Reference Library and Herbarium of Cryptogamic Botany, and Orchid Herbarium and Economic Herbarium of Oakes Ames at the Botanical Museum—all housed separately.

The Harvard University Herbaria are best known for their plant specimens of historical interest and those from particular geographic regions. Among the most significant collections are the plant collections of Asa Gray and collaborators; early collections from Asia, particularly China; archives of Harvard botanists; and libraries.

The herbaria have a worldwide collection of vascular plants, with emphasis on the New World, especially North America, including the West Indies and Mexico. Included in the collection are specimens from east and southeast Asia and Malaysia, a large representation of orchids from Mexico and the Philippines, nonvascular cryptograms, plants useful or harmful to humans, cultivated plants, and wild plants involved in the origin of cultivated plants. The collections—which are not open to the public—are distributed among three buildings.

Harvard University Herbaria, 22 Divinity Ave., Cambridge, MA 02138. Phone: 617/495-2365. Hours: not open to the public.

## Arnold Arboretum of Harvard University

Chartered in 1872, the Arnold Arboretum of Harvard University in suburban Jamaica Plain, Massachusetts, is the oldest public arboretum in America. Part of Boston's park system, it occupies 265 acres and has over 7,000 varieties of ornamental trees and shrubs from throughout the north temperate zone.

The arboretum, named for its benefactor, James Arnold, is one of the nation's best known, most comprehensive, and most actively used botanical gardens. It also is a world center for the study of trees. In addition to its living collections,

it has an extensive herbarium, libraries in Jamaica Plain and Cambridge, a visitor center, and Case Estates, which serves as a nursery and has a working farm and several display gardens in Weston, Massachusetts.

Charles Sprague Sargent, the first director, collaborated with Frederick Law Olmsted in designing the arboretum's beautiful grounds. Approximately 250,000 visit the arboretum each year to see its many trees and woody plants along extensive road and path systems. One area focuses on leguminous trees, while another features shrubs and vines. Native wildflowers can be found among willow and flowering shrubs in the meadow. Asiatic plants line the Chinese Path, while rhododendrons, azaleas, and mountain laurels crown Hemlock Hill, and bonsai are located in a pavilion near the Dana Greenhouses. Other noteworthy collections include lilacs, maples, crab apples, viburnums, conifers, and dwarf conifers.

The Hunnewell Visitor Center is open every day. The arboretum offers many courses, workshops, lectures, walks, and events during the years and conducted tours on Sunday afternoons in October and May.

Arnold Arboretum of Harvard University, 125 Arborway, Jamaica Plain, MA 02130. Phone: 617/524-1718. Hours: grounds—dawn–dusk daily; visitor center—10–4 daily. Admission: free.

## *Harvard Forest and Fisher Museum*

Harvard University's 3,000-acre Harvard Forest and its Fisher Museum are located in Petersham, about 70 miles west of Cambridge in north central Massachusetts. The forest is dedicated to the study of forest land use, biology, and development, while the museum interprets the forest's history, ecology, and research, as well as the history of the region's forests.

The forest has doubled in size since it was given to Harvard in 1907 by donors interested in forest biology and forestry. Its development was spearheaded by Professor Richard Fisher, founder and first director of the forest. The university now also owns two related research areas—a primeval forest tract in Winchester, New Hampshire, and the Black Brook Plantation in Hamilton, Massachusetts.

Harvard Forest's varied topography contains a wide range of microclimates, which, when combined with soil differences, create habitats that span almost the entire New England spectrum, including northern, transition, and central forest types; marshes; hardwood swamps; conifer bogs; and a lake.

The forest's research and education complex consists of Fisher Museum, featuring 23 dioramas depicting land use and forest management in central Massachusetts; Shaller Hall, with offices, laboratories, and a library; J. G. Torrey Laboratory, which serves as a bridge between field sites and indoor laboratories; and a large laboratory/garage facility. The museum, which Fisher envisioned in the late 1920s as a means of conveying the knowledge of forestry to the public, opened in 1940. The dioramas still remain the focal point, but other exhibits and the E.M. Gould Audiovisual Education Center have been added to describe forest history, ecology, and research.

Harvard Forest and Fisher Museum of Forestry, Harvard University, Athol Rd., Peter-
sham, MA 01366-0068. Phone: 508/724-3302. Hours: forest—dawn–dusk daily; mu-
seum—9–5 Mon.–Fri.; May–Oct.—12–4 Sat.–Sun.; closed holidays. Admission: free.

## HAVERFORD COLLEGE
### Haverford College Arboretum

The beginning of the Haverford College Arboretum in Haverford, Pennsyl-
vania, goes back to the founding of the college in 1833. An English gardener,
William Carvill, was hired the following year to convert the farmland into an
attractive functioning campus. It is his landscape design that is still evident today
in the campus arboretum.

The arboretum has been helped over the years by two concerned groups—
the Campus Club, founded in 1901, and the Campus Arboretum Association,
established in 1974. Both sought to preserve and enhance the horticultural and
botanical heritage of the college. More than 1,000 of the campus trees have been
labeled, and a self-guided tour highlighting 33 special trees is available. Most
of the trees are oaks, maples, beeches, and conifers.

Two special attractions are the Pinetum, a scientific collection of 332 conifer
trees arranged in five family groupings southwest of the campus, and the Ger-
trude Chattin Teaf Memorial Garden, a traditional Zen garden opened in 1990.
Haverford College Arboretum, 370 Lancaster Ave., Haverford, PA 19041. Phone: 215/
896-1101. Hours: dawn–dusk daily. Admission: free.

## HIGHLAND COMMUNITY COLLEGE
### Highland Community College Arboretum

The Highland Community College Arboretum, founded in 1970 in Freeport,
Illinois, has approximately 5,000 plantings representing over 300 species of
ground coverings, trees, and shrubs.
Highland Community College Arboretum, Pearl City Rd., Freeport, IL 61032. Phone:
815/235-6121. Hours: 7–7 Mon.–Sat.; closed holidays. Admission: free.

## IDAHO STATE UNIVERSITY
### Idaho Museum of Natural History Herbarium

(See Natural History Museums and Centers section.)

## INDIANA UNIVERSITY
### Hilltop Garden and Nature Center

The Hilltop Garden and Nature Center at Indiana University in Bloomington
is a cooperative environmental education project of the university's Department

of Recreation and Park Administration, the city's Department of Parks and Recreation, the Bloomington Garden Club, and other community organizations. Started in 1948, it serves as a laboratory for university students and primarily seeks to further environmental education among children and adults in the community. It has a 5.5-acre garden and offers lectures, workshops, and other programs during the summer and off-season.

Hilltop Garden and Nature Center, Indiana University, Dept. of Recreation and Park Administration, 133 HPER Bldg., Bloomington, IN 47405. Phone: 812/855-2799. Hours: summer—8–12 Mon., Wed., and Fri.; other times—varies. Admission: free.

## KANSAS STATE UNIVERSITY
### Kansas State University Herbarium

Started in 1871, the Kansas State University Herbarium in Manhattan is one of the oldest parts of the Kansas Agricultural Experiment Station. Operated by the Division of Biology, it has approximately 185,000 specimens of bryophytes, ferns, conifers, and flowering plants and 45,000 specimens of fungus. There also is a separate seed collection of almost 2,000. The bryophyte collection includes over 8,000 mosses and liverworts and about 2,000 lichens.

Kansas State University Herbarium, Div. of Biology, Ackert Hall, Manhattan, KS 66506-4901. Phone: 913/532-6619. Hours: 8–5:30 Mon.–Fri.; by appointment Sat.–Sun.; closed holidays. Admission: free.

## LA SIERRA UNIVERSITY
### World Museum of Natural History Arboretum

(See Natural History Museums and Centers section.)

## LOUISIANA STATE UNIVERSITY
### Louisiana State University Herbarium

Vascular plants of Louisiana and the United States are featured at the Louisiana State University Herbarium in the Life Sciences Building on the Baton Rouge campus. The herbarium collection began in 1869. It includes asteraceae, fabaceae, poaceae, and tropical America specimens.

Louisiana State University Herbarium, Life Sciences Bldg., Dept. of Botany, Baton Rouge, LA 70803-1705. Phone: 504/388-8485. Hours: 8:30–5 Mon.–Fri. Admission: free.

### Windrush Gardens (LSU Rural Life Museum)
(See Agricultural Museums section.)

## MICHIGAN STATE UNIVERSITY

Michigan State University has five botanical/horticultural facilities—the W.J. Beal Botanical Garden and Beal-Darlington Herbarium in East Lansing, Hidden Lake Gardens in Tipton, Fred Russ Experimental Forest in Decatur, and W.K. Kellog Experimental Forest in Augusta. The latter is described in the Natural History Museums and Centers section as part of the W.K. Kellog Biological Station.

### W.J. Beal Botanical Garden

The W.J. Beal Botanical Garden at Michigan State University in East Lansing was established by Professor Beal in 1873 as an outdoor laboratory to assist in the teaching of botany and agriculture. It now is the oldest continuously operating botanical garden in North America. The five-acre garden has approximately 4,500 species and varieties of herbaceous and wood plants arranged in systematic, economic, ecological, and landscape groupings.

W.J. Beal Botanical Garden, Michigan State University, 412 Olds Hall, East Lansing, MI 48824-1047. Phone: 517/355-9582. Hours: open 24 hours. Admission: free.

### Beal-Darlington Herbarium

Founded in 1863, the Beal-Darlington Herbarium at Michigan State University in East Lansing has vascular plants from all areas, with emphasis on Michigan, alpine areas of North America, Mexico, South America, West Indies, and northern Borneo.

Beal-Darlington Herbarium, Michigan State University, East Lansing, Michigan 48824. Phone: 517/355-4696. Hours: 8–5 Mon.–Fri.; closed holidays. Admission: free.

### Hidden Lake Gardens

The Hidden Lake Gardens, located in the scenic Irish Hills of southeastern Michigan, were started in 1926 by Harry A. Fee, an Adrian businessman. In 1945, Mr. and Mrs. Fee gave the arboretum to Michigan State University. Since then, the 226-acre gardens have been increased to 755 acres of rolling countryside, and two major facilities have been added—the Visitor Center building in 1966 and the Plant Conservatory in 1968, both with the support of the Herrick family.

The arboretum's most important collections are the Harper dwarf, rare conifer, hosta, and flowering crab apple collections. Over 2,500 different species and cultivars representing more than 150 genera have been planted since 1960. Outdoor plant collections include azaleas, rhododendrons, lilacs, magnolias, and ornamental shrubs, while among the indoor plants are bamboo, banana, cactus, camphor, cocoa, coffee, fig, palm, sisal, sugarcane, tapioca, and vanilla.

Hidden Lake Gardens, Michigan State University, 6280 W. Munger Rd., Tipton, MI 49287. Phone: 517/431-2060. Hours: Apr.–Oct.—8–dusk daily; Nov.–Mar.—8–4 daily. Admission: weekdays, $1; weekends and holidays, $3.

## Fred Russ Experimental Forest

Michigan State University's Fred Russ Experimental Forest in Decatur is a 939-acre forest established in 1942 by a land gift from a Cassopolis business-man. It is open to the public year-round for hiking, mushrooming, cross-country skiing, and nature study. A historic stage coach trail leads through the natural area, and a pioneer home on the grounds is open to visitors from 1 to 4 P.M. Sundays. The experimental forest's major research trust is developing trees that are compatible with southwestern Michigan's environment.

Fred Russ Experimental Forest, Michigan State University, Rte. 3, Decatur, MI 49045. Phone: 616/782-5652. Hours: 8–sunset. Admission: free.

## NORTH CAROLINA STATE UNIVERSITY
### North Carolina State University Arboretum

The North Carolina State University Arboretum in Raleigh has about 5,000 kinds of plants and trees on an eight-acre site near the state fairgrounds. The arboretum was opened in 1977. The Department of Horticultural Science also has greenhouses and a conservatory on the campus.

North Carolina State University Arboretum, 4301 Beryl Rd., Raleigh, NC 27636. Phone: 919/515-7641. Hours: dawn–dusk daily. Admission: free.

## OHIO STATE UNIVERSITY
### Chadwick Arboretum

The 1,600-acre Ohio State University campus in Columbus is part of the Chadwick Arboretum. Pocket gardens are scattered throughout the grounds, with 40 acres being the focal gardens. Established in 1980, the arboretum, adjoining Mirror Lake, has some plant specimens that are over 100 years old. Arboretum collections include viburnums, crab apples, conifers, and grasses.

Chadwick Arboretum, Ohio State University, 2001 Tyffe Ct., Columbus, OH 43210. Phone: 614/292-3136. Hours: dawn–dusk daily. Admission: free.

## PURDUE UNIVERSITY
### Arthur Herbarium

An internationally recognized collection of rust fungi is the focus of the Ar-thur Herbarium at Purdue University in West Lafayette, Indiana. The herbarium was started in 1887 by Dr. John Charles Arthur, professor of botany, and now includes approximately 100,000 specimens.

Arthur Herbarium, Purdue University, Dept. of Botany, Lilly Hall of Life Sciences, West Lafayette, IN 47907. Phone: 317/494-4623. Hours: 8–5 Mon.–Fri.; closed holidays. Ad-mission: free.

## RHODES COLLEGE
### Rhodes College Herbarium

The Rhodes College Herbarium has over 7,500 specimens from the region in Memphis, Tennessee. The herbarium, part of the Department of Biology, was founded in 1925.

Rhodes College Herbarium, Dept. of Biology, 2000 N. Parkway, Memphis, TN 38112. Phone: 901/726-3558. Hours: 8:30–4:30 Mon.–Fri.; closed major holidays. Admission: free.

## RUTGERS UNIVERSITY
### Rutgers University Research and Display Gardens

The Rutgers University Research and Display Gardens in New Brunswick, New Jersey, were started in 1935 by Dr. Charles Connors and later became part of the state university. Approximately 1,200 kinds of plants are on the 30 acres open to the public. They include American hollies, yews, rhododendrons, and other ericaceous plants.

Rutgers University Research and Display Gardens, Cook College, Ryders Lane, Box 231, New Brunswick, NJ 08903. Phone: 908/932-9639. Hours: dawn–dusk daily. Admission: free.

## SMITH COLLEGE
### Botanic Garden of Smith College

The Botanic Garden of Smith College in Northampton, Massachusetts, was created in 1895 by the college's first president, L. Clarke Seelye, to support the academic programs and to beautify the campus. It includes a large collection of plants representing a wide variety of families and genera.

Among the garden's featured attractions are rock/alpine plants, orchids, bromeliads, gesneriads, and hardy ornamental trees and shrubs. Two special shows are presented each year—a spring bulb and flower show in March and a chrysanthemum show in November. The garden's facilities include the Lyman Plant House, which is a collection of glasshouses dating from 1895 through 1981.

Botanic Garden of Smith College, Lyman Plant House, College Lane, Northampton, MA 01063. Phone: 413/585-2748. Hours: 8–4:15 daily. Admission: free.

## STATE UNIVERSITY OF NEW YORK AT STONY BROOK
### Museum of Long Island Natural Sciences Herbarium

(See Natural History Museums and Centers section.)

## SWARTHMORE COLLEGE
### Scott Arboretum

More than 5,000 kinds of plants are featured at the 300-acre Scott Arboretum at Swarthmore College in Swarthmore, Pennsylvania. The arboretum, established in 1929 as a living memorial to Arthur Hoyt Scott, an 1895 graduate, by his family, seeks to grow and display the best hardy ornamental trees, shrubs, and perennials for home gardens in the Delaware Valley.

Among the major plant collections are flowering cherries, corylopsis, crab apples, daffodils, dogwoods, hollies, lilacs, maples, magnolias, native azaleas, pinetum, quinces, rhododendrons, roses, tree peonies, viburnums, wisteria, and witch hazels. Special areas include the new Terry Shane Teaching Garden, Scott Entrance Garden, Dean Bond Rose Garden, Sue Schmidt Garden, Theresa Lang Garden of Fragrance, Harry Wood Garden, and Frorer Holly Collection.
Scott Arboretum, Swarthmore College, 500 College Ave., Swarthmore, PA 19081-1397. Phone: 215/328-8025. Hours: dawn–dusk daily. Admission: free.

## UNIVERSITY OF ALABAMA
### University of Alabama Arboretum

The University of Alabama Arboretum in Tuscaloosa has 60 acres of plant collections for botanical education and appreciation. Founded in 1958, it is divided into four sections—native woodland, the largest area, with walking trails and most of the important trees, shrubs, and vines native to western Alabama; ornamental, composed of native and exotic trees and shrubs; wildflower, with more than 250 plant species; and experimental, which features familiar and unusual food plants and demonstrates organic gardening techniques for family vegetable patches.
University of Alabama Arboretum, Dept. of Biological Sciences, PO Box 870344, Tuscaloosa, AL 35487-0344. Phone: 205/553-3278. Hours: winter—7–5 daily; summer—7–7 daily; closed holidays. Admission: free.

## UNIVERSITY OF ALASKA FAIRBANKS
### University of Alaska Museum Herbarium

(See Natural History Museums and Centers section.)

## UNIVERSITY OF ARIZONA
### Boyce Thompson Southwestern Arboretum

Plants from all parts of the earth's arid lands can be seen at the Boyce Thompson Southwestern Arboretum, a branch of the University of Arizona located in Superior, about 100 miles north of the main campus in Tucson. The arboretum was founded in 1925 by copper and mining magnate William Boyce Thompson,

incorporated as Arizona's first nonprofit corporation in 1927, and turned over to the university for management in 1964. A similar cooperative management agreement was expanded in 1976 to include the Arizona State Parks.

Planted gardens comprise 40 of the arboretum's 350 acres. The living plants include approximately 12,000 specimens representing 2,350 taxa. The collection is rich in woody landscaping plants, woody legumes, herbs, and cacti and other succulents and contains significant numbers of rare, threatened, or endangered species. Major plant families include agavaceae, aizoaceae, cactaceae, crassulaceae, euphorbiaceae, labiatae, leguminosae, liliaceae, myrtaceae, and palmae.

Among the permanent exhibitions are the Desert Legume Garden, demonstration gardens featuring low water–use plants for landscaping, economic plants of arid regions, landscapes representing major subdivisions of North American desert, Freemont Cottonwood/Gooding Willow gallery forests, and simulated plant communities of arid portions of Australia, central Asia, the Mediterranean, southern Africa, the Saharo-Arabian region, and South America. The arboretum also has numerous trails, two conservatories, and the Smith Interpretive Center with exhibits in the lobby of a historic 1926 visitor center.

Boyce Thompson Southwestern Arboretum, University of Arizona, 37615 U.S. Hwy. 60, Superior, AZ 85273-5100. Phone: 602/689-2723. Hours: 8–5 daily; closed Christmas. Admission: adults, $4; children, $2.

## UNIVERSITY OF CALIFORNIA, BERKELEY
### University of California Botanical Garden

The University of California Botanical Garden in Berkeley has one of the largest university collections of living plants in the nation. Its holdings include over 21,000 accessions from more than 320 plant families, with the largest concentrations in the cactus, lily, heath, sunflower, orchid, stonecrop, rose, amaryllis, and iris families.

The botanical garden originally was founded on the main campus in 1890 and then moved to its present site in Strawberry Canyon behind the campus beginning in 1919.

The garden has approximately 13,000 plant species, mostly wild in origin. The outdoor collection is arranged primarily geographically by continent, with California native plants accounting for about one-third of the garden. The garden is known for its cacti and succulents, orchids, rhododendrons, and California natives. It also has plants from most major temperate regions of the world. Among its specialized areas are the Palm Garden, Japanese Pool, Herb Garden, Garden of Economic Plants, Chinese Medicinal Herb Garden, and Mather Redwood Grove.

The botanical garden serves teaching, research, and public needs. Plants and seeds are provided to scientists and students throughout the world, with a biennial seed list being exchanged with over 600 other botanical gardens and arboreta. In addition to serving nearly 300,000 visitors annually, the garden

offers tours, classes, and special events to the public. The facilities include a visitor center, three public greenhouses, five research greenhouses, a propagation house, two associated lath houses, and facilities for volunteers, utilities, and administration.

University of California Botanical Garden, 200 Centennial Dr., Berkeley, CA 94720-5045. Phone: 510/642-3343. Hours: 9–4:45 daily (also to 7 Wed. during summer); closed Christmas. Admission: free.

### University and Jepson Herbaria

The University of California, Berkeley has two herbaria—the University Herbarium and the Jepson Herbarium—operated by the Integrative Biology Department. The collections—which number over 1.7 million specimens—are intermingled.

The University Herbarium, which has a worldwide plant collection, was founded in 1872, while the Jepson Herbarium, focusing on California plants, was established in 1950. The herbaria were located in Oakland until being moved to the Berkeley campus in 1994.

University and Jepson Herbaria, University of California, Berkeley, Integrative Biology Dept., Valley Life Sciences Bldg., Berkeley, CA 94720. Phone: 510/642-2465. Hours: 8–12 and 1–5 Mon.–Fri.; closed holidays. Admission: free.

## UNIVERSITY OF CALIFORNIA, DAVIS
### Davis Arboretum

The Davis Arboretum at the University of California, Davis, has more than 150 acres of its 250 total acres planted, with the emphasis on drought-tolerant plants of central California. Collections of the arboretum, which opened in 1936, include native and exotic trees and plants, including conifers, redwoods, eucalyptuses, acacias, American desert plants, and native California plants.

Davis Arboretum, University of California, Davis, CA 95616. Phone: 916/752-2498. Hours: 24 hours daily; closed holidays. Admission: free.

## UNIVERSITY OF CALIFORNIA, IRVINE
### University of California, Irvine, Arboretum

The University of California, Irvine, Arboretum is best known for its south African flowers and bulbs. Founded in 1965, the 13-acre facility has collections of African xerophytes, petalloid monocots, iridaceae, liliaceae, amaryllidaceae, geraniaceae, and other plants.

University of California, Irvine, Arboretum, Irvine, CA 92717. Phone: 714/856-5833. Hours: 9–3 Mon.–Sat.; closed holidays. Admission: free.

### Museum of Systematic Biology Herbarium

(See Natural History Museums and Centers section.)

# UNIVERSITY OF CALIFORNIA, LOS ANGELES
## Mildred E. Mathias Botanical Garden and UCLA Herbarium

The Mildred E. Mathias Botanical Garden was established in 1930 at the University of California, Los Angeles, as part of the university's teaching and research functions. Originally 31 acres, the garden was reduced to its present size of approximately eight acres as the campus expanded southward. In 1979, it was named for Dr. Mathias, a distinguished botanist and long-time director of the garden.

The botanical garden emphasizes subtropical and tropical plants and features plant specimens of California (especially the Mojave Desert), Hawaii, Australia, the Mediterranean, and Central America. It has more than 4,000 species in 225 families. Among the major collections are palms, cycads, myrtles, lilies, ficus trees, rhododendrons, melastomes, and acacia trees. The garden has focused on species from montane tropical forests in recent years.

The UCLA Herbarium, located in the nearby Botany Building, is part of the botanical garden. It also was founded in 1930 shortly after the university moved to Westwood.

Mildred E. Mathias Botanical Garden, University of California, Los Angeles, 405 Hilgard Ave., Los Angeles, CA 90024-1606. Phone: 310/825-1260. Hours: 8–5 Mon.–Fri.; 8–4 Sat.–Sun.; closed holidays. Admission: free.

### UCLA Hannah Carter Japanese Garden

The UCLA Hannah Carter Japanese Garden was donated to the University of California, Los Angeles, in 1965 by Edward W. Carter, then chairman of the Board of Regents. The garden—which resembles those in Kyoto, Japan—was created by Mr. and Mrs. Gordon Guiverson and designed by landscape architect Nagao Sakurai.

Nearly all the trees and plants belong to species that are grown in Japan. The garden's major structures—main gate, teahouse, bridges, and shrine—were built in Japan and reassembled here by Japanese artisans. The major symbolic rocks, antique stone carvings, and water basins also came from Japan.

UCLA Hannah Carter Japanese Garden, University of California, Los Angeles, 10619 Bellagio Rd., Los Angeles, CA 90024. Hours: 10–1 Tues. and 12–3 Wed. by reservation. Admission: free.

# UNIVERSITY OF CALIFORNIA, RIVERSIDE
## University of California, Riverside, Botanic Gardens

More than 3,500 kinds of plants are displayed at the University of California, Riverside, Botanic Gardens. The 39-acre facility's featured areas include the Cactus and Succulent Garden, Rose Garden, Iris Garden, Herb Garden, and Daylily Garden. The woody plantings emphasize Southwest-desert and Australian shrubs and trees. The gardens were founded in 1963.

University of California, Riverside, Botanic Gardens, Dept. of Botany and Plant Sciences, off E. Campus Dr., Riverside, CA 92521. Phone: 909/787-4650. Hours: 8–5 daily; closed New Year's Day, Fourth of July, Thanksgiving, and Christmas. Admission: free.

## UNIVERSITY OF CALIFORNIA, SANTA CRUZ
### UCSC Arboretum

The UCSC Arboretum at the University of California, Santa Cruz, specializes in woody plants of special scientific interest and ornamental shrubs from mild climate regions. Half of the 80 acres open to the public display approximately 4,000 types of plants. The arboretum was founded in 1969.
UCSC Arboretum, University of California, Santa Cruz, High St., Santa Cruz, CA 95064. Phone: 408/427-2998. Hours: 2–4 Wed., Sat., and Sun.; closed holidays. Admission: free.

## UNIVERSITY OF COLORADO AT BOULDER
### University of Colorado Museum Herbarium

(See Natural History Museums and Centers section.)

## UNIVERSITY OF CONNECTICUT
### Connecticut State Museum of Natural History Herbarium

(See Natural History Museums and Centers section.)

## UNIVERSITY OF CONNECTICUT AT STAMFORD
### Bartlett Arboretum

The 63-acre Bartlett Arboretum at the University of Connecticut at Stamford functions primarily as a teaching facility for public education. Started in 1965, it features dwarf conifers, ericaceous shrubs, azaleas, rhododendrons, and small flowering trees. The arboretum also has an herbarium.
Bartlett Arboretum, University of Connecticut at Stamford, 151 Brookdale Rd., Stamford, CT 06903-4199. Phone: 203/322-6971. Hours: 8:30–sunset daily. Admission: free.

## UNIVERSITY OF FLORIDA
### Florida Museum of Natural History Herbarium

(See Natural History Museums and Centers section.)

## UNIVERSITY OF GEORGIA
### State Botanical Garden of Georgia

Native and exotic plants—including rare, threatened, and endangered species—are featured at the State Botanical Garden of Georgia at the University of

Georgia in Athens. The 313-acre garden, opened in 1968, has a visitor center, conservatory, and conference facilities and presents temporary exhibitions, usually of botanical and nature-inspired art. It attracts 150,000 visitors annually.

State Botanical Garden of Georgia, University of Georgia, 2450 S. Milledge Ave., Athens, GA 30605. Phone: 706/542-1244. Hours: 9–4:30 Mon.–Sat.; 11:30–4:30 Sun.; closed holidays. Admission: free.

## University of Georgia Herbarium and Julian H. Miller Mycological Herbarium (University of Georgia Museum of Natural History)

(See Natural History Museums and Centers section.)

## UNIVERSITY OF HAWAII AT MANOA
### Harold L. Lyon Arboretum

The beautiful Harold L. Lyon Arboretum of the University of Hawaii at Manoa started in 1918 as a forest-restoration project by the Hawaii Sugar Planters' Association Experiment Station on land that was denuded of vegetation by grazing cattle. The experiment station acquired 124 acres of land and put a young botanist, Dr. Harold L. Lyon, in charge of the project. He brought in approximately 2,000 tree species and developed what became known as the Manoa Arboretum.

In 1953, Lyon persuaded the experiment station to deed the arboretum to the university with the provision that it must be used as an arboretum and botanical garden in perpetuity. In recognition of his nearly four decades of dedication to the arboretum, the facility was renamed the Harold L. Lyon Arboretum when he died in 1957.

After the university took over the arboretum, the emphasis shifted from forestry to horticulture, and later the property was expanded to 194 acres. Nearly 2,000 ornamental and economically useful plants were introduced to the grounds. More recently, the arboretum has become a center for the rescue and propagation of rare and endangered native Hawaiian plants.

Nestled in Manoa Valley against the backdrop of the Koolau Mountains on the island of Oahu, the arboretum is a major center of education and research in the fields of conservation, biology, ethnobotany, and horticulture. It also is the nation's only rain forest affiliated with a university. Much of the arboretum is a research facility, with only 80 of the 194 acres being open to the public.

The arboretum has a rich assortment of more than 5,000 native and exotic tropical species, including 700 kinds of palms—the largest collection in the world. Among the exotic ornamental plants are species and cultivars of palms, figs, aroids, gingers, prayer plants, bird of paradise plants, ornamental ti plants, and Malaysian rhododendrons. Visitors can see the colorful foliage of ti plants and bromeliads; such important economic plants as tea, coffee, cocoa, Chinese tallow, and acerola; an herb and spice garden with plant species that were useful

to early Hawaiians, such as kukul, koa, hala, noni, and kava; a Chinese-style garden for meditation and reflection; and an herbarium with approximately 5,000 species.

The arboretum has an active public on-site and outreach program that includes over 150 classes in horticulture, cooking, and arts and crafts; botanical and environment programs for schools and colleges; lecture series; publications program; and such special events as the Ethnic Festival, Honohono Orchid and Hibiscus Show and Sale, Lyon Arboretum Plant and Craft Sale, and Chef Showcase.

Harold L. Lyon Arboretum, University of Hawaii at Manoa, 3860 Manoa Rd., Honolulu, HI 96822-1180. Phone: 808/988-3177. Hours: 9–3 Mon.–Sat.; closed holidays. Admission: donation—$1.

## UNIVERSITY OF KANSAS
### McGregor Herbarium

The McGregor Herbarium at the University of Kansas in Lawrence has more than 415,000 vascular plant specimens of North America, with the emphasis on Kansas and the Great Plains region. The herbarium, established in 1873 and housed in the Bridwell Botanical Laboratory, also has extensive paleobotanical collections from the Cretaceous and Carboniferous periods, as well as regional mosses, liverworts, and fungi.

The herbarium is one of four facilities that comprise the newly created University of Kansas Natural History Museum. Descriptions of the other three are provided elsewhere—the Museum of Natural History in the Natural History Museums and Centers section, Snow Entomological Museum in the Entomology Museums section, and Museum of Invertebrate Paleontology in the Geology, Mineralogy, and Paleontology Museums section.

McGregor Herbarium, University of Kansas, Bridwell Botanical Laboratory, Campus West, Lawrence, KS 66047. Phone: 913/864-4493. Hours: 8–12 and 1–5 Mon.–Fri.; closed major holidays. Admission: free.

## UNIVERSITY OF MAINE
### Fay Hyland Arboretum

The Fay Hyland Arboretum at the University of Maine in Orono was founded in 1934. The arboretum, which borders the Stillwater River, consists largely of plants of Maine, with a few exotic specimens.

Fay Hyland Arboretum, University of Maine, 202 Deering Hall, Orono, ME 04469-5722. Phone: 207/581-2970. Hours: dawn–dusk daily. Admission: free.

### University of Maine Herbarium

Approximately 100,000 specimens can be found at the University of Maine Herbarium in Merrill Hall on the Orono campus. The Department of Plant Biology collection is especially strong in fungi.

University of Maine Herbarium, Dept. of Plant Biology, Merrill Hall, Orono, ME 04469-5722. Phone: 207/581-2970. Hours: 8–4:30 Mon.–Fri.; closed major holidays. Admission: free.

## UNIVERSITY OF MICHIGAN

The University of Michigan in Ann Arbor has a botanical garden, an arboretum, and an herbarium—the Matthaei Botanical Gardens, Nichols Arboretum, and University of Michigan Herbarium.

### *Matthaei Botanical Gardens*

The Matthaei Botanical Gardens at the University of Michigan in Ann Arbor evolved from the nineteenth-century plantings of Asa Gray, the university's first professor and botanist, for the study of medicinal plants. In 1907, the botanical gardens were formally organized under the directorship of George P. Burns, a botany professor and city planning pioneer.

Burns was instrumental in securing 55 acres adjoining the Nichols Arboretum for the initial gardens. In 1915, the need for agricultural field plots and research greenhouses prompted a move to a site in southeast Ann Arbor. By 1955, the gardens required more space. That is when gifts from Mr. and Mrs. Frederick C. Matthaei, Sr., made possible the development of the present site along Dixboro Road. The final phase of the building-greenhouse complex was completed in 1966 with funds from the National Science Foundation.

The Matthaei Botanical Gardens now consist of 265 acres, featuring more than 2,000 specimens of diverse plants of botanical, economic, and aesthetic interest. The specialty gardens include a medicinal garden, rock garden, grass collection, herb knot garden, and spreads of roses, peonies, bulbs, and perennials. Among the other features are a conservatory with tropical, warm-temperate, and desert plant exhibits; such natural habitats as wooded flood plains and wetlands, a wildflower garden, meadows, an upland forest, several ponds, and a reconstructed prairie; four nature trails that follow Fleming Creek through a variety of natural habitats; research greenhouses; and a main building that houses an auditorium, classrooms, laboratories, offices, and a gift shop.

Matthaei Botanical Gardens, University of Michigan, 1800 N. Dixboro Rd., Ann Arbor, MI 48105-9741. Phone: 313/998-6205. Hours: 8–sunset daily; closed New Year's Day, Thanksgiving, and Christmas. Admission: general admission, $2; children under 6, free.

### *Nichols Arboretum*

Founded in 1907 with a 27.5-acre gift from Esther and Walter Nichols, the Nichols Arboretum at the University of Michigan in Ann Arbor functions as a botanical and environmental education and research resource for the university, community, and state. It now comprises 123 acres of glacially carved terrain, ranging from steep ravines to rolling hills and prairie, and serves more than 100,000 people each year.

Professor O.C. Simonds, founder of the university's Department of Landscape Design, designed the sweeping vistas and intimate coves still evident in the arboretum. Among the prized collections are antique peony cultivars dating from 1927, exotic and native trees and shrubs of the north temperate regions, and collections of rhododendrons, lilacs, and Appalachian plants.

Nichols Arboretum, University of Michigan, Geddes Ave. and Washington Heights, Ann Arbor, MI 48109-1115. Phone: 313/763-5832. Hours: dawn–dusk daily. Admission: free.

## University of Michigan Herbarium

The University of Michigan Herbarium in Ann Arbor has more than 1.7 million specimens in its collections. Founded in 1921, it has a wide range of specimens from throughout the world, but is best known for its extensive New World plant collection. The herbarium, which occupies 18,000 square feet in the University North Building, is one of five facilities that comprise the Museums of Natural History.

University of Michigan Herbarium, North University Bldg., Ann Arbor, MI 48109-1057. Phone: 313/764-2407. Hours: 8–5 Mon.–Fri.; closed major holidays. Admission: free.

# UNIVERSITY OF MICHIGAN–DEARBORN
## Henry Ford Estate Gardens

(See Historical Museums, Houses, and Sites section.)

# UNIVERSITY OF MINNESOTA
## Minnesota Landscape Arboretum

The University of Minnesota, Twin Cities in Minneapolis operates the 905-acre Minnesota Landscape Arboretum in Chanhassen, 30 miles west of the main Twin Cities campus. The arboretum was started in 1958 as a joint effort of the Minnesota State Horticultural Society, Minneapolis Men's Garden Club, and University of Minnesota.

The site now includes collections, formal display gardens, research plots, ecosystems, and several buildings. A deciduous forest, an oak savanna, and a tall grass prairie can be found at the arboretum. The collections include cold hardy, woody, and herbaceous plants; crab apple, maple, lilac, linden, pine, and flowering shrub collections; and one of the largest hosta collections in the nation.

Minnesota Landscape Arboretum, University of Minnesota, Twin Cities, 3675 Arboretum Dr., PO Box 39, Chanhassen, MN 55317. Phone: 612/443-2460. Hours: 8–sunset daily. Admission: adults, seniors, and students, $4; children, $1.

# UNIVERSITY OF MONTANA
## University of Montana Zoological Museum and Herbarium

(See Zoology Museums section.)

## UNIVERSITY OF NEBRASKA–LINCOLN
### University of Nebraska State Museum Herbarium

(See Natural History Museums and Centers section.)

## UNIVERSITY OF NEVADA AT LAS VEGAS
### Marjorie Barrick Museum of Natural History Botanical Garden

(See Natural History Museums and Centers section.)

## UNIVERSITY OF NEW HAMPSHIRE
### Jesse Hepler Arboretum

The Jesse Hepler Arboretum at the University of New Hampshire in Durham is known for its varieties of lilac species. Founded in 1941, it now is in the process of being relocated.

Jesse Hepler Arboretum, University of New Hampshire, Dept. of Plant Biology, Nesmith Hall, Durham, NH 03824-3597. Phone: 603/862-9222. Hours: normally 9–4:30 Mon.–Fri.; closed holidays. Admission: free.

## UNIVERSITY OF NORTH CAROLINA AT ASHEVILLE
### Botanical Gardens of Asheville

(See Unaffiliated Museums section.)

## UNIVERSITY OF NORTH CAROLINA AT CHAPEL HILL
### North Carolina Botanical Garden

Native plants of the southeastern United States are featured at the North Carolina Botanical Garden at the University of North Carolina at Chapel Hill. The 600-acre site was founded in 1952—first serving as a research facility and then moving into public education and service.

Many of the growing plants are shown in habitat settings. Herbs and carnivorous plants are among the special collections. The garden has nature trails, greenhouses, research plots, and classroom, library, and office facilities at Totten Center. Coker Arboretum (described separately) also is part of the botanical garden.

North Carolina Botanical Garden, University of North Carolina at Chapel Hill, CB 3375 Totten Center, Chapel Hill, NC 27599-3375. Phone: 919/962-0522. Hours: 8–5 Mon.–Fri.; mid-Mar.–mid-Nov.—8–5 Sat.–Sun.; closed New Year's Day, Thanksgiving, and Christmas. Admission: free.

### Coker Arboretum

The Coker Arboretum of the North Carolina Botanical Garden at the University of North Carolina at Chapel Hill goes back to 1903. Its offerings emphasize native species of the Southeast and include dwarf conifers, daffodils, daylilies, as well as Asian species.

Coker Arboretum of the North Carolina Botanical Garden, University of North Carolina at Chapel Hill, Raleigh Rd. and Cameron Ave., Chapel Hill, NC 27514. Phone: 919/962-0522. Hours: dawn–dusk daily. Admission: free.

## UNIVERSITY OF NOTRE DAME
### Greene-Nieuwland Herbarium

The first collections of what became the Greene-Nieuwland Herbarium at the University of Notre Dame in Notre Dame, Indiana, were acquired by Catholic priest-missionaries, who deposited them at the university in 1879. The herbarium now has approximately 265,000 specimens.

Nearly 4,400 type specimens of western North American plant taxa are in the collections. The herbarium is best known for the Edward Lee Greene personal collection of 65,000 plant specimens, collected between 1862 and 1915 in western North America.

Greene-Nieuwland Herbarium, University of Notre Dame, Dept. of Biological Sciences, Notre Dame, IN 46556. Phone: 219/631-6684. Hours: by appointment. Admission: free.

## UNIVERSITY OF OKLAHOMA
### Robert Bebb Herbarium

Vascular plants of Oklahoma, the Great Plains, the Southwest, and the Southeast are featured in the Robert Bebb Herbarium at the University of Oklahoma in Norman. The herbarium, founded in 1920, has approximately 250,000 specimens. It is administered by the Department of Botany and Microbiology in cooperation with the Oklahoma Biological Survey.

Robert Bebb Herbarium, University of Oklahoma, Dept. of Botany and Microbiology, 770 Van Vleet Oval, Room 203, Norman, OK 73019. Phone: 405/325-6443. Hours: 9–5 Mon.–Fri.; closed holidays. Admission: free.

## UNIVERSITY OF THE PACIFIC
### University of the Pacific Herbarium

The University of the Pacific Herbarium in Stockton, California, is known for its collection of allium specimens. Founded in 1929 by Botany Professor E.E. Stanford as a teaching collection, it now is used for teaching and research. It is located on the second floor of the Science Classroom Building.

University of the Pacific Herbarium, Biology Dept., 228 Science Classroom Bldg., Stockton, CA 95211. Phone: 209/946-2181. Hours: by appointment; closed holidays. Admission: free.

## UNIVERSITY OF PENNSYLVANIA
### Morris Arboretum of the University of Pennsylvania

The Morris Arboretum of the University of Pennsylvania in Philadelphia is a 166-acre interdisciplinary resource center and a living museum of temperate woody plants, a historical garden, a research facility, and an educational institution. It features approximately 6,800 labeled trees and shrubs from eastern North America, Europe, and eastern Asia and is used extensively for plant research, undergraduate and graduate work, and public on-site and outreach programs.

The arboretum is the legacy of John T. and Lydia Morris, a brother and sister, who began developing their Chestnut Hill estate—known as Compton—in the tradition of the English landscape garden in 1887. Upon their death, an Advisory Board of Managers, consisting of representatives from the University of Pennsylvania and the trustee of the Morris Foundation, was established to oversee the property. The Morris Arboretum became part of the university in 1932 and was designated the official arboretum of the Commonwealth of Pennsylvania in 1989.

The Morris Arboretum has natural woodlands, meadows, landscaped gardens, a mature collection of trees, winding paths, outdoor sculpture, and natural and constructed water attractions. The many rare and invaluable tree collections include hollies, viburnums, Asian maples, witch hazels, cherries, and stewartias. Among the other offerings are the Rose Garden, Oriental Gardens, English Park, Azalea Meadow, Magnolia Slope, Oak Allee, and Swan Pond.

A number of structures from the mid-1800s and early 1900s can be seen at the arboretum. The former Morris Mansion carriage house has been renovated and converted into the George D. Widener Education Center, the 1899 Fernery Greenhouse has been restored, and the log cabin once used by Lydia Morris as a quiet pastoral retreat has become an interpretive pavilion. Other restorations include the Mercury Loggia, the Step Foundation, the Orange Balustrade, and the waterways. Among the improvements have been an expanded horticultural research center, a renovated administration building, a new garden-level phytogeographical study center for plants, and plant laboratories.

Morris Arboretum of the University of Pennsylvania, 100 Northwestern Ave., Philadelphia, PA 19118. Phone: 215/247-5777. Hours: 10–4 daily (also to 5 Sat.–Sun. Apr.–Oct.); closed Thanksgiving and Christmas through New Year's Day. Admission: adults, $3; seniors and students, $1.50.

## UNIVERSITY OF PUGET SOUND
### James R. Slater Museum of Natural History Herbarium

(See Natural History Museums and Centers section.)

## UNIVERSITY OF TENNESSEE
### *University of Tennessee Arboretum*

The University of Tennessee Arboretum occupies 250 acres at the university's Forestry Experiment Station in Oak Ridge. Opened in 1965, the facility has over 2,000 specimens of shade trees, holly, and other plants and a visitor center with exhibits and demonstrations on forest tree breeding, adaptation, and other aspects of research and natural history.

University of Tennessee Arboretum, 901 Kerr Hollow Rd., Oak Ridge, TN 37830. Phone: 615/483-3571. Hours: 8–sunset daily. Admission: free.

## UNIVERSITY OF UTAH
### *Red Butte Garden and Arboretum*

The Red Butte Garden and Arboretum of the University of Utah in Salt Lake City consist of a 350-acre botanical garden and natural areas at the mouth of Red Butte Canyon and an 1,800-acre arboretum on the campus. The arboretum opened in 1965, while the botanical garden was established in 1983. They now serve approximately 115,000 visitors annually.

The Red Butte Garden features a hybrid oak grove, cacti, dwarf conifers, beech and birch trees, and tree species for urban landscape use; native grasses; daylilies and other flowers; hiking trails; waterfalls; ponds; a sculpted ornamental glass collection; and a visitor center. It offers educational programs and a summer concert series. The arboretum is known for its woody plant and weedy collections. The garden/arboretum public programming includes floral and art temporary exhibitions and environmental, horticultural, and art classes.

Red Butte Garden and Arboretum, University of Utah, Red Butte Canyon and 390 Wakara Way, Salt Lake City, UT 84108. Phone: 801/582-5322. Hours: botanical garden—8–sunset daily; closed Christmas; arboretum—open 24 hours. Admission: free.

## UNIVERSITY OF VIRGINIA

The University of Virginia in Charlottesville has four botanical facilities—the Pavilion Gardens, Morea Gardens, and Carr's Hill Gardens on the campus and the Orland E. White Arboretum in Boyce. The Morea Gardens at the end of Sprigg Lane surround the 1830 former home of John Emmet, first professor of natural history, and include an arboretum planted by the Albemarle Garden Club in 1963. Carr's Hill, home of the university president, has a terraced landscape of lawn, flower beds, and trees on the knoll northwest of The Rotunda. Descriptions of the Pavilion Gardens and the Orland E. White Arboretum follow.

### *Pavilion Gardens*

The Pavilion Gardens are part of Thomas Jefferson's "academical village" plan for the University of Virginia in Charlottesville. From the time of Plato's

"groves of academe," gardens have been linked to the contemplative and scholarly life. Jefferson saw the university as a set of buildings "arranged around an open square of grass and trees," providing "the quiet retirement so friendly to study" (also see Historical Museums, Houses, and Sites section).

The Rotunda—modeled after the Pantheon in Rome—is the focal point of Jefferson's rectangular village, containing historic buildings, an expansive lawn, and a series of 10 formal gardens—each with a different configuration. The garden walls were completed by 1824, but Jefferson left no specific record of his intentions for the gardens. It appears that Jefferson trusted the pavilion residents with the design, planting, and maintenance of their own gardens.

Through the years, various faculty members cultivated some of the gardens, while other gardens were used primarily for utilitarian purposes—sometimes having smokehouses and animal sheds. In 1948, the Garden Club of Virginia offered to restore the gardens, hiring Alden Hopkins, noted Williamsburg landscape architect, to draw up the plans. He supervised restoration of the West Gardens. When he died, his assistant, Donald H. Parker, finished the work in the East Gardens. The restored garden designs reflect Jefferson's gardens at Monticello and landscape plans in his collection of books.

The Pavilion Gardens contain many of the flowers and shrubs that Jefferson grew at Monticello, as well as those recommended by eighteenth-century gardeners and writers. They include Madonna lilies, Virginia bluebells, carnations, crown imperial lilies, dwarf Persian irises, snapdragons, double hyacinths, peonies, parrot and striped tulips, and African and French marigolds. Native and exotic trees—such as dogwoods, maples, hollies, hemlocks, ashes, and fruit trees—beautify the gardens.

Pavilion Gardens, University of Virginia, Charlottesville, VA 22903. Phone: 804/924-7969. Hours: open 24 hours. Admission: free.

## Orland E. White Arboretum

The Orland E. White Arboretum of the University of Virginia is part of the Blandy Experimental Farm in Boyce. It accounts for 150 acres of the 700-acre farm, which is on state and national registers of historic landmarks. The arboretum was founded in 1927, but the administration/public program building dates partly from before 1810 and served as slave quarters from the 1830s to the 1860s.

The arboretum, named for its first director, is known for its extensive collection of mature trees from around the world. The woody plant familia collections occupy 90 acres and represent the primary collections, consisting of 5,400 specimens of trees and shrubs, representing 778 taxonomically verified species and varieties. It has the largest number of species of pine trees, the only flowering Chinese tulip trees, and the largest collection of boxwood varieties in North America.

Orland E. White Arboretum, University of Virginia, Blandy Experimental Station, Rte. 50, PO Box 175, Boyce, VA 22620-0175. Phone: 703/837-1758. Hours: dawn–dusk daily. Admission: free.

## UNIVERSITY OF WASHINGTON
### Washington Park Arboretum

The 200-acre Washington Park Arboretum is a partnership of the City of Seattle and the University of Washington. Founded in 1934, the facility is administered by the university's Center for Urban Horticulture. Many of the original plantings, trails, roads, and buildings—including the 1936 Stone Cottage—were part of the state and federal work-relief programs of the 1930s. The arboretum now serves 300,000 visitors each year.

The arboretum has over 5,000 taxa of woody plants. Its major collections include oaks, maples, conifers, hollies, camellias, rhododendrons, magnolias, and cherries. In addition to Northwest natives, the specimens come from around the world—Australia, China, Japan, New Zealand, Europe, North Africa, Siberia, South America, and the eastern United States.

Among the arboretum highlights are the Azalea Way; Mulligan Sorbus Collection; Woodland Garden, featuring Japanese maples; Loderi Valley, containing large-leaved rhododendrons and Loderi hybrids; Rhododendron Glen; a traditional Japanese Garden; Witt Winter Garden, with witch hazels and viburnums; and Foster Island natural and wildlife sanctuary, featuring cherries, azaleas, and dogwoods.

The Donald G. Graham Visitors Center provides information about the environment and plant collections. Additional resources at the Center for Urban Horticulture include an herbarium, a research greenhouse, a library, and a conference hall.

Washington Park Arboretum, University of Washington, 2300 Arboretum Dr., E., Seattle, WA 98195. Phone: 206/543-8800. Hours: grounds—dawn–dusk daily; visitor center—10–4 Mon.–Fri.; 12–4 Sat.–Sun.; closed New Year's Day, Thanksgiving, and Christmas. Admission: free.

## UNIVERSITY OF WISCONSIN–MADISON
### University of Wisconsin–Madison Arboretum

Founded in 1934, the 1,280-acre University of Wisconsin–Madison Arboretum has pioneered in the collection and restoration of entire ecological communities of plants—serving as a model for similar work elsewhere. It now has the world's oldest and largest collection of restored biological communities, with an annual attendance surpassing 600,000.

Forty-four different biological communities occupy 1,000 acres. The arboretum also has a woody plant collection covering 60 acres. Approximately 2,500 specimens of woody plants can be seen on the grounds. A visitor center in the center of the arboretum has exhibits and classes.

University of Wisconsin–Madison Arboretum, 1207 Seminole Hwy., Madison, WI 53711-3726. Phone: 608/263-7888. Hours: grounds—7 A.M.–10 P.M. daily; visitor center—9–4 Mon.–Fri.; 12–4 Sat.–Sun.; closed holidays. Admission: free.

## UNIVERSITY OF WISCONSIN–STEVENS POINT
*Museum of Natural History Herbarium*

(See Natural History Museums and Centers section.)

## UNIVERSITY OF WYOMING
*Rocky Mountain Herbarium*

More than 650,000 plant specimens from the Northern Hemisphere—with an emphasis on the western United States—are in the collections of the Rocky Mountain Herbarium and its two affiliated herbaria—the Solheim Mycological Herbarium and the U.S. Forest Service National Herbarium—at the University of Wyoming in Laramie.

The Rocky Mountain Herbarium, founded in 1893, has the bulk of the collections—over 480,000 specimens. Opened in 1978, the Solheim herbarium contains approximately 50,000 specimens, consisting largely of parasitic fungi. The Forest Service herbarium, which was founded in 1910 and moved to the campus in 1982, has more than 120,000 plant specimens.

Rocky Mountain Herbarium, University of Wyoming, Aven Nelson Bldg., Ninth and University Sts., Laramie, WY 82071-3165. Phone: 307/766-2236. Hours: academic year—8–5 Mon.–Fri.; summer—7:30–4:30 Mon.–Fri. Admission: free.

## UTAH STATE UNIVERSITY
*Intermountain Herbarium*

The Intermountain Herbarium at Utah State University in Logan has more than 209,000 specimens in its collections—mostly vascular plants of the intermountain region. Among the collections are mosses, lichens, rusts, seeds, and pollens. The herbarium was founded in 1931.

Intermountain Herbarium, Utah State University, Dept. of Biology, Logan, UT 84322-5305. Phone: 801/750-1586. Hours: 8–5 Mon.–Fri.; closed when university not in session. Admission: free.

## VANDERBILT UNIVERSITY
*Vanderbilt University Arboretum*

The entire 350-acre campus of Vanderbilt University in Nashville, Tennessee, is part of the university's arboretum. It had its beginnings when the university was founded in 1873—and only the institution's president could approve the removal of a tree.

A two-mile walking tour of the campus winds past 61 species of trees, including several of the largest officially identified examples of their species in Tennessee. These include a September elm, a scholar tree, and a pair of Japanese

zelkovas. The self-guided tour also lists 10 other points of interest along the route, such as sculptures, statues, and other exterior art.

Vanderbilt University Arboretum, West End Avenue, Nashville, TN 37240. Phone: 615/ 322-2715. Hours: open 24 hours. Admission: free.

## WAKE FOREST UNIVERSITY
### Reynolda Gardens

The Reynolda Gardens of Wake Forest University in Winston-Salem, North Carolina, were developed in 1916 as part of the estate of R.J. Reynolds, founder of the R.J. Reynolds Tobacco Company. The 129 acres of formal and natural plantings were donated to the university by the Mary Reynolds Babcock Foundation in 1962.

The gardens have 4.5 acres of formal gardens, featuring boxwood, annual, and perennial beds. There are three other gardens—the Upper Gardens, with vegetables, fruits, and flowers; All-America Rose Garden; and Greater Gardens, covering 125 acres of open fields and natural woodland.

The grounds also are the site of the Lord and Burnham Conservatory, built in 1912 and displaying a variety of tropical plants. The 1917 house of R.J. Reynolds, which features a collection of American art, is located on an adjoining 20 acres, but is operated separately by a nonprofit organization.

Reynolda Gardens of Wake Forest University, 100 Reynolda Village, Winston-Salem, NC 27106. Phone: 910/761-5593. Hours: sunrise–sunset daily. Admission: free.

## WELLESLEY COLLEGE
### Margaret C. Ferguson Greenhouses, Alexandra Botanic Garden, and Hunnewell Arboretum

The Margaret C. Ferguson Greenhouses, Alexandra Botanic Garden, and Hunnewell Arboretum occupy 24 acres at Wellesley College in Wellesley, Massachusetts. The 15 greenhouses were built in 1922, with the botanic garden and arboretum following later. The facilities, which contain over 1,000 types of plants and trees, are part of the Science Center.

Margaret C. Ferguson Greenhouses, Alexandra Botanic Garden, and Hunnewell Arboretum, Wellesley College, 106 Central St., Wellesley, MA 02181. Phone: 617/283-3074. Hours: 8:30–4:30 daily. Admission: free.

## WEST VIRGINIA UNIVERSITY
### Core Arboretum

The Core Arboretum at West Virginia University in Morgantown has several hundred species of native trees, shrubs, and herbaceous plants, as well as nearly three miles of trails known for an old-growth forest, colorful wildflowers, and many varieties of birds.

The arboretum was founded in 1948 and opened on a tract of open fields, wooded hillside, and low, moist bottom land bordering the Monongahela River that was acquired as part of a campus expansion. The arboretum, which now consists of 50 acres, is named for Dr. Earl L. Core, a botanist who provided the stimulus and direction leading to the establishment and development of the facility.

Core Arboretum, West Virginia University, Evansdale Campus, Monongahela Blvd.–Rte. 7, PO Box 6057, Morgantown, WV 26506-6057. Phone: 304/293-5201. Hours: dawn–dusk daily. Admission: free.

## YALE UNIVERSITY
### Marsh Botanical Garden

The Marsh Botanical Garden at Yale University in New Haven, Connecticut, has a synoptic collection of living plants of the world in Othniel March Hall and 150 species of trees and shrubs outdoors. Marsh Hall was built in 1885, and the garden was founded in 1900.

Marsh Botanical Garden, Yale University, Dept. of Biology, Othniel Marsh Hall, 227 Mansfield St., PO Box 6666, New Haven, CT 06511. Phone: 203/432-6320. Hours: 8–4:30 Mon.–Fri.; closed summer and holidays. Admission: free.

# Costume and Textile Museums

*Also see Archaeology, Anthropology, and Ethnology Museums; Art Galleries; Art Museums; and Natural History Museums and Centers sections.*

## COLORADO STATE UNIVERSITY
### Gustafson Gallery

Historic costumes and textiles are the focus of the Gustafson Gallery at Colorado State University in Fort Collins. The 700-square-foot gallery, which opened in Aylesworth Hall in 1986, presents selections from the Department of Design, Merchandising, and Consumer Sciences' research collection and temporary and traveling exhibitions.

Started in 1950, the university collection now has approximately 7,000 historical costumes and 500 textile pieces—primarily from the mid-nineteenth century to the present—as well as clothing accessories and sewing-related notions. Gustafson Gallery, Colorado State University, Aylesworth Hall (collections at 318 Gifford), Fort Collins, CO 80523. Phone: 970/491-1983. Hours: academic year—9–5 Mon.–Thurs.; summer—by appointment; closed Thanksgiving and Christmas. Admission: free.

## FASHION INSTITUTE OF TECHNOLOGY
### Museum at F.I.T.

The Museum at F.I.T.—at the Fashion Institute of Technology in New York City—is the repository of the world's largest collection of costumes, textiles,

and accessories of dress. Two block-long storerooms contain indexed collections of clothing and more than 4 million textile swatches.

The collections contain regional clothing, furs, children's wear, and lingerie, ranging from the eighteenth century to the present and including the work of the great European and American designers. The textile collection has 300 textile mill swatch books and samples of fabric dating from 1835. The twentieth-century collection, especially women's wear, is the largest and most significant.

A wide spectrum of exhibitions relevant to the fashion and satellite industries can be seen in the museum's galleries. The museum draws upon its extensive collections for exhibitions, develops special projects with other institutions, and presents traveling exhibitions.

Museum at F.I.T., Fashion Institute of Technology, E Bldg., 27th St. and Seventh Ave., New York, NY 10001-5992. Phone: 212/760-7970. Hours: 12–8 Tues.–Fri.; 10–5 Sat.; closed holidays. Admission: free.

## INDIANA UNIVERSITY
### Elizabeth Sage Historic Costume Collection

The Elizabeth Sage Historic Costume Collection in Memorial Hall at Indiana University in Bloomington has collections and exhibits of nineteenth- and twentieth-century American and Western European clothing, textiles, and accessories. The collection was established in 1935.

Elizabeth Sage Historic Costume Collection, Indiana University, 224 E. Memorial Hall, Bloomington, IN 47405. Phone: 812/855-4627. Hours: 9–5 Mon.–Fri.; closed Christmas recess. Admission: free.

## KANSAS CITY ART INSTITUTE
### Kemper Museum of Contemporary Art and Design Textiles Collection

(See Art Museums section.)

## KENT STATE UNIVERSITY
### Kent State University Museum Costumes Collection

(See Art Museums section.)

## MOUNT MARY COLLEGE
### Historic Costumes and Textiles Collection

The Fashion Department at Mount Mary College in Milwaukee, Wisconsin, has a Historic Costumes and Textiles Collection of over 6,000 pieces. Most of the costumes and textiles are from the nineteenth and twentieth centuries, although some date from the eighteenth century. Established in the late 1960s,

the collection is used primarily for teaching purposes. The exhibits are presented in Stiemke Hall in the principal academic building, Notre Dame Hall.

Historic Costumes and Textiles Collection, Mount Mary College, Fashion Dept., Notre Dame Hall, 2900 N. Menomonee River Pkwy., Milwaukee, WI 53222. Phone: 414/258-4810. Hours: 8–4 Mon.–Fri.; by appointment Sat.–Sun.; closed holidays. Admission: free.

## PHILADELPHIA COLLEGE OF TEXTILES AND SCIENCE
### Paley Design Center

The Paley Design Center at Philadelphia College of Textiles and Science in Philadelphia has more than 1.5 million international textiles dating from the first century to the present, as well as a fabric archive of over 300,000 original samples of actual work and design models from many American and European textile mills.

The historic and contemporary textile, costume, and swatch collections of the center—which opened in 1978 in the former home of Goldie Paley—are used by students, designers, historians, and craftsmen.

The center is best known for its wealth of nineteenth-century swatches. All samples are sewn to acid-free cards containing all known information. Another important collection consists of Coptic fragments.

Six exhibitions are presented each year in the center's gallery. They range from shows presenting works in the permanent collections to shows focusing on local and international designers and artists.

Paley Design Center, Philadelphia College of Textiles and Science, 4200 Henry Ave., Philadelphia, PA 19144-5497. Phone: 215/951-2860. Hours: 10–4 Tues.–Fri.; 12–4 Sat.–Sun.; closed holidays and when college not in session. Admission: free.

## RHODE ISLAND SCHOOL OF DESIGN
### Museum of Art Costumes and Textiles Collection

(See Art Museums section.)

## TEXAS WOMAN'S UNIVERSITY
### DAR Museum/First Ladies of Texas Historic Costumes Collection

The DAR Museum at Texas Woman's University in Denton features the inaugural ball and other gowns worn by the wives of the governors of Texas, the presidents of the Republic of Texas, and two presidents and a vice president of the United States. The museum, located on the ground floor of the Human Development Building, was founded in 1940.

The collection was created by the late Dr. Marion Day Mullins, a prominent genealogist, historian, and civic leader; assembled by the Texas Society of the

Daughters of the American Revolution (DAR); and then presented to the university by the DAR.

In addition to the authentic garments or copies of gowns worn by outstanding women since the founding of the Republic of Texas in 1836, the collection includes dresses worn at formal events at the White House by the wives of President Lyndon B. Johnson, President Dwight D. Eisenhower, and Vice President John Nance Garner.

DAR Museum/First Ladies of Texas Historic Costumes Collections, Texas Woman's University, Human Development Bldg., Box 23925, TWU Station, Denton, TX 76204. Phone: 817/898-3201. Hours: by appointment. Admission: free.

## UNIVERSITY OF MINNESOTA, TWIN CITIES
### Goldstein Gallery

The Goldstein Gallery is a textile, decorative arts, and design museum that is part of the Department of Design, Housing, and Apparel at the University of Minnesota, Twin Cities, in St. Paul. The museum came into being in 1976 when it was decided to bring together the various departmental collections—much of which was gathered by Harriet Vetta Goldstein, who taught in the College of Home Economics (now Human Ecology) from the 1910s to 1949.

The museum now has over 12,000 objects in its permanent collection. They include 9,000 items of historic and contemporary dress, including accessories; 1,500 decorative arts pieces, such as drawings, furniture, glass, metal, and ceramics; and 1,500 flat textiles, consisting largely of interior furnishings and ethnic materials. Among the significant collections are late-nineteenth- and early-twentieth-century dress, designer fashions, and art pottery from the 1960s to the present.

The exhibits interpret the art and design of everyday life, and designed objects are presented in their social, cultural, historical, and/or aesthetic context. The temporary exhibitions have design-related themes and include faculty, student, and traveling shows.

Goldstein Gallery, University of Minnesota, Twin Cities, 244 McNeal Hall, 1985 Buford Ave., St. Paul, MN 55108. Phone: 612/624-7434. Hours: 10–4 Mon.–Fri. (also to 8 Thurs.); 1:30–4:30 Sat.–Sun.; closed holidays. Admission: free.

## UNIVERSITY OF WASHINGTON
### Henry Art Gallery Textiles and Costumes Collection

(See Art Museums section.)

## UNIVERSITY OF WISCONSIN–MADISON
### Helen Louise Allen Textile Collection

The Helen Louise Allen Textile Collection at the University of Wisconsin–Madison is a textile and costume museum that began in 1968. It has more than

12,000 textiles, costumes, and related objects, spanning a broad spectrum of temporal, geographical, and technological diversity.

Among the holdings are archaeological textiles; fifteenth- to eighteenth-century historic textiles; eighteenth- to twentieth-century American and European coverlets, quilts, and domestic needlework; eighteenth- to twentieth-century American and European furnishing and apparel fabrics; nineteenth- and twentieth-century ethnographic costumes and textiles; and contemporary fiber art.

Helen Louise Allen Textile Collection, University of Wisconsin–Madison, 1300 Linden Dr., Madison, WI 53706. Phone: 608/262-1162. Hours: 10–4 Mon.–Fri. and by appointment; closed holidays. Admission: free.

# Entomology Museums

*Also see Natural History Museums and Centers section.*

## PENNSYLVANIA STATE UNIVERSITY
### *Frost Entomological Museum*

In 1937, Professor Stewart Ward Frost began collecting the insect specimens that resulted in a museum that was named for him in 1969—the Frost Entomological Museum at Pennsylvania State University in University Park. It now is housed in a remodeled greenhouse on the campus.

The museum has three specialty collections: the dragonfly and damselfly collection of George and Alice Beatty, aphid collection of J.O. Pepper, and louse collection of Dr. K.C. Kim. The exhibits include insects from Pennsylvania, large tropical insects, insect nests, various uses of insects, an observation beehive, live tarantulas, giant roaches, and an aquarium with aquatic insects.

Frost Entomological Museum, Pennsylvania State University, Headhouse #3, University Park, PA 16802-3500. Phone: 814/863-2865. Hours: 9:30–4:30 Mon.–Fri.; closed holidays and when university not in session. Admission: free.

## UNIVERSITY OF CALIFORNIA, BERKELEY
### *Essig Museum of Entomology*

The Essig Museum of Entomology at the University of California, Berkeley, began in 1940 as an offshoot of a California insect survey. It now has more than 4.5 million terrestrial arthropods in its collections. Among its most signif-

icant collections are aphids, coleoptera, hymenoptera, hemiptera, and microlepidoptera. The museum occupies three levels of the Wellman Hall rotunda section.

Essig Museum of Entomology, University of California, Berkeley, 311 Wellman Hall, Berkeley, CA 94720. Phone: 510/642-4779. Hours: 9–4 Mon.–Fri.; closed holidays. Admission: free.

## UNIVERSITY OF CALIFORNIA, DAVIS
### Bohart Museum of Entomology

The Bohart Museum of Entomology, which began as a teaching collection in 1947 at the University of California, Davis, has 6 million arthropod specimens in its collections. They include hymenoptera, strepsiptera, and lepidoptera insects and other terrestrial arthropods. The museum, which moved into a new building in 1994, also has an insect zoo of 20 species and 24 loan exhibits.

Bohart Museum of Entomology, University of California, Davis, Dept. of Entomology, Davis, CA 95616-8584. Phone: 916/752-0493. Hours: 8–5 Mon.–Fri.; closed when university not in session. Admission: free.

## UNIVERSITY OF CALIFORNIA, RIVERSIDE
### UCR Entomological Teaching and Research Collection

The Department of Entomology at the University of California, Riverside, has the UCR Entomological Teaching and Research Collection, consisting of insects and related noninsectan arthropods, which is partially displayed in the main entomology building and in the foyer of the collection's new building. The collection is best known for its *Apoidea* and *Chalcidoidea* hymenoptera.

UCR Entomological Teaching and Research Collection, University of California, Riverside, Dept. of Entomology, Riverside, CA 92521-0314. Phone: 909/787-4315. Hours: 8–5 Mon.–Fri. by appointment; closed holidays. Admission: free.

## UNIVERSITY OF FLORIDA
### Allyn Museum of Entomology (Florida Museum of Natural History)

(See Natural History Museums and Centers section.)

## UNIVERSITY OF KANSAS
### Snow Entomological Museum

The Snow Entomological Museum at the University of Kansas in Lawrence was established in 1897 by Professor Francis Huntington Snow as part of a cabinet of natural history. It now is a major center for research and graduate training into the systematics, evolution, and behavior of insects.

The museum, a division of the newly reorganized University of Kansas Natural History Museum (described in the Natural History Museums and Centers section), has more than 3.2 million specimens, including world representative collections of bees, scorpion flies, lygaeid bugs, and other insects. Current research is focused on crane flies, bees, wasps, beetles, and scorpion flies, with emphasis on the neotropics.

Snow Entomological Museum, University of Kansas, Snow Hall, Lawrence, KS 66045-2106. Phone: 913/864-3065. Hours: 8:30–5 Mon.–Fri. by appointment; closed holidays and when university not in session. Admission: free.

# General Museums

## ADAMS STATE COLLEGE
### *Luther E. Bean Museum*

The Luther E. Bean Museum at Adams State College in Alamosa, Colorado, began as an anthropology/ethnology museum in 1968. In the years that followed, the museum's scope was expanded to include western art and historical objects. It now is more of a general museum that occupies 5,000 square feet on the second floor of remodeled Richardson Hall, the first building on the campus and formerly the library.

Among the museum's collections and exhibits are Native American artifacts that formed the original collection; 17 paintings and bronze sculptures (including a full-sized cowboy with horse in front of the building) by Bill Moyers, cowboy artist and alumnus; antique furniture and other materials from Europe and Asia in the Charles and Beryl Woodard Collection; and pottery and santos dating back to the early 1800s from southern Colorado and northern New Mexico.

Luther E. Bean Museum, Adams State College, Richardson Hall, Alamosa, CO 81102. Phone: 719/589-7151. Hours: 1–5 Mon.–Fri.; closed holidays. Admission: free.

## ARKANSAS STATE UNIVERSITY
### *Arkansas State University Museum*

The Arkansas State University Museum in State University has permanent exhibits on history, natural history, decorative arts, and ethnology to support university studies and to teach about Arkansas. It also presents temporary ex-

hibitions rotated from its collections and in response to university and community needs. The museum's collections include Native American artifacts, fossils, minerals, clothing, china, glass, military items, and decorative art.

Arkansas State University Museum, Museum Bldg., PO Box 490, State University, AR 72467-0490. Phone: 501/972-2074. Hours: 9–4 Mon.–Fri.; 1–4 Sat.–Sun.; closed holidays. Admission: free.

## BETHEL COLLEGE
### Kauffman Museum

(See Archaeology, Anthropology, and Ethnology Museums section.)

## BRIDGEWATER COLLEGE
### Reuel B. Pritchett Museum

The Reuel B. Pritchett Museum at Bridgewater College in Bridgewater, Virginia, largely reflects the wide interests and collections of its founder, who acquired rare books and Bibles, tools, bottles, guns, coins, and many other articles in his travels. The Reverend Pritchett, a farmer-preacher in Tennessee, gave his collections to the college in 1954 and spent years establishing and arranging the museum on the campus. Since then many other persons have donated materials from China, Africa, India, the Philippines, and elsewhere.

The museum now has over 6,000 items of historical, cultural, and religious interest, including more than 175 rare books and Bibles (such as the three-volume Venice Bible published in 1482 and one of the largest collections of eighteenth-century Bibles printed by Christopher Sauer); over 1,000 different bottles, jugs, and glassware items; collections of wooden carpentry tools, cobbler's equipment, and spinning and weaving accessories; racks of guns, swords, and pistols dating from the Kentucky long-rifle; and coins and currency of many countries.

Reuel B. Pritchett Museum, Bridgewater College, E. College St., College Box 627, Bridgewater, VA 22812. Phone: 703/828-2501. Hours: 2–4 Tues.–Thurs. (also open by appointment); closed holidays. Admission: free.

## CENTRAL MICHIGAN UNIVERSITY
### Center for Cultural and Natural History

The Center for Cultural and Natural History at Central Michigan University in Mt. Pleasant is a general museum with collections and exhibits predominately of regional history and natural history. Its holdings include historical materials (including a 1901 one-room schoolhouse), archaeological and anthropological materials, rocks and minerals, paleontological and zoological objects, and Native American art and artifacts. Opened in 1971, it is located in Rowe Hall.

Center for Cultural History, Central Michigan University, 103 Rowe Hall, Bellows St., Mt. Pleasant, MI 48859. Phone: 517/774-3829. Hours: 8–12 and 1–5 Mon.–Fri.; 1–4 Sat.–Sun. during academic year; closed holidays. Admission: free.

## CENTRAL MISSOURI STATE UNIVERSITY
### Central Missouri State University Archives/Museum

The Central Missouri State University Archives/Museum in Warrensburg is a general museum with archaeological, ethnological, historical, and biological materials, as well as university history items. The Rohmiller Seashell Collection and the Haymaker Hispanic Collection are among its most important collections. Central Missouri State University Archives/Museum, 117 University Union, Warrensburg, MO 64093-5040. Phone: 216/543-4649. Hours: 9–12 and 1–4 Mon.–Fri. (other items by appointment); closed holidays and when university not in session. Admission: free.

## FRIENDS UNIVERSITY
### Fellow-Reeve Museum of History and Science

(See Historical Museums, Houses, and Sites section.)

## HAMPTON UNIVERSITY
### Hampton University Museum

The Hampton University Museum in Hampton, Virginia, is a general museum with strong collections of ethnic art, consisting largely of traditional African, Asian, Oceanian, and Native American art; contemporary African art; and nineteenth- and twentieth-century African-American art.

The museum, which began with a Hawaiian and Pacific region collection in 1868, now has more than 10,000 objects in its collections. They include materials in art, anthropology, and history. Among the collections are Zairian art, especially from the Kuba people; Native American objects from nearly all the cultural areas of North America, with the Plains Indians predominating; Oceanic sculptures from Australia, Melanesia, Micronesia, Polynesia, and the Philippines; and contemporary art in a variety of media by African and African-American artists.

The museum, which occupies 12,200 square feet in an 1881 National Historic Landmark building, plans to expand to nearly 34,300 square feet in another building in 1997.

Hampton University Museum, Academy Bldg., Marshall Ave. at Shore Rd., Hampton, VA 23668. Phone: 804/727-5308. Hours: 8–5 Mon.–Fri.; 12–4 Sat.–Sun.; closed holidays and Christmas recess. Admission: free.

## HENDERSON STATE UNIVERSITY
### Henderson State University Museum

The Henderson State University Museum is a general museum in a historic Victorian house—Stone House—built in Arkadelphia, Arkansas, in 1906. It contains Native American artifacts, natural history specimens, military hardware, antique guns, craft items, and local memorabilia.
Henderson State University Museum, 1100 Henderson St., PO Box H-7841, Arkadelphia, AR 71923-0001. Phone: 501/246-7311. Hours: afternoons and by appointment during academic year. Admission: free.

## INDIANA UNIVERSITY OF PENNSYLVANIA
### University Museum

The University Museum at Indiana University of Pennsylvania in Indiana, Pennsylvania, is a general museum with emphasis on art, anthropology, and history. Founded in 1976, the museum is located in John Sutton Hall, a National Historic Landmark, with its collections being stored elsewhere on campus.

The museum's collections and exhibits focus on art and cultural history, nineteenth- and twentieth-century American art, Native American artifacts, Inuit Indian sculpture, and paintings and drawings by Milton Bancroft. A favorite with visitors is a turn-of-the-century dormitory room, restored and furnished to recall the days when Sutton Hall housed classrooms, offices, and dormitories for the Indiana Normal School, which later became Indiana University of Pennsylvania.
University Museum, Indiana University of Pennsylvania, Sutton Hall, Indiana, PA 15705. Phone: 412/357-7930. Hours: 11–4 Tues.–Fri. (also 7–10 P.M. Thurs.); 1–4 Sat.–Sun.; closed holidays and when university not in session. Admission: free.

## KALAMAZOO VALLEY COMMUNITY COLLEGE
### Kalamazoo Public Museum

(See Historical Museums, Houses, and Sites section.)

## McPHERSON COLLEGE
### McPherson Museum

McPherson College is a partner with the City of McPherson, Kansas, in the McPherson Museum, a general community museum, which started as a study museum for anthropology, archaeology, and geology in 1890. In 1968, pioneer artifacts were added to depict Kansas history. The museum, now housed in the 1921 F.A. Vaniman Home, has collections of Pleistocene fossils, rocks and minerals, meteorites, early American glass, Indian artifacts, Oriental porcelains,

coins, art, antique furniture and clocks, and pioneer farm tools and household goods.

McPherson Museum, McPherson College, 1130 S. Euclid St., McPherson, KS 67460. Phone: 316/245-2547. Hours: 1–5 Tues.–Sun.; closed holidays. Admission: free.

## OREGON STATE UNIVERSITY
### Horner Museum

The Horner Museum at Oregon State University in Corvallis is a general museum with history, natural history, and human culture collections and exhibits. It was closed in 1993 for budgetary reasons and then reopened in 1994 as a result of campus and community pressure. Its future is now under study.

Founded in 1925, the museum occupies 24,000 square feet—of which 13,000 are devoted to exhibits—in the basement of Gill Coliseum. The principal focus is Oregon pre-history, history, natural history, and ethnic heritages.

The museum has approximately 50,000 items in its collections, as well as 220 linear feet of documents and photographs. About 67 percent of the collection is historic artifacts, while natural history specimens account for 23 percent and Native American and world cultural materials 10 percent.

The historic artifacts are mainly military, religious, political, agricultural, social, and domestic objects from the 1840s to the present. The natural history collection includes marine and invertebrate shells, fossils, rocks, minerals, birds, reptiles and mammals, insects, and wood specimens. The ethnographic materials consist largely of textiles, costumes, and other objects from throughout the world.

Horner Museum, Oregon State University, Gill Coliseum L-1, Corvallis, OR 97331-4104. Phone: 503/737-2951. Hours: 10–5 Tues.–Fri.; 12–4 Sat.–Sun.; closed holidays. Admission: adults, $1.50; school children, 50¢; children 6 and under, free.

## PRINCIPIA COLLEGE
### Principia School of Nations Museum

The Principia School of Nations Museum has two locations—on the Principia College campus in Elsah, Illinois, and in St. Louis, Missouri. Founded in 1929, the museum has an eclectic collection used to develop exhibits and academic programs and to enhance educational offerings in nearby schools. The collection includes pre-Columbian and Native American artifacts, Oriental art objects, decorative arts, costumes, textiles, dolls, and pottery—most of which were received from donors who gathered the materials during their travels.

Principia School of Nations Museum, Principia College, Elsah, IL 62028. Phone: 618/374-5259. Hours: 10–3 Tues. and Fri.; weekends by appointment; closed holidays and when college not in session. Admission: free.

Principia School of Nations Museum, Principia College, 13201 Clayton Rd., St. Louis, MO 63131. Phone: 314/434-2100. Hours: 8:30–4 Mon.–Wed., Fri.; closed holidays and when college not in session. Admission: free.

## SOUTHEAST MISSOURI STATE UNIVERSITY
### Southeast Missouri State University Museum

Modern fine art, Mississippian archaeological objects, and regional, military, and university history materials are displayed at the Southeast Missouri State University Museum in Cape Girardeau. The museum also has from 12 to 17 temporary exhibitions each year. The offerings usually are integrated with the university studies curriculum.

Southeast Missouri State University Museum, 1 University Plaza, Cape Girardeau, MO 63701-4799. Phone: 314/651-2260. Hours: 9–4 Mon.–Fri.; closed holidays and when university not in session. Admission: free.

## SOUTHERN ILLINOIS UNIVERSITY AT CARBONDALE
### University Museum

The human condition and the world environment are the focus of the University Museum at Southern Illinois University at Carbondale. Established in 1869 and opened in 1874 when classes began at the university, the general museum has collections and exhibits in the fine and decorative arts, anthropology and archaeology, history, geology, and natural history.

Among the museum holdings are a collection of 2,500 artworks and more than 23,000 objects in the prehistoric and scientific collections. The prehistoric collections include items from southern Illinois, North America, Mexico, and Canada, while the scientific collections have specimens in geology, zoology, and biology. The museum also has ethnographic materials from Oceania, Asia, Africa, Mexico, and South America.

University Museum, Southern Illinois University at Carbondale, Faner Hall, Carbondale, IL 62901. Phone: 618/453-5388. Hours: 9–3 Tues.–Sat.; 1:30–4:30 Sun.; closed holidays and when university not in session. Admission: free.

## SOUTHERN ILLINOIS UNIVERSITY AT EDWARDSVILLE
### University Museum

The University Museum at Southern Illinois University at Edwardsville is a "museum without walls," having collections and exhibits in academic departments, rather than at a central location. It also organizes a monthly temporary exhibition at the University Center. Founded in 1959, the museum is art oriented, although it has anthropological and other collections, such as African masks and other artifacts, Korean pottery, architectural ornaments, and musical instruments.

University Museum, Southern Illinois University at Edwardsville, Box 1150, Edwardsville, IL 62026. Phone: 618/692-2996. Hours: 8 A.M.–10 P.M. Mon.–Fri.; closed holidays. Admission: free.

## SOUTHWESTERN MICHIGAN COLLEGE
### Southwestern Michigan College Museum

(See Historical Museums, Houses, and Sites section.)

## TEXAS TECH UNIVERSITY
### Museum of Texas Tech University

The Museum of Texas Tech University in Lubbock is a general museum concerned primarily with regional history, culture, and natural history. The 167,591-square-foot museum has five primary structures—a main building, a planetarium, a natural science laboratory, a research center, and an orientation building for the Ranching Heritage Center (which consists of a 14-acre outdoor exhibit area with 33 structures).

The museum has approximately 1.5 million objects in its collections. The collections include large mammalogy holdings in skins, skulls, and preserved and frozen tissues; archaeological materials; fine arts; clothing and textiles; and paleontological materials. Opened in 1929, the museum has an annual attendance of over 200,000.

Museum of Texas Tech University, Fourth St. and Indiana Ave., PO Box 43191, Lubbock, TX 79409-3191. Phone: 806/742-2442. Hours: 10–5 Tues.–Sat. (also to 8:30 Thurs.); 1–5 Sun.; closed holidays. Admission: free.

## UNIVERSITY OF ARKANSAS
### University Museum

The University Museum of the University of Arkansas in Fayetteville is a general museum that traces its beginnings to 1873. Among the museum's diverse collections and exhibits are prehistoric Arkansas Indian artifacts, quartz crystals, bird eggs and nests, early American pressed glass and textile equipment, and ethnology, malacology, herpetology, ichthyology, geology, and paleontology materials.

University Museum, University of Arkansas, 202 Museum Bldg., Fayetteville, AK 72701. Phone: 501/575-3555. Hours: 9–5 Mon.–Sat.; 1–5 Sun.; closed major holidays. Admission: free.

## UNIVERSITY OF MISSISSIPPI
### University Museums

The University Museums at the University of Mississippi in University consist of two connecting museums—the Mary Buie Museum and the Kate Skipwith Teaching Museum—located in the university's Cultural Center. The Mary Buie Museum was established in 1939 and was given to the City of Oxford by her

family. In the 1970s, the museum was turned over to the university, and in 1976, an addition named for Ms. Buie's sister, Kate Skipwith, was constructed with family and state funds.

The museum complex has two permanent exhibits—one on Greek and Roman antiquities and another on nineteenth-century scientific instruments. It also has a semi-permanent exhibit on southern folk art and a hands-on children's room and presents six to eight temporary exhibitions each year on art, history, anthropology, and science.

Among the collections are the David M. Robinson Memorial Collection of Greek and Roman sculpture and coins, Greek decorated pottery, Roman copies of Greek artworks, inscribed Sumerian clay tablets, and other ancient artifacts; Millington-Barnard Collection of approximately 500 nineteenth-century scientific instruments; Theora Hamblatt Collection of her folk art; and Southern Folk Art Collection in a wide range of media, including textiles, wood, clay, paintings, and natural materials.

University Museums, University of Mississippi, Fifth St. and University Ave., University, MS 38677. Phone: 601/232-7073. Hours: 10–4 Tues.–Sat.; 1–4 Sun.; closed holidays. Admission: free.

# UNIVERSITY OF SOUTH CAROLINA
## McKissick Museum

The McKissick Museum at the University of South Carolina in Columbia is a general museum with collections and exhibits of material culture, natural science, and decorative and fine arts. The museum opened in 1976 in a remodeled 53,800-square-foot library building, but its collections began in 1823 when the university purchased the mineral and fossil collection of Thomas Cooper, the prominent natural scientist. Since then extensive collections have been developed in history, art, and natural science as they relate to the social, cultural, and scientific development of South Carolina and the Southeast.

The historical holdings contain more than 25,000 materials of regional significance. These collections have important concentrations of southern material/ folk culture, and they include such objects as African-American coiled baskets, alkaline-glazed stoneware, Catawba Indian pottery, hand-crafted wood and metal objects, textiles, and antique silver. The fine and decorative arts collection consists of approximately 2,000 artworks—largely works by faculty and alumni, historic portraits, and ceramics.

The museum's natural science collection has over 100,000 research and exhibit specimens in geology and paleontology, with an emphasis on regional minerals and fossils. The collection is a historical record of human interaction with the natural environment in the Southeast, as well as a strong research resource.

Between 15 and 20 changing exhibitions are offered annually by the museum.

Approximately one-third interpret objects from the museum's collections, and the remainder present materials on loan from public and private sources.
McKissick Museum, University of South Carolina, Pendleton and Bull Sts., Columbia, SC 29208. Phone: 803/777-7251. Hours: 9–4 Mon.–Fri.; 10–5 Sat.; 1–5 Sun.; closed major holidays. Admission: free.

## UNIVERSITY OF TENNESSEE AT KNOXVILLE
### Frank H. McClung Museum

The Frank H. McClung Museum at the University of Tennessee at Knoxville is a general museum with collections in anthropology, archaeology, decorative arts, medicine, local history, and natural history. The exhibits document ways of life, cultural trends, and technology from the prehistoric to the contemporary—focusing largely on the culture, history, art, and geology of Tennessee's past.

The 38,500-square-foot museum, which began in 1961 as a result of a bequest, has a wide range of collections, including the Lewis-Kneberg Collection of Tennessee archaeology, Dr. Samuel Joseph Platt Medical Collection, Eleanor Deane Audigier Art Collection, archaeological collections from Tennessee reservoirs, Native American and ancient Egyptian artifacts, and historical, natural science, and ethnological collections.

Major exhibits are presented on archaeology and Native American history, the geology and fossil history of Tennessee, ancient Egypt, human fossils, early medical practices in eastern Tennessee, and decorative arts from different cultures and times. Temporary exhibitions on telecommunications, Cherokee basketry, antique quilts, the Civil War in Tennessee, and other topics have been shown in the Raoul and Marie Louise Verhagen Gallery.
Frank H. McClung Museum, University of Tennessee at Knoxville, 1327 Circle Park Dr., Knoxville, TN 37996-3200. Phone: 615/974-2144. Hours: 9–5 Mon.–Fri.; 10–3 Sat.; 2–5 Sun.; closed major holidays. Admission: free.

## UNIVERSITY OF TENNESSEE AT MARTIN
### University Museum

The University Museum at the University of Tennessee at Martin is a general museum and archives facility that has art, history, and science collections and exhibitions. Established in 1981, it is located in the former Home Economics Building, which has been renovated and renamed the Holland McCombs Center and Archives.
University Museum, University of Tennessee at Martin, Holland McCombs Center and Archives, Martin, TN 38238-5023. Phone: 901/587-2084. Hours: 1–4 Mon.–Fri.; closed when university not in session. Admission: free.

# Geology, Mineralogy, and Paleontology Museums

*Also see Natural History Museums and Centers section.*

## AMHERST COLLEGE
### Pratt Museum of Natural History

(See Natural History Museums and Centers section.)

## ARIZONA STATE UNIVERSITY
### Museum of Geology

The Museum of Geology at Arizona State University in Tempe has fossils, a seismograph, a Focault pendulum, and other exhibits in the first floor lobby area of the F-wing of the Physical Sciences Building. The museum came into being in 1977 when it was incorporated into the new building.

Museum of Geology, Arizona State University, Physical Sciences Bldg., Box 871404, Tempe, AZ 85287. Phone: 602/965-7065. Hours: 9–3 Mon.–Fri.; closed holidays. Admission: free.

### Center for Meteorite Studies

One of the three largest meteorite collections in the world can be seen at the Center for Meteorite Studies at Arizona State University in Tempe. The center has a small, but comprehensive, museum that began in 1961 with the acquisition of the Nininger Meteorite Collection. Located in the Research Wing of the

Science Complex, it features representative meteorites from individual falls and finds.

Center for Meteorite Studies, Science Complex Research Wing, Arizona State University, Tempe, AZ 85287. Phone: 602/965-6511. Hours: 8–4:30 Mon.–Fri.; closed holidays and when university not in session. Admission: free.

# AUGUSTANA COLLEGE
## Fryxell Geology Museum

The Fryxell Geology Museum at Augustana College in Rock Island, Illinois, got its start in the 1920s when Dr. Fritiof M. Fryxell began developing a geology department and used modest displays of fossils, rocks, and minerals to supplement basic geology courses. In 1935, the science departments and the museum moved into Wallberg Hall of Science. The museum was named for retiring Professor Fryxell when it occupied new quarters in the Swenson Hall of Science in 1968.

Among the museum's extensive collections are dinosaur fossils, remains of simple plants and animals, and minerals and rocks from Illinois, the Antarctic, and elsewhere. The exhibits include a mastodon skull and tusks; a block of limestone on which are preserved 50 specimens of the Ordovician trilobite, *Homotelus;* an *Ichthyosaurus,* a Jurassic marine reptile; the skull of a *Triceratops* dinosaur; a full skeleton of a *Tylosaurus;* casts of the skulls of the *Tyrannosaurus rex, Parasaurolopus, Allosaurus,* and *Dunkleosteus;* and insects, arthropods, pterodactyls, fish, and echinoderms from the Solenhofen Collection.

Fryxell Geology Museum, Augustana College, Swenson Hall of Science, 820 38th St., Rock Island, IL 61201. Phone: 309/794-7318. Hours: 8–5 Mon.–Fri.; 1–4 Sat. and Sun.; closed July, first half of Aug., and holidays. Admission: free.

# BAYLOR UNIVERSITY
## Strecker Museum

(See Natural History Museums and Centers section.)

# BEREA COLLEGE
## Wilbur Greeley Burroughs Geologic Museum

Collections of Kentucky agate, minerals, and artifacts can be seen at the Wilbur Greeley Burroughs Geologic Museum at Berea College in Berea, Kentucky.

Wilbur Greeley Burroughs Geologic Museum, Berea College, CPO 1105, Berea, KY 40404. Phone: 606/986-9341. Hours: 9–5 Mon.–Fri.; closed holidays and when college not in session. Admission: free.

## BRIGHAM YOUNG UNIVERSITY
### Earth Science Museum

The Earth Science Museum at Brigham Young University in Provo, Utah, has one of the largest and best collections of Jurassic-period dinosaur fossils. The museum, which was opened in 1987 as part of the Department of Geology's Paleontology Laboratory, has over 120 tons of Jurassic dinosaur fossils, as well as specimens from most geologic periods.

The collection was started by Jim Jensen, who by the 1970s had collected tons of material from the university's Dry Mesa Quarry and Colorado deposits. In the years that followed, fossils of Teritiary-period animals were gathered from the United States and Mexico, and Mesozoic-period dinosaur fossils were found in Utah, Colorado, and surrounding states. The museum's holdings include an *Ultrasaurus,* the largest dinosaur on record, and a *Supersaurus,* the longest known dinosaur.

Earth Science Museum, Brigham Young University, ERTH Bldg., 1683 N. Canyon Rd., PO Box 23300, Provo, UT 84602-3300. Phone: 801/378-3680. Hours: 9–5 Mon.–Fri. (also to 9 Mon.); 12–4 Sat.; closed holidays. Admission: free.

## CHADRON STATE COLLEGE
### CSC Earth Science Museum

The CSC Earth Science Museum at Chadron State College in Chadron, Nebraska, was founded in 1939. Located in the Math and Science Building, it has collections and exhibits in geology, paleontology, and archaeology.

CSC Earth Science Museum, Chadron State College, Math and Science Bldg., Chadron, NE 69337. Phone: 308/432-6293. Hours: by appointment only; closed summer and holidays. Admission: free.

## COLLEGE OF EASTERN UTAH
### College of Eastern Utah Prehistoric Museum

The College of Eastern Utah Prehistoric Museum, located in a remodeled and expanded city gymnasium in downtown Price, features prehistoric collections and exhibits from eastern Utah. It is known for its interpretive dinosaur and prehistoric Native American exhibits. The museum has original fossil dinosaurs from the Cleveland-Lloyd Dinosaur Quarry, early Cretaceous dinosaur materials, dinosaur tracks from coal mines, and Fremont Indian artifacts, including the Pilling figurines.

College of Eastern Utah Prehistoric Museum, 155 E. Main St., Price, UT 84501. Phone: 801/637-5060. Hours: 9–5 daily; closed New Year's Day, Thanksgiving, and Christmas. Admission: free.

GEORGIA SOUTHERN UNIVERSITY

## COLORADO SCHOOL OF MINES
### Geology Museum

Founded in 1874, the Colorado School of Mines Geology Museum in Golden has extensive collections and two floors of exhibits in such fields as mineralogy, paleontology, geology, and Colorado mining. The museum has collections and exhibits of minerals, gems, scientific instruments, and mining equipment and artifacts.

Geology Museum, Colorado School of Mines, 16th and Maple Sts., Golden, CO 80401. Phone: 303/273-3815. Hours: academic year—9–4 Mon.–Sat.; 1–4 Sun.; summer months—9–4 Mon.–Sat.; closed holidays. Admission: free.

## EARLHAM COLLEGE
### Joseph Moore Museum of Natural History

(See Natural History Museums and Centers section.)

## EASTERN NEW MEXICO UNIVERSITY
### Miles Mineral Museum

The minerals of New Mexico are featured at the Miles Mineral Museum at Eastern New Mexico University in Portales. The museum, which started in 1969 with the donation of the mineral collection of Fred A. Miles of Roswell, has extensive calcite, gypsum, and other collections.

Miles Mineral Museum, Eastern New Mexico University, Station 33, Portales, NM 88130. Phone: 505/562-2651. Hours: 8–5 Mon.–Fri. by appointment; closed holidays and when university not in session. Admission: free.

## FORT HAYS STATE UNIVERSITY
### Sternberg Museum of Natural History

(See Natural History Museums and Centers section.)

## FRANKLIN AND MARSHALL COLLEGE
### the Museum of Natural History and Science

(See Natural History Museums and Centers section.)

## GEORGIA SOUTHERN UNIVERSITY
### Georgia Southern Museum

(See Natural History Museums and Centers section.)

## HARVARD UNIVERSITY
### *Mineralogical and Geological Museum*

The Mineralogical and Geological Museum at Harvard University in Cambridge, Massachusetts, grew out of the academic department's teaching and research collections that began in 1784 and always have been exhibited to the public. The museum now has an internationally recognized systematic collection containing many rare species and numerous types of specimens.

The collection consists of more than 250,000 minerals, ores, rocks, meteorites, and gems, many of which are on display. They cover virtually the entire scope of the mineral sciences. They include such minerals as beautiful tourmalines from Maine, amethysts from Rhode Island, hiddenite crystal from North Carolina, one of the two finest specimens of Red Cloud wolfenites, and the largest known jeremejevite crystal.

The already representative collection of American and European specimens was supplemented by the A.F. Holden Collection in 1913 and now exceeds 50,000 specimens. The petrology and economic geology collections have over 75,000 specimens of igneous, sedimentary, and metamorphic rocks and ores from the earth's crust. The museum augmented its holdings of meteorites by acquiring the J. Lawrence Smith Collection in 1883 and others over the years, resulting in a diverse collection of over 500 meteorites. It also has exhibits on cave formations and volcanoes.

The Mineralogical and Geological Museum is one of four museums that comprise the Harvard University Museums of Natural History and share the same building.

Mineralogical and Geological Museum, Harvard University, 24 Oxford St., Cambridge, MA 02138. Phone: 617/495-4758. Hours: 9–4 Mon.–Sat.; 1–4 Sun.; closed major holidays. Admission: adults, $3; seniors and students, $2; children under 15, $1.

## IDAHO STATE UNIVERSITY
### *Idaho Museum of Natural History*

(See Natural History Museums and Centers section.)

## LAMAR UNIVERSITY
### *Spindletop/Gladys City Boomtown Museum*

(See Historical Museums, Houses, and Sites section.)

## LIBERTY UNIVERSITY
### *Museum of Earth and Life History*

(See Natural History Museums and Centers section.)

## LOUISIANA STATE UNIVERSITY
### Museum of Natural Science

(See Natural History Museums and Centers section.)

## MARSHALL UNIVERSITY
### Geology Museum

The Geology Museum at Marshall University in Huntington, West Virginia, contains minerals, rocks, and fossils. The collection is displayed in the second floor reading room of the university library.
Geology Museum, Marshall University, Dept. of Geology, 400 Hal Greer Blvd., Huntington, WV 25755-2550. Phone: 304/696-6720. Hours: 8–4:30 Mon.–Fri.; closed holidays. Admission: free.

## MICHIGAN STATE UNIVERSITY
### Michigan State University Museum

(See Natural History Museums and Centers section.)

## MICHIGAN TECHNOLOGICAL UNIVERSITY
### A.E. Seaman Mineral Museum

The A.E. Seaman Mineral Museum at Michigan Technological University in Houghton has exhibits containing representative specimens from its collection of crystals and lapidary works from 1886 to the present; native copper, silver, and iron ores from upper Michigan; and systematic mineral specimens. The museum collection began in 1902.
A.E. Seaman Mineral Museum, Michigan Technological University, 1400 Townsend Dr., Houghton, MI 49931. Phone: 906/487-2572. Hours: Nov.–Mar.—9–4:30 Mon.–Fri.; July–Oct.—9–4:30 Mon.–Fri.; 12–5 Sat.; closed holidays. Admission: free.

## MISSISSIPPI STATE UNIVERSITY
### Dunn-Seiler Museum

The Dunn-Seiler Museum at Mississippi State University is a natural history museum with collections of Mesozoic and Cenozoic paleontology materials, Upper Cretaceous lepadormorph barnacles, and mineralogical and geological specimens. It was founded in 1947.
Dunn-Seiler Museum, Mississippi State University, Dept. of Geology and Geography, PO Drawer 5167, Mississippi State University, MS 39762. Phone: 601/325-3915. Hours: 8–5 Mon.–Fri.; closed holidays and when university not in session. Admission: free.

## MONTANA COLLEGE OF MINERAL SCIENCE AND TECHNOLOGY
### Mineral Museum

The Mineral Museum at the Montana College of Mineral Science and Technology in Butte has more than 15,000 mineral specimens. The collection began in 1901 with the purchase of 177 specimens. Among the museum's exhibits are fluorescent minerals, minerals from classic world localities, minerals from the Butte area and Montana, and the Highland Centennial Gold Nugget, weighing 27.475 troy ounces, found near Butte in 1989.

Mineral Museum, Montana College of Mineral Science and Technology, 1300 W. Park St., Butte, MT 59701-8997. Phone: 406/469-4172. Hours: Oct.–May—8–5 Mon.–Fri.; 1–5 Sun.; closed holidays; Memorial Day–Sept.—8–5 daily. Admission: free.

## MONTANA STATE UNIVERSITY
### Museum of the Rockies

(See Natural History Museums and Centers section.)

## NEW MEXICO INSTITUTE OF MINING AND TECHNOLOGY
### New Mexico Bureau of Mines Mineral Museum

(See Unaffiliated Museums section.)

## OHIO STATE UNIVERSITY
### Orton Geological Museum

Ohio State University's Orton Geological Museum in Columbus was started in 1893 by Dr. Edward Orton, Sr., professor of geology and first president of the university, who gave his personal collection of 10,000 specimens. Today the museum has more than 47,000 fossil, mineral, and rock specimens representing approximately 7,000 specimen types, including a reference collection of Lower Paleozoic fossils from the mid-continent region.

Among the exhibits are fossils of organisms that lived in Ohio during each of the geologic time periods; an 11-foot-long, 7-foot-tall skeleton of *Megalonyx jeffersoni,* a giant ground sloth found in the state; a *Glyptodon,* a large relative of the South American armadillo; a full-sized cast of the skull of a *Tyrannosaurus rex;* Jurassic dinosaur fossils from the Solenhofen lithographic limestone of Germany; mammoth and mastodon bones and teeth; and the physical properties, crystal systems, color, fluorescence, and other aspects of minerals. Some of the latter are from a collection of over 5,000 specimens donated in 1987 by Jack DeLong, a petroleum exploration geologist.

The museum is housed in Orton Hall, built in 1893 of 40 kinds of Ohio stone.

It is a classic example of Richardsonian Romanesque architecture with massive stone walls, arches, pillars, and a turret-like tower with 24 carved sandstone gargoyles (each representing the head of an actual prehistoric animal).
Orton Geological Museum, Ohio State University, 155 S. Oval Mall, Columbus, OH 43210-1398. Phone: 614/292-6896. Hours: 8–5 Mon.–Fri.; weekends by appointment; closed holidays. Admission: free.

## PENNSYLVANIA STATE UNIVERSITY
### Earth and Mineral Sciences Museum and Gallery

The Earth and Mineral Sciences Museum and Gallery at Pennsylvania State University in University Park was started in 1930 by Dean Edward Steidle, who wanted to further campus understanding of the mining and metallurgical fields and change the science/engineering/industry image of the School of Mines and Metallurgy.

Dean Steidle personally collected many of the artworks now in the museum/gallery in an effort to make the school more of a cultural center. Today the museum/gallery has more than 20,000 mineral, gem, and fossil specimens; over 225 paintings, drawings, and sculptures relating to the mineral industries; and 30 push-button exhibits showing mineral properties.
Earth and Mineral Sciences Museum and Gallery, Pennsylvania State University, 122 Steidle Bldg., University Park, PA 16802-5005. Phone: 814/865-6427. Hours: 9–5 Mon.–Fri.; closed holidays and when university not in session. Admission: free.

## PRINCETON UNIVERSITY
### Princeton University Museum of Natural History

(See Natural History Museums and Centers section.)

## SAN DIEGO STATE UNIVERSITY
### E.C. Allison Research Center

The E.C. Allison Research Center at San Diego State University in San Diego, California, consists of paleontology and geology study collections, a museum, and a library. The collections cover the fields of paleontology, malacology, mineralogy, and geology. The center was founded in 1971.
E.C. Allison Research Center, San Diego State University, Dept. of Geological Sciences, San Diego, CA 92182-1020. Phone: 619/594-5586. Hours: 8–4:30 Mon.–Fri. Admission: free.

## SAN JOAQUIN DELTA COLLEGE
### Clever Planetarium and Earth Science Center

(See Planetaria and Observatories section.)

## SOUTH DAKOTA SCHOOL OF MINES AND TECHNOLOGY
### Museum of Geology

Badlands fossils and Black Hills minerals are featured at the Museum of Geology at the South Dakota School of Mines and Technology in Rapid City. The museum also has a systematic collection of minerals from throughout the world. The collections began in 1885, while the museum was founded in 1939.

Among the museum's fossils are skeletons of giant reptiles and fish from the ancient Cretaceous seas of South Dakota and skeletons of Oligocene saber-toothed cats, a three-toed horse, small camels, a "mother" oreodont, and other animals. Gold samples, polished agates, meteorites, fluorescent minerals, fossil plants, and marine invertebrates are part of the systematic collection.

Museum of Geology, South Dakota School of Mines and Technology, 501 E. St. Joseph St., Rapid City, SD 57701. Phone: 605/394-6131. Hours: academic year—8–5 Mon.–Fri.; 9–2 Sat.; 1–4 Sun.; summer—8–6 Mon.–Sat.; 12–6 Sun.; closed holidays during academic year. Admission: free.

## STATE UNIVERSITY OF NEW YORK AT STONY BROOK
### Museum of Long Island Natural Sciences

(See Natural History Museums and Centers section.)

## STETSON UNIVERSITY
### Gillespie Museum of Minerals

The Gillespie Museum of Minerals at Stetson University in DeLand, Florida, has collections and exhibits of minerals, fossils, and related materials, including a teaching collection of major rock groups.

Gillespie Museum of Minerals, Stetson University, 234 E. Michigan Ave., Box 8401, DeLand, FL 32720. Phone: 904/822-7330. Hours: 9–4 Mon.–Fri.; closed holidays and when university not in session. Admission: free.

## TEXAS LUTHERAN COLLEGE
### A.M. and Alma Fiedler Memorial Museum

Rocks, minerals, fossils, and Native American, New Guinea, and other arti-facts are featured at the A.M. and Alma Fiedler Memorial Museum at Texas Lutheran College in Seguin. Basically a teaching museum in geology, it also has an adjacent rock garden. The museum was founded in 1973—when the Langner Hall classroom building was remodeled—following a collection gift from A.M. Fiedler and his daughter, Evelyn Fiedler Streng, who is museum director and professor emeritus.

A.M. and Alma Fiedler Memorial Museum, Texas Lutheran College, Langner Hall, Seguin, TX 78155. Phone: 201/372-8000. Hours: 1–5 Mon.–Fri.; by appointment Sat.–Sun.; closed holidays and when college not in session. Admission: free.

## TRINIDAD STATE JUNIOR COLLEGE
### Louden-Henritze Archaeology Museum

(See Archaeology, Anthropology, and Ethnology Museums section.)

## UNIVERSITY OF ALABAMA
### Alabama Museum of Natural History

(See Natural History Museums and Centers section.)

## UNIVERSITY OF ARIZONA
### University of Arizona Mineral Museum

The University of Arizona Mineral Museum in Tucson has over 19,000 mineral specimens from Arizona and other parts of the world. Started in 1891 as an original part of the land grant institution, the museum is located in the Flandrau Science Center.
University of Arizona Mineral Museum, Dept. of Geosciences, Gould-Simpson Bldg., Tucson, AZ 85721. Phone: 602/621-4227. Hours: 9–5 Mon.–Fri.; 10–3 Sat.; closed holidays. Admission: free.

## UNIVERSITY OF ARKANSAS
### University Museum

(See General Museums section.)

## UNIVERSITY OF CALIFORNIA, BERKELEY
### Museum of Paleontology

The Museum of Paleontology is one of four natural history and sciences museums at the University of California, Berkeley (see Natural History Museums and Centers section for others). The museum was founded in 1921 and is located in the newly renovated Valley Life Sciences Building.

The museum's collections, which began in 1873, include fossil vertebrates, invertebrates, plants, recent molluscan shells, foraminifera, vertebrate skeletal elements, protists, and sedimentary rock samples. Research activities cover such fields as paleobiology, cytology, anatomy and physiology of protistids, malacology, paleoceanography, morphometrics, ecology, and endangered invertebrate species.

Museum of Paleontology, University of California, Berkeley, Valley Life Sciences Bldg., Berkeley, CA 94720. Phone: 510/642-9006. Hours: 8–5 Mon.–Fri.; 1–5 Sat.; closed holidays. Admission: free.

## UNIVERSITY OF CINCINNATI
### *University of Cincinnati Geology Museum*

The University of Cincinnati Geology Museum was formed as part of the Department of Geology in 1907. It has more than 745,000 cataloged fossils and many more that are uncataloged. The museum is best known for its fossil collections from the Ordovician strata in the region. Other collections include Paleozoic fossils from other areas and the Kopf Collection of invertebrate fossils. University of Cincinnati Geology Museum, Dept. of Geology, Cincinnati, OH 45221-0013. Phone: 513/556-3732. Hours: 9–5 Mon.–Fri.; closed holidays. Admission: free.

## UNIVERSITY OF COLORADO AT BOULDER
### *University of Colorado Museum*

(See Natural History Museums and Centers section.)

## UNIVERSITY OF FLORIDA
### *Florida Museum of Natural History*

(See Natural History Museums and Centers section.)

## UNIVERSITY OF GEORGIA
### *University of Georgia Museum of Natural History*

(See Natural History Museums and Centers section.)

## UNIVERSITY OF ILLINOIS AT URBANA-CHAMPAIGN
### *Museum of Natural History*

(See Natural History Museums and Centers section.)

## UNIVERSITY OF IOWA
### *Museum of Natural History*

(See Natural History Museums and Centers section.)

## UNIVERSITY OF KANSAS
### *Museum of Invertebrate Paleontology*

The Museum of Invertebrate Paleontology, a research facility with collections of more than 500,000 specimens of invertebrate fossils, is administered as part of the newly created University of Kansas Natural History Museum in Lawrence. The combined natural history complex includes four of the five systematic museums. The others are described in the Natural History Museums and Centers, Entomology Museums, and Botanical Gardens, Arboreta, and Herbaria sections.

The museum's greatest strengths are Cambrian fossils of western North America and late Paleozoic fossils of the mid-continent. The collections also contain nearly 50,000 slides of fossil fusulinids from all parts of the world. The museum's exhibits are located in the first and third floor hallways of Lindley Hall. The museum is part of the Department of Geology.

Museum of Invertebrate Paleontology, University of Kansas, Lindley Hall, Lawrence, KS 66045. Phone: 913/864-3338. Hours: by appointment; closed major holidays. Admission: free.

## UNIVERSITY OF MICHIGAN
### *Museum of Paleontology*

The Museum of Paleontology is one of five institutions that comprise the University of Michigan Museums of Natural History in Ann Arbor (see Natural History Museums and Centers section). It is primarily a research collection of fossil remains in the Ruthven Museums Building.

Museum of Paleontology, University of Michigan, Ruthven Museums Bldg., 1109 Geddes Ave., Ann Arbor, MI 48109-1079. Phone: 313/647-0489. Hours: by appointment. Admission: free.

## UNIVERSITY OF MINNESOTA, TWIN CITIES
### *James Ford Bell Museum of Natural History*

(See Natural History Museums and Centers section.)

## UNIVERSITY OF MISSOURI–ROLLA
### *Minerals Museum*

Minerals from around the world are shown at the Minerals Museum at the University of Missouri–Rolla. Most of the 3,000 specimens in the collection came from the 1904 St. Louis World's Fair. The collection is displayed in the hallways of McNutt Hall, which also house the offices and classrooms of six earth science departments.

Minerals Museum, University of Missouri–Rolla, McNutt Hall, 14th St. and Bishop Ave., Rolla, MO 65401. Phone: 314/341-4616. Hours: 8–5 Mon.–Fri.; closed holidays and when university not in session. Admission: free.

## UNIVERSITY OF NEBRASKA–LINCOLN

In addition to the offerings of the University of Nebraska State Museum in Lincoln (described in the Natural History Museums and Centers section), the museum operates two branch facilities with fossil and related collections—the Trailside Museum in Crawford and the Ashfall Fossil Beds State Historical Park near Royal.

### Trailside Museum

The Trailside Museum at Fort Robinson in Crawford, Nebraska, is a satellite geology/paleontology museum of the University of Nebraska State Museum in Lincoln. Opened in 1961, it has more than 200 fossils and other natural science materials from the Tertiary deposits in the area on display.

The museum is known for its extensive collections of mammoths and Oligocene fossils. Two interlocked mammoths that were fighting are the only known specimens demonstrating aggression among Colombian mammoths. Among the other fossils are the remains of a mosasaur, a giant sea lizard; *Plesiosaurus,* an aquatic reptile; *Triceratops,* a three-horned dinosaur; *Diceratherium cooki,* a rhinoceros; *Stenomylus,* a small camel; mastodont, which differs from related mammoths in molar teeth; giant hog; bison; and bighorn sheep. The museum also has artifacts of the late Ice Age people.

Trailside Museum, University of Nebraska State Museum, PO Box 462, Crawford, NE 69339. Phone: 308/665-2929. Hours: winter—10–4 Mon.–Fri.; summer—9–5 daily. Admission: free.

### Ashfall Fossil Beds State Historical Park

The University of Nebraska State Museum has a branch facility at the Ashfall Fossil Beds State Historical Park near Royal. The 10-million-year-old fossil bed has a visitor center, rhino barn, fossil sandbox, and picnic pavilion.

Ashfall Fossil Beds State Historical Park, University of Nebraska State Museum, PO Box 66, Royal, NE 68773. Phone: 402/893-2000. Hours: May until Memorial Day and Labor Day–Sept.—10–4 Wed.–Sat.; 1–4 Sun.; Memorial Day–Labor Day—9–5 Mon.–Sat.; 11–5 Sun. Admission: adults and children over 6, $1.50; children 6 and under, free; cars also must have a Nebraska state park entry permit, $2.50 per day or $14 for season.

## UNIVERSITY OF NEVADA AT LAS VEGAS
### Marjorie Barrick Museum of Natural History

(See Natural History Museums and Centers section.)

## UNIVERSITY OF NEVADA AT RENO
### W.M. Keck Museum

The Mackey School of Mines Museum at the University of Nevada at Reno underwent a name change and major renovation in 1993. It is now the W.M. Keck Museum of the Mackey School of Mines. The museum originally was started in 1908. It has 6,000 square feet of exhibits on two levels that include rocks, minerals, ores, fossils, and mining artifacts—mostly related to Nevada.
W.M. Keck Museum, University of Nevada at Reno, Mackey School of Mines Bldg., Mail Stop 168, Reno, NV 89557. Phone: 702/784-6052. Hours: 9–5 Mon.–Fri.; closed holidays. Admission: free.

## UNIVERSITY OF NEW MEXICO
### Meteorite Museum

The Institute of Meteoritics at the University of New Mexico has one of the largest collections of meteorites in the nation in its Meteorite Museum in Albuquerque. It includes the main mass of the Norton County achondrite, second largest stone meteorite in the world. The museum, located on the first floor of Northrup Hall, also has tektite, impact glasses, and other shocked rock from terrestrial impact craters.
Meteorite Museum, University of New Mexico, Institute of Meteoritics, Norton Hall, Albuquerque, NM 87131-1126. Phone: 505/277-1644. Hours: 9–12 and 1–4 Mon.–Fri.; closed university holidays. Admission: free.

## UNIVERSITY OF NORTHERN IOWA
### University of Northern Iowa Museum

(See Natural History Museums and Centers section.)

## UNIVERSITY OF OKLAHOMA
### Oklahoma Museum of Natural History

(See Natural History Museums and Centers section.)

## UNIVERSITY OF RICHMOND
### Lora Robins Gallery of Design from Nature

(See Art Museums section.)

## UNIVERSITY OF SOUTH CAROLINA
### South Carolina Institute of Archaeology and Anthropology

(See Archaeology, Anthropology, and Ethnology Museums section.)

## UNIVERSITY OF TEXAS AT AUSTIN
### Texas Memorial Museum

(See Natural History Museums and Centers section.)

## UNIVERSITY OF TEXAS AT EL PASO
### Centennial Museum

(See Natural History Museums and Centers section.)

## UNIVERSITY OF UTAH
### Utah Museum of Natural History

(See Natural History Museums and Centers section.)

## UNIVERSITY OF WASHINGTON
### Thomas Burke Memorial Washington State Museum

(See Natural History Museums and Centers section.)

## UNIVERSITY OF WISCONSIN–MILWAUKEE
### Greene Memorial Museum

The Greene Memorial Museum at the University of Wisconsin–Milwaukee is a geology museum with collections of Devonian and Silurian fossils from the Illinois/Wisconsin region and paleontology, mineralogy, and conchology materials. The museum, which recently moved into new facilities in a Lapham Hall addition, is used primarily for teaching and research in the Department of Geosciences.

Greene Memorial Museum, University of Wisconsin–Milwaukee, Dept. of Geosciences, 3209 N. Maryland Ave., Milwaukee, WI 53211. Phone: 414/229-4561. Hours: by appointment; closed holidays. Admission: free.

## UNIVERSITY OF WYOMING
### Geological Museum

The University of Wyoming Geological Museum traces its founding to the opening of the university in 1887 when a small natural history museum was part of the first campus building in the frontier town. After several name and location changes and the expansion of its collections and exhibits, the museum moved into its present home in the east wing of the S.H. Knight Geology Building in 1956.

Exhibits that interpret the physical and historical geology of Wyoming now can be seen in the museum's main hall. They include displays of rocks, minerals,

and vertebrate, invertebrate, and plant fossils. Among the features are the skeletons of a huge *Apatosaurus* dinosaur, one of five in the world, and a horned dinosaur, the first dinosaur found in Wyoming in 1872.

The balcony contains collections of rocks, minerals, and invertebrate fossils, including *Saurolophus* and *Lambeosaurus* duck-billed dinosaurs, a juvenile *Maiasaura* skeleton, and an exhibit of dinosaur nests and eggs. The museum also has extensive research collections of dinosaur fossils and other geological specimens.

Geological Museum, University of Wyoming, S.H. Knight Geology Bldg., Laramie, WY 82071-3006. Phone: 307/766-4218. Hours: 8–5 Mon.–Fri.; 10–1 some weekends; closed holidays. Admission: free.

## VIRGINIA POLYTECHNIC INSTITUTE AND STATE UNIVERSITY
### Museum of the Geological Sciences

The Museum of the Geological Sciences at Virginia Polytechnic Institute and State University in Blacksburg has collections and exhibits in geology, mineralogy, paleontology, and related fields. Founded in 1969, the museum's principal offerings include the Dr. C.A. Michael Collection of gems and minerals, the Dr. A.A. Kirk Collection of cut gemstones, the D. Murray Collection of minerals from Australia and Tsumeb Namibia, and a paleontology collection.

Museum of the Geological Sciences, Virginia Polytechnic Institute and State University, Derring Hall, Blacksburg, VA 24061. Phone: 703/231-6029. Hours: 8–4 Mon.–Fri.; 10–2 Sat.; closed New Year's Day, Thanksgiving, and Christmas. Admission: free.

## WEST CHESTER UNIVERSITY
### Geology Museum

The Department of Geology and Astronomy's Geology Museum at the West Chester University in West Chester, Pennsylvania, has collections and exhibits of rocks and minerals used primarily for teaching and research purposes.

Geology Museum, West Chester University, Dept. of Geology and Astronomy, West Chester, PA 19383. Phone: 610/436-2727. Hours: 9–4 Mon.–Fri.; closed holidays and when university not in session. Admission: free.

## WEST VIRGINIA UNIVERSITY
### Comer Museum

Coal, oil, and natural gas collections and exhibits are featured at the Comer Museum at West Virginia University in Morgantown. The museum, operated by the Mining Extension Service, was opened in 1990 as part of a new $11 million building. It is best known for its extensive collection of mine lamps.

Comer Museum, West Virginia University, PO Box 6070, Morgantown, WV 26506-6070. Phone: 304/293-4211. Hours: 1–4 Mon.–Fri.; closed holidays and when university not in session. Admission: free.

## YALE UNIVERSITY
### *Peabody Museum of Natural History*

(See Natural History Museums and Centers section.)

# Historical Museums, Houses, and Sites

*Also see various history-oriented sections.*

## ACADEMY OF THE NEW CHURCH
### Glencairn Museum

The Glencairn Museum at the Academy of the New Church in Bryn Athyn, Pennsylvania, is a historic house and art museum located in a 1929 Romanesque-style building. Its collections include Egyptian, Mesopotamian, Greek, and Roman sculpture and artifacts; nineteenth- and twentieth-century art; Native American artifacts; medieval stained glass, ivories, enamels, sculpture, arms, and armor; costumes; furniture; Oriental rugs; tapestries; stamps; and coins.

Glencairn Museum, Academy of the New Church, 1001 Cathedral Road, PO Box 75, Bryn Athyn, PA 19009. Phone: 215/947-9919. Hours: academic year—9–5, Mon.–Fri.; 2–5 every second Sun.; July and Aug.—9–5 Mon.–Fri.; closed holidays. Admission: adults and seniors, $3.

## APPALACHIAN STATE UNIVERSITY
### Appalachian Cultural Museum

The history of western North Carolina is featured at the Appalachian Cultural Museum at Appalachian State University in Boone, North Carolina. Opened in 1989, the museum has pre–Civil War furniture and looms, Native American artifacts, musical instruments, general store merchandise, and other materials

from the area. It occupies 10,000 square feet on the first floor of University Hall.

Appalachian Cultural Museum, Appalachian State University, University Hall, Boone, NC 28608. Phone: 704/262-3117. Hours: 10–5 Tues.–Sat.; 1–5 Sun.; closed major holidays and Christmas recess. Admission: adults, $2; seniors, $1.75; children 12–18, $1; children under 12, free.

## AUGUSTANA COLLEGE
### Center for Western Studies

(See Religious Museums section.)

## BAKER UNIVERSITY
### Old Castle Museum

The Old Castle Museum, a part of Baker University in Baldwin City, Kansas, is a historic building complex that includes an 1857 original Santa Fe Trail post office, a replica of the 1857 Kibbee cabin, and an 1858 three-story stone structure. Collections of the museum, which was founded in 1953, include Midwest Native American materials, Southwest Native American pottery, pioneer artifacts, ironstone china pieces, silver and pewter items, dentist and physician equipment, and a nineteenth-century print shop.

Old Castle Museum, Baker University, 515 Fifth, PO Box 65, Baldwin City, KS 66006. Phone: 913/594-6809. Hours: 1–5 Tues.–Fri.; 10–4:30 Sat.–Sun. Admission: free.

## BAYLOR UNIVERSITY
### Governor Bill and Vara Daniel Historic Village (Strecker Museum)

(See Natural History Museums and Centers section.)

## BEREA COLLEGE
### Berea College Museum

The Berea College Museum—formerly known as the Appalachian Museum—is a multidisciplinary museum covering the history, folk art, textiles, music, and other cultural aspects of the southern Appalachian highlands. The museum opened in Berea, Kentucky, in 1973 after receiving the Edna Lynn Simms Collection of approximately 1,400 Appalachian cultural artifacts.

The museum has a major permanent exhibit on Appalachian culture and presents four changing exhibitions each year. Other notable collections include the Eaton Collection of crafts and revival materials and the Fireside Collection of Appalachian weaving.

Berea College Museum, 103 Jackson St., CPO 2298, Berea, KY 40403. Phone: 606/986-9341. Hours: 9–6 Mon.–Sat.; 12–6 Sun.; closed holidays and Jan. Admission: adults, $1.50; seniors, $1; children, 50¢.

## BETHANY COLLEGE
### Historic Bethany

Historic Bethany is a complex of historical buildings and collections largely from the 1840s period at Bethany College in Bethany, West Virginia, that has been designated a National Historic Landmark. The focus is on Alexander Campbell and his family. He was the founder of the college and community and a leader in the founding of the Christian Churches of America.

The complex, which opened in 1920, includes the Campbell family mansion, furnishings, household items, and cemetery; the Thomas Barclay family collection; an 1832 meeting house; the Bethany Memorial Church; and the college's 1858 Old Main building. The mansion—built in four stages between 1792 and 1840—has the original French scenic hand-blocked wallpaper in the visitor parlor. Barclay, who married one of Campbell's daughters, was the nation's first formally commissioned consular officer in 1781. Campbell's books and papers are in the college library.

Historic Bethany, Bethany College, Bethany, WV 26032. Phone: 304/829-7885. Hours: Apr.–Oct.—10–4, Tues.–Sat.; 1–4 Sun.; Nov.–Mar.—by appointment only; closed major holidays. Admission: adults, $3; students (grades 1–12) and children, $1.50; children under 6, free.

## BETHEL COLLEGE
### Mennonite Library and Archives

(See Library and Archival Collections and Galleries section.)

## BLINN COLLEGE
### Star of the Republic Museum

The Star of the Republic Museum—operated by Blinn College—is located on the site of the signing of the Texas Declaration of Independence and the former capital of the Republic of Texas in Washington, Texas. The museum, founded in 1969, has collections and exhibits pertaining to the cultural, social, economic, and political history of pre-1850 Texas.

Star of the Republic Museum, Blinn College, Washington-on-the-Brazos State Historical Park, PO Box 317, Washington, TX 77880. Phone: 409/878-2461. Hours: 10–5 daily; closed New Year's Day, Thanksgiving, and Christmas. Admission: free.

## BRANDEIS UNIVERSITY
### American Jewish Historical Society

(See Unaffiliated Museums section.)

## BROWN UNIVERSITY
### *Annmary Brown Memorial*

The Annmary Brown Memorial at Brown University in Providence, Rhode Island, is a mausoleum, library, and museum named for the daughter of the founder of the institution. Annmary Brown and her husband, General Rush Christopher Hawkins, are buried in the building. The memorial, founded in 1905, has nineteenth- and twentieth-century European and American paintings, Brown family heirlooms and correspondence, and books and Civil War mementos of General Hawkins, who was a book collector.

Annmary Brown Memorial, Brown University, 21 Brown St., Box 1905, Providence, RI 02912. Phone: 401/863-1994. Hours: 1–5 Mon.–Fri.; closed major holidays. Admission: free.

## CALIFORNIA STATE UNIVERSITY, FULLERTON
### *Fullerton Arboretum Historical Collection*

(See Botanical Gardens, Arboreta, and Herbaria section.)

## CENTRAL MICHIGAN UNIVERSITY
### *Center for Cultural and Natural History*

(See General Museums section.)

## CENTRAL MISSOURI STATE UNIVERSITY
### *Central Missouri State University Archives/Museum*

(See General Museums section.)

## THE CITADEL, THE MILITARY COLLEGE OF SOUTH CAROLINA
### *The Citadel Museum*

The history of The Citadel, The Military College of South Carolina, is featured at The Citadel Museum in Charleston. Founded in 1956, the museum originally was a military museum containing weaponry, uniforms, and other artifacts from various wars. In 1989, the museum's mission was changed to represent the history of The Citadel, and the new museum opened the following year.

The museum's exhibits trace the history of the college chronologically from 1842 to the present. Photographs and artifacts portray the military, academic, social, and athletic aspects of cadet life. The museum occupies the third floor of the building that also houses the library.

The Citadel Museum, 171 Moultrie St., Charleston, SC 29409. Phone: 803/953-6846. Hours: 2–5 Mon.–Fri.; 12–5 Sat.; 2–5 Sun.; closed holidays and when college not in session. Admission: free.

## CITY UNIVERSITY OF NEW YORK, BRONX COMMUNITY COLLEGE
### Hall of Fame for Great Americans

(See Sculpture Gardens section.)

## CLEMSON UNIVERSITY
### Clemson University Historic Properties

Clemson University operates six historic properties on its campus in Clemson, South Carolina. Two are historic house museums, the Hanover House and the John C. Calhoun House, both of which are listed in the National Register of Historic Places. The other four historic structures are Hopewell, the ca. 1875 home of General Andrew Pickens and two former governors; the Trustee House, ca. 1891, residence for college trustees in its early years; the Kinard Annex, ca. 1894, which once housed the faculty; and the Sears Mail-Order House, ca. 1928, typical of thousands of prefabricated structures delivered in the 1920s. The university's South Carolina Botanical Garden also has a historical collection (see Botanical Gardens, Arboreta, and Herbaria section).

### Hanover House
Hanover House was built by French Huguenots Paul de St. Julien and his wife, Mary Amy Ravenel, in 1716 in the South Carolina low country, which is now Berkeley County. It was moved to Clemson University in Clemson, South Carolina, and restored in the 1940s after falling into ruin and being in the path of a hydroelectric plant dam development.

The house, constructed of cypress timbers with brick triple-flue chimneys and French details, was named for George Louis, Elector of Hanover, who ascended the English throne as George I. He had befriended French Huguenots when they fled religious and political persecution and emigrated to South Carolina by way of England in the late seventeenth century.

Hanover House, Clemson University, Clemson, SC 29634. Phone: 803/656-2375. Hours: 10–5 Sat.; 2–5 Sun.; closed major holidays. Admission: suggested donations—adults, $3; seniors and students, $2; children 12 and under, $1.

### John C. Calhoun House
The John C. Calhoun House, ca. 1803, at Clemson University in Clemson, South Carolina, was the home of South Carolina's eminent statesman during the last 25 years of his life (1825–1850). The 1,100-acre plantation was named Fort Hill by Calhoun to honor a fort built on the land in 1776 as a protection from a nearby settlement of Indians. The mansion is of upcountry vernacular design

with classical Greek Revival- and Federal-period design elements, featuring three Greek Revival columned piazzas.

A champion of states' rights, Calhoun had served as a congressman, senator, secretary of war, secretary of state, and vice president and ran for president during his 40-year political career. The house, one of a dozen structures on the property, contains many of the personal belongings, furniture, and portraits of Calhoun and his family and of Thomas Green Clemson and his family.

Clemson, a diplomat and the nation's first superintendent of agriculture, married one of Calhoun's daughters and became immersed in the movement to establish scientific and agricultural education as a national priority. He lived in the house from 1872 to 1888 and bequeathed the Fort Hill plantation to the State of South Carolina for a scientific and agricultural college, which became Clemson University.

John C. Calhoun House, Clemson University, Clemson, SC 29634. Phone: 803/656-2475. Hours: 10–5 Mon.–Sat.; 2–5 Sun.; closed major holidays. Admission: suggested donations—adults, $3; seniors and students, $2; children 12 and under, $1.

## COLLEGE OF CHARLESTON
### Avery Research Center for African American History and Culture

The Avery Research Center for African American History and Culture at the College of Charleston in Charleston, South Carolina, is a history museum and archives, which is dedicated to making better known the cultural and historical contributions of Africans and African Americans in the low country of South Carolina and the sea islands of the state and Georgia.

The center, which opened in 1990, has such collections as African art and artifacts from the Joseph Towels Collection; sweetgrass baskets, which illustrate and document the African/low country artistic connection; a painting of former Congressman Thomas E. Miller by Edwin Harleston, Harman Award recipient in 1931; and an anvil used by three generations of African-American blacksmiths, which was donated by master blacksmith Philip Simmons.

In 1994, the center had eight exhibitions, one in the changing gallery and seven others in the traveling exhibition program. The temporary exhibitions are loaned free of charge to schools, churches, and other groups in the area.

Avery Research Center for African American History and Culture, College of Charleston, 125 Bull St., Charleston, SC 29424. Phone: 803/727-2009. Hours: 2–4 Mon.–Fri.; morning group tours and Sat. by appointment; closed holidays. Admission: free.

## COLLEGE OF THE OZARKS
### Ralph Foster Museum

The Ralph Foster Museum at the College of the Ozarks in Point Lookout, Missouri, is concerned primarily with the history of the Ozark region. Founded

in 1922, the museum is named for a radio and television pioneer whose longtime support of the college prompted him to give his large collection of Native American artifacts to the museum.

The 62,000-square-foot museum contains exhibits dealing with the history of the Ozarks; late-nineteenth- and early-twentieth-century artifacts of the region; Rose O'Neill memorabilia and drawings; a room devoted to country, western, and Ozark music; materials on the history of the college; and collections of dolls, textiles, and firearms.

Ralph Foster Museum, College of the Ozarks, Point Lookout, MO 65726. Phone: 417/ 334-6411. Hours: 9–4:30 Mon.–Sat.; irregular schedule in winter; closed major holidays. Admission: adults, $4.50; seniors, $3.50; children, free.

## COLLEGE OF WILLIAM AND MARY
### Ash Lawn–Highland

Ash Lawn–Highland, home of President James Monroe near Charlottesville, Virginia, is part of the College of William and Mary in Williamsburg. The college received the 1799 house built by Monroe and the surrounding 535-acre working farm from Jay Winston-Johns, owner and philanthropist, in 1975. The property actually began functioning as a museum in 1931.

The estate contains American and French furnishings, fine arts, and other objects of the 1790–1825 period related to the nation's fifth president. Exhibit materials pertain to the political, social, and domestic issues of the Monroe era, while research focuses primarily on the papers of Monroe and his contemporaries. Ornamental and kitchen gardens and mountain trails are on the property, which also is the site of a summer music festival.

Ash Lawn–Highland, Home of James Madison, College of William and Mary, James Monroe Parkway, Rte. 6, Box 37, Charlottesville, VA 22902. Phone: 804/293-9539. Hours: Mar.–Oct.—9–6 daily; Nov.–Feb.—10–5 daily; closed New Year's Day, Thanksgiving, and Christmas. Admission: adults, $7; seniors, $6.50; children, $3.

## CONNORS STATE COLLEGE
### Wallis Museum

Historical artifacts, documents, newspapers, and other items concerning Connors State College and the region are part of the Wallis Museum (formerly the Connors State College Museum) on the Warner, Oklahoma, campus. Much of the collection is on display in two locations—the Student Union and the Library amphitheater area.

Wallis Museum, Connors State College, Rte. 1, Box 1000, Warner, OK 74469-9700. Phone: 918/463-6251. Hours: 8–4:30 Mon.–Fri.; closed holidays and when college not in session. Admission: free.

## DELAWARE TECHNICAL AND COMMUNITY COLLEGE
### Treasures of the Sea Exhibit

(See Other Types of Museums section.)

## DUKE UNIVERSITY
### History of Medicine Collections

(See Medical, Dental, and Health Museums section.)

## EARLHAM COLLEGE
### Conner Prairie

Conner Prairie is a 250-acre living history museum in Fishers, Indiana, that is part of Earlham College. The property and an endowment were given to the college in 1964 by pharmaceutical entrepreneur Eli Lilly with the understanding that it would operate the historic site as a museum. Lilly, a history enthusiast, bought the 1823 William Conner House and surrounding property in the 1930s. He restored the house and ran the property as a breeding and test farm until he turned it over to Earlham College.

Conner Prairie—which offered the first person-costumed interpretation in a historic village—has 37 buildings in a 55-acre historic area, which includes the historic Conner House (re-restored in 1992), a 60,000-square-foot modern museum center (built in 1988), a modern crafts/maintenance center, and a large amphitheater. The focus of the outdoor museum is the 1800–1850 period in central Indiana and America.

The museum consists of three historic sections—the 1823 Federal-style Conner House, with guided tours; the 1836 Village of Prairietown, typical of an early nineteenth-century Indiana settlement, with costumed interpreters (a blacksmith, woodworker, doctor, schoolmaster, innkeeper, weaver, and potter); and the Pioneer Adventure Area, where visitors are encouraged to try nineteenth-century activities, such as candle dipping and soap making. The annual attendance totals approximately 285,000.

Conner Prairie, Earlham College, 13400 Allisonville Rd., Fishers, IN 46038-4499. Phone: 317/776-6000. Hours: May–Oct.—10–5 Tues.–Sat.; 12–5 Sun.; Apr. and Nov.—10–5 Wed.–Sat.; 12–5 Sun.; closed Dec.–Mar., Easter, and Thanksgiving. Admission: adults, $8.50; seniors, $8; children 6–12, $6; children under 6, free.

## EASTERN NEW MEXICO UNIVERSITY
### Roosevelt County Museum

The Roosevelt County Museum on the Eastern New Mexico University campus in Portales was built as a WPA project by a local historical society in 1934 and then given to the university. The museum still is affiliated with the university—administered by the coordinator for grant and contract management. But

it is basically a community museum concerned with the history of the area and featuring artifacts and other materials—such as medical equipment, barbed wire, and a Conestoga wagon—donated by residents.

Roosevelt County Museum, Eastern New Mexico University, Station 9, Portales, NM 88130. Phone: 505/562-2592. Hours: 8–5 Mon.–Fri.; 10–4 Sat.; 1–4 Sun.; closed holidays and when university not in session. Admission: free.

## EAST TENNESSEE STATE UNIVERSITY
### Carroll Reece Museum

The Carroll Reece Museum at East Tennessee State University in Johnson City is a combination history museum and art gallery. Founded in 1965, the museum has collections of eighteenth- and nineteenth-century historical artifacts from East Tennessee, contemporary regional art, Tennessee crafts, and paintings, graphics, textiles, costumes, folklore materials, and printing equipment.

Carroll Reece Museum, East Tennessee State University, PO Box 70, 660, Johnson City, TN 37614-0660. Phone: 615/929-4392. Hours: 9–4 Mon.–Sat.; 1–4 Sun.; closed holidays and when university not in session. Admission: free.

## EDINBORO UNIVERSITY OF PENNSYLVANIA
### Fort Leboeuf

Fort Leboeuf—a history museum located at the site of a succession of three 1700s forts in Waterford, Pennsylvania—is operated by the Department of Sociology/Anthropology/Social Work at Edinboro University of Pennsylvania for the Pennsylvania Historical and Museum Commission. The original fort was built by the French in 1753, rebuilt by the British in 1760, and then rebuilt by the governor of Pennsylvania in 1795.

Founded in 1929, the museum has collections of period furniture, artifacts from the French occupation, archives, and other historical materials. Historic buildings include the Amos Judson House and the Eagle Hotel, both built in 1820. Visitors also can see the fort sites.

Fort Leboeuf, Edinboro University of Pennsylvania, 123 S. High St., Waterford, PA 16441. Phone: 814/732-2573. Hours: by appointment. Admission: free.

## FERRUM COLLEGE
### Blue Ridge Institute Farm Museum and Galleries

(See Agricultural Museums section.)

## FRIENDS UNIVERSITY
### Fellow-Reeve Museum of History and Science

The Fellow-Reeve Museum of History and Science at Friends University in Wichita, Kansas, emphasizes state and regional history and the natural sciences.

It is named after two avid collectors, Henry C. Fellow and Mark Reeve, who pledged to build a public museum. They were joined by others to open the museum in 1929.

The museum has numerous historical artifacts and exhibits—many of which relate to the early residents of Kansas. They include a log cabin, covered wagon, tepee, country store, schoolroom, farm bedroom, quilts, arrowheads, and other such things. There also is an African Room containing items brought back by Quaker missionaries.

The natural history collections have over 800 varieties of geological specimens, fossils (including 50,000-year-old mammoth tusks), specimens of North American animals and African wildlife, and collections of birds, sea shells, and coral formations. Among the mounted animals on display in the Cedric Wood Hall are a Kodiak bear, musk ox, polar bear, black wolf, coyote, wolverine, and mountain lion, as well as moose, elk, and deer heads.

Fellow-Reeve Museum of History and Science, Friends University, Davis Administration Bldg., 2100 University, Wichita, KS 67209. Phone: 316/292-5594. Hours: 1–4 Mon., Wed., and Fri.; 9–12 Tues. and Thurs.; closed holidays and when university not in session. Admission: adults, $1; children under 12, 50¢.

## GANNON UNIVERSITY
### Gannon Erie Historical Museum

The Gannon Erie Historical Museum, located in the 1891 Watson-Curtze Mansion, was founded as the Erie Public Museum in 1941 by the school district in Erie, Pennsylvania. In 1959, a planetarium was added to the carriage house by the Junior League of Erie. The museum was operated by a public museum authority from 1979 to 1989, when it was merged with Gannon University.

The 24-room historic house, built of New England brownstone, was constructed by Harrison F. Watson, a paper company owner, and purchased in 1923 by Felix F. Curtze, a banker and manufacturer. It was offered to the Erie School District for use as a museum by Curtze's family after his death. The mansion still contains many of the original furnishings.

The museum collections and exhibits deal largely with regional and Lake Erie maritime history. Visitors also can see Native American materials, Victorian and American Renaissance decorative arts, Moses Billings paintings, and Eugene Iverd paintings and prints, as well as planetarium shows.

Gannon Erie Historical Museum, Gannon University, 356 W. Sixth St., Erie, PA 16541. Phone: 814/871-5790. Hours: 1–5 daily (but opening at 10 weekdays in summer); closed holidays. Admission: adults, $2; seniors, $1.80; children, $1.

## GEORGETOWN UNIVERSITY
### Georgetown University Collection

(See Art Museums section.)

## GEORGIA COLLEGE
### *Museum and Archives of Georgia Education*

The Museum and Archives of Georgia Education at Georgia College in Mil-
ledgeville was founded in 1976 to gather, keep together, and make available
materials related to the history of education in the State of Georgia. The col-
lections include artifacts relating to education, materials from prominent edu-
cators, and memorabilia from students of the college dating from 1891. The
facility occupies a ca. 1900 Victorian building on the edge of the campus.
Museum and Archives of Georgia Education, Georgia College, 131 Clark St., CPO 95,
Milledgeville, GA 31061. Phone: 912/453-6391. Hours: 12–5 Mon.–Fri.; closed holidays.
Admission: free.

## HAMPDEN-SYDNEY COLLEGE
### *Esther Thomas Atkinson Museum*

The history of Hampden-Sydney College since the eighteenth century is de-
picted at the Esther Thomas Atkinson Museum in Hampden-Sydney, Virginia.
Among the highlights are portraits of key figures in the college's history.
Esther Thomas Atkinson Museum, Hampden-Sydney College, College Road, Hampden-
Sydney, VA 23943. Phone: 804/223-6154. Hours: 12:30–4:30 Mon.–Fri.; 10–12 noon
Sat.; closed holidays. Admission: free.

## HILL COLLEGE
### *Confederate Research Center and Museum and Audie L.*
### *Murphy Gun Museum*

The Confederate Research Center and Museum and the Audie L. Murphy
Gun Museum share space and staff in the Hill College library building in Hills-
boro, Texas. The research center/museum contains reference materials on all
3,220 Confederate regiments, special units, and ships; more than 3,500 books,
brochures, and pamphlets on the Civil War, with emphasis on Confederate mil-
itary history; and confederate and U.S. flags carried during the Civil War. The
adjoining Murphy museum features materials related to the World War II hero,
histories of all American divisions in World War II, and weapons, uniforms,
and other items from the Civil War through World War II.
Confederate Research Center and Museum/Audie L. Murphy Gun Museum, Hill College,
102 Lamar Dr., PO Box 619, Hillsboro, TX 76645. Phone: 817/582-2555. Hours: 8–12
and 1–4 Mon.–Fri.; closed holidays and when college not in session. Admission: free.

## HARVARD UNIVERSITY
### *Collection of Scientific Instruments*

(See Science and Technology Museums and Centers section.)

## HEBREW UNION COLLEGE
*Skirball Museum*

(See Archaeology, Anthropology, and Ethnology Museums section.)

## HEBREW UNION COLLEGE–JEWISH INSTITUTE OF RELIGION
*Skirball Museum, Cincinnati Branch*

(See Archaeology, Anthropology, and Ethnology Museums section.)

## HOUSTON BAPTIST UNIVERSITY
*Museum of American Architecture and Decorative Arts*

The Museum of American Architecture and Decorative Arts was founded as a social history museum at Houston Baptist University in Houston, Texas, in 1964. Its exhibits and collections consist largely of furniture, household goods, and decorative arts of the ethnic groups that established the Republic of Texas. The museum also has the Theo Redwood Blank doll collection, pre-Columbian art, and African art.

Museum of American Architecture and Decorative Arts, Houston Baptist University, 7502 Fondren Road, Houston, TX 77074. Phone: 713/774-7661. Hours: Sept.–May— 10–4 Tues.–Fri.; 12–4 Sun.; closed holidays. Admission: free.

## HOWARD UNIVERSITY
*Howard University Museum/Moorland-Spingarn Research Center*

(See Archaeology, Anthropology, and Ethnology Museums section.)

## INDIANA UNIVERSITY OF PENNSYLVANIA
*University Museum*

(See General Museums section.)

## IOWA STATE UNIVERSITY
*Farm House Museum*

(See Agricultural Museums section.)

## IOWA WESLEYAN COLLEGE
*Harlan-Lincoln Home*

The 1861 Harlan-Lincoln Home, located on the campus of Iowa Wesleyan College in Mount Pleasant, contains the original furnishings and memorabilia

of the Harlan and Lincoln families, as well as objects of the same period. Abraham Lincoln's daughter and her husband lived in the historic house, which was opened to the public in 1959.

Harlan-Lincoln Home, Iowa Wesleyan College, 101 W. Broad St., Mount Pleasant, IA 52641. Phone: 319/385-8021. Hours: by appointment only. Admission: free.

# JEFFERSON DAVIS COMMUNITY COLLEGE
## Thomas E. McMillan Museum

Prehistoric-, Colonial-, Revolutionary War–, and Civil War–period artifacts are part of the Thomas E. McMillan Museum of Jefferson Davis Community College, a history museum located on the site of the former 1830 Leigh plantation in Brewton, Alabama. Opened in 1978, the museum has collections and exhibits containing such materials as Native American artifacts and trading wares; War of 1812, Civil War, and other military objects; nineteenth-century carpenter and cabinetmaker tools, medical and dental instruments, and lumbering and turpentining materials; railroad memorabilia; and early blacksmith tools, textiles, quilts, costumes, housewares, printing equipment, cameras, and photographic accessories.

Thomas E. McMillan Museum, Jefferson Davis Community College, 220 Alco Dr., Brewton, AL 36426. Phone: 205/867-4832. Hours: 8 A.M.–9 P.M. Mon.; 8–3 Tues.– Thurs.; 8–1 Fri.; closed major holidays. Admission: free.

# JEWISH THEOLOGICAL SEMINARY OF AMERICA
## Jewish Museum

(See Archaeology, Anthropology, and Ethnology Museums section.)

# JOHNS HOPKINS UNIVERSITY
## Evergreen House

The Evergreen House, an expansive 48-room Italianate mansion with Classical Revival additions on 26 wooded acres, has functioned as the Rare Book Library and Fine Arts Museum of Johns Hopkins University in Baltimore, Maryland, since 1952. The estate, located one mile north of the main campus, was bequeathed and endowed by Alice Warder Garrett to ensure that the house would continue to have an important cultural and educational role in the Baltimore area.

The house originally was built in the 1850s by the Broadbent family. It was purchased in 1878 by John W. Garrett, president of the Baltimore & Ohio Railroad, for his son, T. Harrison Garrett. It then was inherited in 1920 by Ambassador John Work Garrett and his wife, Alice Warder Garrett. During this period, the mansion, private theater, carriage house, and formal gardens underwent two

generations of adaptations and renovations and became a center for cultural and civic activities.

Evergreen House, which is open to the public for tours and programs, contains the Garretts' exceptional collections of Chinese blue-and-white porcelain; Tiffany chandeliers; Japanese netsuke, intro, and lacquer boxes; rare books; and early-twentieth-century paintings.

Evergreen House, Johns Hopkins University, 4545 N. Charles St., Baltimore, MD 21210-2693. Phone: 410/516-0895. Hours: 10–4 Mon.–Fri.; 1–4 Sat.–Sun.; closed holidays. Admission: adults, $5; seniors, $4; students, $2.50.

### Homewood House Museum

An 1801 Federal-period home of the Charles Carroll family is the site of the Homewood House Museum on the main campus of Johns Hopkins University in Baltimore, Maryland. Founded in 1987, the museum contains period furniture, paintings, prints, textiles, tableware, kitchen equipment, porcelain, ceramics, and household items.

Homewood House Museum, Johns Hopkins University, 3400 N. Charles St., Baltimore, MD 21218. Phone: 410/516-5589. Hours: 11–5 Mon.–Fri.; 12–4 Sun.; closed holidays. Admission: adults, $5; seniors, $4; children, $2.50.

## KALAMAZOO VALLEY COMMUNITY COLLEGE
### Kalamazoo Public Museum

Formerly part of the local school district, the Kalamazoo Public Museum was transferred to Kalamazoo Valley Community College district governance in 1991. This resulted in a successful countywide property tax referendum for the community museum's operations and led to a $20 million campaign that will double the size of the museum when its new building opens in 1996.

Founded in 1927, the history and technology museum currently shares the 1959 Kalamazoo Public Library and Museum Building. The new facility will increase the museum's square footage from 30,000 to 60,000 square feet. The museum now has approximately 45,000 objects in its collections—mostly historical, anthropological, and archaeological materials—and three exhibit galleries on regional history, material culture, and technology. It also has a Challenger Learning Center and a Spitz A4P planetarium.

Kalamazoo Public Museum, Kalamazoo Valley Community College, 315 S. Rose St., Kalamazoo, MI 49007. Phone: 616/345-7092. Hours: 9–5 Mon.–Sat.; 1–5 Sun.; closed holidays. Admission: free.

## LAMAR UNIVERSITY
### Spindletop/Gladys City Boomtown Museum

The Spindletop/Gladys City Boomtown Museum—part of Lamar University in Beaumont, Texas—is located near the site of the Spindletop oil field, the nation's first major oil field, discovered in 1901. The museum, founded in 1975, consists of an outdoor re-creation of an oil boomtown and has various oil-field

machinery and tools, paper goods, household items, furniture, textiles, glass items, and photographs of the period.

The museum was created in 1989 with the merger of the Spindletop Museum, a geology/energy museum, and the Gladys City Boomtown Museum, both of which were operated by the university. It has 15 replica buildings—including a general store, post office, and other buildings from the turn-of-the-century oil boomtown—covering approximately six acres.

Spindletop/Gladys City Boomtown Museum, Lamar University, Highway 69 at University Dr., PO Box 10082, Beaumont, TX 77710. Phone: 409/835-0823. Hours: 1–5 Tues.–Sun.; closed major holidays. Admission: adults, $2.50; seniors and children, $1.25.

## LIMESTONE COLLEGE
### Winnie Davis Museum of History

The Winnie Davis Museum of History at Limestone College in Gaffney, South Carolina, contains artifacts, manuscripts, and other materials relating primarily to local and state history, as well as college memorabilia. Founded in 1976, the museum is located in an 1889–1901 building originally constructed to house Confederate records.

Winnie Davis Museum of History, Limestone College, 1115 College Dr., Gaffney, SC 29340. Phone: 803/489-7151. Hours: by appointment. Admission: free.

## LINCOLN MEMORIAL UNIVERSITY
### Abraham Lincoln Museum

One of the nation's largest collections of Lincoln and Civil War items can be found at the Abraham Lincoln Museum at Lincoln Memorial University in Harrogate, Tennessee. The 25,000 pieces include original Lincoln manuscripts, Lincoln personal artifacts, and Cassius M. Clay papers. Most of the materials were collected by Lincoln scholar R. Gerald McMurtry during the 1930s and 1940s.

The university was founded in 1897 with provisions for a historical collection, but it was not until 1977 that the present 20,000-square-foot museum building was opened. In addition to permanent exhibits on Lincoln and the Civil War period, the museum presents rotating temporary exhibitions in one of its galleries.

Abraham Lincoln Museum, Lincoln Memorial University, Cumberland Gap Hwy., Harrogate, TN 37752. Phone: 615/869-6235. Hours: 9–4 Mon.–Fri.; 11–4 Sat.; 1–4 Sun.; closed holidays. Admission: adults, $2; seniors, $1.50; children 6–12, $1; children under 6 and university students, free.

## LOUISIANA STATE UNIVERSITY
### LSU Rural Life Museum

(See Agricultural Museums section.)

## LOUISIANA STATE UNIVERSITY IN SHREVEPORT
### Pioneer Heritage Center

The Louisiana State University in Shreveport has collections, exhibits, and structures that exemplify northwest Louisiana and nineteenth-century Red River regional history at its Pioneer Heritage Center on the campus. The center began in 1977 as a joint project of the university and the Junior League of Shreveport.

Among the collections are early quilts, clothing, needlework, lace, and other textiles; approximately 300 pieces of agricultural tools and implements from the late nineteenth and early twentieth centuries; oral histories; and documents, letters, diaries, journals, and photographs of a historical nature. The exhibits make use of the collections in presenting past customs, activities, and achievements of the tri-state region.

The Pioneer Heritage Center is best known for its six examples of southern vernacular architecture. They include the Caspiana House, a neoclassical American cottage that is a National Historic Landmark; Doctor's Office, an ornate spindled shotgun cottage; Webb and Webb Commissary, a raised-parapet commercial structure; kitchen, a rare board-and-batten structure; and two classic examples of log construction—the Blacksmith's Shop and the Thrasher House, a "dog-trot," which also is a National Historic Landmark.

Pioneer Heritage Center, Louisiana State University in Shreveport, 8515 Youree Dr., Shreveport, LA 71115-2399. Phone: 318/797-5332. Hours: 9–4 Mon.–Fri.; 1:30–4:30 Sun.; closed holidays and when university not in session. Admission: free.

## MARY WASHINGTON COLLEGE
### Belmont, The Gari Melchers Estate and Memorial Gallery

Belmont, The Gari Melchers Estate and Memorial Gallery is a 27-acre estate with a 1790s manor house, a 1924 studio with three galleries, and seven additional facilities located one mile from Mary Washington College, which administers the property, in Fredericksburg, Virginia. Melchers, a prominent American realist/impressionist painter, and his wife, Corinne, purchased the estate in 1916. The artist's widow gave the property and collections to the Commonwealth of Virginia in 1955. The Virginia Museum of Fine Arts administered the estate until it was placed under the control of Mary Washington College in 1960. It opened to the public in 1975.

The mansion is furnished with a rich selection of antiques, most of which were collected by the Melchers during their residences and travels abroad. Paintings and prints by Melchers, his American and European contemporaries, and older masters decorate the walls. The stone studio houses the largest collection of Melchers' work anywhere. Approximately 500 of his paintings and 1,200 drawings, studies, and prints can be found at Belmont, as well as a variety of works by Morisot, Zorn, Hassam, Snyders, and others. The exhibitions consist

of rotating selections from the collection and occasional shows of works by contemporaries of Melchers.

Belmont, The Gari Melchers Estate and Memorial Gallery, Mary Washington College, 224 Washington St., Fredericksburg, VA 22405. Phone: 703/899-4860. Hours: Apr.–Sept.—10–5 Mon.–Sat.; 1–5 Sun.; Oct.–Mar.—10–4 Mon.–Sat.; 1–4 Sun.; closed holidays. Admission: adults, $3; seniors, $2.40; children 6–18, $1; college students and faculty, free.

### *James Monroe Museum and Memorial Library*

The largest collection of the fifth president's possessions can be found at the James Monroe Museum and Memorial Library at Mary Washington College in Fredericksburg, Virginia. It includes more than 650 objects, 500 books, 1,000 papers, and various clothing, jewelry, furniture, and other materials of President and Mrs. Monroe, including the Louis XVI desk used in the White House in preparing the 1823 Monroe Doctrine.

Changing exhibitions deal with the life and times of Monroe, focusing on specific aspects of the presidency, social history, travels, decorative arts, and other subjects.

Descendants of James and Elizabeth Monroe collected many of the artifacts and purchased the main building housing the museum/library, which was founded in 1927. The building consists of three small office structures (ca. 1815, 1830, and 1850) under one roof; one of the structures was believed by local residents to be Monroe's law office, but it was not. A gallery was added in 1962.

James Monroe Museum and Memorial Library, Mary Washington College, 908 Charles St., Fredericksburg, VA 22401. Phone: 703/899-4559. Hours: Mar.–Nov.—9–5 daily; Dec.–Feb.—10–4 daily. Admission: adults, $3; children, $1; Mary Washington College students, free.

## MASSACHUSETTS INSTITUTE OF TECHNOLOGY
### *MIT Museum*

(See Science and Technology Museums and Centers section.)

## McPHERSON COLLEGE
### *McPherson Museum*

(See General Museums section.)

## MEDICAL UNIVERSITY OF SOUTH CAROLINA
### *Waring Historical Library*
### *Macauley Museum of Dental History*

(See Medical, Dental, and Health Museums section.)

## MIAMI UNIVERSITY
### William Holmes McGuffey House and Museum

The William Holmes McGuffey House and Museum—now a branch of the Miami University Art Museum in Oxford, Ohio—honors the creator of the Mc-Guffey Readers, which were used to educate five generations of Americans from the mid-nineteenth century until 1920. The 1833 house, a National Historic Landmark, was built by and served as the home of the former professor of ancient languages and moral philosophy at the university.

Visitors can see McGuffey's octagon table, lectern, traveling secretary/book-case, copies of the McGuffey Eclectic Readers, and portraits of McGuffey and his wife, Harriet. The Miami University Art Museum also is using the site as a contextual auxiliary exhibition space for its nineteenth-century decorative arts and furnishings.

William Holmes McGuffey House and Museum, Miami University, Oak and Springs Sts., Oxford, OH 45056. Phone: 513/529-2232. Hours: 2–4 Sat.–Sun.; closed Aug. and holidays. Admission: free.

## MICHIGAN STATE UNIVERSITY
### Michigan State University Museum

(See Natural History Museums and Centers section.)

## MISSISSIPPI UNIVERSITY FOR WOMEN
### Archives and Museum

(See Library and Archival Collections and Galleries section.)

## MONTANA STATE UNIVERSITY
### Museum of the Rockies

(See Natural History Museums and Centers section.)

## MOTT COMMUNITY COLLEGE
### Labor Museum and Learning Center of Michigan

Michigan labor history from pre-statehood days to the present is the focus of the Labor Museum and Learning Center of Michigan at Mott Community College in Flint. Founded in 1988 and opened in 1992, the facility has exhibits, artifacts, and archives that trace the labor movement and industrial unionism.

Labor Museum and Learning Center of Michigan, Mott Community College, 711 N. Saginaw, Flint, MI 48503-1729. Phone: 810/762-0251. Hours: 10–5 Tues.–Fri.; 12–5 Sat.; closed holidays and when college not in session. Admission: adults, $2; seniors and children, $1.

## MOUNT HOLYOKE COLLEGE
### Skinner Museum

The Skinner Museum at Mount Holyoke College in South Hadley, Massachusetts, consists of four historic buildings—an 1846 church and schoolhouse and two carriage houses—and assorted collections of birds, furnishings, minerals, glass, and other objects pertaining to American domestic life and work. The museum was founded in 1946 by a private collector, Joseph Skinner, and given to the college. It is administered by the Mount Holyoke College Art Museum.

Skinner Museum, Mount Holyoke College, 35 Woodbridge St., South Hadley, MA 01075. Phone: 413/538-2085 or 413/538-2245. Hours: May–Oct.—2–5 Wed. and Sun.; closed Nov.–Apr. and holidays. Admission: free.

## MURRAY STATE UNIVERSITY
### Wrather West Kentucky Museum

The Wrather West Kentucky Museum at Murray State University in Murray is a regional history museum in the first building on the campus. The eight exhibit halls contain Civil War and university memorabilia, antique furniture and tools, a gun collection, and other historical items.

Wrather West Kentucky Museum, Murray State University, University Dr., Murray, KY 42071-3308. Phone: 502/762-4771. Hours: 8–4:30 Mon.–Fri.; 10–2 Sat.; closed holidays and when university not in session. Admission: free.

## NEBRASKA WESLEYAN UNIVERSITY
### Nebraska United Methodist Historical Center

(See Unaffiliated Museums section.)

## NEW MEXICO MILITARY INSTITUTE
### General Douglas L. McBride Museum

Military history is the focus of the General Douglas L. McBride Museum at the New Mexico Military Institute in Roswell. Founded in 1983 and housed in the 1912 Luna Natatorium, the museum has collections and exhibits dealing with general military history, small arms from the Civil War to the present, artifacts from twentieth-century conflicts, distinguished military leaders, and institute alumni and memorabilia.

General Douglas L. McBride Museum, New Mexico Military Institute, 101 W. College Blvd., Roswell, NM 88201-8107. Phone: 505/624-8220. Hours: 8:30–11:30 and 1–3 Tues.–Fri.; closed major holidays. Admission: free.

## NEW MEXICO STATE UNIVERSITY
### *New Mexico State University Museum*

(See Archaeology, Anthropology, and Ethnology Museums section.)

## NORTH CAROLINA STATE UNIVERSITY
### *Chinqua-Penn Plantation*

The Chinqua-Penn Plantation in Reidsville, North Carolina, is owned by North Carolina State University in Raleigh and operated by the Chinqua-Penn Foundation, a local historical group. The 27-room historic mansion was built in 1925 by Thomas and Beatrice Penn and became part of the university system in 1959.

The house and support structures occupy 22 of the plantation's 1,100 acres, while the remaining land is used for experimental research by the university. The plantation includes an extensive collection of Oriental and religious art, tapestries, Egyptian winged-phoenix furnishings, ceramic artifacts, and other objects collected by the Penns in their global travels; manicured lawns and gardens; greenhouses; lodge houses; a replica of a Chinese pagoda; pools; fountains; and a three-story clock tower at the entrance to the estate.

Chinqua-Penn Plantation House, Rte. 3, Box 682, Reidsville, NC 27320. Phone: 910/349-4576. Hours: 10–6 Tues.–Sat.; 1–5 Sun.; closed Jan., Feb., and major holidays. Admission: adults, $7; seniors, $6; children, $2.50; grounds only, $3.50.

## NORTHEAST MISSOURI STATE UNIVERSITY
### *E.M. Violette Museum*

The E.M. Violette Museum at Northeast Missouri State University in Kirksville is a history museum founded in 1940. It has a collection of historical and military objects, Native American artifacts, and other materials.

E.M. Violette Museum, Northeast Missouri State University, Kirksville, MO 63501. Phone: 816/785-4038. Hours: by appointment only; closed holidays and when university not in session. Admission: free.

## NORTHERN OKLAHOMA COLLEGE
### *A.D. Buck Museum of Natural History and Science*

(See Natural History Museums and Centers section.)

## NORTHWESTERN STATE UNIVERSITY OF LOUISIANA
### *Cammie G. Henry Research Center*

(See Library and Archival Collections and Galleries section.)

## NORWICH UNIVERSITY
### Norwich University Museum

The Norwich University Museum in Northfield, Vermont, is devoted primarily to the history of the university. It also contains personal memorabilia of founder Alden Partridge, exhibits on the achievements of prominent alumni, and such other materials as flags, weapons, military accouterments, and nineteenth-century academic paraphernalia.

Norwich University Museum, White Chapel, Northfield, VT 05663. Phone: 802/485-2000. Hours: 1–4 Mon.–Fri.; other times by appointment; closed summer, holidays, and when university not in session. Admission: free.

## OREGON STATE UNIVERSITY
### Horner Museum

(See General Museums section.)

## PACIFIC UNIVERSITY
### Pacific University Museum

The Pacific University Museum in Forest Grove, Oregon, is a history museum with artifacts and other materials related to the history of the university, Tualatin Academy, Asian cultures, and missionary activity. Founded in 1949, it is housed in the 1850 Old College Hall.

Pacific University Museum, Old College Hall, 2043 College Way, Forest Grove, OR 97116. Phone: 503/359-2915. Hours: 1–4:30 Tues.–Fri.; closed holidays and when university not in session. Admission: free.

## PANHANDLE STATE UNIVERSITY
### No Man's Land Historical Museum

(See Unaffiliated Museums section.)

## PENNSYLVANIA STATE UNIVERSITY
### Penn State Football Hall of Fame

(See Other Types of Museums section.)

### Penn State Room/University Archives
(See Library and Archival Collections and Galleries section.)

## SAM HOUSTON STATE UNIVERSITY
### Sam Houston Memorial Museum

The Sam Houston Memorial Museum—administered by Sam Houston State University—is located on 15 acres that comprised the original homestead of

pioneer leader Sam Houston from 1847 to 1857 in Huntsville, Texas. Houston led the fight for Texas's independence, serving as commander of the Texas army, president of the fledgling Republic of Texas, and senator and then governor of the State of Texas.

The living history museum was established through the efforts of the university's faculty, students, and townspeople, who began raising funds to purchase Houston's house and land in 1905, turned them over to the State of Texas in 1936, and obtained state funds to build the main rotunda building, which houses the bulk of the museum's collection of artifacts and memorabilia of Houston and his family; Santa Anna, Mexican general and later president who was defeated by Houston at the Battle of San Jacinto; and other figures of early Texas history.

The museum complex now consists of the Woodland Home, built by Houston in 1848 and occupied by his family during much of his tenure as senator; the Steamboat House, where Houston came to live after resigning the governorship in 1861 and where he died in 1863; Houston's law office; a blacksmith shop; a pottery shed; a period kitchen building; an exhibit hall; and the main museum building. The exhibits depict Houston's life and times and Texas history. Costumed interpreters demonstrate cooking, blacksmithing, woodworking, glass blowing, and the making of textiles, pottery, and black powder.

Sam Houston Memorial Museum, Sam Houston State University, 1836 Sam Houston Ave., PO Box 2057, Huntsville, TX 77341. Phone: 409/294-1832. Hours: 9–4:30 Tues.–Sun.; closed Thanksgiving and Christmas. Admission: free.

## SHASTA-TEHAMA-TRINITY JOINT COMMUNITY COLLEGE
### Shasta College Museum

The Shasta College Museum at Shasta-Tehama-Trinity Community College in Redding, California, is primarily a local history museum. Founded in 1970, it has collections of historical artifacts, papers, and photographs from the area; early farming, logging, and mining equipment; coroner's records from 1851 to 1939; early grocery store records, clothing, and accessories; and northern Sacramento Valley pre-history materials.

Shasta College Museum, Shasta-Tehama-Trinity Joint Community College, 1155-5 Old Oregon Tr., Redding, CA 96003. Phone: 916/225-4754. Hours: by appointment. Admission: free.

## SIOUX VALLEY HOSPITAL SCHOOL OF NURSING
### Sioux Empire Medical Museum

(See Medical, Dental, and Health Museums section.)

## SOUTH DAKOTA STATE UNIVERSITY
### State Agricultural Heritage Museum

(See Unaffiliated Museums section.)

## SOUTHEAST MISSOURI STATE UNIVERSITY
### Southeast Missouri State University Museum

(See General Museums section.)

## SOUTHWESTERN MICHIGAN COLLEGE
### Southwestern Michigan College Museum

The Southwestern Michigan College Museum in Dowagiac, Michigan, is a history museum and a contemporary science/technology center. It was founded in 1982 to further public understanding and appreciation of the historical development of Cass County and southwest Michigan and to enable a broad public audience to explore science and technology through hands-on exhibits.

The museum, which moved into a new 15,000-square-foot building in 1993, has four exhibit halls. The permanent historical exhibits relate to Native Americans, early settlers, the underground railroad, agriculture, and industry in the area. The hands-on exhibits deal with scientific principles and technological applications in such areas as light and optics, electrical energy, magnetic fields, computer technology, and the human body. The museum also presents locally produced and traveling exhibitions.

Southeastern Michigan College Museum, 58900 Cherry Grove Rd., Dowagiac, MI 49047. Phone: 616/782-7800. Hours: 1–5 Mon.–Fri.; 10–5 Sat.–Sun.; closed holidays and when university not in session. Admission: free.

## SPERTUS COLLEGE OF JUDAICA
### Spertus Museum

(See Archaeology, Anthropology, and Ethnology Museums section.)

## STEPHEN F. AUSTIN STATE UNIVERSITY
### Stone Fort Museum

The stone building housing the Stone Fort Museum on the campus of Stephen F. Austin State University in Nacogdoches, Texas, is a replica of a 1780 structure that variously served as a public building, grocery, candy store, saloon, and temporary fortification. It initially was built by Don Antonio Gil Y'Barbo, founder of the city, as the formal portals to the Spanish District of Texas. The building was torn down for new construction in 1902 and rebuilt with the original stones in 1936 as part of the Texas centennial observance.

The museum interprets the history of east Texas and Nacogdoches prior to 1900, placing special emphasis on the Spanish and Mexican periods, beginning in 1690 with the establishment of the Spanish Mission Tejas and ending with the overthrow of the Mexican government by Texas revolutionists in 1836. In addition to the permanent exhibit, it presents a changing exhibition each year.

Stone Fort Museum, Stephen F. Austin State University, Clark and Griffith Blvds., PO

Box 6075, Nacogdoches, TX 75962-6075. Phone: 409/568-2408. Hours: 9–5 Tues.–Sat.; 1–5 Sun.; closed holidays. Admission: free.

## SUL ROSS STATE UNIVERSITY
### Museum of the Big Bend

Historical and archaeological materials from the Big Bend region in western Texas are featured at the Museum of the Big Bend at Sul Ross State University in Alpine, Texas. Founded on the campus in 1937, but originally operated by the West Texas Historic and Scientific Society, the museum was transferred to the university when the society became inactive in 1968.

The museum has more than 80,000 objects, including archaeological artifacts; Native American artifacts; late-nineteenth- and early-twentieth-century historical materials; regional art; archival collections in ranching, mining, and business; and rare photographs and books about Texas and the Big Bend region.

The permanent exhibits have a historical story line to the Big Bend region, prehistoric and historic Native American artifacts, a nineteenth-century stage-coach with bullet holes, a 1930s–1940s general store, and a children's discovery center.

Museum of the Big Bend, Sul Ross State University, PO Box C-210, Alpine, TX 79832. Phone: 915/837-8143. Hours: 9–5 Tues.–Sat.; 1–5 Sun.; closed holidays. Admission: free.

## SWEET BRIAR COLLEGE
### Sweet Briar Museum

The Sweet Briar Museum is located in a nineteenth-century Tuscan villa left to Sweet Briar College along with a 9,000-acre plantation and all of the donor's clothing, jewelry, furniture, tools, and other belongings of the period. The donor, Indiana Fletcher Williams, founded the college in 1901 (through her will) in memory of her only child, who died at the age of 16.

The museum shares the building, known as the Old College Inn, with the alumnae association in Sweet Briar, Virginia. Alumnae gathered all the nineteenth-century objects that were scattered around the plantation and put them in the museum, which was established in 1978. The museum contains alumnae archives as well as historic material culture from the plantation. The 200-plus farm tool collection is displayed in a restored slave cabin adjacent to the main building.

Sweet Briar Museum, Sweet Briar College, Sweet Briar, VA 24595. Phone: 804/381-6246. Hours: by appointment. Admission: free.

## TEMPLE UNIVERSITY
### Historical Dental Museum

(See Medical, Dental, and Health Museums section.)

## TEXAS A&M UNIVERSITY–KINGSVILLE
### *John E. Conner Museum*

(See Natural History Museums and Centers section.)

## TEXAS TECH UNIVERSITY
### *Ranching Heritage Center (Museum of Texas Tech University)*

(See General Museums section.)

## TRANSYLVANIA UNIVERSITY
### *Museum of Early Philosophical Apparatus*

(See Science and Technology Museums and Centers section.)

## TRI-STATE UNIVERSITY
### *Lewis B. Hershey Museum*

Memorabilia of General Lewis B. Hershey, director of the nation's Selective Service System from 1941 to 1970 and an alumnus, are displayed at the Lewis B. Hershey Museum at Tri-State University in Angola, Indiana. They include the lottery bowl and capsule mixer from World War II and the Korea and Vietnam conflicts, as well as draft materials since the Civil War.

Lewis B. Hershey Museum, Tri-State University, Hershey Hall, PO Box 307, Angola, IN 46703-0307. Phone: 219/665-4141. Hours: 8–4:30 Mon.–Fri.; 1–4 Sat.–Sun. and holidays; closed when university not in session. Admission: free.

## TULANE UNIVERSITY
### *Gallier House*

The Gallier House, opened in 1969 and administered by Tulane University in New Orleans, Louisiana, is a historic house with a decorative arts collection. The 1857 residence of architect James Gallier, Jr., in the French Quarter also has period furnishings and artifacts of the mid-nineteenth century.

Gallier House, Tulane University, 1118-32 Royal St., New Orleans, LA 70116. Phone: 504/532-6722. Hours: 10–4:30 Mon.–Sat.; 12–4:30 on selected Sun.; closed major holidays. Admission: adults, $4; seniors and students, $3; children 6–12, $2.25; children under 6, free.

## TUSCULUM COLLEGE
### *President Andrew Johnson Museum and Library*

The personal library of President Andrew Johnson and artifacts of his era are featured at the President Andrew Johnson Museum and Library at Tusculum

College in Greeneville, Tennessee. The museum/library, opened in 1993, is located in an 1841 building on the campus, where Johnson twice served on the Board of Trustees.

Nearby is the Andrew Johnson National Historic Site, containing historic houses and artifacts of the 1820s–1875 period. They include the 1830s–1851 Johnson house, 1830s–1840s Johnson tailor shop, and 1851–1875 Johnson homestead. The historic site is operated by the National Park Service.

President Andrew Johnson Museum and Library, Tusculum College, Greeneville, TN 37743. Phone: 615/636-7348. Hours: 9–5 Mon.–Sat.; 1–5 Sun.; closed holidays. Admission: free.

### Doak-Johnson Heritage Museum

The Doak-Johnson Heritage Museum at Tusculum College in Greeneville, Tennessee, is located in the 1818 home of Samuel Doak, founder of the college. It features artifacts, documents, period furniture, and printed and written media related to the history of the college and eastern Tennessee.

Doak-Johnson Heritage Museum, Tusculum College, PO Box 5026, Greeneville, TN 37743. Phone: 615/636-8554. Hours: 9–5 Mon.–Fri. by appointment; closed major holidays and last two weeks of Dec. Admission: free.

## TUSKEGEE UNIVERSITY
### George Washington Carver Museum

(See Unaffiliated Museums section.)

## U.S. AIR FORCE ACADEMY
### U.S. Air Force Academy Visitor Center

Pictorial and audiovisual exhibits on the history and programs of the U.S. Air Force Academy are offered at the academy's Visitor Center, which opened in 1961 in Colorado.

U.S. Air Force Academy Visitor Center, 2346 Academy Dr., USAF Academy, CO 80840. Phone: 719/472-2025. Hours: summer—9–6 daily; remainder of year—9–5 daily. Admission: free.

## U.S. COAST GUARD ACADEMY
### U.S. Coast Guard Museum

The focus of the U.S. Coast Guard Museum at the U.S. Coast Guard Academy in New London, Connecticut, is on the history of the service since 1790 and on the Coast Guard's major missions, such as law enforcement, suppression of smuggling, aids to navigation, marine safety, and search and rescue.

Although the museum was not founded formally until 1967, the collections have been growing for more than 85 years. They contain material from the U.S.

Lighthouse Service, U.S. Life-Saving Service, and U.S. Revenue Cutter Service—a forerunner agency—as well as the Coast Guard. The holdings include historic marine artifacts, paintings, prints, photographs, figureheads, flags, uniforms, swords, small arms, scrimshaw, china, silver, ordnance, nautical instruments, historic boats, and ship and aircraft models.

U.S. Coast Guard Museum, U.S. Coast Guard Academy, 15 Mohegan Ave., New London, CT 06320-4195. Phone: 203/444-8511. Hours: 9–4:30 Mon.–Fri.; 10–5 Sat.; 12–5 Sun.; closed holidays. Admission: free.

## U.S. MILITARY ACADEMY
### West Point Museum

Military history—told through exhibits, artifacts, and artworks—is the mission of the West Point Museum at the U.S. Military Academy in West Point, New York. The emphasis is on the history of the academy, U.S. Army, and American and European warfare, as well as Western military strategy.

The museum's exhibits deal with military events and personalities and display collections of weapons, uniforms, documents, paintings, sculpture, prints, photographs, and various other historical objects. Among the prized possessions are trophies of war captured since the British defeat at Saratoga by Colonial troops; the individual weapons of Washington, Napoleon, Pershing, Eisenhower, and other military leaders; an extensive collection tracing the development of small arms; a collection of American and European uniforms; and military art, including Sully portraits and Rindisbacher watercolors.

The museum, located in Olmsted Hall, has six galleries divided among six themes—history of American wars, history of the American Army in peace, history of warfare, history of the U.S. Military Academy and its cadets, history of small arms, and history of large weapons. The annual attendance is approximately 250,000.

West Point Museum, U.S. Military Academy, Olmsted Hall, West Point, NY 10996-5000. Phone: 914/938-2203. Hours: 10:30–4:15 daily; closed major holidays. Admission: free.

## U.S. NAVAL ACADEMY
### U.S. Naval Academy Museum

The nation's naval history is the focus of the U.S. Naval Academy Museum in Annapolis, Maryland. The museum has collections and exhibits of naval paintings, prints, documents, uniforms, ship models, navigational instruments, weapons, flags, medals, memorabilia, and other materials that tell the story.

The museum originated in 1845 with the establishment of the Naval Academy Lyceum, a collection of historical and natural objects, scientific models and apparatus, and works of art brought together for study and discussion. In the years that followed, the collections grew with the addition of historic flags, ship

models, trophies of war, weapons, expedition and diplomatic mission items, more artworks, and other objects.

Among the collections are the Henry Huddleston Rogers Ship Models Collection, with 108 ship and small boat models of the sailing ship era from 1650 to 1850; Beverly R. Robinson Collection of naval battle prints, consisting of over 1,000 graphic prints depicting major naval engagements from the sixteenth century to 1873; Malcolm Storer Naval Medals Collection, comprised of 1,210 commemorative coins and medals from 254 B.C. to 1936 gathered from 30 countries; and U.S. Navy Trophy Flag Collection, with more than 600 historic American flags and captured foreign ensigns.

A permanent four-story museum building was constructed in 1939—and expanded in 1962—to house and display the materials. Articles from the collections also are on exhibit in most academy buildings and on the grounds to further interest in naval history.

U.S. Naval Academy Museum, 118 Maryland Ave., Annapolis, MD 21402-5034. Phone: 410/923-2108. Hours: 9–5 Mon.–Sat.; 11–5 Sun.; closed New Year's Day, Thanksgiving, and Christmas. Admission: Free

## U.S. NAVAL WAR COLLEGE
### Naval War College Museum

The Naval War College Museum—located in the college's 1820 Founders Hall in Newport, Rhode Island—chronicles the history of naval warfare and the history of the U.S. Navy in Narragansett Bay.

The Naval War College, first naval war college in the world, began in the museum building in 1884. It also was there, in 1890, that Captain Alfred Thayer Mahan, second president of the college, wrote the epochal *The Influence of Sea Power upon History, 1660–1783,* which revolutionized naval thinking throughout the world. The building was converted to a museum in 1978.

Exhibits occupy approximately half of the 13,000-square-foot building on two floors. In addition to the permanent exhibits on the development of war at sea and the Navy in the Newport region, three to four temporary exhibitions on naval-related subjects are presented each year. Among the museum's collections are numerous naval artifacts and miniature naval ship models.

Naval War College Museum, Founders Hall, Coasters Harbor Island, Newport, RI 02841-1207. Hours: 10–4 Mon.–Fri.; 12–4 Sat.–Sun. in Jun.–Sept.; closed holidays. Admission: free.

## UNIVERSITY OF ALABAMA
### Gorgas House

The 1829 home of Josiah and Amelia Gayle Gorgas serves as the site of a historic house museum—known as the Gorgas House—at the University of Alabama in Tuscaloosa. Founded in 1954, the historic house has a collection of

eighteenth- and nineteenth-century Spanish silver.
Gorgas House, University of Alabama, PO Box 870266, Tuscaloosa, AL 35487-2066.
Phone: 205/348-5906. Hours: 10–12 and 2–5 Mon.–Sat.; 3–5 Sun.; closed holidays. Admission: free.

### Paul W. Bryant Museum

(See Other Types of Museums section.)

## UNIVERSITY OF ARIZONA
### Center for Creative Photography

(See Photography Museums section.)

## UNIVERSITY OF BALTIMORE
### Steamship Historical Society of America Collection

(See Other Types of Museums section.)

## UNIVERSITY OF CALIFORNIA, LOS ANGELES
### Fowler Museum of Cultural History

(See Archaeology, Anthropology, and Ethnology Museums section.)

## UNIVERSITY OF CALIFORNIA, RIVERSIDE
### California Museum of Photography

(See Photography Museums section.)

## UNIVERSITY OF COLORADO AT BOULDER
### University of Colorado Heritage Center

The University of Colorado Heritage Center in Boulder has artifacts and displays relating to the university's history in Old Main, the first campus building constructed in 1876. Among the exhibits are photographs, trophies, books, furniture, clothing, uniforms, and materials pertaining to past presidents, faculty, and distinguished alumni, including sports figures, orchestra leader Glenn Miller, and the university's 12 astronauts.
University of Colorado Heritage Center, Old Main, Campus Box 459, Boulder, CO 80309-0459. Phone: 303/492-6329. Hours: 10–4 Tues.–Fri.; closed major holidays. Admission: free.

## UNIVERSITY OF CONNECTICUT HEALTH CENTER
### Friends Museum of the University of Connecticut Health Center

(See Medical, Dental, and Health Museums section.)

## UNIVERSITY OF FLORIDA
### Florida Museum of Natural History

(See Natural History Museums and Centers section.)

## UNIVERSITY OF HARTFORD
### Museum of American Political Life

(See Other Types of Museums section.)

## UNIVERSITY OF ILLINOIS AT CHICAGO
### Jane Addams' Hull-House Museum

The University of Illinois at Chicago created Jane Addams' Hull-House Museum in 1967 at the site of Chicago's first settlement house and a prototype of most that followed. It consists of two original buildings of the pioneering settlement house founded in 1889 by Jane Addams and Ellen Gates Starr.

The two buildings—the Hull Mansion (1856) and the Residents' Dining Hall (1905)—have been restored and are operated as a museum and historic site. They contain exhibits of artifacts, memorabilia, furniture, paintings, photographs, documents, books, and other materials relating to the life and work of Jane Addams, her associates, and the history of Hull-House and the neighborhood, which now includes the Chicago campus of the University of Illinois.

Jane Addams' Hull-House Museum, University of Illinois at Chicago, 800 S. Halsted St., Chicago, IL 60607-7017. Phone: 312/413-5353. Hours: 10–4 Mon.–Fri.; 12–5 Sun.; closed holidays. Admission: free.

## UNIVERSITY OF ILLINOIS AT URBANA-CHAMPAIGN
### World Heritage Museum

(See Archaeology, Anthropology, and Ethnology Museums section.)

## UNIVERSITY OF IOWA
### Old Capitol

The Old Capitol in Iowa City was Iowa's last territorial capitol in 1842–1846 and the state's first capitol with the admission of Iowa to the Union in 1846. It now is a historic structure with furniture and furnishings of the period—as well as the original library collection. Opened in 1976 as part of the nation's bicentennial celebration, the Old Capitol is administered by the University of Iowa.

Old Capitol, University of Iowa, 24 Old Capitol, Iowa City, IA 52242. Phone: 319/335-0548. Hours: 10–3 Mon.–Sat.; 12–4 Sun.; closed holidays. Admission: free.

### University of Iowa Hospitals and Clinics Medical Museum
(See Medical, Dental, and Health Museums section.)

## UNIVERSITY OF KANSAS
### Ryther Printing Museum

Antique printing equipment is featured at the Ryther Printing Museum at the University of Kansas in Lawrence. Founded in 1955, the museum contains typefaces, typesetting equipment, printing machines, mailing equipment, and other such materials.

Ryther Printing Museum, University of Kansas, 2425 W. 15th St., Lawrence, KS 66049. Phone: 913/864-4188. Hours: 8–5 Mon.–Fri.; closed holidays. Admission: free.

### Clendening History of Medicine Library and Museum
(See Medical, Dental, and Health Museums section.)

## UNIVERSITY OF KENTUCKY
### Photographic Archives

(See Photography Museums section.)

## UNIVERSITY OF LOUISVILLE
### Photographic Archives

(See Photography Museums section.)

## UNIVERSITY OF MARYLAND AT BALTIMORE
### Dr. Samuel D. Harris National Museum of Dentistry

(See Medical, Dental, and Health Museums section.)

## UNIVERSITY OF MASSACHUSETTS, LOWELL
### Center for Lowell History

(See Library and Archival Collections and Galleries section.)

## UNIVERSITY OF MEMPHIS
### C. H. Nash Museum–Chucalissa

(See Archaeology, Anthropology, and Ethnology Museums section.)

## UNIVERSITY OF MICHIGAN–DEARBORN
### Henry Ford Estate

The Henry Ford Estate, known as Fairlane, is operated by the University of Michigan–Dearborn as a historic house and nature center. The property of the founder of Ford Motor Company was given to the university by the company in 1957. The 1914 house contains many of the original furnishings and decorative arts. A still-working 1915 hydroelectric power plant and five acres of restored gardens also can be seen at the estate. Guided tours are available.

Henry Ford Estate, University of Michigan–Dearborn, 4901 Evergreen Road, Dearborn, MI 48128-1491. Phone: 313/593-5590. Hours: 8–5 Mon.–Fri.; 9:30–4 Sat.–Sun.; closed some holidays. Admission: adults, $6; seniors, students, and children, $5.

## UNIVERSITY OF MINNESOTA, DULUTH
### Glensheen

Glensheen, the 39-room neo-Jacobean mansion and 22-acre estate of Chester A. Congdon, is a historic house museum operated by the University of Minnesota, Duluth. The manor house, built in 1905–1908, and grounds were donated to the university by heirs of the Congdon family in 1979. It now is listed on the National Register of Historic Places.

The furnishings of Glensheen are intact, comprising one of the finest collections of the arts and crafts style of furniture in the Midwest. Also located on the property are a carriage house, gardener's cottage, boathouse, clay tennis court, and bowling green.

Glensheen, University of Minnesota, Duluth, 3300 London Road, Duluth, MN 55804. Phone: 218/724-8864. Hours: May–Oct.—9–5 Thurs.–Tues.; Nov.–Apr.—1–2 Mon.–Tues. and Thurs.–Fri.; 1–3 Sat.–Sun.; closed major holidays. Admission: adults, $6; seniors, $5; children 6–11, $3.

## UNIVERSITY OF MISSOURI–COLUMBIA
### State Historical Society of Missouri Gallery

(See Unaffiliated Museums section.)

## UNIVERSITY OF PITTSBURGH
### Stephen C. Foster Memorial

The Stephen C. Foster Memorial at the University of Pittsburgh is a tribute to America's first professional songwriter. It was opened in 1937 as a museum and research library following a gift of Foster materials by Josiah Kirby Lilly of the Indianapolis pharmaceutical family.

The facility, adjacent to a concert hall and classrooms, contains a collection

of original documents, musical instruments, music editions, photographs, and other artifacts of Foster and artworks inspired by his music.

Stephen C. Foster Memorial, University of Pittsburgh, Forbes Ave. and Bigelow Blvd., Pittsburgh, PA 15260. Phone: 412/624-4100. Hours: 9–4 Mon.–Fri.; closed holidays and when university not in session. Admission: free. Guided tours: $1.

## UNIVERSITY OF PUERTO RICO
### Museum of Anthropology, History, and Art

(See Archaeology, Anthropology, and Ethnology Museums section.)

## UNIVERSITY OF RICHMOND
### Virginia Baptist Historical Society Exhibit Area and Archives

(See Unaffiliated Museums section.)

## UNIVERSITY OF SAN DIEGO
### Mission Basilica de Alcala

(See Religious Museums section.)

## UNIVERSITY OF SOUTH DAKOTA
### W.H. Over State Museum

(See Unaffiliated Museums section.)

## UNIVERSITY OF SOUTHERN INDIANA
### Historic New Harmony

Historic New Harmony, a living history village museum located on the site of two early utopian experiments in New Harmony, Indiana, is operated jointly by the University of Southern Indiana and the Indiana State Department of Natural Resources. The outdoor museum was founded in 1973.

It was the site of George Rapp's 1814–1825 Harmony Society and New Harmony, developed in 1824–1827 by Robert Owen, Welsh-born social reformer and industrialist. It also was the location of the early headquarters of the U.S. Geological Survey, which provided many of the first collections of the Smithsonian Institution.

The outdoor museum contains approximately 12 historic structures from the c. 1814–1824 period and 20 from the 1830–1920 period. The collections include geological and natural science specimens from the earliest geological surveys,

early theater materials, manuscripts, and 81 hand-colored lithographs from the New Harmony Maximilian-Bodner Collection.

Historic New Harmony, 506½ Main St., New Harmony, IN 47631. Phone: 812/682-4488. Hours: Apr.–Oct.—9–5 daily; Nov.–Mar.—varies, call for hours. Admission: adults, $3.50 to $8, and children 7–17, $3.50 to $4.50 depending on options selected; children under 7, free; family, $20.

## UNIVERSITY OF TEXAS AT AUSTIN

The University of Texas at Austin has four history-oriented museums—the Texas Memorial Museum (see Natural History Museums and Centers section) and Lyndon Baines Johnson Library and Museum (in Unaffiliated Museums section) in Austin, Sam Rayburn Library and Museum in Bonham (in Library and Archival Collections and Galleries section), and Winedale Historical Center in Round Top (described below).

### Winedale Historical Center

The Winedale Historical Center at Round Top, Texas, contains houses, furniture, decorative arts, folk art, tools, and agricultural implements pertaining to the German settlement of Texas in the nineteenth century. The center resulted from a gift of a restored 1834-period farmstead by Ima Hogg to the University of Texas at Austin in 1967.

Among the historic buildings comprising the center are the 1832–1848 Lewis-Wagner farmstead, an 1861 Anglo-German house, and the McGregor-Grimm house and an Anglo-American farmstead of the mid-nineteenth century. The center is the site of conferences, festivals, crafts workshops and exhibitions, plays, antique fairs, and an Oktoberfest celebration.

Winedale Historical Center, University of Texas at Austin, FM Road 2714, PO Box 11, Round Top, TX 78954-0111. Phone: 409/278-3530. Hours: weekdays by appointment; 10–5 Sat.–Sun.; closed holidays. Admission: adults, $2; students, 50¢.

## UNIVERSITY OF TEXAS AT DALLAS
### Frontiers of Flight Museum

(See Unaffiliated Museums section.)

## UNIVERSITY OF TEXAS AT SAN ANTONIO
### University of Texas Institute of Texan Cultures at San Antonio

The University of Texas Institute of Texan Cultures at San Antonio is an educational center concerned with the history and cultures of Texas. Its primary purpose is to study the ethnic and cultural history of the state and to

present the resulting information to the public in a variety of ways, including exhibits, tours, publications, teaching materials, special events, and an outreach program.

The institute first opened in 1968 as the Texas Pavilion at the HemisFair exposition. It was so well received during the six-month run that the state decided to continue and to expand its offerings. The institute maintains more than 50,000 square feet of exhibits and has nearly 400,000 visitors annually. It also produces traveling exhibitions, circulating exhibits on 26 Texas-related topics, such as Texas women, immigration, archaeology, folk toys, and cowboys.

The permanent exhibits explore the history and culture of 27 ethnic and cultural groups, examining who they are, where they come from, how they live, and other aspects. Visitors can touch the buffalo-hide tipi in the Native American section, grind corn in the Mexican jacal, search for a photo of a German ancestor, examine the contents of a Lebanese peddler's pack, and see the *Faces and Places of Texas* multimedia dome show. In the "Back 40" area behind the building, the public can experience the life of early Texans in a one-room schoolhouse, at a windmill, on a pioneer wagon, in a traditional barn, at a frontier fort, and in a west Texas adobe house.

Among the institute's special events are the Texas Children's Festival, Pioneer Sunday, and Texas Folklife Festival. At the folklife festival in August, more than 30 ethnic and cultural groups share their music, crafts, food, stories, and dance with 100,000 visitors.

University of Texas Institute of Texan Cultures at San Antonio, 801 S. Bowie St., PO Box 1226, San Antonio, TX 78205. Phone: 210/558-2300. Hours: 9–5 Tues.–Sun.; closed Thanksgiving and Christmas. Admission: free.

## UNIVERSITY OF VIRGINIA
### The Rotunda

The Rotunda at the University of Virginia in Charlottesville was designed by Thomas Jefferson as the architectural and academic heart of his community of scholars, which he called the "academical village." The Rotunda, built in 1822–1826, still is the focal point of the "village," which includes pavilions housing faculty, student rooms, an expansive lawn, and formal gardens (also see Botanical Gardens, Arboreta, and Herbaria section).

The Rotunda—modeled after the Pantheon in Rome—initially served as the library. It remained as a library for a century until the much larger Alderman Library was constructed. An annex was added onto the north facade in 1853 to provide more classrooms and a large auditorium. A fire in 1895 destroyed much of the building and annex. It was reconstructed by architect Stanford White as an elaborate Beaux Arts interpretation in the Roman style. It remained this way until 1973–1976 when the building was restored to Jefferson's original design.

The Dome Room is the center of The Rotunda, which has lower and upper entrance halls, five Oval Rooms, and an exhibition of materials relating to the founding of the university and its architectural history, prints and engravings of the grounds, and early-nineteenth-century American furniture. Guided tours are given throughout the year.

The Rotunda, University of Virginia, Charlottesville, VA 22903. Phone: 804/924-7969. Hours: 9–4 daily; closed Thanksgiving and the next day and Christmas recess. Admission: free.

## UNIVERSITY OF WYOMING
### American Heritage Center

(See Library and Archival Collections and Galleries section.)

## UTAH STATE UNIVERSITY
### Ronald V. Jensen Living Historical Farm

(See Agricultural Museums section.)

## VIRGINIA MILITARY INSTITUTE

The Virginia Military Institute (VMI) in Lexington has three historically oriented museum facilities. They are the Virginia Military Institute Museum and George C. Marshall Foundation Museum (see Unaffiliated Museums section) in Lexington and the Hall of Valor Civil War Museum and New Market Battlefield Historical Park in New Market.

### Virginia Military Institute Museum

The Virginia Military Institute Museum in Lexington began with the gift of a Revolutionary War musket in 1856. It now contains artifacts, drawings, paintings, and photographs relating to the history of VMI and its immediate vicinity, as well as memorabilia of alumni and faculty. The museum is best known for its collection of materials relating to General T.J. ''Stonewall'' Jackson, a Confederate hero in the Civil War.

Virginia Military Institute Museum, Jackson Memorial Hall, Lexington, VA 24450. Phone: 703/464-7334. Hours: 9–5 Mon.–Sat.; 2–5 Sun.; closed major holidays. Admission: free.

### Hall of Valor Civil War Museum and New Market Battlefield Historical Park

The Hall of Valor Civil War Museum and the New Market Battlefield Historical Park in New Market, Virginia, are part of the Virginia Military Institute. It was in the 1864 Battle of New Market that 257 VMI cadets fought on the Confederate side. The historical park, which consists of 280 acres of the

original battlefield, was opened in 1967, followed by the museum in 1970. Both were donated to the institute by a 1911 graduate, George R. Collins, in 1964. The museum contains Civil War artifacts and personal items owned by General Stonewall Jackson.

Hall of Valor Civil War Museum and New Market Battlefield Historical Park, Virginia Military Institute, PO Box 1864, New Market, VA 22844. Phone: 703/740-3101. Hours: 9–5 daily; closed New Year's Day, Thanksgiving, and Christmas. Admission: adults, $5; children 7–15, $2.

## VIRGINIA POLYTECHNIC INSTITUTE AND STATE UNIVERSITY

The Virginia Polytechnic Institute and State University has three historical museums. Two are centered around historic homesteads—the Cyrus H. Mc-Cormick Memorial Museum in Steeles Tavern and the Reynolds Homestead in Critz. The other, the American Work Horse Museum in Paeonian Springs, is described in the Other Types of Museums section. The McCormick Memorial Museum is described in the Agricultural Museums section.

### Reynolds Homestead

The Reynolds Homestead in Critz, Virginia, features the 1843 boyhood home of tobacco magnet R.J. Reynolds; Reynolds's family paintings, silver, and furnishings of the Victorian era; and a continuing education center with gallery, education, and concert facilities. The property was donated to the Virginia Polytechnic Institute and State University in 1976.

Reynolds Homestead, Virginia Polytechnic Institute and State University, Rte. 1, Box 190, Critz, VA 24082-9707. Phone: 703/694-7181. Hours: 9–4:30 Mon.–Fri.; 1–5 Sat.–Sun.; closed major holidays. Admission: adults, $1; seniors and students, 50¢.

## WASHINGTON AND LEE UNIVERSITY
### Lee Chapel and Museum

The historic Lee Chapel at Washington and Lee University in Lexington, Virginia, was built in 1867–1868 under the direction of General Robert E. Lee, who served as president of the university for the last five years of his life. Lee died in 1870 and was buried near the center of the chapel's present museum.

Following completion of an addition to the chapel in 1883, the general's remains were moved to the family crypt where he and his wife, mother, father, children, and other relatives are buried. His beloved horse, Traveller, also was reinterred in a plot outside the chapel in 1971.

When Lee was president of the university, he used a room on the lower level of the building as his office and attended daily worship services with students in the chapel. Lee's office is preserved much as he left it. The lower level

became the Lee Museum in 1928, containing many items belonging to Lee and his family and other materials associated with them.

Among the prized possessions in the chapel is a collection of eighteenth- and nineteenth-century portraits of members of the Washington, Custis, and Lee families. The 18 paintings include the famous Charles Willson Peale portrait of George Washington wearing the uniform of a colonel in the British army of General Braddock and the Theodore Pine portrait of Lee in Confederate uniform. Among the other portraits are those of Martha Washington; Lee's wife, Mary Randolph Custis Lee; Washington's and Lee's children and relatives; and the Marquis de Lafayette, also painted by Peale.

Lee Chapel and Museum, Washington and Lee University, Lexington, VA 24450. Phone: 703/463-8768. Hours: mid–Apr. to mid–Oct.—9–5 Mon.–Sat.; 2–5 Sun.; mid–Oct. to mid–Apr.—9–4 Mon.–Sat.; 2–5 Sun.; closed major holidays. Admission: free.

## WAYLAND BAPTIST UNIVERSITY
### Museum of the Llano Estacado

The history, geology, and archaeology of the region are featured at Wayland Baptist University's Museum of the Llano Estacado in Plainview, Texas. The museum, which was established by a joint university-community effort in 1976, emphasizes the cultural and economic development of the area. The collections and exhibits include military and Native American artifacts, natural history specimens, and historical items.

Museum of the Llano Estacado, Wayland Baptist University, 1900 W. Eighth St., Plainview, TX 79072. Phone: 806/296-4735. Hours: 9–5 Mon.–Fri.; 1–5 Sat.–Sun.; closed holidays. Admission: free.

## WESTERN CAROLINA UNIVERSITY
### Mountain Heritage Center

Artifacts relating to Indians and European pioneers in the Appalachian region are housed in the Mountain Heritage Center of Western Carolina University in Cullowhee, North Carolina. The center, founded in 1975, has early tools, photographs, folklore recordings, and other materials. The early manuscripts and records are in the university's library.

Mountain Heritage Center, Western Carolina University, Cullowhee, NC 28723. Phone: 704/227-7129. Hours: 8–5 Mon.–Fri.; closed New Year's Day and Christmas recess. Admission: free.

## WESTERN KENTUCKY UNIVERSITY
### Kentucky Museum

The Kentucky Museum at Western Kentucky University in Bowling Green is a repository for the heritage of the State of Kentucky. Among its collections

and exhibits are early furniture, quilts, textiles, toys, musical instruments, tools, art, political memorabilia, and Shaker material culture. The museum shares the 80,000-square-foot Kentucky Building with the Kentucky Library and Manuscripts and Folklife Archives.

Kentucky Museum, Western Kentucky University, Kentucky Building, Western Kentucky University, Bowling Green, KY 42101. Phone: 502/745-2592. Hours: 9:30–4 Tues.–Sat.; 1–4 Sun.; closed holidays. Admission: families, $5; adults, $2; children, $1.

## WESTERN TEXAS COLLEGE
### Scurry County Museum

(See Unaffiliated Museums section.)

## WESTMINSTER COLLEGE
### Winston Churchill Memorial and Library in the United States

The Winston Churchill Memorial and Library in the United States is located at Westminster College in Fulton, Missouri, where the former British prime minister delivered his famous Sinews of Peace speech in 1946. The memorial/library was founded in 1962.

The tribute to Churchill is located in the reconstructed Church of St. Mary the Virgin, Aldermanbury, which was designed by Christopher Wren, the noted English architect. It contains Churchill memorabilia, Wren architectural materials, and collections of rare maps, paintings, graphics, sculpture, manuscripts, numismatics, philatelic materials, motion pictures, photographs, and sound recordings.

Winston Churchill Memorial and Library in the United States, Westminster College, Seventh and Westminster Aves., Fulton, MO 65251. Phone: 314/642-6648. Hours: 10–4:30 daily; closed New Year's Day, Thanksgiving, and Christmas. Admission: adults, $2.50; seniors and groups, $2; students, $1; Westminster students and children 12 and under, free.

## WEST TEXAS A&M UNIVERSITY
### Panhandle-Plains Historical Museum

The Panhandle-Plains Historical Museum at West Texas A&M University in Canyon focuses on the history of the Panhandle area as it relates to Texas and the Southwest. The museum was started by the Panhandle-Plains Historical Society in 1921 and became part of the university in 1932. The society technically still owns the collections.

The 280,000-square-foot museum, which has an annual attendance of approximately 120,000, has collections and exhibits dealing with Plains Indian

ethnology, anthropology, archaeology, paleontology, pioneer life, the cattle industry, transportation, agriculture, art, petroleum, clothing and textiles, firearms, furniture, and science and technology. One of its most popular offerings is a storefront pioneer village. The original T-Anchor Ranch House, constructed in the late 1870s, also has been reconstructed on the museum grounds, complete with outbuildings and windmill.

The museum has over 3.5 million artifacts, more than 250,000 historical photographs, and extensive archives on the history of Texas and the Southwest.

Panhandle-Plains Historical Museum, West Texas A&M University, 2401 Fourth Ave., Canyon, TX 79015. Phone: 806/656-2244. Hours: academic year—9–5 Mon.–Sat.; 2–6 Sun.; summer—9–6 Mon.–Sat.; closed New Year's Day, Thanksgiving, and Christmas. Admission: free.

## WEST VIRGINIA UNIVERSITY
### Jackson's Mill Museum

The Jackson's Mill Museum, which is affiliated with West Virginia University, is part of a historic area in Weston. Founded in 1968, the museum is located in the restored grist mill where Confederate General T.J. ''Stonewall'' Jackson worked as a boy. It contains original letters from Jackson, grist and saw milling equipment, and agricultural tools and items.

Also located in the Jackson's Mill Historic Area are Blaker's Mill, an operating grist mill; the McWhorter Cabin, an 1800s homestead; the Mary Conrad Cabin, which is being restored and moved near the museum; and the Jackson's Mill Conference Center.

Jackson's Mill Museum, West Virginia University, PO Drawer 670, Weston, WV 26452. Phone: 304/269-5100. Hours: Memorial Day to Labor Day—12–5 Tues.–Sun. Admission: adults, $2; children, $1.

### Comer Museum
(See Geology, Mineralogy, and Paleontology Museums section.)

## WHEATON COLLEGE
### Billy Graham Center Museum

(See Religious Museums section.)

## YALE UNIVERSITY
### Harvey Cushing/John Hay Whitney Medical Library/ Historical Library

(See Library and Archival Collections and Galleries section.)

## YESHIVA UNIVERSITY
### *Yeshiva University Museum*

(See Archaeology, Anthropology, and Ethnology Museums section.)

# Library and Archival Collections and Galleries

## AMHERST COLLEGE
### *Folger Shakespeare Library*

The Folger Shakespeare Library, a historic book and manuscript library and museum in Washington, D.C., is one of the nation's major resources on the Renaissance civilization of England and the European continent. It was founded in 1932 by an alumnus of Amherst College who placed the governance of the library under the college's Board of Trustees in Amherst, Massachusetts.

The library has a collection of more than 250,000 volumes and over 55,000 manuscripts on the English and Continental Renaissance—of which approximately 115,000 are rare books from the fifteenth to the eighteenth centuries. The collection includes materials on William Shakespeare, theater history from the Middle Ages to the twentieth century, and paintings, prints, drawings, and art memorabilia from the foregoing periods.

Perhaps the most valuable resource of the Folger Shakespeare Library is its collection of editions of Shakespeare's plays—from the time they were first issued in thin, one-play volumes to the latest products of modern textual studies. Among the 182 play quartos (as the first volumes were called because they were folded twice, or quartered) are two unique pieces—the 1594 *Titus Andronicus* and a portion of the first edition of *1 Henry IV*. The 79 copies of the 1623 First Folio edition of *Mr. William Shakespeare's Comedies, Histories, & Tragedies* are considered to be the most famous and extraordinary feature of the Shakespeare collection.

The library also has a gallery for exhibitions, an Elizabethan theater, and an

extensive program of readings, lectures, films, seminars, and other public pro-
grams.
Folger Shakespeare Library, Amherst College, 201 E. Capitol St., S.E., Washington, DC
20003. Phone: 202/544-4600. Hours: library—8:45–4:45 Mon.–Sat.; gallery—10–4
Mon.–Sat.; closed holidays. Admission: free.

## AUGUSTANA COLLEGE
### *Center for Western Studies*

(See Religious Museums section.)

## BAKER UNIVERSITY
### *William A. Quayle Bible Collection*

(See Religious Museums section.)

## BAYLOR UNIVERSITY
### *Armstrong Browning Library*

The world's largest collection of material relating to Robert Browning and
his poetry can be found at the Armstrong Browning Library at Baylor University
in Waco, Texas. It includes letters and manuscripts written by or to Browning,
all of the first and many of the successive editions of his poetry, secondary
works and materials, and his poetry set to music, portraits, and memorabilia.

Opened in 1951, the library also has become known as a nineteenth-century
research center. It includes major Elizabeth Barrett Browning, John Ruskin,
Charles Dickens, Matthew Arnold, and Ralph Waldo Emerson book and man-
uscript collections and significant cultural materials related to the Victorian age.

The library resulted from the efforts of Dr. A.J. Armstrong, chairman of the
English Department, who donated his personal Browning collection to the uni-
versity in 1918 and was instrumental in raising the funds and other materials
for the library building over the next 40 years. In addition to the Browning
collection, the building has the largest collection of secular stained glass win-
dows in the world.
Armstrong Browning Library, Baylor University, Eighth and Speight Sts., PO Box
97152, Waco, TX 76798-7152. Phone: 817/755-3566. Hours: 9–12 and 2–4 Mon.–Fri.;
9–12 Sat.; closed holidays. Admission: free.

## BETHEL COLLEGE
### *Mennonite Library and Archives*

The Mennonite Library and Archives, founded in 1938 at Bethel College in
North Newton, Kansas, contains Anabaptist and Mennonite manuscripts, prints,
paintings, lithographs, and archival materials.

Mennonite Library and Archives, Bethel College, 300 E. 27th St., North Newton, KS 67117. Phone: 316/283-2500. Hours: 10–12 and 1–5 Mon.–Fri.; closed holidays. Admission: free.

## BOWDOIN COLLEGE
### *Peary-Macmillan Arctic Museum Archives*

(See Archaeology, Anthropology, and Ethnology Museums section.)

## BRANDIES UNIVERSITY
### *American Jewish Historical Society Library and Archives*

(See Unaffiliated Museums section.)

## BROWN UNIVERSITY
### *Annmary Brown Memorial Library*

(See Historical Museums, Houses, and Sites section.)

## CARNEGIE MELLON UNIVERSITY
### *Hunt Institute for Botanical Documentation*

(See Botanical Gardens, Arboreta, and Herbaria section.)

## CASE WESTERN RESERVE UNIVERSITY
### *Dittick Museum of Medical History Library*

(See Medical, Dental, and Health Museums section.)

## CENTENARY COLLEGE OF LOUISIANA
### *Margale Library Gallery*

(See Art Galleries section.)

## CENTRAL METHODIST COLLEGE
### *Missouri United Methodist Archives*

(See Religious Museums section.)

## CENTRAL MISSOURI STATE UNIVERSITY
### *Central Missouri State University Archives/Museum*

(See General Museums section.)

# CITY UNIVERSITY OF NEW YORK, FIORELLO H. LaGUARDIA COMMUNITY COLLEGE
## LaGuardia and Wagner Archives Museum

Fiorello H. LaGuardia Community College, part of the City University of New York, has a museum as part of its LaGuardia and Wagner Archives in Long Island City. The archives were established in 1981, with the museum opening in 1993.

The museum features exhibits on the social and other historical aspects of twentieth-century New York City and the life and times of former mayors Fiorello H. LaGuardia and Robert F. Wagner—making use of documents, artifacts, photographs, films, and other materials from the archival collections.

LaGuardia and Wagner Archives Museum, Fiorello H. LaGuardia Community College of the City University of New York, 31-10 Thomson Ave., Long Island City, NY 11101. Phone: 718/482-5065. Hours: 10–4 Mon.–Fri.; closed holidays. Admission: free.

# CITY UNIVERSITY OF NEW YORK, QUEENS COLLEGE
## Queens College Art Center

(See Art Galleries section.)

# CLEMSON UNIVERSITY
## Strom Thurmond Institute

The Strom Thurmond Institute at Clemson University in Clemson, South Carolina, has an archive relating to the work and papers of the long-time senator from the state.

Strom Thurmond Institute, Clemson University, PO Box 34513, Clemson, SC 29634-5130. Phone: 803/665-4700. Hours: 8–4:30 Mon.–Fri.; closed major holidays and when university not in session. Admission: free.

# COLBY COLLEGE
## Colby College Museum of Art Archive of Maine Art

(See Art Museums section.)

# COLLEGE OF CHARLESTON
## Avery Research Center for African American History and Culture

(See Historical Museums, Houses, and Sites section.)

## DUKE UNIVERSITY
### History of Medicine Collections

(See Medical, Dental, and Health Museums section.)

## EASTERN COLLEGE
### Warner Memorial Library

The Warner Memorial Library at Eastern College in St. Davids, Pennsylvania, has a collection of prints, artifacts, and fine and rare books, which opened in 1980.

Warner Memorial Library, Eastern College, 10 Fairview Dr., St. Davids, PA 19087. Phone: 215/341-5857. Hours: by appointment only. Admission: free.

## ELMHURST COLLEGE
### Elmhurst College Library Collection

The Elmhurst College Library has managed and displayed the permanent art collection of the college in Elmhurst, Illinois, since 1971. The collection consists of over 100 pieces, including 25 works by Chicago imagist artists.

Elmhurst College Library Collection, 190 Prospect Rd., Elmhurst, IL 60126. Phone: 708/617-3553. Hours: 8 A.M.–10 P.M. Mon.–Thurs.; 8–5 Fri.; 10–5 Sat.; 1–5 Sun. Admission: free.

## FERRUM COLLEGE
### Blue Ridge Heritage Archive (Blue Ridge Institute Farm Museum and Galleries)

(See Agricultural Museums section.)

## FORT LEWIS COLLEGE
### Center of Southwest Studies Museum

(See Archaeology, Anthropology, and Ethnology Museums section.)

## GEORGIA COLLEGE
### Museum and Archives of Georgia Education

(See Historical Museums, Houses, and Sites section.)

## GRINNELL COLLEGE
### Print and Drawing Study Room

Grinnell College's Print and Drawing Study Room contains a teaching collection to encourage students and visitors to examine, study, and enjoy works

of art on paper. The gallery, created in 1982 as part of the Burling Library renovation in Grinnell, Iowa, displays works from the college's collection of more than 1,400 woodcuts, engravings, etchings, drypoints, lithographs, monotypes, photographs, watercolors, and drawings from sixteenth-century Europe to twentieth-century America.

Print and Drawing Study Room, Grinnell College, Sixth Ave. and High St., Grinnell, IA 50112-0811. Hours: 1–5 Mon.–Fri.; 1–5 Sun.; closed on holidays. Admission: free.

## HARTWICK COLLEGE
### Hartwick College Archives

The Hartwick College Archives in Oneonta, New York, contain over 200 years of records and memorabilia. The collection includes records of Hartwick Seminary and Academy and of Hartwick College and photographs from the Pine Lake campus, a former resort for vacationing New York City vaudeville stars. The archives are one of four facilities that constitute the Museums at Hartwick.

Hartwick College Archives, Oneonta, NY 13820. Phone: 607/431-4480. Hours: by appointment; closed holidays. Admission: free.

## HARVARD UNIVERSITY
### Dumbarton Oaks Research Library and Collection

The Dumbarton Oaks Research Library and Collection in Washington, D.C., came into being in 1940, when Robert Woods Bliss and his wife, Mildred, donated their Dumbarton Oaks mansion, gardens, and collections to Harvard University. Since then, it has become one of the world's leading centers of Byzantine, pre-Columbian, and landscape architecture study, as well as an architectural, botanical, and historical showcase.

Mr. Bliss, an alumnus of Harvard, was a retired Foreign Service officer and former ambassador to Argentina, while Mrs. Bliss was heiress to the Fletcher's Castoria fortune. Their Federal-style house was built for William Hammond Dorsey in 1800. Over the years, it underwent many changes. Nineteenth-century additions were replaced with new wings, and the interior was remodeled and enlarged to accommodate the library and collections.

Dumbarton Oaks now is primarily a residential research institute with an academic mission, although some parts are open to the public. Scholars from throughout the world come on fellowships to make use of the Byzantine, pre-Columbian, and landscape architecture resources in their studies. Each area has its own research library, containing over 100,000 volumes. The collections, which are largely on public display, include Byzantine and pre-Columbian art and rare books and prints relating to gardens. Visitors can also see sculpture, paintings, tapestries, and antique furniture in the various rooms, as well as acres of formal gardens.

The various collections basically were accumulated by Mr. and Mrs. Bliss.

The collection of Byzantine art consists chiefly of objects from the East Roman, or Byzantine, Empire, whose capital was Constantinople from 326 to 1453. The pre-Columbian collection covers the major cultures of Mexico and Central and South America from their origins to the time of the Spanish conquest in the first half of the sixteenth century. The program in the history of landscape architecture is concerned with the art and history of gardens through the ages.

The Dumbarton Oaks grounds now consist of 16 acres, including the formal gardens. Twenty-seven acres of the original estate were set aside by Mr. and Mrs. Bliss for public enjoyment and now form Dumbarton Oaks Park, which is under the care of the National Park Service. Among the principal garden attractions are magnolias, forsythias, cherries, herbaceous borders, and bulbs in the spring; roses, magnolias, and gardenias in the summer; and chrysanthemums in the autumn. There are 10 pools and 9 fountains on the grounds.

Dumbarton Oaks Research Library and Collection, Harvard University, 1703 32nd St., NW, Washington, DC 20007. Phone: 202/342-3200. Hours: galleries—2–5 Tues.–Sun.; gardens—2–6 daily Apr.–Oct.; 2–5 daily Nov.–Mar.; closed holidays. Admission: galleries—free; gardens—adults, $3; seniors and children, $2.

## Botanical Museum Archives and Library

(See Botanical Gardens, Arboreta, and Herbaria section.)

## HOWARD UNIVERSITY
### Howard University Museum/Moorland-Spingarn Research Center

(See Archaeology, Anthropology, and Ethnology Museums section.)

## INDIANA UNIVERSITY
### Lilly Library

The Lilly Library is a general research library in the arts, humanities, and sciences at Indiana University in Bloomington that mounts 3 to 4 major exhibitions and 15 to 20 minor shows each year. The library was founded in 1960 to house the university's collections of rare books and manuscripts following a major gift of such materials by J.K. Lilly, Jr., of the pharmaceutical family.

The library's collections include manuscripts of twentieth-century British and American authors, important rare books, historical children's literature, American history publications, and materials related to voyages, exploration, and the Spanish, Dutch, and Portuguese colonial empires.

Lilly Library, Indiana University, Bloomington, IN 47405. Phone: 812/855-2452. Hours: 9–5 Mon.–Fri.; 9–1 Sat.; closed holidays. Admission: free.

## INSTITUTE OF AMERICAN INDIAN ARTS
### Institute of American Indian Arts Museum

(See Art Museums section.)

## JOHNS HOPKINS UNIVERSITY
*Rare Book Library (Evergreen House)*

(See Historical Museums, Houses, and Sites section.)

## JOHNSON AND WALES UNIVERSITY
*Culinary Archives and Museum*

(See Other Types of Museums section.)

## KENNESAW STATE COLLEGE
*Sturgis Library Gallery*

(See Art Galleries section.)

## LUTHER COLLEGE
*Preus Library Fine Arts Collection*

The Preus Library at Luther College in Decorah, Iowa, has a Fine Arts Collection of approximately 1,000 works that include paintings by Norwegian-American artist Herbjørn Gausta; pottery by Margeurite Wildenhain; prints, drawings, and sculpture by German expressionist Gerhard Marcks; and pottery and drawings by ceramics artist Frans Wildenhain. The collection, which began at the turn of the century, is displayed in the library's gallery space and display cases.
Preus Library Fine Arts Collection, Luther College, 700 College Dr., Decorah, IA 52101. Phone: 319/387-1195. Hours: open all hours when college in session. Admission: free.

## MARY WASHINGTON COLLEGE
*James Monroe Museum and Memorial Library*

(See Historical Museums, Houses, and Sites section.)

## MASSACHUSETTS INSTITUTE OF TECHNOLOGY
*Hart Nautical Galleries Archives (MIT Museum)*

(See Science and Technology Museums and Centers section.)

## MEDICAL UNIVERSITY OF SOUTH CAROLINA
*Waring Historical Library*

(See Medical, Dental, and Health Museums section.)

## MIDDLE GEORGIA COLLEGE
### Roberts Memorial Library Museum Room

Middle Georgia College in Cochran has a Museum Room in the Roberts
Memorial Library. Opened in 1990, the room contains case exhibits of rare
books, Native American artifacts, college historical materials, and other such
items.
Roberts Memorial Library Museum Room, Middle Georgia College, 1100 Second St.
SE, Cochran, GA 31014. Phone: 912/934-3074. Hours: 8 A.M.–10 P.M. Mon.–Thurs.; 8–
5 Fri.; 6–10 Sun.; closed major holidays. Admission: free.

## MISSISSIPPI COLLEGE
### Mississippi Baptist Historical Commission Collection

(See Unaffiliated Museums section.)

## MISSISSIPPI UNIVERSITY FOR WOMEN
### Archives and Museum

The Mississippi University for Women's Archives and Museum in Columbus,
Mississippi, comprise a historical resource center housed in the 1885 Orr Build-
ing on the campus. Founded in 1978, it contains university documents and pho-
tographs, memorabilia from alumni, rare books, china, dolls, early science and
domestic implements, history of dance materials, and other artifacts and mate-
rials.
Archives and Museum, Mississippi University for Women, Box W 1603, Columbus, MS
39701. Phone: 601/329-7142. Hours: by appointment. Admission: free.

## MOTT COMMUNITY COLLEGE
### Labor Museum and Learning Center of Michigan Archives

(See Historical Museums, Houses, and Sites section.)

## NEBRASKA WESLEYAN UNIVERSITY
### Nebraska United Methodist Historical Center

(See Unaffiliated Museums section.)

## NEW MEXICO HIGHLANDS UNIVERSITY
### Arrott Art Gallery

Southwest Hispanic and Native American art exhibitions are featured at the
Arrott Art Gallery, founded in 1982 at New Mexico Highlands University in
Las Vegas. It is located on the second floor of Donnelly Library.

Arrott Art Gallery, New Mexico Highlands University, Donnelly Library, National Ave., Las Vegas, NM 87701. Hours: 8–12 and 1–5 Mon.–Fri.; closed holidays and Christmas recess. Admission: free.

## NORTHWESTERN STATE UNIVERSITY OF LOUISIANA
### Cammie G. Henry Research Center

The Cammie G. Henry Research Center, located in the Eugene P. Watson Memorial Library at Northwestern State University of Louisiana in Natchitoches, houses a rich treasure of historical materials, documenting one of the oldest outposts in the Louisiana Purchase. Colonial Natchitoches was unique in its diversity of cultures—Indian tribes, French and Spanish explorers, and a large number of persons of African descent—that influenced its settlement and development.

The center has 594 collections of historic documents, a Louisiana book collection with over 8,000 titles, and more than 13,000 regionally authored volumes on the literature, geography, anthropology, archaeology, and history of Louisiana, southern Arkansas, western Mississippi, and eastern Texas.

Cammie G. Henry Research Center, Northwestern State University of Louisiana, Eugene P. Watson Memorial Library, Natchitoches, LA 71497. Phone: 318/357-4585. Hours: 8–5 Mon.–Fri.; closed holidays and when university not in session. Admission: free.

## PENNSYLVANIA ACADEMY OF THE FINE ARTS
### Museum of American Art Library and Archives

(See Art Museums section.)

## PENNSYLVANIA STATE UNIVERSITY
### Penn State Room/University Archives

The Penn State Room/University Archives at Pennsylvania State University's Pattee Library in University Park contain a wide variety of materials about the history of the university and local area. Among the materials are copies of student publications, Board of Trustees' meeting minutes, Faculty Senate documents, papers of past university presidents and notable faculty, photographs, films produced by students, television programs, and videotapes of intercollegiate athletic events.

Penn State Room/University Archives, Pennsylvania State University, Pattee Library, University Park, PA 16802. Phone: 814/865-7931. Hours: 9:30–5 Mon.–Fri.; 9–1 Sat.; closed when university not in session. Admission: free.

### Pattee Library Galleries

A variety of art and library-related exhibitions is offered in the Pattee Library Galleries at Pennsylvania State University in University Park. The art exhibitions, which primarily feature local and regional artists, are displayed in the East

Corridor Gallery, Lending Services Gallery, and West Lobby Gallery. Pattee Library also has a Rare Books Room, which has exhibits based on its extensive collections of rare books, letters, and manuscripts of noted authors.

Pattee Library Galleries, Pennsylvania State University, University Park, PA 16802. Phone: 814/865-2112. Hours: varies with university calendar. Admission: free.

## PRINCETON UNIVERSITY
### *Milberg Gallery for the Graphic Arts*

The Milberg Gallery for the Graphic Arts at the Princeton University Library in Princeton, New Jersey, contains prints, drawings, illustrated books, and other aspects of the arts of the book. The Graphic Arts Collection is a division of the library's Rare Books and Special Collections.

The collection consists of over 10,000 finely printed and illustrated books and approximately 25,000 prints and drawings covering all phases of the history of book arts. The principal categories within the collection include calligraphy, papermaking, illustration, typography, and binding.

Milberg Gallery for the Graphic Arts, Princeton University Library, 1 Washington Rd., Princeton, NJ 08544-0298. Phone: 609/258-3197. Hours: 9–5 Mon.–Fri.; closed when university not in session. Admission: free.

## SAINT OLAF COLLEGE
### *Norwegian-American Historical Association Archives*

(See Unaffiliated Museums section.)

## STATE UNIVERSITY OF NEW YORK AT BUFFALO
### *Burchfield Penney Art Center Archives*

(See Art Museums section.)

## SUL ROSS STATE UNIVERSITY
### *Museum of the Big Bend Archives*

(See Historical Museums, Houses, and Sites section.)

## TEXAS A&M UNIVERSITY–KINGSVILLE
### *South Texas Archives (John E. Conner Museum)*

(See Natural History Museums and Centers section.)

## TULANE UNIVERSITY
### *Southeastern Architectural Archive*

The Southeastern Architectural Archive is one of the special collections of the Howard Tilton Library at Tulane University in New Orleans, Louisiana. It displays architectural models, drawings, and other materials from Louisiana and from the southeastern region of the nation in a 7,000-square-foot exhibition space on the lower level of the library. The archive became a separate division in 1980. It formerly was part of the Manuscripts Division.

Southeastern Architectural Archive, Tulane University, Howard Tilton Library, 7001 Freret St., New Orleans, LA 70118. Phone: 504/865-5699. Hours: 8:30–5 Mon.–Fri.; closed major holidays. Admission: free.

## TUSCULUM COLLEGE
### *President Andrew Johnson Museum and Library*

(See Historical Museums, Houses, and Sites section.)

## UNIVERSITY OF ARIZONA
### *Center for Creative Photography Archives*

(See Photography Museums section.)

## UNIVERSITY OF BALTIMORE
### *Steamship Historical Society of America Collection*

(See Other Types of Museums section.)

## UNIVERSITY OF CALIFORNIA, BERKELEY
### *University Art Museum and Pacific Film Archive*

(See Art Museums section.)

## UNIVERSITY OF CALIFORNIA, RIVERSIDE
### *California Museum of Photography Study Center Library*

(See Photography Museums section.)

## UNIVERSITY OF IOWA
### *Old Capitol Library*

(See Historical Museums, Houses, and Sites section.)

## UNIVERSITY OF KANSAS
### Clendening History of Medicine Library and Museum

(See Medical, Dental, and Health Museums section.)

## UNIVERSITY OF KENTUCKY
### Photographic Archives

(See Photography Museums section.)

## UNIVERSITY OF LOUISVILLE
### Photographic Archives

(See Photography Museums section.)

## UNIVERSITY OF MASSACHUSETTS, LOWELL
### Center for Lowell History

Archives and special collections related to the local area are part of the Center for Lowell History at the University of Massachusetts, Lowell, Library. Community-sponsored exhibitions are offered in connection with the program.
Center for Lowell History, University of Massachusetts, Lowell, Library, 40 French St., Lowell, MA 01852. Phone: 508/934-4998. Hours: 9–5 Mon.–Fri.; 10–3 Sat.–Sun.; closed holidays. Admission: free.

## UNIVERSITY OF NEW MEXICO
### Tamarind Institute Archive (University Art Museum)

(See Art Museums section.)

## UNIVERSITY OF MISSOURI–COLUMBIA
### State Historical Society of Missouri Library

(See Unaffiliated Museums section.)

## UNIVERSITY OF PENNSYLVANIA
### Institute of Contemporary Art Archives

(See Art Galleries section.)

## UNIVERSITY OF PITTSBURGH
### Stephen C. Foster Memorial Library

(See Historical Museums, Houses, and Sites section.)

## UNIVERSITY OF RICHMOND
### Virginia Baptist Historical Society Exhibit Area and Archives

(See Unaffiliated Museums section.)

## UNIVERSITY OF TENNESSEE AT MARTIN
### University Museum Archives

(See General Museums section.)

## UNIVERSITY OF TEXAS AT AUSTIN
### Sam Rayburn Library and Museum

The Sam Rayburn Library and Museum was established in Bonham, Texas, in 1957 by Congressman Samuel T. Rayburn, who served as Speaker of the United States House of Representatives longer than any other person. He dedicated it to the people of Fannin County, who elected him to Congress 24 times, beginning in 1912.

The library/museum became a unit of the University of Texas at Austin in 1991—when it was incorporated into the university's Center for American History. The east wing houses the library and main reading room. It contains Rayburn's personal library, books and papers related to his life and career, and gifts received by Rayburn, including a 2,500-year-old Grecian urn. The west wing has two exhibit galleries. One hall has items from Rayburn's childhood on the family farm to his days as one of the nation's most powerful political leaders, while the other hall features portraits of Rayburn, Lyndon B. Johnson, and eight presidents with whom Rayburn served during his 48 years in Congress. Sam Rayburn Library and Museum, University of Texas at Austin, 800 W. Sam Rayburn Dr., PO Box 309, Bonham, TX 75418. Phone: 903/583-2435. Hours: 10–5 Mon.–Fri.; 1–5 Sat.; 2–5 Sun.; closed holidays. Admission: free.

### Lyndon Baines Johnson Library and Museum
(See Unaffiliated Museums section.)

## UNIVERSITY OF TEXAS AT DALLAS
### History of Aviation Collection

The History of Aviation Collection at the Eugene McDermott Library at the University of Texas at Dallas is one of the major aeronautical research library collections. Formally dedicated in 1979 after more than a half century of collecting, it contains over 2.5 million items from more than 200 collections that cover virtually every facet of aviation.

The nucleus of the original collection was provided by George E. Haddaway,

founder of *Flight* magazine, who started an aviation library when he was a student at the University of Texas in 1926. The collection was first established at Austin in 1963 and then moved to the university campus in Richardson (a Dallas suburb) when it acquired the extensive lighter-than-air history collection of Admiral Charles E. Rosendahl.

Among the significant parts of the collection are the Erik Hildesheim Collection, consisting of early European lighter-than-air history dating from the 1700s and early heavier-than-air history; the newly acquired General James Doolittle Collection, containing his papers, files, and office furniture; the original published works of Sir George Cayley, considered the father of the modern airplane; first editions of books documenting the Montgolfier balloon flights in 1783 and Otto Lilienthal's glider flights; and the papers of such aviation notables as Octave Chanute, the Wright brothers, Admiral Richard Byrd, Charles Lindbergh, and Amelia Earhart.

The collection is divided into five components—the library, archive, Rosendahl Room, Business Aviation Historical Center, and display area. In addition to its many historical documents, books, and periodicals, the collection includes rare aviation artifacts, memorabilia, and models—many of which are on display.

History of Aviation Collection, University of Texas at Dallas, Eugene McDermott Library, 2601 N. Floyd Rd., Richardson, TX 75083-0643. Phone: 214/690-2570. Hours: 9–6 Mon.–Thurs.; 9–5 Fri.; closed holidays. Admission: free.

## UNIVERSITY OF WYOMING
### American Heritage Center

The American Heritage Center at the University of Wyoming in Laramie is primarily a research institution with extensive collections of western history and art. It was developed as an outgrowth of the university's libraries. The center is located in the new Centennial Complex, a striking conical facility for archives and museums that was dedicated in 1993. The structure also houses the university's art museum.

Only 6,000 of the center's 75,000 square feet are devoted to exhibits, which reflect its main areas of collecting—western history, conservation, water resources, contemporary history, transportation, geology, and mining.

American Heritage Center, University of Wyoming, Centennial Complex, PO Box 1924, Laramie, WY 82071-3924. Phone: 307/766-4114. Hours: 8–5 Mon.–Fri. (7:30–4:30 in summer); 11–5 Sat.; closed holidays. Admission: free.

## VIRGINIA MILITARY INSTITUTE
### George C. Marshall Foundation Museum Library and Archives

(See Unaffiliated Museums section.)

## WESTERN NEW MEXICO UNIVERSITY
### Western New Mexico University Museum Archives

(See Archaeology, Anthropology, and Ethnology Museums section.)

## WESTMINSTER COLLEGE
### Winston Churchill Memorial and Library in the United States

(See Historical Museums, Houses, and Sites section.)

## WEST TEXAS A&M UNIVERSITY
### Panhandle-Plains Historical Museum Archives

(See Historical Museums, Houses, and Sites section.)

## WILLIAMS COLLEGE
### Chapin Library of Rare Books

The Chapin Library of Rare Books at Williams College in Williamstown, Massachusetts, resulted from a 1915 proposal by Alfred C. Chapin, a lawyer and public official, to build a collection of original books and manuscripts that would document civilization. The board of trustees accepted the offer, and Chapin purchased 12,000 of the 45,000 volumes now in the library, which opened upon completion of the building in 1923.

The library's collections include 1750–1800 Americana; works by Walt Whitman, Samuel Butler, Joseph Conrad, E.A. Robinson, William Faulkner, and others; and materials on ornithology, smallpox, reform movements of the nineteenth century, and illustrated books of the period. Exhibits draw attention to the strengths of the collections.

Chapin Library of Rare Books, Williams College, Stetson Hall, Box 426, Williamstown, MA 01267. Phone: 413/597-2462. Hours: 10–12 and 1:30–4:30 Mon.–Fri.; closed holidays, except Fourth of July. Admission: free.

### Prendergast Archive and Study Center (Williams College Museum of Art)

(See Art Museums section.)

## WOFFORD COLLEGE
### Sandor Teszler Library Gallery

The Sandor Teszler Library Gallery at Wofford College in Spartanburg, South Carolina, features the Teszler Collection of Hungarian impressionist and post-

impressionist art, the Leonard Baskin Collection of prints and books, and fine press books. It was opened in 1969.

Sandor Teszler Library Gallery, Wofford College, 429 N. Church St., Spartanburg, SC 29303-3663. Phone: 803/597-4300. Hours: 8 A.M.–12 midnight, Mon.–Fri.; 10–5 Sat.; 1–12 midnight Sun.; closed holidays. Admission: free.

# YALE UNIVERSITY
## Harvey Cushing/John Hay Whitney Medical Library/ Historical Library

The Harvey Cushing/John Hay Whitney Medical Library at the Yale University School of Medicine in New Haven, Connecticut, has a Historical Library, which contains early medical volumes, graphics, paintings, and medical instruments and equipment.

The Yale medical library was founded in 1814. In 1941, the collections of three great bibliophiles—Drs. Harvey Cushing; John F. Fulton, a Yale physiologist; and Arnold C. Klebs of Switzerland—were brought together in a new Y-shaped library building that allowed readers equal access to historical works in the north arm and general collection material in the south wing. By 1970, the library was experiencing overcrowding. This led to a major expansion funded by Betsey Cushing Whitney and her family in 1985. The library now has over 360,000 volumes, including more than 2,500 current serial titles and an internationally recognized historical collection.

The Historical Library—which amounts to a library/museum within a library—has manuscript volumes from the twelfth through the sixteenth centuries, 317 incunabula, more than 2,000 images in the Clements C. Fry Print Collection, and broadly representative weights and measures of the Edward Streeter Collection.

Harvey Cushing/John Hay Whitney Medical Library/Historical Library, Yale University School of Medicine, 333 Cedar St., New Haven, CT 06510. Phone: 203/785-5354. Hours: 8 A.M.–12 midnight Mon.–Thurs.; 8 A.M.–10 P.M. Fri.; 10–7 Sat.; 11 A.M.–12 midnight Sun.; closed New Year's Day and Christmas. Admission: free.

# Marine Sciences Museums and Aquariums

*Also see Natural History Museums and Centers and Science and Technology Museums and Centers sections.*

## COLLEGE OF WILLIAM AND MARY
### *Virginia Institute of Marine Science Fish Collection*

The Virginia Institute of Marine Science, a branch of the College of William and Mary, has a Fish Collection open to qualified students and scientists at the Colonial Village archaeological site in Gloucester Point. The scientific ichthyology collection and a 29,000-volume library are part of the marine teaching and research facility.

The Fish Collection contains approximately 90,000 specimens of preserved fish, marine fish from the Chesapeake Bay and the mid-Atlantic, deep-sea fish and sharks, and Appalachian freshwater fish.

Virginia Institute of Marine Science Fish Collection, College of William and Mary, Gloucester Point, VA 23062. Phone: 804/642-7317. Hours: 8:30–4:30 Mon.–Fri. (open only to qualified students and scientists); closed when college not in session. Admission: free.

## OREGON STATE UNIVERSITY
### *Mark O. Hatfield Marine Science Center Aquarium*

Oregon State University's Mark O. Hatfield Marine Science Center Aquarium is part of a major ocean-related research and teaching facility on the Yaquina

Bay estuary in Newport. Between 250,000 and 450,000 visitors tour the aquarium and some of the hands-on laboratories each year.

The aquarium has approximately 20 exhibit tanks with about 1,300 specimens of 120 species of saltwater animals native to Oregon's shores, bays, and ocean floor. Exhibits also deal with marine and coastal environments, tidal forces, ocean circulation, movements of the earth's crust, and related subjects. Visitors can take a guided nature walk along the bay and participate in various other educational activities.

The marine science center was founded in 1965 with the cooperation of local, state, and federal agencies. In addition to the aquarium and a 25,000-volume marine library, the center has research facilities for investigations in marine fisheries, aquaculture, water quality, marine biology, botany, microbiology, zoology, and oceanography. The university's marine experiment station, sea grant, neurophysiology research, cooperative marine resources studies, and coastal productivity enhancement programs conduct research at the site, as do the National Oceanic and Atmospheric Administration, National Marine Fisheries Service, Environmental Protection Agency, U.S. Fish and Wildlife Service, and Oregon Department of Fish and Wildlife.

Mark O. Hatfield Marine Science Center Aquarium, Oregon State University, 2030 Marine Science Dr., Newport, OR 97365-5296. Phone: 503/867-0100. Hours: summer—10–6 daily; winter—10–4 daily; closed Christmas. Admission: free.

# UNIVERSITY OF CALIFORNIA, SAN DIEGO
## Stephen Birch Aquarium-Museum

The aquarium-museum idea at the Scripps Institution of Oceanography at the University of California, San Diego, goes back to 1903 when the institute was founded as the Marine Biological Association of San Diego. The charter called for ''a public aquarium and museum,'' as well as oceanographic research and related activities.

The first public display area was opened in 1905, consisting of a few shelves and a counter with containers of live specimens. When the institution's first permanent building was constructed in 1910, a small public aquarium and some museum space were included in the George H. Scripps Memorial Marine Biological Laboratory. In 1915, the first building devoted solely to an aquarium was erected next to the laboratory, while the museum was housed in a library-museum building. A three-story Scripps Aquarium-Museum building was completed in 1951, and it was replaced in 1992 by a 35,000-square-foot structure and renamed the Stephen Birch Aquarium-Museum (made possible largely by a $6 million grant from the Stephen and Mary Birch Foundation).

The marine institute became the Scripps Institution for Biological Research in 1912 when the association's assets were turned over to the University of California. In 1925, the name was changed to the Scripps Institution of Ocean-

ography to better reflect the scope of its operations. It later became a part of the University of California, San Diego.

The Stephen Birch Aquarium-Museum interprets ocean sciences and the Scripps Institution's research program. The aquarium has 33 tanks and over 3,000 species of fish from the cold waters of the Pacific Northwest to the tropical waters of Mexico and the Indo-Pacific. The largest tank is the 50,000-gallon La Jolla kelp bed tank. The four other major sections deal with the Northwest Coast, southern California, Mexico, and expeditions. A venomous lionfish, moray eels, a giant Pacific octopus, sharks, and many other species of marine life can be seen in the tanks. The aquarium also has a rocky tide pool with numerous local sea animals.

The museum portion has the largest oceanographic exhibit in the United States—called *Exploring the Blue Planet.* The displays—many of which are interactive—cover virtually all aspects of oceanography, including earthquakes, waves, weather patterns, and life in the deep ocean. The museum also has a gallery that features temporary exhibits in the marine sciences.

This aquarium-museum has one of the largest attendances among university and college museum facilities, totaling approximately 350,000 visitors annually. Stephen Birch Aquarium-Museum, Scripps Institution of Oceanography, University of California, San Diego, 2300 Expedition Way, La Jolla, CA 92093-0207. Phone: 619/ 534-4086. Hours: 9–5 daily; closed Thanksgiving and Christmas. Admission: adults, $6.50; senior citizens, $5.50; students, $4.50; children 4–12; $3.50; children under 4, free.

# UNIVERSITY OF HAWAII
## *Waikiki Aquarium*

Started in 1904 as a for-profit attraction operated by the Honolulu Rapid Transit Authority, Waikiki Aquarium became a part of the University of Hawaii in 1919. Today it is a major center of education and research in Hawaiian and Pacific Ocean tropical fauna and flora.

Through its exhibits, collections, and programs, the aquarium offers an interpretive study of the origins, ecology, and behavior of marine life in Hawaii and its relationship with the South Pacific. It was the first in the United States to display chambered nautiluses, cuttlefish, and black-tip reef sharks and has one of the world's largest collections of Hawaiian corals.

The exhibits include a wide range of fishes, giant clams, Hawaiian monk seals, green sea turtles, sharks, cnidarians, mollusks, crustaceans, echinoderms, and coastal plants. The research focuses on husbandry, primarily the cultivation of corals and the propagation of marine animals, such as mahimahi, nautiluses, and reef fishes. Other studies involve the physiology of sharks and monk seals.

The aquarium, located on the oceanfront in Waikiki about four miles from the main university campus, is housed in a building with four galleries, a theater,

and an alcove for viewing sharks and has additional exhibits outdoors. The annual attendance is approximately 320,000.

Waikiki Aquarium, University of Hawaii, 2777 Kalakaua Ave., Honolulu, HI 96815. Phone: 808/923-9741. Hours: 9–5 daily; closed Thanksgiving and Christmas. Admission: adults, $6; seniors, $4; juniors (13–17), $2.50; students and children 12 and under, free.

## UNIVERSITY OF PUERTO RICO
### Marine Sciences Museum

The Department of Marine Sciences at the University of Puerto Rico in Mayaguez has a museum with collections of invertebrates, fish, shells, copepoda, and tropical algae. Founded in 1954, the department and museum have a field research station and offer expeditions to such neighboring islands such as Mona, Santo Domingo, St. Croix, and St. Thomas.

Marine Sciences Museum, University of Puerto Rico, Dept. of Marine Sciences, PO Box 5000, Mayaguez, PR 00681-5000. Phone: 809/834-4040. Hours: by appointment. Admission: free.

## UNIVERSITY OF SOUTHERN MISSISSIPPI
### J.L. Scott Marine Education Center and Aquarium

The J.L. Scott Marine Education Center and Aquarium in Biloxi is part of the Gulf Coast Research Laboratory, a state facility administered by the University of Southern Mississippi. The education center/aquarium, founded in 1972 and relocated to expanded facilities in 1984, devotes 20,000 square feet to public education programming and aquarium exhibits.

The aquarium contains 41 tanks featuring native fish and other creatures from open ocean environments to coastal streams. The centerpiece is a 42,000-gallon Gulf of Mexico tank, which is home to sharks, sea turtles, eels, and some of the aquarium's largest specimens. The aquarium also has turtles and alligators in a vivarium, nonpoisonous native snakes in a lobby display, a 23-foot central aquarium and 13 smaller tanks, a touch tank, a collection of over 900 seashells from around the world, and other exhibits and programs.

J.L. Scott Marine Education Center and Aquarium, Gulf Coast Research Laboratory, University of Southern Mississippi, 115 Beach Blvd., Biloxi, MS 39530. Phone: 601/374-5550. Hours: 9–4 Mon.–Sat.; closed major holidays. Admission: adults, $3; seniors, $2; children, $1.50.

# Medical, Dental, and Health Museums

*Also see Historical Museums, Houses, and Sites and Science and
Technology Museums and Centers sections.*

## CASE WESTERN RESERVE UNIVERSITY
### Dittrick Museum of Medical History

The Dittrick Museum of Medical History in Cleveland is operated through
the Cleveland Health Sciences Library, a partnership of the Cleveland Medical
Library Association and Case Western Reserve University. Founded in 1926,
the museum was an outgrowth of the historical interests of the medical library
association, established in 1894.

More than 50,000 historical objects related to the practice of medicine, den-
tistry, pharmacy, and nursing can be found at the museum, which originally was
designed only for use by the medical profession and historians. It was opened
to the public in 1936 and became affiliated with Case Western Reserve Uni-
versity in 1967.

The museum's core collection came from Dr. Dudley Peter Allen, who gave
his medical instruments, papers, and other mementos of early Western Reserve
Territory physicians to the medical library association in 1899. The museum is
named for Dr. Howard Dittrick, who served as director from its establishment
in 1926 until his death in 1954.

The collections and exhibits have a regional focus and emphasize medicine
in the nineteenth and twentieth centuries. It has the nation's largest collection
of surgical instruments, ca. 1850–1930, and one of the major microscope col-

lections. The exhibits include a five-section display with the theme *Medicine in the Western Reserve Since 1800,* several re-created doctor's offices, and a nine-teenth-century pharmacy. There is also a 10,000-volume library of medical history and manuscript and instrument collections.

Dittrick Museum of Medical History, 11000 Euclid Ave., Cleveland, OH 44106. Phone: 216/368-6391. Hours: 10–5 Mon.–Fri.; 12–5 Sat.; closed holidays. Admission: free.

## DUKE UNIVERSITY
### History of Medicine Collections

The History of Medicine Collections at the Duke University Medical Center Library in Durham, North Carolina, contain medical instruments and artifacts, as well as books, journals, manuscripts, prints, and photographs relating to the history of medicine.

History of Medicine Collections, Duke University Medical Center Library, Durham, NC 27710. Phone: 919/684-3325. Hours: 8–8 Mon.–Fri.; closed major holidays. Admission: free.

## KIRKSVILLE COLLEGE OF OSTEOPATHIC MEDICINE
### Still National Osteopathic Museum

The Still National Osteopathic Museum has three facilities on the campus of Kirksville College of Osteopathic Medicine in Kirksville, Missouri. They include the museum with artifacts, memorabilia, and materials illustrative of the development of the osteopathic field; the log cabin birthplace of A.T. Still, founder of osteopathy; and the college's first classroom building, built in 1892. The museum was founded in 1978.

Still National Osteopathic Museum, Kirksville College of Osteopathic Medicine, 311 S. Fourth St., Kirksville, MO 63501. Phone: 816/626-2359. Hours: 10–2 Mon.–Fri.; other times by appointment. Admission: free.

## MEDICAL UNIVERSITY OF SOUTH CAROLINA
### Waring Historical Library

The Waring Historical Library at the Medical University of South Carolina in Charleston is a combination medical library and museum located in an 1894 octagonal building with a fortress appearance, which originally was built as a library for a military preparatory school. It now houses largely rare books and historical objects.

The library, which began in 1966 and now has about 7,000 books, got started when Dr. Joseph I. Waring, the first director, obtained the holdings of the Medical Society of South Carolina Library. Founded in 1791, the medical society's library consisted largely of books dating from the eighteenth and nineteenth

centuries; early journals of the period from England, France, and the United States; and some publications from the sixteenth century.

The library also has a South Carolina collection, including books written by and about South Carolinians, files of biographical and general material bearing on the history of medicine in the state, and a collection of valuable papers and documents relating to South Carolina.

The library's collections include approximately 500 museum objects, such as old instruments, medicine chests, and saddle bags, as well as prescription and day books, handwritten theses of students from 1825 to 1860, early graduation diplomas, and lecture notes.

Waring Historical Library, Medical University of South Carolina, 171 Ashley Ave., Charleston, SC 29425. Phone: 803/792-2289. Hours: 8:30–5 Mon.–Fri.; closed holidays. Admission: free.

### Macaulay Museum of Dental History

The Macaulay Museum of Dental History at the Medical University of South Carolina in Charleston has some 6,000 dental artifacts and books largely donated by Dr. Neill W. Macaulay, a long-time Columbia dentist, dental association official, and member of the university's Board of Trustees.

Included in the collection are antique dental chairs, foot-powered drills, wooden dental cabinets, a dental lathe, old dental X-ray units, medicine cases of itinerant dentists, cases of crown molds, and books and manuscripts related to dentistry and medicine. Among the earliest instruments in the collection is one designed by Paul Revere, Revolutionary War patriot and craftsman, for Dr. Josiah Flagg, the first native-born American to make dentistry his life's work. The museum also has a dental office from the late nineteenth century with an 1860 dental chair.

Macaulay Museum of Dental History, Medical University of South Carolina, 171 Ashley Ave., Charleston, SC 29425. Phone: 803/792-2289. Hours: 8:30–5 Mon.–Fri.; closed holidays. Admission: free.

## SCHOLL COLLEGE OF PODIATRIC MEDICINE
### Feet First Exhibit

The Scholl College of Podiatric Medicine in Chicago has a permanent ground-floor exhibit—titled *Feet First: The Scholl Story*—which opened in 1993. It consists primarily of attributes relating to the anatomy, function, and care of feet; historical treatment and educational training in the foot-care field; and the life and contributions of Dr. William M. School, founder of the foot-care company.

Feet First Exhibit, Scholl College of Podiatric Medicine, 1001 N. Dearborn St., Chicago, IL 60610-2856. Phone: 312/280-2487. Hours: 9–4 Mon.–Fri.; closed holidays. Admission: free.

## SIOUX VALLEY HOSPITAL SCHOOL OF NURSING
### Sioux Empire Medical Museum

The Sioux Empire Medical Museum at the Sioux Valley Hospital School of Nursing in Sioux Falls, South Dakota, tells the historical story of health care in the area. Founded by the alumni association in 1975, the museum has a patient's room that depicts hospital life in the early 1930s; a replica of an early operating room with a 1912 operating table, showing a doctor and a scrub nurse preparing to perform surgery; an iron lung used in polio treatments in the 1940s; a large collection of health care uniforms from 1910 to the present; and various other medical equipment.

Sioux Empire Medical Museum, Sioux Valley Hospital School of Nursing, 1100 S. Euclid Ave., Sioux Falls, SD 57105-5039. Hours: 1–4 Mon.–Fri.; closed holidays. Admission: free.

## SOUTHERN ILLINOIS UNIVERSITY
### Pearson Museum

Medical, dental, and pharmaceutical artifacts and exhibits are displayed at the Pearson Museum, a medical science museum at the Southern Illinois University School of Medicine in Springfield. The collections pertain to the practice of medicine, dentistry, and pharmacy in the nineteenth and early twentieth centuries in the upper Mississippi River basin area. The museum was founded in 1974.

Pearson Museum, Southern Illinois University School of Medicine, 801 N. Rutledge, Springfield, IL 62702. Phone: 217/785-2128. Hours: 9–3 Tues.; other times by appointment. Admission: free.

## TEMPLE UNIVERSITY
### Historical Dental Museum

The Historical Dental Museum at Temple University's School of Dentistry in Philadelphia, Pennsylvania, was founded in 1938 by Dr. Harold L. Faggart, the school historian. Started in the basement of the old Administration Building, it now is located off the lobby of the school. The museum features an extensive collection of dental artifacts and oddities.

Among the museum's collections and exhibits are the nation's oldest surviving dentist chair (ca. 1790); foot-powered dental drills; ivory-handled eighteenth-century "extraction keys"; early X-ray machines, Civil War–era dental kits, and "scarificators" used in bleeding patients; skulls, jawbones, and facial models with removable teeth used to train student dentists; eighteenth- and nineteenth-century newspaper ads of dentists; and materials related to America's most flamboyant dentist, Edgar "Painless" Parker.

Historical Dental Museum, Temple University, School of Dentistry, 3223 N. Broad St., Philadelphia, PA 19140. Phone: 215/707-2816. Hours: 8:30–4:30 Mon.–Fri. (by appointment only); closed holidays. Admission: free.

## TRANSYLVANIA UNIVERSITY
### Museum of Early Philosophical Apparatus

(See Science and Technology Museums and Centers section.)

## UNIVERSITY OF CONNECTICUT HEALTH CENTER
### Friends Museum of the University of Connecticut Health Center

The Friends Museum of the University of Connecticut Health Center, School of Medicine, in New Britain is a dental health museum with a collection of dental antiques and memorabilia. It was founded in 1979.

Friends Museum of the University of Connecticut Health Center, School of Medicine, 45 Park Pl., New Britain, CT 06052. Phone: 203/225-3307. Hours: 9–4 Mon.–Tues. and Thurs.–Fri.; closed holidays. Admission: free.

## UNIVERSITY OF IOWA
### University of Iowa Hospitals and Clinics Medical Museum

The donation of a case of old surgical instruments was the stimulus for establishing the University of Iowa Hospitals and Clinics Medical Museum in Iowa City in 1989. The gift came from Phoebe Wilcox of Newton in 1982. The instruments belonged to her grandfather, Dr. Vinton S. Wilcox, who was a member of the university's fourth medical graduating class in 1874 and who became a general practitioner in Iowa.

The museum serves as an educational resource for patients, visitors, the hospital community, and the general public, focusing on the progress of medicine and patient care, with the emphasis on the role of the University Hospitals and Clinics in these advances. Major revolutions in medicine—from antibiotics to robotics—and rapidly changing notions of health and health care are covered in the exhibits. Other exhibits examine the structure and functions of the human body, explain some of the common diseases and injuries, and show the university's role in meeting medical challenges. The museum is located in the Patient and Visitor Activities Center, which also includes a library, lounge area, and meeting and conference space.

University of Iowa Hospitals and Clinics Medical Museum, 200 Hawkins Dr., Iowa City, IA 52242-1616. Phone: 319/356-7106. Hours: 8–5 Mon.–Fri.; 1–4 Sat.–Sun. and holidays; closed New Year's Day and Christmas. Admission: free.

## UNIVERSITY OF KANSAS
### Clendening History of Medicine Library and Museum

Over 30,000 printed volumes and thousands of medical instruments and pieces of medical equipment can be found at the Clendening History of Medicine Library and Museum at the University of Kansas Medical Center in Kansas City, Kansas.

The library/museum, which has exhibits of early surgical instruments, microscopes, X-ray tubes, and other medical artifacts, was opened in 1945, following gifts from the estate of Dr. Logan Clendening, a longtime faculty member, book collector, and founder of the medical center's history of medicine program.

Clendening History of Medicine Library and Museum, University of Kansas Medical Center, 3901 Rainbow Blvd., Kansas City, KS 66160-7311. Phone: 913/588-7040. Hours: 8–4:30 Mon.–Fri.; closed holidays. Admission: free.

## UNIVERSITY OF MARYLAND AT BALTIMORE
### Dr. Samuel D. Harris National Museum of Dentistry

The Dr. Samuel D. Harris National Museum of Dentistry at the University of Maryland Dental School in Baltimore is a continuation of the original Baltimore College of Dental Surgery Museum, founded in 1840. In 1988, the museum's collections were placed on permanent loan with the National Museum of Dentistry, a nonprofit organization on the campus. The Baltimore College of Dental Surgery was the world's first dental college.

Now located in the 1970 Dental School Building, the museum will be relocated to the university's 1904 Dental Department Building, which is being renovated. The museum's collections consist of approximately 20,000 dental objects, including dental instruments, equipment, furniture, materials, and historic artifacts, such as George Washington's dentures.

Dr. Samuel D. Harris National Museum of Dentistry, University of Maryland at Baltimore, 666 W. Baltimore St., Room 5A28, Baltimore, MD 21201-1586. Phone: 410/706-8314. Hours: 9–5 Mon.–Fri.; closed holidays and when university not in session. Admission: free.

## UNIVERSITY OF SOUTH ALABAMA–SPRINGHILL
### Eichold-Heustis Medical Museum of the South

(See Unaffiliated Museums section.)

## UNIVERSITY OF VIRGINIA
### University of Virginia Health Sciences Center Children's Museum

The University of Virginia Health Sciences Center in Charlottesville has a Children's Museum off the main lobby of its Primary Care Center. The museum,

which opened in 1980 in collaboration with the Junior League, is a hands-on health education center where three- to six-year-old children can learn about themselves.

Exhibits measure children's hands, feet, height, weight, coordination, and ability to match colors and shapes and to recognize words. Other units include a three-foot-high functioning torso model that shows the interrelation of body systems, a mouth and tongue slide that increases a child's imagination, and distorted mirrors that show children to be tall and skinny or short and fat.

Children's Museum, University of Virginia Health Sciences Center, Primary Care Center, Lee St. and Park Pl., Hospital Box 231, Charlottesville, VA 22908. Phone: 804/924-1593. Hours: 9–4 Mon.–Fri.; closed holidays. Admission: free.

## YALE UNIVERSITY
### *Harvey Cushing/John Hay Whitney Medical Library/ Historical Library*

(See Library and Archival Collections and Galleries section.)

# Musical Instruments Museums

## INDIANA UNIVERSITY
### Ethnomusicology Collection (William Hammond Mathers Museum)

(See Archaeology, Anthropology, and Ethnology Museums section.)

## UNIVERSITY OF MICHIGAN
### Stearns Collection of Musical Instruments

The Stearns Collection of Musical Instruments at the University of Michigan in Ann Arbor is a museum of antique and modern Western and non-Western musical instruments. The museum, which opened in 1912, began with a gift of musical instruments from Frederick Stearns in 1899. It consists of three galleries and hall exhibits in the School of Music Building. Electronic music and European traditional instruments are among its most popular attractions.

Stearns Collection of Musical Instruments, University of Michigan, School of Music, Ann Arbor, MI 48109-2085. Phone: 313/763-4389. Hours: 10–5 Wed.–Sat.; closed when university not in session. Admission: free.

## UNIVERSITY OF PITTSBURGH
### Stephen C. Foster Memorial

(See Historical Museums, Houses, and Sites section.)

## UNIVERSITY OF SOUTH CAROLINA AT SPARTANBURG
### George E. Case Collection of Antique Keyboards

The George E. Case Collection of Antique Keyboards from the eighteenth and nineteenth centuries can be seen at the library at the University of South Carolina at Spartanburg. The collection shows the evolution of keyboard instruments from early types through variations that led to the development of the modern piano.

The collection—consisting largely of antique keyboards acquired and restored by George E. Case, Jr., and the family that established the Case Brothers Piano Company—consists of square, upright, and grand pianos; a foot-pumped reed organ; a massive Euphonicon with a cast-iron lyre; and an Italian harpsichord from approximately 1700. The collection was opened at the university in 1990. George E. Case Collection of Antique Keyboards, University of South Carolina at Spartanburg, Library, 800 University Way, Spartanburg, SC 29303. Phone: 803/599-2620. Hours: academic year—7:30–11 A.M. Mon.–Thurs.; 7:30–5 Fri.; 1–5 Sat.; 2–11 P.M. Sun.; call for summer hours. Admission: free.

## UNIVERSITY OF SOUTH DAKOTA
### Shrine to Music Museum

The Shrine to Music Museum on the University of South Dakota campus in Vermillion has one of the world's most comprehensive collections of musical instruments. The collection consists of over 6,000 musical instruments, as well as sheet music, recordings, tools, books, periodicals, photographs, and related musical memorabilia.

The museum began in 1973 with the donation of the Arne B. Larson Collection of Musical Instruments and Library, which is the nucleus of the holdings. The Wayne Sorensen Collection of fine nineteenth-century woodwind instruments was acquired in 1982–1983, followed by the purchase of early Italian stringed instruments in 1984. The museum also has the Higbee-Abbott-Zylstra Collection of early flutes and recorders.

The museum has seven galleries and a concert hall, where concerts are presented in which music is played on original instruments of various historical periods.
Shrine to Music Museum, University of South Dakota, 414 E. Clark St., Vermillion, SD 57069-2390. Phone: 605/677-5306. Hours: 9–4:30 Mon.–Fri.; 10–4:30 Sat.; 2–4:30 Sun.; closed New Year's Day, Thanksgiving, and Christmas. Admission: free.

## YALE UNIVERSITY
### Yale University Collection of Musical Instruments

The Yale University Collection of Musical Instruments in New Haven, Connecticut, is devoted to the documentation and exhibition of the history of music

through historical instrumentation. It was founded in 1900 when Morris Steinert gave Yale his collection consisting primarily of keyboard instruments.

The collection has grown over the years to more than 800 instruments, with particular strength in European music from 1550 to 1850. Among the additions have been the Belle Skinner Collection, Emil Herrmann Collection, and Robyna Neilson Ketchum Collection of bells.

Two permanent exhibits and changing special exhibits are presented at the museum. The permanent exhibits include keyboard instruments of 1550–1850 and European and American stringed and wind instruments ranging from 1550 to 1736. Representative examples of the various instruments have been restored and are played in performances and demonstrations.

Yale University Collection of Musical Instruments, 15 Hillhouse Ave., PO Box 2117, New Haven, CT 06520. Phone: 203/432-0822. Hours: 1–4 Tues.–Thurs.; closed July–Aug., Thanksgiving, Christmas, and when university not in session. Admission: suggested donation—adults and children, $1; Yale students, free.

# Natural History Museums and Centers

*Also see Archaeology, Anthropology, and Ethnology Museums; Botanical Gardens, Arboreta, and Herbaria; Entomology Museums; Geology, Mineralogy, and Paleontology Museums; Planetaria and Observatories; Science and Technology Museums and Centers; and Zoology Museums sections.*

## ALBION COLLEGE
### Whitehouse Nature Center

Albion College operates the Whitehouse Nature Center in Albion, Michigan. Established in 1972, the facility has nature trails and an interpretive center with exhibits on typical southern Michigan habitats and natural history specimens. Whitehouse Nature Center, Albion College, Albion, MI 49224. Phone: 517/629-2030. Hours: 9–4:30 Mon.–Fri.; 10–4:30 Sat.–Sun.; closed holidays. Admission: free.

## AMHERST COLLEGE
### Pratt Museum of Natural History

Collections and exhibits of vertebrate and invertebrate paleontology, minerals, and crystals can be seen at the Pratt Museum of Natural History at Amherst College in Amherst, Massachusetts. The current museum, which opened in 1947, had its origins in a small museum-like collection in natural history in 1838. The original facility reflected the collecting interests (mainly in ichnology) of Edward Hitchcock, a professor and the third president of the college.

The Pratt Museum's present collections come from local areas and around the world. Exhibits illustrate the evolution and ecology of major groups of animals and the geological processes that have formed the earth and local structures. A world-famous dinosaur track collection from the sedimentary rocks of the Connecticut Valley is particularly noteworthy. The 17,500-square-foot museum is located in an 1883 renovated gymnasium, which was converted for the museum in the 1940s.

Pratt Museum of Natural History, Amherst College, Amherst, MA 01002. Phone: 413/542-2165. Hours: academic year—9–3:30 Mon.–Fri.; 10–4 Sat.; 12–5 Sun.; summer—closed weekdays; 10–4 Sat.; 12–5 Sun.; closed New Year's Day, Thanksgiving, and Christmas. Admission: free.

## ANTIOCH COLLEGE
### Trailside Museum

Antioch College's Trailside Museum is located in the Glen Haven Nature Preserve north of the campus in Yellow Springs, Ohio. Opened in 1952, it serves as a nature/information center for the college's preserve and features educational exhibits with live animals (from 6 to 10 at a time) and a nature library.

Trailside Museum, Glen Haven Nature Preserve, Antioch College, 405 Corry St., Yellow Springs, OH 45387. Phone: 513/767-7798. Hours: 9:30–4:30 Tues.–Sat.; 1–4:30 Sun.; closed New Year's Day and Christmas. Admission: free.

## ARIZONA STATE UNIVERSITY
### Southwest Center for Education and the Natural Environment

The Southwest Center for Education and the Natural Environment opened in 1993 at Arizona State University in Tempe. Its exhibits emphasize environmental education, with materials on zoology, meteorites, and archaeology.

Southwest Center for Education and the Natural Environment, Arizona State University, Tempe, AZ 85287. Phone: 602/965-4179. Hours: 8:30–5 Mon.–Fri.; closed weekends and holidays. Admission: free.

### Museum of Geology
### Center for Meteorite Studies
(See Geology, Mineralogy, and Paleontology Museums section.)

## AUGUSTANA COLLEGE
### Fryxell Geology Museum

(See Geology, Mineralogy, and Paleontology Museums section.)

## BALL STATE UNIVERSITY
### *Biology Teaching Museum and Nature Center*

(See Botanical Gardens, Arboreta, and Herbaria section.)

## BAYLOR UNIVERSITY
### *Strecker Museum*

Natural history collections and exhibits from central Texas are featured at the Strecker Museum at Baylor University in Waco, Texas. The museum also has two branch facilities—the Governor Bill and Vara Daniel Historic Village on a 13-acre site on the north side of the campus and the Youth Cultural Center, a hands-on learning center in downtown Waco.

The museum began in 1856 as a collection of geological specimens. It now has collections and exhibits in both natural and cultural history. Among its holdings are a wide range of items from central Texas, an extensive herpetological collection, one of the largest prehistoric sea turtles on exhibit, and a late-nineteenth-century east Texas farming community. The museum's principal exhibit galleries and offices are in the Sid Richardson Science Building.

Strecker Museum, Baylor University, S. Fourth St., PO Box 97154, Waco, TX 76798-7154. Phone: 817/755-1110. Hours: 10–4 Tues.–Sat.; 1–4 Sun.; closed holidays. Admission: main museum and cultural center—free; historic village—adults, $3; seniors, $2, non-Baylor students, $1; Baylor students, free.

## BENEDICTINE COLLEGE
### *Benedictine College Museum*

The Benedictine College Museum in Atchison, Kansas, traces its beginnings to a cabinet of natural history in 1878. It became a comprehensive natural history museum in the 1920s, but it is in danger of fading away today because of lack of adequate funds and staff. A number of its collections have been auctioned off or placed on long-term loan, and the museum can be seen only by appointment at its Westerman Hall basement location.

The museum still has collections of Southwest Indian art, pottery, basketry, and blankets; minerals; plant and vertebrate animal fossils; mounted mammals and birds; and other specimens and artifacts. The Department of Biology's collections of herbarium plants, insects, mammal and bird skins, and mounted birds and mammals are in the process of being consolidated with the museum's collections to strengthen the museum and teaching offerings.

Benedictine College Museum, Dept. of Biology, 1020 N. Second St., Atchison, KS 66002. Phone: 913/367-5340. Hours: by appointment only. Admission: free.

## BEREA COLLEGE
### *Wilbur Greeley Burroughs Geologic Museum*

(See Geology, Mineralogy, and Paleontology Museums section.)

## BETHEL COLLEGE
### Kauffman Museum

(See Archaeology, Anthropology, and Ethnology Museums section.)

## BRIGHAM YOUNG UNIVERSITY
### Monte L. Bean Life Science Museum

The Monte L. Bean Life Science Museum at Brigham Young University in Provo, Utah, was founded in 1978 following a major gift of natural history specimens by a businessman. Its collections and exhibits have been expanded over the years and now cover the fields of entomology, herpetology, ichthyology, ornithology, and mammalogy and include a collection of shells and an herbarium.

Monte L. Bean Life Science Museum, Brigham Young University, Monte L. Bean Museum Bldg., Provo, UT 84602. Phone: 801/378-5052. Hours: 10–9 Mon.–Fri.; 10–5 Sat.; closed major holidays. Admission: free.

### Earth Science Museum

(See Geology, Mineralogy, and Paleontology Museums section.)

## CENTRAL METHODIST COLLEGE
### Stephens Museum of Natural History

The Stephens Museum of Natural History at Central Methodist College in Fayette, Missouri, traces its beginning to 1879. Located in the 1896 T. Berry Smith Hall, it has collections and exhibits of birds, skins, eggs, shells, mammals, minerals, and the history of and art of the Boonslick region.

Stephens Museum of Natural History, Central Methodist College, T. Berry Smith Hall, Fayette, MO 65248. Phone: 816/248-3391. Hours: 1–5 Tues. and Thurs.; closed holidays and when college not in session. Admission: free.

## CENTRAL MICHIGAN UNIVERSITY
### Center for Cultural and Natural History

(See General Museums section.)

## CHADRON STATE COLLEGE
### CSC Earth Science Museum

(See Geology, Mineralogy, and Paleontology Museums section.)

## COLLEGE OF THE ATLANTIC
### *Natural History Museum*

Dioramas, skeletons, models, and hands-on exhibits relating to animals and plants of Mount Desert Island and the region are on display at the College of the Atlantic's Natural History Museum in Bar Harbor, Maine. More than 50 regional animals are depicted in the exhibits, most of which are student generated. The museum is located on the first floor of a renovated 1895 historic house. Natural History Museum, College of the Atlantic, 105 Eden St., Bar Harbor, ME 04609-1105. Phone: 207/288-5015. Hours: academic year—10–4 Mon.–Fri.; 10–4 Sat.–Sun. in Sept.–Oct.; summer—9–5 daily; closed holidays. Admission: adults, $2.50; seniors and teen-age students, $1.50; children 3–12, $1; children under 3 and the college's students, free.

## COLORADO SCHOOL OF MINES
### *Geology Museum*

(See Geology, Mineralogy, and Paleontology Museums section.)

## DIABLO VALLEY COLLEGE
### *Diablo Valley College Museum*

The Diablo Valley College Museum in Pleasant Hill, California, is a natural history museum founded in 1960. It has anthropology, zoology, mineralogy, and scientific instruments collections. The college has a separate planetarium and a botanical garden. Diablo Valley College Museum, Golf Club Rd., Pleasant Hill, CA 94523. Phone: 510/685-1230. Hours: 9–4 Mon.–Fri.; closed summer and holidays. Admission: free.

## EARLHAM COLLEGE
### *Joseph Moore Museum of Natural History*

The Joseph Moore Museum of Natural History at Earlham College in Richmond, Indiana, started with the early collections of President Joseph Moore in the mid-nineteenth century. The museum opened in 1905 and now has collections and exhibits of vertebrate and invertebrate fossils, bird and mammal skins, dried and liquid-preserved insects, live and preserved reptiles, and Native American artifacts. It also has the 30-seat Ralph Teetor Planetarium. The museum building, constructed in 1954, is attached to the Science Complex. Joseph Moore Museum of Natural History, Earlham College, National Rd., W., Richmond, IN 47374-4095. Phone: 317/983-1405. Hours: 1–4 Mon., Wed., and Fri.; 1–5 Sun.; closed summer and holidays. Admission: free.

## EASTERN MENNONITE COLLEGE AND SEMINARY
### D. Ralph Hostetter Museum of Natural History

The D. Ralph Hostetter Museum of Natural History is a one-room museum with adjoining hallway exhibits and a planetarium in the D.B. Suter Science Center at Eastern Mennonite College and Seminary in Harrisonburg, Virginia. The museum, founded in 1968 by Dr. Hostetter, professor of biology and geology, has mineral, rock, fossil, bird, and small mammal collections and exhibits. D. Ralph Hostetter Museum of Natural History, Eastern Mennonite College and Seminary, Harrisonburg, VA 22801-2462. Phone: 703/432-4409. Hours: Oct.–Mar.—2–3:30 first and third Sun.; Sept.–Apr.—7 P.M.–8 P.M. Thurs.; other times by appointment. Admission: museum—free; planetarium—$1.50.

## EASTERN NEW MEXICO UNIVERSITY
### Natural History Museum

Native wildlife and related exhibits from the southern High Plains region are shown at the Eastern New Mexico University Natural History Museum in Portales. The museum, which opened in 1968 and is located in a renovated dormitory, has approximately 10,000 specimens of fish, 9,000 specimens of mammals, 5,000 specimens of reptiles and amphibians, and 600 specimens of birds in its collections. Natural History Museum, Eastern New Mexico University, Station 33, Portales, NM 88130. Phone: 505/562-2174. Hours: 8–5 Mon.–Fri.; also open first and third Sun.; closed holidays and when university not in session. Admission: free.

### Miles Mineral Museum

(See Geology, Mineralogy, and Paleontology Museums section.)

## ELLSWORTH COLLEGE
### Ellsworth College Museum

The Ellsworth College Museum is a natural history museum that serves as the interpretive center for Hardin County's Calkins Nature Area in Iowa Falls, Iowa. The museum, which was started in 1890, moved to the nature center in 1995 after its old building on the campus was demolished. It has collections and exhibits of mounted bird and mammal specimens, Native American artifacts, eggs from 197 species of birds, fossils and minerals, shells, insects, and other invertebrates. Ellsworth College Museum, Calkins Nature Area, Rural Rte. 1, Box 109A, Iowa Falls, IA 50126. Phone: 515/648-9878. Hours: 8–4 Mon.–Sat.; 12–4 Sun. Admission: free.

## EMPORIA STATE UNIVERSITY
### Richard H. Schmidt Museum of Natural History

The Richard H. Schmidt Museum of Natural History was founded in 1959 at Emporia State University in Emporia, Kansas. Emphasizing ornithology, mammalogy, ichthyology, and herpetology, it has skins and mounted specimens of birds, fishes, reptiles, and mammals. The museum, which is part of the Division of Biological Sciences, also operates a nature center and a field research station. Richard H. Schmidt Museum of Natural History, Emporia State University, 1200 Commercial St., Emporia, KS 66801. Phone: 316/341-5611. Hours: 8–5 Mon.–Fri.; 8–12 Sat.; closed holidays and breaks. Admission: free.

## FORT HAYS STATE UNIVERSITY
### Sternberg Museum of Natural History

Fort Hays State University in Hays, Kansas, combined two natural history museums—the Sternberg Memorial Museum and the Museum of the High Plains—in 1994. They were separate and in different locations, but shared a common director. Then the museums moved into a larger, renovated building with 80,000 square feet of space, including nearly 30,000 square feet devoted to exhibits, as the Sternberg Museum of Natural History.

The Sternberg Memorial Museum began as a collection of taxidermy mounts in 1902. In 1926, paleontological collector George Sternberg was hired to develop and expand the collections as an organized museum. It became known for its collections of Cretaceous and late Tertiary fossils.

The Museum of the High Plains started as an herbarium in 1929. The other collections of plant fossils, arthropods, fish, amphibians, reptiles, birds, and mammals were added in the 1960s. The museum developed comprehensive collections of plants and animals from the Great Plains and representative specimens from other areas of North America.
Sternberg Memorial Museum of Natural History, Fort Hays State University, Hays, KS 67601-4099. Phone: 913/628-5664. Hours: academic year—9–5 Tues.–Fri.; 1–5 Sun.–Mon.; summer—9–9 Tues.–Sat.; 1–9 Sun.–Mon. Admission: adults, $4; seniors, children in school groups, and children 7 and under, $2.

## FRANKLIN AND MARSHALL COLLEGE
### North Museum of Natural History and Science

The North Museum of Natural History and Science at Franklin and Marshall College in Lancaster, Pennsylvania, has approximately 150,000 specimens and artifacts in its collections. They cover such diverse fields as ornithology, entomology, botany, geology, mineralogy, paleontology, zoology, conchology, anthropology, archaeology, ethnology, reptiles and amphibians, and Native

American artifacts. The collection began in 1901, and the present museum opened in 1943.

The museum's principal exhibit halls are the Geology Hall, Zoology Hall, and Native Culture Hall. The museum also has an herbarium and a 100-seat planetarium. The 30,000-square-foot facility is operated under a five-year contract with a local nonprofit educational organization.

North Museum of Natural History and Science, Franklin and Marshall College, College and Buchanan Aves., PO Box 3003, Lancaster, PA 17403-3003. Phone: 717/291-3943. House: 9–5 Tues.–Sat.; 1:30–5 Sun.; closed New Year's Day and Christmas. Admission: free.

## FRIENDS UNIVERSITY
### Fellow-Reeve Museum of History and Science

(See Historical Museums, Houses, and Sites section.)

## GEORGIA SOUTHERN UNIVERSITY
### Georgia Southern Museum

The natural and cultural history of Georgia's coastal plain is the focus of the Georgia Southern Museum at Georgia Southern University in Statesboro. Opened in 1982, the museum occupies a 7,500-square-foot Georgian Colonial building on the campus.

The museum is best known for its 27-foot mosasaur lizard fossil skeleton. Among its other holdings are fossils of a 20-foot Middle Eocene archaeocete whale, oysters, and vertebrates of the region; skeletons of a dolphin and Bryde's whale; specimens of fish, butterflies and moths, invertebrates, and bees; artifacts of southeastern Indians; and a Wiss cutlery, scissors, and shears collection.

Georgia Southern Museum, Georgia Southern University, 8061 Rosenwald Bldg., Statesboro, GA 30480-8061. Phone: 912/681-5444. Hours: academic year—9–5 Mon.–Fri.; 2–5 Sun.; summer—10–5 Mon.–Fri.; closed major holidays and Christmas week. Admission: free.

## HARVARD UNIVERSITY
### Harvard University Museums of Natural History

Four science-oriented museums—all located in the same building—comprise the Harvard University Museums of Natural History in Cambridge, Massachusetts. They are the Botanical Museum, Mineralogical and Geological Museum, Museum of Comparative Zoology, and Peabody Museum of Archaeology and Ethnology. See the separate section listings for complete descriptions: the Botanical Museum in the Botanical Gardens, Arboreta, and Herbaria section; Mineralogical and Geological Museum in the Geology, Mineralogy, and Paleontology Museums section; Comparative Zoology Museum in the Zoology

Museums section; and Peabody Museum of Archaeology and Ethnology in the Archaeology, Anthropology, and Ethnology Museums section.)

## IDAHO STATE UNIVERSITY
### Idaho Museum of Natural History

The Idaho Museum of Natural History at Idaho State University in Pocatello has just completed the renovation of its 20,000-square-foot building, which originally was the university library. The museum, founded in 1934 and opened in its present location in 1956, has extensive collections in paleontology, anthropology, and ethnology.

Among its holdings are collections in Great Basin archaeology, ethnology, and linguistics; Amazon Basin ethnology; vertebrate fossils from Idaho and the area; modern osteol and vertebrate specimens; flintworking; western rocks and minerals; herbarium specimens; and manuscripts and photographs of the north Rocky Mountain region.

Idaho Museum of Natural History, Idaho State University, Campus Box 8096, Pocatello, ID 83209-8096. Phone: 208/236-3168. Hours: 9–5 Mon.–Sat.; closed holidays. Admission: free.

## ILLINOIS BENEDICTINE COLLEGE
### Jurica Nature Museum

The Jurica Nature Museum at the Illinois Benedictine College in Lisle is named for two remarkable brothers, the Reverends Hilary S. and Edmund Jurica, who assembled the thousands of specimens in the collections and exhibits over a half century. They were Benedictine monks who wanted their students to get firsthand knowledge of what they were studying.

The 3,800-square-foot museum, founded in 1970 and housed in the science building, contains approximately 10,000 specimens of birds, mammals, reptiles, fish, insects, plants, corals, sponges, crustaceans, minerals, and Native American artifacts. It has a 38-foot skeleton of a Rorqual whale; a pair of passenger pigeons and a Carolina parakeet, now extinct, mounted grizzly bears, Rocky Mountain goats, bighorn sheep, American bison, and an orangutan; and two new dioramas—one of the African savanna (with a giraffe, cape buffalo, Burchells zebra, baboon, bushbuck, and other savanna antelopes) and the other on northern Illinois (with three displays—woodland, prairie, and wetland—featuring animals native to those areas).

The Jurica brothers pioneered the audiovisual method of teaching science, with charts, slides, models, and motion pictures. Their Jurica Biology Flip Charts for high school and college use have been translated into 13 languages and are still being used today.

Jurica Nature Museum, Illinois Benedictine College, 5700 College Rd., Lisle, IL 60532-0900. Phone: 708/960-1500. Hours: 2–5 Mon.–Fri.; 2–4 Sun.; closed holidays and when college not in session. Admission: free.

## INDIANA UNIVERSITY
### Hilltop Garden and Nature Center

(See Botanical Gardens, Arboreta, and Herbaria section.)

## KALAMAZOO VALLEY COMMUNITY COLLEGE
### Kalamazoo Public Museum

(See Historical Museums, Houses, and Sites section.)

## LA SIERRA UNIVERSITY
### World Museum of Natural History

The World Museum of Natural History at La Sierra University in Riverside, California, was founded in 1968 after collections of taxidermy were donated to the university. It now contains mounted specimens of reptiles, birds, and mammals; minerals, especially spheres and petrified wood; an arboretum; and artifacts of Native Americans in southern California. The museum occupies a wing of a general classroom building.

World Museum of Natural History, La Sierra University, 4700 Pierce St., Riverside, CA 92515-8247. Phone: 909/785-2209. Hours: 2–5 Sat.; other times by appointment. Admission: free.

## LIBERTY UNIVERSITY
### Museum of Earth and Life History

The Museum of Earth and Life History at Liberty University in Lynchburg, Virginia, was founded as a natural history and geology museum in 1985. It has a 3,000-square-foot exhibit space that features fossils and minerals.

Museum of Earth and Life History, Liberty University, Box 20000, Lynchburg, VA 24506. Phone: 804/582-2537. Hours: academic year—8–5 Mon.–Fri.; closed major holidays. Admission: free.

## LOUISIANA STATE UNIVERSITY
### Museum of Natural Science

Louisiana State University's Museum of Natural Science in Baton Rouge began in 1936 when its founder and longtime director, George H. Lowery, Jr., assembled a few old study specimens of birds in a classroom in Audubon Hall. In 1950, the museum moved to its present more-spacious location in Foster Hall to accommodate its growing collections and expanding exhibit offerings. Today it has one of the most comprehensive natural history collections, exhibitions, and public programs in the region.

For nearly a half century, museum personnel have been penetrating the unexplored regions of the world. The special area of interest has been the neotropics—the tropical forests, plains, mountains, and deserts of Central and South America. The museum's bird collection for the New World tropics now is regarded as the most valuable of its type.

The museum's research collections, which now exceed 2 million specimens, include approximately 240,000 fish, 158,000 birds, 56,000 reptiles and amphibians, 36,000 mammals, and 39,000 genetic resources (frozen tissues). When the LSU Geoscience Museum was closed in 1992, the Museum of Natural Science added a geoscience division with its associated research collections (including vertebrate paleontology, 4,000; invertebrate paleontology, 258,000; microfossils, 18,000; and ethnology-archaeology, 1,250,000).

The public exhibits fall into three basic categories—six large habitat groups showing specific places with their characteristic plants and animals, special identification panels displaying many of the vertebrates found in Louisiana, and biological exhibits explaining basic principles of biology in three-dimensional displays.

Museum of Natural Science, Louisiana State University, 119 Foster Hall, Baton Rouge, LA 70803-1216. Phone: 504/388-2855. Hours: 8–4 Mon.–Fri.; 9:30–1 Sat.; closed major holidays. Admission: free.

## LOUISIANA TECH UNIVERSITY
### Louisiana Tech Museum

(See Archaeology, Anthropology, and Ethnology Museums section.)

## MARSHALL UNIVERSITY
### Geology Museum

(See Geology, Mineralogy, and Paleontology Museums section.)

## McPHERSON COLLEGE
### McPherson Museum

(See General Museums section.)

## MICHIGAN STATE UNIVERSITY
### Michigan State University Museum

The Michigan State University Museum in East Lansing is a natural and cultural history museum that traces its founding to 1857. Located in a three-story, 36,000-square-foot building in the center of the campus, the museum has collections and exhibits of mammals, birds, reptiles and amphibians, fossils,

skeletons, and archaeological, ethnographic, historic, cultural, and agricultural artifacts. It attracts approximately 400,000 visitors each year.

Among the highlights are complete skeletons of *Allosaurus* and *Stegosaurus* dinosaurs and a six-ton African elephant; the skull of a *Tyrannosaurus rex;* a femur from a *Brontosaurus;* and some of the largest collections in a number of fields—including mammals; fish, amphibian, and reptile skeletons; Great Lakes archaeological materials; and agricultural artifacts.

The extensive collections include approximately 34,000 specimens of mammals; 8,000 bird specimens; 13,000 herpetological specimens; 4,000 vertebrate fossil specimens; 4,000 fish, amphibian, and reptile skeletons; 400 mounted animals; 1 million archaeological items; 25,000 ethnographic artifacts; 63,000 historical and cultural artifacts; and 2,000 quilts and 5,000 files on Michigan quilts and quilters.

The first floor contains exhibits on Michigan's history, featuring a 1774 trader's cabin, an 1880s farm scene, and a turn-of-the-century general store; vertebrate animals from the state; and folkways. Second-floor exhibits include dinosaur and elephant skeletons; North American forest, grassland, tropic, and tundra dioramas; the traditions and skills of the weaver, silversmith, cobbler, and other early artisans; and special exhibitions. On the ground floor, the exhibits are concerned with life from early marine organisms through the evolution of mammals, prehistoric fossils, artifacts from cultures around the world, and the history and culture of Great Lakes Indians.

Michigan State University Museum, West Circle Dr., East Lansing, MI 48824-1045. Phone: 517/355-2370. Hours: 9–5 Mon.–Wed. and Fri.; 9–9 Thurs.; 1–5 Sat.–Sun.; closed major holidays. Admission: free.

## *W.K. Kellogg Biological Station*

The W.K. Kellogg Biological Station, a branch of the School of Agriculture and Natural Resources at Michigan State University, consists of four parts largely donated by W. K. Kellogg, founder of the Kellogg cereal company. They include the biological station itself with Kellogg's 1910–1924 manor house and grounds in Hickory Corners, a bird sanctuary, an experimental forest, and a dairy farm. All are open to the public without charge except the bird sanctuary, which serves as the visitor information center for the various facilities.

The 300-acre W. K. Kellogg Bird Sanctuary in Augusta is the world's largest inland sanctuary operated by a university. It is a restored natural habitat that was opened in 1927 on what formerly was abused cropland. It has a small museum, trails, a 40-acre lake, and avian, mammal, fish, reptile, and botanical study collections. The habitat is home to native waterfowl and birds of prey.

The W.K. Kellogg Experimental Forest, also in Augusta, is a 600-acre forest with a 2.5-mile driving loop and hundreds of trails. It opened in 1930. The Kellogg Farm Dairy Center is a 1,100-acre dairy operation in Hickory Corners that was purchased by the university and opened in 1985. It features a visitor center, milking observation room, and self-guided tours.

W. K. Kellogg Biological Station, Michigan State University, 3700 E. Gull Lake Dr., Hickory Corners, MI 49060. Phone: 616/671-5117. Hours: 8–sunset daily. Admission: free. W. K. Kellogg Bird Sanctuary, Michigan State University, 12865 East C Ave., Augusta, MI 49012. Phone: 616/671-2510. Hours: Nov.–Apr.—9–5 daily; May–Sept. 30—9–dusk daily. Admission: adults, $2; seniors, $1.50; children 4–12, 50¢; children 3 and under, free. W. K. Kellogg Experimental Forest, Michigan State University, 42nd St., Augusta, MI 49012. Phone: 616/731-4597. Hours: 8–sunset daily; closed New Year's Day, Easter, Thanksgiving, and Christmas. Admission: free. Kellogg Farm Dairy Center, Michigan State University, 10461 N. 40th St., Hickory Corners, MI 49060. Phone: 616/671-2507. Hours: 8–sunset daily. Admission: free.

## MICHIGAN TECHNOLOGICAL UNIVERSITY
### A. E. Seaman Mineral Museum

(See Geology, Mineralogy, and Paleontology Museums section.)

## MISSISSIPPI STATE UNIVERSITY
### Dunn-Seiler Museum

(See Geology, Mineralogy, and Paleontology Museums section.)

## MONTANA COLLEGE OF MINERAL SCIENCE AND TECHNOLOGY
### Mineral Museum

(See Geology, Mineralogy, and Paleontology Museums section.)

## MONTANA STATE UNIVERSITY
### Museum of the Rockies

The Museum of the Rockies at Montana State University in Bozeman is a regional museum dedicated to the interpretation of the physical and cultural heritage of the northern Rocky Mountains region. Weaving a thread of historical continuity through its offerings, the museum features the geology, paleontology, archaeology, and ethnology of the region.

The museum started as the McGill Museum in three quonset huts in 1957, moved to a dairy barn in 1959, received its new name and settled in a new 32,000-square-foot building in 1972, and opened a $9.5 million, 60,000-square-foot addition in 1989 (the university's centennial year).

In addition to expanding its facilities, collections, research exhibits, and programs over the years, the museum has added an art gallery, discovery room, planetarium, nature area, and photo archives. The history of the region is revealed in the fossilized remains of dinosaurs and Ice Age mammoths, the art

and artifacts of the Plains Indians, and the traces left behind by early explorers and settlers.

Visitors are greeted at the entrance by an animated model of a 23-foot-high, plant-eating *Triceratops* dinosaur. Among the other exhibits are a dinosaur hall, featuring two life-sized *Maiasaura* sculptures, three *Pteranodon* flying reptiles, a duck-billed *Edmontausaurus,* and nests of fossilized dinosaur eggs; a Native American exhibit that tells the story of the Plains Indians through the things they designed and used; an exhibit on the history of Montana; a gallery containing western and Native American artwork (including the works of Olaf Seltzer, Edgar Paxson, R.E. DeCamp, William Standing, and Charles Russell); and a discovery room with exhibits about art, history, and science.

The museum also has a gallery for changing exhibitions, a 3-D slide show on Montana and the northern Rocky Mountains in a 220-seat auditorium, and star shows in the 100-seat Ruth and Vernon Taylor Planetarium, which features a Digistar computer graphics projection system and has laser/light shows. The museum's annual attendance is nearly 150,000.

Museum of the Rockies, Montana State University, 600 W. Kagy Blvd., Bozeman, MT 59717-0272. Phone: 406/994-2682. Hours: museum—academic year—9–5 Mon.–Sat.; 12:30–5 Sun.; summer—9–9 daily; planetarium—1 and 3 Sun.–Fri. (also 7 and 8 Fri.); 10, 11, 1, 2, 3, 4, 7, and 8 Sat.; closed New Year's Day, Thanksgiving, and Christmas. Admission: museum—adults, $5; children 13–18, $3; children 5–12, $2; children under 5, free; planetarium—$2.50; laser/light show—$4.

## MONTANA STATE UNIVERSITY–NORTHERN
### Hagener Science Center

Natural history exhibits are scattered throughout the Hagener Science Center at Montana State University–Northern in Havre. The exhibits are developed by the Department of Science-Mathematics.

Hagener Science Center, Montana State University–Northern, Dept. of Science-Mathematics, Havre, MT 59501. Phone: 406/265-3757. Hours: 8–5 Mon.–Fri.; closed holidays. Admission: free.

## NORTHERN OKLAHOMA COLLEGE
### A.D. Buck Museum of Natural History and Science

The A.D. Buck Museum of Natural History and Science at Northern Oklahoma College in Tonkawa contains natural history specimens and historic artifacts from pioneer days.

A.D. Buck Museum of Natural History and Science, Northern Oklahoma College, 1220 E. Grand, PO Box 310, Tonkawa, OK 74653. Phone: 405/628-6200. Hours: by appointment only. Admission: free.

## NORTHWESTERN OKLAHOMA STATE UNIVERSITY
### Stevens-Carter Natural History Museum

The Stevens-Carter Natural History Museum at Northwestern Oklahoma State University in Alva was started in 1902, but was only recently renamed for Drs. G. W. Stevens and T.C. Carter, who gathered and developed most of the early collections. Located in the renovated library in Jesse Dunn Hall, the museum's most prized specimens and exhibits are the mounted bird collection and the Pleistocene bone collection.

Stevens-Carter Natural History Museum, Northwestern Oklahoma State University, Jesse Dunn Hall, U.S. Hwy. 64, Alva, OK 73717. Phone: 405/327-1700. Hours: by appointment. Admission: free.

## OHIO STATE UNIVERSITY
### Orton Geological Museum

(See Geology, Mineralogy, and Paleontology Museums section.)

## OKLAHOMA STATE UNIVERSITY
### Oklahoma State University Museum of Natural and Cultural History

Collections and exhibits on the conservation of natural resources and international cultures are featured at the Oklahoma State University Museum of Natural and Cultural History in Stillwater. The diverse holdings include mounted ungulate heads, gems and minerals, Oriental robes, Ethiopian artifacts and mounted birds, folk art wood carvings, Southeast Asian weaponry, western and Maori art, and materials confiscated at customs. The museum opened in 1966.

Oklahoma State University Museum of Natural and Cultural History, 103 U.S. Dept. of Agriculture Bldg., Stillwater, OK 74078. Phone: 405/744-6531. Hours: 8–5 Mon.–Fri.; closed holidays. Admission: free.

## OREGON STATE UNIVERSITY
### Horner Museum

(See General Museums section.)

## PENNSYLVANIA STATE UNIVERSITY
### Shaver's Creek Environmental Center

Pennsylvania State University operates Shaver's Creek Environmental Center in the Stone Valley Recreation Area in the university's experimental forest at Petersburg, 12 miles south of the campus in University Park. Founded in 1976,

the environmental facility features a Nature Center with natural and cultural history exhibits and live animals and a Raptor Center containing injured hawks, owls, and eagles. The recreational area also has camping facilities, hiking and cross-country skiing trails, and herb, bee, butterfly, and hummingbird gardens. Shaver's Creek Environmental Center, Pennsylvania State University, Stone Valley Recreation Area, Petersburg, PA 16669. Phone: 814/863-2000. Hours: 10–5 daily; closed Christmas recess. Admission: $2.50 per person over 4.

### Earth and Mineral Sciences Museum and Gallery
(See Geology, Mineralogy, and Paleontology Museums section.)

### Frost Entomological Museum
(See Entomology Museums section.)

## PITTSBURG STATE UNIVERSITY
### Pittsburg State University Natural History Museum

Founded in 1903, the Pittsburg State University Natural History Museum in Pittsburg, Kansas, has collections and exhibits of mammals, birds, insects, and other specimens. It also has a planetarium and study specimens of skin and skulls.
Pittsburg State University Natural History Museum, Dept. of Biology, Pittsburg, KS 66762. Phone: 316/231-7000. Hours: 8–5 Mon.–Fri.; closed holidays. Admission: free.

## PRINCETON UNIVERSITY
### Princeton University Museum of Natural History

The Princeton University Museum of Natural History in Princeton, New Jersey, began as a teaching collection in 1805 and moved into its present building in 1910. It now has excellent ornithology, osteology, and Northwest Indian anthropology collections, as well as collections in invertebrate paleontology, geology and mineralogy, archaeology, and ethnology.

The museum's exhibits deal primarily with the geology of New Jersey, dinosaurs, birds, and bone specimens. The museum probably is best known for its Princeton dinosaur, an *Allosaurus,* a large bipedal carnivorous dinosaur.
Princeton University Museum of Natural History, Guyot Hall, Princeton, NJ 08544-1003. Phone: 609/258-3832. Hours: 8–5 Mon.–Fri.; 9–5 Sat.–Sun.; sometimes closed on holidays. Admission: free.

## SAN DIEGO STATE UNIVERSITY
### E.C. Allison Research Center

(See Geology, Mineralogy, and Paleontology Museums section.)

## SOUTH DAKOTA SCHOOL OF MINES AND TECHNOLOGY
### Museum of Geology

(See Geology, Mineralogy, and Paleontology Museums section.)

## SOUTHERN ILLINOIS UNIVERSITY AT CARBONDALE
### University Museum

(See General Museums section.)

## SOUTHERN OREGON STATE COLLEGE
### Museum of Vertebrate Natural History

The Department of Biology's Museum of Vertebrate Natural History at Southern Oregon State College in Ashland has a collection of vertebrate specimens that include bird and mammal skins, reptiles, amphibians, and fish. The museum was founded in 1969.

Museum of Vertebrate Natural History, Southern Oregon State College, Dept. of Biology, 1250 Siskiyou Blvd., Ashland, OR 97520. Phone: 503/552-6415. Hours: by appointment only. Admission: free.

## SOUTHWEST STATE UNIVERSITY
### Museum of Natural History

The animals and flora of southwest Minnesota are featured at the Museum of Natural History at Southwest State University in Marshall, Minnesota. Founded in 1972, the museum also has a planetarium and a nature/conservation center.

Natural History Museum, Southwest State University, 1501 State St., Marshall, MN 56258. Phone: 507/537-6178. Hours: 8–4:30 Mon.–Fri.; closed Easter, Thanksgiving, and Christmas. Admission: free.

## STATE UNIVERSITY OF NEW YORK AT STONY BROOK
### Museum of Long Island Natural Sciences

The Museum of Long Island Natural Sciences, founded in 1973, is located in the Earth and Space Sciences Building at the State University of New York at Stony Brook. The museum has a collection of modern and fossil marine invertebrates, especially mollusks; insects, their host plants, and other natural history specimens from Long Island; and minerals and fossils. It also has an herbarium.

Museum of Long Island Natural Sciences, State University of New York at Stony Brook, Earth and Space Sciences Bldg., Stony Brook, NY 11794. Phone: 516/632-8230. Hours: 9–5 Mon.–Fri.; closed holidays. Admission: free.

## STATE UNIVERSITY OF NEW YORK COLLEGE AT CORTLAND
### Bowers Science Museum

The Bowers Science Museum at the State University of New York College at Cortland is a natural history museum with a planetarium used primarily for instructional purposes. Founded in 1964, it is located in Bowers Hall. The collections and exhibits cover such areas as anatomy, biology, ecology, ethnology, geology, and physics and include specimens of plants, birds, mammals, fish, fossils, mollusks, and gems.

Bowers Science Museum, State University of New York College at Cortland, Bowers Hall, Cortland, NY 13045. Phone: 607/753-2715. Hours: academic year—7 A.M.–10 P.M. Mon.–Fri.; vacation periods—8–5 Mon.–Fri.; closed holidays. Admission: free.

## STETSON UNIVERSITY
### Gillespie Museum of Minerals

(See Geology, Mineralogy, and Paleontology Museums section.)

## TEXAS A&M UNIVERSITY–KINGSVILLE
### John E. Conner Museum

The John E. Conner Museum at Texas A&M University–Kingsville is a regional natural history and history museum founded in 1925 when the university opened as a state teachers college. People inundated the Department of History with family treasures and Texana archival materials and urged the establishment of a museum.

Among the museum's collections today are mounted game animals, pre-Columbian pottery, textiles, farm and ranch tools, knives and guns, and butterflies from around the world. Its major exhibits concern the natural history of the Tamaulipan Biotic Province; dioramas show regional biotas and prehistoric periods. The museum also has a touch-and-feel area for children, changing exhibitions, and a South Texas Archives Division.

John E. Conner Museum, Texas A&M University–Kingsville, 821 W. Santa Gertrudis, PO Box 2172, Kingsville, TX 78363. Phone: 512/595-2819. Hours: 9–5 Tues.–Sat.; closed holidays. Admission: free.

## TEXAS LUTHERAN COLLEGE
### A.M. and Alma Fiedler Memorial Museum

(See Geology, Mineralogy, and Paleontology Museums section.)

## TEXAS TECH UNIVERSITY
### Museum of Texas Tech University

(See General Museums section.)

## UNIVERSITY OF ALABAMA
### Alabama Museum of Natural History

The Alabama Museum of Natural History at the University of Alabama consists of two divisions—the Smith Hall Natural History Museum on the Tuscaloosa campus and the Moundville Archaeological Park in nearby Moundville. The campus museum, opened in 1909, is located in the building named for Dr. Eugene Allen Smith, who collected many of the early specimens and started the museum during his 54-year tenure. Moundville Archaeological Park, completed in 1939 by Civilian Conservation Corps workers, is a National Historic Landmark.

The Alabama Museum of Natural History holds approximately 12,000 items in 37 separate collections. The initial collections began in 1831, but most did not survive the burning of the campus during the Civil War in 1865.

Smith Hall is best known for its extensive mineral and rock collection. It has fossils from the Ice, Coal, and Dinosaur ages. Historical materials include early Alabama stoneware, tools, insulators, weapons, and many items from industries depending on natural resources. The photography collection, dating from the nineteenth century, contains almost 24,000 photographs, negatives, glass plates, and lantern slides. Field notes of the Geological Survey of Georgia also date back to the last century. The Great Hall Gallery features geological exhibits.

The 317-acre Moundville Archaeological Park museum has collections and exhibits of Native American artifacts that illustrate the history and lifeways of early Indians. The park has 20 prehistoric Indian ceremonial mounds and a reconstructed ceremonial temple atop the tallest mound. One of the most prized artifacts is the Rattlesnake Disc, a stone palette believed to have been used by Mississippian elite to advertise their claim to supernatural power and divinity.
Alabama Museum of Natural History/Smith Hall Natural History Museum, University of Alabama, Smith Hall, Box 870340, Tuscaloosa, AL 35487-0340. Phone: 205/348-7550. Hours: 8–4:30 Mon.–Fri.; closed holidays. Admission: free. Alabama Museum of Natural History/Moundville Archaeological Park, University of Alabama, PO Box 66, Moundville, AL 35474. Phone: 205/371-2572. Hours: park—8–8 daily; museum—9–5 daily. Admission: adults, $4; students, $2.

## UNIVERSITY OF ALASKA FAIRBANKS
### University of Alaska Museum

The University of Alaska Museum at Fairbanks describes itself as a combination natural history and art museum, but most of its collections and exhibits

are in natural history. The museum was founded in 1929 after archaeologist/paleontologist Otto Geist acquired the initial specimens and artifacts.

The museum has collections in such areas as aquatics, archaeology, birds, botany, earth sciences, ethnology, mammals, and fine arts. It also has an herbarium. The museum is best known for its gold display, mummified 38,000-year-old bison, and Eskimo archaeology.

The museum shows the five ecological regions of Alaska in its exhibits, integrating live art with ethnographic, archaeological, geological, and biological materials to tell the story. Changing exhibitions, usually related to Alaska, are presented in a temporary gallery.

University of Alaska Museum, University of Alaska Fairbanks, 907 Yukon Dr., Fairbanks, AK 99775-1200. Phone: 907/474-7505. Hours: May and Sept.—9–5 daily; June–Aug.—9–7 daily; Oct.–Apr.—12–5 daily; closed New Year's Day, Thanksgiving, and Christmas. Admission: adults, $4; seniors, $3, students, free.

## UNIVERSITY OF ARIZONA
### University of Arizona Mineral Museum

(See Geology, Mineralogy, and Paleontology Museums section.)

## UNIVERSITY OF ARKANSAS
### University Museum

(See General Museums section.)

## UNIVERSITY OF CALIFORNIA, BERKELEY
### University of California Museums of Natural History

The University of California, Berkeley, has four museums concerned with natural history and sciences—the Phoebe A. Hearst Museum of Anthropology (formerly the Robert H. Lowie Museum of Anthropology), Essig Museum of Entomology, Museum of Paleontology, and Museum of Vertebrate Zoology. All four museums are described in other sections—the Phoebe A. Hearst Museum in the Archaeology, Anthropology, and Ethnology Museums section; Essig Museum of Entomology in the Entomology Museums section; Museum of Paleontology in the Geology, Mineralogy, and Paleontology Museums section; and Museum of Vertebrate Zoology in the Zoology Museums section.

In addition, the university has four related facilities—the University Herbarium, Jepson Herbarium, and University of California Botanical Garden (all described in the Botanical Gardens, Arboreta, and Herbaria section), as well as the Lawrence Hall of Sciences (see Science and Technology Museums and Centers section).

## UNIVERSITY OF CALIFORNIA, DAVIS
### Bohart Museum of Entomology

(See Entomology Museums section.)

## UNIVERSITY OF CALIFORNIA, IRVINE
### Museum of Systematic Biology

Representative collections of organisms in Orange County are available at the Museum of Systematic Biology at the University of California, Irvine. The museum, housed in the Faculty Research Facility on North Campus, has teaching collections of plants, shells, and other organisms and an herbarium of Orange County vascular plants. The museum's staff was released and visiting hours changed to appointment only as a result of budget cuts several years ago.

Museum of Systematic Biology, University of California, Irvine, School of Biological Sciences, Faculty Research Facility, North Campus, Irvine, CA 92717. Phone: 417/856-5183. Hours: by appointment. Admission: free.

## UNIVERSITY OF CALIFORNIA, RIVERSIDE
### UCR Entomological Teaching and Research Collection

(See Entomology Museums section.)

## UNIVERSITY OF CINCINNATI
### University of Cincinnati Geology Museum

(See Geology, Mineralogy, and Paleontology Museums section.)

## UNIVERSITY OF COLORADO AT BOULDER
### University of Colorado Museum

Established in 1902, the University of Colorado Museum at Boulder is a natural history museum that encompasses the earth and life sciences, as well as the natural history of humankind. Most of the museum's activities take place in Henderson Hall, named for the first curator, but the museum also has an herbarium in the Clare Small Gymnasium and its geology, zoology, and other collections in the Hunter Building.

The museum's growing collections exceed 3.3 million specimens, artifacts, and archival materials, with the depth being in items from the southern Rocky Mountains and adjacent plains, basins, and plateaus. The anthropology section holds over 1 million archaeological, 7,600 ethnographic, and 50,000 archival items; the entomology collection includes more than 540,000 specimens, with particular strength in hymenoptera, lepidoptera, and spiders; the geology collection consists of over 7,000 plant fossils, 400,000 invertebrate fossils, and 35,000

vertebrate fossils; the zoology section has more than 670,000 mollusks, 4,000 aquatic insects, 16,000 other invertebrates, 77,000 reptiles and amphibians, 11,000 birds, and 12,000 mammals; and the herbarium holds approximately 245,000 tracheophytes, 100,000 bryophytes, 90,000 lichens, 5,700 algae, and 18,000 fungi.

The museum has four exhibition galleries in the Henderson Building. They include Anthropology Hall, the Hall of Life, and two galleries for changing exhibitions. A second-floor hallway also is used for two-dimensional exhibitions. The museum's exhibitions largely feature curatorial research, such as the Yellow Jacket explorations of a prehistoric Anasazi site, paleobiological research, and studies of southwestern Native American textiles.

University of Colorado Museum, Henderson Bldg., Campus Box 218, Boulder, CO 80309-0218. Phone: 303/492-6892. Hours: 9–5 Mon.–Fri.; 9–4 Sat.; 10–4 Sun.; closed holidays. Admission: free.

## UNIVERSITY OF CONNECTICUT
### Connecticut State Museum of Natural History

The Connecticut State Museum of Natural History is located at the University of Connecticut in Storrs. It began as a separate state agency in 1982, but now is operated as part of the university.

The museum collections, located in 14 buildings around campus, include approximately 400,000 insects, 150,000 herbarium sheets, 24,000 mammals, 10,000 birds, 10,000 photographs, 8,000 reptiles and amphibians, 2,000 mollusks, 500 orchids, 200 economic plants, and 3,000 species in greenhouses.

Exhibits are presented at three sites—the Wilbur Cross Building, the Jorgensen Building, and the greenhouses. Among the exhibits are Connecticut Indians, mounted hawks and owls in New England, and an interactive video experience.

Connecticut State Museum of Natural History, University of Connecticut, Wilbur Cross Bldg., 233 Glenbrook Rd., Storrs, CT 06269-3023. Phone: 203/486-4460. Hours: Wilbur Cross Bldg.—12–4 Mon. and Thurs.–Sat.; 1–4 Sun.; Jorgensen Bldg. and greenhouses— 8:30–4 Mon.–Fri.; closed major holidays. Admission: free.

## UNIVERSITY OF FLORIDA
### Florida Museum of Natural History

The Florida Museum of Natural History at the University of Florida in Gainesville is the largest museum of natural history in the South. Founded in 1917, it occupies a 104,000-square-foot building and has such outlying facilities as the Comparative Behavior Laboratory and the Herbarium on campus, Swisher Memorial Sanctuary and Katharine Ordway Preserve near Melrose, and Allyn Museum of Entomology in Sarasota.

The museum has over 10 million lots of specimens and artifacts in the two curatorial departments of anthropology and the natural sciences. The diverse

anthropology holdings exceed 1 million catalogued lots of specimens, including archaeological, ethnological, and physical anthropological materials. The most extensive and systematic collections are in archaeology, especially that of Florida, the southeastern United States, and the Caribbean. Of major importance are approximately 550,000 artifacts of various historical periods, especially the Spanish Colonial era. The department also has a zooarchaeological collection of over 3 million specimens, which is among the largest in the nation.

The natural sciences department has substantial collections in 10 disciplines—botany, herpetology, ichthyology, invertebrate paleontology, lepidoptera, malacology, mammalogy, ornithology/bioacoustics, paleobotany, and vertebrate paleontology. The lepidoptera, malacology, and paleobotany collections are among the top five in the nation, and the other seven collections rank within the top 10 in their fields.

The museum's exhibits present and interpret ecological and anthropological principles, rather than emphasizing systematic or distributional arrays of objects. Thousands of specimens are displayed in a walk-through format that explores natural environments and the entities that have lived or continue to live in them. Among the exhibits are a north Florida cave, geologic cross-sections, mounted skeletons, ecosystem dioramas, Mayan life, a Bonampak palace recreation, Florida historical materials, and a hands-on object gallery. The museum also has two galleries for temporary and traveling exhibitions.

Among the offerings of the outlying facilities are 10 acres for live animals and research activities at the Comparative Behavior Laboratory, over a quarter of a million specimens at the Herbarium in Rolfs Hall, a 9,300-acre open-air research facility to study Florida's living collections at Swisher Memorial Sanctuary and Katharine Ordway Preserve, and the largest butterfly and moth collections in the Western Hemisphere at the Allyn Museum of Entomology.

Florida Museum of Natural History, University of Florida, PO Box 117800, Gainesville, FL 32611-7800. Phone: 904/392-1721. Hours: 9–5 Tues.–Sat.; 1–5 Sun. and holidays; closed Christmas. Admission: free.

## UNIVERSITY OF GEORGIA
### University of Georgia Museum of Natural History

For decades, the University of Georgia in Athens has had large and important natural history collections in seven academic departments. It was not until 1978, however, that the university formally recognized these research collections—numbering nearly 5 million items—as the University of Georgia Museum of Natural History.

The museum—which functions as a consortium of eight separate collections administered and supported primarily by the respective academic departments—still lacks a home and an exhibit program. Its collections, personnel, and programs are scattered in six buildings across the campus.

The eight collections constituting the Museum of Natural History are the

Archaeology Laboratory Collection of more than 3.5 million artifacts and specimens, covering 12,000 years of pre- and post-European settlement of Georgia and the Southeast; University of Georgia Herbarium, repository of over 200,000 samples of the flora of the region; Entomology Collections consisting of approximately 600,000 pinned, 100,000-plus slide-mounted, and 30,000 alcohol-preserved specimens; Geological Collections of approximately 10,000 rock and mineral specimens; Julian H. Miller Mycological Herbarium, a regional repository of 25,000 fungi specimens; Plant Microfossil Laboratory Collection of thousands of recent and fossil pollen spores; Zooarchaeology Laboratory Collection, a reference collection of over 3,700 skeletal specimens of fish, amphibians, reptiles, birds, and mammals; and Zoological Collections, which include approximately 300,000 fish, 25,000 amphibians and reptiles, 5,000 birds, and 10,000 mammal specimens from the region.

University of Georgia Museum of Natural History, Natural History Bldg., Athens, GA 30602-1882. Phone: 706/542-1663. House: 9–5 Mon.–Fri. by appointment; closed holidays. Admission: free.

## UNIVERSITY OF ILLINOIS AT URBANA-CHAMPAIGN
### *Museum of Natural History*

The Museum of Natural History at the University of Illinois in Urbana traces its origins to 1867. It now occupies 18,000 square feet in the Natural History Building, an early classroom/office building that also houses the Department of Geology and classrooms for the School of Life Sciences.

The museum—which features exhibits in biology, anthropology, geology, and paleontology—has collections of mammals, birds, reptiles, amphibians, fish, mollusks, rocks and minerals, fossils, Native American artifacts, and historical items of Gregor Mendel, pioneering Austrian botanist.

Museum of Natural History, University of Illinois, Natural History Bldg., 1301 W. Green St., Urbana, IL 61801. Phone: 217/333-2517. Hours: 9–4:30 Mon.–Sat.; closed holidays. Admission: free.

## UNIVERSITY OF IOWA
### *Museum of Natural History*

The Museum of Natural History at the University of Iowa in Iowa City began as a state legislature–enacted cabinet of natural history in 1858. Originally located in the Old Capitol Building, the museum moved to the newly completed Science Hall (now Calvin Hall) on the campus in 1885 and then to its present home (now Macbride Hall) in 1904.

The museum, which occupies 22,000 square feet in Macbride Hall, has more than 1 million specimens and artifacts in its collections. They include invertebrate fossils, Mesquakie (Iowa) ethnographic materials, and North American birds and mammals.

The principal exhibit is the 6,000-square-foot Iowa Hall gallery, which features state geology, cultural prehistory, and ecology. The exhibit units are linked thematically and chronologically. The museum's major dioramas—such as the Marquette and Jolliet diorama, Devonian Reef diorama, and Paleo-Man diorama—are interspersed with topical exhibits. Other exhibits feature the Laysan Island Cylcorama, a giant ground sloth restoration, and displays of North American mammals and birds.

Museum of Natural History, University of Iowa, Macbride Hall, Iowa City, IA 52242. Phone: 319/335-0481. Hours: 9:30–4:30 Mon.–Sat.; 12:30–4:30 Sun.; closed holidays. Admission: free.

## UNIVERSITY OF KANSAS
### University of Kansas Natural History Museum

The natural history structure at the University of Kansas in Lawrence has undergone change. The directors and staffs of four of the five museums comprising the University of Kansas Systematics Museums (the Museum of Natural History, Snow Entomological Museum, Museum of Invertebrate Paleontology, and McGregor Herbarium) agreed to reorganize into a single administrative unit known as the University of Kansas Natural History Museum, effective June 1994. Only the Museum of Anthropology remains as an administratively independent museum.

Under the new reorganization, the herbarium and the museums of invertebrate paleontology and entomology became co-equal divisions of the new Natural History Museum, and their directors became curators in charge of their respective divisions of botany, invertebrate paleontology, and entomology. The director of the former Museums of Natural History became the director of the new combined University of Kansas Natural History Museum.

The Natural History Museum is described here, while information about the other three components can be found in other sections—the Snow Entomological Museum in the Entomology Museums section; Museum of Invertebrate Paleontology in the Geology, Mineralogy, and Paleontology Museums section; and McGregor Herbarium in the Botanical Gardens, Arboreta, and Herbaria section.

The initial University of Kansas Museum of Natural History was established as a cabinet of natural history by the state legislature in 1864. The first museum collections were made in 1866—the year the university opened—by Francis Huntington Snow, who was one of the first three professors and for whom the entomological museum was later named. The museum moved into Dyche Hall, its present home, in 1903. The building, a Romanesque Revival structure, was named for L.L. Dyche, a taxidermist who created a naturalistic panorama of 112 North American mammals featured in the Kansas Building at the 1893 World's Columbian Exposition in Chicago. The four museums of the Natural History Museum now are located in five campus buildings.

The Natural History Museum is known for its research and graduate education in the systematic and evolutionary biology of plants and animals and as a repository of collections of recent and fossil plants and animals serving the university, the international scientific community, and the public.

The museum's collections now include over 5.1 million specimens of plants and animals emphasizing Kansas, the Great Plains, and other areas of the New World. They are organized into eight scientific divisions—vertebrate paleontology, 115,700 specimens (538 types); ichthyology, 329,100 specimens (113 types); herpetology, 237,400 specimens (433 types); ornithology, 85,700 specimens (10 types); mammalogy, 145,300 specimens (129 types); entomology, 3.2 million specimens (8,700 types); botany, 415,000 specimens (120 types); and invertebrate paleontology, 575,000 specimens (5,000 types). Library holdings of the eight divisions total more than 161,200 books and reprints.

The museum has 130 exhibits, occupying 51,200 of its 190,326 square feet. They include dioramas of Cretaceous swimming and flying reptiles and Pleistocene mammals from the LaBrea tar pits in California, Kansas, and Wyoming; 150 large mammals and other vertebrates, invertebrates, and plants of North America; dioramas of birds of prey, seasonal birds, and endangered species, with exhibits describing the characteristics, life cycles, adaptations, and behavior of the five classes of vertebrates; and "Comanche," the Seventh Cavalry horse from the Battle of the Little Bighorn. The museum also has an extensive program of temporary and traveling exhibitions.

University of Kansas Natural History Museum, Dyche Hall, Lawrence, KS 66045-2454. Phone: 913/864-4540. Hours: 8–5 Mon.–Sat.; 1–5 Sun.; closed New Year's Day, Thanksgiving, and Christmas. Admission: suggested donation—adults, $2; children, $1.

## UNIVERSITY OF MASSACHUSETTS, AMHERST
### Museum of Zoology

(See Zoology Museums section.)

## UNIVERSITY OF MICHIGAN
### University of Michigan Museums of Natural History

Five institutions comprise the University of Michigan Museums of Natural History in Ann Arbor. They include the Exhibit Museum, Museum of Anthropology, Museum of Paleontology, Museum of Zoology, and University of Michigan Herbarium. The Exhibit Museum is described here, while further information on the Museum of Anthropology can be found in the Archaeology, Anthropology, and Ethnology Museums section; Museum of Paleontology in the Geology, Mineralogy, and Paleontology Museums section; Museum of Zoology in the Zoology Museums section; and University of Michigan Herbarium in the Botanical Gardens, Arboreta, and Herbaria section.

All four museums are located in the Ruthven Museums Building, while the

Herbarium is in the adjacent North University Building. Although they are located together, they are administered separately. Each is an independent research unit associated with an appropriate academic department in which curators hold professional appointments and carry out teaching responsibilities. All are part of the College of Literature, Science, and the Arts.

The University of Michigan museum history began in 1837 with the founding of the university. At its first meeting, the Board of Regents created a cabinet of natural history for the university's scientific collections. However, it was not until 1856 that a separate room was provided to house the diverse collections. A building was constructed in 1881–1882 for classrooms, laboratories, and exhibits, and in 1913, the exhibits were designated the Museum of Zoology. As the collections and exhibits grew, the other institutions evolved. The 162,000-square-foot Ruthven Museums Building was built in 1928 to house the various museums.

The Exhibit Museum is the largest and most publicly oriented museum of the facilities. The anthropology, paleontology, and zoology museums are used primarily for research and teaching and either are open to the public by appointment or closed to the public.

### Exhibit Museum

The Exhibit Museum at the University of Michigan in Ann Arbor has over 300 exhibits on four floors. Specimens, dioramas, artifacts, and habitat scenes are used to tell about prehistoric life, wildlife, Native Americans, geology, astronomy, and other areas. The museum also has the 45-seat Ruthven Planetarium Theatre, which uses a Spitz A2C projector for sky shows.

The museum's main exhibits are the Hall of Evolution, which surveys prehistoric life as related to modern flora and fauna and as evidenced by fossil records; Michigan Wildlife Gallery, featuring plant and animal life of the state; and a fourth-floor space with exhibits on North American Indians, astronomy, geology, mineralogy, biological principles, human physiology, and primitive technologies, as well as the planetarium

Exhibit Museum, University of Michigan, Ruthven Museums Bldg., 1109 Geddes Ave., Ann Arbor, MI 48109-1079. Phone: 313/764-0478. Hours: 9–5 Mon.–Sat.; 1–5 Sun.; closed major holidays. Admission: museum—free; planetarium—$2 weekdays and $2.50 weekends.

## UNIVERSITY OF MINNESOTA, TWIN CITIES
### James Ford Bell Museum of Natural History

The James Ford Bell Museum of Natural History at the University of Minnesota in Minneapolis is best known for its more than 100 lifelike dioramas and habitat groups featuring the flora and fauna of Minnesota—many created by noted wildlife artist Francis Lee Jaques. The museum also developed the first hands-on natural history exhibit—called the Touch and See Room—which opened in the 1960s and continues to be updated and popular.

The museum, the oldest in Minnesota, was founded in 1872 as part of the Geological and Natural History Survey. It initially displayed geological specimens in a room in the Old Main building. Over the years, the museum's collections, interests, and space expanded. Even its name changed several times. In 1939, it became the Minnesota Museum of Natural History as its present building was constructed with funding from James Ford Bell and the Public Works Administration. When a wing was added in the late 1960s, the museum was named for Bell, its major benefactor. The museum now is part of the College of Biological Sciences.

The museum's collections are especially strong in Pleistocene bison and musk ox fossils and varieties of seeds. It also has a large collection of Jaques's oil paintings, watercolors, sketches, and studies; the original art for Thomas S. Roberts's *The Birds of Minnesota;* and many of the original woodblocks of Thomas Bewick, the eighteenth-century English natural history artist.

James Ford Bell Museum of Natural History, University of Minnesota, College of Biological Sciences, 10 Church St., SE, Minneapolis, MN 55455-0104. Phone: 612/624-7083. Hours: 9–5 Tues.–Fri.; 10–5 Sat.; 12–5 Sun.; closed holidays. Admission: adults, $3; seniors, students, and children 3–16, $2; university students and children under 3, free; Thursdays are free.

## UNIVERSITY OF MISSOURI–ROLLA
### Minerals Museum

(See Geology, Mineralogy, and Paleontology Museums section.)

## UNIVERSITY OF MONTANA
### University of Montana Zoological Museum and Herbarium

(See Zoology Museums section.)

## UNIVERSITY OF NEBRASKA–LINCOLN
### University of Nebraska State Museum

The University of Nebraska State Museum in Lincoln is a major museum of natural science founded in 1871. It serves as the university and state depository for specimens and related materials documenting the natural history and cultural heritage of Nebraska, the Great Plains, and other areas, with the specimen collections totaling over 13 million.

The museum occupies 180,000 square feet in Morrill Hall and Nebraska Hall in Lincoln, with about one-third being devoted to exhibits. It also is the home of the Ralph Mueller Planetarium and has branches at the Ashfall Fossil Beds State Historical Park near Royal and the Trailside Museum near Crawford (described in the Geology, Mineralogy, and Paleontology Museums section.)

The museum has more than 13 million specimens and artifacts—primarily from the Central Plains—in its collections. They cover the fields of vertebrate paleontology, parasitology, entomology, botany, anthropology, vertebrate zoology, malacology, geology, and meteorites.

The museum's collection of Cenozoic fossil mammals of several hundred types ranks among the top three in the nation, and the vertebrate paleontology collection is considered among the five leading collections in the field. The herbarium is one of the oldest and largest in the region.

Exhibits are offered on all three floors of Morrill Hall. The world-famous Elephant Hall is on the main floor. It contains mounted skeletons of 12 elephants, mammoths, mastodons, and ancestral proboscideans; two life mounts of African elephants and a life-sized reconstruction of a baluchithere; paleontological exhibits on fossil mammals, fossil invertebrates, and lower invertebrates; temporary exhibition space; and the 87-seat Ralph Mueller Planetarium, which uses a Spitz A4 projector and presents sky and laser shows.

Exhibits on other floors include 16 dioramas of Nebraska wildlife; synoptic collections of animal groups; health galleries; a major dinosaur hall; exhibits of systematic geology and mineralogy, anthropology, and the Plains Indians; and the Encounter Center, featuring hands-on exhibits for children and adults.

The Ashfall Fossil Beds State Historical Park, at a 10-million-year-old fossil bed, has a visitor center, rhino barn, fossil sandbox, and picnic pavilion, while the Trailside Museum, located in a historic 1904 building at Fort Robinson State Park, has a skeletal mount of a mammoth excavated locally and other natural history and geology exhibits.

University of Nebraska State Museum, Morrill Hall, 14th and U Sts., Lincoln, NE 68588-0338. Phone: 402/472-3779. Hours: museum—9:30–4:30 Mon.–Sat.; 1:30–4:30 Sun. and some holidays; planetarium—2 Sat.–Sun. in winter; 2 Tues.–Sun. in summer; laser shows—varies; closed New Year's Day, Thanksgiving, and Christmas. Admission: museum—suggested donation, $1; planetarium sky shows—adults, $2.50; students and children, $1.50; laser shows—$4.

## UNIVERSITY OF NEVADA AT LAS VEGAS
### Marjorie Barrick Museum of Natural History

The Marjorie Barrick Museum of Natural History at the University of Nevada at Las Vegas has collections, exhibits, a botanical garden, and sometimes live animals on display. Collections of the museum, which was founded in 1967, include invertebrate and vertebrate fossils, fish, geological and herpetological specimens, and archaeological findings.

Marjorie Barrick Museum of Natural History, University of Nevada at Las Vegas, 4505 S. Maryland Pkwy., Las Vegas, NV 89154-4012. Phone: 702/895-3381. Hours: 9–5 Mon.–Fri.; 10–2 Sat.; other times by appointment; closed holidays. Admission: free.

## UNIVERSITY OF NEVADA AT RENO
### W.M. Keck Museum

(See Geology, Mineralogy, and Paleontology Museums section.)

## UNIVERSITY OF NEW MEXICO
### Museum of Southwestern Biology

The Museum of Southwestern Biology at the University of New Mexico is an education, research, and exhibit center actively pursuing and promoting studies of biodiversity. Founded in 1935, the museum is located in the basement of the Biology Building. The museum is known for its collections of mammals, birds, reptiles, plants, fish, and insects, with specimens from the southwestern United States, South America, Central America, and other countries. It also has a large frozen tissue collection.

Museum of Southwestern Biology, University of New Mexico, Biology Dept., Albuquerque, NM 87131. Phone: 505/277-5340. Hours: by appointment. Admission: free.

### Meteorite Museum

(See Geology, Mineralogy, and Paleontology Museums section.)

## UNIVERSITY OF NORTH DAKOTA
### University of North Dakota Zoology Museum

(See Zoology Museums section.)

## UNIVERSITY OF NORTHERN IOWA
### University of Northern Iowa Museum

The University of Northern Iowa Museum in Cedar Falls is one of only two Iowa natural history collections with international materials. Founded in 1892, the museum has collections of North American ornithology, South American ethnographic materials, Caribbean shells, and Iowa fossils. Its permanent exhibits include rocks, minerals, and Iowa fossils; large mammals and birds; cultures of the world and Iowa archaeology; and history of Iowa and the university.

University of Northern Iowa Museum, 3219 Hudson Rd., Cedar Falls, IA 50614-0199. Phone: 319/273-2188. Hours: 9–4:30 Mon.–Fri.; 1–4:30 Sun.; closed holidays. Admission: free.

## UNIVERSITY OF OKLAHOMA
### Oklahoma Museum of Natural History

The Oklahoma Museum of Natural History at the University of Oklahoma in Norman is the official museum of natural history for the state and an independent

research department of the university. It originally was created in 1899 by Oklahoma's territorial legislature.

The museum—formerly known as the University of Oklahoma Museum and then the Stovall Museum of Science and History—became a state museum in 1987. It has more than 5 million artifacts and specimens pertaining to the composition and evolution of the earth and all forms of life. The collections are organized into three scientific disciplines—earth sciences, life sciences, and social sciences. They are dominated by materials from Oklahoma, but include comparative and reference collections from around the world.

The earth sciences collections include invertebrate fossils, paleobotanical materials, vertebrate fossils, and minerals. The paleontology collection, which is one of the nation's largest, contains many rare and unusual fossils. In the life sciences, the museum has invertebrates, fish, amphibians, reptiles, mammals, and birds. It includes the world's largest collection of riffle beetles.

Approximately two-thirds of the museum's collections are in the social sciences. They include archaeological objects, ethnographic materials, textiles, historic items, and a classics collection. The museum has some of the finest and most extensive Native American artifacts among its holdings, including materials from Caddoan ceremonial centers such as the Spiro Mounds in Oklahoma.

The museum's exhibits feature displays of dinosaur bones and skulls and full skeletons of a mammoth, a 20-foot mosasaur, and early reptiles; 15 life-sized dioramas of mounted animals and birds in their native habitats; pre-Columbian artifacts from the Spiro Mounds archaeological site; and Native American ethnographic objects from Oklahoma tribes. The museum also presents an average of six exhibitions a year in its two temporary galleries and organizes and circulates traveling exhibitions throughout the state and region.

The museum occupies four contiguous buildings built in the late 1930s as WPA projects. One of the buildings is used for exhibits, while the other three are devoted to laboratory work and collections storage.

Oklahoma Museum of Natural History, University of Oklahoma, 1335 Asp Ave., Norman, OK 73019-0606. Phone: 405/325-4712. Hours: 10–5 Tues.–Fri.; 2–5 Sat.–Sun.; closed holidays and when university not in session. Admission: free.

## UNIVERSITY OF OREGON
### *Museum of Natural History*

The natural history, archaeology, and anthropology of the Pacific Northwest are featured at the University of Oregon Museum of Natural History in Eugene. Founded in 1935, the museum moved into a new 10,000-square-foot building in 1987.

The museum has over 500,000 artifacts and specimens in its collections. Among its most important objects are archaeological and ethnographic materials from Oregon, especially prehistoric basketry from dry caves in the eastern part

of the state. The exhibits cover Oregon archaeology and fossils, biology/zoology, and non-Western cultures.

Museum of Natural History, University of Oregon, 1680 E. 15th Ave., Eugene, OR 97403-1224. Phone: 503/346-3024. Hours: 12–5 daily; closed Fourth of July, Thanksgiving, Christmas, and mid-Aug. to mid-Sept. Admission: free.

## UNIVERSITY OF PUGET SOUND
### *James R. Slater Museum of Natural History*

The collecting of natural history specimens began in 1926, but it was not until 1952 that the James R. Slater Museum of Natural History became formalized at the University of Puget Sound in Tacoma, Washington. It now functions as a teaching and research resource of Northwest flora and fauna.

The museum, housed in Thompson Hall, has collections that include over 27,000 mammal skins and skulls, 16,000 bird skins and skeletons, 2,000 bird wings, 4,500 sets of bird eggs, 10,000 reptiles and amphibians, 3,000 invertebrates, and 9,000 plants on herbarium sheets.

James R. Slater Museum of Natural History, University of Puget Sound, Thompson Hall, Tacoma, WA 98416. Phone: 206/756-3798. Hours: by appointment; closed holidays. Admission: free.

## UNIVERSITY OF RICHMOND
### *Lora Robins Gallery of Design from Nature*

(See Art Museums section.)

## UNIVERSITY OF SOUTH CAROLINA
### *McKissick Museum*

(See General Museums section.)

## UNIVERSITY OF SOUTH DAKOTA
### *W.H. Over State Museum*

(See Unaffiliated Museums section.)

## UNIVERSITY OF TEXAS AT AUSTIN
### *Texas Memorial Museum*

The Texas Memorial Museum at the University of Texas at Austin is dedicated to the study and interpretation of the natural and social sciences, with emphasis on Texas, the Southwest, and Latin America. It was chartered in 1936 and opened in 1939 as a permanent memorial of the Texas Centennial celebration.

The museum has more than 4.7 million specimens and objects in its collections, covering the fields of geology, paleontology, zoology, botany, ecology, anthropology, and history. They range from fossils, minerals, and petrological materials to Texas antiquities, pre-Columbian artifacts, and objects of common use from all continents.

The collections include approximately 400,000 vertebrates and invertebrates in the biological collections; more than 150,000 vertebrate, invertebrate, and plant fossils and recent vertebrate skeletons in the paleontological collections; over 50,000 rocks, minerals, gems, meteorites, and tektites in the petrological and mineralogical collections; and more than 4.6 million ethnographic specimens, antique firearms and accessories, numismatics, paintings, drawings, books, photographs, and maps in the historical and material culture collections.

The museum has three gallery floors of semi-permanent exhibits and one floor for special exhibitions in its 20,000-square-foot building. It also has research, laboratory, and collection facilities in other buildings on the central campus and at the university's outlying Balcones Research Center in North Austin.

Among the exhibits in the main building are gems, minerals, rocks, meteorites, tektites, ancient amphibians and reptiles, and Ice Age mammals, including the Onion Creek mounted mosasaur, on the first floor; the original 16-foot Goddess of Liberty statue, which adorned the dome of the Texas Capitol for nearly a century, and special exhibitions on the second (entrance) floor; life-size dioramas of Texas wildlife, habitat groups of native Texas birds, displays of poisonous and harmless reptiles, and an exhibit on native animals that prowl and fly at night on the third floor; and artifacts from prehistoric Indian sites in Texas, exhibits on major Native American cultural groups, and a collection of Peruvian pre-Columbian pottery on the fourth floor. Blocks of dinosaur trackways from a 105-million-year-old limestone bed in Glen Rose, Texas, have been reassembled and are displayed in a small building to the north of the museum building. The museum currently is undergoing full-scale revision of its exhibits.

Texas Memorial Museum, University of Texas at Austin, 2400 Trinity St., Austin, TX 78705. Phone: 512/471-1604. Hours: 9–5 Mon.–Fri.; 10–5 Sat.; 1–5 Sun.; closed major holidays. Admission: free.

## UNIVERSITY OF TEXAS AT EL PASO
### Centennial Museum

The Centennial Museum at the University of Texas at El Paso is a natural and cultural history museum, with emphasis on the region. It focuses on the natural history and the indigenous, colonial, and pre-urban and folk cultures of the border region of the southwestern United States and northern Mexico.

The 15,000-square-foot museum, founded in 1936 when the university was the College of Mines and Metallurgy, is known for its rock, mineral, fossil, and Casas Grandes pottery collections. It also has extensive anthropological and ethnographic materials.

Centennial Museum, University of Texas at El Paso, University Ave. at Wiggins Rd., El Paso, TX 79968-0553. Phone: 915/747-5565. Hours: 10–5 Tues.–Sat.; closed holidays. Admission: free.

## UNIVERSITY OF UTAH
### Utah Museum of Natural History

The Utah Museum of Natural History at the University of Utah in Salt Lake City collects, exhibits, and interprets specimens and artifacts relating to the natural history of Utah from earliest times to the present.

The museum came into being in 1963 when the Utah legislature passed a bill directing the establishment of a state museum of natural history at the university. An 87,000-square-foot structure—built in 1934 and formerly used as a library— became the home of the newly created museum in 1970. The building is located within the President's Circle, a cluster of impressive early Utah architecture placed on the National Register of Historic Places in 1977.

The museum has over 2 million specimens and artifacts in its collections. They include significant anthropological collections of the Great Basin, Desert Archaic, and Fremont Indian artifacts, numbering over 500,000. The museum's biological collections consist of more than 250,000 specimens, with the greatest number in birds, mammals, reptiles, fish, plants, shells, and insects. Other extensive holdings are in geology, gems, minerals, rocks, and fossils.

The museum has five major exhibit halls that display many of the specimens and artifacts. It makes use of dioramas to depict birds and animals in natural settings. The museum also presents temporary exhibitions and circulates traveling exhibits around the state.

Utah Museum of Natural History, University of Utah, President's Circle, Salt Lake City, UT 84112. Phone: 801/581-6927. Hours: 9:30–5:30 Mon.–Sat.; 12–5 Sun. and some holidays; closed New Year's Day, Fourth of July, Pioneer Day (July 24), Thanksgiving, and Christmas. Admission: adults, $3; seniors and children, $1.50; university students, faculty, and children under 3, free.

## UNIVERSITY OF WASHINGTON
### Thomas Burke Memorial Washington State Museum

(See Archaeology, Anthropology, and Ethnology Museums section.)

## UNIVERSITY OF WISCONSIN–MADISON
### University of Wisconsin Zoological Museum

(See Zoology Museums section.)

## UNIVERSITY OF WISCONSIN–MILWAUKEE
### Greene Memorial Museum

(See Geology, Mineralogy, and Paleontology Museums section.)

## UNIVERSITY OF WISCONSIN–STEVENS POINT
*Museum of Natural History*

The Museum of Natural History at the University of Wisconsin–Stevens Point was founded in 1966 and now operates out of three buildings. Its exhibits are in the Learning Resources Building, while other parts are in the Science and Natural Resource buildings. Among the museum's approximately 250,000 specimens are mammals, fish, birds, aquatic insects, parasites, eggs, minerals, and an herbarium. The exhibits are overviews of many of these fields.

Museum of Natural History, University of Wisconsin–Stevens Point, 2100 Main St., Stevens Point, WI 54481-3897. Phone: 715/346-2858. Hours: 8–6 Mon.–Fri.; 9–4 Sat.–Sun.; limited hours or closed on some holidays. Admission: free.

## UNIVERSITY OF WYOMING
*Geological Museum*

(See Geology, Mineralogy, and Paleontology Museums section.)

## VIRGINIA POLYTECHNIC INSTITUTE AND STATE UNIVERSITY
*Virginia Museum of Natural History*

The Virginia Museum of Natural History at Virginia Polytechnic Institute and State University in Blacksburg opened in 1990 in a converted 10,000-square-foot movie theater opposite the university's entrance. Among the museum's holdings are minerals, gemstones, birds, insects, and other natural history materials.

Virginia Museum of Natural History, Virginia Polytechnic Institute and State University, 428 N. Main St., Blacksburg, VA 24061-0542. Phone: 703/231-5360. Hours: 11–5 Wed.–Sat.; 1–5 Sun.; closed holidays and when university not in session. Admission: free.

### *Museum of the Geological Sciences*
(See Geology, Mineralogy, and Paleontology Museums section.)

## WASHINGTON STATE UNIVERSITY
*Charles R. Conner Museum*

Birds and mammals of the Pacific Northwest are featured at the Charles R. Conner Museum at Washington State University in Pullman. The museum's first specimens were exhibited in 1894 after having been displayed at the World's Columbian Exhibition in Chicago the prior year.

The museum, which occupies a large part of the ground floor of the recently remodeled Science Building, now has over 46,000 specimens in its collections, including some of the largest collections of fluid-preserved birds, rosy finches,

tundra and trumpeter swans, Andrean sparrows, birds from the Mariana Islands, and bacula of selected species of mammals.

Charles R. Conner Museum, Washington State University, Science Bldg., Pullman, WA 99164-4236. Phone: 509/335-3515. Hours: 8–5 daily. Admission: free.

## WAYNE STATE UNIVERSITY
### Museum of Natural History

Wayne State University's Museum of Natural History in Detroit has collections and exhibits of birds, mammals, plants, insects, and other specimens. Founded in 1972 and operated by the Department of Biological Sciences, the museum was closed temporarily in May 1994 when renovation began on the Old Main building in which it is located.

Museum of Natural History, Wayne State University, Dept. of Biological Sciences, Detroit, MI 48202. Phone: 313/577-2873. Hours: by appointment. Admission: free.

## WEST CHESTER UNIVERSITY
### Geology Museum

(See Geology, Mineralogy, and Paleontology Museums section.)

## WESTERN MONTANA COLLEGE
### Western Montana College Gallery-Museum

(See Art Galleries section.)

## YALE UNIVERSITY
### Peabody Museum of Natural History

The Peabody Museum of Natural History at Yale University in New Haven, Connecticut, is one of the oldest university museums of natural history, being founded in 1866 with a $150,000 gift from philanthropist George Peabody. It also has one of the largest collections of specimens and artifacts—nearly 11 million—in the fields of natural history, archaeology, and ethnology.

The original museum building opened to the public in 1876, and it immediately was nearly filled with Yale's existing collections. Only one wing of a proposed three-part structure was actually built. The present 125,000-square-foot building was opened in 1925 to accommodate the expanding collections, research, exhibitions, and education programs. The museum's teaching, research, and collections storage now are located in four buildings attached or close to the main museum building.

The museum is especially known for its extensive dinosaur collection, which had its start during the fossil-collecting days of Othniel C. Marsh, the museum's first curator of vertebrate paleontology, in the late nineteenth century. Marsh

and Edward Drinker Cope of the Academy of Natural Sciences in Philadelphia engaged in a longtime bitter and competitive search for dinosaur fossils in Colorado, Wyoming, and elsewhere. Another major feature of the museum is the 110-foot-long mural *The Age of Reptiles* by Rudolph F. Zallinger, which depicts 160 million years in a sweeping panorama of time. Zallinger also painted the 60-foot-long *The Age of Mammals* mural at the museum.

The museum's principal exhibit gallery is the Great Hall of Dinosaurs, which features some of the first dinosaur skeletons to be collected in North America. Among the fossils on display are a 60-foot *Apatosaurus,* which Marsh called *Brontosaurus;* a *Edmontosaurus* duck-billed dinosaur; skulls from the horned dinosaurs *Torosaurus* and *Triceratops;* specimens of *Stegosaurus* and *Camptosaurus;* a 100-million-year-old *Archelon ischyros,* the largest known turtle; a *Deinonychus* "terrible claw" dinosaur, discovered in 1964 in Montana; and a cast of the skull of a *Tyrannosaurus rex.*

The Hall of Human Cultures includes objects from the museum's extensive Mesoamerican and South American collections, Plains Indian materials, and New Guinea and Polynesian artifacts. Among the other halls are the Hall of Primates, Hall of Invertebrate Life, and Hall of Mammals. Other museum exhibits show meteorites, dioramas of North American and southern New England habitats, Egyptian artifacts, birds of Connecticut, Connecticut Indian artifacts, and minerals from the state and world.

Peabody Museum of Natural History, Yale University, 170 Whitney Ave., PO Box 208118, New Haven, CT 05620-8118. Phone: 203/432-3752. Hours: 10–5 Tues.–Sat.; 12–5 Sun.; closed New Year's Day, Easter, Fourth of July, Thanksgiving, and Christmas. Admission: adults, $4; seniors, $3.50; children 3–15, $2.50; 3–5 Tues.–Fri., free.

# Photography Museums

*Also see Art Museums and Art Galleries sections.*

## ARIZONA STATE UNIVERSITY
### *Northlight Gallery*

The Arizona State University School of Art in Tempe has a photography gallery—the Northlight Gallery—which was founded in 1972 by a group of graduate photography students who saw the need for an exhibition area that dealt exclusively with photographic art. The gallery has a study collection and features exhibitions of significant contemporary and historical photography.

Northlight Gallery, Arizona State University, School of Art, Tempe, AZ 85287-1505. Phone: 602/465-6517. Hours: 10:30–4:30 Mon.–Thurs.; 12:30–4:30 Sun.; closed when university not in session. Admission: free.

## COLUMBIA COLLEGE CHICAGO
### *Museum of Contemporary Photography*

Contemporary American photography is the focus of the Museum of Contemporary Photography at Columbia College in Chicago. The museum, founded in 1984 to collect, exhibit, and promote contemporary photography, is the only museum in the Midwest with an exclusive commitment to the medium of photography.

The museum has four galleries located on the first and mezzanine levels of the college's main building. The permanent collection, which includes approx-

imately 3,500 photographs by 435 contemporary American photographers, emphasizes photography produced since the publication of Robert Frank's seminal *The Americans* in 1959. It holds examples of many of the medium's processes and has silver gelatin, chromogenic development, silver dye bleach, internal dye diffusion transfer, dye imhibition, platinum and palladium, photogravure, and mixed media processes.

Each year the museum presents a wide range of exhibitions in recognition of photography's many roles—as a medium of communication and artistic expression, a documenter of life and the environment, a commercial industry, and a powerful tool in the service of science and technology. In addition, special exhibitions are prepared in collaboration with other institutions to combine photographic works with different forms of expression and investigate the medium's interaction with various arts, history, science, and culture.

Museum of Contemporary Photography, Columbia College Chicago, 600 S. Michigan Ave., Chicago, IL 60605-1996. Phone: 312/663-5554. Hours: 10–5 Mon.–Fri. (also 6–8 Thurs.); 12–5 Sat.; closed holidays. Admission: free.

## DAYTONA BEACH COMMUNITY COLLEGE
### Southeast Museum of Photography

Contemporary and historical photographs can be seen at the Southeast Museum of Photography at Daytona Beach Community College in Daytona Beach, Florida. The museum also organizes and circulates traveling exhibitions on photography.

Southeast Museum of Photography, Daytona Beach Community College, 1200 Volusia Ave., Daytona Beach, FL 32115. Phone: 904/255-8131. Hours: 10–3 Tues.–Fri. (also 5–7 Tues.); 1–4 Sun.; closed Christmas. Admission: free.

## FISK UNIVERSITY
### University Galleries Photography Collection

(See Art Museums section.)

## FORT LEWIS COLLEGE
### Center of Southwest Studies Museum Photography Collection

(See Archaeology, Anthropology, and Ethnology Museums section.)

## HARVARD UNIVERSITY
### Fogg Art Museum Photography Collection

(See Art Museums section.)

### Peabody Museum of Archaeology and Ethnology
### Photography Collection
(See Archaeology, Anthropology, and Ethnology Museums section.)

## HEBREW UNION COLLEGE
### I. Solomon and L. Grossman Collection (Skirball Museum)

(See Archaeology, Anthropology, and Ethnology Museums section.)

## JAMES MADISON UNIVERSITY
### New Image Gallery (Zirkle House)

(See Art Galleries section.)

## MASSACHUSETTS INSTITUTE OF TECHNOLOGY
### Harold E. Edgerton Strobe Alley (MIT Museum)

(See Science and Technology Museums and Centers section.)

## MIDDLE TENNESSEE STATE UNIVERSITY
### Photographic Gallery

Contemporary photography of the last 20 years is featured at Middle Tennessee State University's Photographic Gallery in Murfreesboro. Founded in 1963, the gallery presents changing exhibitions from its collection and other sources. It is located in the Learning Resource Center.

Photographic Gallery, Middle Tennessee State University, Learning Resource Center, Box 305, Murfreesboro, TN 37132. Phone: 615/898-2085. Hours: academic year—8–4: 30 Mon.–Fri.; 8–12 Sat.; 6–10 P.M. Sun.; Summer—by appointment; closed mid-Dec.–mid-Jan. Admission: free.

## PENNSYLVANIA STATE UNIVERSITY
### Photo/Graphics Gallery

The Photo/Graphics Gallery at Pennsylvania State University in University Park features exhibitions of photographs and various graphic arts media. They include works from photographic collections and by the university's photographers and graphic designers. The gallery is located on the ground floor of the Mitchell Building.

Photo/Graphics Gallery, Pennsylvania State University, Mitchell Bldg., University Park, PA 16802. Phone: 814/865-4700. Hours: 8–5 Mon.–Fri.; closed holidays. Admission: free.

## RHODE ISLAND SCHOOL OF DESIGN
### Museum of Art Print and Photography Gallery

(See Art Museums section.)

## SOUTH CAROLINA STATE UNIVERSITY
### I.P. Stanback Museum and Planetarium Photography Collection

(See Art Museums section.)

## STATE UNIVERSITY OF NEW YORK AT BUFFALO
### Burchfield Penney Art Center Photography Collection

(See Art Museums section.)

## UNIVERSITY OF ARIZONA
### Center for Creative Photography

The Center for Creative Photography at the University of Arizona in Tucson has one of the leading photographic collections in the world. Established in 1975, the center has more than 70,000 photographs, as well as photographers' archives, galleries, a library, and research facilities.

One of the center's primary objectives is to gather, organize, preserve, and make accessible the complete photographic archives of artists who have made significant and creative contributions to the medium. Among the several dozen major photographic archives housed at the center are those of Ansel Adams, Richard Avedon, Ernest Block, Dean Brown, Wynn Bullock, Harry Callahan, Louise Dahl-Wolfe, Andreas Feininger, Sonya Noskowiak, Marion Palfi, Aaron Siskind, W. Eugene Smith, Frederick Sommer, Paul Strand, and Edward Weston.

The center's large photography collection spans the history of the medium, representing more than 1,800 photographers. Visitors are encouraged to use the print-viewing room to request and see any photos from an archive or the photograph collection. The library has more than 11,000 volumes. The center's two galleries present exhibitions drawn from the permanent collection and traveling shows in the center's new 55,000-square-foot building in the Fine Arts Complex. Center for Creative Photography, University of Arizona, Tucson, AZ 85721. Phone: 602/ 621-7968. Hours: 11–5 Mon.–Fri.; 12–5 Sun.; closed major holidays. Admission: free.

## UNIVERSITY OF CALIFORNIA, BERKELEY
### University Art Museum and Pacific Film Archive

(See Art Museums section.)

## UNIVERSITY OF CALIFORNIA, LOS ANGELES
### Grunwald Center for the Graphic Arts

(See Art Museums section.)

## UNIVERSITY OF CALIFORNIA, RIVERSIDE
### California Museum of Photography

The California Museum of Photography, part of the University of California at Riverside, was founded in 1973 with the donation of some 2,500 cameras and related photographic items. This was followed in 1977 by two additional major gifts—one centered on fine arts and the other on photography as social history. These collections and others brought national attention to the museum.

Originally located in the university's library, the expanding museum moved to a 5,000-square-foot campus space in 1979 and then to a 23,000-square-foot building that was acquired and renovated in downtown Riverside in 1990.

The California Museum of Photography is one of the largest, most comprehensive, and most diverse photographic resources in the West. It interprets photography as technology, social history, and artistic endeavor. The collections include four interlinked subcollections—the Bingham Technology Collection, which has 9,000 cameras and viewing devices; Keystone-Mast Collection, consisting of over 250,000 original glass-plate negatives and more than 100,000 paper prints arranged by geographic or subject categories from the Keystone View Company archive; University Print Collection, with over 20,000 photographs created by more than 1,000 photographers from the 1840s to the present; and CMP Study Center Library Collection, a noncirculating collection of more than 10,000 photography monographs, manuscripts, artists' books, technical volumes, exhibition catalogs, and photography salon annuals, plus an adjunct resource of 15,000 volumes on photography and its history at the university's Thomas Rivera Library.

Among the significant holdings are a Lewis daguerrean camera, a Simon Wing multilens wet-plate camera, original Kodak cameras, a preproduction "null series" Leica prototype, Stero Realist prototypes, calotype negatives, Civil War–era ambrotypes, commercial tintypes, and prints by such artists as Ansel Adams, Manuel Alvarez-Bravo, Yolanda Andrade, Walter Evans, Francis Frith, Barbara Morgan, Albert Renger-Patzsch, Carleton Watkins, and Edward Weston.

A small portion of the collections is exhibited permanently in a historical exhibit of fine prints and 80 cameras and a display of Ansel Adams photographs. This is supplemented annually by an extensive temporary exhibition program from the museum's collections, the community, and elsewhere.

California Museum of Photography, University of California, Riverside, 3824 Main St., Riverside, CA 92501. Phone: 409/787-4787. Hours: 11–5 Wed.–Fri.; 11–5 Sat.; 12–5 Sun.; closed New Year's Day, Fourth of July, Thanksgiving, and Christmas. Admission: adults, $2; seniors, children, and students, free.

## UNIVERSITY OF KENTUCKY
*Photographic Archives*

More than 100,000 photographs—as well as manuscripts—documenting the history of photography, Kentucky, Appalachia, and surrounding areas can be found at the University of Kentucky Photographic Archives, a part of the special collections of the M.I. King Library North in Lexington. The collection of photographic materials opened in 1978.

Photographic Archives, University of Kentucky, Special Collections, M.I. King Library North, Lexington, KY 40506-0039. Phone: 606/257-8371. Hours: 8–4:30 Mon.–Fri.; varied hours Sat.–Sun.; closed holidays. Admission: free.

## UNIVERSITY OF LOUISVILLE
*Photographic Archives*

One of the nation's largest collections of documentary photographs—more than 1.2 million images—can be found in the University of Louisville's Photographic Archives in the Ekstrom Library in Louisville, Kentucky. The archives, opened in 1968, also contain photographic equipment, fine art prints, manuscripts, and photographically illustrated books.

Many of the photographs show the faces, houses, streets, industry, and life of Louisville and the surrounding area over the last century. More than 400,000 of the photographs, covering the period from 1903 to 1972, were a gift of Caufield and Shook Inc., local commercial photographers.

Among the other noteworthy collections are the Fine Print Collection, aesthetic photos emphasizing twentieth-century photographers such as Stieglitz, White, Weston, Meatyard, Caponigro, Coburn, and Adams; Clarence John Laughlin Collection, consisting of 17,000 prints, negatives, and other materials by the Louisiana photographer who created natural surrealism images; and Roy Emerson Stryker Collections, composed of three separate collections of a propagandistic nature taken for Stryker when he headed photographic activities at a government agency, an oil company, and a steel corporation.

In addition to long-term exhibits from the collections, the archives present special temporary and traveling exhibitions.

Photographic Archives, University of Louisville, Ekstrom Library, Louisville, KY 40292. Phone: 502/852-6752. Hours: 10–4 Mon.–Fri. (also to 8 Thurs.). Admission: free.

## UNIVERSITY OF MASSACHUSETTS, AMHERST
*University Gallery Photography Collection*

(See Art Galleries section.)

## UNIVERSITY OF NEW MEXICO
### *University Art Museum Photography Collection*

(See Art Museums section.)

## UNIVERSITY OF NORTH CAROLINA AT CHAPEL HILL
### *Ackland Art Museum Photography Collection*

(See Art Museums section.)

## UNIVERSITY OF NOTRE DAME
### *Snite Museum of Art Photography Collection*

(See Art Museums section.)

## UNIVERSITY OF OKLAHOMA
### *Fred Jones Jr. Museum of Art Photography Collection*

(See Art Museums section.)

## UNIVERSITY OF RHODE ISLAND
### *Fine Arts Center Galleries Photography Collection*

(See Art Galleries section.)

## UNIVERSITY OF THE SOUTH
### *University Gallery Photography Collection*

(See Art Galleries section.)

## UNIVERSITY OF SOUTH DAKOTA
### *Stanley J. Morrow Collection (W.H. Over State Museum)*

(See Unaffiliated Museums section.)

## UNIVERSITY OF SOUTH FLORIDA
### *Contemporary Art Museum Photography Collection*

(See Art Museums section.)

## UNIVERSITY OF WASHINGTON
### *Henry Art Gallery Photography Collection*

(See Art Museums section.)

## UNIVERSITY OF WISCONSIN–MADISON
### *Mayer Print Center (Elvehjem Museum of Art)*

(See Art Museums section.)

## UNIVERSITY OF WYOMING
### *University of Wyoming Art Museum Photography Collection*

(See Art Museums section.)

## WELLESLEY COLLEGE
### *Davis Museum and Cultural Center Photography Collection*

(See Art Museums section.)

## WESLEYAN UNIVERSITY
### *Davison Art Center Photography Collection*

(See Art Museums section.)

## WEST TEXAS A&M UNIVERSITY
### *Panhandle-Plains Historical Museum Photography Collection*

(See Historical Museums, Houses, and Sites section.)

# Planetaria and Observatories

*Also see Natural History Museums and Centers; Science and Technology Museums and Centers; and Contract Facilities sections.*

## ADAMS STATE COLLEGE
### *Harry Zacheis Planetarium*

The Science Department at Adams State College in Alamosa, Colorado, operates the Harry Zacheis Planetarium, which opened in 1964. The planetarium, which has a Spitz A3P projector and 65 concentric seats, is used for instructional and public programs.

Harry Zacheis Planetarium, Adams State College, Science Dept., Alamosa, CO 81102. Phone: 719/589-7256. Hours: varies. Admission: free.

## ANGELO STATE UNIVERSITY
### *University Planetarium*

The University Planetarium at Angelo State University in San Angelo, Texas, is one of the largest planetaria in the state. Opened in 1985, the 10,000-square-foot facility has a Spitz 512 projector and 114 unidirectional seats. It presents public sky shows on Thursday evenings and Saturday afternoons.

University Planetarium, Angelo State University, Dept. of Physics, San Angelo, TX 76909. Phone: 915/942-2136. Hours: 8 P.M. Thurs.; 2 Sat.; closed when university not in session. Admission: adults, $3; seniors, university students, and children, $1.50.

## ASSOCIATED UNIVERSITIES INC.
*National Radio Astronomy Observatory*

(See Contract Facilities section.)

## ASSOCIATION OF UNIVERSITIES FOR RESEARCH IN ASTRONOMY INC.
*National Optical Astronomical Observatories*

(See Contract Facilities section.)

## AUGUSTANA COLLEGE
*John Deere Planetarium*

Programs and exhibits are presented by the John Deere Planetarium at Augustana College in Rock Island, Illinois. The planetarium, opened in 1969, has a Spitz A3PR projector and 92 unidirectional seats. The exhibits contain meteorites, space materials, and astronomical equipment.

John Deere Planetarium, Augustana College, Rock Island, IL 61201. Phone: 309/794-7327. Hours: gallery—8–4 Mon.–Fri.; planetarium—by reservation; closed summer and holidays. Admission: free.

## BALL STATE UNIVERSITY
*Ball State University Planetarium*

The Ball State University Planetarium in Muncie, Indiana, was opened in 1967 as part of a new science building. Located on the lower level, the planetarium has a Spitz A3P projector, 77 concentric seats, and a small display area. An observatory is located on the roof of the building.

Ball State University Planetarium, Muncie, IN 47306-0505. Phone: 317/285-8871. Hours: by appointment. Admission: free.

## BEREA COLLEGE
*Weatherford Planetarium and Roberts Observatory*

Berea College in Berea, Kentucky, has a planetarium and an observatory. Weatherford Planetarium, established in 1985, and Roberts Observatory, opened in 1972, are located in the Science Building. The planetarium, which has 51 seats, uses a Minolta MS-10 projector and presents Sunday evening public programs.

Weatherford Planetarium/Roberts Observatory, Berea College, Science Bldg., CPO 2326, Berea, KY 40404. Phone: 606/986-9341. Hours: 7 P.M. Sun.; closed when college not in session. Admission: adults, seniors, and children, $1; college students, free.

## BOB JONES UNIVERSITY
### *Howell Memorial Planetarium*

Bob Jones University in Greenville, South Carolina, operates the Howell Memorial Planetarium, which was founded in 1927. It primarily presents sky shows for school children.

Howell Memorial Planetarium, Bob Jones University, Greenville, SC 29614. Phone: 803/242-5100. Hours: open during school hours; closed school holidays. Admission: free.

## BOWLING GREEN STATE UNIVERSITY
### *Bowling Green State University Planetarium*

The Bowling Green State University Planetarium in Bowling Green, Ohio, was founded in 1983 as part of a new science building. The planetarium, which has a Minolta Viewlex S-IIB projector and 118 seats, presents public programs three nights a week.

Bowling Green State University Planetarium, Dept. of Physics and Astronomy, Bowling Green, OH 43403-0224. Phone: 419/372-8666. Hours: 8 P.M. Tues. and Fri.; 7:30 P.M. Sun.; closed when university not in session. Admission: donation.

## BREVARD COMMUNITY COLLEGE
### *Astronaut Memorial Planetarium and Observatory*

Florida's largest planetarium and public access telescope can be found at the newly renovated Astronaut Memorial Planetarium at Brevard Community College in Cocoa. The facility, originally opened in 1976, underwent a $4.5 million modernization, completed in 1994, that converted it into one of the world's most technologically advanced planetarium and observatory complexes.

The 51,455-square-foot facility includes a 70-foot-diameter planetarium with the Western Hemisphere's first Minolta Infinium projector and 210 seats; a 70-mm IWerks Theater with 175 seats; a 24-inch Cassegrain telescope in the observatory; and an exhibit area devoted to American astronauts.

The planetarium/observatory is a memorial to the men and women of the astronaut corps. Its exhibits include lunar mock-ups used in training Apollo-era astronauts for manned lunar landing missions; a training mock-up of John Glenn's Friendship 7 Mercury space capsule; a German V-2 combustion chamber; and a history of the United States' space program.

Astronaut Memorial Planetarium and Observatory, Brevard Community College, 1519 Clearlake Rd., Cocoa, FL 32922. Phone: 407 632-1111, Ext. 3500. Hours: planetarium—7:30 and 8:30 P.M. Thurs.–Sat.; 3:30 Sat.–Sun.; theater—7:15 and 8:15 P.M. Thurs.–Sat.; 2:45 and 3:45 Sat.–Sun.; closed holidays. Admission: planetarium *or* theater—adults, $4; seniors and students, $3; children 12 and under, $2; combination ticket—adults, $7; seniors and students, $5; children 12 and under, $4.

## BRIGHAM YOUNG UNIVERSITY
### Sarah Summerhays Planetarium

The Sarah Summerhays Planetarium at Brigham Young University in Provo, Utah, was built as a laboratory to support astronomy classes in 1955. The planetarium, which uses a Viewlex/Goto Venus projector and has 65 seats, presents public shows on Friday evenings.

Sarah Summerhays Planetarium, Brigham Young University, Dept. of Physics and Astronomy, Eyririg Science Center, Provo, UT 84602. Phone: 801/378-2805. Hours: 7:30 and 8:30 P.M. Fri.; closed when university not in session. Admission: $1.

## BROWARD COMMUNITY COLLEGE
### Buehler Planetarium

The Buehler Planetarium at Broward Community College in Davie, Florida, offers laser/light shows and telescope viewing as well as planetarium programs. The two-theater facility, built in 1965, has Zeiss M 1015 and Goto projectors. The larger theater has 93 concentric seats.

Buehler Planetarium, Broward Community College, 3501 S.W. Davie Rd., Davie, FL 33314. Phone: 305/475-6681. Hours: 8–5 Mon.–Fri.; 12 noon–4 and 6 P.M.–1 A.M. Sat.–Sun.; closed holidays. Admission: $3, $4, and $5, depending upon times and shows.

## BUTLER UNIVERSITY
### J.I. Holcomb Observatory and Planetarium

The Department of Physics and Astronomy at Butler University operates the J.I. Holcomb Observatory and Planetarium in Indianapolis. Opened in 1954, the planetarium has a Spitz A3P projector and 80 seats for its star shows.

J.I. Holcomb Observatory and Planetarium, Butler University, 4600 Sunset Ave., Indianapolis, IN 46208. Phone: 317/283-9333. Hours: 7:30 and 8:45 P.M. Fri.; 4, 7:30, and 8:45 P.M. Sat. Admission: adults, $2.25, seniors and children 5 and over, $1.25.

## CALIFORNIA ASSOCIATION FOR RESEARCH IN ASTRONOMY
### W.M. Keck Observatory

The world's largest and most powerful optical and infrared telescope is located at the W.M. Keck Observatory—operated by the California Association for Research in Astronomy (a scientific partnership between the California Institute of Technology and the University of California) at the Mauna Kea Observatories complex near Hilo, Hawaii.

The Keck I telescope—made possible by a $70 million grant from the W.M. Keck Foundation—combines 36 hexagonal segments into a 33-foot mirror array with four times the light-gathering power of the 200-inch Hale telescope of

Palomar Observatory. By gathering infrared light passing through interstellar dust clouds shrouding regions where new stars and planets are created, the telescope is designed to enable scientists to see how stars are formed and perhaps planets orbiting newborn stars. The studies are aimed at determining how the solar system developed and how common planetary systems are in the Milky Way.

Keck I, which began full-scale research operations in 1994, has a Visitors' Gallery, open from 9 A.M. to 4 P.M. weekdays. A second identical telescope—called Keck II—is now under construction and will open in 1996. It was made possible by an additional $80 million grant from the W.M. Keck Foundation.

The Mauna Kea Observatories complex, located on a nearly 13,800-foot extinct volcano on the island of Hawaii, is operated as an outstation of the Institute of Astronomy at the University of Hawaii in Honolulu (see University of Hawaii in this section for further information).

W.M. Keck Observatory, California Assistant for Research in Astronomy, PO Box 220, Kamuela, HI 96743. Phone: 808/885-7887. Hours: visitors' gallery—9–4 Mon.–Fri. Admission: free.

## CALIFORNIA INSTITUTE OF TECHNOLOGY
### Palomar Observatory Museum and Gallery

The Palomar Observatory, one of the major astronomical research facilities of the California Institute of Technology, is located on Palomar Mountain, about three hours' driving time from the Pasadena campus. Opened in 1948, it has a small museum and a special gallery overlooking its 200-inch Hale telescope, one of the largest telescopes in the world. However, since the observatory is an ongoing research facility, no public viewing through its telescopes is permitted.

The Hale telescope has had great impact in the astronomical field. It has been used for studies of asteroids and comets within the solar system and stars in the Milky Way galaxy, as well as other galaxies, quasars, and distant objects. Among the other instruments at Palomar are a 48-inch Oschin telescope, which functions as a camera to photograph the entire northern sky; an 18-inch Schmidt telescope; and a 60-inch reflecting telescope, operated jointly by the California Institute of Technology and the Carnegie Institution of Washington.

Palomar Observatory Museum and Gallery, California Institute of Technology, 35899 Canfield Rd., Palomar Mountain, CA 92060. Phone: 818/395-4033. Hours: 9–4:30 daily; closed Christmas Eve and Day. Admission: free.

## CENTRAL CONNECTICUT STATE UNIVERSITY
### Copernican Observatory and Planetarium

The Copernican Observatory and Planetarium at Central Connecticut State University in New Britain opened in 1973. It uses a Spitz 512 projector and has

108 unidirectional seats for its instructional and public sky shows. It also has an observatory open to the public.

Copernican Observatory and Planetarium, Central Connecticut State University, 1615 Stanley St., New Britain, CT 06050. Phone: 203/832-3200. Hours: varies. Admission: adults, $3.25; children, $1.50.

## CLEMSON UNIVERSITY
### Clemson University Planetarium

The Clemson University Planetarium in Clemson, South Carolina, opened in 1961. Located in the Department of Physics and Astronomy's Kinard Laboratory, it uses a Spitz A3P projector and has 45 seats. It presents free programs on a reservation basis.

Clemson University Planetarium, Dept. of Physics and Astronomy, Kinard Laboratory, Clemson, SC 29631. Phone: 803/656-3417. Hours: by group reservation; closed holidays and when university not in session. Admission: free.

## DIABLO VALLEY COLLEGE
### Diablo Valley College Planetarium

(See Natural History Museums and Centers section.)

## EARLHAM COLLEGE
### Ralph Teetor Planetarium (Joseph Moore Museum of Natural History)

(See Natural History Museums and Centers section.)

## EASTERN KENTUCKY UNIVERSITY
### Arnim D. Hummel Planetarium

Academic and public programs are offered at the Arnim D. Hummel Planetarium at Eastern Kentucky University in Richmond. The planetarium opened in 1979 and has a Spitz Sp. Voyager projector and 164 concentric seats.

Arnim D. Hummel Planetarium, Eastern Kentucky University, Richmond, KY 40475. Phone: 606/622-1547. Hours: 7:30 P.M. Thurs.–Fri.; 3:30 and 7:30 Sat.–Sun. Admission: adults, $3.50; seniors and students, $3; children 12 and under, $2.75.

## EASTERN MENNONITE COLLEGE AND SEMINARY
### M.T. Brackhill Planetarium

M.T. Brackhill Planetarium shows are presented in the lobby of the Science Center at Eastern Mennonite College and Seminary in Harrisonburg, Virginia.

The planetarium, which opened in 1968 as part of the new science building and natural history museum, has a Spitz A4 projector and 79 seats.

M.T. Brackhill Planetarium, Eastern Mennonite College and Seminary, Science Center, 1200 Park Rd., Harrisonburg, VA 22801-2462. Phone: 703/432-4400. Hours: by appointment Mon.–Fri.; first and third Sun. Oct.–Mar.; closed holidays. Admission: $1.

## FRANCIS MARION COLLEGE
### Francis Marion College Planetarium

The Francis Marion College Planetarium in Florence, South Carolina, presents free school group and public sky shows. It opened in 1970 and has a Spitz 512 projector and 73 seats.

Francis Marion College Planetarium, Cauthen Educational Media Center, Palmetto St., Florence, SC 29501. Phone: 803/662-3081. Hours: school groups—weekdays by reservation; public shows—3 P.M. second and fourth Sun. Admission: free.

## FRANKLIN AND MARSHALL COLLEGE
### North Museum of Natural History and Science Planetarium

(See Natural History Museums and Centers section.)

## GANNON UNIVERSITY
### Gannon Erie Historical Museum Planetarium

(See Historical Museums, Houses, and Sites section.)

## HARVARD UNIVERSITY
### Harvard-Smithsonian Center for Astrophysics

The Harvard-Smithsonian Center for Astrophysics—a joint operation of Harvard University and the Smithsonian Institution in Cambridge, Massachusetts—combines the resources, staffs, and research facilities of the Harvard College Observatory and the Smithsonian Astrophysical Observatory to study the basic physical processes that determine the nature and evolution of the universe.

The relationship between the Harvard College Observatory, founded in 1839, and the Smithsonian Astrophysical Observatory, established in 1890, began in 1955 when the Smithsonian observatory moved to Cambridge. It was formalized in 1973 by the creation of a joint faculty. The Harvard observatory was a pioneering astronomical facility in America. Its Great Refractor—a 15-inch telescope installed in 1847—was the nation's largest telescope for 20 years.

Today approximately 200 Harvard and Smithsonian scientists work together in a broad range of astrophysical research. These investigations, touching on almost all major topics in modern astronomy, are organized into seven divisions, covering atomic and molecular physics, high energy astrophysics, optical and

infrared astronomy, planetary sciences, radio and geoastronomy, solar and stellar physics, and theoretical astrophysics.

The Harvard-Smithsonian center has been a pioneer in the development of instrumentation for orbiting observatories in space, ground-based gamma-ray astronomy, application of computers to problems of theoretical astrophysics, electronic detectors for optical telescopes, and related image processing by computer; a leader in X-ray astronomy experiments aboard satellites, development of Very Long Baseline Interferometry techniques for radio astronomy, and infrared astronomy; and a participant in the landmark CFA Redshift Survey, a precise determination of distances to some 10,000 galaxies and basis for the Slice of the Universe Survey showing galaxies distributed on the shells of huge, bubble-like, cosmic voids.

The center operates two major field stations—the Fred Lawrence Whipple Observatory at Amado, Arizona, and the Oak Ridge Observatory at Harvard, Massachusetts. The Whipple Observatory, located on 8,500-foot Mount Hopkins, has a visitor center with exhibits; two 34-foot optical reflectors and small "searchlight" reflectors; 48- and 60-inch reflector telescopes; various meteorological instruments; and the Multiple Mirror telescope with a 176-inch equivalent aperture, a joint facility operated by the Smithsonian with the University of Arizona. Guided tours of the observatory are conducted on Mondays, Wednesdays, and Fridays from March through November, with reservations being required. The Oak Ridge Observatory has a 61-inch reflector, sky patrol cameras, and an 84-foot radio antenna (now being used in a search for extraterrestrial intelligence).

The Harvard-Smithsonian Center for Astrophysics presents free programs in popular astronomy on the third Thursday of every month at its headquarters in Cambridge. The evening programs feature a nontechnical lecture, a film, and telescopic observing when weather permits. Special programs for children also are offered twice a year.

Harvard-Smithsonian Center for Astrophysics, 60 Garden St., Cambridge, MA 02138. Phone: 617/495-7461. Hours: 8 P.M. third Thurs. of every month. Admission: free.

Fred Lawrence Whipple Observatory, 670 Mt. Hopkins Rd., PO Box 97, Amado, AZ 85645. Phone: 602/670-5707. Hours: visitor center–9–5 Mon.–Fri.; guided tours—leave at 9 and return at 4 Mon., Wed., and Fri.; closed holidays. Admission: visitor center—free; tours—adults, $7; children, $2.50.

## ILLINOIS STATE UNIVERSITY
### Physics Department Planetarium

The Physics Department Planetarium at Illinois State University in Normal offers public sky shows on Friday evenings and Saturday mornings. Founded in 1964, the planetarium uses a Spitz A3P projector and has 110 concentric seats.

Physics Department Planetarium, Illinois State University, Mail Stop 4560, Normal, IL 61790-4560. Phone: 309/438-8756. Hours: 7:30 P.M. Fri.; 10:30 A.M. Sat.; closed when university not in session. Admission: adults, $1.50; seniors, students, and children 5–12, $1; children under 5, free.

## JAMES MADISON UNIVERSITY
### John C. Wells Planetarium

The John C. Wells Planetarium at James Madison University in Harrisonburg, Virginia, presents free public programs on Thursday evenings. The planetarium opened in 1960 and installed a Goto GX projector in 1975. It has 72 unidirectional seats.

John C. Wells Planetarium, James Madison University, Dept. of Physics, Miller Hall, Harrisonburg, VA 22807. Phone: 703/568-6109. Hours: 7–9 P.M. Thurs.; other times by appointment. Admission: free.

## KALAMAZOO VALLEY COMMUNITY COLLEGE
### Kalamazoo Public Museum Planetarium

(See Historical Museums, Houses, and Sites section.)

## MICHIGAN STATE UNIVERSITY
### Abrams Planetarium

The Abrams Planetarium—part of the College of Natural Science at Michigan State University in East Lansing—is used for public shows and instructional purposes by more than a dozen academic departments. It has served more than a million people since it opened in 1964.

The planetarium has an exhibit gallery with astronomy, meteorite, and space displays and a domed sky theater with a Spitz STP projector and 252 unidirectional seats. It also provides outdoor telescopic observing after evening programs, when sky conditions permit.

The planetarium has offered the nation's first graduate training program for planetarium professionals and National Science Foundation–funded earth science institutes for teachers. More than 30,000 sky-watchers from throughout the world use the planetarium's monthly "Sky Calendar" to guide them in looking at the night sky.

Abrams Planetarium, Michigan State University, Shaw Lane, East Lansing, MI 48824. Phone: 517/355-4676. Hours: exhibit hall—8:30–12 and 1–4:30 Mon.–Fri.; programs— 8 P.M. Fri.–Sat.; 4 Sun.; various other times for public; closed holidays. Admission: exhibit hall—free; programs—adults, $3; seniors and students, $2.50; children 12 and under, $2.

## MONTANA STATE UNIVERSITY
### Ruth and Vernon Taylor Planetarium (Museum of the Rockies)

(See Natural History Museums and Centers section.)

## MUSKEGON COMMUNITY COLLEGE
### Carr-Fles Planetarium

The Carr-Fles Planetarium at Muskegon Community College in Muskegon, Michigan, offers lectures and programs on Tuesday and Thursday evenings. The facility, which opened in 1972, has a Spitz A3P projector and 46 unidirectional seats. An adjacent hallway gallery displays minerals and meteorites.

Carr-Fles Planetarium, Muskegon Community College, 221 S. Quarterline Rd., Muskegon, MI 49442. Phone: 616/777-0289. Hours: 7 P.M. Tues. and Thurs.; closed holidays and when college not in session. Admission: free.

## NIAGARA COUNTY COMMUNITY COLLEGE
### Niagara County Community College Planetarium

The Niagara County Community College Planetarium presents sky shows only to community groups by reservation. Opened in 1973, it has a Spitz A3P projector and 27 semicircular seats.

Niagara County Community College Planetarium, 3111 Saunders Settlement Rd., Sanborn, NY 14132. Phone: 716/713-3271. Hours: by group reservation. Admission: $50 per show for a group.

## OCEAN COUNTY COLLEGE
### Robert J. Novins Planetarium

The Robert J. Novins Planetarium at Ocean County College in Toms River, New Jersey, is named for the founding president of the college. The theater, opened in 1974, has a 40-foot dome, a Minolta Viewlex S-IIB projector, and 119 concentric seats.

Robert J. Novins Planetarium, Ocean County College, College Dr., PO Box 2001, Toms River, NJ 08754-2001. Phone: 908/255-0343. Hours: 8 P.M. Fri.; 1, 2, 3:15, and 8, Sat.; 2 and 3:15 Sun.; schools by appointment. Admission: adults, $4; seniors and college students, $3; children, $3; school groups, varies.

## OHIO STATE UNIVERSITY
### Ohio State University Planetarium

The Ohio State University Planetarium in Columbus was opened in 1968 as a component of the Department of Astronomy and its curriculum. Located on

the fifth floor of an academic building, the planetarium presents monthly public shows. It has a Spitz A3PR projector, 85 chevron seats, and hallway displays. Ohio State University Planetarium, Dept. of Astronomy, 174 W. 18th Ave., Columbus, OH 43210. Phone: 614/292-1773. Hours: hallway exhibits—7 A.M.–9 P.M.; planetarium show—varies. Admission: free.

## OTTERBEIN COLLEGE
### Weitkamp Observatory/Planetarium

The Weitkamp Observatory/Planetarium is located on the rooftop of a campus building at Otterbein College in Westerville, Ohio. The facility, which opened in 1955, has a theater with a Spitz A1 projector and 35 seats and a 30 × 40-foot observing deck with six telescopes, including a 14-inch Celestron telescope. The observatory/planetarium is used 70 percent for classes and 30 percent for public programs.

Weitkamp Observatory/Planetarium, Otterbein College, Dept. of Physics/Astronomy, Westerville, OH 43081. Phone: 614/822-3601. Hours: for class—dusk–10 P.M. Mon.–Fri.; public—dusk to closing (depending upon attendance and weather) Sat.–Sun. Admission: free.

## PARKLAND COLLEGE
### William M. Staerkel Planetarium

The William M. Staerkel Planetarium is part of a cultural center at Parkland College in Champaign, Illinois. Opened in 1987, the planetarium has a 50-foot diameter dome, Zeiss M-1015 projector, 144 seats, and a 4,000-square-foot exhibit area surrounding the theater. The displays feature a wraparound mural, titled *Cosmic Blink,* by Billy Morrow Jackson; a space photo gallery; and a stained glass solar window that disperses the spectrum of colors from the sun. Public planetarium shows are on Friday and Saturday evenings and Saturday afternoon.

William M. Staerkel Planetarium, Parkland College, 2400 W. Bradley Ave., Champaign, IL 61821-1899. Phone: 217/351-2568. Hours: 8–5 Mon.–Fri. (also 7–9:30 Fri.); 11–1 and 7–9:30 Sat.; closed holidays and when college not in session. Admission: adults, $2.50; seniors and college students, $2; children, $1.50.

## PENSACOLA JUNIOR COLLEGE
### Science and Space Theater

The Science and Space Theater at Pensacola Junior College in Pensacola, Florida, opened in 1993 as an upgraded version of an older planetarium (the E.G. Owens Planetarium founded in 1966). It now has a Digistar multidisciplinary system to expand its offerings.

Science and Space Theater, Pensacola Junior College, 1000 College Blvd., Pensacola, FL 32514. Phone: 904/484-2516. Hours: public programs—4 Thurs.; 4, 7, and 8 P.M.

Fri.; 7 and 8 P.M. Sat.; school groups—10 and 11:15 Mon.–Wed.; 11:15 Thurs.; closed holidays and when college not in session. Admission: adults, $3; seniors, $2.50; students and children, $2.

## PITTSBURG STATE UNIVERSITY
### Pittsburg State University Natural History Museum Planetarium

(See Natural History Museums and Centers section.)

## RICHLAND COLLEGE
### Richland College Planetarium

The Richland College Planetarium in Dallas, Texas, presents free public programs on the second and third Saturdays of the month in cooperation with the Texas Astronomical Society. Opened in 1972, the planetarium has a Spitz 512 projector and 102 seats.
Richland College Planetarium, 12800 Abrams Rd., Dallas, TX 75243. Phone: 214/238-6013. Hours: 2 and 3 second and third Sat. Admission: free.

## RICKS COLLEGE
### Ricks College Planetarium

Academic and public programs are presented by the Ricks College Planetarium in Rexburg, Idaho. The planetarium, opened in 1963, has a Spitz A3P projector and 60 concentric seats.
Ricks College Planetarium, Physics Dept., Rexburg, ID 83440. Phone: 208/356-1917. Hours: varies. Admission: adults, $1.25; students, $1.

## SAN FRANCISCO STATE UNIVERSITY
### San Francisco State University Planetarium

The San Francisco State University Planetarium—operated by the Department of Physics and Astronomy—came into being in 1973 as part of a new 10-floor science building. The planetarium is located on the fourth floor and an observatory on the roof. Star shows are presented with a Spitz 512 projector in a theater with 50 concentric seats.
San Francisco State University Planetarium, Dept. of Physics and Astronomy, 1600 Holloway Ave., San Francisco, CA 94132. Phone: 415/338-1852. Hours: school groups—11 A.M. Tues. and Thurs.; public program—12 noon Fri. Admission: free.

## SAN JOAQUIN DELTA COLLEGE
### Clever Planetarium and Earth Science Center

The Clever Planetarium and Earth Science Center at San Joaquin Delta College in Stockton, California, presents star, hemispheric film, and laser shows

and has a dinosaur exhibit with approximately 100 specimens from its collection of over 600 fossils. The facility, which opened in 1983, has a Spitz 512 projector and a 35-mm "fish-eye" optical projection system with 67 concentric seats. The fossil collection—from all parts of the world—was donated by the International Living Fossil Society and Phillip R. Langdon of Placerville.

Clever Planetarium and Earth Science Center, San Joaquin Delta College, 5151 Pacific Ave., Stockton, CA 95207. Phone: 209/474-5051. Hours: 8–12 noon Mon.–Fri. (also 7–9 Fri.); 7–9 P.M. Sat.; 2–4 Sun. Admission: adults, $6; seniors, students, and children, $4.50.

## SAN JUAN COLLEGE
### San Juan College Planetarium

The San Juan College Planetarium in Farmington, New Mexico, presents free sky shows during the academic year. The public shows are scheduled twice a month, with group shows by reservation. The planetarium opened in 1977. It has a Spitz 373 projector and 48 concentric seats.

San Juan College Planetarium, 4601 College Blvd., Farmington, NM 87401. Phone: 505/326-3311. Hours: varies. Admission: free.

## SANTA MONICA CITY COLLEGE
### Santa Monica City College Planetarium

The Santa Monica City College Planetarium in California opened in 1971 with a Minolta MS-8 projector and 55 concentric seats. In addition to its academic programming, the planetarium normally gives public shows. However, the planetarium shows have been discontinued temporarily because of earthquake damage to the building.

Santa Monica City College Planetarium, 1900 Pico Blvd., Santa Monica, CA 90405. Phone: 310/450-5150. Hours: closed temporarily.

## SANTA ROSA JUNIOR COLLEGE
### Santa Rosa Junior College Planetarium

The Santa Rosa Junior College Planetarium in Santa Rosa, California, presents 150 to 200 public shows, 150 to 200 school group shows, and 75 to 100 instructional programs for its college students each year. The planetarium, opened in 1981, has a 40-foot dome, a Spitz-Goto SG-12 projector, 115 special effects projectors, and 87 concentric seats. It offers six different planetarium presentations to school groups.

Santa Rosa Junior College Planetarium, Dept. of Earth and Space Sciences, 1501 Mendocino Ave., Santa Rosa, CA 95472. Phone: 707/527-4640. Hours: school groups—9–4 Tues.–Fri.; public programs—7 and 8:30 P.M. Fri.–Sat.; 1:30 and 3 Sun.; closed some holidays and when college not in session. Admission: school groups—$1 per student; public programs—adults, $3; students and children, $2.

## SOUTH CAROLINA STATE UNIVERSITY
### *I.P. Stanback Museum and Planetarium*

(See Art Museums section.)

## SOUTHWEST STATE UNIVERSITY
### *Museum of Natural History Planetarium*

(See Natural History Museums and Centers section.)

## STATE UNIVERSITY OF NEW YORK AT BUFFALO
### *Whitworth Ferguson Planetarium*

The Whitworth Ferguson Planetarium at the State University of New York at Buffalo has been operating since 1964 when it was opened as part of the new Science Building. It has a Spitz A3P projector and 70 seats.

Whitworth Ferguson Planetarium, State University of New York at Buffalo, 1300 Elmwood Ave., Buffalo, NY 14222-1095. Phone: 716/878-4911. Hours: 9–3 Mon.–Fri.; 1:30–3 Sun.; closed holidays. Admission: weekdays—$1 per person; Sunday programs—adults, $3; seniors and children, $2; university students, $1.

## STATE UNIVERSITY OF NEW YORK COLLEGE AT CORTLAND
### *Bowers Science Museum Planetarium*

(See Natural History Museums and Centers section.)

## TRANSYLVANIA UNIVERSITY
### *W.S. Jones Planetarium (Museum of Early Philosophical Apparatus)*

(See Science and Technology Museums and Centers section.)

## TRITON COLLEGE
### *Cernan Earth and Space Center*

The Cernan Earth and Space Center at Triton College in River Grove, Illinois, is a planetarium with exhibits related to astronomy, space, science, and earth science. Founded in 1974 and reopened in a new building in 1984, the center is named for Eugene A. Cernan, an astronaut from the area who flew aboard the Gemini 9, Apollo 10, and Apollo 17 space missions.

The planetarium has a 44-foot-diameter domed theater equipped with a planetarium star projector, a special C-360 motion picture projector, a laser projection system, a large-format video projection system, a stereo sound system, and

scores of slide and special effects projectors. It presents a wide range of programming, including earth and sky shows, children's shows, and laser light shows that choreograph laser images and special visual effects to music. The planetarium shows deal with such subjects as the current night sky, planets in the solar system, the weather and climate of Earth, the space shuttle, and the age of dinosaurs.

The Space Hall contains Cernan's Apollo 10 spacesuit and coverall garment, an Apollo lunar landing diorama, a space shuttle interactive video exhibit, a color weather radar station, a small-scale space shuttle model, an Illinois fossil exhibit, a telescope exhibit, Apollo 17 moon gloves, and a teacher-in-space memorial exhibit. Outdoor exhibits include an Apollo practice capsule and a Nike Tomahawk missile.

Cernan Earth and Space Centers, Triton College, 2000 N. Fifth Ave., River Grove, IL 60171. Phone: 708/456-0300. Hours: 9–5 Mon.–Wed.; 9–10 P.M. Thurs.–Fri.; 1–10 Sat.; 1–4 Sun.; closed major holidays. Admission: earth and sky show—adults, $5; seniors and children, $2.50; laser show—adults, $5.50; seniors and children, $2.75.

## TROY STATE UNIVERSITY
### W.A. Gayle Planetarium

The W.A. Gayle Planetarium in Montgomery, Alabama, is a joint facility of the city and Troy State University. Founded in 1968, it has a Spitz Nova III projector and 236 seats for its star shows.

W.A. Gayle Planetarium, Troy State University, 1010 Forest Ave., Montgomery, AL 36106. Phone: 205/241-4799. Hours: public programs—2 Sat.–Sun.; school programs—Mon.–Fri. by reservation. Admission: adults, $2; students, $1; children under 6 not admitted to public programs.

## U.S. AIR FORCE ACADEMY
### Center for Educational Multimedia

The Center for Educational Multimedia at the U.S. Air Force Academy near Colorado Springs, Colorado, presents public planetarium programs as well as supporting courses in academic and military training for cadets. The 150-seat planetarium, which opened to the public in 1959, uses a Digistar projection system for its sky shows.

Center for Educational Multimedia, U.S. Air Force Academy, CWISP, 2120 Cadet Dr., USAF Academy, CO 80840-6100. Phone: 719/472-2779. Hours: varies; closed major holidays. Admission: free.

## UNIVERSITY CORPORATION FOR ATMOSPHERIC RESEARCH
### National Center for Atmospheric Research

(See Contract Facilities section.)

# UNIVERSITY OF ARIZONA
## *Flandrau Science Center and Planetarium*

(See Science and Technology Museums and Centers section.)

# UNIVERSITY OF ARKANSAS AT LITTLE ROCK
## *University of Arkansas at Little Rock Planetarium*

The University of Arkansas at Little Rock Planetarium, which opened in 1975, uses a Minolta/Viewlex S-IIB projector and has 150 concentric seats for its star shows.

University of Arkansas at Little Rock Planetarium, 2801 S. University Ave., Little Rock, AR 72204. Phone: 501/569-3259. Hours: 8–4:30 Mon.–Fri. (also at 7:30 Fri.); 2:30 Sun.; closed major holidays. Admission: adults, $3; students and children, $2.

# UNIVERSITY OF CALIFORNIA
## *Lick Observatory*

The University of California's Lick Observatory—located on Mount Hamilton, near San Jose and Santa Cruz—has been a major astronomical research center since 1888. It is one of the oldest permanently occupied mountain observatories. It bears the name of James Lick, an eccentric millionaire who donated $3 million for such an observatory in 1874. He is buried at the base of the observatory's 90-centimeter telescope (the world's largest at the time it was built).

The Lick Observatory has pioneered in many fields of astronomy. Its contributions include double-star observations, discovery of four of Jupiter's moons, proof of widespread absorption and reddening of starlight by interstellar particles, determination of spectral characteristics of interstellar extension, counting of galaxies, and historic spectroscopic investigations and radial velocity determinations. It currently is focusing on the problems of galaxies and quasars and the structure, composition, and evolution of stars and star clusters.

The observatory has seven major optical instruments and extensive auxiliary equipment. The largest telescope is the 120-inch Shane reflecting telescope, while the newest is a 30-inch Katzman robotic reflector. Others include the 40-inch Anna Nickel reflector, 36-inch refracting telescope, 36-inch Crossley reflector, Coude auxiliary telescope, 24-inch Cassegrain reflector, and 20-inch Carnegie photographic refractor.

Lick Observatory has a Visitors' Center, a gallery overlooking the 120-inch Shane reflecting telescope, and photographic exhibits. It operates a Friday evening summer program that includes a lecture and viewing of selected astronomical objects with the 36-inch refracting telescope.

Lick Observatory, University of California, PO Box 85, Mount Hamilton, CA 95140. Phone: 408/274-5061. Hours: visitors' center—12:30–5 Mon.–Fri.; 10–5 Sat.–Sun.; gallery—10–5 daily; closed Thanksgiving and Christmas Eve and Day. Admission: free.

## UNIVERSITY OF CALIFORNIA, BERKELEY
### William K. Holt Planetarium (Lawrence Hall of Science)

(See Science and Technology Museums and Centers section.)

## UNIVERSITY OF COLORADO AT BOULDER
### Fiske Planetarium and Science Center

The Fiske Planetarium and Science Center at the University of Colorado in Boulder offers planetarium shows and lectures, science exhibits, and observatory viewing. Built with funds left to the university by Wallace Fiske, it opened in 1975.

The 8,000-square-foot facility, part of the Astrophysical, Planetary, and Atmospheric Sciences Department, offers programs for university classes, school groups, and the general public.

The theater makes use of a Zeiss Mark VI projector, two panorama systems, over 100 special effects projectors, more than 70 slide projectors, and a digital automation projection system. A lobby exhibit area contains displays on telescopes, the solar system, and optics. The Sommers-Bausch Observatory is open to public viewing on Friday evenings.

Fiske Planetarium and Science Center, University of Colorado, Regent Dr., Campus Box 408, Boulder, CO 80309-0408. Phone: 303/492-5002. Hours: academic year—8–5 Mon.–Fri. (also 7–9 Fri.); 1:30–3:30, Sat.; summer—8–5 Mon.–Fri. (also 7:30–9:30 Fri.); observatory—sunset–11 P.M. Fri.; closed major holidays. Admission: science center and observatory—free; evening planetarium shows—adults, $3; seniors, students, and children, $1.75; matinee planetarium shows—adults, $2.25; children, $1.50.

## UNIVERSITY OF HAWAII
### Mauna Kea Observatories

The Mauna Kea Observatories comprise an extensive astronomical complex located on Mauna Kea (White Mountain), a nearly 13,800-foot extinct volcano near Hilo on the island of Hawaii, that is operated as an outstation of the University of Hawaii's Institute of Astronomy in Honolulu. It has a number of telescopes and observatories and a visitor center near the Onizuka Center for International Astronomy, about 8.5 miles below the mountain summit.

Mauna Kea, which rises approximately 32,000 feet from the ocean floor and is the highest island-mountain in the world, has special qualities that make it one of the best astronomical observing sites—very dry air allows for sharp images, 50 percent of all nights are clear and stable over long periods, and the sky is extremely dark because of the low population density and the lack of low-level clouds that normally obscure populated areas at night.

The initial 24-inch optical telescopes were built in 1968–1969 by the Institute

for Astronomy after the National Aeronautics and Space Administration (NASA) showed interest in erecting a giant telescope on Mauna Kea in connection with its planetary programs. Since then, NASA and the University of Hawaii have added an 88-inch optical/infrared telescope; NASA installed a 120-inch infrared telescope facility; Canada, France, and Hawaii built a 144-inch optical/infrared telescope; the United Kingdom constructed a 150-inch infrared telescope; the California Institute of Technology and the National Science Foundation added a 410-inch submillimeter observatory; the United Kingdom, the Netherlands, and Canada built the 590-James Clerk Maxwell telescope for millimeter and submillimeter work; and the California Association for Research in Astronomy (a scientific partnership of the California Institute of Technology and the University of California) has opened the world's largest and most powerful optical/infrared telescope, which combines 36 hexagonal segments into a 33-foot mirror array with four times the light-gathering power of the 200-inch Hale telescope at Palomar Observatory (see California Association for Research in Astronomy in this section).

The astronomical research programs carried out at Mauna Kea cover nearly every aspect of astronomy. They include optical and infrared studies of planetary atmospheres, surfaces and atmospheres of planetary satellites, extended coronas of planets, and planetary ring systems; studies of solar-like variations in stars of various ages, the chemical composition of stars, and stellar evolution; and studies of distant faint objects, such as galaxies beyond our own, which play a fundamental role in determining the nature, origin, and future evolution of the universe.

The Visitors' Information Station, located at 9,300 feet, is open Friday through Sunday year-round. The 88-inch telescope and the Canada-France-Hawaii telescope also have visitors' galleries. On weekends, guided tours are given. On Friday and Saturday evenings, an information program beginning at 7 P.M. is presented in the information center, followed by stargazing through the 11- and 18-inch telescopes, weather permitting. During the summer, tours to the summit of Mauna Kea are given at 2 P.M. Saturday and Sunday.

Mauna Kea Observatories, Visitors' Information Station, Saddie Rd. near Rte. 20, Hilo, HI (address inquiries to Institute of Astronomy, University of Hawaii at Manoa, 2680 Woodlawn Dr., Honolulu, HI 96823). Phone: 808/961-2180. Hours: 1–5 Fri.; 8–12 and 1–2 Sat.–Sun. Admission: free.

## UNIVERSITY OF LOUISVILLE
### Joseph Rauch Memorial Planetarium

The Joseph Rauch Memorial Planetarium at the University of Louisville in Louisville, Kentucky, presents instructional and public programs. The planetarium, which opened in 1962, uses a Spitz 512A projector and has 100 concentric seats.

Joseph Rauch Memorial Planetarium, University of Louisville, Belknap Campus, Louisville, KY 40292. Phone: 502/588-6665. Hours: varies; closed holidays. Admission: adults, $3.50; seniors, students, and children 12 and under, $2.50.

## UNIVERSITY OF MAINE
### Maynard E. Jordan Planetarium

Weekend star shows are presented in the 50-seat Maynard E. Jordan Planetarium at the University of Maine in Orono. Opened in 1954, the planetarium has a Spitz 373 projector. It is located in a nineteenth-century classroom/laboratory building.

Maynard E. Jordan Planetarium, University of Maine, 5781 Wingate Hall, Orono, ME 04469-5781. Phone: 207/581-1341. Hours: 7–8 P.M. Sat.–Sun. Admission: adults, $4; seniors and children, $3; university students, free.

## UNIVERSITY OF MICHIGAN
### Ruthven Planetarium Theatre (Exhibit Museum)

(See Natural History Museums and Centers section.)

## UNIVERSITY OF NEBRASKA–LINCOLN
### Ralph Mueller Planetarium (University of Nebraska State Museum)

(See Natural History Museums and Centers section.)

## UNIVERSITY OF NEBRASKA–OMAHA
### Mallory Kountze Planetarium

The Department of Physics at the University of Nebraska at Omaha presents sky and laser shows in the Mallory Kountze Planetarium. The planetarium, which opened in 1987, has a Spitz 512 projector and 60 unidirectional seats.

Mallory Kountze Planetarium, University of Nebraska at Omaha, Dept. of Physics, 60th and Dodge, Omaha, NE 68182. Phone: 402/554-3727. Hours: sky shows—2 and 3:30 Sat.–Sun.; laser shows—7, 8:30, and 10 P.M. Fri.–Sat. Admission: sky shows—adults, $3; children 12 and under, $2; laser shows—adults, $4; children 12 and under, $3.

## UNIVERSITY OF NEVADA AT RENO
### Fleischmann Planetarium

The Fleischmann Planetarium at the University of Nevada at Reno was founded in 1963 as the Fleischmann Atmospherium/Planetarium with a gift from the Max C. Fleischmann Foundation of Nevada. It was the first to feature an all-sky motion picture system to photograph and project hemispheric time-lapse films of weather systems and clouds. Over the years, the emphasis of public

programs changed from meteorology to astronomy. The planetarium now has star shows, Cinema-360 hemispheric films, astronomy/space sciences exhibits, and observatory viewing.

The planetarium has a Minolta Viewlex S-IIB projector and 50 seats. The exhibits consist of 6-foot globes of the Earth and Moon, interactive computer-based learning exhibits, transparencies of astronomical objects, and a meteorite collection. The observatory's telescope viewing is offered two to three nights per week in the summer and weekly in the winter.

Fleischmann Planetarium, University of Nevada at Reno, Mail Stop 272, Reno, NV 89557-0010. Phone: 702/784-4812. Hours: exhibit area—8–5 and 7–9 Mon.–Fri.; 12–10 Sat.–Sun.; planetarium shows—3 and 7:30 Mon.–Fri.; 12, 1:30, 3, 5:30, 7:30, and 9 Sat.–Sun. Admission: exhibit area—free; planetarium shows—adults, $5; university students, $4.50; seniors and children, $3.50.

## UNIVERSITY OF NORTH CAROLINA AT CHAPEL HILL
### Morehead Planetarium

The Morehead Planetarium at the University of North Carolina in Chapel Hill resulted from John Motley Morehead's wish to do something special for the children of North Carolina. Harlow Shapley, the eminent Harvard astronomer, advised him that a planetarium could be a source of great cultural enrichment to citizens of all ages—and Morehead agreed.

The planetarium, which opened in 1949, emphasizes science education for all ages largely through the presentation of lecture-demonstrations on astronomical and scientific topics in a 330-seat theater with a Zeiss Mark VI projector. The programs take the form of presentations for students and the general public about the universe and special programming to meet the needs of space science educators in public schools.

The exhibit halls have exhibits on the science of astronomy, a collection of artworks, and changing shows by contemporary artists. A sundial Rose Garden is outside the domed planetarium building.

In the 1960s and 1970s, the planetarium staff worked with the National Aeronautics and Space Administration in training Mercury, Gemini, Apollo, and Apollo-Soyuz mission astronauts in celestial recognition, orbital mechanics, and aspects of mission profiles.

Morehead Planetarium, University of North Carolina at Chapel Hill, E. Franklin St., CB 3480, Chapel Hill, NC 27599-3480. Phone: 919/962-1236. Hours: 12:30–5 and 7–9:45 Sun.–Fri.; 10–5 and 7–9:45 Sat.; closed Christmas Eve and Day. Admission: Adults, $3; seniors, students, and children, $2.50.

## UNIVERSITY OF TEXAS
### McDonald Observatory

The University of Texas McDonald Observatory, founded in 1932, is located on Mount Locke in the Davis Mountains near Fort Davis. Visitors check in at

the W.L. Moody Jr. Visitors' Information Center, which features astronomy exhibits, films, tours, and observatory viewing. The center staff conduct solar viewing sessions at 11 A.M. and 3:30 P.M. daily and offer observatory complex tours at 2 P.M. daily (with an additional tour in March and June–August).

The center hosts a star party every Tuesday, Friday, and Saturday at the Public Observatory at 30 minutes after sunset. Visitors have an opportunity to view the planets, moons, galaxies, and other celestial objects through 14- and 24-inch telescopes. The McDonald Observatory's largest telescope—a 107-inch telescope—is opened to the public for an evening program once a month. Attendance is limited to 60 people, with reservations being required approximately six months in advance.

McDonald Observatory, Visitors' Information Center, University of Texas, PO Box 1337, Fort Davis, TX 79734. Phone: 915/426-3263. Hours: 9–5 daily, as well as evening programs certain days; closed New Year's, Thanksgiving, and Christmas. Admission: free; public night on 107-inch telescope—adults, $5; students and seniors, $4; children under 12, $2.50.

## UNIVERSITY OF VIRGINIA
### Leander J. McCormick Observatory

A 26-inch Alvin Clark refracting telescope is featured at the Leander J. McCormick Observatory at the University of Virginia in Charlottesville. The observatory, which opened in 1885, has a photographic plate archive from 1914 to the present, as well as an exhibit of astronomical photographs.

Leander J. McCormick Observatory, University of Virginia, Dept. of Astronomy, PO Box 3818, Charlottesville, VA 22903-0818. Phone: 804/924-7494. Hours: 8–10 P.M. first and third Fri. of month. Admission: free.

## UNIVERSITY OF WISCONSIN–LaCROSSE
### University of Wisconsin–LaCrosse Planetarium

The University of Wisconsin–LaCrosse Planetarium was opened in 1967 as part of a new science building. Located in the basement of the Cowley Hall of Science, it has a Spitz A3P projector and 50 concentric seats.

University of Wisconsin–LaCrosse Planetarium, Cowley Hall of Science, LaCrosse, WI 54601. Phone: 608/785-8669. Hours: public programs—7–9 P.M. Mon.–Fri.; school groups—by appointment; closed holidays and when university not in session. Admission: adults, $1.50; seniors and students, $1.

## UNIVERSITY OF WISCONSIN–MILWAUKEE
### Manfred Olson Planetarium

The Manfred Olson Planetarium in the Physics Building at the University of Wisconsin–Milwaukee presents public shows as well as academic offerings. Opened in 1964, it has a Spitz A3P projector and 65 concentric seats.

Manfred Olson Planetarium, Physics Bldg., University of Wisconsin–Milwaukee, Milwaukee, WI 53201. Phone: 414/229-4961. Hours: 7 and 8:15 P.M. Fri.; closed summer and when university not in session. Admission: adults and children over 6, $1; university students, 75¢.

## UNIVERSITY OF WISCONSIN–STEVENS POINT
### Planetarium and Observatory

The University of Wisconsin–Stevens Point offers planetarium and laser light shows and observatory viewing in the Science Building. Opened in 1964 and operated by the Department of Physics and Astronomy, the Planetarium uses a Spitz A3P projector and has 70 seats. The Observatory is open after evening planetarium shows when weather permits.

Planetarium and Observatory, University of Wisconsin–Stevens Point, Dept. of Physics and Astronomy, Science Bldg., Stevens Point, WI 54481-3897. Phone: 715/346-2208. Hours: planetarium programs—8 P.M. Mon.; 2 Sun.; laser light shows—8 and 9:30 P.M. Wed.; closed holidays and when university not in session. Admission: planetarium—free; laser light shows—$1 per person.

## VIRGINIA MILITARY INSTITUTE
### Klink Observatory

The Klink Observatory at the Virginia Military Institute in Lexington is used primarily for research purposes, but does present occasional school group and public programs. Founded in 1966 as the VMI Observatory, the Department of Physics and Astronomy facility has a 20-inch computerized telescope. The department's Sale Planetarium has been discontinued.

Klink Observatory, Virginia Military Institute, Dept. of Physics and Astronomy, Lexington, VA 24450. Phone: 703/464-7225. Hours: by appointment; closed holidays and when institute not in session. Admission: free.

## WEST CHESTER UNIVERSITY
### Planetarium and Observatory

West Chester University's Department of Geology and Astronomy operates the Planetarium and Observatory on the campus in West Chester, Pennsylvania. The Planetarium, which opened in 1969, has a Spitz A4 projector and 73 unidirectional seats.

Planetarium and Observatory, West Chester University, Dept. of Geology and Astronomy, West Chester, PA 19383. Phone: 610/436-2727. Hours: planetarium—by group reservation; observatory—sunset–10:30 P.M. Thurs.; closed holidays and when university not in session. Admission: free.

## WESTERN KENTUCKY UNIVERSITY
### Hardin Planetarium

The Hardin Planetarium at Western Kentucky University in Bowling Green has astronomical exhibits and an observatory in addition to a planetarium. Opened in 1967, it has a Spitz A3P projector and 150 concentric seats.

Hardin Planetarium, Western Kentucky University, 1526 Russellville Rd., Bowling Green, KY 42101. Phone: 502/745-2592. Hours: 8–4:30 Mon.–Fri.; closed summer and holidays. Admission: free.

## WIYN CONSORTIUM
### WIYN Observatory

The WIYN Observatory on Kitt Peak near Tucson, Arizona, is owned and operated by the WIYN Consortium, consisting of the University of Wisconsin, Indiana University, Yale University, and the National Optical Astronomy Observatories. The universities provided most of the capital costs of the observatory, while the National Optical Astronomy Observatories—operated by the Association of Universities for Research in Astronomy Inc. under a National Science Foundation contract—furnish most of the operating services.

The WIYN Observatory is part of the world's largest concentration of optical telescopes on Kitt Peak (see Association of Universities for Research in Astronomy Inc. in the Contract Facilities section). The observatory has a 3.5-meter telescope, completed in 1994, equipped with state-of-the-art scientific instruments for astronomical spectroscopy and imaging. A multiple-object spectrograph employing optical fibers allows the simultaneous observation of the spectra of 100 objects. The imaging cameras employ highly sensitive arrays of electronic detectors.

Exhibits about the WIYN Observatory can be seen at the Kitt Peak Visitor Center, which serves all the facilities at the site.

Kitt Peak Visitor Center, PO 26732, Tucson, AZ 85726. Phone: 602/322-3426. Hours: 9–3:45 daily; closed major holidays. Admission: free.

## WOFFORD COLLEGE
### Wofford College Planetarium

The Wofford College Planetarium in Spartanburg, South Carolina, presents free public education programs by appointment. Opened by the Department of Physics in 1953, it has a Viewlex projector and 50 seats.

Wofford College Planetarium, 429 N. Church St., Spartanburg, SC 29303-3663. Phone: 803/597-4640. Hours: by reservation. Admission: free.

## YOUNGSTOWN STATE UNIVERSITY
### *Ward Beecher Planetarium*

The Ward Beecher Planetarium at Youngstown State University in Youngstown, Ohio, presents star shows, laser light programs, science demonstrations, and live concerts. The facility, opened in 1967 in the science building, uses a Spitz A3PR projector and has 145 seats.

Ward Beecher Planetarium, Youngstown State University, 410 Wick Ave., Youngstown, OH 44555-0001. Phone: 216/742-3616. Hours: varies. Admission: free.

# Religious Museums

## ANDERSON UNIVERSITY
### Gustav Jeeninga Museum of Bible and Near Eastern Studies

Archaeological objects and replicas of major Biblical finds can be seen at the Gustav Jeeninga Museum of Bible and Near Eastern Studies, which is part of the Department of Bible and Religion located in the School of Theology Building at Anderson University in Anderson, Indiana. The museum was founded in 1963.

Gustav Jeeninga Museum of Bible and Near Eastern Studies, Anderson University, 1123 E. Third St., Anderson, IN 46011. Phone: 317/649-9071. Hours: 8–5 Mon.–Fri.; closed holidays and when university not in session. Admission: free.

## AUGUSTANA COLLEGE
### Center for Western Studies

The Center for Western Studies at Augustana College in Sioux Falls, South Dakota, is a library, archives, and museum concerned primarily with the history and study of the Episcopal Church, United Church of Christ, and Plains Indians in the region.

Founded in 1970, the center occupies 9,000 square feet on the ground floor of the college library. Approximately 10 percent of the space is devoted to the museum. Among the center collections are the archives of the college, Episcopal Diocese of South Dakota, and United Church of Christ–South Dakota Conference; Native American artifacts; paintings and prints of regional artists; Nor-

wegian rosemal furniture from the nineteenth century; and the papers of Stephen
Riggs, Herbert Krause, Emil Loriks, and Harold Shunk.
Center for Western Studies, Augustana College, 29th and Summit, Box 727, Sioux Falls,
SD 57197. Phone: 605/336-4007. Hours: 8–5 Mon.–Fri.; closed holidays. Admission:
free.

## BAKER UNIVERSITY
### William A. Quayle Bible Collection

The William A. Quayle Bible Collection at Baker University in Baldwin City,
Kansas, consists of approximately 600 Bibles or portions thereof, including il-
luminated manuscripts and incunabula. Established in 1925, the collection is
located in the Spencer Quayle Wing of Collins Library.
William A. Quayle Bible Collection, Baker University, Collins Library, Eighth and Grove
Sts., Baldwin City, KS 66006. Phone: 913/594-6451, Ext. 414. Hours: academic year—
8–5 and 6:30–11 Mon.–Fri.; 1–5 Sat.; 1–5 and 7–11 Sun.; summer—8–4:30 Mon.–Fri.;
closed holidays and when university not in session. Admission: free.

## BETHEL COLLEGE
### Kauffman Museum

(See Archaeology, Anthropology, and Ethnology Museums section.)

### Mennonite Library and Archives
(See Library and Archival Collections and Galleries section.)

## BOB JONES UNIVERSITY
### Bob Jones University Collection of Sacred Art

The Bob Jones University Collection of Sacred Art in Greenville, South Car-
olina, has one of the most outstanding collections of religious art in America.
The collection was started in 1951 by Dr. Bob Jones, chancellor of the university
founded in 1927 to "train outstanding Christian leaders in all walks of life."
The museum features 30 galleries with more than 400 paintings and other
works, including European sacred art from the thirteenth to the nineteenth cen-
turies. It contains important works by such major artists as Rembrandt, Tinto-
retto, Titian, Veronese, Sebastiano del Piombo, Cranch, Gerard David, Murillo,
Ribera, Rubens, Van Dyck, Honthorst, and Doré.
The museum has seven paintings by Benjamin West from the *Revealed Re-
ligion* series, originally planned for a chapel at Windsor Castle that never ma-
terialized. It also has the Bowen Bible Lands Collection, which includes
life-sized mannequins with Biblical costumes, 4,000-year-old Egyptian and Syr-
ian vases, an 80-foot-long Hebrew Torah scroll written on gazelle skin, and a
model of Solomon's temple.
The museum's collection of Russian icons shows their development over the

centuries, while its Renaissance furniture has been called among the finest in America. The latter includes several large hand-carved walnut chests, along with chairs, tables, a section of a hand-carved choir stall, and an oak ecclesiastical throne.

Bob Jones University Collection of Sacred Art, 1700 Wade Hampton Blvd., Greenville, SC 29614. Phone: 803/242-5100, Ext. 1050. Hours: 2–5 Tues.–Sun.; closed New Year's Day, Fourth of July, and Dec. 20–25. Admission: free.

## BRIDGEWATER COLLEGE
### Reuel B. Pritchett Museum

(See General Museums section.)

## CENTRAL METHODIST COLLEGE
### Missouri United Methodist Archives

The Missouri United Methodist Archives—containing materials related to the development of the Methodist Church in the state and area—are located in the Central Methodist College library in Fayette, Missouri. The archives were established in 1972.

Missouri United Methodist Archives, Central Methodist College, Library, Fayette, MO 65248. Phone: 816/248-3391. Hours: 8–5 Mon.–Fri.; closed holidays. Admission: free.

## GEORGETOWN UNIVERSITY
### Georgetown University Collection

(See Art Museums section.)

## HEBREW UNION COLLEGE
### Skirball Museum

(See Archaeology, Anthropology, and Ethnology Museums section.)

## HEBREW UNION COLLECTION–JEWISH INSTITUTE OF RELIGION
### Skirball Museum, Cincinnati Branch

(See Archaeology, Anthropology, and Ethnology Museums section.)

## INDIANA UNIVERSITY
### Indiana University Art Museum Religious Collection

(See Art Museums section.)

## JEWISH THEOLOGICAL SEMINARY OF AMERICA
### *Jewish Museum*

(See Archaeology, Anthropology, and Ethnology Museums section.)

## LAWRENCE UNIVERSITY
### *Bjorklunden Chapel*

The Bjorklunden Chapel, located in Baileys Harbor, Wisconsin, on the Door County peninsula is a replica of an ancient Norwegian stavkirke. Founded in 1939, it is a cooperative project of Lawrence University with the Door County Chamber of Commerce. The chapel contains hand-carved articles and paintings. Bjorklunden Chapel, Lawrence University, 7603 Chapel Lane, PO Box 92, Baileys Harbor, WI 54202. Phone: 414/839-2216. Hours: mid-June–Aug.—1–3:30 Mon. and Wed.; closed remainder of year. Admission: adults, $2.

## LOUISVILLE PRESBYTERIAN THEOLOGICAL SEMINARY
### *Horn Archaeological Museum*

The Horn Archaeological Museum at Louisville Presbyterian Theological Seminary in Louisville, Kentucky, is a religious and archaeology museum founded in 1930. Its collections include Palestinian pottery, Biblical characters, a Cypriot juglet, a clay tablet, and various Palestinian artifacts. The museum also has a reproduction of the Dead Sea Scroll of Isaiah and a map tracing the exodus of the Israelites from Egypt.
Horn Archaeological Museum, Louisville Presbyterian Theological Seminary, 1044 Alta Vista Dr., Louisville, KY 40205. Phone: 502/895-3411. Hours: 8:30 A.M.– P.M. Mon.–Thurs.; 8:30–5 Fri.; 12–5 Sat.; 5–10 P.M. Sun. Admission: free.

## LOYOLA MARYMOUNT UNIVERSITY
### *Laband Art Gallery*

(See Art Galleries section.)

## LOYOLA UNIVERSITY CHICAGO
### *Martin D'Arcy Gallery of Art*

(See Art Museums section.)

## MARQUETTE UNIVERSITY
### *Patrick and Beatrice Haggerty Museum of Art*

(See Art Museums section.)

# 580

MISSISSIPPI COLLEGE

## MISSISSIPPI COLLEGE
*Mississippi Baptist Historical Commission Collection*

(See Unaffiliated Museums section.)

## NEBRASKA WESLEYAN UNIVERSITY
*Nebraska United Methodist Historical Center*

(See Unaffiliated Museums section.)

## PACIFIC SCHOOL OF RELIGION
*Bade Institute of Biblical Archaeology and Howell Bible Collection*

The Bade Institute of Biblical Archaeology and Howell Bible Collection at the Pacific School of Religion in Berkeley, California, trace their origins to 1926. As the names imply, Biblical archaeology is the focus. The collections include materials from Tell en-Nasbeh, Israel, believed to have been the site of Mizpah; Reformation-printed and other European Bibles; facsimiles of early Greek Biblical codices; and artifacts from Egypt, Syria, Cyprus, Greece, and Rome.
Bade Institute of Biblical Archaeology and Howell Bible Collection, Pacific School of Religion, 1798 Scenic Ave., Berkeley, CA 94709. Phone: 510/848-0528. Hours: 9–12 and 1–4:30 Mon.–Fri.; weekends by appointment. Admission: free.

## SAINT MARY'S COLLEGE OF CALIFORNIA
*Hearst Art Gallery*

(See Art Museums section.)

## SANTA CLARA UNIVERSITY
*de Saisset Museum*

(See Art Museums section.)

## SOUTHERN BAPTIST THEOLOGICAL SEMINARY
*Joseph A. Callaway Archaeological Museum*

The Joseph A. Callaway Archaeological Museum at the Southern Baptist Theological Seminary in Louisville, Kentucky, is a Biblical archaeology museum. Founded in 1963, it has collections of glass, textiles, pottery, papyri, sculpture, numismatics, and excavation materials from Jericho, Macherus, and elsewhere.
Joseph A. Callaway Archaeological Museum, Southern Baptist Theological Seminary, 2825 Lexington Rd., Louisville, KY 40280. Phone: 502/897-4011. Hours: 8–4:30 Mon.–Fri.; closed holidays. Admission: free.

## SPERTUS COLLEGE OF JUDAICA
### Spertus Museum

(See Archaeology, Anthropology, and Ethnology Museums section.)

## UNIVERSITY OF ROCHESTER
### Memorial Art Gallery Religious Collection

(See Art Museums section.)

## UNIVERSITY OF SAN DIEGO
### Mission Basilica de Alcala

The Mission Basilica de Alcala, located in San Diego, California, is a historic site museum affiliated with the University of San Diego and the Roman Catholic Diocese of San Diego. The mission was built in 1769 and served as the first rectory and residence of Fray Junipero Serra. Among its collections are Native American baskets, artifacts from the Spanish colonial and American occupation periods, ecclesiastical objects, archaeological findings, and archives.
Mission Basilica de Alcala, 10818 San Diego Mission Rd., San Diego, CA 92108. Phone: 619/283-7319. Hours: 9–5 daily; closed Thanksgiving and Christmas. Admission: adults, $1; children under 12, free.

## UNIVERSITY OF WISCONSIN–MILWAUKEE
### UWM Art Museum Religious Collection

(See Art Museums section.)

## WHEATON COLLEGE
### Billy Graham Center Museum

A visual history of the growth of evangelism in the United States can be seen at the Billy Graham Center Museum at Wheaton College in Wheaton, Illinois. The exhibits trace evangelism from Colonial church leaders through the ministry of recent American evangelists, including the Reverend Billy Graham, and climax with a presentation of the gospel. The museum, which opened in 1975, has collections of historical materials and manuscripts relating to missions, evangelism, church history, and general theology.
Billy Graham Center Museum, Wheaton College, 500 E. College Ave., Wheaton, IL 60187. Phone: 708/752-5909. Hours: 9:30–5:30 Mon.–Sat.; 1–5 Sun. Admission: free.

# Science and Technology Museums and Centers

*Also see Natural History Museums and Centers and Planetaria and Observatories sections.*

## COLLEGE OF SOUTHERN IDAHO
### *Herrett Museum*

(See Archaeology, Anthropology, and Ethnology Museums section.)

## HARVARD UNIVERSITY
### *Collection of Scientific Instruments*

The Collection of Scientific Instruments at Harvard University in Cambridge, Massachusetts, is a repository of important scientific apparatus and for teaching and research. Established in 1949, the collection includes a broad range of scientific equipment purchased by Harvard since 1750, as well as instruments dating back to about 1450 that have been donated by private collectors.

Telescopes, sundials, clocks, theodolites, vacuum pumps, microscopes, goniometers, electric meters, and early computing devices are among the 15,000 objects in the collection. The collection provides insight into many inventions, discoveries, and developments in the history of science and technology. It is located on the lower level of the university's Science Center.

Collection of Scientific Instruments, Harvard University, Science Center, 1 Oxford St., Room B6, Cambridge, MA 02138. Phone: 617/495-2779. Hours: 10–4 Tues.–Fri.; closed holidays and when university not in session. Admission: free.

## KALAMAZOO VALLEY COMMUNITY COLLEGE
### Kalamazoo Public Museum

(See Historical Museums, Houses, and Sites section.)

## MASSACHUSETTS INSTITUTE OF TECHNOLOGY
### MIT Museum

The MIT Museum, consisting of a main facility and three branch locations at the Massachusetts Institute of Technology in Cambridge, collects, preserves, and exhibits materials associated with the development of science and technology as interrelated with the university.

The museum's collections include scientific instruments and paraphernalia developed or used at MIT; ship models and plans, half models, marine art, and photographs that document the history of naval architecture, yacht design, and shipbuilding; a record of inertial guidance with supplementary written materials; architectural drawings produced by MIT students between 1869 and 1969; photographs of people, events, and settings in MIT's history; portraits and paintings by nineteenth- and twentieth-century American artists; tape, disc, and video recordings and films that document MIT's history; and banners, trophies, and souvenirs that trace MIT's social history.

Founded in 1971, the museum now has three branches at 77 Massachusetts Avenue—the Margaret Hutchinson Compton Gallery, with exhibits on science and technology as related to MIT; Hart Nautical Galleries, containing ship models and archives on naval architecture and marine engineering; and Harold E. Edgerton Strobe Alley, featuring stroboscopic photography and sonar explorations.

MIT Museum, Massachusetts Institute of Technology, 265 Massachusetts Ave., Cambridge, MA 02139. Phone: 617/258-9116. Hours: 9–5 Tues.–Fri.; 1–5 Sat.–Sun.; closed holidays. Admission: adults, $2.00; MIT community, free. Branches (all at 77 Massachusetts Ave.): Margaret Hutchinson Compton Gallery: 9–5 Mon.–Fri.; closed holidays; admission: free. Hart Nautical Galleries and Harold E. Edgerton Strobe Alley: 8–8 daily; admission: free.

## SAN JOAQUIN DELTA COLLEGE
### Clever Planetarium and Earth Science Center

(See Planetaria and Observatories section.)

## SOUTH CAROLINA STATE UNIVERSITY
### I.P. Stanback Museum and Planetarium

(See Art Museums section.)

## SOUTHWESTERN MICHIGAN COLLEGE
### Southwestern Michigan College Museum

(See Historical Museums, Houses, and Sites section.)

## STATE UNIVERSITY OF NEW YORK COLLEGE AT ONEONTA
### Science Discovery Center of Oneonta

Interactive science exhibits—largely in the physical sciences—are presented in the 3,000-square-foot Science Discovery Center of Oneonta at the State University of New York College at Oneonta. The exhibits also are used in instructional programs, mainly in physics and science education courses. The science center was founded in 1987.

Science Discovery Center of Oneonta, State University of New York College at Oneonta, Oneonta, NY 13820-4015. Phone: 607/436-2011. Hours: 12–4 Thurs.–Sat.; closed Thanksgiving and Christmas. Admission: free.

## TRANSYLVANIA UNIVERSITY
### Museum of Early Philosophical Apparatus

Early scientific apparatus and equipment used in teaching medicine in the nineteenth century are featured in the Museum of Early Philosophical Apparatus at Transylvania University in Lexington, Kentucky. The museum, opened in 1948, is located on the third floor of the 1833 administration building. The W.S. Jones Planetarium is part of the museum.

Museum of Early Philosophical Apparatus, Transylvania University, Old Morrison, 300 N. Broadway, Lexington, KY 40508. Phone: 606/233-8213. Hours: 1:30–4:30 Mon.–Fri.; closed holidays and when university not in session. Admission: free.

## TRITON COLLEGE
### Cernan Earth and Space Center

(See Planetaria and Observatories section.)

## UNIVERSITIES RESEARCH ASSOCIATION INC.
### Fermi National Accelerator Laboratory

(See Contract Facilities section.)

## UNIVERSITY OF ARIZONA
### Flandrau Science Center and Planetarium

The Flandrau Science Center and Planetarium at the University of Arizona in Tucson is devoted to furthering greater understanding and appreciation of as-

tronomy and related sciences. Opened in 1975, the center has a 147-seat planetarium, a 16-inch telescope observatory, science exhibits, and instructional facilities.

The planetarium contains two projectors—a Minolta/Viewlex Series IV planetarium projector that can show over 8,600 stars and a Cinema-360 projector that produces motion pictures that cover the entire dome surface. In addition to sky and multimedia shows, laser light presentations, concerts, and plays are given in the planetarium.

The science center has about 10,000 square feet of astronomical and related exhibits on such topics as the optical sciences, sun and solar system, Milky Way, meteorites, astronomical art, and early telescopes, astrolabes, and other instruments. In the observatory, the 16-inch telescope with 35-mm camera adapters enables visitors to view and take photographs of the Arizona sky.

Flandrau Science Center and Planetarium, University of Arizona, Tucson, AZ 85721. Phone: 602/621-4515. Hours: 9–5 Mon.–Fri. (also to 9 Wed. and Thurs. (and to 12 midnight Fri.); 1–12 midnight Sat.; 1–5 Sun.; closed major holidays. Admission: planetarium shows—adults, $4.50; seniors and students, $4; children under 13, $2.50; laser shows—all admissions, $5, except $4 for University of Arizona students, faculty, and staff on Wed. and Thurs.

## UNIVERSITY OF CALIFORNIA, BERKELEY

The University of California has the Lawrence Hall of Science on its Berkeley campus and is responsible for two other science museums/centers at national laboratories it administers—the Bradbury Science Museum at the Los Alamos National Laboratory in Los Alamos, New Mexico, and the Lawrence Livermore National Laboratory Visitors Center in Livermore, California (described in the Contract Facilities section).

### *Lawrence Hall of Science*

The Lawrence Hall of Science at the University of California at Berkeley is a hands-on science center that seeks to further knowledge and understanding of science among students, teachers, and the general public. In addition to having exhibits, a planetarium, and educational programming, the facility is internationally recognized as a science/math curriculum development center and teacher education resource.

Opened in 1968 as a tribute to Ernest Orlando Lawrence, the university's first Nobel laureate and inventor of the cyclotron, the 134,000-square-foot science center offers visitors an overview of the major sciences, shows how they interrelate, and points out why they are important to the present and future. It is known for its development and evaluation of participatory science exhibits and educational programming; its extensive array of computer units in exhibit areas and open, unstructured laboratories; and development of science/math curricula, materials, and exhibits used by schools and science centers.

Lawrence Hall uses art forms, audiovisuals, computer games, lifelike models,

and experimental apparatus in explaining scientific principles and technological applications. It has permanent exhibits on the human brain, lasers, computers, and other areas of science and technology and offers thematic temporary exhibitions on dinosaurs, whales, wolves, and other subjects. It also has Dr. Lawrence's working models, notes, papers, and awards, which are displayed in a memorial room, and the William K. Holt Planetarium, opened in 1973 and equipped with a Viewlex/Goto Mercury projector and 27 concentric seats. Approximately 300,000 people visit the science center each year.

Lawrence Hall of Science, University of California, Berkeley, Centennial Drive, Berkeley, CA 94720. Phone: 510/642-5133. Hours: hall—10–5 daily; closed major holidays; planetarium shows—1, 2:15, and 3:30 weekends, some holidays, and summer. Admission: hall—adults, $6; seniors, students, and children 7–18, $4; children 3–6, $2; planetarium shows—$1.50.

## UNIVERSITY OF COLORADO AT BOULDER
### Fiske Planetarium and Science Center

(See Planetaria and Observatories section.)

## UNIVERSITY OF MISSISSIPPI
### University Museums

(See General Museums section.)

## WEST VIRGINIA UNIVERSITY
### Comer Museum

(See Geology, Mineralogy, and Paleontology Museums section.)

# Sculpture Gardens

*Also see Art Museums and Art Galleries sections.*

## BRANDEIS UNIVERSITY
### *Rose Art Museum Sculpture Collection*

(See Art Museums section.)

## BRIGHAM YOUNG UNIVERSITY
### *Museum of Art Sculpture Garden*

(See Art Museums section.)

## CITY UNIVERSITY OF NEW YORK, BRONX COMMUNITY COLLEGE
### *Hall of Fame for Great Americans*

The Hall of Fame for Great Americans—founded in 1900 by New York University to encourage deeper appreciation of historically significant individuals who contributed to the American experience—now is located at Bronx Community College of the City University of New York. The college acquired the NYU Bronx campus and stewardship of the Hall of Fame in 1973 when the property was transferred to the City University of New York. A multi-million-dollar program has since restored the hall to its original condition and beauty.

A granite colonnade houses the bronze portrait busts of 97 of the 102 distin-

guished Americans elected to the Hall of Fame since 1900. It winds around three neoclassic buildings, including the Gould Memorial Library, on the campus. Among the Americans honored in the hall are Alexander Graham Bell, George Washington Carver, Benjamin Franklin, Oliver Wendell Holmes, Jr., Thomas Jefferson, Abraham Lincoln, Franklin Delano Roosevelt, Harriet Beecher Stowe, Booker T. Washington, George Washington, Walt Whitman, and Wilbur and Orville Wright.

Hall of Fame for Great Americans, Bronx Community College, City University of New York, University Ave. and W. 181st St., Bronx, NY 10455-3102. Phone: 718/220-6003. Hours: 10–5 daily. Admission: free.

## CRANBROOK ACADEMY OF ART
### *Cranbrook Academy of Art Museum Sculpture Garden*

(See Art Museums section.)

## FLORIDA INTERNATIONAL UNIVERSITY
### *ArtPark Sculpture Park (Art Museum at Florida International University)*

(See Art Museums section.)

## GOVERNORS STATE UNIVERSITY
### *Sculpture Park*

More than 20 works of sculpture are featured in the Governors State University Sculpture Park in University Park, Illinois.

Sculpture Park, Governors State University, Wagner House, University Park, IL 60466. Phone: 708/534-4105. Hours: open 24 hours daily. Admission: free.

## HOFSTRA UNIVERSITY
### *Hofstra Museum Outdoor Sculpture*

(See Art Museums section.)

## LEHIGH UNIVERSITY
### *Muriel and Philip Berman Sculpture Gardens (Lehigh University Art Galleries)*

(See Art Galleries section.)

## MASSACHUSETTS INSTITUTE OF TECHNOLOGY
### *Outdoor Sculpture Collection (List Visual Arts Center)*

(See Art Galleries section.)

## MOUNT HOLYOKE COLLEGE
### *Mount Holyoke College Art Museum Sculpture Court*

(See Art Museums section.)

## NORTHWESTERN UNIVERSITY
### *Mary and Leigh Block Gallery Sculpture Garden*

(See Art Galleries section.)

## OAKLAND UNIVERSITY
### *Meadow Brook Art Gallery Outdoor Sculpture Garden*

(See Art Galleries section.)

## OBERLIN COLLEGE
### *Allen Memorial Art Museum Outdoor Sculpture*

(See Art Museums section.)

## PRINCETON UNIVERSITY
### *John B. Putnam Jr. Memorial Collection (The Art Museum)*

(See Art Museums section.)

## RADFORD UNIVERSITY
### *Radford University Galleries Sculpture Court*

(See Art Galleries section.)

## RHODE ISLAND SCHOOL OF DESIGN
### *Museum of Art Sculpture Garden*

(See Art Museums section.)

## SAGINAW VALLEY STATE UNIVERSITY
### *Marshall M. Fredericks Sculpture Gallery*

The original plaster models for over 200 bronze casts that span the career of noted sculptor Marshall M. Fredericks can be seen at the Marshall M. Fredericks Sculpture Gallery at Saginaw Valley State University in University Center, Michigan. Sketches, studies, and scale models for memorials, religious sculptures, portraits, and animals, as well as paintings and drawings by Fredericks, also are on display.

The gallery, which opened in 1988, is housed in the Arbury Fine Arts Center on the campus. A sculpture garden containing more than a dozen bronze casts of Fredericks's sculptures is adjacent to the gallery and center.

Marshall M. Fredericks Sculpture Gallery, Saginaw Valley State University, Arbury Fine Arts Center, 7400 Bay Rd., University Center, MI 48710. Phone: 517/790-5667. Hours: 1–5 Tues.–Sun.; closed holidays and when university not in session. Admission: free.

## SOUTHERN METHODIST UNIVERSITY
### Meadows Museum Sculpture Garden

(See Art Museums section.)

## STANFORD UNIVERSITY
### B. Gerald Cantor Rodin Sculpture Garden (Stanford University Museum of Art)

(See Art Museums section.)

## UNIVERSITY OF CALIFORNIA, LOS ANGELES
### Wight Art Gallery and Franklin D. Murphy Sculpture Garden

(See Art Museums section.)

## UNIVERSITY OF CALIFORNIA, SAN DIEGO
### Stuart Collection

Contemporary outdoor sculpture on the 1,200-acre campus comprises the Stuart Collection at the University of California, San Diego in La Jolla. The collection, started in 1981, now consists of 14 commissioned sculptures by such artists as Terry Allen, Michael Asher, Jackie Ferrara, Ian Hamilton Finlay, Richard Flesichner, Jenny Holzer, Robert Irwin, Bruce Nauman, Nam June Paik, Niki de Saint Phalle, Alexis Smith, and William Wegman.

Stuart Collection, University of California, San Diego, 406 University Center, La Jolla, CA 92093. Phone: 619/534-2117. Hours: 24 hours daily. Admission: free.

## UNIVERSITY OF CHICAGO
### Vera and A. Elden Sculpture Garden (David and Alfred Smart Museum of Art)

(See Art Museums section.)

## UNIVERSITY OF MINNESOTA, DULUTH
*Tweed Museum of Art Sculpture Conservatory and Courtyard*

(See Art Museums section.)

## UNIVERSITY OF NEBRASKA–KEARNEY
*Museum of Nebraska Art Sculpture Garden*

(See Art Museums section.)

## UNIVERSITY OF NEBRASKA–LINCOLN
*Sheldon Memorial Art Gallery and Sculpture Garden*

(See Art Museums section.)

## UNIVERSITY OF NOTRE DAME
*Snite Museum of Art Sculpture Garden*

(See Art Museums section.)

## UNIVERSITY OF PENNSYLVANIA
*Morris Arboretum of the University of Pennsylvania*

(See Botanical Gardens, Arboreta, and Herbaria section.)

## UNIVERSITY OF WYOMING
*University of Wyoming Art Museum Sculpture Terrace*

(See Art Museums section.)

## URSINUS COLLEGE
*Philip and Muriel Berman Museum of Art Sculpture Collection*

(See Art Museums section.)

## VANDERBILT UNIVERSITY
*Vanderbilt University Arboretum*

(See Botanical Gardens, Arboreta, and Herbaria section.)

## WELLESLEY COLLEGE
*Davis Museum and Cultural Center Sculpture Collection*

(See Art Museums section.)

## WESTERN WASHINGTON UNIVERSITY
*Outdoor Sculpture Collection (Western Gallery)*

(See Art Galleries section.)

## WICHITA STATE UNIVERSITY
*Edwin A. Ulrich Museum of Art Outdoor Sculpture Collection*

(See Art Museums section.)

## WINSTON-SALEM STATE UNIVERSITY
*Sculpture Garden*

Winston-Salem State University has a Sculpture Garden with four major pieces on its campus in Winston-Salem, North Carolina. The dream of an outdoor sculpture garden arose in 1970 as part of the plans for a new auditorium to replace a severely rain-damaged auditorium. In 1981, a national competition was held with two goals—to discover excellent sculpture, especially by artists of color whose work had not received the attention merited, and to acquaint the university's students with the vibrancy and diversity of contemporary sculpture—with the support of Gordon Hanes, a former university trustee, and the James G. Hanes Foundation.

A 12-foot stainless steel sculpture, entitled *Southern Sunrise,* by Mel Edwards was selected and then installed in front of the new auditorium in 1983. As a result of a second competition in 1984, three other works were commissioned for the campus—a pink granite work by Beverly Buchanan, called *Garden Ruins;* a cherry wood sculpture, *Arbor Spirit,* by Roberto Bertota; and a large Corten steel sculpture, *Po Tolo,* by Tyrone Mitchell. The first two were installed near the auditorium in 1984, and the third was placed in the courtyard of the R. J. Reynolds Center in 1985.

Sculpture Garden, Winston-Salem State University, 601 Martin Luther King Jr. Dr., Winston-Salem, NC 27110. Phone: 910/750-2458. Hours: open 24 hours. Admission: free.

# Zoology Museums

*Also see Natural History Museums and Centers section.*

## FRANKLIN AND MARSHALL COLLEGE
### Zoology Hall (North Museum of Natural History and Science)

(See Natural History Museums and Centers section.)

## HARVARD UNIVERSITY
### Museum of Comparative Zoology

The research and exhibits at the Museum of Comparative Zoology at Harvard University in Cambridge, Massachusetts, are devoted to animals—how they evolved, where they live, their similarities, and their differences. The museum—also known as the Agassiz Museum—was founded in 1859 by the resourceful Swiss zoologist Louis Agassiz. It is one of the four museums that comprise the Harvard University Museums of Natural History.

The first exhibits reflected the evolutionary and systematic theories of the founder. The museum's exhibits now range from the earliest fossil invertebrates and reptiles to today's fish and reptiles. Among the rare and unique specimens are whale skeletons, the largest turtle shell ever found, the Harvard mastodon, a lobe-finned coelacanth, a *kronosaurus* giant sea serpent, George Washington's pheasants, and extinct birds such as the great auk and the passenger pigeon.

The museum's changing exhibition programs are usually devoted to the recent

discoveries made by the research staff. The research and collections are principally in herpetology, paleontology, ichthyology, archaeology, mammalogy, ornithology, malacology, and marine zoology.

Museum of Comparative Zoology, Harvard University, 26 Oxford St., Cambridge, MA 02138. Phone: 617/495-2463. Hours: 9–4:30 Mon.–Sat.; 1–4:30 Sun.; closed major holidays. Admission: adults, $4; seniors and students, $3; children 5–15, $1; Harvard students, free.

## SANTA FE COMMUNITY COLLEGE
### Santa Fe Community College Teaching Zoo

The Santa Fe Community College Teaching Zoo is part of the institution's Zoo Animal Technology Program to train zookeepers in Gainesville, Florida. Opened in 1972, the zoo houses 85 species and 250 specimens of animals on a seven-acre wooded area on the west edge of the campus. Among the animals are red-ruffed lemurs, bald eagles, and Asian small-clawed otters.

Santa Fe Community College Teaching Zoo, 3000 N.W. 83rd St., Gainesville, FL 32605-6200. Phone: 904/395-5604. Hours: 9–2 daily; holidays and when college not in session. Admission: free.

## UNIVERSITY OF CALIFORNIA, BERKELEY
### Museum of Vertebrate Zoology

The Museum of Vertebrate Zoology is one of four museums concerned with natural history and the natural sciences at the University of California, Berkeley (see Natural History Museums and Centers section for others). Founded in 1908, it recently moved into the newly renovated Valley Life Sciences Building, which it shares with the Museum of Paleontology, University and Jepson Herbaria, Biology Library, and Department of Integrative Biology.

The museum, which occupies approximately 40,000 square feet, does not have exhibits and is not open to the public. However, its research collections of terrestrial vertebrates are among the largest in the world. The mammal collection is especially noteworthy. The museum operates a large research station and maintains specialized laboratories for evolutionary genetic research in such areas as protein biochemistry, cytogenetics, and nucleic acid sequencing and fingerprinting.

Museum of Vertebrate Zoology, University of California, Berkeley, 1120 Valley Life Sciences Bldg., Berkeley, CA 94720. Phone: 510/642-3567. Hours: professional visitors only by appointment. Admission: free.

## UNIVERSITY OF FLORIDA
### Florida Museum of Natural History Zooarchaeological Collection

(See Natural History Museums and Centers section.)

## UNIVERSITY OF GEORGIA
*University of Georgia Museum of Natural History*
*Zoological Collections*

(See Natural History Museums and Centers section.)

## UNIVERSITY OF MASSACHUSETTS, AMHERST
*Museum of Zoology*

The Museum of Zoology at the University of Massachusetts, Amherst has a collection of preserved animals of all types. The museum, which is part of the Department of Biology, generally is closed to the public.

Museum of Zoology, University of Massachusetts, Amherst, Dept. of Biology, Amherst, MA 01003. Phone: 413/545-3565. Hours: by appointment only; closed holidays. Admission: free.

## UNIVERSITY OF MICHIGAN
*Museum of Zoology*

The Museum of Zoology at the University of Michigan in Ann Arbor has collections and research programs relating to malacology, entomology, acarology, ichthyology, herpetology, ornithology, mammalogy, animal behavior, biochemical systematics, molecular systematics, and evolutionary and environmental biology. It is one of five institutions that comprise the University of Michigan Museums of Natural History and got its start in 1837 with the creation of a cabinet of natural history. A separate room for the collections was provided in 1856, and a building was constructed to house the exhibits as well as classrooms and laboratories in 1882–1883. The exhibits became the Museum of Zoology in 1913 and later evolved into the Museums of Natural History complex in the 1928 Ruthven Building.

Museum of Zoology, University of Michigan, Ruthven Museums Bldg., 1109 Geddes Ave., Ann Arbor, MI 48109-1079. Phone: 313/764-0476. Hours: by appointment only. Admission: free.

## UNIVERSITY OF MONTANA
*University of Montana Zoological Museum and Herbarium*

The University of Montana Zoological Museum and Herbarium in Missoula is part of the Division of Biological Sciences. Founded in 1947, the museum emphasizes fish, birds, and mammals from the northern Rockies, particularly Montana, and has representative specimens from around the world.

The Herbarium, which began in 1909, focuses on plants from the Pacific Northwest, especially Montana, and has selections from North America and the rest of the world. Both are research collections seldom open to the public.

University of Montana Zoological Museum and Herbarium, Div. of Biological Sciences, Missoula, MT 59812. Phone: 406/243-4743. Hours: generally not open to public.

## UNIVERSITY OF NORTH DAKOTA
### *University of North Dakota Zoology Museum*

The University of North Dakota Zoology Museum in Grand Forks has a collection of birds, fish, mammals, insects, reptiles, amphibians, and parasites of aquatic invertebrates. The collection began in 1883. The museum is part of the Department of Biology.

University of North Dakota Zoology Museum, Dept. of Biology, Grand Forks, ND 58202. Phone: 701/777-2621. Hours: 8–4:30 Mon.–Fri. by appointment; closed summer and holidays. Admission: free.

## UNIVERSITY OF WISCONSIN–MADISON
### *University of Wisconsin Zoological Museum*

The University of Wisconsin Zoological Museum in Madison is a center for research on taxonomy and distribution of vertebrates and mollusks in Wisconsin and an important part of instruction in such courses as comparative anatomy, ornithology, and mammalian ecology. Founded in 1887, it is located on the fourth floor of the Noland Zoology Building, where it has one public exhibition hall and several case exhibits.

The museum has the world's largest collection of skeletons from the Galapagos Islands. Among the other collections are over 250,000 mollusks; 100,000 histological preparations; 21,000 alcohol- and formalin-preserved vertebrates; 15,000 study skins of birds and animals; 12,000 skeletons representing most vertebrate classes; 2,000 paleontological specimens; 1,500 bird eggs and nests; 800 historical instruments; and a library exceeding 25,000 books and reprints.

University of Wisconsin Zoological Museum, Noland Zoology Bldg., 205 N. Mills St., Madison, WI 53706. Phone: 608/262-3766. Hours: academic year—9–5 by appointment Mon.–Fri.; closed holidays and summer. Admission: free.

# Other Types of Museums

## DELAWARE TECHNICAL AND COMMUNITY COLLEGE
### Treasures of the Sea Exhibit

Delaware Technical and Community College in Georgetown has a maritime historical museum called the *Treasures of the Sea Exhibit.* The museum, which was founded in 1988, features such shipwreck artifacts as coins, firearms, jewelry, cannons, and gold and silver bars.

Treasures of the Sea Exhibit, Delaware Technical and Community College, Rte. 18, PO Box 610, Georgetown, DE 19947. Phone: 302/856-5700. Hours: 10–4 Mon.–Tues.; 12–4 Fri.; 9–1 Sat.; closed holidays and Christmas break. Admission: adults, $2; seniors and students, $1; children 4 and under, free.

## JOHNSON AND WALES UNIVERSITY
### Culinary Archives and Museum

Johnson and Wales University in Providence, Rhode Island, has a culinary and gastronomy museum—called the Culinary Archives and Museum. It contains more than 30,000 cookbooks, 20,000 menus, 20,000 culinary-related postcards, 10,000 culinary pamphlets, and thousands of culinary objects, silver pieces, and fashion and food prints. In addition to permanent exhibits, the museum presents temporary and traveling exhibitions related to culinary and gastronomical topics.

Culinary Archives and Museum, Johnson and Wales University, 315 Harborside Blvd., Providence, RI 02905. Phone: 401/455-2805. Hours: 9–5 Mon.–Sat. by appointment

only; closed major holidays. Admission: adults, $3; seniors, $2; students 18–21, $1; children 5–17, 50¢.

## PENNSYLVANIA STATE UNIVERSITY
### Penn State Football Hall of Fame

Pennsylvania State University in University Park has a campus museum that chronicles the university's football history and highlights. Called the Penn State Football Hall of Fame, it features memorabilia, trophies, equipment, photographs, and other items from the beginning of Penn State football.

Among the objects on display are early sweaters, helmets, and shoes; trophies from bowl games, as well as from the 1982 and 1986 national championships; individual awards of players; photos of past and current all-Americans; and a historical display of great and present head football coaches at the university.
Penn State Football Hall of Fame, Pennsylvania State University, Greenberg Indoor Sports Complex, University Park, PA 16802. Phone: 814/865-0411. Hours: 8–4:30 Mon.–Fri.; Sat.–Sun. hours vary. Admission: free.

## UNIVERSITY OF ALABAMA
### Paul W. Bryant Museum

The Paul W. Bryant Museum at the University of Alabama in Tuscaloosa traces the history of football at the university and honors the longtime service and football coaching success of the late Paul "Bear" Bryant. The 16,000-square-foot museum contains artifacts and memorabilia pertaining to Alabama football since the first team played in 1892, as well as to other university sports. It also has vintage film clips, video montages, and radio recordings of great moments in Alabama football and a short film on the life, career, and philosophy of Coach Bryant.
Paul W. Bryant Museum, University of Alabama, 300 Bryant Dr., Tuscaloosa, AL 35487-0385. Phone: 205/348-4668. Hours: 9–4 Mon.–Sat.; closed holidays. Admission: adults, $2; seniors and children 6–17, $1; children under 5, free.

## UNIVERSITY OF BALTIMORE
### Steamship Historical Society of America Collection

The University of Baltimore Library in Baltimore has the Steamship Historical Society of America Collection of powered shipping and navigation materials. The collection, which began in 1940, has approximately 100,000 photographs, 25,000 postcards, 5,000 books, and various periodicals, booklets, models, and other materials relating to steamships and navigation. The society owns the materials, while the university's library is responsible for their maintenance and availability.

Steamship Historical Society of America Collection, University of Baltimore Library, 1420 Maryland Ave., Baltimore, MD 21201-5779. Phone: 410/837-4334. Hours: 8:30–3:30 Mon.–Fri.; closed holidays. Admission: free.

## UNIVERSITY OF HARTFORD
### *Museum of American Political Life*

More than 60,000 political mementos from George Washington's inaugural buttons to materials from recent presidential campaigns are featured at the Museum of American Political Life at the University of Hartford in West Hartford, Connecticut.

The museum contains American presidential campaign materials from 1789 to the present; items related to historic, social, and economic movements; torchlight and other political parade material; and a wide variety of buttons, banners, posters, leaflets, bumper stickers, cartoons, lapel pieces, and other objects of a political nature.

The nucleus of the museum, which opened in 1989, is the DeWitt Collection of Presidential Americans, which has approximately 40,000 political objects collected by J. Doyle DeWitt, a Travelers Insurance Companies executive, over 40 years.

Museum of American Political Life, University of Hartford, 200 Bloomfield Ave., West Hartford, CT 06117. Phone: 203/768-4090. Hours: 11–4 Tues.–Sat.; closed major holidays. Admission: adults, $3; seniors, students, and children, $1.50.

# Contract Facilities

## ASSOCIATED UNIVERSITIES INC.
### National Radio Astronomy Observatory

The National Radio Astronomy Observatory was established by the National Science Foundation (NSF) in 1956 to provide scientists with large radio telescopes for astronomical research. It was located in Green Bank, West Virginia, because of the area's unique shielding from noise interference provided by the surrounding mountains. The establishment of a "radio-quiet zone" in the area further enhanced the facility's capabilities.

The observatory came into being after a group of astronomers approached NSF in 1954 about funding such a radio telescope center that could be used by all scientists. Associated Universities Inc., a nonprofit corporation organized in 1946 to create and operate large-scale research facilities for the benefit of the interested scientific community, was contracted to build and operate the radio telescope complex.

Radio astronomy is a technique that studies the universe by radio waves that all celestial objects emit and absorb. Many discoveries have been made using radio telescopes, including quasars, pulsars, neutron stars, and black holes.

The National Radio Astronomy Observatory began operations in 1958. The Green Bank site has become the observatory's headquarters and center for single-disk observations in the wavelength range from 2 to 90 centimeters. Its instruments include a 140-foot equatorially mounted telescope—the largest of its type in the world—and three 85-foot radio telescopes that function as an interferometer. A new Green Bank Telescope, now under construction, will have

a diameter of 328 by 360 feet and will be the largest fully steerable telescope in the world.

The observatory also operates at various locations suited to the scientific needs of specific instruments. In Socorro, New Mexico, the observatory operates both the Very Large Array (VLA), an instrument with 27 antennae, each 25 meters in diameter, and the Very Long Baseline Array (VLBA), with 10 telescopes spread across the nation from Hawaii to the Virgin Islands. These two aperture synthesis telescopes are used to make detailed radio images of the sky. The observatory's 12-meter millimeter-wave telescope is located on Kitt Peak near Tucson, Arizona. The elevation is sufficiently high above most atmospheric water that very short wavelength radio waves may be observed from the cosmos.

The Green Bank and Socorro facilities have visitor centers and self-guided tours. The Green Bank center is open from 9 A.M. to 4 P.M. daily from Memorial Day through Labor Day and during the same time on weekends in September and October, while the Socorro facility is open from 8:30 A.M. to sunset daily throughout the year.

National Radio Astronomy Observatory, Main Office, 520 Edgemont Rd., Charlottesville, VA 22903-2475. Phone: 804/296-0345. Also: PO Box 2, Green Bank, WV 24944. Phone: 304/456-2011. Also: PO Box O, Socorro, NM 87801. Phone: 505/835-7000. Also: Campus Bldg. 65, 949 N. Cherry Ave., Tucson, AZ 85721. Phone: 602/882-8250.

## ASSOCIATION OF UNIVERSITIES FOR RESEARCH IN ASTRONOMY INC.
### *National Optical Astronomical Observatories*

Three major astronomical research centers comprise the National Optical Astronomical Observatories, operated by the Association of Universities for Research in Astronomy Inc., consisting of 23 member universities, under contract to the National Science Foundation. They are the National Solar Observatory, near Sunspot, New Mexico; Kitt Peak National Observatory, near Tucson, Arizona; and Cerro Tololo Inter-American Observatory, in northern Chile. The university management group was formed in 1957 by seven charter members during a three-year survey and testing program that led to the selection of the Kitt Peak site.

The National Solar Observatory, located at 9,200 feet on Sacramento Peak in Lincoln National Forest, is a national center for ground-based observations of the sun; the Kitt Peak National Observatory, with facilities at a 6,875-foot site in the Quinlan Mountains of the Sonora Desert, conducts optical and near-infrared astronomy research; and the Cerro Tololo Inter-American Observatory, located on a mountain nearly 300 miles north of Santiago, is used to observe the Southern Hemisphere sky.

The National Solar Observatory complex had its origins in a 1951 agriculture storage shed, known as the Grain Bin Dome. It and other facilities served as the Upper Air Research Observatory for the Air Force's Cambridge Research

Laboratories. In 1976, the observatory was transferred to the National Science Foundation, which turned its operations over to the Association of Universities for Research in Astronomy Inc. in 1976.

The solar observatory makes use of three types of solar instruments to study the sun—coronagraphs to observe the sun's corona, spectrographs to capture and separate the sun's light waves, and telescopes with attached cameras to observe and photograph any unusual activities on the sun.

The largest of the instruments is the vacuum tower telescope, which is 356 feet long, with 220 feet being buried beneath the surface of the peak and the tower portion rising 13 stories above ground. The huge telescope, which is designed to observe extremely small features in the sun's surface and in the lower atmosphere, has an observation room open to the public and a lobby television monitor, which shows a live, closed-circuit picture of the sun taken with a telescope in the nearby Hilltop Dome.

The Big Dome (the John W. Evans Solar Facility), which also has an observation room for visitors, came into operation in 1952. The facility, used for studies of the sun's surface, lower atmosphere, and overlying corona, has a number of separate telescopes attached to a 26-foot spar in the dome. The largest of the instruments is a 16-inch coronagraph, the biggest and most powerful of its type in the nation. The dome also has a 16-inch telescope, with an attached magnetograph, to measure intense magnetic fields in sunspot regions.

The original Grain Bin Dome and the Hilltop Dome are not open to the public. However, visitors can take self-guided tours of the observatory daily. A guided tour, which includes a film/slide presentation and a question-and-answer period, is given at 2 P.M. Saturdays from May through October.

The Kitt Peak National Observatory, located on Kitt Peak, 52 miles southwest of Tucson, has the world's largest concentration of optical telescopes. Its instruments include the Nicholas U. Mayall 4-meter, 2.1-meter Coudé feed, and 1.3-meter and 0.9-meter telescopes, along with the Burrell-Schmidt 0.6-meter telescope jointly operated with Case Western Reserve University.

Also located on the peak are the WIYN Observatory's 3.5-meter telescope, created by a consortium consisting of the University of Wisconsin, Indiana University, Yale University, and the National Optical Astronomical Observatories; University of Arizona's 90-inch, 36-inch, and 20-inch telescopes and the 72-inch CCD transit instrument; Michigan-Dartmouth-MIT Observatory's two telescopes; McGraw-Hill Observatory's 1.3-meter and Hiltner 2.4-meter telescopes; National Radio Astronomy Observatory's 12-meter dish and 25-meter Very Long Baseline Array dish; and MIT/NASA explosive transit camera and rapid moving telescopes.

The National Solar Observatory also operates facilities on Kitt Peak in addition to its Sacramento Peak operations. The facilities include the McMath-Pierce complex, which has the world's largest solar telescopes, with primary mirrors of 1.6 meters for the main telescope and 0.9 meter for its two auxiliary telescopes, and a 0.9-meter vacuum telescope.

The Kitt Peak Visitor Center has exhibits and offers guided and self-guided tours of the complex. Guided tours are conducted daily at 11 A.M. and at 1 and 2:30 P.M., with an additional tour at 9:30 A.M. on weekends.

The Cerro Tololo Inter-American Observatory began in 1963 after extensive tests to select a site for observation of those parts of the sky that cannot be seen from the Northern Hemisphere. Located at an elevation of 6,800 feet on the western slope of the Andes near La Serena, the observatory's telescopes include 4-meter, 1.5-meter, 0.9-meter, and 0.4-meter telescopes; a 0.6-meter Schmidt telescope on loan from the University of Michigan; a 1-meter telescope on loan from Yale University; and a 0.6-meter telescope originally installed by the Lowell Observatory of Flagstaff, Arizona.

The National Optical Astronomy Observatories office is located adjacent to the University of Arizona campus in Tucson. It is the administrative center with computer, software, and support facilities for the observatories and headquarters for the Gemini 8-meter telescopes planned for Mauna Kea in Hawaii and Cerro Pachon, near Cerro Tololo in Chile.

National Optical Astronomy Observatories, Kitt Peak Visitor Center, PO Box 26732, Tucson, AZ 85726. Phone: 602/322-3426. Hours: center—9–3:45 daily; guided tours— 11, 1, and 2:30 daily (also 9:30 A.M. Sat.–Sun.); closed major holidays. Admission: suggested donation—$2.

## UNIVERSITIES RESEARCH ASSOCIATION INC.
### Fermi National Accelerator Laboratory

The Fermi National Accelerator Laboratory, a high-energy physics national laboratory operated by Universities Research Association Inc. for the U.S. Department of Energy in Batavia, Illinois, has three exhibit areas—Wilson Hall and the Observation Area in the 16-story administrative building and the Leon M. Lederman Science Education Center in a separate building west of Wilson Hall. In 1995, the association consisted of 81 universities.

The Wilson Hall exhibits, located on the first floor except for an art gallery on the second floor, cover radioactivity, the Foucault pendulum, and recent Fermilab developments. The gallery contains changing exhibitions of paintings, photographs, and sculpture. The 15th-floor Observation Area features a model of the Fermilab site, a replica of a Tevatron magnet, a full-size reproduction of the accelerator tunnel, Native American implements found on the site, rock and mineral specimens native to the area, a slide presentation on the laboratory, and a video show on the library of Fermilab.

The Leon M. Lederman Science Education Center, a hands-on science center that moved into a new building in 1992, has high-energy physics exhibits and educational programs on colliding beams, accelerators as tools, particle detectors, collisions and scattering, and structure of matter.

Fermi National Accelerator Laboratory, Wilson Hall and Observation Area, Admin. Bldg., PO Box 500, Batavia, IL 60510. Phone: 708/840-3351. Hours: 8:30–5 daily. Ad-

mission: free. Fermi National Accelerator Laboratory, Leon M. Lederman Science Education Center, PO Box 500, MS 777, Batavia, IL 60510. Phone: 708/840-8258. Hours: 8:30–5 Mon.–Fri.; 9–3:30 Sat.–Sun.; closed holidays. Admission: free.

## UNIVERSITY CORPORATION FOR ATMOSPHERIC RESEARCH
### National Center for Atmospheric Research

The National Center for Atmospheric Research, a research and scientific facility operated by the University Corporation for Atmospheric Research, presents science-oriented exhibits at its Mesa Laboratory in Boulder, Colorado. The nonprofit corporation, a consortium of North American institutions granting doctorates in the atmospheric and related sciences, manages over a dozen programs to enhance the pursuit and application of research in the sun, weather phenomena, climate, and atmospheric chemistry. It is funded by the National Science Foundation.

National Center for Atmospheric Research, Mesa Laboratory, 1850 Table Mesa Dr., Boulder, CO 80303. Phone: 303/497-1174. Hours: 8–5 Mon.–Fri.; 9–3 Sat., Sun., and holidays. Admission: free.

## UNIVERSITY OF CALIFORNIA, BERKELEY

The University of California has science museum/center facilities at two federal government laboratories it administers—the Bradbury Science Museum at the Los Alamos National Laboratory in Los Alamos, New Mexico, and the Lawrence Livermore National Laboratory Visitors Center in Livermore, California.

### Bradbury Science Museum

The Bradbury Science Museum is located at the Los Alamos National Laboratory, operated by the University of California for the U.S. Department of Energy, in Los Alamos, New Mexico. The laboratory, where the atomic bomb was developed during World War II, now is engaged in energy, environmental, biomedical, computer, and other types of research and development as well as nuclear work.

Founded in 1963 as the Los Alamos Museum and Science Hall, it became the Bradbury Science Hall in 1970 and then assumed its present name in 1981. The museum has exhibits on the history of the laboratory, development of nuclear weapons, and energy, environmental, biomedical, computer, and other areas of laboratory research and development.

Bradbury Science Museum, Los Alamos National Laboratory, 15th and Central Sts., MSC 330, Los Alamos, NM 87545. Phone: 505/667-4444. Hours: 9–5 Tues.–Fri.; 1–5 Sat.–Mon.; closed holidays. Admission: free.

### *Lawrence Livermore National Laboratory Visitors Center*

The Lawrence Livermore National Laboratory, managed by the University of California for the U.S. Department of Energy, has a Visitors Center with exhibits on its history, programs, and operations in Livermore, California. The laboratory, once a major center of nuclear weapons development, has diversified in recent years, with environmental and other research and development growing in importance.

Lawrence Livermore National Laboratory Visitors Center, Greenville Rd., PO Box 808, Livermore, CA 94550. Phone: 510/422-6408. Hours: 10–4:30 Mon.–Tues. and Thurs.–Fri.; 12:30–4:30 Wed.; closed holidays. Admission: free.

## UNIVERSITY OF HAWAII
### *Mauna Kea Observatories*

(See Planetaria and Observatories section.)

## WIYN CONSORTIUM
### *WIYN Observatory*

(See Planetaria and Observatories section.)

# Unaffiliated Museums

### BRANDEIS UNIVERSITY
*American Jewish Historical Society*

The American Jewish Historical Society has its national headquarters, library, archives, and museum on the Brandeis University campus in Waltham, Massachusetts. Founded in 1892, the society moved into its present building in 1968.

The society is the world's leading institution for the preservation of materials on American-Jewish life and culture. It has 90,000 volumes, over 12 million manuscripts, and thousands of periodicals and artifacts pertaining to Judaica. The collections include portraits and memorabilia of eighteenth- to twentieth-century American Jewish families, posters and programs of Yiddish theaters of the early 1900s, Yiddish motion pictures, and Jewish ceremonial objects.

American Jewish Historical Society, Brandeis University, 2 Thornton Rd., Waltham, MA 02154. Phone: 617/891-8110. Hours: 9–5 Mon.–Fri.; closed major national and Jewish holidays. Admission: free.

### MISSISSIPPI COLLEGE
*Mississippi Baptist Historical Commission Collection*

The Mississippi Baptist Historical Commission has library and archival materials and a few artifacts in the special collections area of the Leland Speed Library at Mississippi College in Clinton. They include Baptist history materials, old church minute books, documents, and manuscript collections.

Mississippi Baptist Historical Commission Collection, Mississippi College, Leland Speed Library, PO Box 51, Clinton, MS 39060-0051. Phone: 601/925-3434. Hours: 8:30–4:30 Mon.–Fri.; closed holidays and when college not in session. Admission: free.

## MURRAY STATE UNIVERSITY
### National Scouting Museum

The National Scouting Museum of the Boy Scouts of America (BSA) originally was founded near the national headquarters in New Jersey in 1959. When the offices were moved to Texas in 1979, the museum was closed, and a new location was sought. Murray State University made a bid and offered support. The National Scouting Museum was reopened on the campus in Murray, Kentucky, in 1980. It now functions as an independent nonprofit corporation with university representation on the governing board.

The museum contains records, photographs, artworks, memorabilia, and other items related to the history of the Boy Scouts of America. It includes 54 original works of art by Norman Rockwell—most with a Scouting theme; a collection of the personal effects and papers of Scouting's founder, Lord Robert S.S. Baden-Powell; a collection of artworks by American artists and illustrators commissioned by the BSA over its 80-plus-year history; the personal papers and artwork of two BSA founders, Ernest Thompson Seton and Daniel Carter Beard, and the first chief Scout executive, James West; and a comprehensive collection of Scout memorabilia, literature, and other materials dating from the organization's founding in 1910.

The museum has interactive exhibits and theaters, in-gallery storytelling daily by professional actors, and an outdoor ropes and teams course.

National Scouting Museum, Murray State University, 1 Murray St., Murray, KY 42071-3313. Phone: 502/762-3383. Hours: 9–4:30 Tues.–Sat.; 12:30–4:30 Sun.; closed major holidays. Admission: adults, $5; seniors and children 6–12, $4; Boy Scouts and leaders, and university faculty and students, $3.50; children under 6, free.

## NEBRASKA WESLEYAN UNIVERSITY
### Nebraska United Methodist Historical Center

The Nebraska United Methodist Historical Center—which contains the archives and artifacts of the United Methodist Church and its predecessor denominations in Nebraska—is located in the Old Main building of Nebraska Wesleyan University in Lincoln, but operates independently of the university. Opened in the 1940s, the center has collections of records, documents, Bibles, hymnals, and objects relating to the church's history.

Nebraska United Methodist Historical Center, Nebraska Wesleyan University, 5000 St. Paul Ave., PO Box 9553, Lincoln, NE 68504-2796. Phone: 402/465-2175. Hours: 9–12 Mon.–Fri.; closed holidays. Admission: free.

## NEW MEXICO INSTITUTE OF MINING AND TECHNOLOGY
### New Mexico Bureau of Mines Mineral Museum

The New Mexico Bureau of Mines Mineral Museum is operated by the state agency on the campus of the New Mexico Institute of Mining and Technology in Socorro. It was opened in 1927 following the donation of an extensive mineral collection by C.T. Brown, president of the institute (then known as the New Mexico School of Mines). It features minerals from New Mexico.

New Mexico Bureau of Mines Mineral Museum, New Mexico Institute of Mining and Technology, Socorro, NM 87801. Phone: 505/835-5420. Hours: 8–5 Mon.–Fri.; weekends by appointment; closed holidays. Admission: free.

## OKLAHOMA STATE UNIVERSITY
### Oklahoma Museum of Higher Education

The Oklahoma Museum of Higher Education, located on the Oklahoma State University campus in Stillwater, is operated by the Oklahoma Historical Society. The museum, which occupies the first building at the university, built in 1894, traces the history of higher education in the state. The building, restored and opened in 1982, contains period rooms, documents, photographs, books, and memorabilia from 1880 to the present.

Oklahoma Museum of Higher Education, Oklahoma State University, Old Central, University and Knoblock, Stillwater, OK 74078-0705. Phone: 405/624-3220. Hours: 9–5 Tues.–Fri.; 10–4 Sat.; closed holidays. Admission: free.

## OTERO JUNIOR COLLEGE
### Koshare Indian Museum

Plains and Southwest Native American art and artifacts are the focus of the Koshare Indian Museum, located at Otero Junior College in La Junta, Colorado. The collections and exhibits consist mainly of basketry, pottery, and art donated by individuals and purchased by local Boy Scouts (known as Koshares), who are best known for their interpretive dances and traveling shows. The museum was founded in 1949 and operates independently.

Koshare Indian Museum, Otero Junior College, 115 W. 18th St., PO Box 580, La Junta, CO 81050-0580. Phone: 719/384-4411. Hours: summer—9–5 daily; winter—12:30–4:30 daily; closed holidays. Admission: adults, $2; seniors and students, $1.

## PANHANDLE STATE UNIVERSITY
### No Man's Land Historical Museum

Regional history is the focus of the No Man's Land Historical Museum, operated by the No Man's Land Historical Society with the assistance of the

Oklahoma Historical Society and Panhandle State University on the university campus in Goodwell. Founded in 1932, the museum has collections and exhibits of Indian and pioneer artifacts, alabaster carvings, costumes, art, minerals, fossils, birds, mammals, and other materials and specimens.

No Man's Land Historical Museum, Panhandle State University, Sewell St., PO Box 278, Goodwell, OK 73939. Phone: 405/349-2670. Hours: 9–5 Tues.–Sat.; closed holidays. Admission: free.

## PENNSYLVANIA STATE UNIVERSITY
### National Cable Television Center and Museum

The National Cable Television Center and Museum has collections and exhibits about cable television at Pennsylvania State University in University Park. A library and an information center also are part of the facilities.

The center/museum was founded in 1988 by Cable TV Pioneers, an organization of cable industry veterans, which continues to manage the operations. The National Cable Television Association and other cable organizations have assisted in the organizational and operating efforts. The collections and exhibits pertain to the history, equipment, programming, and operations of the cable industry.

National Cable Television Center and Museum, Pennsylvania State University, Level B, Sparks Bldg., University Park, PA 16802. Phone: 814/865-1875. Hours: 10–4 Mon.–Fri.; closed holidays. Admission: free.

## RUTGERS UNIVERSITY
### New Jersey Museum of Agriculture

The New Jersey Museum of Agriculture is an independent nonprofit located on leased land on the Cook College agricultural/environmental sciences campus of Rutgers University in New Brunswick. It is concerned with the history of agriculture and has collections and exhibits of farming machinery, equipment, tools, housewares, and photographs. It was founded in 1984.

New Jersey Museum of Agriculture, College Farm Rd. and Rte. 1, PO Box 1978, New Brunswick, NJ 08903. Phone: 908/249-2077. Hours: 10–5 Wed.–Sat.; 12–5 Sun. Admission: adults, $3; seniors, $2; children, $1.

## SAINT OLAF COLLEGE
### Norwegian-American Historical Association Archives

The Norwegian-American Historical Association has archives relating to the Norwegian emigration to and settlement in America on the campus of Saint Olaf College in Northfield, Minnesota. The association is housed in the college library, but is an independent entity.

Norwegian-American Historical Association Archives, St. Olaf College, 1510 St. Olaf Ave., Northfield, MN 55057-1097. Phone: 507/646-3221. Hours: 8–12 and 1–4 Mon.–Fri.; closed holidays. Admission: free.

## SHELDON JACKSON COLLEGE
### Sheldon Jackson Museum

The Sheldon Jackson Museum is an octagonal one-room museum in Sitka with Alaska's oldest anthropological collection. Founded in 1888, the museum is located on the Sheldon Jackson College campus in the first concrete building constructed in the territory of Alaska in 1895. Originally administered by the college, it now is part of the Alaska State Museum system.

The collections include Haida argillite carvings; Eskimo implements, ivory carvings, masks, skin clothing, baskets, kayaks, and unimiak; Athabaskan birch-bark canoes, skin clothing, and implements; and Tlingit totem poles, shaman charms, baskets, ceremonial equipment, and garments.

Sheldon Jackson Museum, Sheldon Jackson College, 104 College Dr., Sitka, AK 99835. Phone: 907/747-8981. Hours: winter—10–4 Tues.–Sat.; summer—8–5 daily. Admission: adults, $2; children under 18 and college students with current ID, free.

## SOUTH DAKOTA STATE UNIVERSITY
### State Agricultural Heritage Museum

The State Agricultural Heritage Museum at South Dakota State University in Brookings is administered by the South Dakota State Historical Society. Founded in 1967, it has collections and exhibits dealing with agricultural history, machinery, and practices; homesteading; archaeology; and ethnography. The museum also has a major farm machinery archive.

State Agricultural Heritage Museum, South Dakota State University, 11th St. and Medary Ave., PO Box 2207C, Brookings, SD 57007. Phone: 605/688-6226. Hours: 10–5 Mon.–Sat.; 1–5 Sun. Admission: free.

## TUSKEGEE UNIVERSITY
### George Washington Carver Museum

The George Washington Carver Museum—which honors the distinguished botanist responsible for many agricultural innovations—was founded in 1938 by Tuskegee University in Alabama and donated to the National Park Service in 1977. It now is owned and administered by the U.S. Department of the Interior agency as part of the Tuskegee Institute National Historic Site, which also includes the home of the institute's founder and first president, Booker T. Washington.

The museum—housed in a 1915 building originally constructed by students and used as the institute's laundry and later as Carver's laboratory—contains

Carver's laboratory equipment, his peanut and other products, and his personal items, such as the paintings he made. It has an annual attendance of approximately 325,000.

George Washington Carver Museum, Tuskegee Institute National Historic Site, 1212 Old Montgomery Rd., PO Drawer 10, Tuskegee Institute, AL 36087-0010. Phone: 205/727-3200. Hours: 9–5 daily; closed New Year's Day, Thanksgiving, and Christmas. Admission: free.

## UNIVERSITY OF MISSOURI–COLUMBIA
### State Historical Society of Missouri Gallery

The State Historical Society of Missouri, located at the University of Missouri–Columbia, but administered separately, has a gallery with historical paintings, sculpture, drawings, prints, photographs, maps, cartoons, and manuscripts. Founded in 1898, the society also has a 440,000-volume library of books, pamphlets, and periodicals, including Missouri newspapers from 1808 to the present.

State Historical Society of Missouri Gallery, University of Missouri–Columbia, 1020 Lowry, Columbia, MO 65201. Phone: 314/882-7083. Hours: 8:30–4 Mon.–Fri.; closed holidays. Admission: free.

## UNIVERSITY OF NORTH CAROLINA AT ASHEVILLE
### Botanical Gardens of Asheville

The Botanical Gardens of Asheville are located on land owned by the University of North Carolina at Asheville, but are operated by an independent nonprofit. The gardens were started in 1960 as the University Botanical Gardens at Asheville, but the name was changed in recent years because of the public impression that the gardens were university operated. The 10-acre gardens are devoted to the preservation and display of native plants of the Blue Ridge region.

Botanical Gardens of Asheville, 151 W.T. Weaver Blvd., Asheville, NC 28804. Phone: 704/252-5190. Hours: dawn–dusk daily. Admission: free.

## UNIVERSITY OF RICHMOND
### Virginia Baptist Historical Society Exhibit Area and Archives

The Virginia Baptist Historical Society has an exhibit area and archives in the University of Richmond's Boatwright Library in Richmond, but operates independently of the university. The materials pertain to Virginia Baptist history.

Virginia Baptist Historical Society, University of Richmond, Boatwright Library, Box 34, Richmond, VA 23173. Phone: 804/289-8434. Hours: 9–12 and 1–4:30 Mon.–Fri.; by appointment Sat.–Sun.; closed holidays. Admission: free.

## UNIVERSITY OF SOUTH ALABAMA–SPRINGHILL
### Eichold-Heustis Medical Museum of the South

The Eichold-Heustis Medical Museum of the South—located in the lobby of the University of South Alabama–Springhill in Mobile, but operated independently—tells the story of the practice of medicine in the Southeast over the last 200 years. Founded in 1962, its collections and exhibits feature historic medical artifacts.

Eichold-Heustis Medical Museum of the South, University of South Alabama–Springhill, 1504 Springhill Ave., Mobile, AL 36608. Phone: 205/476-3752. Hours: 8–5 Mon.–Fri.; closed holidays. Admission: free.

## UNIVERSITY OF SOUTH DAKOTA
### W.H. Over State Museum

The W.H. Over State Museum is located on the University of South Dakota campus in Vermillion, but is administered by the South Dakota Department of Education and Cultural Affairs and the State Historical Society. The museum, which began as a study collection in the natural sciences in 1883 (six years before statehood), is devoted to preserving and interpreting the heritage of the land and the people of South Dakota.

The museum's collections and exhibits are devoted to the state's natural and cultural heritage. It has over 600,000 items in its collections. The most significant collections are the David and Elizabeth Clark Memorial Collection of Lakota Indian material, the Stanley J. Morrow Collection of historical photographs, and a collection of historic clothing and firearms. The museum moved into a new 29,200-square-foot building in 1989.

W.H. Over State Museum, University of South Dakota, 414 E. Clark St., Vermillion, SD 57069-2390. Phone: 605/677-5228. Hours: 8–5 Mon.–Fri.; 1–4:30 Sat.–Sun.; closed holidays. Admission: free.

## UNIVERSITY OF TEXAS AT AUSTIN
### Lyndon Baines Johnson Library and Museum

The Lyndon Baines Johnson Library and Museum on the University of Texas campus in Austin is one of the nation's presidential libraries and museums. The university raised the initial funds, built the facility on 14 acres, and turned it over to the federal government. It now is operated—as are eight other presidential libraries/museums—by the National Archives and Records Administration.

Opened in 1971, the museum has over 50,000 objects that include American political memorabilia from George Washington's time to the present, such as the nineteenth-century desk on which President Johnson signed the Voting

Rights Act of 1965, letters relating to the Vietnam War, and gifts from heads of state. Among the exhibit themes are *The Great Society, The Johnson Style,* and *Life in the White House.* The museum also presents two major temporary exhibitions dealing with American history each year.

The library houses more than 40 million pages of President Johnson's papers and other historical documents, photographs, films, videotapes, audio recordings, books, and serials. Approximately 400,000 people visit the library and museum annually.

Lyndon Baines Johnson Library and Museum, University of Texas–Austin, 2313 Red River St., Austin, TX 78705. Phone: 512/482-5137. Hours: 9–5 daily; closed Christmas. Admission: free.

## UNIVERSITY OF TEXAS AT DALLAS
### Frontiers of Flight Museum

The Frontiers of Flight Museum in the Love Field Terminal is an independent nonprofit museum that works with the History of Aviation Collection at the University of Texas at Dallas. Opened in 1990, the 4,500-square-foot museum contains collections and exhibits from pre–Wright brothers days through the modern space age. The holdings include artifacts, photos, models, and other materials—many of which are from the History of Aviation Collection.

Frontiers of Flight Museum, Love Field Terminal, LB-38, Dallas, TX 75235. Phone: 214/350-3600. Hours: 10–5 Mon.–Sat.; 1–5 Sun.; closed major holidays. Admission: adults, $2; children under 12, $1.

## UNIVERSITY OF WYOMING
### U.S. Forest Service National Herbarium (Rocky Mountain Herbarium)

(See Botanical Gardens, Arboreta, and Herbaria section.)

## VIRGINIA MILITARY INSTITUTE
### George C. Marshall Foundation Museum

The George C. Marshall Foundation was founded in 1953 to honor the American general who served as chief of staff, secretary of state, and secretary of defense and who was the originator of the postwar Marshall Plan for European recovery. The foundation owns and operates a museum, archives, and research library on the Virginia Military Institute grounds in Lexington, Virginia.

The museum exhibits trace the life and times of General Marshall and include an electronic map charting the course of World War II in Europe, a Marshall Plan room, the Nobel Peace Prize that Marshall received for his Marshall Plan work, and many of his papers, medals, and memorabilia. Among the other foundation collections are the military collections of James A. Van Fleet and Lucius

Clay, William and Elizabeth Friedman Collection of cryptography material, and Frank McCarthy Collection of ''Patton'' motion picture material.
George C. Marshall Foundation Museum, Virginia Military Institute Parade, PO Drawer 1600, Lexington, VA 24450-1600. Phone: 703/463-7103. Hours: 8:30–4:30 daily; closed holidays. Admission: free.

## WESTERN TEXAS COLLEGE
### Scurry County Museum

The Scurry County Museum, operated by the Scurry County Museum Association, is located on the Western Texas College campus in Snyder. The local history museum, which receives support from the city, county, and university, has exhibits and collections of farming and ranching equipment, frontier furniture, Victorian lamps, costumes, production equipment and tools, contemporary prints, and county records and memorabilia. The museum was founded in 1970.
Scurry County Museum, Western Texas College, PO Box 696, Snyder, TX 79550. Phone: 915/573-6107. Hours: 8–5 Mon.–Thurs.; 8–4 Fri.; 1–4 Sun.; closed major holidays. Admission: free.

# Universities and Colleges with Museums, Galleries, and Related Facilities

**Academy of the New Church, Bryn Athyn, PA**
Glencairn Museum
**Adams State College, Alamosa, CO**
Harry Zacheis Planetarium
Luther E. Bean Museum
**Agnes Scott College, Decatur, GA**
Dalton Art Gallery
**Albertson College of Idaho, Caldwell**
Rosenthal Gallery of Art
**Albion College, Albion, MI**
Bobbit Visual Arts Center
Whitehouse Nature Center
**Albright College, Reading, PA**
Freedman Gallery
**Alfred University, Alfred, NY**
Museum of Ceramic Art at Alfred
**Allegheny College, Meadville, PA**
Allegheny College Art Galleries
Bowman Gallery
Megahan Gallery
Penelec Gallery
**American University, Washington, DC**
Watkins Gallery
**Amherst College, Amherst, MA**

Folger Shakespeare Library, Washington, DC
Mead Art Museum
Pratt Museum of Natural History
**Anderson University, Anderson, IN**
Gustav Jeeninga Museum of Bible and Near Eastern Studies
**Andrews University, Berrien Springs, MI**
Siegfried H. Horn Archaeological Museum
**Angelo State University, San Angelo, TX**
University Planetarium
**Anna Maria College, Paxton, MA**
Moll Art Center
**Antioch College, Yellow Springs, OH**
Trailside Museum
**Appalachian State University, Boone, NC**
Appalachian Cultural Museum
**Arizona State University, Tempe**
Arizona State University Art Museum
Center for Meteorite Studies
Deer Valley Rock Art Center
Gallery of Design
Harry Wood Art Gallery
Memorial Union Gallery
Museum of Anthropology
Museum of Geology
Northlight Gallery
Southwest Center for Education and the Natural Environment
**Arkansas State University, State University**
Arkansas State University Museum
Fine Arts Center Gallery
**Art Institute of Boston, Boston, MA**
Gallery East
Gallery West
**Associated Universities Inc., Green Bank, WV**
National Radio Astronomy Observatory
Green Bank Observatory
Very Large Array, Socorro, NM
Very Long Baseline Array, Socorro, NM
**Association of Universities for Research in Astronomy Inc., Tucson, AZ**
National Optical Astronomical Observatories
Cerro Tololo Inter-American Observatory, Chile
Kitt Peak National Observatory, Tucson, AZ
National Solar Observatory, Sunspot, NM
**Atlanta College of Art, Atlanta, GA**
Atlanta College of Art Gallery

**Augustana College, Rock Island, IL**
Augustana College Art Gallery
Fryxell Geology Museum
John Deere Planetarium
**Augustana College, Sioux Falls, SD**
Center for Western Studies
**Aurora University, Aurora, IL**
Schingoethe Center for Native American Cultures
**Austin Peay State University, Clarksville, TN**
Trahern Gallery
**Avila College, Kansas City, MO**
Thornhill Gallery
**Bacone College, Muskogee, OK**
Ataloa Lodge Museum
**Baker University, Baldwin City, KS**
Old Castle Museum
William A. Quayle Bible Collection
**Ball State University, Muncie, IN**
Ball State University Museum of Art
Ball State University Planetarium
Biology Teaching Museum and Nature Center
**Bard College, Annandale-on-Hudson, NY**
Bard Graduate Center for Studies in the Decorative Arts, New York City
**Barton College, Wilson, NC**
Case Art Gallery
**Bates College, Lewiston, ME**
Museum of Art
**Baylor University, Waco, TX**
Armstrong Browning Library
Martin Museum of Art
Strecker Museum
Governor Bill and Vara Daniel Historic Village
Youth Cultural Center
University Art Gallery
**Beaver College, Glenside, PA**
Beaver College Art Gallery
**Beloit College, Beloit, WI**
Museums of Beloit College
Logan Museum of Anthropology
Wright Museum of Art
**Benedictine College, Atchison, KS**
Benedictine College Museum
**Berea College, Berea, KY**
Berea College Museum

Doris Ulmann Galleries
Roberts Observatory
Weatherford Planetarium
Wilbur Greeley Burroughs Geologic Museum
**Bethany College, Bethany, WV**
Historic Bethany
**Bethany College, Lindsborg, KS**
Birger Sandzen Memorial Gallery
**Bethel College, North Newton, KS**
Kauffman Museum
Mennonite Library and Archives
**Blinn College, Washington, TX**
Star of the Republic Museum
**Bloomsburg University of Pennsylvania, Bloomsburg**
Haas Gallery of Art
**Bob Jones University, Greenville, SC**
Bob Jones University Collection of Sacred Art
Howell Memorial Planetarium
**Boston College, Chestnut Hill, MA**
Boston College Museum of Art
**Boston University, Boston, MA**
Boston University Art Gallery
**Bowdoin College, Brunswick, ME**
Bowdoin College Museum of Art
Peary-Macmillan Arctic Museum
**Bowling Green State University, Bowling Green, OH**
Bowling Green State University Galleries
    Dorothy Uber Bryan Gallery
    Hiroko Nakamoto Gallery
    School of Art Galleries
Bowling Green State University Planetarium
**Brandeis University, Waltham, MA**
American Jewish Historical Society
Rose Art Museum
**Brenau University, Gainesville, GA**
Brenau University Galleries
**Brevard College, Brevard, NC**
Sims Art Center
**Brevard Community College, Cocoa, FL**
Astronaut Memorial Planetarium and Observatory
**Bridgewater College, Bridgewater, VA**
Reuel B. Pritchett Museum
**Brigham Young University, Provo, UT**
Earth Science Museum

Monte L. Bean Life Science Museum
Museum of Art
Museum of Peoples and Cultures
Sarah Summerhays Planetarium
**Broward Community College, Davie, FL**
Buehler Planetarium
**Brown University, Providence, RI**
Annmary Brown Memorial
David Winton Bell Gallery
Haffenreffer Museum of Anthropology, Bristol
**Bucknell University, Lewisburg, PA**
Center Gallery
**Bucks County Community College, Newton, PA**
Artmobile
Atrium Gallery
Hicks Art Gallery
**Butler University, Indianapolis, IN**
J.I. Holcomb Observatory and Planetarium
**California Association for Research in Astronomy, Kamuela, HI**
W.M. Keck Observatory
**California College of Arts and Crafts, Oakland**
Oliver Art Center Gallery
**California Institute of Technology, Pasadena**
Palomar Observatory Museum and Gallery, Palomar Mountain
**California Polytechnic State University, San Luis Obispo**
Robert F. Hoover Herbarium
**California State University, Chico**
Janet Turner Print Gallery
Museum of Anthropology
**California State University, Dominguez Hills**
University Art Gallery, Carson
**California State University, Fullerton**
Art Gallery
Fullerton Arboretum
Museum of Anthropology
**California State University, Hayward**
C.E. Smith Museum of Anthropology
**California State University, Long Beach**
University Art Museum
**California State University, Northridge**
Art Galleries
**California State University, San Bernardino**
University Art Gallery
**Calvin College, Grand Rapids, MI**

Center Art Gallery
**Capital University, Columbus, OH**
Schumacher Gallery
**Carnegie Mellon University, Pittsburgh, PA**
Hunt Institute for Botanical Documentation
**Case Western Reserve University, Cleveland, OH**
Dittrick Museum of Medical History
**Cazenovia College, Cazenovia, NY**
Chapman Art Center Gallery
**Centenary College of Louisiana, Shreveport**
Magale Library Gallery
Meadows Museum of Art
Turner Art Center Gallery
**Center for Creative Studies–College of Art and Design, Detroit, MI**
Center Galleries
**Central Connecticut State University, New Britain**
Copernican Observatory and Planetarium
Museum of Central Connecticut State University
**Central Methodist College, Fayette, MO**
Ashby-Hodge Gallery of American Art
Missouri United Methodist Archives
Stephens Museum of Natural History
**Central Michigan University, Mt. Pleasant**
Center for Cultural and Natural History
**Central Missouri State University, Warrensburg**
Central Missouri State University Archives/Museum
**Central Washington University, Ellensburg, WA**
Anthropology Museum
**Chadron State College, Chadron, NE**
CSC Earth Science Museum
**Chaffey Community College, Rancho Cucamonga, CA**
Wignall Museum/Gallery
**The Citadel, The Military College of South Carolina, Charleston**
The Citadel Museum
**City University of New York, Baruch College, New York, NY**
Sidney Mishkin Gallery
**City University of New York, Bronx Community College, Bronx, NY**
Hall of Fame for Great Americans
**City University of New York, Brooklyn College, Brooklyn, NY**
Art Gallery of Brooklyn College
**City University of New York, Fiorello H. LaGuardia Community College, Long Island City, NY**
LaGuardia and Wagner Archives Museum
**City University of New York, Lehman College, Bronx, NY**

Lehman College Art Gallery
**City University of New York, Queens College, Flushing, NY**
Frances Godwin and Joseph Ternbach Museum
Queens College Art Center, New York City
**Clarion University of Pennsylvania, Clarion**
Sandford Gallery
**Clemson University, Clemson, SC**
Clemson University Historic Properties
Hanover House
Hopewell
John C. Calhoun House
Kinard Annex
Sears Mail-Order House
Trustee House
Clemson University Planetarium
Rudolph E. Lee Gallery
South Carolina Botanical Garden
Strom Thurmond Institute
**Cleveland State University, Cleveland, OH**
Art Gallery
**Coker College, Hartsville, SC**
Cecelia Coker Bell Gallery
**Colby College, Waterville, ME**
Colby College Museum of Art
**Colgate University, Hamilton, NY**
Picker Art Gallery
**College of the Atlantic, Bar Harbor, ME**
Ethel H. Blum Art Gallery
Natural History Museum
**College of Charleston, Charleston, SC**
Avery Research Center for African American History and Culture
Halsey Gallery
**College of the Desert, Palm Springs, CA**
Moorten Botanic Garden and Cactarium
**College of Eastern Utah, Price**
College of Eastern Utah Prehistoric Museum
Gallery East
**College of the Holy Cross, Worcester, MA**
Iris and B. Gerald Cantor Art Gallery
**College of Mount Saint Joseph, Cincinnati, OH**
Studio San Giuseppe Art Gallery
**College of Notre Dame, Belmont, CA**
Wiegand Gallery
**College of the Ozarks, Point Lookout, MO**

Ralph Foster Museum
**College of Saint Benedict, St. Joseph, MN**
Benedicta Arts Center
**College of Southern Idaho, Twin Falls**
Herrett Museum
**College of William and Mary, Williamsburg, VA**
Ash Lawn–Highland, Charlottesville
Joseph and Margaret Muscarelle Museum of Art
Virginia Institute of Marine Science Fish Collection, Gloucester Point
**College of Wooster, Wooster, OH**
College of Wooster Art Museum
**Colorado School of Mines, Golden**
Geology Museum
**Colorado State University, Fort Collins**
Curfman Gallery
Duhesa Lounge
Gustafson Gallery
Hatton Gallery
**Columbia College Chicago, Chicago, IL**
Columbia College Art Gallery
Museum of Contemporary Photography
**Columbia University, New York, NY**
Miriam and Ira D. Wallach Art Gallery
**Concordia College, Seward, NE**
Marxhausen Art Gallery
**Concordia University Wisconsin, Mequon**
Concordia University Gallery
**Connecticut College, New London**
Connecticut College Arboretum
**Connors State College, Warner, OK**
Wallis Museum
**Converse College, Spartanburg, SC**
Milliken Gallery
**Cornell College, Mt. Vernon, IA**
Armstrong Gallery
**Cornell University, Ithaca, NY**
Cornell Plantations
Herbert F. Johnson Museum of Art
L.H. Bailey Hortorium
**Cranbrook Academy of Art, Bloomfield Hills, MI**
Cranbrook Academy of Art Museum
**Crowder College, Neosho, MO**
Longwell Museum
**Dartmouth College, Hanover, NH**

Hood Museum of Art
**Davidson College, Davidson, NC**
William H. Van Every Jr. Gallery
**Daytona Beach Community College, Daytona Beach, FL**
Southeast Museum of Photography
**De Anza College, Cupertino, CA**
Euphrat Museum of Art
**Delaware Technical and Community College, Georgetown**
Treasures of the Sea Exhibit
**Delta State University, Cleveland, MS**
Fielding L. Wright Art Center
**Denison University, Granville, OH**
Denison University Gallery
**DePaul University, Chicago, IL**
DePaul University Art Gallery
**DePauw University, Greencastle, IN**
DePauw University Anthropology Museum
**Diablo Valley College, Pleasant Hill, CA**
Diablo Valley College Museum
**Dickinson College, Carlisle, PA**
Trout Gallery
**Drew University, Madison, NJ**
Elizabeth P. Korn Art Gallery
**Drexel University, Philadelphia, PA**
Drexel University Museum
**Duke University, Durham, NC**
Duke University Museum of Art
History of Medicine Collections
**Earlham College, Richmond, IN**
Conner Prairie, Fishers
Joseph Moore Museum of Natural History
Ralph Teetor Planetarium
**East Carolina University, Greenville, NC**
Wellington B. Gray Gallery
**Eastern Arizona College, Thatcher**
Museum of Anthropology
**Eastern College, St. Davids, PA**
Warner Memorial Library
**Eastern Illinois University, Charleston**
Tarble Arts Center
**Eastern Kentucky University, Richmond**
Arnim D. Hummel Planetarium
**Eastern Mennonite College and Seminary, Harrisonburg, VA**
D. Ralph Hostetter Museum of Natural History

M. T. Brackhill Planetarium

**Eastern New Mexico University, Portales**
Blackwater Draw Museum
Miles Mineral Museum
Natural History Museum
Roosevelt County Museum

**Eastern Washington University, Cheney**
University Galleries

**East Tennessee State University, Johnson City**
Carroll Reece Museum
Slocumb Galleries

**Edinboro University of Pennsylvania, Edinboro**
Fort Leboeuf, Waterford

**Edison Community College–Lee County Campus, Fort Myers, FL**
Gallery of Fine Art

**Ellsworth College, Iowa Falls, IA**
Ellsworth College Museum

**Elmhurst College, Elmhurst, IL**
Elmhurst College Library Collection

**Emory University, Atlanta, GA**
Michael C. Carlos Museum

**Emporia State University, Emporia, KS**
Norman R. Eppink Art Gallery
Richard H. Schmidt Museum of Natural History

**Everett Community College, Everett, WA**
Northlight Gallery

**Evergreen State College, Olympia, WA**
Evergreen Galleries

**Fairfield University, Fairfield, CT**
Thomas J. Walsh Art Gallery

**Fashion Institute of Technology, New York, NY**
Museum at F.I.T.

**Ferrum College, Ferrum, VA**
Blue Ridge Heritage Archive
Blue Ridge Institute Farm Museum
Blue Ridge Institute Galleries
Jessie Ball du Pont Fund Gallery
King Gallery

**Fisk University, Nashville, TN**
University Galleries
Aaron Douglas Gallery
Carl Van Vechten Gallery

**Florida Community College, Jacksonville**
Kent Campus Gallery

**Florida International University, Miami**
Art Museum at Florida International University
**Florida School of the Arts, Palatka**
Florida School of the Arts Gallery
**Florida State University, Tallahassee**
Florida State University Museum of Fine Arts
**Florida State University and Central Florida Community College, Ocala**
Appleton Museum of Art
**Fort Hays State University, Hays, KS**
Moss-Thorns Gallery
Sternberg Museum of Natural History
**Fort Lewis College, Durango, CO**
Center of Southwest Studies Museum
**Framingham State College, Framingham, MA**
Danforth Museum of Art
**Francis Marion College, Florence, SC**
Francis Marion College Planetarium
**Franklin and Marshall College, Lancaster, PA**
North Museum of Natural History and Science
**Friends University, Wichita, KS**
Fellow-Reeve Museum of History and Science
**Gannon University, Erie, PA**
Gannon Erie Historical Museum
**Georgetown University, Washington, DC**
Fine Arts Gallery
Georgetown University Collection
**George Washington University, Washington, DC**
Dimock Gallery
**Georgia College, Milledgeville**
Museum and Archives of Georgia Education
**Georgia Southern University, Statesboro**
Georgia Southern Museum
**Georgia State University, Atlanta**
Georgia State University Art Gallery
**Gertrude Herbert Institute of Art, Augusta, GA**
Gertrude Herbert Institute of Art Gallery
**Gonzaga University, Spokane, WA**
Ad Gallery
**Goshen College, Goshen, IN**
Goshen College Art Gallery
**Goucher College, Baltimore, MD**
Rosenberg Gallery
**Governors State University, University Park, IL**
Sculpture Park

**Greensboro College, Greensboro, NC**
    Irene Cullis Gallery
**Grinnell College, Grinnell, IA**
    Print and Drawing Study Room
**Grossmont College, El Cajon, CA**
    Hyde Gallery
**Guilford College, Greensboro, NC**
    Guilford College Art Gallery
**Hamilton College, Clinton, NY**
    Emerson Gallery
**Hamline University, St. Paul, MN**
    Hamline University Galleries
**Hampden-Sydney College, Hampden-Sydney, VA**
    Esther Thomas Atkinson Museum
**Hampton University, Hampton, VA**
    Hampton University Museum
**Hartnell College, Salinas, CA**
    Hartnell Gallery
**Hartwick College, Oneonta, NY**
    Museums at Hartwick
        Foreman Gallery
        Hartwick College Archives
        Hoysradt Herbarium
        Yager Museum
**Harvard University, Cambridge, MA**
    Arnold Arboretum of Harvard University, Jamaica Plain
    Collection of Scientific Instruments
    Dumbarton Oaks Research Library and Collection, Washington, DC
    Fisher Museum, Petersham
    Harvard Forest, Petersham
    Harvard-Smithsonian Center for Astrophysics
        Fred Lawrence Whipple Observatory, Amado, AZ
    Harvard University Art Museums
        Arthur M. Sackler Museum
        Busch-Reisinger Museum
        Fogg Art Museum
            Center for Conservation and Technical Studies
    Harvard University Herbaria
    Harvard University Museums of Natural History
        Botanical Museum
        Mineralogical and Geological Museum
        Museum of Comparative Zoology
        Peabody Museum of Archaeology and Ethnology
        Oak Ridge Observatory, Harvard, MA

Semitic Museum
**Haverford College, Haverford, PA**
Haverford College Arboretum
**Hawaii Pacific University, Honolulu**
Hawaii Pacific University Gallery
**Hebrew Union College, Los Angeles, CA**
Skirball Museum
**Hebrew Union College–Jewish Institute of Religion, Cincinnati, OH**
Skirball Museum, Cincinnati Branch
**Henderson State University, Arkadelphia, AR**
Henderson State University Museum
**Highland Community College, Freeport, IL**
Highland Community College Arboretum
**Hill College, Hillsboro, TX**
Audie L. Murphy Gun Museum
Confederate Research Center and Museum
**Hobart and William Smith Colleges, Geneva, NY**
Houghton House Gallery
**Hofstra University, Hempstead, NY**
Hofstra Museum
Emily Lowe Gallery
Filderman Gallery
Lowenfeld Gallery
**Housatonic Community-Technical College, Bridgeport, CT**
Housatonic Museum of Art
**Houston Baptist University, Houston, TX**
Museum of American Architecture and Decorative Arts
**Howard University, Washington, DC**
Howard University Gallery of Art
Howard University Museum
**Humboldt State University, Arcata, CA**
Reese Bullen Gallery
**Hunter College, New York, NY**
Hunter College Art Galleries
**Idaho State University, Pocatello**
Idaho Museum of Natural History
**Illinois Benedictine College, Lisle**
Jurica Nature Museum
**Illinois State University, Normal**
Physics Department Planetarium
**Indiana State University, Terre Haute**
Turman Art Gallery
**Indiana University, Bloomington**
Elizabeth Sage Historic Costume Collection

Fine Arts Gallery
Hilltop Garden and Nature Center
Indiana University Art Museum
Lilly Library
William Hammond Mathers Museum
**Indiana University of Pennsylvania, Indiana**
Kipp Gallery
University Museum
**Institute of American Indian Arts, Santa Fe, NM**
Institute of American Indian Arts Museum
**Iowa State University, Ames**
University Museums
Art on Campus Program
Brunnier Art Museum
Farm House Museum
**Iowa Wesleyan College, Mount Pleasant**
Harlan-Lincoln Home
**Jacksonville University, Jacksonville, FL**
Alexander Brest Museum and Gallery
**James Madison University, Harrisonburg, VA**
John C. Wells Planetarium
Sawhill Gallery
Zirkle House
**Jamestown Community College, Jamestown, NY**
Forum Gallery
**Jefferson Davis Community College, Brewton, AL**
Thomas E. McMillan Museum
**Jewish Theological Seminary of America, New York, NY**
Jewish Museum
**John C. Calhoun State Community College, Decatur, AL**
Art Gallery
**Johns Hopkins University, Baltimore, MD**
Evergreen House
Homewood House Museum
Johns Hopkins University Archaeological Collection
**Johnson and Wales University, Providence, RI**
Culinary Archives and Museum
**Johnson County Community College, Overland Park, KS**
Gallery of Art
**Kalamazoo Institute of Arts, Kalamazoo, MI**
Kalamazoo Institute of Arts
**Kalamazoo Valley Community College, Kalamazoo, MI**
Kalamazoo Public Museum
**Kansas City Art Institute, Kansas City, MO**

Kemper Museum of Contemporary Art and Design
**Kansas State University, Manhattan**
Kansas State University Herbarium
Marianna Kistler Beach Museum of Art
**Kean College of New Jersey, Union**
James Howe Gallery
**Keene State College, Keene, NH**
Thorne-Sagendorph Art Gallery
**Kendall College, Evanston, IL**
Mitchell Indian Museum
**Kennesaw State College, Marietta, GA**
Fine Arts Gallery
Sturgis Library Gallery
**Kent State University, Kent, OH**
Kent State University Art Galleries
Gallery in the School of Art
William H. Eells Art Gallery
Kent State University Museum
**Kentucky State University, Frankfort**
Jackson Hall Gallery
**Kirksville College of Osteopathic Medicine, Kirksville, MO**
Still National Osteopathic Museum
**Lafayette College, Easton, PA**
Art Gallery
**LaGrange College, LaGrange, GA**
Lamar Dodd Art Center
**Lakeland College, Sheboygan, WI**
Bradley Gallery of Art
**Lake-Sumter Community College, Leesburg, FL**
Art Gallery
**Lamar University, Beaumont, TX**
Dishman Art Gallery
Spindletop/Gladys City Boomtown Museum
**Lane Community College, Eugene, OR**
Lane Community College Art Gallery
**La Salle University, Philadelphia, PA**
La Salle University Art Museum
**La Sierra University, Riverside, CA**
World Museum of Natural History
**Lawrence University, Appleton, WI**
Wriston Art Center Galleries
**Lawrence University, Baileys Harbor, WI**
Bjorklunden Chapel
**Lehigh University, Bethlehem, PA**

Lehigh University Art Galleries
DuBois Gallery
Hall Gallery
Ralph L. Wilson Gallery
Siegel Gallery
Study Gallery
**Liberty University, Lynchburg, VA**
Museum of Earth and Life History
**Limestone College, Gaffney, SC**
Winnie Davis Museum of History
**Lincoln Memorial University, Harrogate, TN**
Abraham Lincoln Museum
**Long Island University, C.W. Post Campus, Brookville, NY**
Hillwood Art Museum
**Longwood College, Farmville, VA**
Longwood Center for the Visual Arts
**Louisburg College, Louisburg, NC**
Louisburg College Art Gallery
**Louisiana State University, Baton Rouge**
Louisiana State University Herbarium
LSU Museum of Art
LSU Rural Life Museum
Windrush Gardens
LSU Union Art Gallery
Museum of Natural Science
**Louisiana State University in Shreveport**
Pioneer Heritage Center
**Louisiana Tech University, Ruston**
Louisiana Tech Museum
**Louisville Presbyterian Theological Seminary, Louisville, KY**
Horn Archaeological Museum
**Lower Columbia College, Longview, WA**
Art Gallery
**Loyola Marymount University, Los Angeles, CA**
Laband Art Gallery
**Loyola University Chicago, Chicago, IL**
Martin D'Arcy Gallery of Art
**Luther College, Decorah, IA**
Preus Library Fine Arts Collection
**Maine College of Art, Portland**
Baxter Gallery
**Manchester Institute of Arts and Sciences, Manchester, NH**
Manchester Institute of Arts and Sciences Gallery
**Marquette University, Milwaukee, WI**

Patrick and Beatrice Haggerty Museum of Art
**Marshall University, Huntington, WV**
Geology Museum
**Mary Baldwin College, Staunton, VA**
Hunt Gallery
**Maryland Institute, Baltimore**
Decker Gallery
Meyerhoff Gallery
**Marylhurst College, Marylhurst, OR**
Art Gym at Marylhurst College
**Maryville University, St. Louis, MO**
Morton May Gallery
**Mary Washington College, Fredericksburg, VA**
Belmont, The Gari Melchers Estate and Memorial Gallery
James Monroe Museum and Memorial Library
Mary Washington College Art Galleries
    DuPont Gallery
    Ridderhof Martin Gallery
**Marywood College, Scranton, PA**
Marywood College Art Galleries
    Contemporary Gallery
    Sucaci Gallery
**Massachusetts Institute of Technology, Cambridge**
List Visual Arts Center
    Hayden Gallery
    Kakalar Gallery
    Reference Gallery
MIT Museum
    Harold E. Edgerton Strobe Alley
    Hart Nautical Galleries
    Margaret Hutchinson Compton Gallery
**McPherson College, McPherson, KS**
McPherson Museum
**Medical University of South Carolina, Charleston**
Macaulay Museum of Dental History
Waring Historical Library
**Memphis College of Art, Memphis, TN**
Frank T. Tobey Memorial Gallery
**Merritt Community College, Oakland, CA**
Merritt Museum of Anthropology
**Metropolitan State College of Denver, Denver, CO**
Center for the Visual Arts
**Miami-Dade Community College, Miami, FL**
Centre Gallery, Wolfson Campus

Kendall Campus Art Gallery
**Miami University, Oxford, OH**
Miami University Art Museum
William Holmes McGuffey House and Museum
**Michigan State University, East Lansing**
Abrams Planetarium
Beal-Darlington Herbarium
Fred Russ Experimental Forest, Decatur
Hidden Lake Gardens, Tipton
Kellogg Farm Dairy Center, Hickory Corners
Kresge Art Museum
Michigan State University Museum
W.J. Beal Botanical Garden
W.K. Kellogg Biological Station, Hickory Corners
W.K. Kellogg Bird Sanctuary, Augusta
W.K. Kellogg Experimental Forest, Augusta
**Michigan Technological University, Houghton**
A.E. Seaman Mineral Museum
**Middlebury College, Middlebury, VT**
Middlebury College Museum of Art
Christian A. Johnson Memorial Gallery
**Middle Georgia College, Cochran**
Roberts Memorial Library Museum Room
**Middle Tennessee State University, Murfreesboro**
Photographic Gallery
**Millikin University, Decatur, IL**
Birks Museum
Perkinson Gallery
**Mills College, Oakland, CA**
Mills College Art Gallery
**Minneapolis College of Art and Design, Minneapolis, MN**
MCAD Gallery
**Mississippi College, Clinton**
Mississippi Baptist Historical Commission Collection
**Mississippi State University, Mississippi State**
Dunn-Seiler Museum
Lois Dowdle Cobb Museum of Archaeology
**Mississippi University for Women, Columbus**
Archives and Museum
**Montana College of Mineral Science and Technology, Butte**
Mineral Museum
**Montana State University, Bozeman**
Haynes Fine Arts Gallery
Museum of the Rockies

Ruth and Vernon Taylor Planetarium
**Montana State University–Northern, Havre**
Hagener Science Center
Northern Gallery
**Montclair State College, Upper Montclair, NJ**
Montclair State College Art Gallery
**Moore College of Art and Design, Philadelphia, PA**
Atrium Gallery
Goldie Paley Gallery
Levy Gallery
**Morehead State University, Morehead, KY**
Folk Art Center
**Morgan State University, Baltimore, MD**
James E. Lewis Museum of Art
**Mott Community College, Flint, MI**
Labor Museum and Learning Center of Michigan
**Mount Holyoke College, South Hadley, MA**
Mount Holyoke College Art Museum
Skinner Museum
**Mount Mary College, Milwaukee, WI**
Historic Costumes and Textiles Collection
**Murray State University, Murray, KY**
Clara M. Eagle Gallery
National Scouting Museum
Wickliffe Mounds, Wickliffe
Wrather West Kentucky Museum
**Muskegon Community College, Muskegon, MI**
Carr-Fles Planetarium
**Nassau Community College, Garden City, NY**
Firehouse Art Gallery
**Nebraska Wesleyan University, Lincoln**
Elder Gallery
Nebraska United Methodist Historical Center
**New England College, Henniker, NH**
New England College Gallery
**New Mexico Highlands University, Las Vegas**
Arrott Art Gallery
**New Mexico Institute of Mining and Technology, Socorro**
New Mexico Bureau of Mines Mineral Museum
**New Mexico Military Institute, Roswell**
General Douglas L. McBride Museum
**New Mexico State University, Las Cruces**
New Mexico State University Museum
University Art Gallery

**New York University, New York City**
Grey Art Gallery and Study Center
**Niagara County Community College, Sanborn, NY**
Niagara County Community College Planetarium
**Niagara University, Niagara University, NY**
Castellani Art Museum
**North Carolina Agricultural and Technical State University, Greensboro**
Mattye Reed African Heritage Center
**North Carolina Central University, Durham**
NCCU Art Museum
**North Carolina State University, Raleigh**
Chinqua-Penn Plantation, Reidsville
North Carolina State University Arboretum
Visual Arts Center
**North Dakota State University, Fargo**
Memorial Union Art Gallery
**Northeast Missouri State University, Kirksville**
E.M. Violette Museum
**Northern Arizona University, Flagstaff**
Northern Arizona University Art Museum and Galleries
**Northern Illinois University, DeKalb**
Anthropology Museum
NIU Art Museum
Northern Illinois University Art Gallery in Chicago
**Northern Kentucky University, Highland Heights**
Museum of Anthropology
Northern Kentucky University Art Museum
**Northern Oklahoma College, Tonkawa**
A.D. Buck Museum of Natural History and Science
**North Florida Junior College, Madison**
Art Gallery
**Northwestern Michigan College, Traverse City**
Dennos Museum Center
**Northwestern Oklahoma State University, Alva**
Stevens-Carter Natural History Museum
**Northwestern State University of Louisiana, Natchitoches**
Cammie G. Henry Research Center
**Northwestern University, Evanston, IL**
Mary and Leigh Block Gallery
**Northwest Missouri State University, Maryville**
DeLuce Fine Arts Gallery
**Norwich University, Northfield, VT**
Norwich University Museum
**Oakland University, Rochester, MI**

Meadow Brook Art Gallery
**Oberlin College, Oberlin, OH**
Allen Memorial Art Museum
**Ocean County College, Toms River, NJ**
Ocean County College Gallery
Robert J. Novins Planetarium
**Ohio State University, Columbus**
Chadwick Arboretum
Hopkins Hall Gallery
Ohio State University Planetarium
Orton Geological Museum
Wexner Center for the Arts
**Ohio University, Athens**
Trisolini Gallery
**Oklahoma State University, Stillwater**
Gardiner Art Gallery
Oklahoma Museum of Higher Education
Oklahoma State University Museum of Natural and Cultural History
**Old Dominion University, Norfolk, VA**
University Gallery
**Oregon State University, Corvallis**
Horner Museum
Mark O. Hatfield Marine Science Center Aquarium, Newport
Memorial Union Concourse Gallery
**Otero Junior College, La Junta, CO**
Koshare Indian Museum
**Otis College of Art and Design, Los Angeles, CA**
Otis Gallery
**Otterbein College, Westerville, OH**
Weitkamp Observatory/Planetarium
**Pacific School of Religion, Berkeley, CA**
Bade Institute of Biblical Archaeology and Howell Bible Collection
**Pacific University, Forest Grove, OR**
Pacific University Museum
**Palm Beach Community College, Lake Worth, FL**
Palm Beach Community College Museum of Art
**Palomar College, San Marcos, CA**
Boehm Gallery
**Panhandle State University, Goodwell, OK**
No Man's Land Historical Museum
**Parkland College, Champaign, IL**
Parkland College Art Gallery
William M. Staerkel Planetarium
**Passaic County Community College, Paterson, NJ**

Broadway Gallery
LRC Gallery
**Pembroke State University, Pembroke, NC**
Native American Resource Center
**Pennsylvania Academy of the Fine Arts, Philadelphia**
Museum of American Art
**Pennsylvania State University, University Park**
Clark Kerr Apple Variety Museum
Earth and Mineral Sciences Museum and Gallery
Frost Entomological Museum
Hetzel Union Galleries
Kern Exhibition Area
Mascaro/Steiniger Turfgrass Museum
Materials Research Laboratory Museum of Art and Science
Matson Museum of Anthropology
National Cable Television Center and Museum
Palmer Museum of Art
Pasto Agricultural Museum, Rock Springs
Pattee Library Galleries
East Corridor Gallery
Lending Services Gallery
Rare Books Room
West Lobby Gallery
Paul Robeson Cultural Center Gallery
Penn State Football Hall of Fame
Penn State Room/University Archives
Photo/Graphics Gallery
Shaver's Creek Environmental Center, Petersburg
Zoller Gallery
**Pensacola Junior College, Pensacola, FL**
Science and Space Theater
Visual Arts Center
**Philadelphia College of Textiles and Science, Philadelphia, PA**
Paley Design Center
**Phillips University, Enid, OK**
Grace Phillips Johnson Gallery
**Pittsburg State University, Pittsburg, KS**
Pittsburg State University Natural History Museum
**Plymouth State College, Plymouth, NH**
Karl Drerup Fine Arts Gallery
**Pomona College, Claremont, CA**
Montgomery Gallery
**Pratt Institute, Brooklyn, NY**
Pratt Manhattan Gallery, New York City

Rubelle and Norman Schafler Gallery
**Presbyterian College, Clinton, SC**
Harper Center Gallery
**Princeton University, Princeton, NJ**
The Art Museum
Milberg Gallery for the Graphic Arts
Princeton University Museum of Natural History
**Principia College, Elsah, IL**
Principia School of Nations Museum, Elsah and St. Louis, MO
**Purdue University, West Lafayette, IN**
Arthur Herbarium
Purdue University Galleries
**Queensborough Community College, Bayside, NY**
QCC Art Gallery
**Radford University, Radford, VA**
Radford University Galleries
**Rancho Santiago College, Santa Ana, CA**
Rancho Santiago College Art Gallery
**Randolph-Macon Woman's College, Lynchburg, VA**
Maier Museum of Art
**Reed College, Portland, OR**
Douglas F. Cooley Memorial Gallery
**Rhode Island School of Design, Providence, RI**
Museum of Art
**Rhodes College, Memphis, TN**
Rhodes College Herbarium
**Rice University, Houston, TX**
Sewall Art Gallery
**Richland College, Dallas, TX**
Richland College Planetarium
**Ricks College, Rexburg, ID**
Ricks College Planetarium
**Ringling School of Art and Design, Sarasota, FL**
Selby Gallery
**Rockford College, Rockford, IL**
Rockford College Art Gallery
**Rocky Mountain College of Art and Design, Denver, CO**
Philip J. Steele Gallery
**Rollins College, Winter Park, FL**
George D. and Harriet W. Cornell Fine Arts Museum
**Rowan College of New Jersey, Glassboro**
Westby Art Gallery
**Rutgers University, New Brunswick, NJ**
Jane Voorhees Zimmerli Art Museum
New Jersey Museum of Agriculture

Rutgers University Research and Display Gardens
**Rutgers University–Camden, Camden, NJ**
Stedman Art Gallery
**Saginaw Valley State University, University Center, MI**
Marshall M. Fredericks Sculpture Gallery
**Saint Anselm College, Manchester, NH**
Chapel Art Center
**Saint Bonaventure University, St. Bonaventure, NY**
University Art Gallery
**Saint Cloud State University, St. Cloud, MN**
Evelyn Payne Hatcher Museum of Anthropology
**Saint Francis College, Loretto, PA**
Southern Alleghenies Museum of Art
Southern Alleghenies Museum of Art at Altoona
Southern Alleghenies Museum of Art at Johnstown
**Saint Gregory's College, Shawnee, OK**
Mabee-Gerrer Museum of Art
**Saint John's College, Annapolis, MD**
Mitchell Art Gallery
**Saint Joseph College, West Hartford, CT**
Art Study Gallery
**Saint Joseph's University, Philadelphia, PA**
University Gallery
**Saint Lawrence University, Canton, NY**
Richard F. Brush Art Gallery
**Saint Mary's College of California, Moraga**
Hearst Art Gallery
**Saint Mary's College of Maryland, St. Mary's City**
Dwight Frederick Boyden Gallery
**Saint Olaf College, Northfield, MN**
Norwegian-American Historical Association Archives
Steensland Art Museum
**Salisbury State College, Salisbury, MD**
Salisbury State University Galleries
**Sam Houston State University, Huntsville, TX**
Sam Houston Memorial Museum
**San Diego State University, San Diego, CA**
E.C. Allison Research Center
University Art Gallery
**San Francisco Art Institute, San Francisco, CA**
Diego Rivera Gallery
Walter/McBean Gallery
**San Francisco State University, San Francisco, CA**
San Francisco State University Galleries

Art Gallery
Student Center Art Gallery
San Francisco State University Planetarium
Treganza Anthropology Museum
**San Joaquin Delta College, Stockton, CA**
Clever Planetarium and Earth Science Center
**San Jose State University, San Jose, CA**
Gallery 1
Union Gallery
**San Juan College, Farmington, NM**
San Juan College Planetarium
**Santa Clara University, Santa Clara, CA**
de Saisset Museum
**Santa Fe Community College, Gainesville, FL**
Santa Fe Community College Teaching Zoo
Santa Fe Gallery
**Santa Monica City College, Santa Monica, CA**
Santa Monica City College Planetarium
**Santa Rosa Junior College, Santa Rosa, CA**
Jesse Peter Museum
Santa Rosa Junior College Planetarium
**Scholl College of Podiatric Medicine, Chicago, IL**
Feet First Exhibit
**School of American Research, Santa Fe, NM**
Indian Arts Research Center
**School of the Art Institute of Chicago, Chicago, IL**
Betty Rymer Gallery
Gallery 2
**Scripps College, Claremont, CA**
Ruth Chandler Williamson Gallery
**Seton Hall University, South Orange, NJ**
Seton Hall University Museum
**Shasta-Tehama-Trinity Joint Community College, Redding, CA**
Shasta College Museum
**Sheldon Jackson College, Sitka, AK**
Sheldon Jackson Museum
**Siena Heights College, Adrian, MI**
Klemm Gallery
**Simpson College, Indianola, IA**
Farnham Galleries
**Sioux Valley Hospital School of Nursing, Sioux Falls, SD**
Sioux Empire Medical Museum
**Skidmore College, Saratoga Springs, NY**
Schick Art Gallery

**Smith College, Northampton, MA**
Botanic Garden of Smith College
Smith College Museum of Art
**Sonoma State University, Rohnert Park, CA**
University Art Gallery
**South Carolina State University, Orangeburg**
I.P. Stanback Museum and Planetarium
**South Dakota School of Mines and Technology, Rapid City**
Museum of Geology
**South Dakota State University, Brookings**
South Dakota Art Museum
State Agricultural Heritage Museum
**Southeast Missouri State University, Cape Girardeau**
Southeast Missouri State University Museum
**Southern Baptist Theological Seminary, Louisville, KY**
Joseph A. Callaway Archaeological Museum
**Southern Illinois University at Carbondale**
University Museum
**Southern Illinois University at Edwardsville**
University Museum
**Southern Illinois University School of Medicine, Springfield**
Pearson Museum
**Southern Methodist University, Dallas, TX**
Meadows Museum
**Southern Oregon State College, Ashland**
Museum of Vertebrate Natural History
Schneider Museum of Art
**Southern Utah University, Cedar City**
Braithwaite Fine Arts Gallery
**Southern Vermont College, Bennington**
Southern Vermont College Art Gallery
**Southwestern Michigan College, Dowagiac**
Southwestern Michigan College Museum
**Southwest State University, Marshall, MN**
Museum of Natural History
**Spertus College of Judaica, Chicago, IL**
Spertus Museum
**Stanford University, Stanford, CA**
B. Gerald Cantor Rodin Sculpture Garden
Keesing Museum of Anthropology
Stanford Art Gallery
Stanford University Museum of Art
**State University of New York at Albany**
University Art Museum

**State University of New York at Binghamton**
 University Art Museum
**State University of New York at Buffalo**
 Burchfield Penney Art Center
 Whitworth Ferguson Planetarium
**State University of New York at Stony Brook**
 Museum of Long Island Natural Sciences
 University Art Gallery
**State University of New York College at Brockport**
 Tower Fine Arts Gallery
**State University of New York College at Cortland**
 Bowers Science Museum
 Dowd Fine Arts Gallery
**State University of New York College at Fredonia**
 Michael C. Rockefeller Arts Center Gallery
**State University of New York College at Geneseo**
 Bertha V.B. Lederer Fine Arts Gallery
**State University of New York College at New Paltz**
 College Art Gallery
**State University of New York College at Oneonta**
 Science Discovery Center of Oneonta
**State University of New York College at Oswego**
 Tyler Art Gallery
**State University of New York College at Plattsburgh**
 SUNY Plattsburgh Art Museum
**State University of New York College at Potsdam**
 Roland Gibson Gallery
**State University of New York College at Purchase**
 Neuberger Museum of Art
**Stephen F. Austin State University, Nacogdoches, TX**
 Stone Fort Museum
**Stephens College, Columbia, MO**
 Davis Art Gallery
**Stetson University, DeLand, FL**
 Gillespie Museum of Minerals
 Pope and Margaret Duncan Gallery of Art
**Sul Ross State University, Alpine, TX**
 Museum of the Big Bend
**Swarthmore College, Swarthmore, PA**
 List Gallery
 Scott Arboretum
**Sweet Briar College, Sweet Briar, VA**
 Sweet Briar College Art Gallery
 Sweet Briar Museum

**Syracuse University, Syracuse, NY**
   Joe and Emily Lowe Art Gallery
   Syracuse University Art Collection
**Teikyo Westmar University, Le Mars, IA**
   Teikyo Westmar Gallery
**Temple University, Philadelphia, PA**
   Historical Dental Museum
   Tyler Galleries
      Elkins Park Campus Galleries
      Temple Gallery
**Tennessee Tech University, Smithville**
   Appalachian Center for Crafts
**Texas A&M University, College Station**
   J. Wayne Stark University Center Galleries
   MSC Forsyth Center Galleries
**Texas A&M University–Kingsville**
   John E. Conner Museum
**Texas Christian University, Fort Worth**
   Moudy Gallery
**Texas Lutheran College, Seguin**
   A.M. and Alma Fiedler Memorial Museum
**Texas Tech University, Lubbock**
   Museum of Texas Tech University
   Ranching Heritage Center
**Texas Woman's University, Denton**
   DAR Museum/First Ladies of Texas Historic Costumes Collection
   Texas Woman's University Art Galleries
      East Gallery
      West Gallery
**Thomas College, Waterville, ME**
   Thomas College Art Gallery
**Tougaloo College, Tougaloo, MS**
   Warren Hall Art Gallery
**Towson State University, Towson, MD**
   Roberts Gallery
**Transylvania University, Lexington, KY**
   Museum of Early Philosophical Apparatus
**Trinidad State Junior College, Trinidad, CO**
   Louden-Henritze Archaeology Museum
**Trinity College, Hartford, CT**
   Widener Gallery
**Tri-State University, Angola, IN**
   Lewis B. Hershey Museum
**Triton College, River Grove, IL**
   Cernan Earth and Space Center

**Troy State University, Montgomery, AL**
    W.A. Gayle Planetarium
**Tufts University, Medford, MA**
    Tufts University Art Gallery
**Tulane University, New Orleans, LA**
    Gallier House
    Newcomb Art Gallery
    Southeastern Architectural Archive
**Turabo University, Gurabo, PR**
    Archaeology Museum
**Tusculum College, Greeneville, TN**
    Doak-Johnson Heritage Museum
    President Andrew Johnson Museum and Library
**Tuskegee University, Tuskegee, AL**
    George Washington Carver Museum
**U.S. Air Force Academy, Colorado Springs, CO**
    Center for Educational Multimedia
    U.S. Air Force Academy Visitor Center
**U.S. Coast Guard Academy, New London, CT**
    U.S. Coast Guard Museum
**U.S. Military Academy, West Point, NY**
    West Point Museum
**U.S. Naval Academy, Annapolis, MD**
    U.S. Naval Academy Museum
**U.S. Naval War College, Newport, RI**
    Naval War College Museum
**Unity College, Unity, ME**
    Unity College Art Gallery
**Universities Research Association Inc., Batavia, IL**
    Fermi National Accelerator Laboratory
        Leon M. Lederman Science Education Center
        Observation Area
        Wilson Hall
**University Corporation for Atmospheric Research, Boulder, CO**
    National Center for Atmospheric Research
**University of Alabama, Tuscaloosa**
    Alabama Museum of Natural History
        Moundville Archaeological Park, Moundville
        Smith Hall Natural History Museum
    Gorgas House
    Moody Gallery of Art
    Paul W. Bryant Museum
    University of Alabama Arboretum
**University of Alabama at Birmingham**

Visual Arts Gallery
**University of Alabama in Huntsville**
Church Gallery
University Center Gallery
**University of Alaska Fairbanks**
University of Alaska Museum
**University of Arizona, Superior**
Boyce Thompson Southwestern Arboretum
**University of Arizona, Tucson**
Arizona State Museum
Center for Creative Photography
Flandrau Science Center and Planetarium
Student Union Galleries
Main Gallery
Open Lounge Gallery
University of Arizona Mineral Museum
University of Arizona Museum of Art
**University of Arkansas, Fayetteville**
University Museum
**University of Arkansas at Little Rock**
Fine Art Galleries
University of Arkansas at Little Rock Planetarium
**University of the Arts, Philadelphia PA**
Rosenwald-Wolf Gallery
**University of Baltimore, Baltimore, MD**
Steamship Historical Society of America Collection
**University of Bridgeport, Bridgeport, CT**
Carlson Gallery
**University of California**
Lick Observatory, Mount Hamilton
**University of California, Berkeley**
Jepson Herbarium
Lawrence Hall of Science
William K. Holt Planetarium
Lawrence Livermore National Laboratory, Livermore, CA
Visitors Center
Los Alamos National Laboratory, Los Alamos, NM
Bradbury Science Museum
University Art Museum and Pacific Film Archive
University Herbarium
University of California Botanical Garden
University of California Museums of Natural History
Museum of Paleontology
Museum of Vertebrate Zoology

        Essig Museum of Entomology

        Phoebe A. Hearst Museum of Anthropology

**University of California, Davis**

    Bohart Museum of Entomology

    Davis Arboretum

    Memorial Union Art Gallery

    Richard L. Nelson Gallery and Fine Arts Collection

**University of California, Irvine**

    Fine Arts Gallery

    Museum of Systematic Biology

        Herbarium

    University of California, Irvine, Arboretum

**University of California, Los Angeles**

    Fowler Museum of Cultural History

    Franklin D. Murphy Sculpture Garden

    Mildred E. Mathias Botanical Garden

    UCLA at the Armand Hammer Museum of Art and Cultural Center

        Grunwald Center for the Graphic Arts

        Wight Art Gallery

        UCLA Hannah Carter Japanese Garden

    UCLA Herbarium

**University of California, Riverside**

    California Museum of Photography

    UCR Entomological Teaching and Research Collection

    University Art Gallery

    University of California, Riverside, Botanic Gardens

**University of California, San Diego**

    Stephen Birch Aquarium-Museum

    Stuart Collection

    University Art Gallery

**University of California, Santa Barbara**

    University Art Museum

**University of California, Santa Cruz**

    UCSC Arboretum

**University of Chicago, Chicago, IL**

    David and Alfred Smart Museum of Art

    Oriental Institute Museum

    Renaissance Society

**University of Cincinnati, Cincinnati, OH**

    University of Cincinnati Geology Museum

**University of Colorado at Boulder**

    Fiske Planetarium and Science Center

    UMC Art Gallery

    University of Colorado Art Galleries

University of Colorado Heritage Center
University of Colorado Museum
    Herbarium
**University of Colorado at Colorado Springs**
    Gallery of Contemporary Art
**University of Connecticut, Storrs**
    Connecticut State Museum of Natural History
    William Benton Museum of Art
**University of Connecticut Health Center, New Britain**
    Friends Museum of the University of Connecticut Health Center
**University of Connecticut at Stamford**
    Bartlett Arboretum
**University of Delaware, Newark**
    University Gallery
**University of Denver, Denver, CO**
    Museum of Anthropology
**University of Florida, Gainesville**
    Florida Museum of Natural History
        Allyn Museum of Entomology, Sarasota
        Comparative Behavior Laboratory
        Herbarium
        Katharine Ordway Preserve, Melrose
        Swisher Memorial Sanctuary, Melrose
    Samuel P. Harn Museum of Art
    University Galleries
        Focus Gallery
        Grinter Gallery
        University Gallery
**University of Georgia, Athens**
    Georgia Museum of Art
    State Botanical Garden of Georgia
    University of Georgia Museum of Natural History
**University of Guam, Mangilao**
    Isla Center for the Arts
**University of Hartford, West Hartford, CT**
    Joseloff Gallery
    Museum of American Political Life
**University of Hawaii, Honolulu**
    Waikiki Aquarium
**University of Hawaii at Manoa**
    Art Gallery
    Harold L. Lyon Arboretum
    Mauna Kea Observatories, Hila
        Visitors' Information Station

**University of Houston, Houston, TX**
Sarah Campbell Blaffer Gallery
**University of Illinois at Chicago**
Gallery 400
Jane Addams' Hull-House Museum
**University of Illinois at Urbana-Champaign**
Krannert Art Museum and Kinkead Pavilion
Museum of Natural History
World Heritage Museum (Spurlock Museum)
**University of Iowa, Iowa City**
Museum of Natural History
Old Capitol
University of Iowa Hospitals and Clinics Medical Museum
University of Iowa Museum of Art
**University of Kansas, Kansas City**
Clendening History of Medicine Library and Museum
**University of Kansas, Lawrence**
Museum of Anthropology
Ryther Printing Museum
Spencer Museum of Art
University of Kansas Natural History Museum
    McGregor Herbarium
    Museum of Invertebrate Paleontology
    Natural History Museum
    Snow Entomological Museum
**University of Kentucky, Lexington**
Museum of Anthropology
Photographic Archives
University of Kentucky Art Museum
**University of Louisville, Louisville, KY**
Dario A. Covi Gallery
Joseph Rauch Memorial Planetarium
Morris B. Belknap Jr. Gallery
Photographic Archives
**University of Maine, Orono**
Fay Hyland Arboretum
Hudson Museum
Maynard E. Jordan Planetarium
Museums by Mail Program
University of Maine Herbarium
University of Maine Museum of Art
**University of Maryland at Baltimore**
Dr. Samuel D. Harris National Museum of Dentistry
**University of Maryland at College Park**

Art Gallery at the University of Maryland at College Park
**University of Massachusetts, Amherst**
Museum of Zoology
University Gallery
**University of Massachusetts, Dartmouth**
University Art Gallery
**University of Massachusetts, Lowell**
Center for Lowell Library
**University of Memphis, Memphis, TN**
Art Museum
C. H. Nash Museum–Chucalissa
**University of Miami, Coral Gables, FL**
Lowe Art Museum
**University of Michigan, Ann Arbor**
Jean Paul Slusser Gallery
Kelsey Museum of Archaeology
Matthaei Botanical Gardens
Nichols Arboretum
Stearns Collection of Musical Instruments
University of Michigan Museum of Art
University of Michigan Museums of Natural History
Exhibit Museum
Museum of Anthropology
Museum of Paleontology
Museum of Zoology
University of Michigan Herbarium
**University of Michigan–Dearborn**
Henry Ford Estate
**University of Minnesota, Duluth**
Glensheen
Tweed Museum of Art
**University of Minnesota, Twin Cities, Minneapolis**
Frederick R. Weisman Art Museum
Goldstein Gallery, St. Paul
James Ford Bell Museum of Natural History
Minnesota Landscape Arboretum, Chanhassen
**University of Mississippi, University, MS**
University Museums
Kate Skipwith Teaching Museum
Mary Buie Museum
**University of Missouri–Columbia**
Museum of Anthropology
Museum of Art and Archaeology
State Historical Society of Missouri Gallery

**University of Missouri–Kansas City**
University of Missouri–Kansas City Gallery of Art
**University of Missouri–Rolla**
Minerals Museum
**University of Montana, Missoula**
Museum of Fine Arts
    Paxson Gallery
University of Montana Zoological Museum and Herbarium
**University of Nebraska–Kearney**
Museum of Nebraska Art
**University of Nebraska–Lincoln**
Center for Great Plains Studies Art Collection
Sheldon Memorial Art Gallery and Sculpture Garden
University of Nebraska State Museum
    Ashfall Fossil Beds State Historical Park, Royal
    Ralph Mueller Planetarium
    Trailside Museum, Crawford
**University of Nebraska–Omaha**
Mallory Kountze Planetarium
**University of Nevada at Las Vegas**
Donna Beam Fine Art Gallery
Marjorie Barrick Museum of Natural History
**University of Nevada at Reno**
Fleischmann Planetarium
Sheppard Fine Arts Gallery
W. M. Keck Museum
**University of New Hampshire, Durham**
The Art Gallery
Jesse Hepler Arboretum
**University of New Mexico, Albuquerque**
Harwood Foundation Museum, Taos
Jonson Gallery
Maxwell Museum of Anthropology
Meteorite Museum
Museum of Southwestern Biology
University Art Museum
**University of North Carolina at Asheville**
Botanical Gardens of Asheville
**University of North Carolina at Chapel Hill**
Ackland Art Museum
Coker Arboretum
Morehead Planetarium
North Carolina Botanical Garden
**University of North Carolina at Greensboro**

Weatherspoon Art Gallery
**University of North Dakota, Grand Forks**
North Dakota Museum of Art
University of North Dakota Zoology Museum
**University of Northern Colorado, Greeley**
Mariani Gallery
**University of Northern Iowa, Cedar Falls**
Gallery of Art
University of Northern Iowa Museum
**University of North Texas, Denton**
University of North Texas Art Gallery
Cora Stafford Gallery
Lightwell Gallery
**University of Notre Dame, Notre Dame, IN**
Greene-Nieuwland Herbarium
Snite Museum of Art
**University of Oklahoma, Norman**
Fred Jones Jr. Museum of Art
Oklahoma Museum of Natural History
Robert Bebb Herbarium
**University of Oregon, Eugene**
Museum of Natural History
University of Oregon Museum of Art
**University of the Pacific, Stockton, CA**
University of the Pacific Herbarium
**University of Pennsylvania, Philadelphia**
Arthur Ross Gallery
Institute of Contemporary Art
Morris Arboretum of the University of Pennsylvania
University of Pennsylvania Museum of Archaeology and Anthropology
**University of Pittsburgh, Pittsburgh, PA**
Stephen C. Foster Memorial
University Art Gallery
**University of Puerto Rico, Rio Piedras**
Marine Sciences Museum, Mayaguez
Museum of Anthropology, History, and Art
**University of Puget Sound, Tacoma, WA**
James R. Slater Museum of Natural History
Kittredge Gallery
**University of Redlands, Redlands, CA**
Peppers Art Gallery
**University of Rhode Island, Kingston**
Fine Arts Center Galleries
**University of Richmond, Richmond, VA**

Lora Robins Gallery of Design from Nature
Marsh Art Gallery
Virginia Baptist Historical Society Exhibit Area and Archives
**University of Rochester, Rochester, NY**
Memorial Art Gallery
**University of San Diego, San Diego, CA**
Founders Gallery
Mission Basilica de Alcala
**University of the South, Sewanee, TN**
University Gallery
**University of South Alabama–Springhill**
Eichold-Heustis Medical Museum of the South
**University of South Carolina, Columbia**
McKissick Museum
South Carolina Institute of Archaeology and Anthropology
**University of South Carolina at Spartanburg**
George E. Case Collection of Antique Keyboards
**University of South Dakota, Vermillion**
Shrine to Music Museum
University Art Galleries
W. H. Over State Museum
**University of Southern California, Los Angeles**
Fisher Gallery
**University of Southern Indiana, Evansville**
Historic New Harmony, New Harmony
New Harmony Gallery of Contemporary Art, New Harmony
**University of Southern Maine, Gorham**
Art Gallery
**University of Southern Mississippi, Biloxi**
J. L. Scott Marine Education Center and Aquarium
**University of South Florida, Tampa**
Contemporary Art Museum
**University of Southwestern Louisiana, Lafayette**
University Art Museum
**University of Tampa, Tampa, FL**
Hartley Gallery
Lee Scarfone Gallery
**University of Tennessee at Chattanooga**
George Ayers Cress Gallery of Art
**University of Tennessee at Knoxville**
Frank H. McClung Museum
University of Tennessee Arboretum, Oak Ridge
**University of Tennessee at Martin**

University Museum
**University of Texas at Arlington**
  Center for Research in Contemporary Art
**University of Texas at Austin**
  Archer M. Huntington Art Gallery
  Lyndon Baines Johnson Library and Museum
  McDonald Observatory, Fort Davis
      W. L. Moody Jr. Visitors' Information Center
  Sam Rayburn Library and Museum, Bonham
  Texas Memorial Museum
  Winedale Historical Center, Round Top
**University of Texas at Dallas**
  History of Aviation Collection, Richardson
      Frontiers of Flight Museum
**University of Texas at El Paso**
  Centennial Museum
**University of Texas at San Antonio**
  Art Gallery
  University of Texas Institute of Texan Cultures at San Antonio
**University of Utah, Salt Lake City**
  Red Butte Garden and Arboretum
  Utah Museum of Fine Arts
  Utah Museum of Natural History
**University of Vermont, Burlington**
  Francis Colburn Gallery
  Robert Hull Fleming Museum
**University of Virginia, Charlottesville**
  Bayly Art Museum
  Carr's Hill Gardens
  Leander J. McCormick Observatory
  Morea Gardens
  Orland E. White Arboretum, Boyce
  Pavilion Gardens
  The Rotunda
  University of Virginia Health Sciences Center Children's Museum
**University of Washington, Seattle**
  Henry Art Gallery
  Thomas Burke Memorial Washington State Museum
  Washington Park Arboretum
**University of West Florida, Pensacola**
  University of West Florida Art Gallery
**University of Wisconsin–Eau Claire**
  Foster Gallery
**University of Wisconsin–LaCrosse**

University of Wisconsin–LaCrosse Planetarium
**University of Wisconsin–Madison**
Elvehjem Museum of Art
Helen Louise Allen Textile Collection
University of Wisconsin–Madison Arboretum
University of Wisconsin Zoological Museum
Wisconsin Union Art Galleries
Porter Butts Gallery
**University of Wisconsin–Milwaukee**
Greene Memorial Museum
Manfred Olson Planetarium
Union Art Gallery
UWM Art Museum
Art History Gallery
Fine Arts Gallery
**University of Wisconsin–River Falls**
Gallery 101
**University of Wisconsin–Stevens Point**
Museum of Natural History
Planetarium and Observatory
**University of Wisconsin–Stout, Menominie**
John Furlong Gallery
**University of Wisconsin–Whitewater**
Crossman Gallery
**University of Wyoming, Laramie**
American Heritage Center
Geological Museum
Rocky Mountain Herbarium
Solheim Mycological Herbarium
U.S. Forest Service National Herbarium
University of Wyoming Anthropology Museum
University of Wyoming Art Museum
**Ursinus College, Collegeville, PA**
Philip and Muriel Berman Museum of Art
**Utah State University, Logan**
Intermountain Herbarium
Nora Eccles Harrison Museum of Art
Ronald V. Jensen Living Historical Farm, Wellsville
**Valdosta State University, Valdosta, GA**
Fine Arts Gallery
**Valencia Community College, Orlando, FL**
East Campus Galleries
**Valparaiso University, Valparaiso, IN**
Museum of Art

**Vanderbilt University, Nashville, TN**
  Vanderbilt Fine Arts Gallery
  Vanderbilt University Arboretum
**Vassar College, Poughkeepsie, NY**
  Frances Lehman Loeb Art Center
**Vermont College, Montpelier**
  Wood Art Gallery
**Virginia Commonwealth University, Richmond**
  Anderson Gallery
**Virginia Military Institute, Lexington**
  George C. Marshall Foundation Museum
  Hall of Valor Civil War Museum and New Market
      Battlefield Historical Park, New Market
  Klink Observatory
  Virginia Military Institute Museum
**Virginia Polytechnic Institute and State University, Blacksburg**
  American Work Horse Museum, Paeonian Springs
  Cyrus H. McCormick Memorial Museum, Steeles Tavern
  Museum of the Geological Sciences
  Reynolds Homestead, Critz
  Virginia Museum of Natural History
**Wake Forest University, Winston-Salem, NC**
  Fine Arts Gallery
  Museum of Anthropology
  Reynolda Gardens
**Washburn University, Topeka, KS**
  Mulvane Art Museum
**Washington and Jefferson College, Washington, PA**
  Olin Fine Arts Gallery
**Washington and Lee University, Lexington, VA**
  Du Pont Gallery
  Lee Chapel and Museum
  Reeves Center for Research and Exhibition of Porcelain and Paintings
**Washington State University, Pullman**
  Charles R. Conner Museum
  Museum of Anthropology
  Museum of Art
**Washington University, St. Louis, MO**
  Washington University Gallery of Art
**Watkins Institute, Nashville, TN**
  Watkins Institute Art Gallery
**Wayland Baptist University, Plainview, TX**
  Museum of the Llano Estacado
**Wayne State University, Detroit, MI**

Museum of Natural History
Wayne State University Community Arts Gallery
Wayne State University Museum of Anthropology
**Weber State University, Ogden, UT**
Art Gallery
**Webster University, St. Louis, MO**
Hunt Gallery
**Wellesley College, Wellesley, MA**
Alexandra Botanic Garden
Davis Museum and Cultural Center
Hunnewell Arboretum
Margaret C. Ferguson Greenhouses
**Wenatchee Valley College, Wenatchee, WA**
Gallery '76
**Wesleyan University, Middletown, CT**
Davison Art Center
Ezra and Cecile Zilkha Gallery
**West Chester University, West Chester, PA**
Geology Museum
McKinney Gallery
Planetarium and Observatory
**Western Carolina University, Cullowhee, NC**
Mountain Heritage Center
**Western Illinois University, Macomb**
Western Illinois University Art Gallery/Museum
**Western Kentucky University, Bowling Green**
Hardin Planetarium
Kentucky Museum
Western Kentucky University Gallery
**Western Michigan University, Kalamazoo**
Western Michigan University Art Galleries
Gallery II
Space Gallery
Student Art Gallery
Rotunda Gallery
South Gallery
**Western Montana College, Dillon**
Western Montana College Gallery-Museum
**Western New Mexico University, Silver City**
Francis McCray Galleries
Western New Mexico University Museum
**Western Oregon State College, Monmouth**
Paul Jensen Arctic Museum
**Western Texas College, Snyder**

Scurry County Museum
**Western Washington University, Bellingham**
Viking Union Gallery
Western Gallery
**Westminster College, Fulton, MO**
Winston Churchill Memorial and Library in the United States
**West Texas A&M University, Canyon**
Panhandle-Plains Historical Museum
T-Anchor Ranch House
**West Virginia University, Morgantown**
Comer Museum
Core Arboretum
Creative Arts Center Galleries
Jackson's Mill Museum, Weston
**Wheaton College, Norton, MA**
Watson Gallery
**Wheaton College, Wheaton, IL**
Billy Graham Center Museum
**Whitman College, Walla Walla, WA**
Donald H. Sheehan Gallery
**Wichita State University, Wichita, KS**
Edwin A. Ulrich Museum of Art
**Widener University, Chester, PA**
Widener University Art Museum
**Wilkes University, Wilkes-Barre, PA**
Sordoni Art Gallery
**William Paterson College of New Jersey, Wayne**
Ben Shahn Galleries
**Williams College, Williamstown, MA**
Chapin Library of Rare Books
Williams College Museum of Art
Prendergast Archive and Study Center
**Winston-Salem State University, Winston-Salem, NC**
Diggs Gallery
Sculpture Garden
**WIYN Consortium, Tucson, AZ**
WIYN Observatory, Kitt Peak
**Wofford College, Spartanburg, SC**
Sandor Teszler Library Gallery
Wofford College Planetarium
**Wright State University, Dayton, OH**
Wright State University Galleries
**Xavier University, Cincinnati, OH**
Xavier University Art Gallery

**Yakima Valley Community College, Yakima, WA**
 Larson Gallery
**Yale University, New Haven, CT**
 Harvey Cushing/John Hay Whitney Medical Library/Historical Library
 Marsh Botanical Garden
 Peabody Museum of Natural History
 Yale Center for British Art
 Yale University Art Gallery
 Yale University Collection of Musical Instruments
**Yeshiva University, New York, NY**
 Yeshiva University Museum
**Youngstown State University, Youngstown, OH**
 John J. McDonough Museum of Art
 Ward Beecher Planetarium

# Selected Bibliography

Adlmann, Jan Ernest. "Museums in Academic Garb" (report on two symposia held at Vassar College). *Museum News,* Vol. 67, No. 2, 1988, p. 46.

Alexander, Edward P. *Museums in Motion: An Introduction to the History and Functions of Museums.* Nashville, TN: American Association for State and Local History, 1979.

American Association of Museums. "Toward Working with University Natural History Museums." *Curator,* Vol. 35, No. 2, 1992, pp. 93–94.

Auer, H. "The Curator-University Professor." In *Museum and Research* (papers from the Eighth General Conference of ICOM), pp. 104–110. Munich: Deutsches Museum, 1970.

Baramki, D. "The Museum and the Student." In *Museum and Research* (papers from the Eighth General Conference of ICOM), pp. 30–38. Munich: Deutsches Museum, 1970.

Birney, Elmer C. "Collegiate Priorities and Natural History Museums." *Curator,* Vol. 37, No. 2, 1994, pp. 99–107.

Black, C.C. "Dilemma for Campus Museums: Open Door or Ivory Tower?" *Museum Studies Journal,* Vol. 4, 1984, pp. 20–23.

Bryant, Edward. "The Boom in U.S. University Museums." *Artnews,* September 1967, pp. 30–47, 73–75.

Burcaw, G. Ellis. "Museum Training: The Responsibility of College and University Museums." *Museum News,* Vol. 47, No. 4, 1969, pp. 15–16.

Cato, Paisley S. "The Effect of Governance Structure on the Characteristics of a Sample of Natural History–Oriented Museums." *Museum Management and Curatorship,* Vol. 12, 1993, pp. 73–90.

Coleman, Laurence Vail. *The Museum in America.* Vol. 1. Washington, DC: American Association of Museums, 1939.

―――. *College and University Museums: A Message for College and University Presidents.* Washington, DC: American Association of Museums, 1942.

Coolidge, John. "The University Art Museum in America." *Art Journal,* Vol. 26, No. 3, p. 11.

Craig, Tracey Linton. "Off-Campus Audiences Benefit from Museums in Academe." *Museum News,* Vol. 67, No. 2, 1988, pp. 52–55.

Cuno, James. *Assets? Well, Yes—of a Kind.* Harvard University Art Museums Occasional Papers, Cambridge: Vol. 1, 1992.

Danilov, Victor J. "Museum Systems and How They Work." *Curator,* Vol. 33, No. 4, 1990, pp. 306–311.

―――. *Museum Careers and Training: A Professional Guide.* Westport, CT: Greenwood Press, 1994.

Davis, Gordon. "Financial Problems Facing College and University Museums." *Curator,* Vol. 19, No. 1, 1976, pp. 116–122.

Diamond, Judy. "University Natural History Museums and Public Service." *Curator,* Vol. 35, No. 2, 1992, pp. 89–93.

Feldstein, Martin, ed. *The Economics of Art Museums.* Chicago: University of Chicago, 1991.

Freedman-Harvey, G. "University Museums and Accreditation." *ACUMG Newsletter,* Vol. 6, No. 1, 1989, pp. 5–7.

Freundich, August T. "Is There Something the Matter with College Museums?" *Art Journal,* Vol. 24, Winter 1965, pp. 150–151.

Gaines, Thomas A. *The Campus as a Work of Art.* Westport, CT: Praeger Publishers, 1991.

Heffernan, Hdiko. "The Campus Art Museum Today." *Museum News,* Vol. 65, No. 5, 1987, pp. 26–35.

Hill, May Davis. "The University Art Museum." *Curator,* Vol. 10, No. 1, 1966, p. 16.

Holo, Selma. "The University Museum: Creating a Better Fit." *ACUMG Newsletter,* Vol. 1, No. 1, 1993/1994, pp. 1–3.

Humphrey, Philip S. "The Nature of University Natural History Museums." In *Natural History Museums: Directions for Growth,* edited by Paisley S. Cato and Clyde Jones, pp. 5–11. Lubbock: Texas Tech University Press, 1991.

―――. "University Natural History Museum Systems." *Curator,* Vol. 35, No. 1, 1992, pp. 49–70.

Huntley, David, Lyndel King, and Tom Toperzer. *Current Issues in University Museums 1986.* Edwardsville, IL: Southern Illinois University at Edwardsville; University of Minnesota, Twin Cities; and University of Oklahoma, 1986.

King, Mary Elizabeth. "University Museum Staffs: Whom Do They Serve?" *Museum News,* Vol. 58, No. 1, 1979, p. 27.

Newsom, Barbara Y., and Adele Z. Silver, eds. *The Art Museum as Educator.* Berkeley: University of California Press, 1978.

Odegaard, Charles E. "The University and the Museum." *Museum News,* Vol. 42, September 1963, p. 34.

Rodeck, Hugo G. "The University Museum." In *Museums and Research* (papers from the Eighth General Conference of ICOM), pp. 39–44. Munich: Deutches Museum, 1970.

Rosenbaum, Allen. "Where Authority Resides." *Museum News,* Vol. 67, No. 2, 1988, pp. 47–48.

Schmidt, Karl P. "The Function of the University Museum." *Museum News,* Vol. 30, No. 5, 1987, pp. 5–8.

Shapiro, Michael Steven, with Louis Ward Kemp. *The Museum: A Reference Guide.* Westport, CT: Greenwood Press, 1990.

Sloan, Blanche Carlton, and Bruce R. Swinburne. *Campus Art Museums and Galleries.* Carbondale: Southern Illinois University Press, 1981.

Solinger, Janet W., ed. *Museums and Universities: New Paths for Continuing Education.* New York: American Council on Education and Macmillian Publishing Co., 1990.

Spencer, John R. "The University Museum: Accidental Past, Purposeful Future?" In *Museums in Crisis,* edited by Brian O'Doherty, pp. 131–143. New York: George Braziller Inc., 1972.

Tirrell, Peter B. "Memote Control: Strategic Planning for Museums." *ACUMG Newsletter,* Vol. 1, No. 4, 1994, pp. 2–9.

Vassar College Art Gallery. *Museums in Academe II* (proceedings of a symposium). Poughkeepsie, NY: Vassar College Art Gallery, 1988.

Waller, Bret. "Museums in the Groves of Academe." *Museum News,* Vol. 58, No. 1, 1980, pp. 17–23.

Warhurst, Alan. "University Museums." In *Manual of Curatorship: A Guide to Museum Practice,* edited by John M. A. Thompson, pp. 93–100. 2nd ed. Oxford, England: Butterworth-Heinemann Ltd., 1992.

Williams, Stephen. "A University Museum Today." *Curator,* Vol. 12, No. 4, 1969, pp. 293–306.

Wilson, Ronald C. "Obscured by Ivory Towers." *Museum News,* Vol. 67, No. 2, 1988, pp. 48–50.

Wittkowever, Rudolf. "The Significance of the University Museum in the Second Half of the Twentieth Century." *Art Journal,* Vol. 27, No. 4, 19, p. 178.

Zeller, Terry. "The Role of the Campus Art Museum." *Curator,* Vol. 28, No. 2, 1985, pp. 87–95.

# Index

**About the Author**

VICTOR J. DANILOV is Director of the Museum Management Program at the University of Colorado. He is the former president and director of Chicago's Museum of Science and Industry. He is the author or editor of 16 books, including *Museum Careers and Training* (Greenwood, 1994), *Corporate Museums, Galleries, and Visitor Centers* (Greenwood, 1991), *Planning Guide to Corporate Museums* (Greenwood, 1991), and *America's Science Museums* (Greenwood, 1990), in addition to many professional articles. Danilov has served as consultant for the development of museums around the world.

ISBN 0-313-28613-2

90000>

EAN

9 780313 286131

HARDCOVER BAR CODE